LIGHTING
FOR ACTION

LIGHTING
FOR ACTION

JOHN HART

AMPHOTO
An Imprint of Watson-Guptill Publications/New York

John Hart is a professional photographer who writes, lights, and produces theatrical, film, and video projects. His company, JH Productions, is located in New York City, and his radio and television talks on photography have brought him national exposure. His photographs have been exhibited at the Louvre, as well as New York City's Nikon House and Soho Photo gallery. Hart received his B. A. from Fordham University and his M. A. from Notre Dame. He is also the author of the best-selling Amphoto title, *50 Portrait Lighting Techniques for Pictures that Sell* (1983).

Editorial concept by Robin Simmen
Page layout by Bob Fillie, Graphiti Graphics
Graphic production by Hector Campbell

Copyright © 1992 by John Hart
First published 1992 in New York by AMPHOTO,
an imprint of Watson-Guptill Publications,
a division of BPI Communications, Inc.,
1515 Broadway, New York, NY 10036

Library of Congress Cataloging-in-Publication Data
Hart, John.
 Lighting for action/John Hart.
 Includes index.
 ISBN 0-8174-4225-1 (cloth)
 ISBN 0-8174-4226-X (pbk.)
 1. Cinematography—Lighting. 2. Television—Lighting.
 I. Title.
 TR891.H37 1992
 778.5'2343—dc20 91-43986
 CIP

Manufactured in Singapore

1 2 3 4 5 6 7 8 9/99 98 97 96 95 94 93 92

Special huzzahs to Joe Bevelacqua, Bill Cress, Herb Fogelson, Les Johnson, Ron Massaro, Charles Matz, Jim McKenny, and Maureen Sheehan; my sister, Kate Hart, who is a great listener; and Amphoto Senior Editor Robin Simmen and Editor Liz Harvey.

To Jim Hanlon, my co-producer, who was with me through all the highs and lows of production.

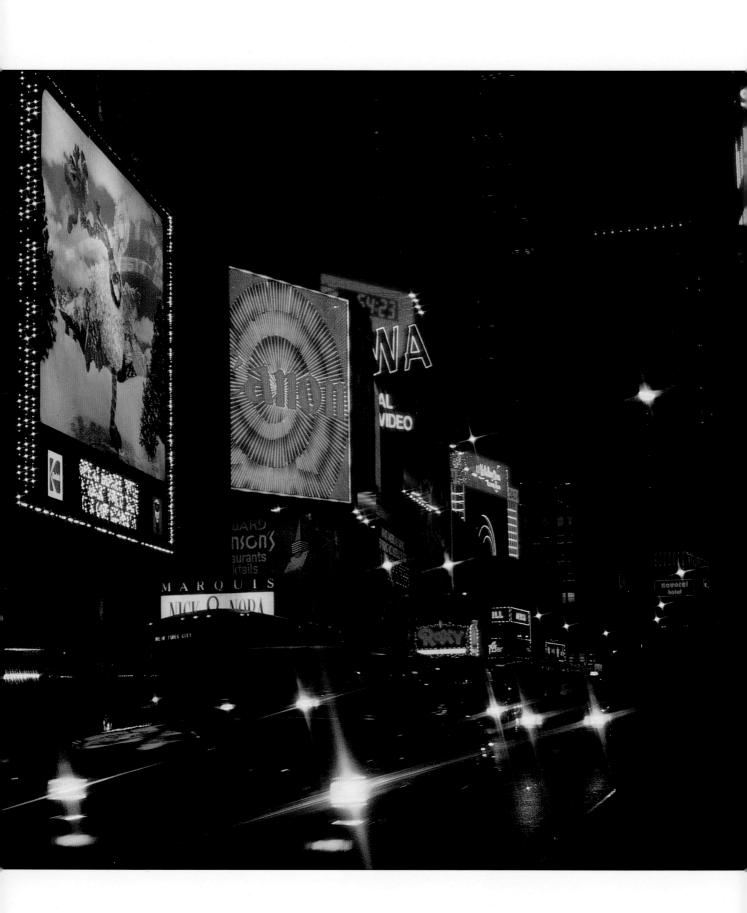

CONTENTS

INTRODUCTION

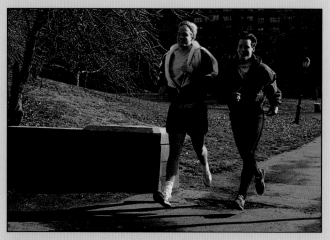

When you decide to make the switch from still photography to film or video, you can begin shooting subjects in available light and then advance to more challenging projects.

In the beginning there was light—outdoor light. And in the beginning there was only still photography: portraits, still lifes, and scenics. Then came Thomas Edison, who invented the motion-picture camera. Suddenly, still images began to move. This happened a *century* ago. So what are you waiting for?

Lighting for Action isn't meant to be a technical manual or a film-equipment catalog. It is intended to help you, the still-portrait photographer, to create new, vital live-action video and film images—starting with your present equipment. The purpose of *Lighting for Action* is to enable you to move up to a higher, more professional level by shooting broadcast-quality projects like those commonly seen on television or in the movies. Of course, superior lighting still makes a big difference no matter what camera you use, whether it is a Sony camcorder that costs 2,000 dollars or a Sony studio camera that costs 100,000 dollars.

So now that you've finally convinced yourself that there is more to photographic life than still photography, it is time to expand your lighting horizons. You want to learn the lighting secrets of the "pros." What techniques do they use to get those beautifully lighted images? Surprisingly, their "secrets" don't require anything that is very far off from what you and other still photographers have at your disposal; you can use the equipment that is already available in your present studio lighting setups to unleash your imagination.

Remember, artists can be intimidated or even swallowed up by too much technical data. Lights, cameras, and meters are only the tools—the "paints and brushes"—that artists use to achieve the final "moving" images. Fortunately, today's new high-speed films and more light-sensitive videotapes make recording action in various types of light with these tools easier than ever. But simply pointing a camera at people and filming them isn't enough. This just puts you in the category of movie buffs known as "home-movie" makers who shoot footage that might be interesting to members of their immediate family but is often boring to outsiders. Ideas are the thing. Creativity is the watchword. You actually become the "director of photography" when you move into video and film.

You'll also join the ranks of people who were fascinated by the idea of capturing motion on film in the first part of this century. During the silent-movie era, faster films and more sophisticated cameras and lenses were perfected. Because these cameras recorded action and images that were illuminated entirely by the sun, early moviemakers moved to Southern California. They needed to have consistent sunlight when they were working because it was their main, or "key," light. The sun was used for shooting not only exteriors but also interiors. Because the filmmakers' interior rooms, or sets, didn't have any ceilings, they stretched white silk or cotton sheets over the sets to diffuse the sun's glare; this softened the harsh sunlight on the actors.

D. W. Griffith, one of these pioneers, is credited with inventing the "language" of filmmaking, coming up with such terms as the "long shot," the "medium shot," the "closeup," the "crane shot," the "tracking shot," "editing," and "montage." But many people often overlook that Billy Bitzer, Griffith's camera operator and lighting designer, also helped perfect the use of key lighting; "backlighting"; "fill lighting"; and "rim lighting," among others. Together, these film geniuses gave the moviegoing public a much more dynamic and aesthetically satisfying visual experience. They had expanded their lighting horizons.

Going one step further, Griffith and Bitzer, who wanted to make Lillian Gish, their leading lady, look even more gorgeous on film, placed a newly developed electric "spotlight" on a tall stand and focused it directly on her face. This separated her from the rest of the world, putting her in a special, glamorous realm of her own. Next, they covered the camera lens with a piece of silk both to soften Gish's face and to give her an ethereal "glow." Griffith and Bitzer perfected a softer spotlight and placed it behind the actress in darker scenes to give her hair a halo of light, which also separated her from the background.

Bitzer realized that Gish looked even more attractive outside when she was in shaded light. Then he noticed that when she stood next to a white wall with her back to the sunlight, the wall threw a bounced light onto her face that was very flattering. This was how reflected light was identified for the first time. Griffith and Bitzer found that when they photographed moving figures in a given amount of space, there was both more interest and more life in the scenes when illuminated from several different angles. Instead of flat figures moving around on a flat film emulsion, Griffith and Bitzer now had forms that imitated three-dimensional reality.

So, you ask, what does this short history of film lighting have to do with expanding your lighting horizons? A great deal. These early techniques are still being used today, even in rock videos. And as you make the move from still to action photography, you'll emulate those pioneer filmmakers. Although this approach might sound overwhelming or overly ambitious, you'll see that you can adapt most of the lighting setups illustrated in *50 Portrait Lighting Techniques for Pictures That Sell*, my first book for Amphoto, to your needs as a new video/film professional. The key light is in exactly the same spot, and a "hair" light, a "back" light, and a "fill" light for shadows are used. You might decide on a "kicker" light that falls on the back of the subject or an "eye" light that adds an extra highlight to the eyes. Although the number and type of lights required may increase with video and film, the arrangement of the lights is basically the same as in still photography.

In addition, even the lenses you've always used for still photography can be adapted to certain camcorder models. Movie cameras also take medium-format lenses; portrait lenses, such as the 105mm lens, for closeups; and wide-angle lenses for expanded views. Video/film professionals also experiment with diffusion screens, fabric, colored gels and filters, as well as other image-manipulation devices. So still photographers often feel quite at ease as they switch to video and/or film. As a matter of fact, still photographers have often been ahead in this area because of their expertise with different cameras, and various lenses and meters, as well as lighting.

One of the only differences between still photography and video/film work is the names given to the types of shots. Instead of "head," "head-and-shoulders," and "full-length" shots, you'll use such Hollywood-screenplay terms as "closeup," "medium," and "long" shots. For video and film work, the term "closeup" simply means that you're lighting a regular portrait setup, only now your subject speaks. When the screenplay calls for that same subject to get up and go into the kitchen for a cup of coffee, you're lighting for a medium shot. If the subject suddenly runs out of the house, you must zoom back with the camera to get a long shot. To

simplify matters, you don't have to light medium and long shots as carefully or in as much detail as the "star's" closeups. A fill light and a back light are usually enough for medium and long shots.

In *Lighting for Action*, I use photographs, diagrams, and storyboards to explain these fundamental concepts thoroughly. I offer many suggestions to help you get your feet wet. Ideas for shooting such subjects as a soap opera, a commercial, a scene from a dramatic movie, an MTV-like rock video, a standup comic's routine, and a nightclub act are illustrated. Becoming familiar with these possible projects and mastering the technical aspects will help you to step up into the lucrative world of professional-level lighting for action. Don't let any technical books on the subject of lighting throw you. Rise above details; you already know the basics anyway, such as color temperatures and depth of field. Your main job now is deciding how you want to shoot your footage. Ask yourself the following questions: Are you going to use video or film? Are you going to buy a good camcorder or a good movie camera? Is your primary goal to get into television or film production? As you make these essential decisions, keep in mind that, technical books and electronic gadgetry aside, the greatest filmmakers were the creative ones with imagination, verve, and daring. They broke new ground and explored new vistas. They knew their equipment yet they weren't controlled by it. They rose above it—probably on a movie crane.

Before you make your final decision, consider these variables. With video cameras, electronic silicon chips control light metering. Unlike movie cameras, which involve film and film speeds, camcorders are concerned with videotape and foot candles (lux). Also, video cameras are more light sensitive than still or movie cameras. Low lux ratings seem to be a selling point, but you can't get sharp shots in continual low-light situations. A lux is 1/10th of a foot candle. So the difference in lighting is apparent. Camcorders that range in price from 1,000 to 2,000 dollars are light sensitive from 4

to 10 lux. Very expensive models can reach 2,000 lux and require still-photography lighting equipment to be diffused and placed farther away from the subject. (The reasons for this "less-light" approach with the camcorder will become clear when you experiment a bit.)

The film speed, or ISO rating, on film cameras or movie cameras remains constant, but can be "pushed" from ISO 400 to ISO 1000 for low-light situations. The newer Kodak movie films with speeds of up to ISO 5947 for day shooting and ISO 5994 for night shooting determine what the meter reading will be. However, on video cameras, the ISO rating has been eliminated. You simply turn on the camcorder, check the white balance, and shoot; the lens openings, film speed, and color resolution are taken care of for you.

Video cameras and movie cameras are in a constant state of flux, but the basic lighting techniques discussed here provide a lasting reference source that will give you a sense of security whichever format you choose. There is a fantastic amount of expensive equipment out there but who could possibly own—or need— each and every piece of it? You already have your own equipment, so you are off to a good start. In fact, the advice many of the top cinematographers and videographers offer is "Keep it simple." And you'll find that the illustrations in this book are just that: simple, but effective and professional. Motivating you to produce top-notch lighting for your performers and their surroundings is my primary goal. If you can do that, you can compete more effectively with the professionals working in the film/video market. And to help you understand what being behind the camera is really like, four working professionals offer an insider's view of the film/video industry (see pages 140-141). They explain their roles, offer practical advice, and discuss their projects.

In Sony advertisements, you're referred to as a "Pro Plus"; in Lowell lighting ads, you are the "New Pro"; and in Panasonic ads, you're called "Pro Video." To me, in that same vein, you are now an "Action Pro." Go for it!

GETTING
STARTED

I'm getting ready to shoot with my Ikegami studio video camera at ELA Studios in New York City. (© James Hanlon.)

Perhaps after years of still photography—shooting portraits and still-life images—you've reached the point where you want to expand your lighting horizons and to get into video and/or film. Making the switch from still photography to live-action photography is simple because you can use exactly the same hot lights and backgrounds. Perhaps *Lighting for Action* will push you over the edge. "Lights, camera, action!" might even become your motto.

Once you know that you are ready to make the big move to shooting live action, your primary concern is choosing a format. More still photographers seem to switch to videography rather than cinematography partly because they can make more money more quickly with a video camera. (See Chapter 8 for more information on ways to supplement and increase your present income.) Of course, the expanding video market for weddings, birthdays, bar and bas mitzvahs, anniversaries, and family video albums is perfect for beginners. These opportunities may even make it possible for you to move up to shooting *industrials*, which consist of a company's manufacturing procedures and product lines, as well as the marketing and sales of each of those lines. The main thrust of industrials is to illustrate a company's excellence and product superiority.

Training films, on the other hand, are simply videos or films geared toward a company's new employees. In essence, they are teaching tools that explain how the employee's particular job functions, what the job's goals are, and what methods produce maximum results. *Commercials* are usually 15, 30, or 60 seconds long and are intended to sell the public on the superiority of one company's product over another's. Although this is a specialized market, you can start locally and build up to shooting for big-city advertising agencies. (Keep in mind, however, that some commercials are shot on film first and then transferred to videotape.) With proper training and good connections, you might even start shooting "made-for-TV" movies.

But you might decide to try another approach. Do you want to get into the movie industry? Does Hollywood's glamour intrigue you? Do you want to film short subjects, documentaries, or full-length feature films? Once again you can start small with, perhaps, a Super 8mm movie camera. This basic, less expensive camera is a good first choice for aspiring professionals; in fact, these cameras are now being used for filming commercials.

You can then try a 16mm movie camera. Next, after serving an apprenticeship, you might get to be a director of photography in charge of a Panavision 35mm movie camera worth one million dollars, an Arriflex, or a Clairmont. That is the big time. The jobs are limited to a select few, but this is true of every field. Whether you start with videography or cinematography, there is always room at the top for talented photographers. The choices are yours; the basic lighting setups are the same.

THE TIMELESSNESS OF BLACK AND WHITE

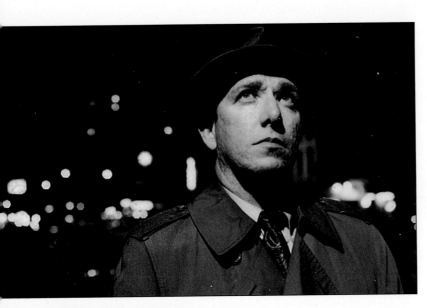

I photographed this nighttime street scene featuring Detective Sam Solo in black and white to enhance the dramatic intrigue in this video.

There is something magical about black-and-white photography. It has a life of its own when compared to color. Still black-and-white photographs are distinct; they depend entirely on tonal shifts from black to gray to white to give them energy and vitality, not color. Black-and-white photography and cinematography get their perspective and dimensionality from the subtle chiaroscuro of black-and-white *grain* in the emulsion. Black and white occupies its own space and time and has its own appeal. In fact, many agree that it has a certain sophistication that even the color spectrum can't match.

Historically, starting with the *camera obscura* and continuing right up to Thomas Edison's invention of the motion picture, images were, of course, recorded in black and white. In time, the Eastman-Kodak Company eventually came up with Kodachrome and Ektachrome films for still photography and started "developing" strip film for "motion" pictures. During the silent-movie era, innovators D. W. Griffith and Billy Bitzer developed the "language" of filmmaking. In addition, they also perfected camera movement; the closeup; backlighting, which is also called *halo* lighting; the *iris* shot, in which the image recedes in a circular motion to a fade-out; the *dolly* shot, in which the camera moves horizontally with the action; the *crane* shot, in which the camera moves from low to high; diffusion; and *editing*, in which the scenes are cut for more dramatic impact. (In fact because silent films, which were shot in black and white, reached such a level of artistry, many film historians still regret the "invasion" of sound.)

During the 1920s, superb black-and-white features were produced in Germany, in particular, and in Italy. Such early masterpieces as Fritz Lang's *Metropolis* and F. W. Murnaus and Karl Freund's *Sunrise*, which continue to influence filmmaking today, broke ground that led the way to the black-and-white "stunners" of the 1930s. One of the classics made during this decade is Orson Welles's *Citizen Kane*, photographed by Gregg Toland. He used camera movements, extreme depth of field, low

angles, and long shadows to give the film its luscious visual punch, and delineated characters via the interplay of light and shade.

Perhaps a prototype of the black-and-white image from the height of the Golden Age of Hollywood is the sublime face of actress Greta Garbo. Ernest Haller, Garbo's favorite cinematographer, illuminated her magnificent bone structure brilliantly. After making *Torrent* for Metro-Goldwyn-Mayer (MGM) in the late 1920s, Garbo appeared in such classics as *Anna Karenina* (1935), *Camille* (1936), *Ninotchka* (1939), and *Two-Faced Woman* (1940). MGM selected another black-and-white film, *Anna Christie* (1930), as Garbo's first "talkie." The setting was well suited for black and white: a misty, bleak, cold waterfront in Maine; fog lurking insidiously behind every window and door in the seedy bar where Anna first makes her entrance; stark silhouettes of figures in door frames, slowly coming and going through a gray, backlit purgatory; and murky, dark shadows that fall on forgotten faces. Against this sadness and despair appears Anna's luminous, tortured face, which glows with an inner mystery that only black-and-white cinematography could capture. Shooting this scene in glaring color? Unimaginable.

Another difference between shooting black and white and color is that the videographer/cinematographer delineates perspective by using only receding lines and planes instead of colors. This makes the composition more robust, and the contrasts starker and bolder. Black and white is another world, with its own very special gray scale. In David Lean's *Great Expectations* (1946), the opening scene in the graveyard is so boldly composed and starkly illuminated, it sends chills up the spine. Another film that contains effectively composed scenes is Carol Reed's *The Third Man* (1949). Set in postwar Vienna, many of the gripping images were shot tilted to create the disjointed, world-gone-crazy atmosphere that drives the story forward. The chase in the sewers, in which Orson Welles is pursued through a black-and-white hell, was photographed with circular compositions that become concentric tensions of planes within planes.

Studying several other black-and-white films can also help you work successfully in this medium. The stunning black-and-white images in Michael Curtiz's *Casablanca* (1942) are timeless. In fact, the movie best exemplifies where black-and-white films were in America during the 1940s. The shadow patterns from the cookaloris that fall on and beyond white arches in the foreground are as memorable as the wet fog blanketing the airport at the end of the movie; the final scene was illuminated with just the right blend of murkiness, dramatic light and shade, and romanticism. This is no easy feat for a cinematographer.

John Huston's film about the Civil War, *The Red Badge of Courage* (1951), is visually compelling, too. Starkly photographed in black and white by Robert Benson, the shots of young soldiers, innocent, scared, their expectant faces shown in extreme closeup against mud-smeared faces receding from them in trenches, is quite powerful. However, I think that Jean Cocteau's *Beauty and the Beast* (1946) can provide the best learning experience in terms of the art and craft of black-and-white cinematography. This classic fairy tale contains some of the most exquisite visuals you'll ever encounter; the rich blacks, sensuous grays, and ephemeral whites convey the enchanting story perfectly. Cocteau transports you to another world, a far country of the imagination. The film is a surrealist dream that takes place in black and white.

Black and white continues to work its magic today, appearing more and more in print advertisements and commercials. And the number of black-and-white music videos is almost as high as that of color videos. Furthermore, black and white is often combined with color. For example, a beautiful singer in the midst of a black-and-white rock show holds a single red rose, or black-and-white figures hold *blue* guitars. Such imagery is startling because—and only because—of the contrast of black and white against color. Obviously, then, cinematographers and videographers working exclusively in black and white can create some of their strongest, boldest, starkest imagery in the telling of their story. These professionals can "sculpt" the foreground, middleground, and background of their films and videos with lighting for more dynamic, pulsating images.

FILM NOIR

Adopted by the French, the term *film noir* simply means "dark film." More accurately, it stands for the combination of deep shadows, strong whites, and creamy grays that is used to convey mystery. The storyline often involves a detective and an unsolved murder. During the 1940s, when most of the film-noir projects were done, color film was at a premium and avid moviegoers wanted escapist melodramas because of World War II. Smaller studios, such as Columbia Pictures, got a large part of the film-noir market primarily because these films were relatively inexpensive to produce. The film-noir scripts called for minimal sets, not big, elaborate ones. Real locales and backgrounds that didn't demand extensive and expensive decor and costumes—often a seedy bar in Mexico—were used. To conceal these cost-cutting sets, cinematographers devised stark lighting arrangements for scenes that often took place at night; this approach resulted in deep, murky shadows.

To Have and To Have Not (1945), a Warner Brothers picture directed by Howard Hanks and starring Humphrey Bogart contains all the trademarks of the film-noir genre. Desperate characters move in and out of a black-and-white chiaroscuro of intrigue. The hotel rooms are usually illuminated by only one light source and are pretty dark. So when Bogart lights Lauren Bacall's cigarette, both of their faces stand out in the dark against the deep-black background. Director of photography Sid Hickox had a table lamp serve as the key light that illuminated the actors' faces. In addition, Bacall was softly backlit by a diffused spotlight that was positioned at about a 45-degree angle directly behind her. *The Big Sleep* (1946) involved some of the same creative minds, Hanks and Hickox, and lead actors, Bogart and Bacall. But the art director on this later production was Carl Jules Weyl, and the set decorator was Fred W. McLean. All of these talents worked together to achieve the "inky" atmosphere of private eye Philip Marlowe's world. Slashed background shadows hover over the quicksilver movements of the gorgeous woman, the lurking

blackmailer, the chauffeur/murderer, the gambler, and other assorted characters. The exciting shootout between Marlowe and Eddie the Gambler's killers is the climax of this "fun" film-noir enterprise.

One of the best examples of the film-noir style is *Out of the Past* (1947), made by Columbia Pictures. Directed by Jacques Tourneur and starring Robert Mitchum and Jane Greer, the film depicts gangsters and lovers swallowed up in a cauldron of murder and mayhem. And one of the best ways to fully appreciate film noir is to compare this movie to the color remake, *Against All Odds* (1986). This version stars Jeff Bridges and Rachel Ward, with a special appearance by none other than Jane Greer as the evil matriarch. Which medium, black and white or color, tells the story better? Which style best conveys what the script tries to say? Which film has more visual punch?

You can have fun with film noir, too. Since you'll be shooting your scenario in black and white, you should, of course, use black-and-white film and an 8mm or 16mm movie camera. Or if you are game, try a different approach: use a camcorder. Although you'll actually be filming the scene in color, you'll be able to see what you're shooting in black and white on the monitor. This is because many of the camcorders that range between 1,000 and 2,000 dollars in price have two outputs: a "V" for black and white and a "C" for color.

So by turning off the "C" and switching to "V," you can view your colored videotape in black and white on the monitor. Then when you want to watch what you shot in black and white, you simply have to turn off the color control on your television set. (You can turn off the *chroma*, or color, signal on large studio video cameras to shoot in black and white, but ordinarily you can't do this on less expensive camcorders intended for home use. Check your camcorder's instruction book.) Although this alternative approach to film noir is interesting, keep in mind that you won't get quite the same contrast that using black-and-white film with a movie camera produces.

While this genre might seem intimidating, remember that the original film-noir movies featured sets and actors who were, naturally, in color. No one painted Bogart, Bacall, their costumes, or the sets in shades of gray. So to use the black-and-white film stock, backgrounds were painted in medium shades. Stark blacks and brilliant whites were avoided because of their obvious contrasts. The cinematographers also knew that blacks would record on film as too murky and deep, with no shadow detail. White, on the other hand, would appear too vibrant and too "pushy."

In addition, when the cinematographers shot a film in black and white, they selected colors that fell into the same family of medium tones as the gray scale. They kept contrast ratios in mind as well in order to steer clear of values that might fight each other. Generally, pastels—yellows, pinks, pale blues—translated better into black and white, and deep browns and purples produce better blacks than black itself. The only notable exceptions to these film-noir guidelines involved the deep, dark diagonal shadows that added an air of mystery to a scene. Even then if the shadows were too hard-edged and distracted from the action, they were softened with fill light or diffused.

Perhaps the simplest solution for shooting your script in a film-noir style is to use a *video filter* with your camcorder. This takes the color out of the images. Another solution is to take your color videotape to a postproduction facility where trained personnel can convert it into black and white via electronic processing. But this is quite expensive.

The following suggestions will make shooting a film-noir script easier for you. If you don't have a movie camera at your disposal, rent one. Using black-and-white film stock is the best way to achieve the high-contrast look that is characteristic of this genre—and is less expensive than shooting in color and transferring to black and white. When you plan the storyboard for your script, be sure to include plenty of shaded walls, furniture, and actors; aim a great deal of intense light directly on the lead performers; and arrange for lots of dark shadows to fall behind them. Have the actress(es) wear strapless, dark-colored silk or satin dresses.

If you want to have fun and make the film look like it was done in the 1940s, borrow or rent costumes and, perhaps, a car or two from that era. Try to do much of the shooting at night with fast film, and shoot at least one scene in front of car headlights. Most important, rent any of the film-noir movies discussed here, and watch them over and over again. Film noir is bound to take hold of you.

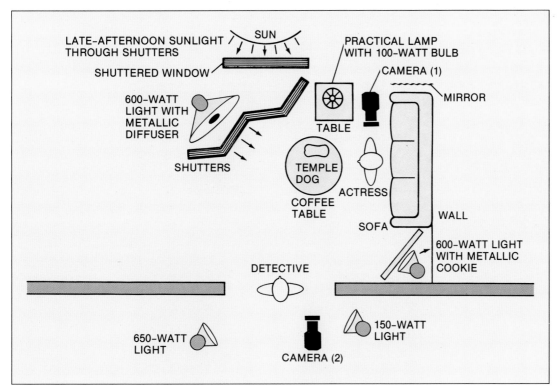

To create the film-noir look shown on pages 18-19, I aimed two 600-watt lights with metallic diffusers at the actress and positioned two 150-watt lights behind the detective. The late-afternoon sun and a household lamp with a 100-watt bulb provided the rest of the light in the scene.

1
ESTABLISHING SHOT. Gail
approaches door to detective's office.

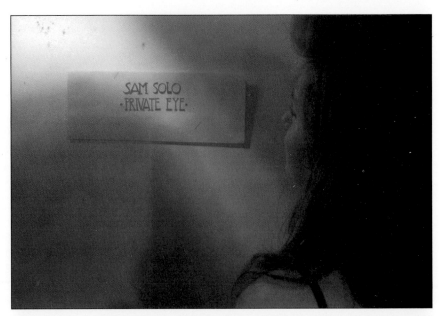

2
MEDIUM SHOT. Gail knocks on door
and is surprised to find no one there.
Gail: "Is anybody here? Hmmm. I
wonder where the secretary is."

3
MEDIUM SHOT. Gail picks up priceless
statue.

4
MEDIUM SHOT. Sam returns to office and smokes in doorway as he watches Gail.

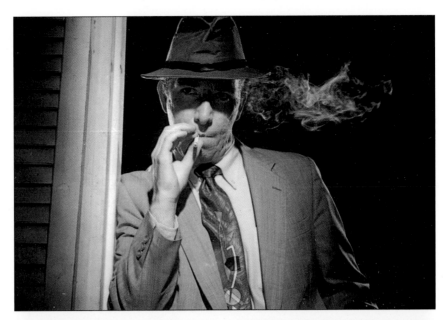

5
OVER-THE-SHOULDER SHOT. Gail examines statue more closely; Sam continues to watch her.
Sam: "What do you think you're doing?"
Gail: "I've been looking for this statue for ten years."

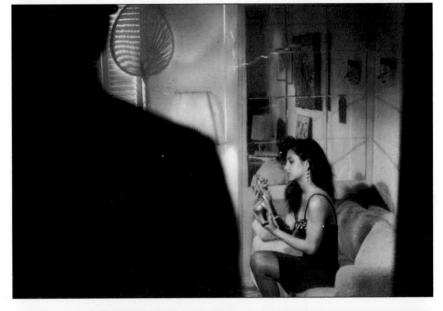

6
MEDIUM SHOT. Sam points gun at Gail and tells her to put down statue.
Sam: "That's funny. So has my client. Put it down now or I'll shoot."

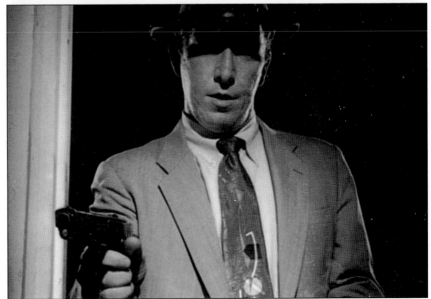

THE COLOR EXPLOSION

Remember Dorothy in *The Wizard of Oz* (1939)? The scenes in the beginning of the film when she appears with Auntie Em, Uncle Henry, Elmira Gulch, the three farmhands, and Toto, and sings "Over the Rainbow" while leaning against a hay wagon with a cloudy sky behind her were photographed in black and white. After the tornado hits and she and the farmhouse are swept up into the sky and then drop to the ground with a thud, Dorothy awakens, walks quietly to the front of the house, opens the door slowly, and BOOM! She finds herself walking out of a black-and-white world into the magical, enthralling, vibrant, incandescent world of color.

The use of color in films started back in 1910 when still photographer Louis Dufay worked out a primitive three-color element while tinting films. One of his color negatives or "chromes" was selected for reproduction in a magazine. His color photograph was printed via a three-color separation process, in which three individual negatives—one red, one green, and one blue—are overlaid and finally printed as one. This is called *subtractive* color because it's subtracted from the white light that exists around us. Conversely, colors added to white are called *additive* colors. For example, when movies were first being made, if a filmstrip were tinted with blue, the blue dyes absorbed the red and green dyes and let the blue color show through. (Another additive two-color process called *Kinacolor* was often used back in the early 1900s, but its popularity faded.)

And in the days of silent black-and-white movies, individual frames of film were even colored by hand to enhance a particular scene's emotional tone. In *The Phantom of the Opera* (1926) starring Lon Chaney, the entire screen becomes a brilliant red when the phantom's mask is pulled off. The result is effective—and creepy. Similarly, various scenes in *Robin Hood* (1922) starring Douglas Fairbanks were tinted to break up the monotony of the black-and-white action sequences.

Around the same time, Thomas Edison worked with George Eastman to come up with a system of coloring his early films until a fire destroyed their studios. Finally in 1928, Eastman Kodak came out with *Kodacolor*, an additive film process for the amateur market that was first geared to 16mm cameras and later to still photographers. After much trial and error, as well as arduous experimentation, *Technicolor*, a two-color process, hit the movie world. Invented by Comstock and Westcott, this process was given a big public-relations push by Herbert Kalmus and, in turn, gave audiences a full spectrum of color in the films they were seeing. It was at this point that the color explosion began. Directed by Rouben Momoulian, *Becky Sharp* (1935) was the first three-color-separation Technicolor film. This process hit its first peak with the transitional *The Wizard of Oz* and culminated with the luscious *Gone With the Wind* (1939).

Lighting-for-action techniques truly came to the fore in the scenes in which Scarlett O'Hara is in the makeshift hospital in Atlanta helping to care for wounded Confederate soldiers. Cinematographers Ernest Haller and Ray Rennahan had the main light source filter through the broken stained-glass windows to illuminate the bloody bandages, thereby creating dark, murky browns and reds. You can almost actually feel the heat because the Technicolor cameras demanded lights of very high intensity. During the massive evacuation of Atlanta, Scarlett stands on the steps of the hospital framed by the soiled white columns and is illuminated from the front with reflectors. The yellowish brown colors of the evacuees mixed with the reddish brown dust of the unpaved streets enhance the chaotic mood of the scene. Wagons filled with desperate people trying to flee from Atlanta roll past her. Then more of the panicking populace rush out of the background into Scarlett's space (the middleground) and eventually into the foreground. Clearly, the lighting, costumes, Victor Fleming's direction, and William Cameron Menzies's production designs work together to create a rich tapestry of a city caught in the hell-grip of war.

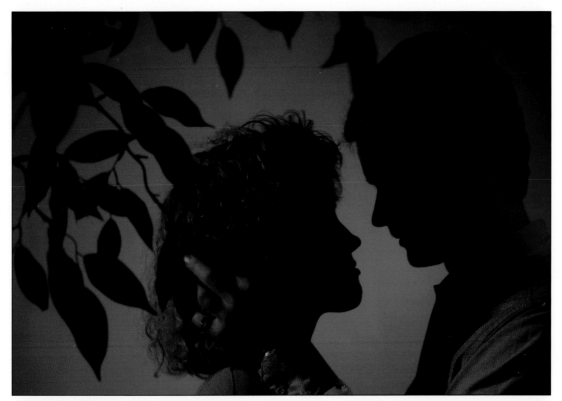

For this screen test, inspired by the scene in Gone With the Wind when Rhett leaves Scarlett after the burning of Atlanta, I used artificial leaves for foreground framing and red gels to make the background "glow" (left). Then I added a white highlight to give the actress's hair extra dimension and to bring out the actor's hand (below).

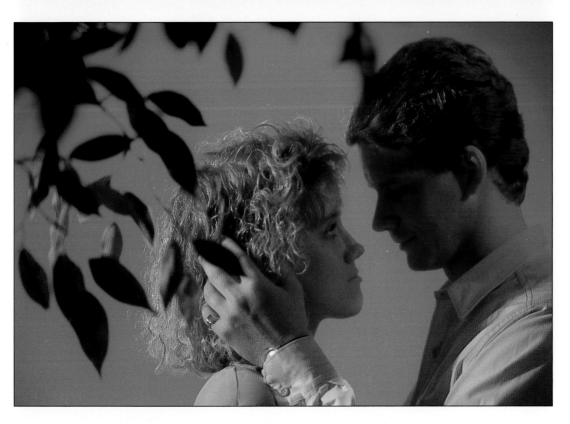

THE SOUND-RECORDING PROCESS

In the entertainment industry, sound got its start in 1927 when Al Jolson, the star of *The Jazz Singer*, yelled at his audience, "Wait a minute, you ain't heard nothin' yet!" Although Thomas Edison and D. W. Griffith both experimented with sound earlier, it wasn't until Jolson's voice was recorded on the Vitaphone system that the modern era of sound really began. Developed in conjunction with Western Electric, this system saved Warner Brothers. Subsequently, every Hollywood studio converted to sound. Unfortunately, all of the dynamic lighting techniques that were developed during the silent-film era were put on hold because performers had to stand very still when using the new microphones.

Naturally, sound technicians continued to improve recording techniques; these included the "variable area sound track" and the "variable density sound track." In the 1950s, they came up with the "magnetic tape sound track," a high-fidelity composite print on film. The technicians were now able to mix multiple sound tracks and record them optically on the filmstrip. Dolby sound, which has virtually eliminated any distracting recording "noises," is widely used today in movie theaters equipped with special stereographic speakers. These are placed not only behind the screen, but also to the sides of and behind the audience for "surround sound." Thanks to the diligence and genius of these generations of sound technicians, your sound-recording tasks are relatively simple.

When you shoot video projects or scripts with your camcorder, keep in mind that the microphone is built-in or attached to the upper part of the camera. For more sophisticated sound, you might want to purchase a *lavaliere*, or *clip-on*, *microphone*. These range in price from 25 to 95 dollars. You'll understand the difference in cost; the expensive models have a more controlled, fuller, less "noisy" vocal reproduction.

If you are very serious and want professional audio quality, consider investing in a wireless receiver, such as the Samson MR-1, which mounts easily on any video camera. Azden puts out a top-of-the-line wireless system with a 300-foot range, a *unidirectional microphone* for

A boom microphone was used to record the performers' dialogue during this romantic scene at the beach.

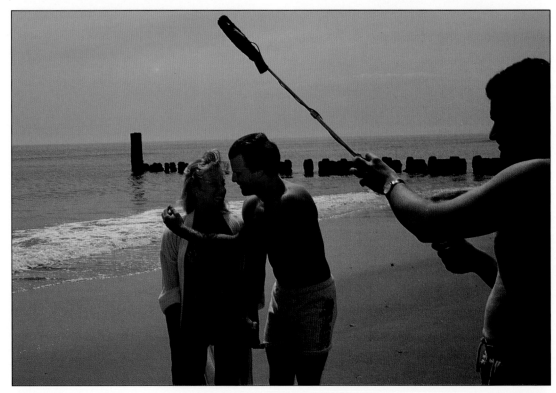

"zoom-in-on-the-performer" shots, an MS headphone with a *boom microphone* for adding narration as you record. This mike, which is at the end of a long metal pole, can come in handy for your sound-recording needs for either video or film productions. Its purpose, of course, is to unobtrusively record the performers' voices. And to pick up the voices without being part of the action, such as when you want to record wedding vows, use a *shotgun microphone*. Like a very extended boom mike, it has the ability to zero in on dialogue that is being spoken at a distance. Finally, always remember to use headphones to monitor your sound (see the "Resources" list on page 142 for more information on sound-recording equipment).

If you don't have to record the sound yourself, make sure that the *sound recordist* attends the preproduction meetings and is involved in the storyboarding process. This individual is instrumental during the actual production and, just as important, will supervise the postproduction sound editing; this responsibility is particularly demanding on video productions because the crews are usually smaller.

To understand this procedure step by step, take a look at the soap-opera scene on the beach (see page 48). Think about the sound-recording options available to you for your soundtrack. When you storyboard the action, you need to make sure that the sounds match the visuals. You may want to confer with the sound engineer, special-effects coordinator, and/or musical director on a large project.

During the preproduction phase, give some thought to the environmental circumstances that may affect the recording, such as squawking seagulls and crashing waves. If you're shooting on location, what sound equipment is called for? Will any equipment have to be rented? How much dialogue is there? What other sounds are needed to complete the mood of the shots?

After everyone involved in the production arrives on location, you determine that the *multidirectional shotgun microphone* is needed in order to "zoom in" on the models' voices.

Although a *handheld microphone* and a clip-on wireless mike are other possibilities, the shotgun mike seems to be the best choice. With your trusty headphones on, record at least 60 seconds of the ambient, natural sounds that you hear, such as waves lapping on the shore and seagulls on a second track. For the sound edit later, you might want to get the performers' voices with both the shotgun and the wireless mikes in order to have soundtrack choices. For film sound, their voices are usually recorded on a *Nagra*, a separate recording unit. For high-budget videos, the performers' voices can be recorded on a Betacam; however, for most video productions the sound is recorded directly onto the tape.

Sound mixing and editing are pretty much the same for film and video. You have at your disposal two, three, four, or more separate sound mixes to blend into a final *audio master* (for video). On the visual side, you work to achieve a *release print*, which goes to the movie theaters for exhibition. Keep in mind that during the final film sound-editing phase, you have to synchronize the soundtrack to the filmstrip; with videos, the soundtrack is already on the tapes.

For the beach scene, you have several different soundtracks: the recorded dialogue; the natural sounds of waves, seagulls, wind, and footsteps; and the *background music* or *score* that you might want to use to enhance the emotional and visual impact of the love story. Sound professionals refer to the music tracks as the *MIDI*, which stands for *musical instrument digital interface*. On a *track sheet*, each musical sound and each different instrument is "heard" individually. As the designated *mixing engineer*, you then mix each sound with each scene. You might want to add special sound effects, either of your own making or bought or rented from a stock sound library (in the same way that you might buy or rent stock footage). As you do the postproduction sound editing and mixing, strive to get the clearest, purest sound on each and every track—the right sound for the right blend for that final audio master or release print, ready for television or theater viewing.

Cinematography or Videography?

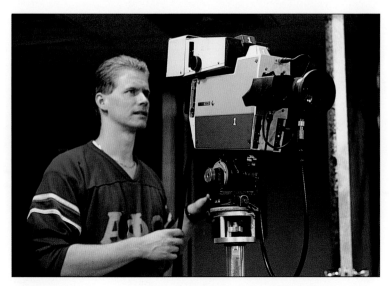

Jim Hanlon, my assistant, checks out the monitor on my Ikegami studio video camera.

Continue to remind yourself that most lighting designs are applicable no matter what format or movie camera you buy and use. The basic lighting setups are the same for both formats; the only difference is the intensity of the light: less for video, more for film. Whether you choose to shoot video or film, or black and white or color, the memory chips in the electronic-filing systems of your brain will tell you that you've worked expertly at still photography and absorbed and learned from numerous movies, documentaries, short subjects, television films and series, and cartoons. So you're obviously qualified to move into the exciting world of videography/cinematography—with its extra income—and to determine which format you want to work in. To help you make this decision, stop and think about the differences between film and video.

Color Saturation
Simply put, the Technicolor process used in cinematography begins with three black-and-white strips of film photographed at the same time (with one lens) via a beam-splitting prism. Next, after the three black-and-white negatives are separated, one is dyed yellow (the complement of blue); one, cyan (the complement of red); and one, magenta (the complement of green). These three colors are layered, one on top of the other, and then printed in full color—just as the three colors are separated for still photography.

Technicolor is widely used even today in many motion pictures. And because of its sensitivity to such an extensive variety of color ranges, it is also used in commercials where clarity and visual "snap" are demanded by the advertising agencies involved. Other color processes developed for film include *Metrocolor*, which is pastel-looking; *Trucolor*, which looks like faded colors in an old book; and *Cinecolor*, a European process that falls somewhere in between.

Kodak has a variety of one-strip process films. Eastman 5296 film is currently popular with cinematographers for action films because of its unusually high speed and the latitude it offers for night shooting. Fuji is making its presence known among moviemakers thanks to the technically advanced and versatile F-250, which is suited for both day and night shooting.

Color saturation in the video field is completely different. In camcorders, a light-sensitive, electronically motivated Plumbicon tube reproduces the color images, and color is taken for granted. Most new models feature *CCD imagers* (*charged coupling device imagers*) that have between 250,000 and 300,000 *pixels*, which are points or dots that constitute the image and are comparable to *film grain*. In addition, many of the new camcorders are light-sensitive to as low as 3 lux.

Image Quality
Something else to consider is image quality. The differences between the clarity and sharpness of a videotape image and a film image might become a deciding factor when you choose which format to work with. You'll notice that in all of the literature, catalogs, and press releases on video cameras, ranging from VHS models that are between 1,000 and 2,000 dollars in price to the more expensive models that cost anywhere from 5,000 to 100,000 dollars, the manufacturer insists that its particular model offers images comparable in quality to film images.

But don't be misled. Although these video cameras have a higher number of both pixels (some camcorders have as many as 450,000) and *lines of resolution* (the average number is 450), the results still don't compare with precise, crystal-clear film images because of the "snap" of film stock. In fact, television commercials are very often shot on film and then transferred to video for broadcast quality. (Keep in mind that manufacturers will begin pushing *high-definition television*, or *HDTV*, which has a very high number of lines of resolution and is even closer to broadcast quality. Furthermore, the pixels that make up the television-screen images are even tighter.) Of course, good lighting designs are still paramount!

If you're leaning toward the film format, start with a Super 8mm camera model. (Don't confuse these cameras with the new Super 8mm video cameras, which take 8mm cassette tapes. Once again, camcorder manufacturers want to emphasize this film comparison in order to push the new sharpness of video imaging.) A Super 8mm movie camera is less expensive than a 16mm Bolex model or a 35mm Arriflex that costs about 100,000 dollars. You may want to look for comparative bargains at your local film store or in the used-camera section of *American Cinematographer* magazine. You'll have a much easier time camera shopping if you decide on the video format. The camcorder market offers dozens of models to choose from; go to your local video store to see what is available or read the listings in *Videomaker* magazine.

Lighting

Is it easier to light action for video or for film? The answer comes down to how light-sensitive your particular camera is. If your camcorder has a low lux rating, you can use lower-intensity lights than you can for film lighting. For example, if the lux rating on your very expensive Ikegami video camera is 2,000, you'll be lighting with the same intensity as if you were lighting for film. Although faster-speed films allow for very low light levels too, just as when working with video you don't want to shoot an entire feature in a low-light situation. As you choose between video and film, keep in mind that the formats call for exactly the same

This overhead view shows the lights in position for a cat-food commercial. The cat's unpredictable behavior made the subject a perfect candidate for the video format.

positioning of the lights; enable you to add gels, filters, and diffusion devices; and call for the three-source lighting plot of the key light, back light, and fill light.

Ease of Operation

The video format provides a greater ease of operation in both the production and postproduction phases. You work with lighter equipment; the lights are smaller and have less intensity. You can also take advantage of the cameras' built-in metering, light balance, automatic focus, fade-in and fade-out capabilities, and a CCD for color reproduction. You can work creatively with any camcorder that comes with a zoom lens, which can take you from closeup to wide-angle perspectives. Video cameras record sound directly onto the videotape with an attached microphone or a *boom mike* (see page 31).

Selecting a video camera is advantageous other ways. Some camcorders accept still-camera 35mm lenses, and you can purchase adaptor rings that permit your zoom lens to take a wider-angle lens, a longer telephoto lens, or a more "macro" macro lens. Some video cameras even have high-speed-shutter *flying eraser heads* that permit in-camera editing without any *glitches*, which are the brief, jumpy blurs between takes. Finally, you can look at the scenes that you've just shot simply by pushing the *review button*. So if you didn't record a scene the first time through, you can try it again; the only exceptions are news and sports. You also have the *counter-reset button*, a

memory display, and a *dated-time display* that makes the editing process easier. Clearly, video cameras make for ease of operation from beginning to end.

Having worked longer in the film industry than in the video field, I think that cinematography is a bit harder. Both the visual and the audio equipment are heavier, and creative expression and marketing are more challenging. Possibilities exist, but taking the step toward producing an added source of income is slow and sometimes difficult. The lights needed for shooting film are more massive and have higher intensities. In addition, metering is more critical because it often involves incident-light and reflected-light readings of the same scene to ensure overall accuracy. Furthermore, cinematography requires you to give much more careful consideration to film speeds when determining exposure than videography does.

Postproduction Tasks

After you finish shooting the project either entirely or for the day (or night), you have some postproduction work to do. For example, the soundtrack must be fine-tuned. Film sound is recorded separately on a NAGRA sound unit, and there is a great deal of flexibility in the choice of microphones. Recording sound for videos hasn't reached this advanced level of options yet, but separate sound units are now being used with the more expensive video cameras.

Another film-related postproduction task is the running of *tests*, or *dailies*, of the scenes that you've shot. This isn't always easy. For example, many production units working in a remote jungle have to fly the exposed film back to the United States and wait for its return before they can see what they've successfully shot. This review process is much simpler with videography. On many commercial shoots, the director can see an immediate replay of the action that the video camera has just recorded;

this eliminates having to wait for the film to be processed at a lab.

Another area where videography wins out over cinematography is the incorporation of graphics and special effects (SFX). These techniques aren't nearly as simple for film as they are for video. The equipment is much larger, and the technology involved is more complicated. One such film technique is a group of *matte processes* through which scenics are added to complete a set where only the bottom is constructed. Suppose you build only the drawbridge and gate of a castle in order to eliminate the expense of constructing the entire castle. To effectively create this illusion, you'll have to paint the top of the castle on glass, position the glass about 10 feet in front of the lens, align the glass with the lens, illuminate the glass so that it matches the lower third of the picture frame, and—finally—shoot it.

With a video, the same type of imaging is comparatively simple. When Superman soared through the air on film, he was photographed flying (with the help of wires) in front of a blue screen. This image then had to be superimposed on an image of the New York City skyline and carefully blended because the blue sky disappears. This *blue-screen process* has been simplified dramatically via video's image manipulation. One method is to use Amiga's "Scenic Generator" video software program .

The postproduction process for videography makes the blending of soundtracks and graphics, video and sound editing, and title generation easier, and offers limitless special-effects possibilities. (I'll leave the purchase of video hardware and software up to you, but it is out there; just drop in to your local video store. This is basically a book on lighting, and a full description of the mercurial advances in video technology would take an entire separate volume.) So shooting film is obviously more expensive in terms of both time and money from preproduction, through production itself, to postproduction.

PREPRODUCTION PLANNING

Before you can say "Lights, camera, action!" you must do some extensive preparation, which is referred to as *preproduction planning*. This includes determining what is required for the project: which lights, and what size, wattage, and height they should be; which type of cameras and lenses; which type of microphones are most appropriate to record the sound; what the set designs for interior and/or exterior scenes should look like; which sets need to be built; which outdoor locations call for shooting permits; which actors to hire; and which costumes and props to choose. You also should draw up *storyboards* to help you decide which camera angles to use in each scene.

Obviously, you must devote a great deal of time and energy to this stage. The more details that you take care of before the shoot, the fewer problems you'll have to solve once production begins. Storyboarding is the first priority (see page 100). Another preliminary concern is figuring out who is going to do what on your shoot. The talent you select will have a considerable effect on how smoothly the shoot proceeds—and, most important, how well the film or video turns out.

Organizing Duties

After an initial "think-tank" session with the creative people involved with your project, you'll start parcelling out assignments. You must assign individuals to be in charge of the script, storyboards, lighting, casting, sound, costumes, financing, and editing. If the film or video is simply a family enterprise, one relative will become the executive producer and will select both the videographer/cinematographer and the director, or might even do his or her own shooting.

Someone ultimately has to coordinate all the creative efforts that go into the making of a film or video. The *producer* is in complete charge of the project and is responsible for hiring individuals who will bring the script to life. The producer, who also oversees all of the finances for the project, selects, among others: *the director*, who is in charge of the actors; the

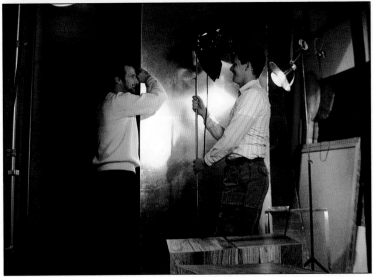

Here, my assistants construct the "Send to Win" set shown on pages 46-47.

videographer/cinematographer, who is also known as the director of photography; the *lighting designer*, the actors; and the *production designer*. The producer, director, and videographer/cinematographer have the most significant roles; every other assignment comes from them. For example, the director of photography hires the *camera operator*. In turn, the camera operator hires the *gaffer*, who helps to determine the light levels needed for each scene and setup. The gaffer then hires the *key grip*, who usually rents such essentials as the lights, stands, sandbags, and flags.

Once the director is hired, he or she works with the actors and, in particular, the lighting and production designers in order to realize the scenes that the storyboarded script calls for. After the producer, the director has the final say about who does what on the set, including where the actors move, how they interpret the script and speak their lines, how the actors are illuminated, and when the camera remains stationary or moves. The director works very closely with the videographer/cinematographer to ensure maximum visualization of the script.

The producer hires the videographer/cinematographer based on whether or not that person's imagination, creativity, and skills will help to realize the script's potential. The videographer/cinematographer must dominate the shooting of the script, working of course in close collaboration with the production designer, art director, and set decorator. The videographer/cinematographer's expert knowledge of lighting and its variable moods and emotions, and his or her ability to make the story seem real will give the photography its professional stamp. This, in turn, will convey the filmmaker's personality, imagery, and artistic outlook.

On a large production, somewhere along the chain of command you'll find the production

This is the budget I worked with for the race-car project shown on pages 58-59. When you make a list of the costs that a specific project entails, be sure to include travel expenses. You might also want to consider having a miscellaneous category to cover emergencies.

INDY GO KART SHOOT, 1988
For Ron Massaro, Summer Productions

Budget

Panasonic Super VHS camera	Have on hand
Lowell Omni Light Kit rental	$300
(weekend rate of $100/day for 3 days)	
Tripod rental	$135
($45/day)	
Lavalier mike and cables rental	$87
($29/day)	
Videographer	$750
($250/day)	
Still photographer	$750
($250/day)	
Lighting designer	$600
($200/day)	
Roundtrip airfare tickets	$1,050
(producer, videographer, still photographer, $350/ticket)	
Lodging	$675
(3 rooms for 3 nights, $75/night)	
Food	$270
(3 persons, $30/person/day)	
	———
TOTAL	$4,617

designer, who creates the storyboards; the art director, who designs and oversees set construction; the *construction manager*, who actually builds the sets; and the set decorator, who arranges the set. Also involved in the project are the members of the *sound crew*, who are responsible for recording the dialogue; the *composer*, who comes up with the musical score; and the members of the *script department*, who write the dialogue. (Don't forget that without a good script, or *property*, you can't have a good production.)

Further down the chain of command, you'll find the *focus puller*, who helps the camera operator keep the images in focus, and the *SFX supervisor*. In addition, the *script boy* or *girl* makes sure that all the words are spoken correctly and keeps track of how much of the script has been shot. Finally, there are the people in charge of wardrobe and makeup, the hairdresser, and your personal assistant (also known as the *best boy* or "gofer" who gets you coffee, looks for a nail, and shakes the actor taking a nap behind the set).

But on any project, the production designer, videographer/cinematographer, and art director, must know what they're doing. Television and motion-picture images aren't the result of happy accidents. They are well thought out by all of the artistic minds and talents involved in the realization of the script. On most major films, every shot photographed is designed—storyboarded for composition, color, and lighting—before the actual shooting begins. The producer wants to know exactly how expensive the sets and costumes will be, as well as how much lighting is needed in order "to get the shot." No matter how small or large the project, everyone answers to the producer. In the end, the film or video is the producer's "baby," and each and every cost, for every detail—wigs, cans of paint, publicists, sound technicians—is a matter of concern.

Working Within the Budget

Financial matters are always important. Even if you wind up shooting a film or video with a budget of 20 million dollars—or more—the producer(s) will hold you responsible for how and where that money is spent. You won't be able to throw it away. After all, you'll be working with technical crews whose film credits at the end of the film alone call for another five minutes of theme music.

As the videographer/cinematographer, you have to work with the production designer, the art director, your very own key grip, the costume designer, the sound crew—everyone, right down to the best boy. All of these people have to get paid, *and* they all have to know what you want them to do. This takes some preproduction work on your part so that the producers have an idea of where every penny will be spent.

Although you're probably at the level of most aspiring filmmakers who own a camcorder, some studio lights, and some editing equipment and are subject to very severe budget constraints, just suppose that you suddenly have a budget of 500,000 dollars to work with. (This may not be enough to make a film today, so consider this a short-subject enterprise.) One of your first tasks is to choose the locations, and where exactly in those cities or towns you'll shoot. What time of day or night? How many lights and reflectors will you need? What sets, if any, have to be built? If you need a soundstage, how big should it be? (Be careful not to go overboard, buying film or renting equipment that you don't actually need.) How much will all of this cost, including the architects, carpenters, and painters? Don't forget about the script boy or girl, your personal assistant, as well as the producer's *and* the star's assistants. And if you want to use a major star, plan on spending about a third of your budget right there.

You also have to take into consideration such postproduction details as the soundtrack, editing, lab costs for the final release or tape, distribution costs, and advertising budgets. Of course, it goes without saying that all of this money for your film or television movie (which can be shot on film or video, the only difference being a shorter shooting schedule for video projects) has to be painstakingly planned and accounted for down to the very last lens. Finally, build in a category for unexpected expenses to allow for emergencies. Keep your budget tight but flexible.

LIGHTING THE MOVING IMAGE

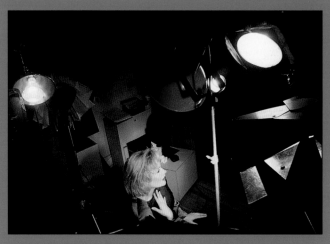

This high-angle view shows model Kathy Reidman surrounded by a "hot" lighting setup during the light test. You must pay careful attention to the lighting plot for each scene if you hope to create successful videos and films.

Suddenly, waking up from a nightmare about how your competition is switching from still photography to videography and cinematography and earning "big bucks," you say to yourself, "Hey, I've been a still portrait photographer for "X" years. Maybe it's time to expand. Get into video or film work. Sounds good . . . now what do I do?"

First, think simple. Make a list of your present "hot-light" equipment. If you've been using only strobes, you'll have to start from scratch. But most portrait photographers, including myself, use both types of lights. You'll probably find that you already have key lights, reflectors, rim lights, eye lights, and fill lights; you just might have called them something else. If you still want to purchase more, go ahead. But I can assure you that for your first effort shooting a video, your present equipment should be quite adequate because of the low-light sensitivity of the latest camcorders. The light sensitivity of a typical camcorder can be as slow as 2, 4, 8, or 10 lux, while in more sophisticated video cameras it can be as high as 2,000 lux. To cover these ranges for shooting video or film, you'll need lights that vary in intensity from 150 to 250 watts for camcorders, and from 650 to 1,000 watts for studio video cameras. And keep in mind that when you're shooting film, the light readings taken with your trusty incident-light meter will be accurate.

And so, there they are, staring at you—all the different lighting units with their wires, clips, clamps, and stands. Here, however, you need to think about only your hot lights when looking at the lighting arrangements, or *plots*. (Disregard strobe units for a while. Although they can be synched to various expensive video cameras for stop-motion commercials, this endeavor is limited to a very small percentage of professionals.) These pieces of equipment will enable you to discover the magic of the videographer/cinematographer/lighting designer that is lurking inside of you waiting to be released.

The variety of artistic expression that you can realize with your present equipment puts you on a professional level, but how you position those lights is what *Lighting for Action* is all about. The *boom light*, which is a light on a long pole balanced on a lightstand for backlighting, possibly for portraits, is also very adaptable to video and film needs. In fact, you can even put a microphone on the pole for a makeshift boom mike (which is usually handheld).

This is a perfect example of how your new "action" expands the lighting setups used for still photography to include the movements of the actors, actresses, and models who are involved in preplanned scenes with scripted dialogue. These lighting plots take into account the performers operating in an enlarged space that goes beyond the bounds of the portrait. The positioning of the key light, back light, hair light, and fill light is basically the same for still and action photography. The only difference is that when a performer gets up from a sitting position and moves around the room, the key light has to throw a much larger beam or you have to add more key lights, more *scoop lights*, and more luminaires (lamps) to encompass the new movements.

How Lights Work

When you look at a particular light in front of you, you might ask yourself, "What does this light do?" Use your imagination. What does it look like? What color is it: black, red, silver, or dusty rose? Is it large or small? Is it round, square, or oblong? What kind of bulb or lamp does it take: tungsten, quartz, tungsten halogen, fluorescent, or floodlight (sealed beam)? How large is the bulb? What intensity is the bulb: a 150-watt spotlight that can be a harsh light or a soft spotlight that throws either a diffused beam of focused light or a pleasing fill light in certain situations? The bulb can also be a low-level key light or fill light. I've even used a 150-watt diffused spot for hair lights, set at an almost 90-degree angle behind the actor. And if you use a camcorder, a 150-watt spotlight can certainly be used as your key light because of the camcorder's low-light (lux) sensitivity. In fact, you'll find that a diffused, or *coated*, spot is especially suitable as a low-level key light because it is more flattering and prevents burned-out highlights.

As you get into the 250-watt, 650-watt, or 1,000-watt range, you are ready for more intensely illuminated scenes that, naturally, demand more light. At this point, you have to use a movie camera or a more expensive studio camcorder in the 6,000-dollar range, each of which is able to absorb the higher wattage without burning out the image. Because higher-wattage bulbs put out a high-intensity beam with a *long throw*, which means that it can reach as far as 30 feet, you need to check your meter's lux rating, or the speed of your movie film.

You may also wonder about what kind of reflective surface surrounds the bulb in its canister. Most reflectors have a shiny, aluminum surface that increases the intensity of the bulb. Others have a gold surface that imparts a warmer glow to the image. The Lowell Tota/Omni System lights, for example, have multiple-use, halogen sources. Their reflectors provide noncrossover beams for maximum efficiency and are *double-parabolic*, which means that the soft and highly reflective sides can be interchanged; they also have a focus range of 6:1 with the DYS 600-watt lamp.

By changing this light's silver reflector, you can use it as a key or back light, and with diffusion or an umbrella, as a soft-fill source. You can also change it to a super spot for exceptionally long throws at all voltages.

Other questions might include, "How recessed is the bulb in its light case, deep or shallow? If it is deep in the reflector, it gives you a softer flood effect. But if you move it forward to the front of the reflector, it provides a more focused, higher-intensity spotlight effect. Most of the Lowell lights have the double-parabolic *peened*, or mottled, (to soften the light) reflectors that are easily adjustable to give you a variety of light effects, ranging from the soft-flood mode to a medium softness to the more intense (hard) spotlight. In other words, you can go from flood (at 10 feet) with a 297 lux rating, to spot with a 3,066 lux rating, to super spot with a 5,667 lux rating. (Try a studio camera.) You may also want to know if you can use the light indoors, outdoors, or both. What is the bulb's Kelvin rating? (It is 3200K or 3400K for tungsten light, and around 5500K for natural light.) Does the light accept barndoors, so that you can focus it? Does it take diffusion or color filters?

What you do with your lights depends on the specific lighting setups you've planned for. For example, if you're doing a closeup shot, your key light (at a 45-degree angle), back light (also at a 45-degree angle), and fill light (at a 20-degree angle) will be concentrated directly on the "star" performer. If you photograph more than one person in a room, you'll have to increase the light by aiming two or three more key lights directly at the performers. You'll also have to add two or three more back lights in order to produce dimensional lighting. Here, you can point a couple of extra floods (at a 20-degree angle) directly at the models to provide fill light. Naturally, if they move away from the designated light areas, you'll have to rearrange the light plot. Each scene requires its own lighting arrangement.

If your lights are designated to illuminate the background area, such as a vase of flowers, they should point down at the flowers at a 90-

degree angle. You might use a Tota clamp on a pole or a stand that is fully extended. Keep the illumination rather soft because it is in the background; this will prevent it from being too distracting. The beam will be a concentrated spot effect without too much spill, and you'll even be able to use a filter or a pink or yellow gel on the spot to enrich the color of the flowers. The color of the gels or filters (not the Kelvin rating of the scene you photograph) depends on the mood that you want to create: lighter, brighter for comedy, and darker, moodier for drama (see page 80). The larger the light, the sturdier your lightstands have to be, of course. Make sure that they can carry the weight, so that they don't topple over on people.

If you think that your lighting system is inadequate or if you want to start from scratch on a minimal budget, check out the various packages available from Lowell. For example, the Intro-Kit, which comes with a carrying case for easy transportation to location shoots, includes the following:

1 V-light. This is perfect for ultrawide-angle shots and allows for a wider range of movement. Its halogen bulb (500-watt maximum) can be used to illuminate a small room. The V-light can be used as a broad key light, a fill light (when used with a diffusion gel or an umbrella), a back light, or a background light. Advantages include its 16-foot cable, protective lamp sleeve, L-link, stand fitting, and weight of 1 1/2 pounds.

2 Pro Lights. This multiple-use halogen source light has a peened parabolic reflector with a maximum wattage of 250 watts and protective front glass. The Pro Light can be used as a low-level key or accent light, a fill light (with diffusion), a back light, and a background light. You can change the reflector to a super-spot reflector for extremely long throws. The Pro Light comes with other light controls that you might not have on hand in your particular studio situation: expandable barndoors, scrims (see Solo Kit), diffusers, a dichroic filter, a *snoot* (to focus and narrow the light source to hit a specific area such as a flower-filled vase), a gel frame, and flags (to control light falloff of sources; these act almost like additional, detached barndoors). The light mounts on a stand; with clamps on a wall, window, or door

top; and on a dropped ceiling grid. It can also be handheld, for example, to follow an actor.

3 VIP Stands. Used with the Pro Lights, these have single-strut leg braces and solid bar legs. The medium-sized KS stand, intended for average-weight lights, flags, grip equipment, and rigs is perfectly adequate for most lighting needs. It has double-strut leg braces, as well as tubular legs with holes for casters and anchors, which come in handy for sandy or grassy areas.

2 Pro Light Barndoors. These are four-way barndoors.

2 Tota Frames. These frames hold 10 x 12-inch gels.

Assorted Gels. These add any kind of color to a scene to enhance its emotional content.

1 V-pod with Stud-Link. This supports VIP lights on the floor or other flat surfaces. It can be screwed, attached with gaffer tape, or clamped to vertical surfaces. The stud link is removable.

1 VIP Lampak. This pack stores several tungsten lamps of various widths to accommodate different lights. (The lamps themselves aren't included.)

1 VIP Shoulder Case. This accommodates all of this equipment, which you carry to those exotic locations everybody dreams of. Lowell's is followed by the All Pro Kit, which includes more of the above equipment as well as extra diffusers, scrims, reflectors, and gels. The Solo Kit is quite comprehensive. Besides lights, reflectors, stands, and barndoors, it comes with diffused glass, *full scrims* (stainless steel screens that reduce light by one stop, no diffusion), *graduated scrims* (these decrease light intensity on walls and subjects), *cookies* (various cut-out patterns that throw shadows on the background or foreground), gels, flags, clamps, gaffer tape, umbrellas, frames (for gels), and a carrying case.

And since the light sensitivity of a typical camcorder can be as low as 2 lux and in other, more sophisticated video cameras can be as high as 2,000 lux, you'll want lights that vary from 150 to 250 watts, and 650 to 1,000 watts. These lights should cover all ranges of lighting requirements for video or film. And when shooting film using the same equipment, keep in mind that light readings taken with your trusty incident-light meter will be accurate.

After you check your equipment to see what you're missing, you should figure out how you can supplement your existing lighting equipment. For instance, you might need extra flags (to help keep light out of the lens), cookies, diffusion materials, lightstands, and sandbags for exterior shots (make your own!). Don't spend a great deal of money right away. Experiment with what you have in the studio first. You might find, especially with video work, that less is more.

When thinking about getting additional lights, you should keep in mind that instead of lighting one stationary person or group, as you do for still photography, you are about to have these individuals get up and move about an entire room. So buying a few extra Lowell Tota lights might be worthwhile; these elongated lights bounce more light off the corner of a ceiling in a room for increased illumination. Perhaps you'll find that an *eye light* for closeups, a clamp light, and more scrims and booms will also come in handy. Finally, remember the limitations of your production budget.

In my own studio, I use some perennial favorites, including an old movie *scoop light* that now has a 1,000-watt tungsten light in it. I made a protective screen out of hardware-store screening. Sometimes I diffuse it with a heat-resistant white fabric. Another trusty choice is a Lowell DP spotlight that can go from flood to spot; it has a 650-watt quartz light and a protective wire-mesh screen that also provides diffusion. I also have a clip-on spotlight that holds a diffused 150-watt spotlight with snap-on barndoors. I usually bounce this light off the ceiling to illuminate a 4 x 8-foot sheet of reflective Mylar that serves as a background. Both of my Smith-Victor floodlights contain a 150-watt spot. Some of these lights have Fresnel-type surfaces. I use these as portrait hair lights, as well as for key lights when I shoot camcorder videos. I have several 10 x 14-inch black flags on metal stands to control light spill. For fill light, I place an aluminum reflector on a stand, below the subject's face. This reflector provides fill light for backgrounds for videos.

1

2

3

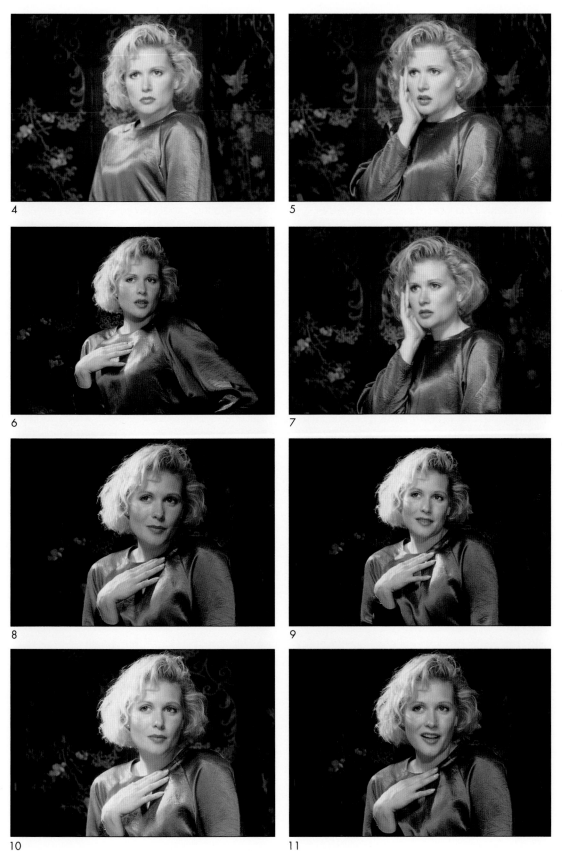

4

5

6

7

8

9

10

11

This series of shots shows the many effects you can achieve by combining different lights. After positioning only (1) a key light, I added to it: (2) a reflector, (3) a fill light and reflector, (4) a background light, (5) a background light and fill light, (6) a background light, fill light, and reflector, and (7) a background light, fill light, hair lights, reflector, and star filter. To this lighting plot, I then added: (8) a rim light, (9) a stronger rim light and kicker light, and (10) an even stronger rim light. The full lighting setup (11) is quite appealing.

For both my still photography and videography, I have colored floods: 85 watts, green, red, blue, yellow, and amber. It is unbelievable how many different professional effects you can get just by moving these colored lights around, especially with the light-sensitive video cameras now available. Some blue and red gels just about complete my accessories collection. My tripod is actually a stand for video cameras, but I also use it for portrait work because it is even steadier than the average camera stand.

In terms of specific lighting effects, the *key light* is most often used in reference to the closeup and is the main source of light that falls on the talent. This type of light can be either harsh when it isn't diffused (make sure that the models wear makeup) or soft when it is diffused via some material falling on the light source, on the camera lens itself, or with some video or movie cameras, behind the lens. To determine the intensity of the light, think about how close to the performers you want it to go. You don't want to make them uncomfortable with the heat; in most cases, the minimum distance is 5 or 6 feet. A key light can be a scoop light, in which the quartz or tungsten light is deep inside the circular reflector, or a more focused spotlight, in which the light source is closer to the outer rim of the circular reflector. In either case, the key light can be hard or soft.

Outside, the sun itself can be the key light. But because it is a very harsh one, you should use it only infrequently (mostly for sports or Westerns), and almost always on men, not women. To estimate the best subject-to-key-light distance, continually test the image on the video monitor or camera viewing screen when you experiment. Incidentally, using two key lights for a *crosslighting effect* can be a little awkward. Here, two lights play off each other. One light is positioned at a 45-degree angle in front of the model on the left side, and another is placed in the same spot on the right side. As a result, you get two separate shadows on the performer's nose. Furthermore, when the actor moves, so do the shadows. You'll find that just one key light is neater.

Most video and film images are diffused to some degree, but the use of a *fill light* softens facial shadows a bit. This can be a reflector or another small light positioned just below the performer's face and the camera lens. Next, you'll probably want to add one or two *hair lights*. You can angle them down from above and behind with a boom light to illuminate the back of the head or the background; with this arrangement, the stand won't be visible. The main functions of a hair light are, of course, to enhance the hair, especially that of a female model, and to separate the performer from the background. The hair light can be as soft or as intense as you prefer and is usually between one third as strong as the key light and equal to it. Vary the intensity until you get the effect you want. To create the illusion of being outside while shooting in the studio, you can use the hair light to almost overexpose the hair, which is the way it would look if you shot outdoors in the sun. So don't be too timid.

Next, you might want to add a *rim light*. But keep in mind that this lower-angled back light is positioned to throw extra *sidelighting* onto the model's face or figure. This type of light is ordinarily used to give even more strength to a man's bone structure. It outlines the shaded side of the face. A *kicker light* is a back light that you throw in to the lighting plot in order to give the illumination extra punch.

Another option is a *zinger light*, which adds a little bit more direct illumination to the face. Suppose that you're filming an actress in a low-light situation, such as a night scene. You already have a soft key light on her face, a fill light for facial shadows, and an *eye light* that puts an extra highlight in the eyes. But you decide that you want to add another special light to her face to bring out even more details. A zinger light will provide this added dimension.

The amount of experimentation you do is, of course, up to you. If you've ever visited a movie or television set, either on a soundstage or on location, you know that the director of photography, with the aid of assistant electricians (who are referred to in the business as grips and gaffers), take many hours setting up and realizing the light plot. Naturally, some are faster than others and budget requirements can play a hand; however, they need—and take—time to arrange the key, fill, hair, and rim lights. So you, too, can take your time to play around a bit. Mix and match the lights until you arrive at the desired effect. Finally, don't get thrown by all of the specifications on each light unit.

OUTDOOR LIGHTING

Shooting outdoors with a basic camcorder is easy because its single electronic tube records color just as readily outside as inside. All you have to do is put on the "outdoor" mode. Two important reminders: Don't forget your battery pack, and don't shoot around high noon. This leads to overexposure. Go out early in the morning or late in the afternoon.

For most productions, the lighting equipment required for outdoor shooting isn't excessive or elaborate. All you need for some simple commercials or short subjects are a white reflector and/or an aluminum reflector. If, however, during your preproduction planning you realize that the scenario you're going to shoot demands more specialized lighting equipment (this happens more often at night than during the day), you must lug key lights, back lights, and fill lights to the location. Remember, these lights call for a power source, which involves bringing along batteries and transformers. Flags, diffusion materials, reflectors (handheld or on stands), lightstands, sandbags, microphones, and sound-recording devices (for film) are also necessary (see page 22). Whenever you can, though, keep the lighting plot as simple as possible; use the sun as the back light and reflectors as the key lights for scenes with simple conversations and limited movement. You can even have an assistant hold the reflector steady as the performers, for example, amble down the street, walk up the stairs, or get out of cars.

As the key light, the direct sun on the actors and actresses is an intense light source. My favorite approach for softening the harsh rays of the sun on performers' faces is to have them turn their backs to the sun and light their face, using either a white or gold reflector. The sun then becomes the hair light and/or the rim light, so the lighting design and setup are very simple. Don't make your light plots more complicated than necessary.

Another lighting choice is *crosslighting*. This produces shadows on faces, such as shadows on either side of the nose that shift position a bit, which can be distracting. However, I've used them on shoots. One light hits the face from the left, and another from the right, resulting in two competing shadows, one on either side of the nose. When you shoot outside, a better technique is to have one white reflector illuminate the face with the sun's rays coming from the subject's head and shoulders. With just one light source on the face, no distracting shadows appear. Remember, when lighting for video or film, keep it simple.

To eliminate disruptive shadows, try *area lighting*. As performers move around a room, they move through larger areas of light. These long and medium shots require more wattage than closeup shots do. Combining sidelighting on figures with the illumination from a large scoop light makes the light seem to be coming from one logical light source, such as windows or open doors (see page 32 for information on *full area illumination*).

Shooting a film or video outdoors greatly simplifies your lighting concerns, leaving you free to direct the performers.

Besides the lighting systems themselves, you have to give some thought to what goes on behind the lights and the models being illuminated. The backgrounds also have to be illuminated properly, so that they don't detract from the main action. You should also ask yourself a few questions. What really makes a background? What kind of form and texture does it have? What color is it? How much contrast do you want it to provide for the foreground action? How does it complement the foreground action? Again, it might be a good idea to check the backgrounds that you have on hand in your studio to determine which, if any, you can adapt for your new video/film action shoots. You probably have background paper, some chairs, a few boxes, artificial trees, and pedestals, among other potential background objects. But it might make sense to consider purchasing, borrowing, or finding some new backgrounds and props that will expand creative zones for your beginning efforts in video/film production.

A good way to start is by taking a look at the various background catalogs available (see the "Resources" list on page 142). For example, Studio Dynamics, based in Long Beach, CA, offers an extensive range of backdrops that you can purchase or rent, including ones made of canvas or prewrinkled muslin. The muslin is perfect for shooting either a commercial that requires minimal movement or a rock video with a few gyrating musicians. The canvas is thicker and must be used flat, and like the muslin, comes in a wide variety of colors and textures in addition to forest-type scenics. Scenics, such as those of planets in outer space, are especially dramatic and graphic, and are great for science-fiction scenes. By using additional gels or colored lights, you can experiment and intensify these painted backdrops. Incidentally, you can paint the 9-foot cardboard cores that the backgrounds are wrapped around and use them as pillars, porch supports, doorways, or abstract backgrounds arranged in an angular fashion.

Because this television talk show was filmed with two sophisticated Ikegami HC 350 studio cameras, the lighting design was complicated (right). I used three 1,000-watt Lowell Softbox lights with diffusers and two 500-watt Lowell Tota lights as hair lights and back lights. To illuminate the performers from the front, I used two 1,000-watt Fresnel spotlights as key lights and one 500-watt light as fill; I placed a gray gel on one spotlight to balance the guests' skin tones, and a pink gel on the other to balance the host's.

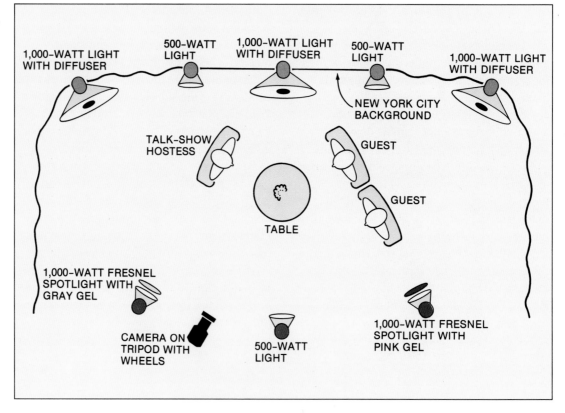

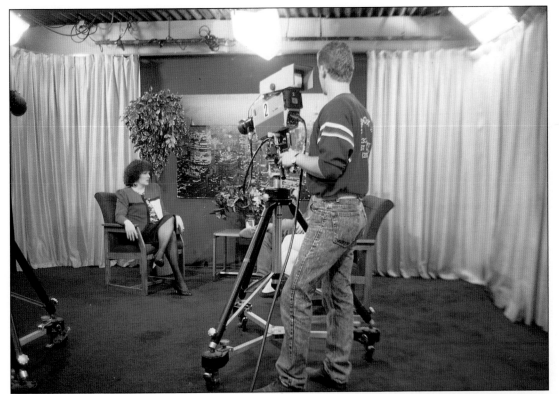

The New York City skyline background adds depth and dimension to the set at ELA Studios (left). In the medium shots, such as the one of the two talk-show guests, drapes provide a simple but elegant background (below).

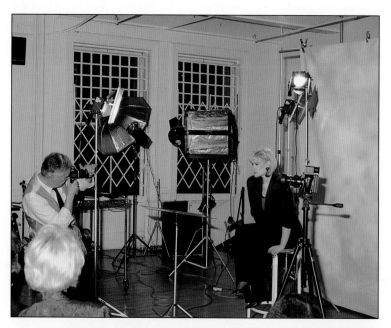

During one of my glamour-lighting seminars, I demonstrated how different backgrounds can dramatically affect a video or film (top). A glittering backdrop looks particularly great when blown by a fan (directly above). (© James Hanlon.)

Another catalog that offers a range of even more dimensional backgrounds is the Set Shop, located in New York City. Besides painted or unpainted muslin that comes in sizes up to 16 x 30 feet for larger areas of movement and every possible color of seamless, three-dimensional types of backgrounds are also available. The board surfaces of red, white, and tan brick for standup-comedy backgrounds come in 4 x 8-foot boards. The Set Shop also offers weatherboard, a realistic siding that looks like a barn or an old house, and is great for indoor/outdoor shoots. It comes only in gray, but you can touch it up with matching stain or paint it any color you want. Stucco, a three-dimensional pattern that is imprinted on a 4 x 8-foot Masonite board and colored off-white is ideal for exterior or room-interior scenes. You can also gels of different colors or shaded with various patterns. These Masonite boards also make for sturdier sets. (Another potential source of suitable backgrounds are house-demolition sites; look for discarded windows, doors, and fireplace units, depending on your requirements.)

The Set Shop even has canned paint that provides a flecked-stone or faux-granite finish. In "Gotham Grey," this texture makes an ideal neutral background that doesn't interfere with more vibrant foreground colors. The tileboard background simulates mounted 4-inch-square high-gloss tiles. "White/white Lines" is perfect for backgrounds for cooking shows, kitchen scenes in soap operas, and movie scenes shot for video or film.

Flip through the catalog from Studio Specialties, Ltd., which has locations in Chicago, Los Angeles, San Francisco, and Montreal. This company has a wide range of extra-wide seamless, Varitone, gradation backgrounds, acrylic ice products and cones, velours, reflective Mylars, Hollywood rocks (for cowboy scenes), grid-pattern papers (for school or news shows), artificial-snow items, risers,

and laminated cubes and circulars in two sizes (for rock videos). Studio Specialties' "1120 Vinyl Backing" in black velour, 52 inches wide, is great when you want the background to completely absorb any shadows or when you want the foreground action to dominate the scene. You might also want to take a look at Charles Broderson's backdrop catalog, another New York City-based firm. Here, you'll find spectacular, diverse backdrops available for rental, including clouds, beaches, snow scenes, and pyramids (see the "Resources" list on page 142).

There are a million different ways to handle backgrounds. In my medium-size studio, I keep blue, red, black, and green background paper; silver and gold reflective Mylar, a painted gray-black background; an artificial tree; an oriental vase filled with flowers on a pedestal; a blond-wood folding door; a 4 x 8-foot painting of an opera star; three louvered screens; a black-and-gold, four-panel silk screen; a folding screen with a Fragonard scene painted on it; and an 8-foot-tall mirror with a gold Victorian frame. I also use my reception room, which is mirrored and contains a beige sofa, a circular glass-topped coffee table, and an 8 x 15-foot wall mural of the Pacific Ocean (this area works to great advantage for my still photography, too). I also have many cubes of varying heights, a desk that folds up and disappears, a fully stocked kitchen, an office, and a large fan.

I can use any or all of these props and backgrounds in a number of ways and for various applications. For example, I can shoot a half-hour soap opera in my studio with a camcorder, a Super 8mm movie camera, or a 16mm camera. I could even squeeze in a 35mm EMI Arriflex, and I can certainly work with a Sony, Ikegami, or Panasonic camera in the 6,000-dollar range. Start building up your background collection and prop supplies for new, timely, useful choices to supplement what you already have. They'll give you many more creative outlets.

This folding screen with a Fragonard scene painted on it provides a simple but perfect background for closeups and medium shots of this ballet dancer .

SPECIAL EFFECTS

The term *special effects* doesn't necessarily mean laser beams, matting, miniatures, and blue-screen imagery—the kinds you see in *Superman*, *Star Wars*, and numerous other science-fiction epics. With your photographic visual sense and imagination, you can create many special effects very easily in the studio by utilizing, once again, the equipment you have on hand. This is truer of video than film. You might have tried a few on your own already. Here are several I've come up with by just moving lights and gels (and a few props) around a bit.

One eye-opening background special effect I've used is simply to project a 35mm slide on a light-gray background paper. For a ballet-slipper commercial, I positioned a standing ballerina correctly and projected her very same image (in the same pose) on the actual dancer. The size of the image matched the actual height of the ballerina as she stood in front of the paper. Startlingly, she blended right into her own projected image. I recorded her on video; the lamp projector's light was sufficient to illuminate her, too. The copy for the commercial stated, "I could do a pas de deux over my Sleeping Beauties." As the dancer spoke, she stepped away from her own projected image, leaving it on the gray paper and thus becoming two people. Then, standing just to the left of the projected image, she said, "As a matter of fact, *both* of us just adore Sleeping Beauty Slippers!"

You can project any image you want—scenics, seascapes, landscapes, outer-space shots—on a not-too-dark background paper or wall. Choose whatever slide you think fits the mood and action of your scene. Just be sure to illuminate the performers from the side to avoid the shadows of their figures falling on the background. Rear-view scenes, of course, have been used in Hollywood films for years. A moving image, most often a lake, ocean, or street scene, is projected onto a thin, translucent screen that is positioned behind the models. You can achieve the same effect in a less expensive way. Get a cloth scrim used on theater sets, place it behind the sidelighted performers, and project movie footage onto it.

Recently, I videotaped a short horror film in my studio, complete with a setting-sun effect behind a small New England village on the Atlantic shore. In the story, an evil being aglow in red light predicts the upcoming destruction of the village, "By the time the sun sets, this village will belong to Hell." For this production, I gathered the following:

- 1 blue background paper
- 1 piece of green fabric laid across a small rectangular table or box
- 4 miniature houses in RR scale size, including 1 steepled church
- 1 miniature boat with a tall mast
- 1 rectangular cutout of light-blue paper
- 1 large magnifying glass
- 3 150-watt GE spotlights colored red, gold, and gray
- 1 actor
- 1 10-inch cutout of a tree shape

I placed the houses on the edge of the green fabric with the boat behind them and just to the right on a platform 2 inches below (for perspective). I painted a few thin white waves on light-blue paper for ocean-water imaging. After positioning the base of the dark-blue paper so that the horizon level was just below the roofs of the houses (my camera was eye-level with the village), I attached it with glue. Then I illuminated the houses with the 150-watt spotlight to the left; next, I used a gray gel to give the houses some dimension and to prevent shadows on the background.

Next, I asked the actor to sit on the floor just to the left of the village scene and illuminated him with a red-gelled 150-watt spot. Using a third 150-watt gold-gelled spot, I had my assistant lighting designer shine the spot through the large magnifying glass. By his tilting and moving the beamed golden orb through the glass, a sun effect appeared on the blue paper. And by his aiming the gold rays correctly, the sun moved slowly through the sky until it set on the horizon as the actor talked about the village's destruction.

To compose the moving image, I placed the 10-inch-tall cutout of the tree to the right side of

the framed action, so that the final framed image included the actor to the left, the tree to the right, and the village below and to the right center of the actor on the horizon. The setting sun came directly behind the boat. As the sun descended, the red-devilled actor spoke slowly and pointed to the doomed village. Then the camera slowly zoomed in and followed his pointed finger to a medium closeup of the village and boat. When the camera lens zoomed in to the village, the actor disappeared and another assistant shook the village set. At the same time, the actor's red light was turned on to illuminate it. Now the whole scene was bleached out with the intensified red spot. A fade-out followed. The first soundtrack consisted of horror music that built to a climax, and the second soundtrack contained earthquake sounds. This type of scene calls for some experimentation and rehearsal, but when all of the elements are blended on videotape, the results are spectacular!

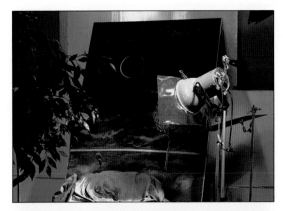

Three-dimensional objects placed in front of a two-dimensional background combine to make realistic three-dimensional representations of scenes in film and video images, as you can see in these shots from my New England village horror film.

CREATING YOUR OWN SET

Although you might be a good carpenter used to taking a sketch of a set designed for a specific scene and, working from architectural elevations, constructing the actual set, keep in mind that this is expensive. If your budget allows for it, fine. But if you're dealing with a limited budget, like most other working videographers/cinematographers, then imagination and inventive energies are the norm. You can use the backgrounds and props in your studio, especially the screens, to create sets. Remember the power of illusion: show just part of a scene, and viewers will fill in the missing details in their mind's eye. And whenever possible, use rooms that are already at your disposal. Borrowing props and furniture from your neighbors or relatives might also be a possibility; perhaps you can shoot in their rooms or pool area. Just be sure that you don't leave a mess behind.

Putting together two or three elements, such as a table screen, two chairs, and a table gives the impression of a larger room. This is particularly effective when viewers hear the sounds of the rest of the room on the soundtrack; these should be modulated, of course, so that they don't dominate the main action. "Less is more" certainly is appropriate when it comes to putting sets together. In my studio, with one artificial tree illuminated by an amber spotlight to throw shadows on the white wall and a shutter screen near the white doorway, I can create a sunset feeling in Arizona. When the performers talk to each other in extreme closeup, they can say that they are in Arizona at the end of the day. The audience will believe them. When you pull back for a medium shot, all you need are a few props and some atmospheric lighting to keep the suspension of disbelief going. (While an establishing shot is called for at the beginning of a scene before you can shoot closeups, the idea once again is to keep everything as simple as possible.)

If you are the set designer as well as the videographer/cinematographer for your project, you'll be working with the set decorator, who dresses the set. Together, you are in charge of the decor. These areas of artistic endeavor are part of creating the locale and mood of a scene. Once the set is decorated and ready, the lighting crew can begin working with the director of photography (you), and get the approval of the director and the producer.

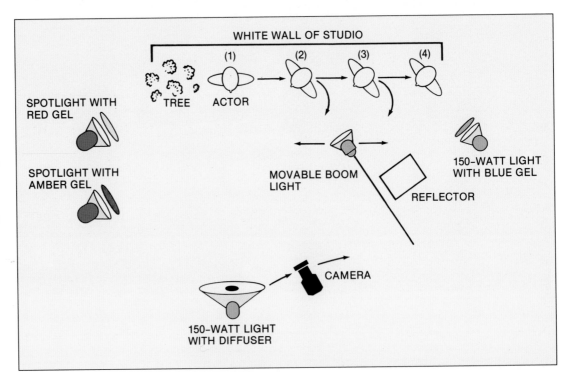

To create a southwestern look for this actor's audition tape, I used a diffused white 150-watt spotlight as the key light on the actor, a blue-gelled 150-watt spotlight to give his face a blue rim light, a movable boom light as the hair light, and one amber-gelled 150-watt and one red-gelled 150-watt spotlight to cast tree-leaf patterns on the white background.

The scene can then be photographed. It is that simple. Or is it?

Suppose, for example, that you're shooting a horror-movie script. This might call for *aging* the walls and the decor. So before you start repainting any rooms, experiment with a number of blue and green gels or spots. Be sure to keep lights at a low level and to use red and blue gels when sidelighting the performers' faces. If these lighting techniques don't seem convincing enough, you can choose inexpensive furniture and dust it with talcum powder; you can also use Fuller's Earth to make props, furniture, and even people look old and dusty. And a latex "Cobweb Gun" sprays cobwebs around the haunted house (you can rent one of these guns from a professional prop or supply house in New York City, Los Angeles, or perhaps even Orlando, FL, where movie production is getting an East Coast shot in the arm—see the "Resources" list on page 142).

Holding a can of spray paint at a reasonable distance from a piece of scenery or wall enables you to coat the surface with an aged, murky effect, especially if you use a gray-brown mixture and lay one color on top of the other for more texture. If you want to avoid the strong odor spray cans produce, try *stippling* the paint on by standing back about 3 feet from the wall and hitting the paintbrush bristles against your other (gloved) hand while aiming at the wall, of course. For a finer stipple or *grain*, run the brush across a piece of screening. I've painted quite a few sets, and this is how I always get a textured granite, rock, or old-room effect. Finally, to make horror-scene drapes, dye inexpensive gauze a deep gray or paint it gray.

These are just a few of the many special effects that I use, including several of the imaginative ways I've put backgrounds to use, which are appropriate for either indoor or outdoor shooting needs. With some experimentation and imagination, you'll be able to come up with additional ideas for special effects using your own collectibles. Another source of inspiration is the February 1991 issue of *Videomaker* magazine. An article by Mark Swain and Megan McKay contains a list of 60 simple special-effects setups. Some of these special effects are achieved via the use of light manipulation, camera angles, and filters. Others involve such props as bloody hands and disembodied heads, fog, snowflakes, storm clouds, and other atmospheric phenomena. Finally, although special effects are a great deal of fun, you shouldn't rely on them excessively. When you use them only for their own sake, they draw attention to themselves and detract from the story being told. Include special effects only when they enhance and give impetus to the narrative.

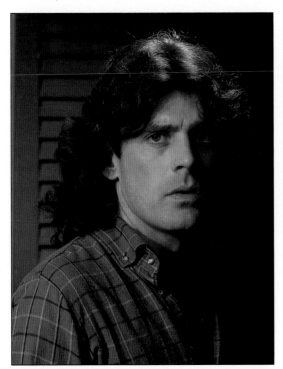

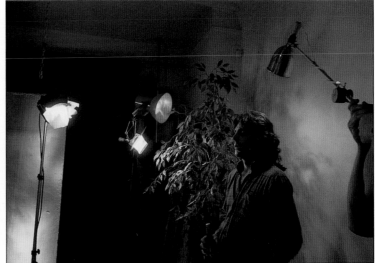

I followed the actor with a Sharp camcorder; his voice was recorded with a condenser microphone (above). By carefully planning the lighting design for this video, I was able to achieve the desired effect of a southwestern locale (left).

When shooting indoors, you can use a 4 x 8-foot section of reflective Mylar mounted on *foamcore* behind the subject and tilted at a 45-degree angle against the wall or background paper. Another option is to tilt the Mylar at a 45-degree angle toward the subject by suspending it on two small chains with clamps to hold it in place. The reflective board absorbs all shadows in either position. In the back-tilt position, it can reflect a spotlight bounced off the ceiling, thereby giving the background a soft, gray-sky glow for an outdoors feeling. Placing a 15 x 24-inch metallic reflector that is mounted on a stand just below and in front of the model's face gives a nice, soft fill to the shadows created by the key light.

You can use both methods for closeup and medium shots in videos and films at different angles and for various color effects; simply bounce different colored lights off the ceiling to give added interest to the background. For full-length shots or fuller medium shots, you can clip the 4 x 8-foot reflector onto a lightstand. With the key light to the right of the actor, the reflector fills the shadow on the left side of his figure with a soft glow. Of course, you have to correctly angle the shiny reflector in order not to cause glare. Tilt it so that the shiny surface doesn't reflect the hot lights and shine them into the lens. Placing a flag near the camera lens can also prevent spill into the lens. For an even softer fill on the left side of the actor, simply turn the reflector around and use the white side.

Naturally, the area of action limits the use of these positions. Having an assistant hold either the silver or white side of the reflector elongates the playing area as the actors move forward or backward in relation to the camera.

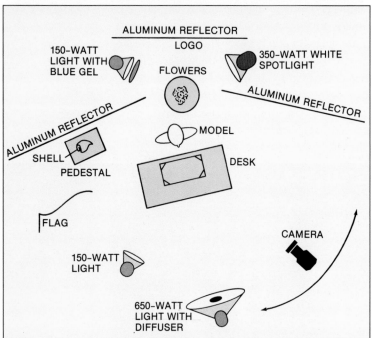

The two aluminum reflectors placed behind the shell and the flowers and a third placed to the right of the model provided the background for this television-studio setup (above). It is important to place reflectors carefully, so that they aren't too reflective. The diffused 650-watt spotlight aimed at the model and the flag to her left minimized the reflections. This lighting design worked well for both medium shots (opposite page, top) and tighter shots (opposite page, bottom).

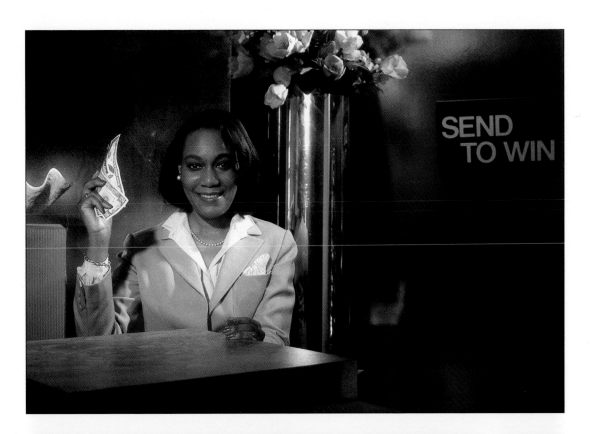

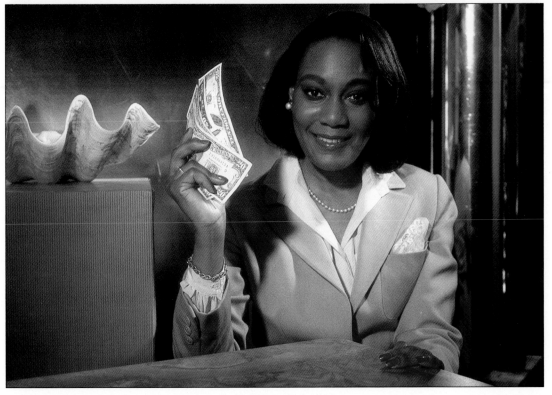

It is possible to use smaller reflectors outside for closeup shots. But because so much outdoor shooting consists of one, two, or more people in a scene, you should take large reflectors on location with you. The beautiful silver-squared reflectors used on actors and actresses in elaborate Hollywood productions are very expensive because they're mounted on sturdy stands and anchored with sandbags for wind resistance.

As with most of your present studio equipment, try to use what you've already paid for. So take your 4 x 8-foot reflectors outside and prop them against a tree, a telephone pole, or the side of a porch. Weigh them down with plastic milk containers filled with sand or have your assistants hold them in case a strong breeze comes up. If your budget allows, buy portable background stands. These are available from Adorama, located in New York City, your local photo store, photography magazines, and mail-order catalogs (see the "Resources" list on page 142).

With reflectors alone, you can shoot a beautifully illuminated scene, particularly outside. You can also bounce outside light into the windows of a room for a more elaborate effect. When shooting black-and-white portraits, studio photographers place a silver reflector under and just beyond the subject's face. This adds a bright, sharp fill light to the face. Sometimes they substitute a white reflector for a softer fill. If, however, they're shooting in color, both the white and silver reflectors can be used. But when they add a gold reflector, it introduces a warm, summer glow to the face—an added dimension to the coloring of the face.

You might want to adapt these three colors to your reflector palette for video or film work. Think of people standing in the snow with their backs to the sun; this is white reflection. When these same people stand on honey-colored sand, you have gold reflection. And when they stand in front of an aluminum truck, the reflection is silver. Which one you use is determined by the emotional mood of the scene you're shooting. As with your lights, experiment a bit and then decide which one gives you the best results. Does white, silver, or gold reflected light best capture the look you want in the scene?

The average reflector or fill meter reading won't make an appreciable difference in your basic exposure reading unless you use it only as a low-illumination key light. This includes the *bounce* light from a properly directed reflected light, such as reflected lighting on a face or reflected light near a pool. In any case, continue checking your exposures in any reflected-light situation.

Shooting this video with my Sharp camcorder on the beach, I was faced with bright sunlight and reflective sand. So as you can see in the diagram, I had to devise a flexible lighting design. I had my assistant (1) hold a white reflector above his head for (5) long shots, (2) over-the-shoulder shots, and (6) medium shots. For (3, 4) closeups, he used a mottled aluminum reflector to maintain the amount of reflection.

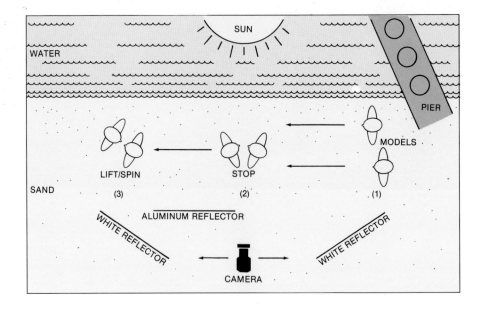

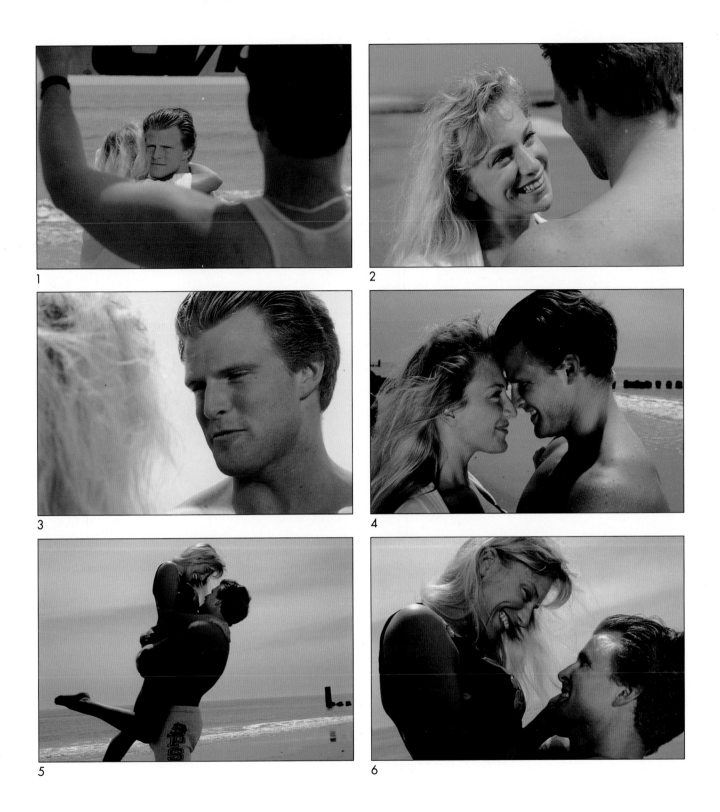

1

2

3

4

5

6

CHAPTER 3

EXPOSURE CHOICES

Because you can more readily control the lighting in your studio than you can outside, determining exposure when shooting inside is easier.

The amount of light that you allow to enter your camera through its lenses and the light's subsequent penetration of the film emulsion or videotape determines *exposure*. In a given lighting situation, the original light sources can be as simple as one light or one window. They can also be complicated, with many lights of different wattages or many windows of different heights at different positions in the room. Determining the correct—the most effective—exposure for accurate readings can be tricky. And not only do you have to keep in mind the positions of the lights, but also the position of the camera in relation to the light sources.So with your camcorder or studio video camera, you can photograph action shots of people and the scenes they are involved in indoors or outdoors, as well as during the day—at sunrise and early in the morning—or at night—at dusk and sunset. (Shooting at high noon produces unflattering images in films and videos, just as it does with still photography.)

You can use reflectors to manipulate and augment all of these lighting conditions, inside or outside. If you shoot naturally lighted scenes, you have certain exposure concerns. And if you intend to shoot indoors, you have a different set of exposure choices to consider. You might decide to use artificial light alone or available light. Keep in mind, though, that if you choose to combine natural and artificial illumination, you have to give some thought to balancing the color temperature of daylight (5700K) with that of artificial light, such as quartz, halogen, and neon light (see pages 60-61 for more information). For example, quartz hot lights have a color temperature of 3200K.

Finally, remember that whatever light readings you get from your exposure meter, that same light has to enter your lens accurately. All still photographers know that the three major factors controlling exposure are the film speed, *f*-stops, and shutter speed. *Lighting for Action* isn't a technical primer on exposures. I simply want to get you excited about all the different new lighting situations available to you once you make the move to video or film. Don't let the hundreds of lighting situations and exposure choices at your disposal—in addition to all of the lighting equipment available to you—overwhelm you. You can keep the lighting simple and still get great results. Once you do your lighting design, the films and videos that you create will look professional, whether you take reflected-light or incident-light readings, if your exposures are consistently correct.

As still photographers know, it doesn't make any difference whether a scene is heavily diffused or has high-key or low-key lighting. You must always take accurate meter readings of the lighting setup. Fortunately, the metering needs of camcorders and movie cameras are, like the various lighting setups themselves, basically the same as those of still photography. You're still dealing with hot lights, and the camera lens still wants to know how much or how little light it needs to record the scene with perfect black-and-white or color saturation.

Although you must take incident- and reflected-light readings with movie cameras, the video format offers another distinct advantage: metering is built in. A camcorder responds to a reflected-light reading by having light-sensitive chips in the video tube automatically read the color-contrast ratios and color temperatures emanating from the light source simply by putting the *white-balance control* on automatic. The lens opening and speed are adjusted accordingly. In an interior lighting situation with artificial lights, turn to the "*" indication on the white-balance control.

In an exterior lighting situation, use the "0" (sun) symbol on the white-balance control.

When you place the performers near a bright-sky light source, angle the camera or zoom in to their faces in order to get a light reading from their skin tone first. Don't let the natural light surrounding them dominate the meter reading. Another way to meter this type of scene is to point the camera at a neutral area, such as a gray-concrete street, so that its tones approximate the skin tones of the performers. This prevents the meter from reading the sky too much. You can apply this same technique to houses, skyscrapers, or other buildings that are so far off in the distance that taking an accurate meter reading would be impossible.

When you work with film, whether 8mm, 16mm, or 35mm, metering can get more complicated. You have several options to choose from. First, although you can buy movie cameras with built-in light meters, I think that there are too many variables in terms of film emulsions and lighting plots. Interior lighting setups are usually read with ball-type *incident-light meters*; these either record the illumination

During the preparation for this project, my assistant took a reflected-light reading by pointing the meter toward the subject.

from the key light or are pointed toward the camera. Frequently used on movie sets, variations of this type of light meter are available from Spectra, Weston, Gossen, and Luna Pro (see the "Resources" list on page 142). Visit your local photo store, too. Any of these versatile meters can read your incident-light levels from several different parts of the set and average them, thereby giving you an accurate meter reading.

For most video/film interior lighting situations, you'll use *reflected-light meters*. After you set the ISO rating on the meter, point it toward the key light for an incident-light reading. Then take the reflected-light reading of the light bouncing off the main players in the scene, and balance the readings. The set will be exposed correctly. All other meter readings taken of different sections of the set are secondary. Next, you must figure out the light-balance ratio between the middleground and the background. You don't want the background, no matter how cleverly built or illuminated it is, to dominate the action in the foreground. This balancing act with light placement and intensity is always a challenge. Experimenting and running tests can help you achieve a pleasing overall light level for both the set and the performers occupying it. Walking around the set with an incident-light meter pointed at the various lights enables you to average the light-meter readings.

As a matter of fact, you have to keep checking the set and the performers because you want the mood and color temperature of the lighting to be consistent. For example, you don't want a reverse over-the-shoulder shot of a couple to be radically different from the first shot if they are in exactly the same lighting situation. (You can, of course, have a good lab correct any mistakes—even color-correcting ugly fluorescent greens—but you shouldn't come to depend on this safeguard.)

Conversely, for exterior lighting scenes, use a *spot meter* to average the light from the sky and the amount of light reflected by the ground objects illuminated by the sun. Spot meters, which zero in a closeup reading of the performer or the environment, help you average the amount of light entering your lens and falling on the film emulsion.

For cinematography, it is best to actually have on hand several different types of meters, including a spot meter, an incident-light meter, and a reflected-light meter. This will enable you to be prepared for any interior or exterior lighting "crisis." For example, my Luna Pro meter measures the reflected light emanating from a model's face and then when I slide the white plastic ball over the light-meter opening and point it at the key light, I get an incident-light reading. In effect, I've double-checked the light reading from two different vantage points for a truly accurate reading.

In order to do your best work, you must be aware of the technical advances that come along in the video/film market each and every day. Electronic digital-readout meters must only be secondary elements, not primary factors in the video/film canvasses that you'll continue to create. As with any art form, creative instincts, time, patience, trial and error (minimized via the use of storyboards), testing, and rehearsals are the dynamic sources of a new career, whether in the videography field or the world of cinematography.

Accurate meter readings help you project and reproduce clear, sharp, color-saturated images. You don't want your shots to be overexposed or underexposed (unless you do this deliberately). Light levels have to be consistent from one shot to the next and from one scene to the next. If you finish taking some shots at the end of one day and have to shoot more of them the next day, the second day's footage has to match the preceding day's. So continual meter-reading checks ensure exposure accuracy.

Once you get to the point where you're editing your video or film, you'll naturally want to see a consistency of exposures in scenes that are logically or sequentially related. For example, scenes of a family in the kitchen might include entrances into the main source of light (probably the window above the sink), as well as shots of the family members at the kitchen table, at the oven checking the cake, and getting dishes out of the cabinets. These all must have the same lighting look, the same color, and the same feel in each consecutive scene. Otherwise, if the viewer notices dark scenes following light scenes, or if one model is tinted slightly green in one scene and then too pink in another, you are in trouble. Of course, avoiding this problem is easier with video exposures than with film exposures, which require multiple-light readings.

What steps can you take to ensure accurate exposures for professional-looking videotapes and/or films? Many still photographers, including myself, memorize black-and-white lighting situations. I know that if I'm in the studio doing a closeup using Tri-X ISO 100 film and my 1,000-watt tungsten scoop light with a diffusion screen as my key light, the exposure will be 1/60 sec. between $f/5.6$ and $f/8$. Shooting the same film outside with the sun as my back light and a white reflector as my key bounce light, the exposure will be between $f/5.6$ and $f/8$ for 1/250 sec. In a shaded area, the exposure will again be between $f/5.6$ and $f/8$ for 1/60 sec. In case of doubt, I have my trusty, automatic spot meter in my Nikon F3. I still have a circa 1950 Guardian exposure meter that I can use for stills or film. It has an

exposure-index window, a time-second window, and a range selector that reads from "LO" to "HI" (Bright Light). As you shoot, be it film or video, always keep in mind that when you use lighting setups that involve hot lights, the designs are applicable to still photography and video and film work.

If your first move is to film, your present light meters are perfectly adequate using your incident-light readings as the norm. Because the usual set has many lights—key lights, fill lights, back lights, floods—aimed at different *light zones*, or parts of the set, you have to consider what amount of light will enter the camera lens lights (especially when you're shooting film) and to carefully balance the light falling on the performers and the set that serves as the background for the action. Illuminating the actors and actresses correctly is the main object of your lighting design. After all, they are the ones telling the story that you're videotaping or filming. So viewers have to be able to see (and hear) them with maximum clarity. If one part of the set is too hot, you must tone down the lighting on it, so that it doesn't shift focus away from the main action.

Light meters are your chief tools for getting correct light exposures, but you shouldn't discount the human eye's ability to telegraph that someone made a mistake, using an over-hot light or pointing another light directly at the camera lens. As a matter of fact, many designers of photography are so attuned to the nuances of their various lighting instruments that their practiced eye is often enough. However, most directors of photography continually check their light readings as a shooting progresses. They have some leeway because even if they overexpose or underexpose by one, two, or even three f-stops, the timer in the film-processing lab can compensate or make adjustments. But this is not the norm. Only in a situation when the videographer/cinematographer feels that a certain effect is compatible with the mood or look of the scene being shot are such aberrations utilized. In fact, most directors want the scene shot the way they want it shot and

make the final decision. The director of photography is basically there to adhere to the director's creative eye.

If your first move is going to be to video (the better choice, I think), you can handle the metering quite easily. Your camcorder automatically reads the scene. Also, the control panel of the camera contains a readily apparent automatic or manual white balance. The more expensive *electronic-news-gathering* (*ENG*) cameras have a white balance, as well as a black balance and a gray scale.

There are other differences between camcorders for home use and the Sony CCD camera that sells for about 7,000 dollars as well. Sony CCD cameras have a high sensitivity of *f*/5 at 2,000 lux; a variable-speed electronic shutter, with shutter speeds of 1/60 sec., 1/100 sec., 1/250 sec., 1/500 sec., 1/1000 sec., and 1/2000 sec.; the integration of more than 250,000 *picture-sensing elements* with a 6.4 x 4.8mm image-sensing area; automatic white and black balances; and color-temperature conversion filters. And the DXC-3000A CCD camera, which is even more top-of-the-line, has three interline-transfer CCD chips (each 2/3-inch chip has more than 250,000 picture elements for over 580 lines of horizontal resolution); excellent sensitivity in low light; and 25-lux minimum illumination. Picture-sensing elements are the most important feature. In videography, light metering is programmed into the camera. In cinematography, on the other hand, the film-emulsion exposure depends on the lens opening, shutter speeds, film speeds, and such other variables as filters and color temperatures of lights.

White Balance

On your camcorder, you'll see a white-balance button; it reads "auto" for automatic, in which case the light sensitivity of what you're recording will read on your video image. If that image is too white or raw in color, the white balance will automatically adjust to an acceptable gray-scale reading, so that you don't get overly hot highlights on your subject (makeup can help control those highlights). You know that you want an even, middle-tone reading on the objects you photograph: not too light, not too dark, but with a pleasing gradation

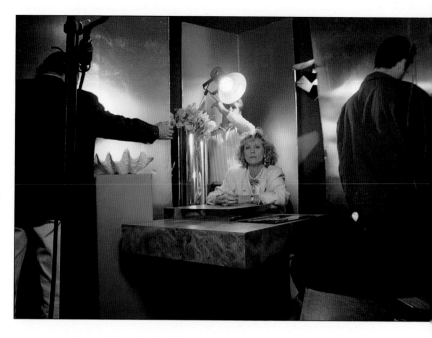

of colors that range from light to dark. The white balance is like a built-in meter that correctly reads your video image. When shooting with your back to the sun, you should point the camera at a neutral color first, never at the bright sky. After all, you don't want to burn out your camera. Also, there are manual white-balance settings for sunlight and for tungsten or interior lighting. In any case, check your white balance first for proper color readings.

Lighting Changes

Once you set your white balance, you'll be able to follow the given action and your camcorder will read each scene or color shift correctly. Remember not to shift scenes too abruptly, such as going from shade to bright sky suddenly. This thoroughly confuses your camcorder. Shoot one scene completely using one lighting setup.

For meter-reading consistency, keep the scene in, for example, medium tones. Suppose that an actor's running through a dark hallway into the bright sunlight. Don't stay with the running figure. First film or videotape him in the hallway, and cut the shot when he gets to the door. Then go outside the door, and record him coming down the steps toward the camera. Next, you might pan him running toward brighter light. With this shot sequence, you won't shock the delicate electron tube inside your camcorder.

As you shoot your film or video, have an assistant continually check the light-meter readings to make sure that exposure is constant.

Working with Available Light

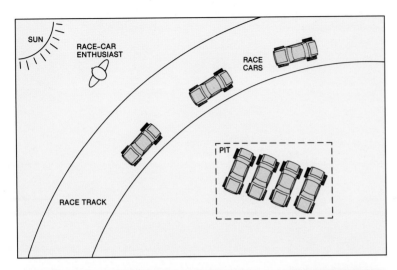

The sun provided golden available light for this long shot of a car zooming along a racetrack (above). To best capture the late-afternoon sunlight, I asked my subject, race-car enthusiast Donna Dismore, to face the sun for this medium shot (opposite page).

These light sources are already set up; you don't have to rent them or buy them or put them in place. Available light is also referred to as *natural light*. The sun is the best example because it is free and ready to use. (This is true both outside, of course, as rays of sunlight stream through leaves in a forest, and inside as it filters through a broken stained-glass window and spotlighting a minister.) To use available light effectively, you have to determine where it's coming from, at what angle, and at what intensity it is entering the room. These factors tell you where to place the performers in a given scene.

For example, an actress sits on a windowsill reading and the sunlight comes in at a 45-degree angle. You have enough exposure clues to indicate where you might want to set up a reflection on her figure, as well as to place the camera or extra lights when dusk falls. In other words, if you want to illuminate her face fully, position a white reflector directly in front of her, directly below the camera. If you decide that you want a slight shading on the left or right side of her face, shift the reflector to the opposite side.

When photographers yell, "We're losing our light!" as evening approaches, the light meters come out. They're needed to see if there is enough light left to shoot the scene. In order to measure the amount of available light, you can use a spot meter or an incident-light meter pointed at the light source. In this shooting situation, you might want to try a reflected-light meter, too, aimed at the woman's face. When your available light goes, there goes the scene!

Adding Artificial Light

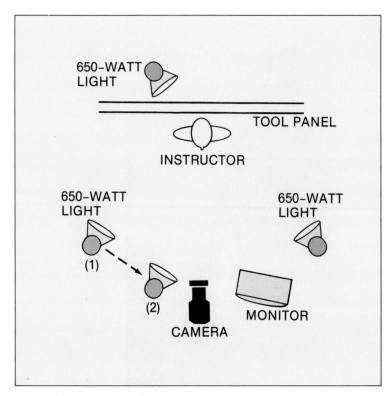

For this instructional video featuring race-car driver Mark Dismore, I planned a simple but effective lighting setup with a Lowell Omni Kit (above). I positioned two Lowell 650-watt lights in front of him, one on either side (opposite page, top); for tighter shots (opposite page, bottom), I moved the light on the left to a spot directly in front of Mark and angled it at 45 degrees. Another 650-watt light behind him provided the hair light.

Any light source that isn't directly from the sun (or natural fire) is called *artificial light*. So any light or lamp that you buy to illuminate the set or the performers is considered an artificial light—a Smith-Victor 150-watt light, a Lowell Tota 650-watt light, a Mole-Richardson 4,000-watt quartz light, up to a 30,000-watt arc light for large-area night scenes. In fact, there are so many artificial lights on the market that many professionals simply rent them as needed from the manufacturer or distributor.

The scope of the scenes that you want to shoot largely determines both the size and the wattage of the artificial lights. Other influential factors include the mood and storytelling demands of the script that you'll be shooting. Of course, it is smart for beginning videographers/ cinematographers to start small. Once again, you'll be pleasantly surprised to find out that much of the lighting equipment you own and use for your still photography is perfectly suitable for your new projects.

In a studio situation, you can make tungsten or quartz lights imitate available-light sources. One way is to build a set with a curtained window and a window seat and then to place the actress on the seat reading. Positioning a large, 1,000-watt spotlight outside and above the window at a 45-degree angle will produce that natural look of sunlight falling on her head and shoulders.

My favorite studio lighting is the kind that simulates available light. Lately, I've been putting a 650-watt spotlight behind the model instead of the typical 150-watt hair light. This extra hot light on the hair gives the image an out-of-doors feeling and appears to be sunlight in the subject's hair. I compensate for the stronger, more intense back light with a balancing key light. I still use a metallic-reflector fill light on the face to lighten shadows. Best of all, I can easily transfer this lighting style to film or video; with video, however, there will be some softening.

When I was first designing sets for the theater, I always illuminated the set first, before adding performers. Suppose a set consists of a large white living room with a fireplace where a "father" and a "prospective son-in-law" have an argument. Some natural light comes into the room through a large bay window to the left of the fireplace, and sunlight falls in rectangular patterns across the fireplace wall and the portrait above it. The actors enter the room through a door opposite the bay window and walk to the fireplace.

It is more logical to illuminate the room correctly before the actors make their entrance. You can't illuminate the actors first because you don't know the effect of the lighted environment on them. For example, the natural light coming into the room from the window might not be enough to illuminate them fully. And even if it were, you might have to add fill lights to compensate for the dark shadows that would form on the shaded side of their figures. You might need a couple of Lowell Tota 1,000-watt lights bounced off the ceiling in the direction of the fireplace. To help you understand this, think of a theater set, which is illuminated before the performers enter—otherwise, they'd be walking into a dark room.

In order to balance the natural sunlight (which has a bluish cast) in this scene with the tungsten lights (which have a reddish cast) you introduce, you can place *dichroic* filters over the Tota lights, such as Lee 201 Full Color Temperature blue filters. ("Dichroic" filters have a vapor-deposited coating that reflects unwanted portions of the light spectrum.) These convert tungsten light's Kelvin rating (3200K) to daylight temperature (5700K). When you need to convert interior tungsten lights into exterior daylight temperatures, you can place large dichroic sheets over the windows. Another helpful (but expensive) solution is to use an OSRAM HMI filter. It saves you from having to use filters or gels in order to convert the lights to the daylight color temperature. Conversely, if you want to convert daylight to tungsten, you can use orange Lee filters, numbers 204, 205, or 206. And to

minimize the greenish tinge of fluorescent lights, you can use rose and pink filters, such as Lee filter number 247 (see the "Resources" list on page 142).

Before you can shoot an interior sequence, you must learn how to handle lighting for action indoors. Ask yourself, "What are the light sources in the room?" If the sunlight is streaming in, then it should dictate all the "logical" light that hits the performers. Don't forget to cover the windows with a blue gel to convert the available light to tungsten light, so that it blends with the interior tungsten light. Once again, by your illuminating the room first, the actor and actress walk into an environment that has already been created for them and gives them a sense of place. Because they've become part of the preplanned action, they pick up the mood of the scene when they see the room in which they'll carry out the plot. In addition, when you illuminate the set first, whether it takes the form of a room, staircase, or castle tower, the lighting for the performers comes more easily. With the other fill lights already taken care of, all you have to do is give the stars their own key and back lights in order to make them stand out against the background or the crowd.

Turning your attention to the set's lighting design, you can "paint" the walls with light by throwing a couple of "specials" (lights) on the fireplace, the plant in the corner, or the stretch of brick behind the performers. These specials vary in light intensity, so don't let the background be hotter than the foreground—unless, of course, that is where the window is. If this is the case, your own experimentation will help you decide how long you want that window to be included in the action. Naturally, the specials can be directed and used with *gobos*, or shaded with barndoors and flags. This type of light manipulation can be quite effective.

Now suppose that you decide to shoot your story in color. First, you must position your lights for the maximum illumination required, either for the room setting or for closeups. Next, you have to make storyboards for your sequences, complete with the accompanying

dialogue, or *copy*. Rehearse the copy with the performers to ensure that they know what they're going to say, when, and with what type and degree of emotion.

Consider this simple action sequence involving an actress named Lillian. The storyboard reads as follows :

1. Lillian stands still waiting with a note in her hand at the art gallery where Tom wanted to meet her.
2. She sees him in the doorway. Tom moves to her.
3. She is angry as he apologizes.
4. He takes the drink she offers him.
5. She loosens up.
6. He gives her the earrings he had promised.
7. They both move to the garden area.
8. They kiss and make up.

To keep the shooting and lighting simple, you would do all of Lillian's shots first (with Tom's shoulder in the foreground). You would then switch the same lighting composition to Tom and shoot all of his scenes (with the back of Lillian's shoulder framing Tom's face). You'll edit your out-of-sequence shots and put them back in order according to the storyboard later (see Chapter 5 for more information).

Finally, you decide that you're going to use a combination of hard and soft lighting. If you want Lillian to look more glamorous in a scene, use a soft-focus filter on your lens or place a piece of diffusion material over your key light. If you want Tom to look mean and angry, you have several options. You can sharpen his key light, throw his face into a partial shadow, or intensify the amount of light hitting him. So experiment. Practice your lighting before you shoot even after you've designed your lighting setups on the storyboards. (Incidentally, anger is a strong emotion. To enhance the mood of a scene, you can use colored gels similar to those that I selected for the New England village mystery (see page 42). Manufacturers make a kaleidoscope of colors to enhance any mood or emotion (see the "Resources" list on page 142).

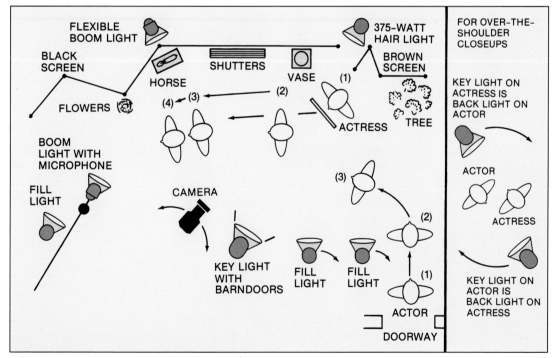

The interior soap-opera sequence shown on pages 62-65 required a rather complicated light plot. A key light with barndoors and two fill lights followed the actor as he crossed the room in the art gallery to provide even illumination (above). Similarly, a 375-watt hair light, two boom lights, and a fill light were aimed at the actress as the scene proceeded. One black and one brown screen were on opposite ends of the set. For over-the-shoulder closeups, the actress's key light served as the actor's hair light, and vice versa.

1
ESTABLISHING SHOT. Art-gallery
owner Maria reads note before
opening of important exhibition.

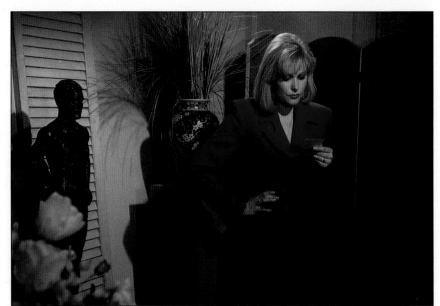

2
MEDIUM SHOT. Maria gets angry as
she reads message from Brad.
Maria (voiceover): "See you promptly
at 4 P.M. Brad."

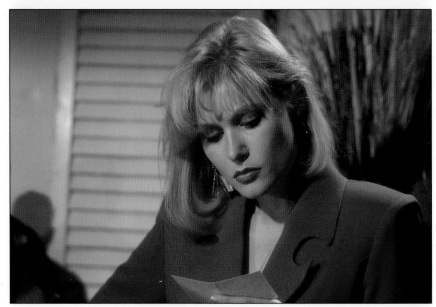

3
CLOSEUP. Maria thinks about how late
Brad is.
Maria (voiceover): "How can he do this
to me? I can't wait for him. People will
be arriving any minute."

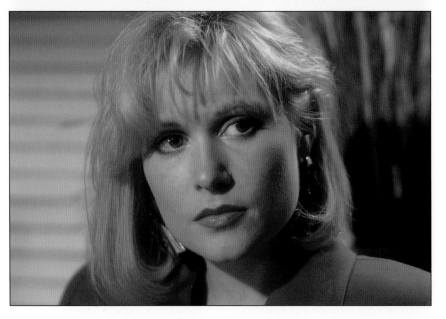

4
MEDIUM SHOT. Maria gets even angrier as she realizes that she'll have to get started without Brad.
Maria (voiceover): "This is my opening. I'm furious. That's it! We're through. The engagement's off."

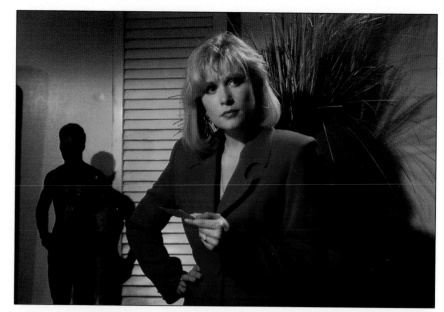

5
CLOSEUP. Brad stands in doorway to gallery.
Brad: "Hi, sweetheart!"

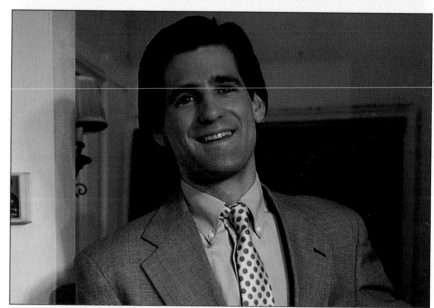

6
TWO SHOT. Brad tries to apologize to Maria for being late.
Brad: "Sorry I'm late, but my client insisted that"
Maria: "Big deal! I've got guests coming and a million things to do."

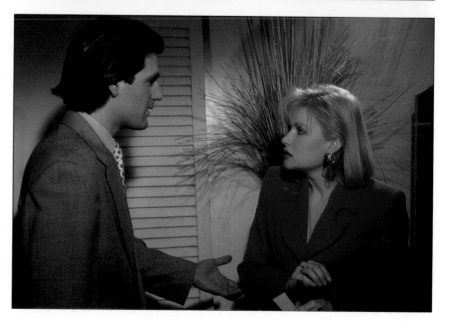

7
OVER-THE-SHOULDER SHOT. Brad continues to explain why he was delayed.
Brad: "Give me a break, darling. I had no choice."

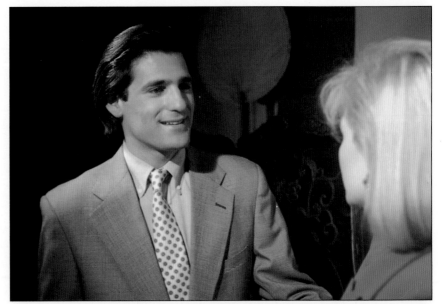

8
MEDIUM SHOT. Maria pulls away and turns her back to Brad.
Brad: "Wait. There's something I want to say"

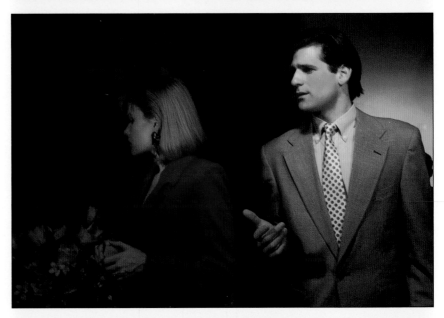

9
OVER-THE-SHOULDER SHOT. Brad starts to hand Maria something.
Brad: "Drop something?"

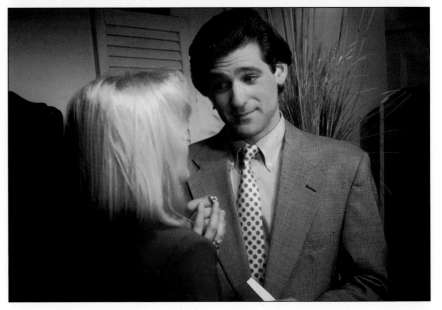

10
TWO SHOT. Maria realizes that Brad is giving her an engagement ring.
Maria: "Why . . . I don't . . . Oh, Brad! It's gorgeous!"

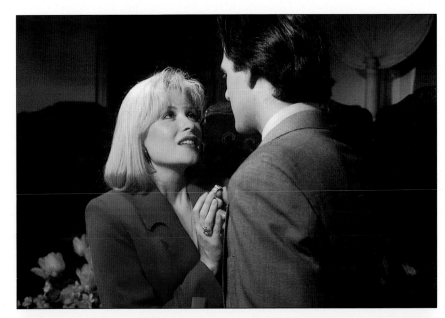

11
MEDIUM SHOT. Maria and Brad celebrate their engagement.
Brad: "Let's have a drink."

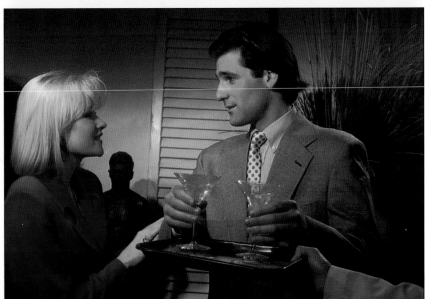

12
MEDIUM SHOT. Maria and Brad toast their engagement.

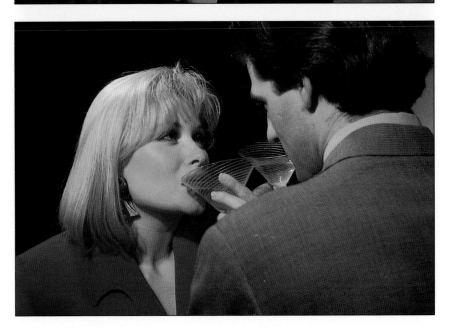

SHOOTING OUTDOORS

Many videographers and cinematographers claim that shooting outside is more difficult than shooting inside because when you shoot in the studio, the lighting situation is more controlled. When you work outside on location, you are often at the mercy of the elements. I find this odd. For my portrait work, whenever the weather cooperated, I'd immediately say, "Let's take some outdoor shots!" In other words, I came up with any excuse to film outside. All I needed was my camera and a reflector. I used the sun as my back light and the white reflector as my key light, which illuminated my client's face. I usually got some terrific head shots. To make subjects come alive with three-dimensional qualities, you must correctly delineate the light and shade on them. Whether shooting in color or black and white, you can have the models stand in the shadows, walk or run through the reflected light, or even leap over a wall with the sun directly on them. I prefer late-afternoon light because the lower angle of the sun produces less shadow on the eyes. The result: shots that are always full of vigor and life.

Unfortunately, these still-photography situations are simpler than video or film shoots. Scenes might involve action sequences that can last all day, depending on fickle weather patterns. You wonder if the the sun will stay out long enough for you to finish the scenes? Getting rained out is a too-frequent nightmare. High winds can come up and blow reflectors, lights, camera stands, and actors around.

However, outdoor shoots can proceed very smoothly. You can grab your camcorder or movie camera, run outside, and get great shots that utilize whatever elements you happen to find: bright sun, overcast skies, storms, rain, snow, or sleet. Once you write a story and decide on the time and place of the action, you have to be able to adapt your shooting schedule to the weather forecasts. You can also plan ahead for just such exigencies, and choose an alternate shooting location. Suppose the scene that you wanted to shoot in a sunlit corn field

The natural overcast light aided by a gold reflector provided enough illumination to give this dramatic scene its visual punch (right). I simply had an assistant hold the reflector vertically to the right of the actors or below them (opposite page).

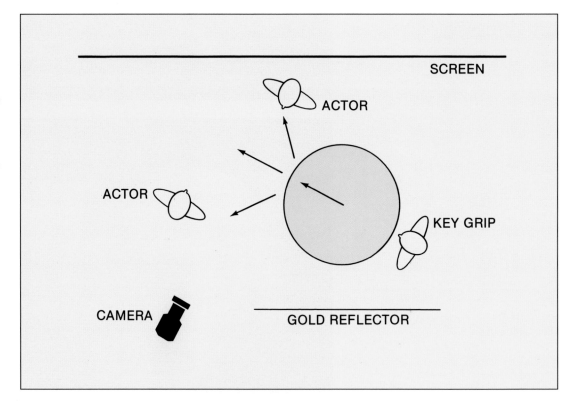

suddenly gets rained out. You can shoot the other scene that takes place inside the barn or, in desperation, you can rewrite the scene in the corn field, moving the dialogue and action to the front porch.

But if the weather cooperates for the corn-field scene, you might decide to photograph the performers as they face directly into the sun. In this farm situation, using the sun as your key light suggests the gritty reality of life on a farm and provides a documentary-like feeling. In order to photograph the woman in the farm story in more flattering light, you might want to have her turn her back to the sun, making it the back light instead of the key light. Then, as before, you can fill her face with reflected light bouncing from a white or gold reflector (a gold reflector gives faces a warmer, tanned look). Here, then, the reflector acts as a soft fill light that adds diffusion to the actress's face. When you illuminate full-length figures standing with their backs to the sun with reflected light, the sun acts as a strong back light or rim light and gives them added dimension. It effectively separates them from the background (see page 37). And remember, wherever you shoot the action—inside the barn or outside in the corn field—be sure to grab your light meter!

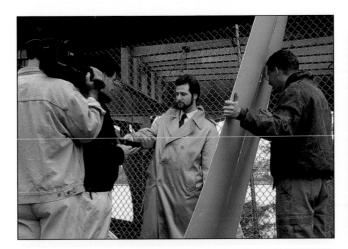

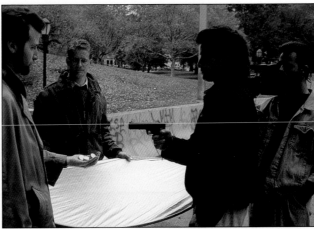

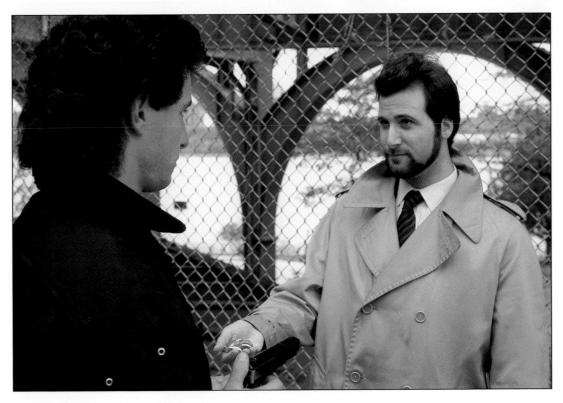

SHADED LIGHT AND OVERCAST CONDITIONS

One of my favorite still-photography lighting situations is photographing individuals in *shaded light*. This is soft, even illumination that features more gray tones than strong highlights and shadows. Yet if the shooting situation is bright enough, focusing can be quite sharp. One variation on shaded light is *tunnel lighting*, in which the actor might be standing near either end of a large tunnel, just inside the start of the shaded area in the tunnel. Here, the sunlit sky acts like a huge, diffused spotlight at either end of the tunnel. This type of shaded light is very flattering to subjects, and I've used it to great advantage.

For one such shot, I put my camcorder on my shoulder camera brace, checked the white balance, focused on the actor's face, and walked backward, keeping my focus as steady as possible. This produced a soft light transition from a medium facial illumination at mid-tunnel to a brighter facial lighting as the actor approached one end of the tunnel. This scene was effective because of the continuous movement as the actor walked and talked (I used the built-in mike on the camcorder to achieve a hollow, echoing sound).

On overcast days the illumination is soft, and the shadows are naturally diffused. As with tunnel lighting, the sky is often bright enough just before or after high noon to render sharp focus. But deliberately choosing to shoot on an overcast day is risky at best. In most cases, you shoot then only because the sun suddenly decides to go in. So instead of overall brightness, strong highlights, and deep shadows, you wind up with a moody, foggy effect. Unfortunately, if a given scene calls for an overcast day, you might have to wait a long time for one.

Murder mysteries are great for overcast days. But this weather condition can impart a romantic mood, too. *The French Lieutenant's Woman*, was beautifully photographed by British cinematographer Freddie Francis; the Pre-Raphaelite look of the film is impressive. In lieu of an overcast day and wanting to capture something in this mood, you can opt for open shade on a porch, on the shaded side of a house, deep in the forest, or in a tunnel. (Reflectors aren't needed quite as much on overcast days because the light behind the 360-degree cloud cover bounces all over the scene.)

This scene was recorded in New York's Central Park on a sunny December day. After the models jogged a bit of a distance as I filmed them, they "rested" near a tunnel. This kind of diffused illumination makes subjects look particularly appealing.

SHADOWS

One of the primary elements affecting moods and emotions is shadow. Obviously, any light that falls on a subject casts a shadow. As the videographer/cinematographer, your job is to decide if the shadow is effective or detrimental. In order to figure this out, just ask yourself the following questions. How did the shadow get there? How can I get rid of it if it doesn't enhance the scene? Do I really want to get rid of it? Can I use the shadow to good advantage, perhaps even exploit it for psychological impact? But the most important question is, does the shadow have substance? Often you get shadows where you don't want them.

Besides determining if a shadow is "good" or "bad," you have to realize that all shadows are either horizontal or vertical. So combining two or more shadows results in a cross-hatch pattern that can include diagonal shadows. By placing a *cookaloris*, or *cookie*, which is a black metal or cardboard sheet with different patterns—squares, circles, water currents—cut out of it, in front of a spotlight, you can create shadowed patterns on whatever background you have in mind. For example, shadows of Venetian blinds or leaf patterns on interior or exterior walls can break up a boring background and give it more visual punch. But if shadows don't add to the overall look of a scene, you must modify or eliminate them.

Distracting Shadows

These shadows don't add to anything you're trying to achieve. They are a definite distraction, and they can even look ugly. All shadows fall on two types of basic subjects: faces and figures, used in the foreground, middleground, or background, and on buildings or flora and fauna. If shadows add dimension to and strengthen an image, you might want to keep them. If they don't, get rid of them. It is that simple. When shooting portraits, I avoid having the dark shadow of the subject's head or figure fall directly behind the person because it detracts from the subject's persona. To eliminate them, I move the subject closer to the camera and farther away from the background. Another approach that I use in the studio in order to have shadowless backgrounds is to position the dulled mirror surface of a 4 x 8-foot sheet of Mylar at a 45-degree angle back and away from the subject.

Despite your conscientious efforts, bad shadows can still appear. These are caused by having the lights too close to the performers or props, placing the lights at a wrong angle, not having a *motivated light source* (the key light), or the crossing of one shadow over another (sometimes you can prevent this with performers simply by having one model move slightly, so that the shadow cast by the back light on one model's head causes his or her shadow to fall on the face of the other). You can also eliminate unnecessary shadows by lighting correctly in the first place; however, if they can still be seen during a lighting rehearsal, check to see if you've placed the light at an awkward angle or too close to the subject. You might want to flood or fill the shadows with more reflectors or lights to diminish the blackness of certain shadows.

Other ways to minimize or correct distracting shadows include shifting the position of the key light, moving the subject closer to or farther away from the key light, heightening or shortening the lights, trying a more diffused light on the performer, and covering the offending spot with more diffusion. Here, you use a diffusion filter on your lens and move the lamp position in your light from spot to flood position. Finally, you might even rethink the original light plot if you wind up with too many nonmotivated, distracting shadows.

Effective Shadows

Good shadows help to model a figure or inanimate object, and the imaginative use of shadow can help subjects stand out in space or give them a three-dimensional quality. Effective shadows can also help create the mood of a scene by enhancing the psychological underpinnings of the narrative action in such genres as dramas, mysteries, and films about the occult. Effective shadows can add depth, whether they're used in the foreground, the middleground, or the background. But you

As I set up the low-key lighting for this shoot, I noticed unwanted shadows on the left side of the subject (top). One shadow appeared next to her nose, and the shadow between her cheek and hair was too dark (above). To eliminate them, I adjusted the lights slightly and asked the model to pose differently. The resulting composition is much more effective (opposite page).

don't want a woman's face to have too many dark shadows consistently; they work better on a man's face. Furthermore, you don't want the subject's head to cast a shadow on the background, so either move the performer forward or move the background back. Another technique is to use backgrounds that can absorb shadows, such as foliage, bookshelves, furniture, and mirrors.

Positioning the lights carefully with the gaffer, who is in charge of renting lights and placing them on the set, after some rehearsal, enables you to eliminate ineffective shadows from the start. This step will save you a great deal of time because you won't have to fix them later. Keep the following tips in mind as you arrange the lights. When illuminating the walls of a set, shade them a bit at the top, several feet down from the ceiling; this will help to concentrate the main lighting. And to make an actress look gorgeous when you shoot film, give her what I call an "inner-glow" image. This effect imparts a radiance to the face. To achieve it, bounce a 650-watt quartz light off the inside of a silver-lined umbrella for a soft yet sharp light. You'll get virtually no shadows on the actress's face. If she is a good actress responding to another performer, her face can really shine. For a low-lux video, you can bounce a 150-watt spotlight off the umbrella as the reflected key light. For more expensive studio video cameras, use the same light intensity as the film you're shooting with.

You might also want to try the following approach when you first work with shadows. Begin with a completely dark room; think of this as a black box. Cover the windows with black paper. Try to have absolutely no light sources. Have an actor sit in a chair, next to one small table with one lamp (which is turned off) on it. If you want to use the light coming in the window as the motivated light source, take the paper off it. If, however, you want the lamp to be the key light source, then turn it on first.

If you start with the window, you have to see if there is enough light for the entire room. You might have to add more fill light. Since the actor is the center of attention and the action revolves around him, all the other lighting should be supplemental. Next, you have to think about how much light you want on the visible walls. If you're shooting a comedy, you'll

want plenty of light; if you're shooting a film-noir scenario, you'll want less. At what point do you feel that you have to augment the lights you already have? Do you want to add a back light to the actor's hair? If so, where will it come from? Does it have to be motivated?

You can consider other types of supplemental lighting as well. Do you want to add a fill light to soften any shadows on the actor's face? Do you want to add any shadow patterns, perhaps from the window frame on the back wall or, if you chose the lamp as your main light source, from it? Do you want to add a rim light to the performer, a zinger light to his back, or an eye light to give his eyes even more highlights? During the action sequence, if the actor goes to the window to look out at an adjacent building, do you have enough light to stay on him as he moves from the chair to the window, especially if you have only the one lamp as your main light source?

Faces are meant to be seen. If they can't be—if they are shaded too much or are hidden behind special shadows for too long—the viewers will be lost in a dark fog and will lose interest. And remember, the closeup is what counts. So illuminate it straight on with no overly dark, conflicting shadows. As always, keep the lighting as simple as possible. The story should dominate the scene, not the lighting. Another important point is to try not to use any one lighting design too often. Varying your lighting plots to maintain interest is important. You have to keep the audience entertained visually with the lighting, too.

There are thousands of variations on the basic lighting setups. Adapt them to the best interests of the storyline, the mood, the look, or your own distinct visual personality that best conveys what the storyboards and the script demand of you. Spend some time sitting in on the initial readings of the script, attend rehearsals, watch the director (with whom you, the director of photography, will collaborate) block the performers' movements, and make visual sketches as you try to pick up the mood of the script. After all, you're going to help interpret and give life to the script. The biggest transitions you have to make are thinking in terms of continuity and learning to match the sequence of shots that tell the story. You must arrange the lighting so that it looks exactly the same the next day on the set as it did the day before. What happened in the shot that you just filmed? What happens now in this shot? What will happen in the next shot? Matching one shot so that it blends in with the other is your responsibility.

SHOOTING DAY FOR NIGHT

This type of lighting is similar to an overcast-lighting situation. *Day for night* lighting is perfect when you don't want to actually shoot at night but want to give the impression that you did, such as for crime and beach scenes. This technique produces more of a feeling of late dusk than of midnight, but it is quite effective. To achieve this look, wait until at least late afternoon; you don't want the sky to be too bright. Then place a *neutral-density (ND) filter* on your lens. It reduces the amount of light entering your lens by one stop. The result is a night-like scene that has the contrast ratios of a daylight scene: there are more dimension and detail in the faces and costumes of the performers, as well as the environment. The audience assumes that the action is taking place at night, but they also know that something unusual is about to happen. This is because actual night shoots have an inky reality about them.

Shooting day for night, incidentally, is also cheaper. You don't have to pay for night crews and/or lighting equipment. If, however, you find that a late-afternoon shoot is impossible with your shooting schedule, you can shoot day for night in broad daylight. The trick is to use a #6 ND filter, which will decrease the intensity of the daylight measurement. (You can also use a graduated filter.) Then simply underexpose by two stops. In terms of backlighting and fill light, the lighting setups are exactly the same as the ones you use for normal shoots. When shooting day for night, you should use silver metallic reflectors to record sharper shadow detail.

Keeping in mind some other basic points makes shooting day for night easier. Because late-afternoon light changes so rapidly, it is important for you to work fast. Try using more than one camera and a capable assistant or two; this will enable you to get long shots, medium shots, and closeups at the same time. And for closeups, you need to stop down only one or one and a half stops, not two. Also, don't close down the lens too much. If you do, you'll increase the depth of field, which isn't seen in night shoots very often. (Of course, you might have to continue opening up as the late-afternoon light fades.) Finally, avoid getting the sky in your shots by including tall buildings. But if you don't have a choice, use a graduated filter to darken the sky. For this day for night interior scene, I used a blue gel on the window to create a moonlight effect.

For this day-for-night sequence, I created a moonlight effect by covering the window with a thick blue gel. The only other lighting source was a 650-watt Lowell light covered with a blue gel and a dichroic filter; this balanced the actors' skin tones.

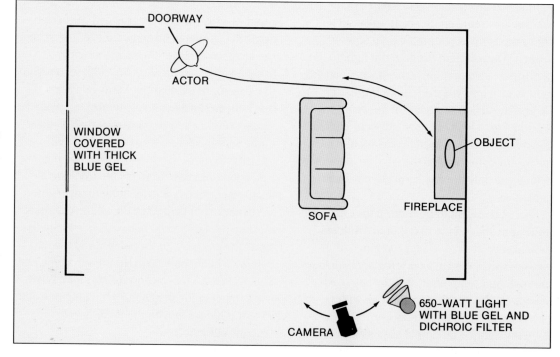

1
ESTABLISHING SHOT. FBI agent
surveys room.
FBI agent (voiceover): "Okay. Looks like
everything's in order. Now all we need
is our man."

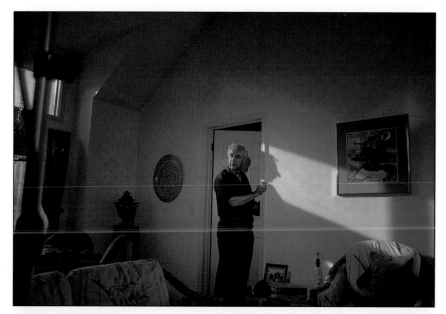

2
LONG SHOT. Thief enters room.
Thief (voiceover): "So far, so good.
Great. There's the statue."

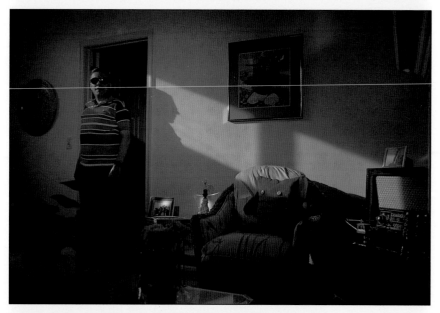

3
MEDIUM SHOT. Thief takes statue off
fireplace mantle and hears noise.
Thief (voiceover): "What's that? I better
get out of here fast."

SHOOTING AT NIGHT

To successfully shoot a video or film at night, you have to give some thought to several points. First, try to find a location where there is a great deal of readily available artificial light, such as Times Square and Coney Island, or under a brightly illuminated theater marquee—any place where there are lots of hot street lights. This saves you from having to lug around many heavy lights and sandbags. Use a higher-speed film, such as Kodak 5994, or have the lab push your film, just as it might for your still photography. Fortunately, camcorders and their very low lux ratings make shooting at night much simpler.

But when a film script requires that you shoot at night, you have to transport quite a bit of equipment, including lights, stands, sandbags, portable battery units or packs, dimmers, and flags. So you should seriously consider options before you invest time and money in one. If there is absolutely no way that you can substitute a camcorder for an expensive movie camera, shooting day for night can be an acceptable alternative. You might also entertain the idea of shooting close to home. You'll be able to run some extension cords from the house for backyard shots and for shots of lovers on a porch swing.

Shooting at night can be a major project, and problem. Even for a supposedly simple commercial, as many as three huge 12,000-watt HMI lights, which can illuminate an entire street, and the cranes to hold them can be required—and those are just for the exterior shots. When you first switch to shooting video and/or film, try to use equipment that you already have in your studio. For most night shoots, all you need to illuminate the actors and actresses are one strong key light and one strong back light to separate them from the background. Two 1,000-watt spotlights should be adequate, with perhaps a third 1,000-watt light to illuminate a wall or doorway in the background.

Finally, be sure to use a great deal of blue backlighting or rim lighting on the performers. This gives them dimension and adds to the mood and mystery of night, just as strong moonlight does. And red gels on the key light or back lights are fun for cops-and-robbers scenarios. You can also play the red against the blue for stark color contrast. Even with simple lighting setups, you can get impressive results.

I find that combining motion and bright colors when I shoot at night always results in spectacular images, like this scene of an Italian festival in New York City's Greenwich Village.

LIGHTING TWO OR MORE PEOPLE

When illuminating two or more people, always do the set first. This type of lighting calls for plenty of high-wattage area lighting, usually floods, plus specific lighting for the stars in the center of the action. Each performer has *three-point lighting*: a key light, a back light, and a fill light for closeups. This is ideal when you shoot a talk show or news show with two or more people behind a desk. This, of course, is the ideal lighting design. For those of you just starting out, you can illuminate the general area. Then when you move in for a closeup, make sure that the model is pointed toward one of the 1,000-watt floods to avoid conflicting shadows.

To keep the lighting plot for this group situation simple, use Fresnels. Their lenses are mottled and provide softer edges for better blending. Position these large floods *frontally*, or behind your camera. Next, place the other floods up and behind the group of models, aimed down at their backs at a 45-degree angle; barndoors will help keep the light out of your camera lens. Don't forget to always illuminate the set first, even though area illumination usually produces enough light to spill on the walls to cover you. If not, throw a spotlight or two on sections that must be featured, such as a map.

When you light two or more people, keep in mind that the stars in the storyline must look good in closeup shots. So if their faces are shown in extreme detail, they have to be illuminated very carefully. Use the key light at a right angle to their bone structure, the fill light to keep the shadows from looking dead, the back light or hair light to enhance the performers' hair and give their figures dimension, and perhaps an extra eye light to call attention to their eyes. Don't skimp on this "star treatment"; after all, the principal performers are the ones who get noticed—and who make or break your project.

When secondary players appear in closeups, you don't have to devote as much time and energy to their lighting, makeup, hair, or costumes. Because these performers have such minor roles as the detective or the star's boyfriend or mother, they're often illuminated with only one key light and one back light, or they move within the perimeters of the area lighting. Character actors, then, perform under "secondary" lighting conditions. In fact, most of the time, a character actor has to step aside during a scene so that he or she doesn't interfere with the star's "special lighting."

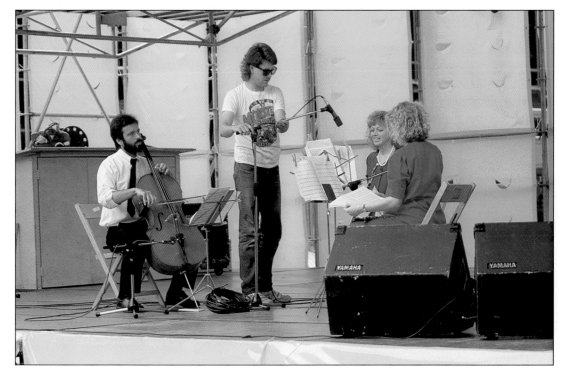

The yellow background behind the stage made for an original color concept for this shot of local musicians performing.

Soft and Hard Lighting

Soft lighting is exactly that: soft and shadowless. Often diffused and romantic looking, it flatters the subject's face. But it is difficult to control because it throws a larger, splashier light than more focused hard light does. So you need to have some light-manipulation devices handy, such as black flags; large, black-backed reflectors; and other barndoor-like panels that help you channel and refocus the softer lights, which tend to spill more.

In my studio, I have a 10,000-watt tungsten Hollywood scoop light. Its large concave bowl has a reflective surface that throws a soft, pleasing light at the subject. The light is covered with a metal protective screen and has one sheet of rather thick, white diffusion material over it. I use this scoop light for head-and-shoulders stills, as well as for video work. Of course, I take my video camera's low-light lux rating into account when I shoot video. I also have a Lowell DP, which I can adjust with a mere touch of a dial to switch from a spot position to a flood position. These two lights provide me with two different degrees of softness and diffusion: very soft with the scoop light, and less soft with the Lowell DP light.

Although the technical manuals don't mention this, keep in mind that you can vary the softness of your light source simply by rolling or moving the light toward or away from your subject. You can also move it to the right or to the left of the performer to give the opposite side of the face a more shaded modeling. You can experiment with this technique on your camcorder very inexpensively. With your movie camera, you

have to experiment through your viewfinder—and don't forget the incident-light reading!

Hard lighting is more contrasty than soft lighting, and produces more distinct shadows. Models' faces have a more definite sculpted look, their features are sharper, and their cheekbones are more prominent. In fact, the entire image is sharper and more defined. Use a fill light to augment these darker shadows. You might want to try a hard back light on the hair for strong, bright illumination.

Of course, you might prefer soft, diffused hair lights. Again, the choice between soft and hard light often depends on script. What does the scene's mood call for? Is it romantic, with roses all over the room? Is there a soft light filtering through the French doors? Is there a beautiful woman standing in the doorway, her figure backlighted with a soft, golden light? If so, soft light is appropriate. On the other hand, scripts featuring a detective story, a barroom brawl, or a car chase call for hard lighting. Sometimes either within an individual scene or in different scenes, you might want to use both soft and hard light. For example, you might want to bathe an innocent child in soft light and the mean-looking adult with him in hard light.

Each shooting situation is different. If my tungsten light set at 650 watts is too intense for a video situation, I'll use my trusty 150-watt spotlight straight on. Otherwise, I can add a square of diffusion material to soften the tungsten light, positioning it forward or backward from the performer as needed and checking the white balance on the camcorder as I rehearse the scene.

To create a softer lighting approach (left), I used more diffusion and less intense light; the fan enhanced this effect. I achieved the hard studio feeling by using a more focused spotlight, as well as more intense light and less diffusion (right).

DIFFUSION

On both interior and exterior shoots, you might find that you need to add some sort of *diffusion* material. Of course, this effect can be easily overdone, so use it very selectively. Diffusion lends itself to predominantly romantic situations, whether the lighting setups are designed for shooting indoors or outdoors. The effect also appears in soap commercials on television, and cosmetic and exotic-liquor advertisements—any situation in which the company doesn't want the product's image to appear too real or hard-edged.

Like anything else in videography and cinematography, you must handle diffusion with some degree of sophistication. What you observe in current theatrical films or on television is a general, unobtrusive use of diffusion. And if you look around your still-photography studio, you'll probably discover that you've already used such diffusion devices as soft-focus lens covers, star filters, cross-hair filters, and perhaps even a silk stocking. You can, of course, achieve softness when you shoot at lower light levels, but you lose *f*-stop options and sharpness. Experiment and see which diffusion effects are too much or too little for the lighting needs of the particular scene that you're shooting.

I use pre-diffused spots and floods for video/film lighting situations, but you can adapt any number of thicknesses of diffusion fabrics (preferably heat-resistant) that you use in your still work. For your own video setups, you'll want to put diffusion material over your existing floods or spots because of video's more light-sensitive low-lux readings. Sometimes you'll need to pull them back from the performers to avoid "video burnout," so keep checking the white-balance control on the camcorder panel—even if it is on "automatic." In most of the higher-priced video and film cameras, filter

holders, either for diffusers or colored gels, are often placed in front of or behind the lens.

The first step, of course, is to find out what the scene requires. Does it revolve around a romantic, candlelit dinner or a hardboiled detective in an interrogation room at a police precinct? By reading the script carefully, you'll be able to determine how much diffusion you'll want to use in order to create the mood. Next, remember that women seem to take to diffusion more readily than men simply because of their stronger bone structure. Men are usually photographed with harder lighting and less diffusion—until, perhaps, they get into their fifties and sixties. To diffuse shadows on faces, use one of your trusty reflectors or fill lights. Adding fog or hazy smoke to a scene also softens the light. You might want to add some smoke to the background in a kitchen scene to minimize the presence of a secondary actor and to emphasize the foreground actor, who is in sharp focus.

I used a soft-focus filter for this tight shot of a television spokesperson; the resulting diffusion is subtle but flattering.

Low-Key and High-Key Lighting

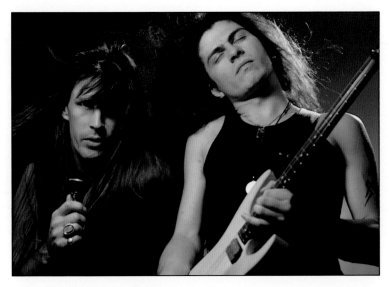

Carefully planning the lighting design is critical to the overall effect of a film or video. Here, I thought low-key lighting was appropriate for the rock musicians (above) and high-key lighting to enhance the exhausted look of the man resting against the wall (directly above).

Like diffusion and soft and hard lighting, two other lighting techniques are very important for still photography, videography, and cinematography: *high-key* and *low-key lighting*. For example, if you want to add a high-key look to a still portrait, you'll print it for a higher contrast in order to eliminate gray tones. Also, when the lights are somewhat overilluminated, bleaching out much of the subject's complexion, the portrait has a more intense, brighter, more alive look. It is "whiter," if you will. The same is true for video and film. For a heightened, high-key look, overexpose the scene a little. Be sure to check it in your monitor, so that you can carefully balance the lighting and avoid bleaching it out completely. In film, this effect is often used when the lead character is knocked out and awakens in a kind of white "heaven" and when the leading lady suddenly finds herself in a dream sequence that projects a heightened reality.

Low-key lighting, on the other hand, produces dark, murky shadows. These might be called for in a murder-mystery scene, most of which is underexposed to enhance the mystery and the dark atmosphere. Unlike high-key lighting, which is played up for more brilliance, low-key lighting is played down with the use of fewer light sources. For example, a scene might call for just one bright spot, such as car lights following a potential victim down a dark alley. Once again, check out what the script requires.

FILTERS AND GELS

It is amazing what a difference filters and gels can make in a scene. When you use them selectively and artistically, they can add visual interest to any lighting setup that is framed for action. They can completely change the mood of the action and give more emotional punch to it. By using either warm colors, cool colors, or a blend of both, you can achieve a veritable rainbow of shades and tones. You can mix, match, and blend colors the way painters do.

"Painting with light" is an integral part of your lighting design. You put gels on lights and filters on lenses or dramatic results. If you want an entire scene to be one overall color, place that color filter on the lens. If you want to add color to different areas within a scene, put gels on the corresponding lights. And, like painters, you have to use your colors wisely, subtly, and with panache. For example, avoid glaring or raw color; too much highlighting isn't professional. Colors should always harmonize with the overall image quality. Besides, in video work, you might get distracting pixel movement, especially with reds because red light waves vibrate more. (So don't place red next to brilliant oranges, greens, or yellows for too long.)

To help you make the use of filters and gels, it is important that you continue to study quality films and observe how the best in lighting design is realized. You'll notice that there are never too many jarring colors fighting for dominance in a scene. Backgrounds are usually in the neutral-color range. This includes tans, pale greens, and grays. Keep in mind that performers' skin tones have to stand out from the surroundings. Raw, indiscriminate use of color takes away from what they're doing and saying. Maintain the contrast, but do it in a harmonic way. Be sophisticated about it. Neon colors have their place in certain locales, but they can get very boring if overused. By doing your testing first on the monitor, you'll know right away what looks good and what comes off looking "cheap." Incidentally, some camcorders now have color monitors that actually let you see the lighting action as you shoot.

Recently, I shot an actor's audition tape, which he sent to commercial and theatrical agents to demonstrate his acting skills and, most important, to show them how he photographs in action. In the first 3-minute scene, he auditioned for Joseph Papp's New York Shakespeare Festival. I felt that this scene demanded a theatrical approach. So I used a hard spotlight effect on the actor. I then supplemented this with a dark, empty stage, a bluish background, and a rim light on the actor's face. To increase the theatrical feel, I put a couple of 4 x 8-foot reflective Mylar boards against a blue background paper and illuminated him with one 150-watt diffused spotlight placed at about a 60-degree angle. This served as a high follow spotlight. Then to separate him from the background, I backlighted him with another 150-watt spot, which I placed very high because he was standing. To add visual interest and dimension, I put a midnight-blue gel on yet another 150-watt spotlight with barndoors, and placed the light behind and to the left of him.

For another interior scene, which takes place near the Mexican border, I wanted a soft, creamy southwestern glow on the walls. So I experimented until I achieved the proper late-afternoon light. I aimed a 150-watt spot with a blue gel on the leaves of an artificial tree in my studio; I had already illuminated them with a green spot (these spots are available at your local hardware store). This provided a leaf-patterned shadow, greenish-blue in color. I also splashed the wall with a pink color that a red 150-watt spotlight placed twice as far back from the wall as the blue-gelled spot produced. (Ordinarily, I use a cookie to create this shadow effect.)

Next, I illuminated the actor's face with a diffused 150-watt white spotlight. To give his face a more sculpted look, I angled the red spotlight, so that some of the illumination fell on his hair and the rest on the wall. On the other side of his face, I repositioned the blue-gelled spotlight, so that it fell on that same side. The result looked quite professional on the television-screen monitor, not flat and ordinary. Color has the ability to enhance what you're filming by adding depth and three-dimensionality to people, as well as to the objects around them.

CHOOSING THE RIGHT FILTER OR GEL

Subtlety is the watchword when it comes to gels and filters. If you want to tone down a scene's too-rich colors, try an ND filter on the lens. It won't change the basic color saturation but remember, you're going to lose about two stops of exposure. These filters are sometimes used for shooting outside in daylight to impart a day for night feeling to the shot. A new popular approach is to use faster-speed Kodak films, such as Kodak 5296, with minimal lights. Be sure to use lots of blue in the shadows at night. And playing blue against red can be very striking when it isn't overdone. This effect is often used in science-fiction films.

Play around with the basic gel and filter colors. Start with the primaries, red, yellow, and blue. Red is a hot color. It shows up everywhere, from glamour commercials, where it is frequently played against gold, to science-fiction and horror films. Red produces dramatic results. Yellow is a warm color that can brighten up even a gray day. Try throwing yellow on a wall behind an actor for a sun-splashed, early-morning feeling. For more of a golden quality, double the thickness of the gel. Let some of the yellow light fall on the model's hair, giving it added warmth. You can also concentrate it on a vase of flowers in a scene by having it come from the same direction as the primary light source, the window. In any case, you have to improvise with the direction and intensity of the gelled light.

Blue seems to be everybody's favorite color; it is used extensively in films and commercials, and even more in rock videos. You might want to imitate a nightclub jazz scene. If you can't find someone who plays a wailing trombone, have a friend or aspiring actor or actress fake it with a tape of someone else playing. Hit the lead player with a red spotlight, and then flood the background—a brick wall, perhaps—with plenty of blue. Try throwing in a gold hair light and a rim light for more modeling. After a couple of rehearsals with both the performer and the lights, videotape the action, and play it back on the television monitor.

For a glamour shot, place a model under some satin sheets. Next, hit the right side of the bed with a blue-gelled light and the left side with a pink-gelled light. Then put a golden-yellow gel on the hair light for backlighting. A diffused white spotlight can serve as the key light. You might even put a star filter on your lens. (If you shoot film, get an accurate incident-light reading.) Have the model talk about how much she loves Chanel No. 5, and you'll shoot an appealing, sexy commercial.

Secondary colors are, of course, blends of the primaries. Green is a mix of blue and yellow. You can use these filters and gels to make greens look even greener, to give an outdoorsy look to the walls of a room near plants, and to enhance a model's skin tones. I've seen it used to backlight monsters in horror movies, too. A

To achieve a realistic submarine effect in "The Search for Red December," I simply placed lights covered with blue and red gels at various spots (right). For the straight-on shots of the actor, I positioned a red-gelled 150-watt spotlight in front of and slightly to his left, and another one in a direct line behind him; I also put a blue-gelled 150-watt spotlight in front of him to his right. Two aluminum reflectors and an aluminum cylinder completed this light plot. Then for the side views of the actor, I simply eliminated the red-gelled spotlight behind him.

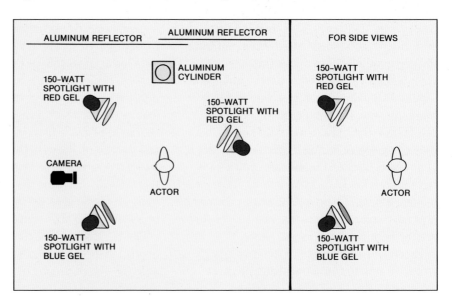

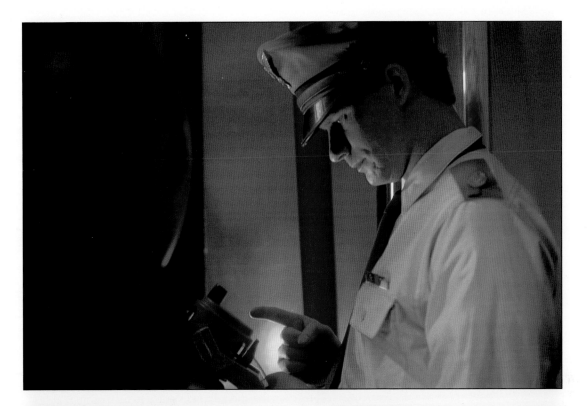

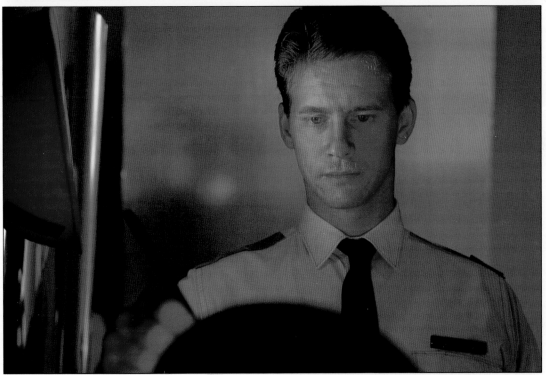

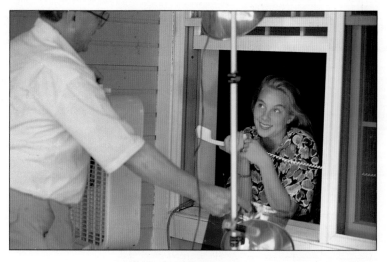

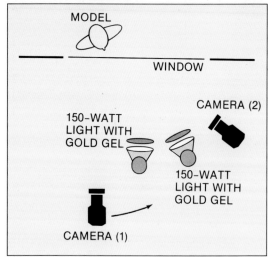

cool color, green, when combined with violet, its complementary color, gives a background depth and perspective.

To get started with green gels and filters, try some simple, short commercials as exercises. First, put some healthy flowering plants on a high table. Have an actor or actress stand behind it, pretending to be a local florist doing a commercial. Put a green gel on one 150-watt flood, and illuminate the white wall behind the plants. Then with a violet-gelled 150-watt light, throw some leaf or flower patterns on the wall over the green. Place a white light as the model's key light and a yellow gel on the hair light. Finally, use a blue-gelled side light on the plants to make the greens even richer. (When you become more practiced with filters and gels, you'll learn that a green filter can tone down a magenta color that is dominating a scene, and vice versa.)

Orange is another warm secondary color. It is the color you usually encounter affecting skin

tones at sunset, but it can also create the illusion of fire or flames. Orange is a very rich color, so use it selectively. Its complement, blue, can, of course, be used to cool it. Try this screen-test exercise with family members, friends, and neighbors. If you have a prop window in the studio, use it. If you don't, build one; it is easy. In this scene, your model looks out of the window just as the sun begins to set. The audience sees only a medium-shot view of the model before you move in for a closeup. The trick is to see the yellow sun on the face of the model slowly turn to orange as the sun sets. The copy might read as follows:

"George is awfully late. He promised that he'd be home by 5 o'clock." (Pause.) "Thank heaven we got that new insurance with Neverpay. The agent made filling out the applications so easy. When we were dropped by Humongous, Ltd., all of the company's personnel were rude." (At this point, the yellow on the model's face starts to turn orange as you manually zoom in for a closeup.)

The copy continues: "Oh, look, here she comes now. My, it looks like she bent a fender. But at least she's home. Yes, thank heaven for Neverpay, the insurance company you can sort of trust." If this copy is too long, you can shorten it or make up your own. Place large cue cards just to the right of the camera, so that all of your models can see and read them. Then position the yellow-gelled key light about 6 feet from the window. When the performer says the word "rude," your assistant should slide the orange filter very slowly over the yellow one. For a nice effect, have a fan blow on the window drapes. Splash some blue light on the background wall to give it a little depth. (The yellow and orange light will fall on it a bit, too, to give it some warmth.) Place some flowers in a vase or pot to add some color to the window that, incidentally, frames the shot.

As always, use a reflector just below the model to fill in the shadows. Your assistant can also imitate the setting sun by slowly lowering the key light as the dialogue progresses. I don't think that a hair light is necessary here, but a violet rim light on the model's hair and shoulders will play well against the deepening orange. The window frame acts as a large gobo (flag) to shield the rim light from the camera lens. Your camcorder will automatically

compensate for the deepening light on her face. With a movie camera, however, you might have to experiment, slowly opening the lens as you zoom in on the face.

If you're using tungsten lighting on the actors in an interior scene but you also want to use the available light coming in through the window as the key light, you can cover the tungsten light sources with a Lee filter, number 201. This converts tungsten light to daylight. Conversely, you might prefer to cover the window with another Lee filter, number 204, which converts daylight to tungsten light. And remember, color-temperature conversions are less critical with video than with film.

With your still-photography background, you might take for granted that you must position the lights properly in order to illuminate your subjects correctly. Whatever your location—a city street, a tenement kitchen, the Gobi Desert, or the Polo Lounge—you must illuminate it, and for purposes of clarity, illuminate it extremely well. And whatever the assignment is—a commercial, a comedy, a documentary, a docudrama, a horror movie, or a rock video—your "lighting for action" must have a new flow to it. You'll be shooting storylines that consist of a beginning, a middle, and an end, so you must strive for continuity.

Your lighting designs have to supplement and enliven your story. Watch as many television shows and films as you possibly can, only this time carefully look at the lighting design. Pay particular attention to the quality of light in each situation or storyline. Watch everything you can—silent films, films from the 1930s and 1940s, television programs and Technicolor movies from the 1950s, MTV rock videos from the 1980s and 1990s, French films, Italian films, and Japanese films. Get to know the style of each. Keep your eye out for the names of the directors of photography, such as the cinematographers who worked on the classic John Ford Westerns. Eventually, you'll develop a sophisticated eye and you'll be able to distinguish the mundane from the spectacular. When looking at films, I can tell the difference between what I call "cheap" lighting and "expensive" lighting. This is as simple as seeing the lighting in a Three Stooges comedy and a Greta Garbo film. The best lighting designs are visually stimulating and impressive.

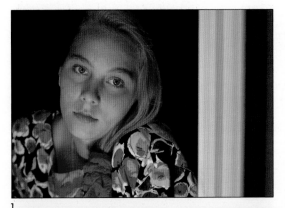

1

2

3

4

For this insurance commercial featuring a young woman looking out the window for her husband, I used graduated gels over the lights (opposite page). I placed (1) two gold-gelled 150-watt lights in front of her to the right, one as the key light and the other for fill. Then (2) as the scene progressed, I slowly introduced (3) orange, pink, and red gels to simulate light from the setting sun. Finally, (4) to complement the foreground coloring, I decided to put a violet-blue gel on a 150-watt flood light; this splashed onto the white wall. And to add some modeling to her figure, I let some of the blue light fall on her blonde hair.

CHAPTER 4

COMPOSING THE MOVING IMAGE

The appeal of this image comes from the exuberance of the happy, young couple and the spring sunshine on their backs and reflected into their faces.

Just as a composer composes a concerto, opera, or symphony, a videographer/cinematographer composes images that exist within the picture frame or picture plane. In other words, many vital elements go into the designing of what may appear to the casual viewer as a simple scene. I can get almost as excited about composition as about lighting. And the best part is that lighting is essential to the overall design that the audience sees in your video or film.

When you think about all the possibilities at your disposal that enable you to construct a special picture—even a still image, such as Henri Cartier-Bresson's photograph of Spanish children playing in the ruins of a civil war bombing—the thrill of creating a well-composed photograph can bring pleasure to any photographer's heart. And now that you're going to apply your still-photography knowledge to moving images, you'll probably get even more excited. You'll certainly be able to bring what you know about composition onto the set of your new video or film production!

Several manufacturers make the transition from still photography to videography or cinematography easier. For example, Canon had still photographers in mind when it designed its video cameras in an 8mm format. The Canon Hi8 model looks like a 35mm camera and can be held like one. Its autofocus capability enables you to automatically track moving subjects. You can even get such professional special effects as *overlapping dissolves*. Another option is Sony's Hi8 CCD-V101 camera; it offers you a choice of manual, *aperture-priority*, *shutter-priority*, portrait, and sports settings, as well as an *electronic gain control* that mimics different film speeds.

But whatever electronic equipment you have, your own artistic sensibilities have to come into play. You are ultimately responsible for each and every image that you translate from reality onto videotape or film. Being in control of that imaging involves the most pleasing arrangement of all the elements that go into your images—your compositions, your *frames* of reference. And of course, audiences, even unsophisticated ones with no formal art training, know when an image was given some thought and well composed. People respond subliminally to aesthetically pleasing images. So be sure to carefully compose individual scenes in order to create a dynamic, integrated film or video.

COMPOSITIONAL ELEMENTS

While filming models Marilyn Heitman and John Hoffmeister, I composed the scene with flowers in the foreground (above). And when shooting Macy's flagship store in New York City at Christmastime, I framed the window display with the mannequins (opposite page, top) and shot Macy's "tree" of light bulbs from below for an unusual angle (opposite page, bottom).

Before you actually begin, give your memory a little push by reviewing some of the elements that will always distinguish your professional work from that of an amateur. And because you're getting reacquainted with the visual demands of movies, you should stop and think about whether you're going into the videography/cinematography business for fun or profit. If you're doing this more for profit than for fun (and I hope and expect that you are), you'll want some return on your investment in video or film equipment. So remember, besides your expert lighting, composing the moving image well gives your work that professional look and edge.

I can't stress enough that you should get all of the art-history books that you can and study them constantly. Most libraries and bookstores are packed with these books, and many excellent ones are available in relatively inexpensive paperback editions. The phrase, "painting with light," can be interpreted many different ways, from leaving the lens open and spraying the room with colored lights to simply giving an image lots of color. In advertising, the term can refer to how much light the photographer can throw on a car. For superb examples of painting with light, take another look at the work of the Impressionists, starting with Manet and Monet, up through Renoir, van Gogh, and Matisse. Theirs was such a beautiful mix of colors and magnificent composition that the art-going public is still transfixed by the brilliant "pleine air" use of lighting.

In addition, I'd like to make a pitch for "sculpting with light," or using lights to give dimension and vitality to the scenes that you shoot. By skillfully using the lights you have available, you can make people and objects, even backgrounds, stand out in a more three-dimensional way. The development of the hair light, key light, rim light, and fill light enabled professionals to give a sculpted quality to their subjects. By knowing how to incorporate the following composition techniques into your video or film work, your results will be more dynamic and will have "stopping power" to arrest the attention of the potential clients that will hire you to present their image to the public. If you're going to be in demand, your videos and/or films must illustrate the confidence that comes with professional know-how.

Perhaps one of the most basic aspects of composition involves filling the picture plane with exciting visuals. Friends often come up to me and ask, "What do you think of this scenic shot?" On most of these occasions, my answer focuses on the primary glaring error in the picture: the sky takes up as much space as the lake, field, or mountains. The photographer split the composition into two separate areas, one half consisting of sky and the other half of some section of the earth. This, of course, is a poor composition strategy. But according to the *golden mean*, a well-composed picture is divided into thirds. Here, the sky should take up one third of the framed shot, and the earth or sea the other two thirds, or vice versa.

Similarly, you often see setting suns right in the center of the horizon. The sun must be positioned a bit to the right or a bit to the left of center; this is usually called the *vanishing point*. This rules applies to the vertical images, too. A house in the foreground, for example, should occupy only one third or two thirds of a scene, whichever you prefer. Put your main subject where it will be most pleasing to the eye.

Suppose that your script calls for Pam and Greg, the two leads, to walk hand in hand along Malibu Beach. Do you want them to walk parallel to your camcorder? If so, you can have the sky occupy the upper one third or two thirds of the frame. You'll probably want more sky to allow space for the performers. Next, do you want the sunset to the right of the models for the first shot, and then pan them as they walk along hand in hand, finishing with the sunset to the left of the couple? Whatever you choose, just be sure that the sun isn't directly in the center of the frame during the entire pan. You might try having it directly behind the performers for an interesting back light or perhaps a closeup to break up the scene.

Another option is to have Pam and Greg walk directly toward the camera. Here, you have to figure out if you want the sun and the horizon above them to the left, or below them to the left? Your choice depends on which point of view seems most interesting to the director, and which shots will best convey the narrative and mood of the scene. You might even decide to do a *tracking shot* (on a dolly) to follow them. You can apply this "one thirds/two thirds" principle to a face in the foreground. For example, the face can take up two thirds of the frame against a smaller face or faces in the middleground or background.

Thinking Like an Artist
Observe, observe, observe. See everything around you the way an artist does when you shoot. You'll see new things if you look for them. After all, as the videographer/ cinematographer, your job is to compose a visually compelling scene. Like a writer facing the proverbial blank page, you have to fill in the blank tape or film with interesting visuals. The shot that you're zeroing in on must contain aesthetically pleasing elements.

The language of still photography must be translated into video and film terminology, including such terms as the *full shot*, the *medium shot*, and the *portrait shot*. In addition, you need to show whether the shots will be done outside or inside.

Master Shots

Also called *establishing shots*, these are usually done with a wide-angle lens. They indicate to the audience where and in what locale the action of the story occurs. Master shots are all-inclusive shots that take in the entire opening scene, such as a helicopter shot of New York City, or show a bird's-eye view of the town where the denouement happens.

Extreme Long Shots

The most common example of this type of shot shows a person or a couple walking toward the horizon. You can use extreme long shots to convey different emotions and moods, such as alienation and loneliness when a solitary figure walks alone, or complete bliss when a couple walks off into the sunset hand in hand. Other possible settings include a long hallway or a crowd in a train station. Save extreme long shots (and long shots) to break up the narrative, as well as variety and dramatic punch.

Long Shots

These are full-length shots that show a performer from head to toe. In this kind of shot, which usually takes place in the middleground or background, the model can be moving forward, backward, sideways, or in as many angles to the camera's point of view that the director comes up with. In long shots, you include the entire figure. A long shot can also be a master shot that has one, two, or more people in it.

Medium Shots

These are still referred to as medium shots. Here, the models are usually photographed from the waist up. Now, however, they often move around a bit. But this doesn't mean that they can't start out in a long shot, walk toward the camera into a

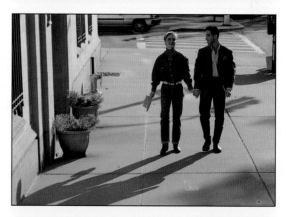

medium shot, and then keep coming toward the camera. Medium shots let the audience see the *attitude*, or the figure and position, of the actors and actresses in a scene. In essence, they are the "middleground" of the storyline.

Closeup Shots

In still photography, these are called *head-and-shoulder* or *portrait shots*. Closeups are always the most carefully illuminated shots. This is because you focus on the performers' facial reactions or to the details of the storyline. Many great directors have stated that closeups must be saved for moments of peak action. In other words, you should consider closeups as very special. Too many closeup shots bore the audience. Any storyline must build toward a climactic action; this is where you should use your primary closeups.

Extreme Closeup Shots

These shots, also called *chokers*, are the tight shots of the performers, usually the "star," that are done with a 105mm or 110mm lens. All of the videographer/cinematographer's talent is lavished on extreme closeups. You can exclude the hairline, concentrating only on the mask of the face. You can even move in for an almost macro shot of the eyes. Of course, you should use this with much directorial discretion.

"Two Shots"

For these shots, you use a 27mm or 35mm lens to take in both figures involved in a scene. In this two-person closeup, the subjects dominate the foreground, thereby eliminating distracting backgrounds. You can also do a "two shot" with both models facing out, such as walking hand in hand or dancing together in a circular motion. Simply make sure that your lights are out of camera range.

Over-the-Shoulder Shots

For these shots, which are usually taken with a 50mm lens, the camera or camcorder sees over one performer's back as he or she looks at the face of the other performer. In the reverse over-the-shoulder shot, the "opposite" model frames the face of the first one. If the first shot is over the performer's right shoulder, the reverse shot must be over the "opposite" performer's right shoulder, so that you don't confuse the audience.

This sequence of a couple strolling down a city street shows the many types of shots that you can use to effectively vary the images in your film or video, to create a rhythm and to emphasize certain scenes.

For steady, no-vibration shooting, you should immediately invest in a good, entry-level tripod designed to carry a camcorder weighing between 3 and 5 pounds. Be sure that the tripod has an all-fluid panhead for very smooth pans and tilts. A folding dolly, which consists of rolling casters for the tripod-legs case, is an absolute must, too.

For example, when you photograph an actress in the middleground of a scene, suppose that you decide to place a vase filled with flowers in front of her to the left. The flowers in the foreground then frame the shot,

Shooting from a high angle to frame this tropical scene made this image more dramatic.

putting a nondistracting background behind the actress. With this valid design, she is literally framed for action!

Framing starts the action of your film or video visually. Of course, you and your camera won't keep that first framed scene forever. You'll probably move in for a medium shot or a closeup in your storyboard sequence. That very first establishing shot, however, catches the audience's eye. Can you imagine how boring it would be for every shot to always have one object forever hovering in the center of the picture area?

Foregrounds

For foreground framing, include any number of objects that help to give the models and the scene more visual impact. When you shoot outside, you can use a tree branch in the upper right or left corner of the frame, a wagon wheel (almost a cliché but it is better than nothing), a fence post, or a street lamp. Whatever locale you are in, you can find something that can do the framing for you—even if you have to hold a few leaves in front of the lens.

When you shoot inside, you have many more choices: a vase filled with flowers, a teapot, a telephone, a child, or a corner of a chair. Just about anything carefully placed can add visual punch to a scene and help frame the action. Using your imagination and discretion also gives the scene more depth because foreground framing pushes the viewer's eye back into the three-dimensional realm of the middleground and background.

Middlegrounds

This is the area in a composition between, of course, the foreground and background. In terms of design, the middleground is basically the center of the set or location where most of the action takes place. Sometimes the performers start in the background, and then move to the middleground and foreground, or vice versa; stay in the middleground for master shots, and then move to the front or back; or stay in the middleground moving only to the left or the right.

Backgrounds

These should help to frame the actors in the rear of the image without detracting from them. For interior shots, the action very often takes place in a living room. So keep the background simple and not too cluttered. Too many framed pictures or paintings, mirrors, or decorations just don't work. A wall with nothing on it behind the models is better than one with too much on it. Watch any "A" film, and you'll consistently see effective background setups.

The same rules apply to kitchen, bedroom, and restaurant-interior settings. Keep hospital scenes particularly simple. When going on location to a business or school, try to rearrange a bit what you see behind the models involved in the action. A large green plant that looks like it is about to devour the school principal or the company president belongs in a comedy, not in an industrial film or documentary. One compositional device is to place your actors in front of a doorway; an arched doorway or window works well. They are unobtrusive and add visual sophistication.

This also works for exterior shots. First, no lighting equipment or accessories—stands, reflectors, sandbags—can show in the scene. So make that your priority. Next, for either a long shot, medium shot, or closeup of your models walking, running, or riding bicycles, have the action take place in front of buildings, walls, fences, trees, and shrubbery. Keep in mind, though, that you can include crowds of people in the background. Just make sure that they're placed interestingly, composed competently, illuminated three-dimensionally, and conform with the requirements of the script, without attracting attention to themselves. This goes for color choices, too. Don't place raw (oversaturated) colors behind quiet action for too long unless the script calls for it. By their very nature, colors are integral to the process of composing. People, objects, and buildings all have a color range. To figure out who goes where, make a storyboard. Storyboards are important because they help the producer, director, director of photography, and the sound engineer know what's happening.

Framing Two or More People

Try different combinations for shots of two or more models. When you have two or more

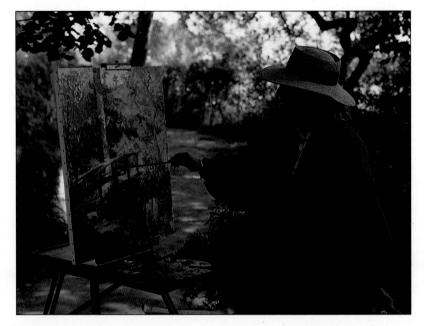

people acting in a drama or commercial, use the over-the-shoulder angle; avoid the side-by-side cliché. Even when young lovers embrace, you'll still want to see one face on the shoulder of the other. Then do a reverse shot to see the other face. Naturally, each model gets a key light and back light placed at the most flattering angle, just as in individual portrait shots.

For scenes involving three or more people, group them as interestingly as possible. Have one in the foreground and the other two behind, or vice versa. Unless the three models are in a lineup at a police station, avoid the straight-line arrangement. Move them around. Try different variations as they work within the larger lighting areas. (Again, video demands less intensity from the lights than film, unless you're using the larger, very expensive studio video cameras.)

When you make your storyboards, you can indicate the particular compositions you want your groups to assume for maximum graphic potential. For a party scene, you might want to handhold your camera and move in and among the crowd, making sure that the actors and actresses don't look at the camera. This will give the scene fluidity. Get a high-angle master shot of everyone in the scene, then move in for your "roving" closeups as the performers mingle. If you're shooting a fight scene in a large bar room, you have to become a choreographer: carefully rehearse each and every punch and fall.

This scene, recorded in Giverny, is effective because the background echoes the foreground. Be sure to think about how the different parts of a scene work together before you shoot.

LENS BASICS

When you make an inventory of your lenses, you might be surprised to learn that you already have a 105mm portrait lens, a 50mm standard lens for shots that most closely approximate the human eye's field of vision, a 28mm wide-angle lens for overall shots of scenes, and a 35-200mm zoom lens for full-length and medium shots. Actually, as professionals say about film work, the zoom lens is great for getting a variety of closeups, medium shots, and long shots.

Remember a typical convex lens, such as the 50mm lens, *refracts*, or repositions and concentrates, all of those light rays emanating from the subject and entering the lens. There they go through a series of four blocks of glass, re-emerge, and converge on the *film plane* or *focal point*. During this process, the original image that you photographed is exposed to the light-sensitive film emulsion, resulting in the final photographic image.

Lenses are categorized by the distance between the lens and the film. A long lens, then, is mounted farther away from the film plane, or film emulsion, and is used to isolate the subject. Conversely, a short lens is positioned closer to the film plane. So the closer a lens is to the film emulsion on which its focused image is projected, the more the lens sees and records on the film emulsion. For example, a wide-angle lens is very short and, therefore, closer to the film. Keep in mind the distortion that wide-angle and fisheye lenses produce; use them sparingly.

Before you invest in any new equipment, carefully explore all of your options. Both the Panasonic WV-D5100 Video Camera System and the Canon L1 take still-photography lenses (some adapters may be required). They are smart choices for professionals making the transition from still photography to videography and/or cinematography.

This fall scene, complete with a pumpkin, is a good example of extensive depth of field. The overall strong lighting caused me to close down the lens while shooting, thereby resulting in foreground-to-background sharpness.

Depth of Field

This concept confuses many photographers. All you have to do is pick up one of your lenses—long, short, standard, zoom, or fisheye—mount it on your camera, focus on the part of the scene that you're interested in, and depth of field is taken care of. You can use your imagination a bit. Suppose that you are on the 50-yard line on a football field. The ball is on the 49-yard line, and the players are directly in front of you. Grab your 105mm lens and shoot a closeup portrait of the player nearest you. Better yet, use your zoom lens to cover all of the intense action.

Then suddenly, the ball is on the 30-yard line. Switch to the 50mm range to be able to include more of both teams in this shot. An interception! The players are back down on the 50-yard line. Zoom into the offensive quarterback within the 105mm range again as he gets "killed" by the defensive tackle. Shoot another closeup, as well as a medium shot in the 55mm range. Then on the next play, the quarterback gets the ball and runs directly at you again. Shoot in the 35mm range for a wide-angle shot to capture more of the intense action.

You use depth of field all over the place all the time, without even once thinking about the equation: f-stop = focal length of lens ÷ diameter of aperture. And you know that the closer the lens is to the focal plane, the sharper the image is. Naturally, the reverse is also true: the farther away the lens is from the focal plane, the more unfocused the final image is. If you look at your lens, you'll see how many feet away from you the object you focused on is. The distance can be anywhere from zero (feet) to infinity. You can also consult the depth-of-field scale on the lens.

My purpose here isn't to give you detailed lessons on the algebraic equations that make up the optical sciences. I simply want to reassure you that you can use your still-photography lenses for your video or film work. The optical rules are the same. For example, suppose that you close down your lens to a smaller aperture while shooting on the football field. More players will be in focus across the field than if you switched to a larger aperture; the larger opening would throw most of them out of focus. Only the quarterback you zeroed in on originally would be sharp.

The Panasonic WV-D5100 camcorder that accepts still-photography lenses with some optional adapters is also compatible with standard *videocassette recorders* (*VCRs*) and high-performance SVHS VCRs. Most camcorders have a zoom lens, most often 10 to 1, and an "auto macro" setting for very close objects. With it, you can go from a 28-35mm wide angle to a 200mm closeup for extreme closeness. (On some professional cameras, you can even go from 7mm to 105mm.) For more experienced—or ambitious—videographers, Panasonic also has a Professional Industrial Video System that has a variety of zoom lenses to choose from. These camcorders ensure high quality and eliminate *burn-in* and *after-image*. There is a wide selection of zoom lenses. For example, the f/1.4 servo zoom lens is available in various focal lengths: the 7.5-90mm, 7-90mm, 7.3-95mm, and 7-112mm. This gives you an idea of what the market offers. However, you can start with your own video camera with its permanent zoom lens (usually 8 or 10 x 1) and eventually build up to a camera in the 4,000-dollar range.

Also, whenever possible, I do all of the shots that require a specific lens, such as my 105mm lens, in succession, along with the appropriate dialogue. I edit these scenes later. Then I do all of the medium shots, and then all of the zoom shots. This technique eliminates having to change lenses for each separate shot. It also gives you an idea of just how flexible lenses can be when you're trying to break up scenes into visually interesting components (see Chapter 5 for more information).

All of the qualities you should look for in a lens, no matter what price range you're considering, are embodied in the advertisements for Panavision Primo lenses: *color balance, veiling glare, contrast/resolution* (sharpness), *field illumination, distortion*, and *ghosting* (white outline shadows). They come in a variety of focal lengths and give you a great deal of artistic control. But before you buy any lenses, be sure to test them first to see if they provide the look you want.

If your goal is to get into videography but you don't want to spend a great deal of money at first, you can purchase a camcorder that either takes most of your present still-photography lenses, such as the Panasonic WV-D5100 Video Camera System, or has only one lens. Raynox manufactures lens kits that contain telephoto and wide-angle *conversion* lenses, which extend the scope of your camcorder. When you work with a one-lens video camera, you still have a very versatile lens on your creative hands. Most one-lens models have an $f/8.5$-68mm spread, an 8:1 power-zoom setting, and an $f/1.6$ auto macro setting for tight closeups.

I've made some great shots with my Sharp VL-L80 camera. It has a high-speed-shutter flying eraser head for glitch-free, in-camera editing. This feature saves me many editing hours later if I cut scenes as I go; it simply requires being handy with the red "start/stop" button. The camcorder also has an 8X 200mm variable-speed lens that enables me to shoot extreme closeups (which demand critical focus), and then zoom back to medium shots and wide-angle shots very easily. Incidentally, I prefer using the manual zoom for more control, but you need a very steady camera and a very steady hand. In addition, my Sharp has a CCD for light-metering sensitivity down to 3 lux. Panasonic's one-lens video camera, the AG-450, has a 10X power-zoom lens with macro capability for very extreme closeups and a 3-speed electronic shutter (1/1000 sec., 1/500 sec., and 1/250 sec.). There are many one-lens camcorders on the market, so you have a number to choose from.

Choosing the Right Lens

After assessing your present lighting equipment and, perhaps, buying some new supplemental lights and stands to expand your studio's capabilities, you should give some thought to which lenses you already have and whether or not you can adapt them to video cameras. (Film cameras have their own lenses. For example, the Bolex 16mm camera comes with three lenses: a long lens, a medium-focal-length lens, and a short lens. Another model even comes with a 12.5-100mm power-zoom lens with a built-in diaphragm control.)

Suppose that you want to shoot your story in color with a video camcorder. Because most camcorders come equipped with a built-in zoom lens, such as the Canon A1 Mark II Hi 8mm video camcorder with its $f/1.4$ zoom lens and autofocus macro capability and the Canon Photura with its 35-105mm $f/2.8$-6.6 zoom lens. The Canon camcorder's lens can move from the 35mm wide-angle setting to the 50mm setting for medium shots, and then to the closeup range with the 105mm setting.

Being able to use your own lenses, which you are familiar with, can ease your transition to shooting action. They also offer more variety of visual expression for your shots than the 8 x 1 or 10 x 1 camcorder standard. (Although you'll be shooting in video and the light readings will be automatic with the CCD *image sensor*, the lighting design will be exactly the same as if you were shooting with film.) You can buy *conversion lenses*, which make it possible for you to retain the full zoom functions of your camcorder. Kenko offers the two most popular conversion lenses, the 2X telephoto lens and the *semi-fisheye lens*.

When you put together your storyboards, you should think about how to photograph an interior scene with a 35mm wide-angle lens, a 50mm lens, a 105mm portrait lens, and a 35-135mm zoom lens. This will enable you break up the scenes into closeups, medium shots, and long shots.

Recently, I did the lighting design for a play entitled *Cellophane* in New York City. After this drama had a decent run of two weeks, I wanted to record a performance on videotape, but I didn't want to photograph it from audience level, or without any cuts or variety in the long and medium shots and closeups. I wanted to shoot it to look like a made-for-television movie. These lighting setups were as easy as those designed for the actual play. On an ad agency storyboard sheet, which is broken up into rows of small television-screen-shaped squares, I made cartoon-like sketches of the individual shots that I wanted.

Both of these video cameras, the Chinon Pocket 8 and the Olympus Movie 8, feature high-speed electronic shutters and automatic and manual focus, and are digital. (Courtesy: Chinon America Inc. and Olympus Corp.)

CAMERA ANGLES

Just like composing, framing, and filtering light sources, the angle of the camera can help establish various moods and emotions. The different camera angles available to you can enhance your images.

The most obvious camera position is the *low angle*. If you illuminate and photograph a model from below, you'll produce a very dramatic shot. This works well for a character in a horror film or a dictatorial tycoon in a drama. If you switch camera positions, and photograph and light the same model from a *high angle*, the figure is no longer imposing. The performer now looks like a humbled individual, such as a criminal whom a judge is looking down at scornfully. Angling the camera this way can cause a disorienting effect, so don't overdo it. A scene calling for someone who has had too much to drink might motivate you to *tilt* the camera. You might also think of other imaginative applications, but make sure that the tilted camera angle will enhance the image, not just call attention to itself.

Alfred Hitchcock was fond of what he called the "peripatetic" movement of the camera. To achieve this *panning* motion, he had the camera operator circle the figure, rotating a full 360 degrees. Slowly, you see the figure from the front, then the side, then the back, and around again, first to the opposite side and then to the front. Another option is to let the camera be the main character's eyes, panning the entire room, starting with one side of the room, going past the windows, circling past the wall filled with photographs, across the doorway, past the wall of books, and then returning slowly back to where the motion began. Such scenes are illuminated by overhead grids, thereby preventing the lights from showing up in the frame. Sometimes the available light coming in through a window is sufficient. Otherwise, you can use supplemental lighting, perhaps a few lights taped to the top of a door and bounced off the ceiling in the least noticeable corner above camera range.

Remember the famous *crane shot* at the Atlanta train station in *Gone With the Wind* when the camera started at ground level, then

slowly moved up and over the top of the station, providing a bird's-eye view of all of the wounded soldiers? Crane shots are appropriate for overhead perspectives of large-crowd scenes.

Like your still-photography lenses, camera angles give you a great deal of flexibility. Take advantage of this freedom in your video/film endeavors. The different angles will allow you to include even more movement and reveal your ingenuity. As always, instinct plays a major role in the working out of *dynamic angles*.

Suppose that you have to shoot a scene from a storyboard that involves two men walking into a large, partially sunny room. Then they move to a space in front of the fireplace where they have an argument. Assuming that the room is already properly illuminated, you'll have to decide how to divide the shots into wide-angle, medium, and closeup shots. The next step is to isolate the emotional mood of the scene in order to determine which camera angles will best serve the dynamics of the actors' confrontation. This is where the storyboard comes in handy; the preproduction sketches and dialogue will help you decide what kind of lighting the scene calls for, what lenses you'll need, and which special camera angles will give the scene visual impact.

Naturally, you have to get an establishing shot of the room first. Perhaps a wide-angle pan starting at the left-wall window, past the fireplace, to the door as the two men enter. Then as they walk to the fireplace, you can zoom in for a medium shot. Follow this with a closeup "two shot." To make the characters' walk to the fireplace more dramatic, use a lower camera angle, possibly even at floor level. This camera position will make the scene more menacing.

Continue shooting with this deep angle all the way to the fireplace if you want. If you're shooting a murder mystery or spy thriller, you might want to tilt the camera a bit as you pan their walk; this will produce a nightmarish feeling. Don't tilt too much initially; test the effect by checking it in the viewing screen or viewfinder. Doing a run-through with the actors as part of the rehearsal process will tell you how far you'll want to tilt.

For this sequence of young people having fun in the park on a beautiful sunny day, shown on pages 97-99, I decided to incorporate a number of camera angles. Visual variety is critical when you shoot continuous action. I began with a typical straight-on shooting position (1) and then shot from lower and lower camera angles (2-6) until I was lying on the ground (7, 8). I switched to a high angle for the final scene (9).

1
ESTABLISHING SHOT. Group of young people have some fun in park during sunny afternoon.
Actor: "Hi! What a great day!"
Announcer (voiceover): "Today's lifestyles require extra energy."

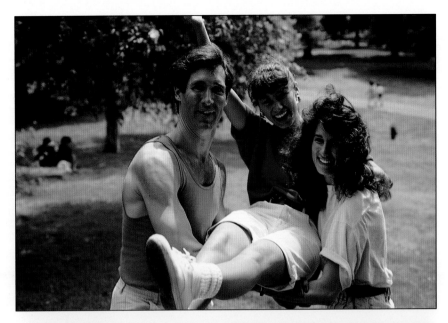

2
MEDIUM SHOT. Actress in center becomes even more animated.
Announcer (voiceover): "Extra energy for family . . ."

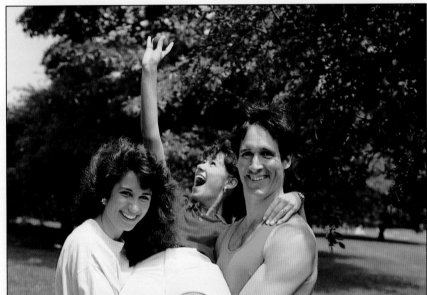

3
MEDIUM SHOT. Actor swings actress higher.
Announcer (voiceover): "And friends, right?"
Actress: "Right!"

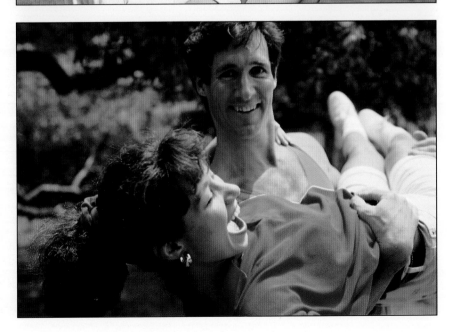

4
CLOSEUP. Friends put their heads together and smile.
Friends: "We're lookin' good and feelin' good!"
Announcer (voiceover): "Any sport, no matter how simple, builds healthy bodies."

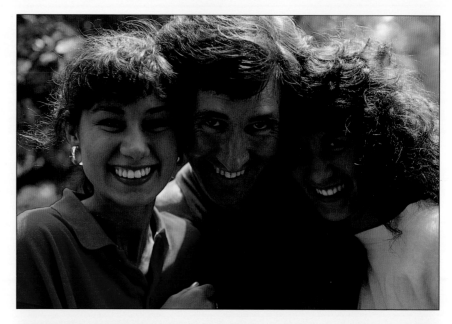

5
MEDIUM SHOT, LOW ANGLE. Actress jumps rope as actor watches.
Announcer (voiceover): "Try jumping rope higher . . ."

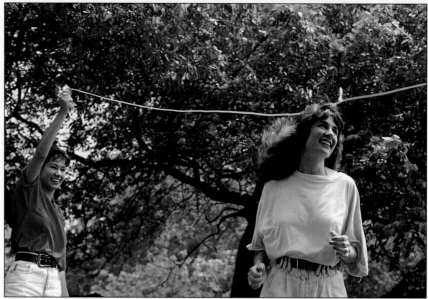

6
MEDIUM SHOT, LOW ANGLE. Actress jumps even higher into the sky.
Announcer (voiceover): "And higher."

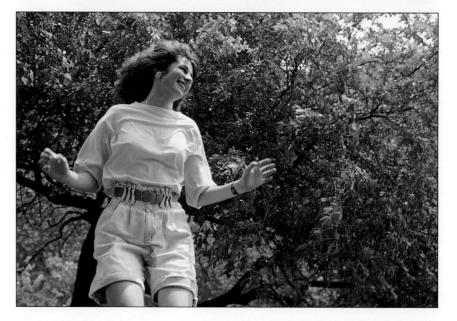

7
MEDIUM SHOT, EXTREME LOW ANGLE. Friends play with ball.
Friends: "Play ball!"
Announcer (voiceover): "If you want energy that lasts, take Vita Gels . . ."

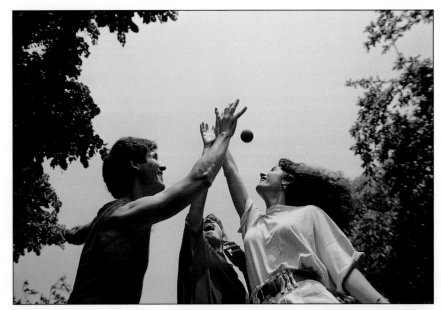

8
MEDIUM SHOT, EXTREME LOW ANGLE. Friends continue to play ball, hitting it harder.
Announcer (voiceover): "Everyday."

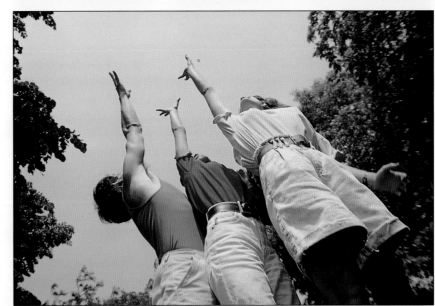

9
MEDIUM SHOT, HIGH ANGLE. Friends fall on ground, laughing.
Announcer (voiceover): "Use Vita Gels. They're not just for laughs."

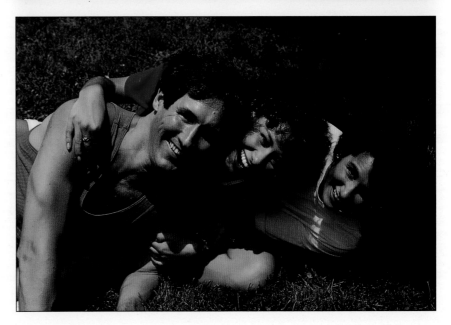

CHAPTER 5

STORYBOARDS

If you have a detailed storyboard to follow, you can organize the sequence of action and then plan the lighting for each scene before you begin shooting the film or video.

You'll notice that in comic books and the funnies, a definite sequence of action in the layout moves the storyline along to its climax. This is the basic purpose of making *storyboards*: to give you a frame-by-frame, step-by-step, organized program for your shooting sequence. With just one look at each frame, you know the characters involved in the scene, where they're placed within the composed picture frame, and what the lighting setup is.

Clearly, then, this storyboard method also lets you know where you're going in the structure of the story. Storyboarding saves you guesswork, as well as the angst associated with the "What do I do now?" syndrome. Improvising, if you need to do any at all, can be done within a preplanned scene structure. Of course, as you shoot your film or video, you might see or conceive of a lighting design that is even more effective than the one you'd sketched earlier, or a sudden change in the weather might force you to modify your basic plan. But at least you won't have to start from scratch.

It is important to make a simple sketch of the basic lighting setup for each frame just outside of it. This logical step will save you precious time; you won't have to try to figure out where to place your lights, lightstands, and reflectors in between shots. Preplanning is the mark of a professional, and it makes you confident that you're doing the best possible job as the director of photography.

Film and video scripts are made up of separate shots within separate scenes. In most scripts, these scenes are numbered to indicate scene changes. For example, #115 might be an interior daytime shot, #116 might be an exterior daytime shot, and #117 might take place on top of a building at night. Other scripts indicate scene changes via the term "Cut to." But whichever way the scene shift or camera move is designated, each scene requires its own lighting design. This is shown on the storyboard.

For example, in an action film featuring police officers and criminals, the lighting for the long shot of the fight in the nightclub differs from that required for the shot of the villain reaching under the table for a hidden gun. Such shots don't happen by magic; you can't get so carried away by the sweeping, dramatic nature of the action that you give inadequate attention to the lighting. You must storyboard, choreograph, and light each scene.

The Need for Preproduction Storyboarding

You may very well want to dispense with preproduction planning and just start shooting off the cuff, pretending that you are the newest member of the old-new French Wave, following in the footsteps of French director Jean-Luc Godard. *Breathless*, his 1959 film, took the international film world by storm with its loose, freewheeling, French-style Neo-realism. Don't. You might make a lot of mistakes and, if you're shooting film rather than video, waste a great deal of money.

You've been seeing storyboards in one form or another all of your visual life. Pick up any newspaper that has cartoons and you'll see prime examples of storyboarding. Comic books, such as *Superman*, *Spiderman*, and *The Teenage Mutant Ninja Turtles*, also contain individual frames that visually carry the action along its storyline. You'll notice a very clever manipulation of the figures in action within each of the cartoon frames. Cartoon artists must make dynamic use of space, compositional devices, and color. For example, in Charles Schulz's *Peanuts* comic strip, he effectively utilizes the foreground, middleground, and background areas. These, in turn, frame the closeups, medium shots, and long shots of the characters.

Cartoonists must keep children and sometimes even adults visually stimulated, so that they don't become bored by the characters and situations. The artists have to come up with an interesting storyline and even stronger visuals to illustrate it. As always with cartoons, the main action revolves around a good-versus-evil conflict. This type of approach can help you develop good storyboards. But you'll deal with conflict in terms of composition. For example, you might want to play a large object or person against a small one, strong verticals against horizontals, red against green, large expanses of sky against a lone tree, or a ferocious thunderstorm against a defenseless man.

Storyboards enable you to organize all of the complicated action depicted in the script; they illustrate what each and every frame of action contains. If you do your storyboards carefully and thoroughly, you'll know exactly what you're going to do before the actual filming begins—every shot, every camera angle. They force you to figure out which lights, reflectors, sets, and props as well as what other pieces of equipment are needed.

Of course, memorable scenes and sets don't just happen. You have to find talented people to create them. And on a commercial project, every piece of board and pound of plaster used in the building of sets, every performer, every costume, and every crew member has to be answered—and paid—for. As the director of photography, you are ultimately responsible for the final project, and you'll be asked to explain what happened if it doesn't work out. You can't merely appear at the shooting location and say, "What's happening?" You must plan all of the various shots and lighting plots ahead of time in detailed storyboards. They are essential. Even George Lucas and Steven Spielberg, the creators of the *Star Wars* trilogy, went through this preproduction planning phase.

Germs of ideas and lengthy conferences involving the director, writer, director of photography, set designer, and costume designer are part of this process. Then, when the producer approves the script and budget, work on the storyboards begins, and each scene in the film is put into a logical narrative sequence. For example, Walt Disney and his animators storyboarded each and every frame, or *cel*, of the first Mickey Mouse cartoons, as well as their more artistic flights of fancy in *Fantasia* (1941). No matter what size budget or what type of film you're shooting, devise storyboards.

In order to do this well, ask yourself and your production heads the following questions. What is the story about? Can you summarize the plot in one sentence? Who are the characters? What do they do and say, if dialogue is indicated? Which characters are in the foreground, middleground, and background? Who are they in conflict with? (Conflict exists even in comedies.) Where does the conflict take place? How many lights and lightstands are needed to illuminate the locales? What intensity is demanded? What should the main light sources

be, for both outdoor or indoor shooting? Where should the key light be positioned? When are long, medium, and closeup shots necessary? Also, what kind of reflectors, filters, gels, diffusers, goboes, and cookies are called for to create the right mood? What colors dominate each scene? What types of sets, costumes, and makeup are required?

When you storyboard interior scenes, you also have to figure out if you'll be mixing daylight and tungsten light. If so, be sure to plan on using a dichroic filter. Exterior daytime shots usually call for reflectors. The intensity of the sun—whether it is out in full force or hiding behind clouds—determines what the exposure is and what reflectors or other accessories you'll need. And if you're going to shoot a day-for-night sequence, you'll want an ND filter. For actual night shooting with film, if you don't have huge 12,000K HMIs or floods with battery packs at your disposal, you might want to use a higher-speed film stock and let your lab timer help process it correctly later.

Finally, when you shoot sunrises and sunsets, it is up to you to decide if you want to leave what you see alone or to jazz it up by adding a yellow, orange, or red filter for more intensity. You can even use a graduated filter; this filter keeps the upper part of the sky a darker blue and makes the sunrise or sunset more yellow or orange. By exposing for the sunset and having the performers stand in the foreground or middleground between you and the horizon, you'll create a silhouette. Using a metallic reflector on them can also add visual interest. Explore all of your options.

This storyboard shows a young couple walking along the beach in (1) a long shot. It also indicates what the other frames of this romantic storyline contain and how they should be recorded. The storyboard continues with (2) an over-the-shoulder shot, and moves on to (3) a two shot, (4) a medium shot, (5) a closeup, and finally (6) another medium shot.

1
ESTABLISHING SHOT. Juliet and Jeff walk along beach.
Jeff: "Aren't you glad we took a different kind of lunch break? This is a perfect place for me to tell you that I love you."

2
OVER-THE-SHOULDER SHOT. Juliet stops in her tracks and directly faces Jeff.
Juliet: "Not so fast."

3
TWO SHOT. Jeff gently touches Juliet's chin.
Jeff: "You know I do, Juliet."

4
MEDIUM SHOT. Jeff and Juliet embrace.
Juliet: "You're always too . . . I don't know . . . serious for me."

5
CLOSEUP. Jeff swings Juliet up.
Jeff: "Too serious, am I?"

6
MEDIUM SHOT. Jeff lifts Juliet even higher.
Juliet: "You do have a silly side, Jeff. But we've got to get back."
Jeff: "Oh, all right. When's your next lunch break?"

PLANNING A LOGICAL SEQUENCE

To be helpful, your storyboards must contain six basic elements. Manipulating animate and inanimate subjects in the foreground, middleground, and background—in other words, composing the image—is the first consideration. Next, and equally important, you have to assess how close to or away from the camera the director wants the performer(s) to be in order to get the best emotional impact for a particular scene. What you're actually doing at this point is determining when to use very long, long, medium, closeup, and extreme closeup shots. The *reaction shot*, which is a variation of the closeup, is a special treatment; it can even include over-the-shoulder framing. Here, you see one performer's response to the other player in the scene.

But matching all of these images with what the models say is essential, too. Although as a visual person you'll put your best artistic feet forward by creating great storyboards, lighting plots, sets, and moods for each scene, you can't minimize the importance of the accompanying sounds. The quality of what the audience sees and hears must be equal.

Writing down the details for every frame enables you to show everyone involved with the shoot what the final product is going to look like before you even begin shooting. Some preproduction sketches are very elaborate and are in color. But simple black-and-white sketches in the storyboard frames are fine—as long as they clearly indicate what your script is going to look like and how the continuous action will play.

In the world of Madison Avenue, when actors and actresses audition for a part in a commercial, the first thing they see before the casting director puts them on camera is a storyboard of the action that contains separate frames for each change in their copy. The storyboard gives them a sense of security when they audition because it shows them what the commercial is about and exactly what they're expected to do in it.

So since you want your videos and films to be as close as possible to broadcast quality, make storyboards that depict the sequence of action.

This way you can, with your assistants, work out all of the production problems you are sure to encounter ahead of time. The shoot will then proceed more smoothly and less expensively.

When you attempt your first storyboard sequence, think about how to make clever use of camera angles and movements. Other important considerations are the type, intensity, and direction of the light sources. Although this step is very rudimentary at this point, concentrating on the lighting for your video or film is part of the visual homework that you have to do. With faithful practice, this should become a habit, if not second nature to you.

The next step is to start getting the story and the copy together. Make thumbnail sketches, which are informal drawings or even doodles, to help you give your ideas visual reality. For example, figure out what you want to say about the product, such as a car, a soap, or exercise equipment, and then decide which performer will say which lines. Give some thought to the models' appearances and wardrobes, too. Slowly, after you draw many sketches and write plenty of dialogue, your basic outline or action sequence will start to shape up. Next, fine tune the lighting. Are you going to shoot in the studio or outside in the park, and on land or sea or in the air? How many artificial lights and reflectors are needed? Where do you want to place them? Finally, what kind of soundtrack do you think is most appropriate?

Now, with all of these notes on the story, the copy, the look of the action, the lighting, and the sound—perhaps just on scraps of paper or index cards—you can devise a logical sequence of action. You may find it necessary to rearrange story points, moving them around to different positions to determine which order best serves the commercial's selling point. When you arrive at the most sensible sequence, draw your storyboards. Be sure to indicate the lighting setups and dialogue for each frame. This kind of preproduction brainstorming and careful attention to detail will prevent a number of problems, as well as save you money, later on when your camcorder or film camera is ready to roll.

Although a storyboard provides a plan, you might alter it as you shoot. While working on this new-car commercial, shown on pages 105-106, I departed from the storyboard. For example, in (3) the image of the father waving hello, the son isn't present. But in the storyboard, he is shown standing next to the car.

1
CLOSEUP. Mother addresses viewers.
Mother: "Hi! I'm Carole Nye. My
husband, Mark, and I just bought a
new car. I'm expecting him any
minute."

2
LONG SHOT. Father drives up in car.
Mother and son greet him.

3
MEDIUM SHOT. Father greets mother
and son.
Father: "Well, what do you think? The
ride is so smooth. I love it!"

4
CLOSEUP. Son speaks directly to father.
Son: "Gee, dad, it's cool!"

5
MEDIUM SHOT. Mother expresses opinion.
Mother: "And I love the color!"

6
MEDIUM SHOT. Mother addresses viewers again.
Mother: "Looks like we've picked a winner."

From Storyboard to Film

You now have all of the basic storyboard elements at your disposal: the storyline, the performers, the copy, the lighting designs, the shots, the camera, the film, the lenses, the microphones, the filters and gels, the locations, the sets, and the props. To make all of this practical, take a look at the imaginary storyboard from the soap opera *Lives We Live*, shown shot by shot on pages 108-112. I've designed a basic lighting setup for each scene and indicated which lens you might use for each shot. After you consider my suggestions, you might want to plan your own lighting plot and lens choices as a helpful exercise. You might even want to write accompanying dialogue. But remember, simplicity should be your motto.

For the establishing, extreme long, and long shots of the street scene (1, 2, 3), all you need is the available light. It is a sunny day in summer. You might consider putting a diffusion filter on the 35mm wide-angle lens on your Panasonic camcorder to soften the hard light. To take in most of the street, shoot from the top of some stairs across the street, preferably at an angle. For good composition, frame the shot with some foreground trees or potted plants on the steps or railing in front of you. For the extreme closeup of Greg in his apartment (4), a 105mm lens captures his facial expression.

For the medium shot of Pam approaching the building (5), continue to use the available light. Again, you might want to diffuse the light a bit to enhance the summer-heat atmosphere. Be sure to check the white balance. Move in until you are about 12 feet from Pam. If you have an assistant or two, have one or both of them hit Pam with an aluminum reflector to add some dimension to her figure. Using the 50mm lens, keep the reflector well out of the lens range. If the sun is behind Pam, use the reflector for face fill. If this metallic reflector is too bright, try a white one. If the sun is hitting her from the left or the right side, hit her with the reflector from the opposite side. Check the camera monitor for her facial exposure and movement. Take the shot from several different angles, so that you'll have some extra footage to work with later during the editing process.

In both the long and medium shots of Pam (2, 3, 5, 6, 8), the sunlight is harsh, so softening it a bit with a reflector is a good idea. If you correctly shoot the closeup of Pam waiting for her friend, Greg, to answer the doorbell (10), there will be a halo light in her hair, thanks to the angle of the sun. Her face will glow softly in the reflected light from the glass window in the door frame. By shooting from inside the hallway, you'll probably get a built-in reflection from the glass door that Pam's standing in front of. If you can't use a 150mm lens here, zoom in on her very slowly using the manual setting. This takes a steady hand, but it gives you much more control.

Next, you need a few shots of Greg from Pam's point of view (7, 9). Since you're seeing Greg from Pam's angle inside on the stairs, the sun can cause a reflective problem in your lens. Covering the window glass with the reflector will shade it. You want Pam's first vision of Greg to look clouded and distorted (unreal) anyway. She sees him silhouetted at the top of the landing in front of the hall window. To make the continuity proceed more smoothly, get the shot of Greg from Pam's point of view when you are with Pam on the front stoop. This will save you from running in and out of the door.

Pan Greg as he walks down the stairs. The hallway is dark, but if you backlight Greg slightly from the hall window behind him, his face will slightly be in shadow. This adds to the mystery of his attitude toward Pam. Use a 28mm or 35mm wide-angle lens for this shot to keep Pam's distorted idea of what's going on intact. As Greg approaches, the light from the front door illuminates his face. Handhold the camera to follow him to the door. Shoot scenes out of sequence when doing so makes your job easier. You can edit all of the shots of Greg into their proper sequence later. In the over-the-shoulder shot of Greg's face (11), be sure to avoid reflections in the glass.

For the extreme closeup of Pam reacting angrily (12), use a 105mm lens and a hair filter

1
ESTABLISHING SHOT. Upper West Side street near New York City's Central Park. Summer. Sunny. Late morning. Front of townhouse.

2
EXTREME LONG SHOT. Taxi pulls up in front of townhouse. Pam gets out of cab and walks toward apartment building.

3
LONG SHOT. Pam hesitates when she reaches the front of the townhouse because Greg, her boyfriend, has forgotten her birthday.
Pam (voiceover): "Should I ring the bell or shouldn't I?"

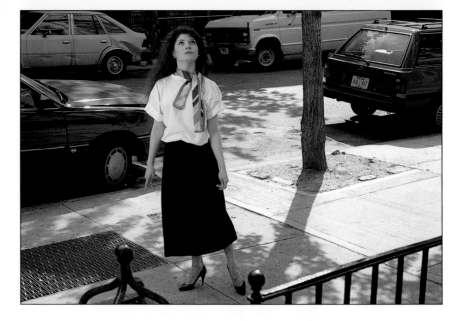

4
EXTREME CLOSEUP. Greg sits typing in his third-floor apartment.

5
MEDIUM SHOT. Angry, Pam decides to confront Greg.

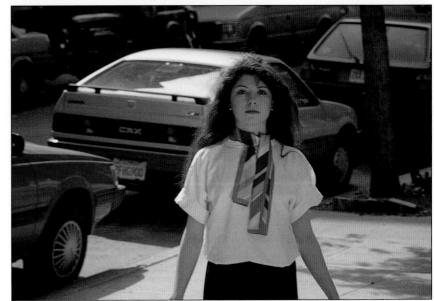

6
LONG SHOT. Pam rings Greg's doorbell.

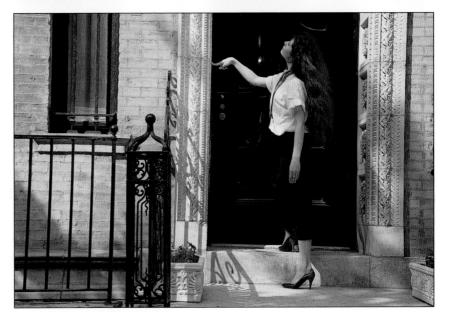

7
LONG SHOT. Greg starts walking downstairs.
Greg (voiceover): "Who could that be ringing the bell?"

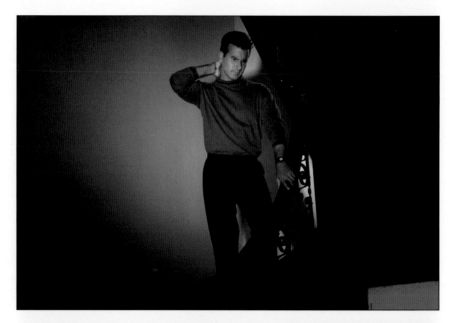

8
MEDIUM SHOT. Pam waits at front door of townhouse.

9
MEDIUM SHOT. Greg stops on second-floor landing.
Greg (voiceover): "I'm coming! Hold on!"

10
CLOSEUP. An impatient Pam waits for Greg to let her in.

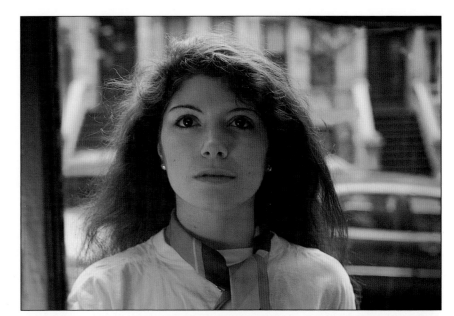

11
OVER-THE-SHOULDER SHOT. Greg finally realizes how upset and annoyed Pam is.
Greg: "Pam! What are you doing here?"

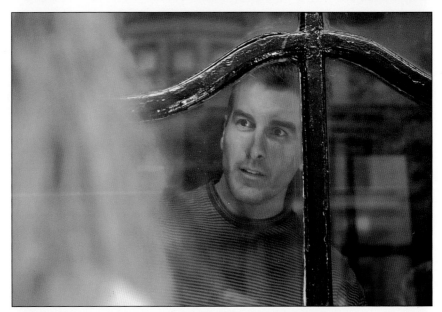

12
EXTREME CLOSEUP. Pam becomes furious.

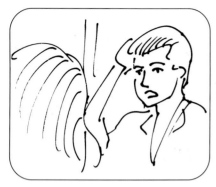

13
MEDIUM SHOT. Pam asks Greg a few questions.
Pam: "Greg, don't you have anything to say to me? Don't you remember what today is?"

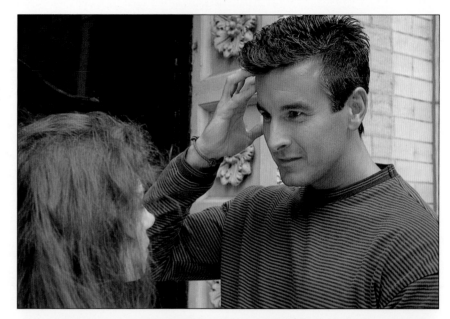

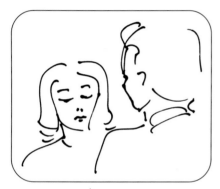

14
OVER-THE-SHOULDER SHOT. Pam listens as Greg realizes what day it is.
Greg: "Oh, no! I forgot your birthday!"

15
CLOSEUP. Greg kisses Pam on cheek after he apologizes.
Greg: "Pam, I'm so sorry. Come on. Let's go celebrate your birthday in style."

16
MEDIUM SHOT. Reconciled, Greg and
Pam embrace.
Greg: "So, how do you want to spend
your birthday?"

to soften the effect of the extreme closeup. You want the heroine to look angelic and attractive. Then go outside for the medium shots of Greg and Pam facing each other on the front stoop (13, 14, 15). Here, the light on Greg's face is harsher looking than Pam's. This effect is appropriate because, after all, he is the villain in this scene. The sun falls on the right side of his face. There should be enough sunlight bouncing off the glass door to fill the shadow on the left side of his of his face. If there isn't enough illumination, try using a silver reflector. You can otherwise leave in the shadow. Check the white balance, and make sure that Greg is wearing makeup to prevent glare from his skin. Then, in the over-the-shoulder shot of Pam from Greg's point of view, keep the halo light from behind on her. Hold the white reflector about 4 feet from her to give her face fill. Use a 50mm lens.

Lighting and shooting exterior scenes are much easier than doing the same for interiors. Just be sure to continually check your meter readings and the white balance. Finally, if shadows appear and are a major distraction, soften them with a fill light or eliminate them completely by moving the performers. The lighting design for this script is a good example of how to achieve the proper look for a scene. Here, you create contrast both visually and cinematically by having Pam stand outside on the steps while Greg stays inside. Using a wide-angle lens when Greg walks down the stairs after Pam rings the bell helps to establish the irritable frame of mind Greg is in. The darker lighting on Greg as he enters the frame also contributes to the look of the scene. To provide more contrast, have Pam wear a smart, stylish outfit and have Greg wear something dark, drab, and dishevelled.

A SHOWCASE OF PROFESSIONAL PRODUCTIONS

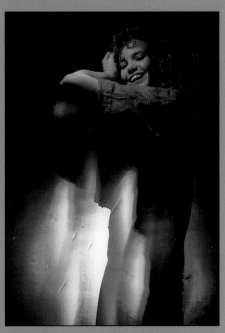

In order to succeed in this field, you must create polished, professional-looking films and videos, complete with sophisticated lighting designs.

As an aspiring cinematographer/videographer, you'll find that being familiar with the different styles of production that television and film professionals have succeeded with is essential. This can only bring you that much closer to having something to offer to potential clients. This is true no matter where you live and work—the East Coast, the West Coast, or the Midwest. As far as the visual components of a professional-quality video or film are concerned, sophisticated taste isn't dictated by geography.

You might want to consider the following projects for your own first shoots. I created several simple but dynamic challenges to help you explore and then expand upon your own artistic urges: a commercial, a music video, a standup-comedy routine, a concert or theatrical performance, and a documentary. The process of shooting these ideas and introducing variations according to your own preferences will prove to be a worthwhile exercise. You'll see how shoots evolve through the preproduction, production, and postproduction phases.

Getting started can be easy. For example, I let standup comics know that I can videotape their performances, which usually last about 10 or 15 minutes. Although this is a small job, it enables me to try new approaches, to do some self-promotion as I mingle, and, as a bonus, to enjoy a show. Networking is also one of the reasons why shooting local sports, civic functions, and school shows and concerts is important.

For each of the projects shown here, I storyboarded the action first and then did the lighting plots. These showcase suggestions demonstrate that even with uncomplicated lighting setups, you can compete with the professional look of what you see on television and in the movies. "One, two, three" might become your motto: one is the key light, two is the hair light or back light, and three is the fill light. Naturally, you have to illuminate the background, and you may want to refine the lighting via the use of, for example, a rim light or a gel for extra modeling.

To illustrate the shoots, I've included a photograph for each frame from the storyboards, which are also minimal. The sound equipment, of course, is up to you. As you have fun with these suggestions, think of them as springboards to the visual dynamics of the professional marketplace. And once you finish and polish them, you might even want to show some of your "test" commercials to local manufacturers and stores. Simply call up and ask for an appointment with the advertising or marketing people. You'll be amazed at how much you can accomplish with telephone calls. Starting as a camera operator at a local television station can lead to work in larger cities. You have to get your feet wet somewhere.

SHOOTING A COMMERCIAL

Do this project outside. For a commercial advertising a common, youth-oriented product like "Velvet Blush" soap, the very simple lighting setups require only available sunlight and reflectors, as well as a small cast. Try a 30-second length the first time. Write down the dialogue at the base of each sequential frame. I suggest using a shotgun mike here for the long shots. Notice that the backgrounds aren't distracting. Also, have the performers wear clothes that aren't too busy or loud, or the same color as the product (or its packaging), which is the focus of the commercial. To avoid costly postproduction editing at a video production house, edit in your camera. Limit the postproduction phase to the addition of appropriate sound effects, *graphics*, or titles, and music. Just make sure that, like the models' clothes, the music isn't so loud that it detracts from the copy.

Throughout this "Velvet Blush" complexion soap commercial, I used both a silver reflector and a large white reflector. As the models, Jenny and Bob, ran down the hill, my assistants carried the reflectors from the first position to the second and third for the various shots. The camera was moved along a dolly track between the second and third shooting spots. Jenny and Bob carefully followed my directions, so filming these two attractive models went quite smoothly.

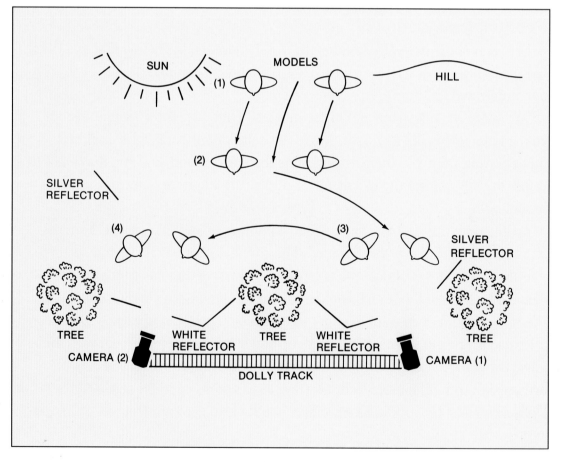

1
LONG SHOT. Jenny and Bob run down hill on sunny spring day.

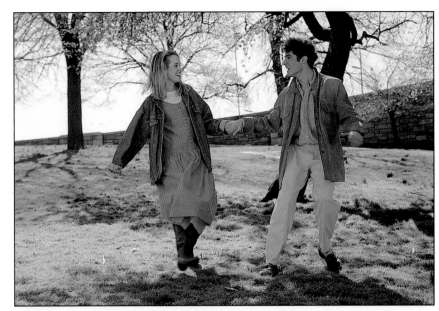

2
MEDIUM SHOT. Bob pulls on Jenny's arm to get her to stop.
Bob: "Jenny, wait!"

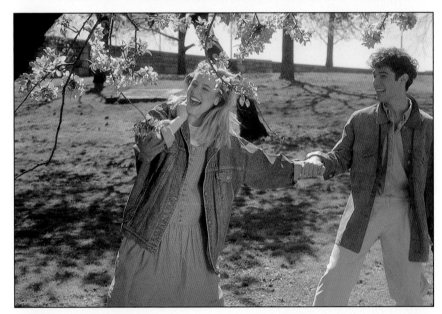

3
MEDIUM SHOT. Bob and Jenny turn toward each other.
Bob: "I just want to look at you for a second."

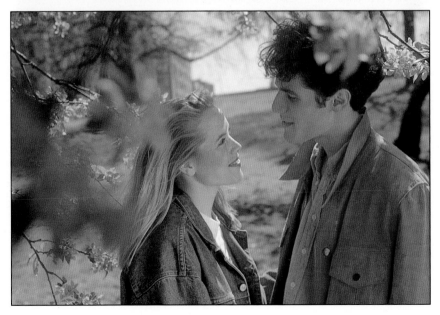

4
MEDIUM SHOT. Jenny beams as Bob
compliments her.
Bob: "You look terrific today, Jenny.
And your skin looks so soft."

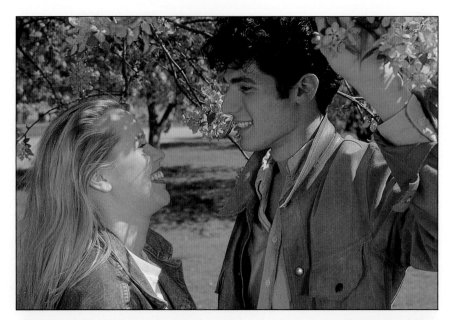

5
CLOSEUP. Bob tells Jenny how pretty
she is.
Bob: "These blossoms can't compete
with you."

6
LONG SHOT. Bob holds Jenny's hand
to keep her from moving toward tree.
Bob: "Stop a second, Jenny. I want to
tell you something."

7
MEDIUM SHOT. Bob and Jenny pause by tree, which partially obscures Bob.
Bob: "I fell in love with you when we ran toward the blossoms."
Jenny: "Me, too."

8
CLOSEUP. Bob admires some blossoms as Jenny puts her hand to her cheek.
Jenny: "These flowers are lovely."
Bob: "Not as lovely as your complexion."
Jenny: "That's because of the new Velvet Blush soap I've been using."

9
MEDIUM SHOT. Smiling brightly, Jenny and Bob face camera.
Announcer (voiceover): "Velvet Blush soap always brings about a happy ending."

For this project, try to re-create the look of a Madonna music video. Find a female model with thick blonde hair that you can backlight very effectively. Put an off-camera fan on her hair. You can spotlight her face and figure with a 650-watt spotlight (or a 150-watt light for low-lux camcorders) as she moves with the music.

Have the performer wear a tight-fitting costume that has lots of glitter or is at least reflective, such as silver or gold lamé.

Illuminate the stage with a variety of colored lights, moving ones if possible. Have the model lip-synch to a Madonna tape. (Have her rehearse before, so that her lips match the recording perfectly.) She can fake the singing using a handheld microphone. If you don't have a mike, make one out of a small cardboard tube and paint it black. Use a star or cross hair filter to turn the highlights into stars. Make quick cuts from closeup to medium shot to long shot. Shoot at angles to the left of her face, then to the right. Go from very low angles to a "behind-the-singer" shot. The "audience" isn't visible in this shot because the lights are in the camera's eye. But make sure that they aren't too close or too hot; you don't want to burn out the image. Go for a halo effect on her figure instead. Remember, you want movement, movement, movement. Edit to music beats, trying to imitate professional rock videos.

For this MTV-like video, I placed one 8 x 10-foot silver Mylar reflector to the left of the dancing partner's singer and another one behind the singer. A blue-gelled 350-watt movie spotlight provided the hair light. To create the kaleidoscope effect, I used a row of lights in front of the singer: a 150-watt blue-gelled spotlight, a boom light, a 650-watt spotlight, a red-gelled 150-watt spotlight, and a gold 150-watt spotlight as well as a 52mm spectrastar filter on the lens.

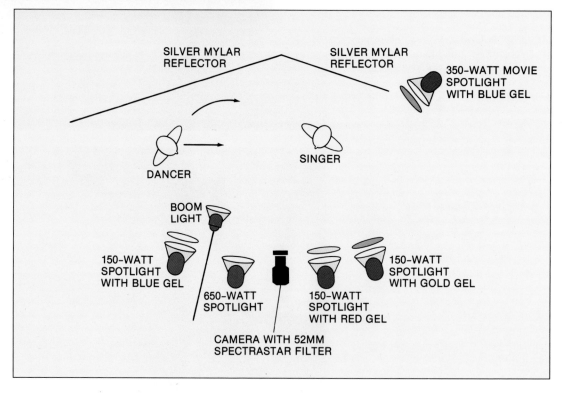

SILVER MYLAR REFLECTOR SILVER MYLAR REFLECTOR 350-WATT MOVIE SPOTLIGHT WITH BLUE GEL

DANCER SINGER

BOOM LIGHT

150-WATT SPOTLIGHT WITH BLUE GEL 650-WATT SPOTLIGHT 150-WATT SPOTLIGHT WITH RED GEL 150-WATT SPOTLIGHT WITH GOLD GEL

CAMERA WITH 52MM SPECTRASTAR FILTER

1
MEDIUM SHOT. Model lip-synchs to pre-recorded song.

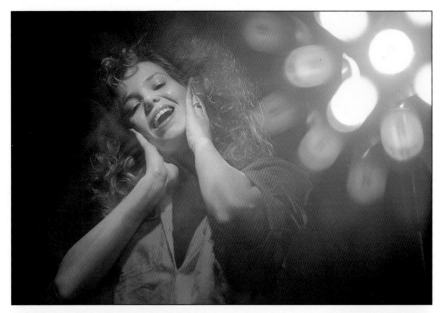

2
EXTREME CLOSEUP. As model "sings," she moves her hands away from her face and straightens her head.

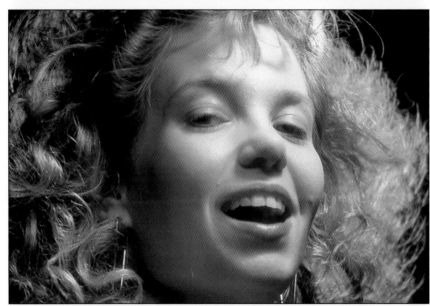

3
MEDIUM SHOT. Model dances with partner as she continues to lip-synch.

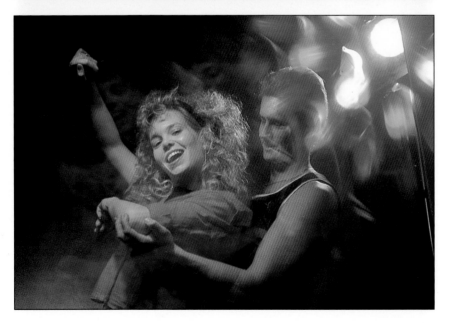

SHOOTING A STANDUP-COMEDY ACT

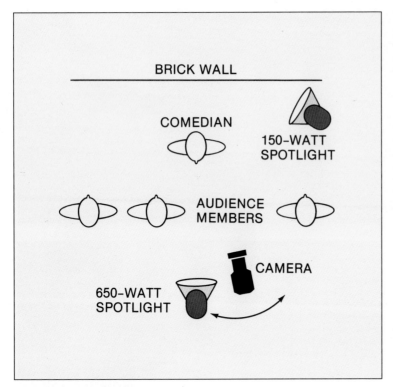

The light plot for this standup-comedy routine called for only a 150-watt light to the performer's right and a 650-watt spotlight in front of him. A brick wall provided the background for comedian Tim Cahill.

To duplicate a comedy-club atmosphere, get a male or female standup comic or someone who wants to pretend to be one, position the person against a brick or imitation-brick wall, and hit the performer with a concentrated 650-watt or 1,000-watt spotlight, with no falloff. Also hit the background with a less intense spot to highlight the title of the club, which you can, of course, make up. To make this look like an on-the-spot location shot, have an "emcee" introduce the comic.

Shoot from the level of the "audience" to give the performer height. Use a zoom lens to capture the action and to break up the basically standing-still image. Get closeups, medium shots, and long shots. In actual clubs, most standup comedians use a mike on a stand; however, if you're photographing a real comic who doesn't have a microphone, use your shotgun mike or camcorder mike. In most cases, though, you can pick up the performer's punchlines very well from the loudspeakers. If you want to shoot this project at home, have the comedian use any handheld mike at your disposal. When editing, keep only the best jokes. If you have no audience in your home or studio, add the laugh track later, which is what happens with television situation comedies.

1
MEDIUM SHOT. Comedian Tim Cahill
begins routine.
Tim: "Hi! I'm Tim Cahill. A funny thing
happened"

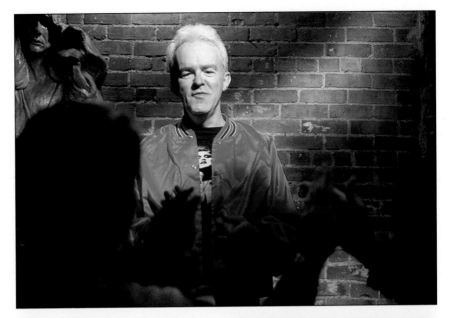

2
CLOSEUP. Tim continues telling jokes.
Tim: "Did you ever wonder why . . . ?"

3
MEDIUM SHOT. Tim gets to punchline.
Tim: "Frosted flakes."

As with sporting events, the lighting is prepared for you when you shoot local performances. All you might want to carry are an extra spot at night and a reflector during the day in order to interview a particular artist. The built-in meter on your video camera will give you an accurate meter reading. When using a movie camera, make sure that you take a reflected-light reading. For closeup action, you might want to use a spot meter. (See Chapter 8 for more information about these events.)

This nightclub performance called for a complicated lighting design including many lights with various colored gels.

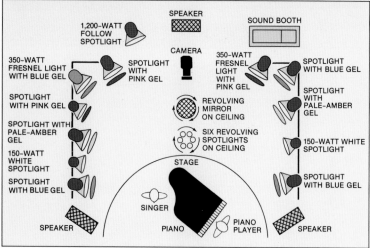

You can easily illuminate a comic play, but it is difficult to direct. All you usually need on the stage is area lighting featuring pinks and ambers. The color scheme also often includes violets, tans, pale blues, and yellow. Use this bright, cool range of pastels for the walls, drapes, costumes, and lights. A daylight effect dominates: plenty of sunlight streams in through the windows. The mood is light and airy. The cheery lead actress often carries flowers from the sunlit garden for her entrance. You can achieve and maintain this buoyant look by determining the appropriate lights, according to their size, direction, color, placement, and intensity.

If you're shooting a comedy video with a camcorder, the lights can stay in the 150-watt range. The direction of the lights depends on whether you want a spotlight coming in through the window to serve as the key light or as the hair light. The intensity of a light also depends on whether it's going to be used as a key, fill, back, or rim light, among others. Because comedy generally calls for a soft-lighting approach, you need to diffuse the intensity of the lights for the area lighting, as well as for the long and medium shots. For closeups, use a slightly harder look in order to break up the potentially monotonous soft light. You can achieve effective comedy lighting if you put your knowledge of lighting to use, experiment, and rehearse.

In general, dramas demand more contrast and a darker mood and look than comedies do. Think of *Macbeth*, *Dracula*, and *Citizen Kane*. The best dramas contain more hard light than soft light. Strive for stark contrasts between black and white, as well as dark, murky shadows and sharply focused images. Once again, the size, direction, color, placement, and intensity of the lights are up to you and the effect you want to produce.

1
MEDIUM SHOT. Emcee introduces nightclub singer.
Emcee: "And now I'd like to introduce the star of Jimmy's Cabaret, Marilyn Scott. I have the pleasure of accompanying her on the piano this evening."

2
MEDIUM SHOT. Marilyn sings popular tune.

3
LONG SHOT. Marilyn and Jimmy wait for applause to stop before starting another song.

Before you decide to do a major motion picture, on your own or with someone else's financing, you might want to test your skills by shooting a short subject or documentary. One of the main differences between the two is the storyline. There is more narrative action in the short subject; it has a beginning, a middle, and an end, just like a full-length film. And you can use actors and actresses. This doesn't mean, however, that your project can't be about one subject, such as a man who can't sleep and the lengths he'll go to to try and fall asleep again, a woman who runs a beauty parlor out of her home and how she copes with different types of customers, or even an unwilling dog getting a bath in the backyard and all of the things that can go wrong.

To clearly distinguish between the two forms, think about how you would treat a subject like college football. You could do a short subject about a new player who meets the coach on the first day of practice and because of his shyness and nervousness, continues to make mistakes, until the end of the day when he catches an exceptionally long pass. You can use an actor, if you wish. On the other hand, if you want to do a documentary about college football, you'll be concerned with the history of the sport. You'll have to include many of the top players, university presidents and sports directors, and winning teams.

One of the purposes of the documentary is to bring about change. The documentary has had a long and distinguished tradition in both film and television. Developing from newsreel footage, they feature real people and actual events, and are socially significant. And some top film directors, including David Lean and John Huston, were attracted to the potential of the form, making superb documentaries during World War II. During the 1950s, Edward R. Murrow's *See It Now*, a documentary television program on CBS, brought about changes in this country's political structures. And echoes of his interviewing methods can be heard today on such shows as Charles Kuralt's *Sunday Morning*, Ted Koppel's *Nightline*, and PBS's *MacNeil-Lehrer Report*. The current approach to documentaries involves making contemporary news items even more dramatic. They seem more like exposés, with an intrusive shooting style and an on-the-spot, brutally realistic look at certain segments of society.

Whichever form you choose, keep in mind that both require storyboards. Although you can improvise some scenes or footage, especially with documentaries, planning what you want to achieve will minimize production costs, in terms of unnecessary equipment, lights, and special effects, as well as maximize your artistry.

When putting together your storyboards for a short subject, you might need to shoot both interior and exterior scenes, or a combination of the two. In some scenes, for example, the available light flooding into a room through a window still has to be supplemented with some artificial lighting. Here, you have to balance the tungsten light with the natural daylight via gels.

Suppose that you actually do a short subject about college football. You don't see much outside light passing through the basement windows in the locker room. Instead, you find overhead bare light bulbs or fluorescent lights. To eliminate the green cast of the fluorescent lights, cover them with pink gels (or your lenses with pink filters: minus green 247). If you want to add more light for the coach's half-time pep talk, bring in a 650-watt tungsten

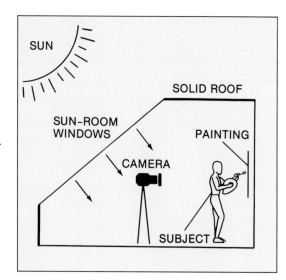

The afternoon sunlight streaming through the sunroof of the Keller home provided soft, flattering bounce light for the interior shot of this documentary (see page 128).

1
ESTABLISHING SHOT. Road that leads to home of artist Arthur Keller.
Narrator (voiceover): "As we approach the home of painter Arthur Keller"

2
EXTREME LONG SHOT. Sally Matz, Arthur's granddaughter, in garden behind house.
Narrator (voiceover): "Keller's granddaughter, Sally Matz, now lives in the house."

3
LONG SHOT. Sally tends to garden.
Narrator (voiceover): "She loves to garden and as you can see, her efforts are rewarded."

4
ESTABLISHING SHOT. View from front of house.
Narrator (voiceover): "A spectacular view can be seen from the front of the Keller home."

5
MEDIUM SHOT. Sally shows some of her grandfather's work.
Sally: "My grandfather's paintings reflect the natural environment."

6
LONG SHOT. Sally's dog scampers through garden.
Narrator (voiceover): "We hope that you enjoyed your visit to the home of Arthur Keller. Thank you for joining us."

broad or scoop light for extra illumination. Using available- and artificial-light sources is often needed for short subjects.

When shooting a true documentary, you use only available light, indoors and outdoors. So no matter what location you choose, you know exactly what lights are present, such as neon light reflected in an office window or on a wet street, or a bare bulb in the ceiling of a sparsely decorated room. You can't use supplemental lighting or manipulate what already exists. This is different from cinema verité, which features stories based on actual events. Although this style tries to look and act like a documentary, it has a different dramatic structure. You can use artificial lights in certain scenes, as well as unusual angles, pans, and tilts for dramatic effects. (Using a camcorder with a 70-210mm zoom lens and a built-in mike or a basic movie camera with a wide-angle, a standard, and a long lens, and a separate microphone, enables you to produce strong documentaries.)

Finding Your Subject
At this point, you've crossed many bridges and confronted many forks in the road. Now it is time for you to make some critical decisions. Are you going to shoot video or film? Are you going to work with a camcorder or an Ikegami studio camera? Do you want to try a movie camera in the 8mm, 16mm, or 35mm range? Do you want to shoot commercials, or perhaps industrials or short subjects? Maybe you want to work with electronic news gathering (ENG) video cameras. You might prefer to shoot soap operas and swing the enormous studio cameras around on the set. And with the lights and camera equipment you have at your disposal, are you interested in shooting a comedy or drama? (See Chapter 5 for guidelines for

stimulating projects.) Which project will you decide upon: a commercial, a soap opera, an industrial, a comedy, a drama, a mystery, or a horror film? Decisions, decisions.

It is essential that you continue to keenly observe each and every television commercial that you can, so that you can see what the professionals are doing in their continual search to satisfy not only the sponsor, but also the viewer at home. Pay careful attention to the lighting setups. How was the scene illuminated? Where is the light coming from? Was a reflector used for the closeup of the beautiful model? How did someone get that shot of gorgeous sunlight backlighting a mother and child? Did the lighting designer originally plan to use a mirror reflection on the child's jacket? Which lenses were used? Were diffusers used on the lenses?

Rate the commercial. Does it have a second-rate look or a quality look (which is the product of thoughtful lighting and composition)? By observing commercials carefully and with a practiced eye, you'll note and be able to utilize all of the preproduction basics: the size, intensity, height, and source of the light used in any situation. Eventually, you'll develop a sophisticated eye.

Every single professional film and video must go through these "building blocks" of creativity. What looks like a simple commercial has gone through an exacting preparation process. Yes, inspiration is great, but you must be able to illustrate for the producers—and eventually the public—exactly what you intend to accomplish. How are you going to spend their money? Is investing in you and your project worthwhile? What is its artistic purpose? You must persuade the producers that you have the eye, the ideas and the skills, as well as the ability to succeed.

POST-PRODUCTION

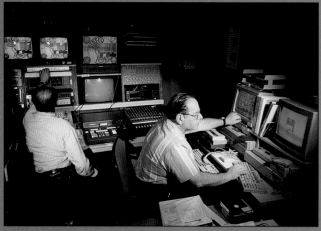

Joe Bevelacqua puts the final touches on a project in his studio during the postproduction phase.

In any creative photography-related endeavor, the person in charge has to have the smarts to know that unless he or she is also the producer, director, and director of photography, then delegating authority is a must. That means hiring the best talent available in every field. And at the top of that "best" list is the videographer/cinematographer. The script may be top rate, and the director who can bring it to life terrific. But if the script is poorly photographed, there is no point. So as the videographer/cinematographer, you have enormous responsibilities. You are the one person in charge of the "look" of the videotape or film. You have to deliver a final product that the public will eventually see—and want to pay to see. The director on your production has called the last "Cut!" And now you have all of the footage that you need to complete the job. It is time to put it all together: the visual and the audio elements of your production, as well as graphics and special effects. Ready?

The first postproduction step is to review all of your footage on your VCR or editing deck. And as usual, there is going to be more than you need—probably a lot more than you need. So be prepared to spend many hours. Fortunately during this process, the strong shots start to dominate, and the weaker ones, or "takes," become more and more obvious. You'll want to select the shots that tell your story. Those are your first consideration. Just because a certain shot looks "pretty," don't feel that you have to include it. You should edit out anything that is extraneous to your original script and storyboard.

Next as you start to do your rough editing, certain weaknesses will start to manifest themselves. You'll then need to do some loupe work. You might notice that certain scenes are over- or underexposed. With film, your lab can often compensate for such problems during processing. But with videos, there is no image enhancement, so check the monitor. Unfortunately, you'll have to reshoot. Be sure that your light-meter readings are accurate to avoid further trouble. At this point, you might even decide to shoot some special effects.

When you do your rough edit, you might also find that you have to re-record voices and want to add sound effects. Professional videographer Joe Bevelacqua suggests checking the audio tracking, which can sound poor if there are crossed cables, and if a fan was on in the background or if people were whispering during the shoot. Such unwanted sounds can be nerve-wracking. So it is critical to check microphones and audiotapes and to clean the heads before each shoot to eliminate postproduction sound problems.

THE EDITING PROCESS

Editing footage is like a musical composition: both have a rhythm and tempo. How you edit can make or break the impact of a film. This is why professional editors are paid a great deal of money to work on major productions and receive screen credit. If you videotape tightly, using the no-glitz, automatic editing device on your unit—the power on/off switch—your postproduction editing is comparatively simple. If, however, you shoot plenty of film or tape, you'll have extensive editing to do.

The first step is to run through all of the coverage several times, at least. The errors and "near misses" stand out startlingly. Eliminate them. Next, tackle the various takes of each scene (if you didn't do all your editing in-camera). Select the best ones, and leave the others on the proverbial cutting-room floor. Similarly, edit the audio portion of your project. Listen for what is appropriate for a particular scene, and discard the rest. You can, of course, add graphics, music, sound effects, and voiceovers later.

On professional productions, editors are in on the preproduction scheduling, working closely with the director so that they know the story action from start to finish. Familiarity with preproduction and postproduction programming is obviously a necessity if you expect to achieve a polished look. Also, make sure that you follow your storyboards when you edit, keeping the proper sequence of action. You need to select just the right angles from the footage or tape; cut scenes at just the perfect moment for dramatic effect; and choose the best establishing, closeup, medium, and long shots for visual impact. In essence, then, you can literally guide the whole dramatic structure of the script by following the storyboards for script continuity, or ruin the final product by "winging it."

Although the sound-editing process is beyond the scope of this book, keeping the basic steps in mind as you edit the footage will enables you to create a seamless video or film. After you make a general outline of what you want to include, you layer the sounds. First, you

add the music and then the dialogue. Recording the performers' lines as you do the actual shooting with good microphones will produce a "clean take." Next, you add the sound effects, which you can purchase from sound-effects libraries, and the background noises (see the "Resources" list on page 142).

The two basic editing methods are *assembly editing* and *insert editing*. For assembly editing, you need a television monitor, two VCRs, and an editing controller (you can rent or buy one) for remote-control capability. On the first VCR, play the raw footage; transfer the scenes that you select during the process of editing onto a blank tape in the second VCR. This will be the master tape that contains the scenes that you want in the proper sequence.

For insert editing, you need an *insert-editing* machine. Here, you simply insert a scene anywhere on the tape without erasing any of the scenes already recorded on it. You can, of course, delete any scenes that are out of focus, too long, completely unnecessary, or under- or overexposed. Then you simply rewind the tape, and review the new sequence. Continue this process, refining and polishing as you go, until you're satisfied with what you see. Each step brings you closer to a finished, professional-looking presentation.

For both editing methods, be sure to do some preplanning. Take notes during the first few viewings of the footage. Think about what you want the final tape to look like. If you do some preparation, the editing process will be much easier.

There are many options available to you in the video/film-editing market. An affordable way to edit videotapes at home is to use SIMCA's Edit Series, Edit/1 and Edit/2. These mini-editors are an ideal place to start. You can do all of your postproduction editing with push-button simplicity, enabling you to add, delete, combine, and rearrange scenes as you choose. At each *edit point*, there are preprogrammed 3-second video and audio *fades*. Both SIMCA units feature instant switching between two camcorder/VCR sources, a *bypass button* to

locate scenes quickly, and a built-in *video-signal booster* to enhance picture quality.

In addition, the Edit/2 adds your music and narration via separate slide controls for each sound input while you edit. For example, if you didn't like the way the models' voices sounded during the beach scene and if after using all of your sophisticated sound equipment, they still sound unclear, you can have the models *loop* their voices later. This means that you can re-record their voices back in your studio as they watch themselves on tape or film and lipsynch their words. This is called *automated dialogue replacement* (*ADR*).

Like camcorders, new editors come out on the market every day, so keep up with the choices, and when production budgets allow, add to your collection of sound-editing and sound-recording equipment.

Editing Equipment

A large number of editing components to fit any budget are available, for both video and film visuals and sound. This is because engineers have made great strides in the development of more sophisticated electronic-editing consoles. When you consider that the sound alone goes through a very complicated synchronization with the tape or film, from a *pre-mix* (depending on the number of soundtracks) to a final sound mix, you can understand the need for using top-notch electronic-editing equipment. And the visuals themselves often have to go through the process of adding fades, *dissolves*, *wipes*, special effects, color balance (tonal quality), and other optical details before they are ready for the *trial* or *answer print* and the final or *release print* that is shown in the theaters or on television.

The market is filled with new video-editing units, but it is in a habitual state of flux. Continue to check the updated equipment and accessories that can enhance the professionalism of the images that you film or tape and the way they're manipulated during postproduction (see the "Resources" list on page 142). Keep the following basics in mind.

Video editing processors are all-in-one, multifunction *audiovisual* (*AV*) editing consoles that feature 16 wipe patterns, video and audio fading, color correction, image enhancement, and audio mixing.

AV Selectors are remote-controlled, 7-line, multipurpose AV switchers. They are fully compatible with Super VHS VCRs. One AV selector, model JX-S300, is a 4-input, 3-output unit that has S-video terminals as well as a remote control. If you don't require remote-control capabilities, a less expensive AV selector is another option.

Character generators enable you to superimpose titles on video movies; they have an 8-page memory.

Stereo super-directional microphones are wireless, two-way microphones that are ideal for zoom shoots; they're used when hearing a specific voice during a scene is critical. When you are ready for more advanced equipment, you can get an Azden VE-100. Its state-of-the-art infrared and "smart card" technologies allow you to create up to 100 scenes, or in other words, 200 cuts. That is enough cuts for a professional working on a major film. In addition, this unit is compatible with all formats. By utilizing the infrared signals of the recording deck and incorporating the "VITC" timecode system, you can make seamless edits with three-frame accuracy! You also can combine scenes from several tapes and add audio from an external source.

Another choice is Videonics' H-10001 DirectED PLUS!, which creates professional-looking productions, automatic ending, titles, graphics, and special effects in 64 colors, and has a wireless remote. JVC also offers a professional editing system. The features of the BR-S811U and the BR-S611U include a chroma enhancer to prevent color spreading, cross-talk-cancellation circuitry to eliminate color blur, luminance signal frequency response, variable-speed dial search, and a tape-stabilizing head drum. In addition, the BR-S811U model has insert-editing circuits, rotary eraser heads, and a blanking switcher.

If you decide that you'd rather not do the editing yourself, you can always take your raw footage or unedited tapes to a postproduction house and pay for editing services. The one I use competently handles all of my audio and visual editing needs: editing, adding sound (soundtracks, sound effects, and music), special effects, and titles. You're usually charged on an hourly basis.

ADDING SPECIAL EFFECTS

You can enhance your tapes and films with special effects two different ways. One method is to make your own "special effects." For example, you can simulate old horror-movie walls by painting them gray and black. You can also use gels and filters on your lights to create the variety of moods that a script might call for. The other way calls for the use of a special-effects generator during the postproduction editing process. With this unit, you can take advantage of such exciting options as Venetian-blind, curtain, and mosaic wipes.

If you think that you might purchase a generator, take a look at the Azden VPC-10. It has a video enhancer and a signal processor to improve both picture quality and color, as well as a "paintbox" that allows you to change the colors on a particular section of a picture. By combining these functions, you can produce a seemingly infinite number of patterns, sizes, colors, and wipes. Other features include a split screen for comparing and altering the incoming and outgoing video signals. The unit's joystick controls the color generator, thereby producing the entire color spectrum. You can also fade between the video picture and background color, and you can edit manually by using the "fade-to-black" button.

Dynamic Applications

Recently, I was involved in an "infomercial" entitled, "How to Get Into Show Business." Since I knew the director, Mitchell Stuart, and the producer, Sal Vasi, I got to be not only an active participant but also one of the lighting consultants. The object of the shoot was to show viewers how I work with and illuminate clients in the studio. So this particular project was a blend of my lighting techniques and "people skills." The first part of the shoot took place in my studio, and the lighting setup was pretty much the one I use day to day.

For this infomercial, a Panasonic CCDIII 300 CLE camera was used. Its 2,000-lux capability is much higher than that of a typical amateur camcorder, which is often 4 to 10 lux. This exceptional light sensitivity enabled me to increase the variety of the lighting. For image

clarity and sharpness, Stuart, Vasi, and I used my 650-watt scoop light and my new Lowell P light for the key lighting, and two 1,000-watt Tota lights as back lights (not background lights). In addition, we bounced two other 1,000-watt Totas off the corner ceiling to produce more total room fill. I insisted on reflector fill below my face during my interview; for the background, I used a 4 x 8-foot Mylar board in order both to absorb the shadows from my figure and to reflect the light bouncing off the ceiling for depth. This resulted in a great deal of light, but the final image was bright and sharp—broadcast quality, actually—and very close to the tight grain of the film image.

Unfortunately, my assistant had recently replaced the 20-amp fuses in my studio with 15-amp ones, so we continued to blow fuses and have light failures. Concerned about potential electrical burnouts in the lower-level power sources, we decided to move to another studio. Here, we used a softer lighting setup. Two 650-watt quartz lights and some silver-lined umbrellas served as our key source. We spaced the lights about 20 feet apart and mounted them on a bar about 12 feet from the principal actors. The back lights were two 1,000-watt Lowell Totas at a height of approximately 14 feet.

The background posed some problems, however. The studio manager had only black background paper on hand that day, no blue; at first we thought that the black was too stark. We experimented with a white dropcloth, but it wasn't wide enough for the medium shots. So we "spiked" the black-paper background with a yellow-gelled 650-quartz spot. Barndoors threw a soft yellow shaft of light that illuminated the black paper yet made the effect interesting: it broke up the darkness with some color that wasn't too distracting.

For the extreme-closeup glamour shot of one of the female models, I decided on my usual single key light. We had her turn toward the one 650-watt umbrella bounced light. The result was sharp and beautiful. Her makeup had been carefully adjusted for the closeup, too, and the back light on her hair was strong enough to produce a pleasing sunlit effect.

With just a few inexpensive props and a little imagination, I created a realistic outerspace look. In (1) the opening shot, I used a 6 x 2-inch rubber "rock" as the meteorite and a 6-inch model of a rocket. To create the starscape background, I punched holes in black paper, backlit them with two 150-watt spotlights, and used a star filter. In (2, 3) the shots of the planet exploding, I enhanced the special effect via a kaleidoscope filter. To provide the action, my assistant wore black gloves and moved the planet and meteorite as I shot the scene. The rocket was pulled across the starry background using invisible wires and was illuminated by a 650-watt Lowell quartz spotlight. This produced an intense, overexposed look and black shadows.

CHAPTER 8

MARKETING
YOUR WORK

I sent out this self-promotional mailer that features one aspect of my work to current and potential clients. To be successful in the business world, you have to advertise and circulate your name.

Successful marketing techniques that you've already used for your still photography can also work for you in the videography and cinematography fields. Today, videos are quickly becoming what still photographs have been to many photographers: sources of pleasure—and profit. You want to sell your videos and films, right? You want to get them to local businesses, schools, and television stations. Eventually, you'll want to go beyond the individual market, such as doing weddings (although you can make quite a bit of money that way), family reunions, family histories, and college-application submissions, to network television shows and/or Hollywood films. All of these fields of artistic endeavor are potentially lucrative, but you must get out into the "war zone" and find out not only who the competition is and what they're doing but also how it affects your business.

Find out what particular marketing artillery they're using against talent like yours. Check out local-newspaper advertisements; call up competitors and ask for their brochures, mailing pieces, and demo tapes; and look at the tapes or footage that they're getting credit for on television. Then go out and beat them at the game with your own strong marketing position, using your own great promotions, direct-mail newsletters, advertising for clients, specialty items, and a simple, direct advertisement that stands out in the *Yellow Pages*. This doesn't have to be big and splashy, just classy and distinctive. Placing an advertisement in your local papers is another excellent way to keep word of mouth going. Put together a superior—eye-catching, clever—ad and you'll really get potential clients talking. Remember, direct-mail newsletters go to prospective clients, telling them more about the new video or film services that you specialize in. In terms of specialty items, have some T-shirts, pens, and bumperstickers emblazoned with your new logo. You might also want to consider giving away a calendar, a daily reminder that you exist.

My own marketing strategy is based on the simple fact that you have to let other people know that you are around. I try to reach those people who will become potential clients and pay me for my video/film services. I get marvelous responses from my monthly mail-out postcards; these include my name, what I do, and my telephone number. I immediately get calls from people requesting a demo. Of course, I send one and then follow through. It is worth the expense to have a distinctive, graphic logo designed for stationery, postcards, business cards, and brochures. I also attend cocktail parties and other civic functions to be seen. You can make contacts at many social occasions. For example in the faculty lounge at the University of Notre Dame, I simply mentioned to a colonel connected with the ROTC that I was working on film projects with my students. I soon found myself doing ROTC training films. You just never know when an opportunity will present itself.

As agents tell actors and actresses, "You can't sit at home waiting for the phone to ring." These words of wisdom hold true for videographers/cinematographers, too. You must let potential clients know that your talent is available, that you can shoot and edit a job in a professional manner—in essence, that you can deliver. And be sure to tell your current clients who can use your new visual services that you've gone into video or film production, or that you are about to.

If amateurs can go for it, you, a professional still photographer with years of experience in marketing your talents, can certainly move into the forefront of new competition. That is what it is all about, isn't it? You're moving from still to video or film in order to make even more money. To do this, you have only to realize that the horizons of videography and cinematography are limitless. The choice is yours. And even if your goal is modest at first— you simply hope to make more professional-looking home videos or movies—you'll want to compete with yourself at least, and impress relatives and friends with visually arresting, broadcast-quality videos and films that will compel them to say, "Great stuff! You should become a pro." When that happens, the decision to seriously pursue a career in this field is up to you.

The most important marketing tool is your very own *audition tape*, *demo tape*, or *promotional tape*. Whatever you want to call it, put together a fabulous videotape that shows prospective clients how good you really are. Keep it simple, keep it clean, and avoid gimmicks. These tapes and/or films are samples of your top-of-the-line products. In other words, they are your video or film portfolio. Therefore, you must spend a great deal of time and effort on them in order to beat out the competition. All of your skills in lighting, set design, storyboarding, editing, and postproduction will be apparent to your prospective clients. So don't make your tape good, make it great!

A good way to begin putting together a list of prospective clients is to continually check your local newspapers. See who's doing what, to whom, and where the event will take place. Read the sports section to find out about upcoming games; the society page, for weddings and engagements; and the community calendar, for political rallies, school events, and class reunions. You might be able to come up with many more potential ideas for new sources of income. Make contacts, make great tapes or films, make money.

Former Business Associates

Contact or re-establish contact with clients that you've dealt with, such as business executives whose portraits you've taken. Tell them that you now do videos and/or films. Discuss how they can utilize your services, such as commercials, in-house instructional films or tapes, and industrial films that explain how their particular products are made and sold. Let them know that you can do their videos in a more professional way. Also mention that you can shoot a history of the company on video or film or perhaps, a history of their own family—a live action "family tree" using professional lighting, cameras, sound, postproduction editing, graphics, animation, and special effects. Explain that you deliver top-quality products. You can apply this same approach to potential clients that are listed in the *Yellow Pages* and other business directories.

I inform the actors and actresses I work with that I can also do their audition tapes, which they show to casting directors and theatrical agents and usually contain a serious and a comic monologue. I've had 5 x 7 cards that illustrate this new service professionally printed, as well as new business cards that highlight these new video services. Naturally, I've also given this information to my executive-portrait clients, which has resulted in new income from doing commercials and industrials. These same 5 x 7 cards make great mailers.

Performers

With my background in lighting and set design for the theater, I've always had good luck contacting the theater groups that I've worked

with. I often wound up shooting films and videotapes of their performances. After screenings of my work, the director, actors, and costume designers wanted copies for their archives. Other potential clients include local rock bands, singers, instrumentalists, orchestras, and country-and-western groups. Many performers want copies of their big opening night. Furthermore, these recordings make great audition tapes for performers who want to break into the big time.

Sports Organizations

The sports field is wide open for enterprising videographers and cinematographers. So go to high-school football games, basketball games, wrestling matches, and track events in your area, and then try to sell your coverage to local television stations. Your work might be better than that of the paid staff. When shooting, be sure to wear a t-shirt or jacket with your snazzy logo on it, and distribute your business cards to everyone in sight, especially to the coaches; they might want to show their teams your videos or films to point out mistakes or poor plays. Try to wear orange or yellow because they always attracts attention. After awhile, you'll get noticed and respected for your excellent work, too.

News Organizations

Carry your camcorder or film camera with you constantly. Consider it an extension of your shooting arm. You never know when you're going to come across a newsworthy accident, fire, or robbery. Local television stations might want your tape or footage. And if it is strong enough, you might even be able to sell it to the major networks or to cable-television networks. Always remember to negotiate your fee first. Don't send the tapes on "spec" (speculation). If, however, the network insists on operating this way, at the very least get a down payment.

You should also stay in touch with friends who are lawyers, and let them know that you also do "legal coverage." For example, you can shoot legal depositions that give a lawyer's clients proof of accidents and medical malpractice. You might even be hired to shoot a surveillance tape for a divorce action (be prepared for low-light situations). These tapes and films are legal in many courts of law.

It's a Wrap!

Congratulations! You've finished reading *Lighting for Action*. I hope that you'll continue to use it as a practical guide that can help you realize your career goals, whether you intend to pursue videography or cinematography. I know that with *Lighting for Action*, you'll move more smoothly, more professionally, and more quickly into the exciting world of industrial, commercial, and entertainment live action.

Camcorder advertisements continue to claim that "you can turn your new skills into cash with your camcorder." To do this successfully, you'll need a good video camera and editing equipment, postproduction skills, and most important, expert lighting techniques. After all, lighting is the main element when it comes to creating truly professional-looking videos and films. No matter which format you choose, top-notch lighting separates the professional from the amateur.

As someone aspiring to be a videographer/cinematographer, you'll begin lending your own artistic sensibilities and imaginative vision to realizing the demands of a script property. After working with *Lighting for Action*, you'll be able to use the professional-level lighting setups discussed here as stepping stones to further your career in video/film lighting. Just remember not to get bogged down by all of the new highly technical equipment in the increasingly electronic world of lights and cameras. Of course, you have to be familiar with and know how to work with this equipment, but that doesn't mean that it should dominate you and your creative impulses. Believe in yourself. Keep in mind that these new technical marvels are only your tools. As an artist, you have the ideas, the energy, and the poetic license to imprint your style on whatever lighting assignment comes your way in the world of visual entertainment, to create a moving image out of chaos.

FOUR PROFESSIONALS AT WORK

David Watkin, English Cinematographer

David Watkin, the Academy Award-winning director of photography for *Out of Africa* (1984), prefers a lighting style that portrays the clarity and definition of an unadulterated image. He doesn't use diffusion on any of his films: no coverups, and no dishonest faces, figures, or objects. He works with the director to achieve a "pure approach" in his photography; he uses Zeiss lenses and Agfa 320 film for sharpness. For Watkin, each film is a "living thing," an entirely new visual experience that he accepts as an artistic challenge.

Watkin's work on *Masquerade* (1988) graphically captured the white interiors of summer homes in East Hampton. The rooms are filled with the special hot light that bounces in through the windows. This reflective luminance serves as the key lighting on the faces of stars Rob Lowe and Meg Tilly. All of the images in the *Masquerade* are extremely sharp and have great resolution and color saturation, yet they don't look harsh. The backlighting and rimlighting appear natural, coming, it seems, from the windows and open doors. A calm, reflected-light look characterizes each scene and provides an effective contrast to the subliminal violence of the screenplay action.

Joe Bevelacqua, Videographer

Joe Bevelacqua started in the photography field as a photojournalist, a job that, he says, "didn't pay much money." So he hired a photo rep who got him started in still-life photography, working for such major companies as Avon and L'Oreal. Then about 10 years ago, Bevelacqua, who is always artistically restless and doesn't like to stay with one thing too long, decided to expand into the video/film market. Bevelacqua founded New Horizons Studios, and he now shoots industrial videos and films, documentaries, short subjects, and commercials. He recently shot three instructional tapes on a Betacam 1-inch master for New York Institute of Photography's Live Action Training. On outdoor locations, he used available light and reflectors. For the interior shots, he used the professional-lighting setups in the classroom.

Bevelacqua also shot a fashion-design documentary with a Sony M7, which he says "holds on to good flesh tones and has great contrast control." In order to capture the excitement of the runway fashions, the cocktail party, and the interview segments, he used two 1,000-watt quartz spots. These were stationary for the runway section and the interviews, but for the cocktail-party and dance segments he put pink and amber gels on the two spots and sprayed the audience with color. This was a great visual effect, requiring only minimal lights and two assistants. He used one main camera downstairs to catch the closeup action on the runway, and then worked with another camera on the balcony to record both the long shots and the fashions.

The equipment Bevelacqua uses now is far different from the "entry-level" equipment he worked with when he first started into video and film work. This consisted of a Sony Beta Portopac package that included an editing console, a complete editing deck, and music and playing decks. Even with just this basic equipment, Bevelacqua won a bronze medal at the International Film and Television Festival for a half -hour documentary entitled, *Looking for Brooklyn*. His success continues; Orion Pictures is considering one of his screenplays.

Bevelacqua acknowledges the developments in the field that make shooting easier. He says, "Home camcorders are now better than what used to be on TV." And, of course, his new postproduction consoles are much more sophisticated than what he started with. He can do image manipulation in all of its variations, as well as graphics for titles and credit rolls, on a twin Amiga. This unit's video "toaster" feature is compatible with his Omega computer, which "is great for accelerated processing." For his future documentary and industrial work, Bevelacqua would like to use the new HI Band 8mm camcorder, which is lightweight and easy to operate. It requires a crew of one (the videographer). Its tape cassette is the size of an audiocassette and can be transferred to 3/4-inch industrial-size tapes and to Betacam 1-inch broadcast-size tapes.

Diseases of the Heart, Chest & Breast
Diagnostic Imaging and Interventional Techniques

J. Hodler · G.K. von Schulthess · Ch.L. Zollikofer (Eds)

DISEASES OF THE HEART, CHEST & BREAST

DIAGNOSTIC IMAGING AND INTERVENTIONAL TECHNIQUES

**39th International Diagnostic Course
in Davos (IDKD)**
Davos, March 25-30, 2007

including the
Pediatric Satellite Course "Kangaroo"
Davos, March 24-25, 2007

presented by the Foundation for the
Advancement of Education in Medical Radiology, Zurich

Springer

J. Hodler
Department of Radiology
University Hospital Balgrist
Zurich, Switzerland

G. K. von Schulthess
Universitätsspital
Nuklearmedizin
Zurich, Switzerland

Ch. L. Zollikofer
Kantonsspital
Institut für Radiologie
Winterthur, Switzerland

Library of Congress Control Number: 2007922632

Springer is a part of Springer Science+Business Media

springer.com

© Springer-Verlag Italia 2007

ISBN 978-88-470-0632-4 Springer Milan Berlin Heidelberg New York

Cover design: Simona Colombo, Milan, Italy
Typesetting: C & G, Cremona, Italy
Printing and binding: Grafiche Porpora, Segrate (MI), Italy

Printed in Italy

Springer-Verlag Italia S.r.l., Via Decembrio 28, 20137 Milan

Preface

The International Diagnostic Course in Davos (IDKD) offers a unique learning experience for imaging specialists in training as well as for experienced radiologists and clinicians wishing to be updated on the current state of the art and the latest developments in the fields of imaging and image-guided interventions.

This annual course is focused on organ systems and diseases rather than on modalities. This year's program deals with diseases of the heart, chest and breast. During the course, the topics are discussed in group seminars and in plenary sessions with lectures by world-renowned experts and teachers. While the seminars present state-of-the-art summaries, the lectures are oriented towards future developments.

Accordingly, this Syllabus represents a condensed version of the contents presented under the 20 topics dealing with imaging and interventional therapies in heart, chest and breast diseases. The topics encompass all the relevant imaging modalities including conventional X-rays, computed tomography, nuclear medicine with PET, ultrasound and magnetic resonance imaging, as well as image-guided interventional techniques.

The Syllabus is designed to be an '*aide-mémoire*' for the course participants so that they can fully concentrate on the lectures and participate in the discussions without the need of taking notes.

Additional information can be found on the IDKD website: www.idkd.org

J. Hodler
G.K. von Schulthess
Ch.L. Zollikofer

Table of Contents

Pediatric Satellite Course "Kangaroo"

List of Contributors

Alkadhi H., 154
Armstrong P., 11
Avni F.E., 201
Berlot G., 74
Bhalla S., 19
Bluemke D.A., 142
Cáceres J., 19
Cassart M., 201
Cleveland R., 55, 204
De Roos A., 137
Desai M.Y., 142
Desai S.R., 93
Dondelinger R.F., 168
Donoghue V., 55
Erasmus J.J., 3
Fleischmann D., 119
Franquet T., 93
Ghaye B., 168
Goodman P., 69
Grenier P.A., 25
Henschke C.I., 17
Higgins C.B., 158
Howarth N., 69
Kaufmann P.A., 154
Kazerooni E.A., 104
Klein J.S., 90
Kubik-Huch R.A., 188

Leung A.N., 3
Lucangelo U., 74
Maffessanti M., 74
Malagari K., 87
Massez A., 201
Miller D.C., 119
Müller-Schimpfle M., 195
Novelline R.A., 83
Owens C., 36, 209
Papaioannou G., 36
Pellegrin A., 74
Pennell D., 149
Prokop M., 131
Revel D., 137
Rieber-Brambs A., 195
Schaefer-Prokop C., 112
Sickles E.A., 188
Siegel M.J., 48, 215
Storto M.L., 31
Tonkin I.L.D., 160
Verschakelen J., 99
Vilar Samper J., 63
Vock P., 99
Vorwerk D., 184
Yankelevitz D.F., 63
Young C., 36

WORKSHOPS

Current Concepts in Diagnosis and Staging of Lung Cancer

J.J. Erasmus[1], A.N. Leung[2]

[1] Division of Diagnostic Imaging, The University of Texas, M. D. Anderson Cancer Center, Houston, TX, USA
[2] Department of Radiology, Stanford University Medical Center, Stanford, CA, USA

Introduction

Thoracic imaging has an important role in the evaluation of patients with lung cancer: it is used in the detection, diagnosis, and staging of the disease as well as in assessing the response to therapy and monitoring for tumor recurrence after treatment. This article reviews the diagnosis and staging of non-small-cell lung cancer (NSCLC), emphasizing the appropriate use of computer tomography (CT), magnetic resonance (MR), and positron emission tomography (PET) imaging in patient management.

Manifestations of Lung Cancer

Radiologic manifestations of primary lung cancer can be divided into five major patterns: pulmonary nodule or mass, multiple pulmonary nodules, obstructive phenomena, parenchymal opacification, and lymphadenopathy.

A solitary pulmonary nodule (SPN) is defined as a single intraparenchymal lesion <3 cm in diameter that is not associated with atelectasis or lymphadenopathy. Lung lesions >3 cm are termed lung masses and, accordingly, are associated with a higher probability of being malignant. A superior sulcus or Pancoast tumor is a lung cancer that occurs at the lung apex and may involve the upper ribs, lower roots (C8-T2) of the brachial plexus, subclavian vessels, stellate ganglion, or vertebral bodies. On chest radiography, ipsilateral pleural thickening >5 mm in thickness or asymmetrical pleural thickening of >5 mm difference should raise concern for a Pancoast tumor. On CT, an apical mass with varying degrees of extension into adjacent structures can be identified (Fig. 1).

The presence of more than a single focus of cancer in the lungs is classified as satellite nodules, multiple primary lung cancers, or hematogenously spread pulmonary metastases. A satellite nodule is defined as an additional focus of lung cancer of the same histologic type and located within the same lobe as that of the primary tumor (Fig. 2). Synchronous tumors are found in approximately 1% of patients diagnosed with lung cancer. Two separate primary lung cancers can be readily recognized if each is of a different histology or has different molecular genet-

Fig. 1. Pancoast tumor in a 55-year-old woman. Coronal reformatted CT image shows right apical soft tissue mass without associated bony destruction. Histology was indicative of adenocarcinoma

Fig. 2. Adenocarcinoma with satellite nodule in a 70-year-old smoker. Coronal reformatted CT image shows two nodules in the right upper lobe associated with diffuse centrilobular emphysema

ic markers. With two tumors of the same histologic type, synchronous primaries are differentiated from hematogenous pulmonary metastases by the absence of concomitant mediastinal and systemic spread [1].

Obstructive phenomena result, by definition, from narrowing of an airway by an endobronchial lesion or extrinsic compression. Atelectasis and pneumonitis are the two most common processes that develop distal to an obstructive bronchogenic carcinoma. On CT, differentiation between the primary tumor and the adjacent post-obstructive changes is often difficult; PET/CT is currently the study of choice in delineating tumor extent for purposes of treatment planning (Fig. 3) [2].

Parenchymal opacification ranging from ground-glass attenuation to consolidation is a CT pattern of lung cancer that is uniquely attributable to adenocarci-

Fig. 4. Adenocarcinoma in a 56-year-old man. Coronal reformatted CT image shows multilobar ground-glass opacities most extensively involving the right lower lobe

nomas (Fig. 4); bronchioloalveolar carcinoma is by far the most common subtype. The extent of involvement may range from focal to diffuse; centrilobular nodules, indicative of aerogenous spread, are common associated findings. Hilar and mediastinal lymphadenopathy are frequently found in lung cancer patients and indicate lymphatic spread of the disease. Sometimes, the primary tumor is occult, with enlargement of hilar or mediastinal nodes as the only radiologic abnormality; this pattern of disease is most frequently associated with small-cell lung cancer.

Evaluation of the Solitary Pulmonary Nodule

Although the differential diagnosis of a SPN is broad, malignancy will account for 15-75% of lesions incidentally discovered on radiographs, depending on the population studied [3]. The essential first step in any SPN workup consists of comparison of the radiograph with a prior radiograph or CT study in order to evaluate temporal evolution. Stability of size over a 2-year period is highly associated with a benign etiology; rarely, nodules that demonstrate 2-year stability slowly grow and ultimately prove to be indolent neoplasms. In the absence of prior studies or with documented radiologic change, CT evaluation should be performed to better characterize the SPN, confirm its solitary nature, and to search for associated findings.

On CT, detection of the presence of calcification in a benign pattern allows a relatively confident diagnosis of a benign SPN in a patient without prior history of malignancy. The four characteristic patterns of benign calcification are central (involving >10% of the cross-sectional

Fig. 3a, b. Obstructive atelectasis in a 77-year-old man with NSCLC. **a** CT image shows atelectasis of right lower lobe with posterior and medial displacement of major fissure. **b** Corresponding fused PET/CT image shows hypermetabolic activity involving entirety of atelectatic lung consistent with proximal tumor

Fig. 5. Hamartoma in a 90-year-old man. In the left lower lobe, a smoothly marginated nodule is present that shows areas of fat attenuation

Fig. 6. Adenocarcinoma in a 65-year-old woman. CT image shows an irregularly marginated nodule in the right upper lobe with intralesional air bronchograms

area of the nodule), diffuse, laminated, and popcorn; the first three are usually indicative of prior granulomatous disease whereas popcorn calcification represents chondroid calcification in a pulmonary hamartoma. Detection of the presence of fat in a SPN is indicative of a hamartoma (Fig. 5) or exogenous lipoid pneumonia.

The margin characteristics of a nodule are helpful in estimating the probability of malignancy. A spiculated appearance consisting of fine linear strands radiating outwards (corona radiata sign) is associated with malignancy in 88-94% of patients [4]. Lobulated or scalloped borders are associated with an intermediate probability of malignancy, whereas a smooth border is more suggestive of benign disease. However, a recent study [5] reported that the margin characteristics of malignant and benign nodules associated with emphysema show considerably more overlap on CT than do nodules in nonemphysematous lungs.

The presence of an air bronchogram or ground-glass opacity within a SPN is suggestive of malignant disease [6, 7]. When seen in cross-section, an air bronchogram manifests as a focal air collection within a SPN, an appearance that has been termed 'pseudocavitation.' In two studies of 93 and 132 patients with SPNs, air bronchograms were identified in 25-29% of malignant nodules as compared to 6-9% of benign lesions [6, 8]. Although it can be seen in all histologic types of lung cancer, the air bronchogram sign is most commonly associated with bronchioloalveolar carcinomas and adenocarcinomas (Fig. 6) [6, 8]. Based upon data derived from a population screened for lung cancer, nodules that are partly solid (mixed solid and ground-glass components; Fig. 7) or that are nonsolid (pure ground-glass in attenuation) in nature are more likely to be malignant than are homogenously solid nodules [7]. The most commonly associated histologies in that study were, again, bronchi-

oloalveolar carcinoma and adenocarcinoma with bronchioloalveolar features [7].

Due to the neovascularity associated with malignancies, malignant nodules typically demonstrate more intense enhancement than benign nodules. Swensen and colleagues [9] reported the results of a multicenter trial that prospectively evaluated 356 indeterminate SPNs and tried to distinguish between malignant and benign etiologies on the basis of nodule enhancement. Using a threshold of 15 Hounsfield units (HU), contrast-enhanced CT had a sensitivity of 98%, a specificity of 58%, and an accuracy of 77% for malignancy. False-positives were at-

Fig. 7. Adenocarcinoma in a 52-year-old woman. CT image shows a sharply marginated nodule in the right lower lobe that has both solid and ground-glass components. Bronchiectasis is present in the right middle lobe

tributed to active infectious granulomatous diseases that manifested similarly intense enhancement. Since only four (2%) of 171 malignant nodules failed to enhance more than 15 HU, the study concluded that the absence of significant lung nodule enhancement at CT is strongly predictive of benignity.

Unlike CT, which primarily uses altered anatomy to detect the presence of disease, PET relies on differences in metabolism between normal and abnormal cells. 18-fluorodeoxyglucose (FDG) is the most commonly used radiotracer for PET imaging of lung cancers. Higher rates of FDG uptake and phosphorylation in malignant cells result in the intracellular accumulation of radiotracer, which serves as the basis for tumor detection. In a recent meta-analysis of 40 studies, Gould and colleagues [10] estimated the sensitivity and specificity of PET for malignant pulmonary lesions to be 97 and 78%, respectively. Currently, with a spatial resolution of 7 mm, PET cannot reliably assess nodules <1 cm in size; other reported false-negatives include indolent cancers, such as bronchioloalveolar carcinoma and carcinoid tumor. A wide variety of false-positives have been reported and include infectious and inflammatory diseases such as mycobacterial (Fig. 8) and fungal infections, sarcoidosis, Wegener's granulomatosis, and rheumatoid nodule.

Fig. 8a, b. False-positive PET study in a 68-year-old woman with nontuberculous mycobacterial infection. **a** CT image shows nodule in right middle lobe. **b** Fused PET/CT image shows that the nodule is intensely hypermetabolic. Correct diagnosis was obtained following surgical resection

Management of the SPN

In any individual presenting with a SPN, the most effective and cost-effective management strategy will depend upon the pre-test probability of malignancy [11]. CT is well-accepted as the initial test of choice (after comparison with archival studies) in nearly all circumstances as it has high specificity for some benign conditions and its results are integral to estimating the likelihood of malignancy. In patients with a low probability of malignancy, serial CT scans should be obtained to document 2-year stability; nonsolid (ground glass) or partly solid nodules may require a longer follow-up to exclude indolent adenocarcinomas. A moderate probability of malignancy warrants further investigation; the specific test chosen will ultimately depend upon the size and location of the nodule, comorbid conditions such as emphysema, local availability of certain procedures, and both physician and patient preferences. Surgery is the most cost-effective option in managing patients with a high pretest likelihood of malignancy [11]. Guidelines for management of indeterminate small pulmonary nodules (≤8 mm) incidentally detected on nonscreening CT scans in persons 35 years of age or older were published in a consensus statement by the Fleischner Society in 2005 [12]. In these guidelines, the specific management course is determined by two variables, size of nodule (calculated as the average of length and width) and patient's relative risk of malignancy (determined by smoking history or other known risk factors).

Staging of Lung Cancer

Staging is typically done according to the recommendations of the International Staging System for Lung Cancer. It describes the anatomic extent of disease in a traditional TMN system that enables a standardized description of NSCLC in terms of the primary tumor (T), lymph nodes (N) and distant metastases (M). The International Staging System for Lung Cancer then combines the TNM subsets to create either clinical (c-) or surgical-pathological (p-) stages, which have similar treatment options and prognosis. Radiologic imaging is usually used to determine the clinical stage of disease and is directed at detecting non-resectable disease (T4 or N3 or M1). The differentiation of T1-3 from T4 lung cancer and the detection of contralateral nodal (N3) and or extrathoracic (M1) metastases are important, as these typically preclude surgical resection or require additional chemo or radiotherapy.

Primary Tumor

The primary tumor is described according to its size, location, and extent of local invasion (Table 1). CT is more accurate than chest radiographs in assessing these para-

Table 1. TNM descriptors (from [13])

Primary tumor (T)	Comment
TX	Primary tumor cannot be assessed, or tumor proven by the presence of malignant cells in sputum or bronchial washings but not visualized by imaging or bronchoscopy
T0	No evidence of primary tumor
Tis	Carcinoma in situ
T1	Tumor ≤3 cm in greatest dimension, surrounded by lung or visceral pleura, without bronchoscopic evidence of invasion more proximal than the lobar bronchus[a] (i.e., in the main bronchus)
T2	Tumor with any of the following features of size or extent: >3 cm in greatest dimension Involves main bronchus, >2 cm distal to the carina Invades the visceral pleura Associated with atelectasis or obstructive pneumonitis that extends to the hilar region but does not involve the entire lung
T3	Tumor of any size that directly invades any of the following: chest wall (including superior sulcus tumors), diaphragm, mediastinal pleura, parietal pericardium; or tumor in the main bronchus <2 cm distal to the carina, but without involvement of the carina; or associated atelectasis or obstructive pneumonitis of the entire lung
T4	Tumor of any size that invades any of the following: mediastinum, heart, great vessels, trachea, esophagus, vertebral body, carina; or tumor with a malignant pleural or pericardial effusion,[b] or with satellite tumor nodule(s) within the ipsilateral primary-tumor lobe of the lung
Regional lymph nodes (N)	
NX	Regional lymph nodes cannot be assessed
N0	No regional lymph node metastasis
N1	Metastasis to ipsilateral peribronchial and/or ipsilateral hilar lymph nodes, and intrapulmonary nodes involved by direct extension of the primary tumor
N2	Metastasis to ipsilateral mediastinal and/or subcarinal lymph node(s)
N3	Metastasis to contralateral mediastinal, contralateral hilar, ipsilateral or contralateral scalene, or supraclavicular lymph node(s)
Distant metastasis (M)	
MX	Presence of distant metastasis cannot be assessed
M0	No distant metastasis
M1	Distant metastasis present[c]

[a] The uncommon superficial tumor of any size with its invasive component limited to the bronchial wall, which may extend proximal to the main bronchus, is also classified T1

[b] Most pleural effusions associated with lung cancer are due to tumor. However, there are a few patients in whom multiple cytopathologic examinations of pleural fluid show no tumor. In these cases, the fluid is non-bloody and is not an exudate. When these elements and clinical judgment dictate that the effusion is not related to the tumor, the effusion should be excluded as a staging element and the patient's disease should be staged T1, T2, or T3. Pericardial effusion is classified according to the same rules

[c] Separate metastatic tumor nodule(s) in the ipsilateral nonprimary-tumor lobe(s) of the lung also are classified M1

meters and is typically used to evaluate patients after initial diagnosis. CT and MR imaging are both useful in confirming gross chest-wall or mediastinal invasion but are inaccurate in differentiating between anatomic contiguity and subtle invasion. MR imaging can be a useful adjunct to CT in showing the extent of great-vessel, pericardial, or cardiac involvement, particularly if there is a contraindication to the intravenous administration of iodinated contrast. Additionally, because of its superior soft-tissue contrast resolution and multiplanar ability, MR imaging is recommended in the evaluation of patients with tumors of the superior sulcus. More recently, there has been increasing use of whole-body PET imaging with [18F]-fluoro-2-deoxy-d-glucose positron emission tomography (FDG-PET) in NSCLC staging [13-15]. However, the relatively poor spatial resolution of PET imaging limits its utility in the evaluation of primary tumors.

It is important to realize that, although the International Staging System designates primary tumors associated with satellite nodules in the same lobe as T4 or non-resectable disease, it has been suggested that this designation may imply a worse prognosis than is warranted. Consequently, some clinicians have advocated that patients with satellite nodules undergo definitive resection if there are no other contraindications to surgery [16, 17]. In contrast, pleural metastases with or without a malignant pleural effusion, present in up to 33% of patients at diagnosis, are non-resectable [18].

Regional Lymph Nodes

The presence of nodal metastases and their location are important in determining management and prognosis in patients with NSCLC [13, 19]. To enable a consistent and standardized description of nodal metastases, nodal stations are defined in relation to anatomic structures or boundaries that can be identified before and during thoracotomy (Table 2) [13, 19]. Unfortunately, there are at least three different lymph-node maps used worldwide, includ-

Table 2. Regional lymph node stations for lung cancer staging (from [13])

Nodal station	Anatomic landmarks
TN2 nodes - All N2 nodes lie within the mediastinal pleural envelope	
1 Highest mediastinal nodes	Nodes lying above a horizontal line at the upper rim of the brachiocephalic (left innominate) vein where it ascends to the left, crossing in front of the trachea at its midline
2 Upper paratracheal nodes	Nodes lying above a horizontal line drawn tangential to the upper margin of the aortic arch and below the inferior boundary of no. 1 nodes
3 Prevascular and retrotracheal nodes	Prevascular and retrotracheal nodes may be designated 3A and 3P; midline nodes are considered to be ipsilateral
4 Lower paratracheal nodes	The lower paratracheal nodes on the right lie to the right of the midline of the trachea between a horizontal line drawn tangential to the upper margin of the aortic arch and a line extending across the left main bronchus at the level of the upper margin of the left upper lobe bronchus, medial to the ligamentum arteriosum and contained within the mediastinal pleural envelope; the lower paratracheal nodes on the left lie to the left of the midline of the trachea between a horizontal line drawn tangential to the upper margin of the aortic arch and a line.
	Researchers may wish to designate the lower paratracheal nodes as no. 4s (superior) and no. 4i (inferior) subsets for study purposes; the no. 4s nodes may be defined by a horizontal line extending across the trachea and drawn tangential to the cephalic border of the azygos vein; the no. 4i nodes may be defined by the lower boundary of the no. 4s and the lower boundary of no. 4, as described above
5 Subaortic (aortopulmonary window)	Subaortic nodes are lateral to the ligamentum arteriosum or the aorta or left pulmonary artery and proximal to the first branch of the left pulmonary artery and proximal to the first branch of the left pulmonary artery and lie within the mediastinal pleural envelope
6 Para-aortic nodes (ascending aorta or phrenic)	Nodes lying anterior and lateral to the ascending aorta and the aortic arch or the innominate artery, beneath a line tangential to the upper margin of the aortic arch
7 Subcarinal nodes	Nodes lying caudal to the carina of the trachea, but not associated with the lower lobe bronchi or arteries with the lung
8 Paraesophageal nodes (below carina)	Nodes lying adjacent to the wall of the esophagus and to the right or left of the midline, excluding subcarinal nodes
9 Pulmonary ligament nodes	Nodes lying within the pulmonary ligament, including those in the posterior wall and lower part of the inferior pulmonary vein
N1 nodes - All N1 nodes lie distal to the mediastinal pleural reflection and within the visceral pleura	
10 Hilar nodes	The proximal lobar nodes, distal to the mediastinal pleural reflection and the nodes adjacent to the bronchus intermedius on the right; radiographically, the hilar shadow may be created by enlargement of both hilar and interlobar nodes
11 Interlobar nodes	Nodes lying between the lobar bronchi
12 Lobar nodes	Nodes adjacent to the distal lobar bronchi
13 Segmental nodes	Nodes adjacent to the segmental bronchi
14 Subsegmental nodes	Nodes around the subsegmental bronchi

ing that proposed by Naruke and colleagues [13, 19, 20]. Size is the only criterion used to diagnose nodal metastases, with nodes having a short-axis diameter >10 mm considered abnormal. Chest radiographs are not sensitive or specific in evaluating nodal metastases. CT and MRI are better in this regard; but, because enlarged nodes can be hyperplastic and small nodes can contain metastases, the accuracy of CT and MR imaging in the detection of metastases to hilar and mediastinal nodes is not optimal [21]. FDG-PET imaging can be used to improve the detection of nodal metastases [22, 23]. In a meta-analysis comparing PET and CT in nodal staging, the sensitivity, specificity, positive predictive value, negative predictive value, and accuracy of PET were 79, 91, 90, 93, and 92% compared to 60, 77, 50, 85, and 75% for CT, respectively [22]. More re-

cently, improved sensitivity (89%), specificity (94%), and accuracy (93%) of regional lymph-node staging has been reported using integrated CT-PET scanners that allow the acquisition of co-registered, spatially matched functional and morphologic data [24]. Current recommendations for FDG-PET imaging are that it should be used in patients with no CT findings of nodal metastatic disease in order to corroborate the CT findings when there are no distant metastasis (M0) or to redirect nodal sampling by identifying an otherwise undetected site of metastasis.

Metastatic Disease

Distant metastases (M1) occur in 11-36% of patients with NSCLC [25]. Although such patients commonly have

metastases to the adrenal glands, kidneys, liver, brain, bones, and lymph nodes at presentation, the role of imaging in the detection of these metastases is not clearly defined. Usually, CT of the chest that includes the adrenal glands is performed to detect metastases. Imaging aimed at detecting occult metastases to other organs, such as the brain and bones, is more variable and is discussed below. Generally, CT is the primary modality used to diagnosis and characterize intra-abdominal lesions, and a confident diagnosis of benignity or malignancy is frequently possible. For instance, if an adrenal mass contains fat or has an attenuation value of less than 10 HU on a noncontrast CT scan, the mass can be considered benign without the need for MR imaging or biopsy [26, 27]. Routine CT or MR imaging of the central nervous system has also been advocated because up to 18% of patients with NSCLC have brain metastases at presentation. However, these metastases are usually associated with neurologic signs and symptoms; thus, if the patient is asymptomatic, imaging of the brain is frequently omitted [28]. Similarly, imaging rarely reveals occult skeletal metastases and therefore bone radiographs, technetium $^{99m}$Tc (technetium)-labeled methylene diphosphonate bone scintigraphy, and MR imaging are usually only done if the patient has focal bone pain or an elevated alkaline phosphatase level [28].

Due to the fact that staging of NSCLC performed on the basis of symptoms, laboratory findings, and conventional radiologic imaging can be inaccurate, whole-body imaging with FDG-PET is being used to improve the accuracy of staging. FDG-PET has a higher sensitivity and specificity than CT in detecting metastases to the adrenal glands, bones, and extrathoracic lymph nodes. Whole-body PET imaging stages intra- and extrathoracic disease in a single study and is useful in the detection of occult extrathoracic metastases [15, 16]. It is important to note that the incidence of detection of occult metastases has been reported to increase as the staging T and N descriptors increase, i.e., 7.5% in early stage disease to 24% in advanced disease [29]. Two recent studies of patients with NSCLC considered resectable by standard conventional imaging showed that PET imaging prevented nontherapeutic surgery in one in five patients [15, 16]. However, a randomized controlled trial of the role of PET in early-stage lung cancer (more than 90% of patients with T1-2N0) showed that distant metastases were rarely detected (<2.5%), although PET improved the accuracy of staging and led to more age-specific therapy [30].

References

1. Martini N, Melamed MR (1975) J Thorac Cardiovas Surg 70:606-612
2. Antoch G, Stattaus J, Nemat AT et al (2003) Non-small cell lung cancer: dual-modality PET/CT in preoperative staging. Radiology 229:526-533
3. Gould MK, Sanders GD, Barnett PG et al (2003) Cost-effectiveness of alternative management strategies for patients with solitary pulmonary nodules. Ann Intern Med 138:724-735
4. Viggiano RW, Swensen SJ, Rosenow EC 3rd (1992) Evaluation and management of solitary and multiple pulmonary nodules. Clin Chest Med 13:83-95
5. Matsuoka S, Kurihara Y, Yagihashi K et al (2005) Peripheral solitary pulmonary nodule: CT findings in patients with pulmonary emphysema. Radiology 234:266-273
6. Kui M, Templeton PA, White CS et al ()1996 Evaluation of the air bronchogram sign on CT in solitary pulmonary lesions. J Comput Assist Tomogr 20:983-986
7. Henschke CI, Yankelevitz DF, Mirtcheva R et al (2002) CT screening for lung cancer: frequency and significance of part-solid and nonsolid nodules. AJR Am J Roentgenol 178:1053-1057
8. Zwirewich CV, Vedal S, Miller RR et al (1991) Solitary pulmonary nodule: high-resolution CT and radiologic-pathologic correlation. Radiology 179:469-476
9. Swensen SJ, Silverstein MD, Ilstrup DM et al (1997) The probability of malignancy in solitary pulmonary nodules. Application to small radiologically indeterminate nodules. Arch Intern Med 157:849-855
10. Gould MK, Maclean CC, Kuschner WG et al (2001) Accuracy of positron emission tomography for diagnosis of pulmonary nodules and mass lesions: a meta-analysis. JAMA 285:914-924
11. Gould MK, Sanders GD, Barnett PG et al (2003) Cost-effectiveness of alternative management strategies for patients with solitary pulmonary nodules. Ann Intern Med 138:724-735
12. MacMahon H, Austin JH, Gamsu G et al (2005) Guidelines for management of small pulmonary nodules detected on CT scans: a statement from the Fleischner Society. Radiology 237:395-400
13. Lardinois D, Weder W, Hany TF et al (2003) Staging of non-small-cell lung cancer with integrated positron-emission tomography and computed tomography. N Engl J Med 348:2500-2507
14. Reed CE, Harpole DH, Posther KE et al (2003) Results of the American College of Surgeons Oncology Group Z0050 trial: the utility of positron emission tomography in staging potentially operable non-small cell lung cancer. J Thorac Cardiovasc Surg 126:1943-1951
15. van Tinteren H, Hoekstra OS, Smit EF et al (2002) Effectiveness of positron emission tomography in the preoperative assessment of patients with suspected non-small-cell lung cancer: the PLUS multicentre randomised trial. Lancet 359:1388-1393
16. Burnett RJ, Wood DE (1999) The new lung cancer staging system: what does it mean? Surg Oncol Clin North Am 8:231-244
17. Mountain CF (1997) Revisions in the international system for staging lung cancer. Chest 111:1710-1717
18. Leong SS, Lima CMR, Sherman CA, Green MR (1999) The 1997 international staging system for non-small cell lung cancer. Chest 115:242-248
19. Mountain CF, Dresler CM (1997) Regional lymph node classification for lung cancer staging. Chest 111:1718-1723
20. Naruke T, Suemasu K, Ishikawa S (1978) Lymph node mapping and curability at various levels of metastasis in resected lung cancer. J Thorac Cardiovasc Surg 76:832-839
21. McLoud TC, Bourgouin PM, Greenberg RW et al (1992) Bronchogenic carcinoma: analysis of staging in the mediastinum with CT by correlative lymph node mapping and sampling. Radiology 182:319-323
22. Dwamena BA, Sonnad SS, Angobaldo JO, Wahl RL (1999) Metastases from non-small cell lung cancer: mediastinal staging in the 1990's - meta-analytic comparison of PET and CT. Radiology 213:530-536
23. Vansteenkiste JF, Stroobants SG, De Leyn PR et al (1998) Lymph node staging in non-small-cell lung cancer with FDG-PET scan: a prospective study on 690 lymph node stations from 68 patients. J Clin Oncol 16:2142-2149
24. Antoch G, Stattaus J, Nemat AT et al (2003) Non-small cell lung cancer: dual-modality PET/CT in preoperative staging. Radiology 229:526-533

25. Quint LE, Francis IR (1999) Radiologic staging of lung cancer. J Thorac Imaging 1999 14:235-246
26. Boland GW, Lee MJ, Gazelle GS et al (1998) Characterization of adrenal masses using unenhanced CT: an analysis of the CT literature. AJR Am J Roentgenol 171:201-204
27. Mayo-Smith WW, Boland GW, Noto RB, Lee MJ (2001) State-of-the-art adrenal imaging. Radiographics 21:995-1012
28. Silvestri GA, Littenberg B, Colice GL (1995) The clinical evaluation for detecting metastatic lung cancer. A meta-analysis. Am J Respir Crit Care Med 152:225-230
29. MacManus MP, Hicks RJ, Matthews JP et al (2001) High rate of detection of unsuspected distant metastases by PET in apparent stage III non-small-cell lung cancer: implications for radical radiation therapy. Int J Radiat Oncol Biol Phys 50:287-293
30. Viney RC, Boyer MJ, King MT et al (2004) Randomized controlled trial of the role of positron emission tomography in the management of stage I and II non-small-cell lung cancer. J Clin Oncol 22:2357-2362

Computed Tomography of Solitary Pulmonary Nodules

P. Armstrong

St Bartholomew's Hospital, London, UK

Introduction

The possible diagnoses of a solitary pulmonary nodule are numerous (Table 1), but over 95% fall into one of three groups:
1. Malignant neoplasm, either primary or metastatic
2. Infectious granulomas, either tuberculous or fungal
3. Benign tumors, notably hamartomas.

In patients old enough to have lung cancer but with no known extrathoracic primary tumor or other clinical indication to point to a specific diagnosis, the evaluation usually centers on deciding whether or not the patient has a primary malignant neoplasm of the lung, notably bronchial carcinoma. A solitary nodule >10 mm in diameter is sufficiently likely to be a primary lung cancer that a definitive diagnosis is required without undue delay. For practical purposes, the only lung cancers that can be recognized on plain chest radiographs as discrete solitary pulmonary nodules (SPNs) are ≥10 mm in diameter. Thus, the diagnostic work-up for SPNs recognized on plain films is different that that of nodules <10 mm, which are found only on CT. (The approach to these smaller nodules is discussed by Dr. Claudia Henschke elsewhere in this volume.)

Morphologic features such as size, shape, and cavitation, which can be diagnostically helpful, are discussed later, but it is important to realize that no radiologic features are entirely specific for lung carcinoma or any other primary malignant tumors. There are, however, four observations that exclude the diagnosis with reasonable certainty: (1) the detection of a benign pattern of calcification; (2) a rate of growth that is either too slow or too fast for the nodule to be primary lung cancer; (3) a specific shape indicating a benign process, and (4) unequivocal evidence on previous examinations that the nodule is the end stage of a previous benign process, such as infarction or granulomatous infection.

Calcification and Fat Density

Various types of calcification may be identified within an SPN: concentric (laminated), popcorn, punctate, cloudlike, and uniform (homogeneous).

Table 1. Differential diagnosis of a solitary pulmonary nodule/mass. From Armstrong (2005)

Neoplastic
 Bronchial carcinoma[a]
 Metastasis[a]
 Pulmonary lymphoma[a]
 Pulmonary carcinoid[a]
 Atypical adenomatous hyperplasia
 Hamartoma
 Connective tissue and neural tumors, e.g., lipoma, fibroma, chondroma, neurofibroma, blastoma,[a] sarcoma

Inflammatory
 Infective
 Granuloma,[a] e.g., tuberculosis, histoplasmosis, cryptococcosis, blastomycosis, coccidioidomycosis, nocardiosis
 Round pneumonia, acute or chronic[a]
 Lung abscess[a]
 Septic emboli[a]
 Hydatid cyst[a]
 Dirofilariasis

 Noninfective
 Rheumatoid arthritis[a]
 Wegener's granulomatosis[a]
 Lymphomatoid granulomatosis[a]
 Sarcoidosis[a]
 Necrotizing sarcoidosis[a]
 Lipoid pneumonia
 Behçet's disease[a]

Congenital
 Arteriovenous malformation
 Sequestration[a]
 Lung cyst[a]
 Bronchial atresia with mucoid impaction

Mimics of SPN
 External object, e.g., nipple, skin nodule
 Bone island in a rib
 Healing rib fracture
 Pleural plaque
 Loculated pleural fluid
 First chondro-costal junction

Miscellaneous
 Organizing pneumonia
 Pulmonary infarct[a]
 Round atelectasis
 Intrapulmonary lymph node
 Progressive massive fibrosis[a]
 Mucoid impaction[a]
 Hematoma[a]
 Amyloidosis[a]
 Pulmonary artery aneurysm or venous varix

[a] May cavitate

Concentric (laminated) calcification is virtually specific to tuberculous or fungal granulomas. *Popcorn calcifications* are randomly distributed, often overlapping small rings of calcification that are seen only when there is cartilage in the nodule, a feature specific to hamartoma and cartilage tumors. *Punctate calcification* occurs in a variety of benign and malignant lesions: granuloma, hamartoma, amyloidoma, carcinoid, and metastases, particularly osteosarcoma. Punctate calcification is rare in bronchial carcinoma unless the tumor engulfs a preexisting calcified granuloma (Fig. 1a, b), in which case the calcification is rarely randomly distributed or at the center of the nodule. The presence of one or more punctate calcifications arranged in an eccentric group and of widespread *cloud-like calcification* of a nodule substantially reduces the probability of bronchial

Fig. 2. Fat within a hamartoma. The nodule shows an area of obvious low density (*arrow*) that, when measured, was clearly fat

carcinoma, but they do not exclude the diagnosis entirely. *Uniform calcification* of an SPN is virtually diagnostic of a calcified granuloma and excludes the diagnosis of bronchial carcinoma.

Unequivocal demonstration of fat within a solitary pulmonary nodule is almost completely specific for hamartoma (Fig. 2). Lipoid pneumonia and metastatic liposarcoma are very rare alternatives. Care must be taken not to include adjacent aerated lung in the CT section, because the density reading may then be a mixture of air and cancer and lie within the fat range.

Rate of Growth

Bronchial carcinomas usually take between 1 and 18 months to double in volume, the average time being 4-8 months, depending on cell type. A few take as long as 24 months or, very occasionally, even longer, and a few double their volume in under a month. Therefore, doubling times faster than 1 month or slower than 18 months make bronchial carcinoma unlikely but do not exclude the diagnosis completely. (An increase in diameter of 26% corresponds to a doubling of volume.)

Volume doubling times faster than 1 month suggest infection, infarction, aggressive lymphoma, or a fast-growing metastasis from tumors such as germ-cell tumor and certain sarcomas. Doubling times slower than 18 months suggest processes such as granuloma, hamartoma, bronchial carcinoid, and round atelectasis. A practical guideline in common use is that if a nodule becomes smaller or has remained the same size over a period of 2 years, it is so likely to be benign that follow-up is a reasonable course of action.

Fig. 1a, b. Benign infectious granuloma showing a partially calcified solitary pulmonary nodule (SPN). The calcification is located centrally within the nodule. The technique used was to view the nodule at lung windows (**a**) and then reduce the window to the minimum possible width and set the level at 200 HU, so that all the voxels >200 HU are white and all those ≤200 HU are black (**b**). If the nodule had not contained calcification, it would have appeared black in **b**

Size and Shape

When the nodule is between 1 and 3 cm in diameter, none of the diagnoses listed in Table 1 can be excluded on the basis of nodule size alone. Above 3 cm, the probabilities begin to change dramatically. Most solitary nodules >3 cm in diameter are bronchial carcinoma. With few exceptions, SPNs above this size that are not primary or metastatic carcinoma prove to be lung abscess, Wegener's granulomatosis, lymphoma, round pneumonia, round atelectasis, or hydatid cyst. The first three resemble one another and may be indistinguishable from bronchial carcinoma. The latter three, however, often show characteristics that permit a specific diagnosis to be made.

Certain shapes at CT or high-resolution CT provide important diagnostic information and, in practice, shape is often used to make management decisions [1]. A very irregular edge makes bronchial carcinoma highly probable, and a corona radiata (Fig. 3), i.e., the appearance of numerous strands radiating into the surrounding lung, is almost specific for bronchial carcinoma. Infectious granulomas and other chronic inflammatory lesions, notably organizing pneumonia, may occasionally have a very irregular edge and may even show a corona radiata [2].

Lobulation and notching, signs that indicate uneven growth, are seen with almost all the diagnostic possibilities, but the more pronounced these two signs are, the more likely it is that the lesion is a bronchogenic carcinoma. A well-defined, smooth, non-lobulated edge is most compatible with hamartoma, granuloma, and metastasis. It is rarely seen in patients with bronchial carcinoma.

If the opacity is composed of one or more narrow linear shadows (Fig. 4) without focal nodularity, the chances of bronchial carcinoma are so low that benign cause can be assumed and follow-up is the only recommendation.

Fig. 4. High-resolution CT shows an abnormal density that looked like a nodule but is in fact made up of clear-cut linear components with no nodular elements. The lesion is therefore benign and likely to be a scar or a small area of atelectasis

The presence of a pleuropulmonary tail associated with a peripherally located nodule is not helpful in the differential diagnosis of SPN. The sign is seen with a variety of lesions, both malignant and benign, particularly granulomas.

The 'feeding vessel sign' can be used to suggest a diagnosis of hematogenous metasasis [3]. The sign refers to a small pulmonary artery shown by CT to lead directly to a nodule.

Enlarged blood vessels directly feeding and draining a nodule should be looked for carefully as they are specific for arteriovenous malformation. The vessels and the malformation itself will show substantial contrast enhancement.

Air Bronchograms and Bubble-Like Lucencies

Air bronchograms are seen on CT with some frequency in primary bronchial carcinoma, particularly on high-resolution CT.

Bubble-like low attenuation areas, similar to air bronchograms but more spherical in configuration, are not uncommon in adenocarcinomas, particularly bronchioloalveolar carcinomas [4]. These lucencies are due to patent small bronchi within the nodule or to lepidic growth of the tumor around alveolar walls.

Cavities and Air Crescent Sign

As can be seen in Table 1, many of the causes of SPN may result in cavitation; thus, the presence or absence of cavitation is of limited diagnostic value. The mor-

Fig. 3. Lung carcinoma showing a corona radiata

phology of any cavity may, however, be helpful. Lung abscesses and benign lesions in general have a thinner, smoother wall than cavitating malignant neoplasms. In practice, the diagnosis of acute lung abscess usually depends on the clinical features together with the appearance of a cavity evolving in an area of undoubted pneumonia. The more difficult problem is distinguishing between cavitating neoplasm and chronic inflammatory processes. Fungal pneumonia, particularly cryptococcosis and blastomycosis, and various connective tissue diseases, particularly Wegener's granulomatosis and rheumatoid arthritis, can appear identical to carcinoma of the lung.

A cavity may contain a mass within it, the air within the cavity forming a peripheral halo or crescent of air between an intracavitary mass and the cavity wall, giving rise to the 'air crescent' or 'air meniscus sign'. Intracavitary masses are most often due to fungal mycetomas. Other causes include complicated hydatid disease, blood clot (as a result of tuberculosis, laceration with hematoma, or infarct), abscess, necrotizing pneumonias (particularly caused by *Klebsiella* or *Aspergillus fumigatus*), and necrotic neoplasm.

The CT Halo Sign

The term 'CT halo sign' refers to ground-glass attenuation surrounding a nodule on CT. Apart from malignant neoplasms and hemorrhage following biopsy, the most common cause of a CT halo sign is infection, notably invasive aspergillosis (Fig. 5). The other causes are candidiasis, coccidioidomycosis, tuberculosis, cytomegalovirus, herpes simplex, Wegener's granulomatosis, metastatic angiosarcoma, and Kaposi's sarcoma. A feature that links many of these conditions is hemorrhage into the region of the lung adjacent to the basic pathology.

Fig. 6. Bronchioloalveolar carcinoma showing a mixed-density mass with ground-glass opacity surrounding a soft-tissue density

It is worth bearing in mind that a CT halo sign surrounding a small asymptomatic nodule in a patient in the lung-cancer age range is likely to be a bronchogenic carcinoma (Fig. 6) and that when a CT halo sign is seen surrounding central consolidation in a patient who is immunocompromised due to leukemia or drug treatment the diagnosis is highly likely to be invasive aspergillosis.

Adjacent Bone Destruction

Invasion of adjacent bone by a pulmonary mass is almost pathognomonic of bronchogenic carcinoma. Actinomycosis and, occasionally, tuberculosis or fungal disease are the alternative possibilities.

Contrast Enhancement

Solitary pulmonary nodules caused by malignant neoplasm show a greater degree of contrast enhancement at CT than benign nodules, presumably due to the presence of angiogenesis in malignant neoplasms. The potential usefulness of this technique now appears to be of 95% or greater predictive value for benignity in nodules ≥5 mm in diameter that fail to enhance by more than 15 HU (Fig. 7a, b). The negative predictive value is, or approaches, 100% if more conservative criteria for enhancement are used [5].

Tuberculous granulomas may show peripheral ring enhancement or curvilinear central enhancement, features that may help diagnostically [6]. The non-en-

Fig. 5. CT halo sign in a leukemic patient with *Aspegillus fumigatus* infection

Fig. 7a, b. Benign nodule showing less than 15 HU of contrast enhancement. This nodule was stable in size during more than 5 years of observation. **a** Pre-contrast scan; **b** scan following a 100 ml bolus of intravenous contrast

hanced portions of the nodules correspond to caseous necrosis. Very dense uniform enhancement, as discussed previously, is a feature of arteriovenous malformations.

Management of a Solitary Pulmonary Nodule

The management of a patient with an SPN depends on a combination of clinical and radiologic factors. A clinical evaluation to find evidence of diseases such as rheumatoid arthritis, Wegener's granulomatosis, hydatid disease, and extrathoracic primary malignant tumor should be undertaken.

Solitary masses >3 cm, unless they show the specific features of round atelectasis or a congenital malformation such as an arteriovenous malformation, are so frequently lung cancers that benign entities should be diagnosed with caution.

The radiological approach for patients in the cancer age group who have an asymptomatic SPN between 1 and 3 cm in diameter is to examine all available images carefully for: visible calcification conforming to a definite benign pattern, fat within the nodule, or stability of size on retrospective review of the images for at least 18 months. Any one of these features is sufficient evidence for a benign lesion to obviate surgical resection.

If the nodule does not show any of these features, thin-section CT can be used assess the morphologic and density characteristics, notably calcification and/or fat (using formal CT density measurements if necessary). The presence of occult calcification must be interpreted with care and is not absolute proof of benignity. However, because the probability of cancer becomes very low when >10% of the nodule shows calcification, it is prudent to institute a 'watch and wait' program. CT densitometry for calcification is not advised for nodules >3 cm in diameter, because the probability of a benign lesion above this size diminishes greatly. If the presence of fat is used to diagnose a hamartoma, care must be taken to ensure the CT section is at the equator of the nodule and that the section does not include adjacent lung which could, by partial volume effect, lower the density of soft tissue to lie within the range of fat.

An SPN that is still indeterminate after all the preceding considerations have been taken into account may be benign, a solitary metastasis (unlikely, as the first presenting feature of an extrathoracic primary malignancy), or a bronchogenic carcinoma. A negative result from FDG PET scanning is an excellent method of determining that lung cancer is highly unlikely, but a positive result is less reliable for predicting malignancy. The same applies to contrast enhancement of the nodule at CT. Fine-needle aspiration biopsy can prove that a nodule is malignant but is less reliable at excluding malignancy. Resection of the nodule, with appropriate prior staging, is the recommended course of action when an SPN cannot be diagnosed as benign on imaging grounds. Exceptions to this recommendations are when the clinical likelihood of primary lung cancer is deemed very low, e.g., young non-smokers or a known extrathoracic tumor likely to have metastasized, or when the risk of pulmonary resection outweighs the potential benefit of removal of possible malignant tumor. When follow-up is deemed a reasonable course of action, an appropriate scheme is CT after 3 months and, if there is no significant growth, at further intervals of 6-12 months until stability has been established. If the nodule has not grown over a 2-year period, or the rate of growth is so slow that its doubling time is well outside the range for lung cancer, then primary lung cancer is sufficiently unlikely that further follow-up can be stopped.

References

1. Zwirewich CV, Vedal S, Miller RR et al (1991) Solitary pulmonary nodule: high-resolution CT and radiologic-pathologic correlation. Radiology 179:469-476
2. Chen SW, Price J (1998) Focal organizing pneumonia mimicking small peripheral lung adenocarcinoma on CT scans. Australas Radiol 42:360-363
3. Milne EN, Zerhouni EA (1987) Blood supply of pulmonary metastases. J Thorac Imaging 2:15-23
4. Kuriyama K, Tateishi R, Doi O et al (1991) Prevalence of air bronchograms in small peripheral carcinomas of the lung on thin-section CT: comparison with benign tumors. AJR Am J Roentgenol 156:921-924
5. Swensen SI, Viggiano RW, Midthun MD et al (2000) Lung nodule enhancement at CT: multicenter study. Radiology 214:13-80
6. Murayama S, Murakami J, Hashimoto S et al (1995) Non-calcified pulmonary tuberculomas: CT enhancement patterns with histological correlation. J Thorac Imaging 10:91-95

Suggested Reading

Armstrong P (2005) Basic patterns of lung disease. In: Hansell DM, Armstrong P, Lynch DA, McAdams HP (eds) Imaging of diseases of the chest, 4th edn. Elsevier Mosby, Philadelphia, pp 107-120

Erasmus JJ, Connolly JE, McAdams HP et al (2000) Solitary pulmonary nodules: Part I. Morphologic evaluation for differentiation of benign and malignant lesions. Radiographics 20:43-58

Erasmus JJ, McAdams HP, Connolly JE (2000) Solitary pulmonary nodules: Part II. Evaluation of the indeterminate nodule. Radiographics 20:59-66

Ko JP, Naidich DP (2003) Lung nodule detection and characterization with multislice CT. Radiol Clin North Am 41:575-597

Kuriyama K, Tateishi R, Doi O et al (1987) CT-pathologic correlation in small peripheral lung cancers, AIR Am J Roentegenol 149:1139-1143

Leef JL III, Klein JS (2002) The solitary pulmonary nodule. Radiol Clin North Am 40:123-143

CT Diagnosis and Management of Focal Lung Disease: Small Pulmonary Nodules

C.I. Henschke

Department of Radiology, Weill Medical College of Cornell University, New York, NY, USA

Introduction

The increasing use of CT, whether for screening for lung cancer or for other reasons, has led to the increasing detection of small pulmonary nodules. It was the development of the knowledge base needed to make scientific recommendations for the work-up of these small nodules that led us to the topic of CT screening for lung cancer [1].

Since our initial publication on this subject, in 1999 [2], screening has become widespread; thus, there is an ever increasing need for the management of small pulmonary nodules. We have continued to update our management protocol since 1999 [3], as most recently published in our long-term follow-up of the International Early Lung Cancer Action Program (I-ELCAP) experience [4]. The latest version is always available on the I-ELCAP website [5] and will continue to be updated based on the latest findings reported at our semi-annual international conferences [6].

It should be recognized that it is important to know the context in which the pulmonary nodules were detected on CT scans, as the work-up should differ and reflect the probability of finding a malignancy according to the particular context. For example, the probability of detecting a malignancy is low on the first (baseline) screening or as an incidental finding on a CT done for reasons other than screening as compared to the probability of detection on repeat screenings [4]. Also, clearly, the probability of malignancy is influenced by the person's risk characteristics, including age and smoking history [7].

Definition of a Nodule

The elusiveness of a precise definition of nodule, as seen on CT images, was recognized by the Fleischner report [8], but it was defined previously in I-ELCAP as a non-linear, rounded opacity. A nodule was classified as non-calcified if: it was <5 mm in diameter and all of it appeared non-calcified (attenuation less dense than the ribs on bone and lung windows); it was 5-20 mm in diameter, wholly non-calcified (by the above-specified criterion) or the edge was spiculated (to any extent) even when the nodule had calcifications of a classical benign pattern (central, lamellated, popcorn); it was >20 mm in diameter and any part of it was non-calcified (by the above-specified criterion). Nodules classified as calcified by these criteria or those containing sufficient fat to be considered as a hamartoma were classified as benign.

Among these non-calcified nodules, there are solid nodules that are defined as completely obscuring the lung parenchyma in them. There are also nodules that do not completely obscure the entire lung parenchyma in them, resulting in a property commonly called 'ground-glass opacities' [9]. We have introduced a different terminology for the term 'ground-glass opacities,' as we feel it is not appropriate in the context of focal abnormalities in the lung. The term 'ground-glass' was introduced for, and is still being applied to, not only focal abnormalities but diffuse ones as well. Thus, for our purposes, the adjective 'focal' needs to be added. We also prefer to use the anatomic term 'nodule' rather than 'opacity,' as the former is in line with other anatomic terms generally used in chest radiology, such as 'bronchi' and 'blood vessels.' Accordingly, we distinguish between a solid and *sub-solid* nodule. The former is defined as a nodule completely obscuring the entire lung parenchyma in it, whereas the latter does not. A sub-solid nodule can be further classified as *part-solid* when there are patches of parenchyma that are completely obscured, and as *non-solid* if there are no such areas.

Work-up

For baseline screening or for an incidental finding on a CT scan done for other purposes, a positive result of the initial low-dose CT comprises: identification of at least one solid or part-solid non-calcified pulmonary nodule ≥5 mm in diameter, or at least one non-solid non-calcified pulmonary nodule ≥8 mm in diameter, or a solid endobronchial nodule. If none of the non-calcified nodules met the criteria for a positive result (semi-positive result) or the test was negative, a repeat CT was to be obtained 12 months later. Nodule diameter was defined as the average of its length and width, as determined on the CT image showing the largest cross-sectional area of a nodule.

If the result is positive, the work-up depends on the nodule's diameter. For nodules 5-14 mm in diameter, the preferred option is to perform another CT at 3 months; if that CT shows growth of the nodule [10-14], biopsy, ideally by fine-needle aspiration, should be done. If there has been no further growth, the work-up is stopped. The other option is to perform a PET scan immediately. If the result is positive, a biopsy should be obtained; otherwise, CT should be repeated at 3 months. For nodules ≥15 mm in diameter (whether solid, part-solid, or non-solid), immediate biopsy is another option in addition to those already specified for smaller nodules. In instances of suspicion of infection, a 2-week course of antibiotics followed by CT 1 month later provides an alternative to any of the above-described options [15]. If no resolution or growth is observed, biopsy should be performed; otherwise, the work-up is stopped. In all patients in whom either the work-up is stopped or biopsy does not lead to a diagnosis of lung cancer, repeat CT 12 months after the initial baseline CT should be performed.

References

1. Henschke CI, Miettien OS, Yankelevitz DF et al (1994) Radiographic screening for cancer: proposed paradigm for requisite research. Clin Imag 18:16-20
2. Henschke CI, McCauley DI, Yankelevitz DF et al (1999) Early Lung Cancer Action Project: overall design and findings from baseline screening. Lancet 354:99-105
3. Henschke CI, Yankelevitz DF, Smith JP, Miettinen OS (2001) International Early Lung Cancer Action Program: origins, aims, principles and protocol. Lung Cancer 35:143-148
4. The International Early Lung Cancer Action Program Investigators (2006) Survival of patients with stage I lung cancer detected on CT screening. N Engl J Med 355:1763-1771
5. I-ELCAP protocol. www.ielcap.org (last access March 2007)
6. International Conferences on Screening for Lung Cancer. 1st to 15th Conferences. Website: http://www.ielcap.org (last access March 2007)
7. The International Early Lung Cancer Action Program Investigators (2007) CT Screening for Lung Cancer: individualizing the benefit of the screening (submitted)
8. MacMahon H, Austin JM, Gamsu G et al (2005) Guidelines for management of small pulmonary nodules detected on CT scans: a statement from the Fleischner Society. Radiology 237:395-400
9. Henschke CI, Yankelevitz DF, Mirtcheva R et al (2002) CT screening for lung cancer: Frequency and significance of part-solid and non-solid nodules. AJR Am J Roentgenol 78:1053-1057
10. Yankelevitz DF, Gupta R, Zhao B, Henschke CI (1999) Repeat CT scanning for evaluation of small pulmonary nodules. Radiology 212:561-566
11. Yankelevitz DF, Reeves AP, Kostis WJ et al (2000) Determination of malignancy in small pulmonary nodules based on volumetrically determined growth rates. Radiology 217:251-256
12. Yankelevitz DF, Reeves A, Kostis W et al (2000) Determination of malignancy in small pulmonary nodules based on volumetrically determined growth rates: preliminary results. Radiology 217:251-256
13. Kostis WJ, Reeves AP, Yankelevitz DF, Henschke CI (2003) Three-dimensional segmentation and growth-rate estimation of small pulmonary nodules in helical CT images. IEEE Trans Med Imaging 22:1259-1274
14. Kostis WJ, Yankelevitz DF, Reeves AP et al (2004) Small pulmonary nodules: reproducibility of three-dimensional volumetric measurement and estimation of time to follow-up CT. Radiology 231:446-452
15. Libby D, Wu N, Lee I et al (2006) CT Screening for lung cancer: the value of short-term CT follow-up. Chest 129:1039-1042

Plain-Film and CT Evaluation of the Adult Mediastinum and Hilum: Pitfalls vs. Disease

S. Bhalla[1], J. Cáceres[2]

[1] Mallinckrodt Institute of Radiology, Washington University School of Medicine, Barnes-Jewish Hospital, St. Louis, MO, USA
[2] Department of Diagnostic Radiology, Hospital Universitari Vall d'Hebron, Universitat Autonoma de Barcelona, Barcelona, Spain

Introduction

Knowledge of the normal mediastinal anatomy and its variants is indispensable for proper interpretation of chest radiology. Mediastinal masses may be found incidentally in asymptomatic individuals, but they can also be symptomatic, depending on their size and location. Cross-sectional imaging with computed tomography (CT) and magnetic resonance (MR) imaging plays an important role in the nonsurgical evaluation of mediastinal lesions.

In this article, we review the anatomy and normal variants of mediastinal structures as well as the radiographic, CT, and MR appearances of some of the most common mediastinal diseases, with emphasis on those features that permit a focused differential diagnosis and help direct management.

Imaging Strategies in Mediastinal Diseases

Conventional Chest Radiography

Many mediastinal masses are incidentally discovered on routine chest examinations obtained for other reasons. Chest radiography is the first imaging modality used in those asymptomatic patients or when a mediastinal mass is suspected. The key to the chest radiograph is to determine whether the lesion is actually within the mediastinum or lung and to make an educated guess as to where the lesion is within the mediastinum. A lesion confined to the posterior mediastinum (paravertebral region) may be better evaluated by MR.

Computed Tomography

Computed tomography is currently the gold standard for the detection of mediastinal pathology. Initial nonenhanced contiguous slices should be obtained to demonstrate calcifications and hemorrhage. The injection of intravenous contrast will define the enhancement patterns of the lesions as well as their relationship with adjacent vascular and mediastinal structures.

Magnetic Resonance Imaging

Magnetic resonance has a complementary role in the evaluation of mediastinal masses. It is mainly used: (a) to solve unanswered questions after CT scan, (b) to assess mediastinal masses in patients allergic to iodinated contrast material, and (c) to better assess the relationship of the mediastinal mass with adjacent structures, e.g., the pericardium, heart cavities, spinal canal, and vessels. For this last reason, MR is usually preferred to CT for the assessment of masses of suspected neurogenic origin. Another indication for mediastinal MR is if the mediastinal mass is suspected to be a cyst (thymic, pericardial, foregut duplication, neuroenteric) and this suspicion cannot be confirmed by CT. With MR subtraction imaging (post contrast image minus pre-contrast image) only enhanced structures are shown. Cysts should be invisible on these images.

Anatomic and Normal Variants Mimicking Mediastinal Pathology

Thymus

The thymus has a wide variation in appearances on cross-sectional imaging and its size and morphology are directly related with age [1]. Whereas relatively large in the neonate and young infant, after puberty, there is a gradual reduction of the thymus size due to a progressive replacement of the atrophied thymic follicles by adipose tissue. However, there is a broad variation in this involution and significant residual thymic tissue may be present in individuals over the age of 30.

Superior Pericardial Recess

The superior pericardial recess is a semicircular space surrounding the ascending aorta. The most superior extent of this recess is at the level of the innominate artery. On rare occasions, pericardial effusion within the superior pericardial recess can simulate a cystic mediastinal mass [2].

Lymph Nodes

The maximal diameter of normal lymph nodes ranges from 6 to 14 mm. However, the short axis of mediastinal nodes has been advocated as the most predictable measure of nodal enlargement; 1.0 cm is considered the upper limit of normal [3]. When mediastinal fat is scanty, the collapsed esophagus may be confused with a lymph-node mass on CT and MR.

Left Pulmonary Artery

On rare occasion, the main and left pulmonary arteries are positioned at an unusually high level with respect to the aortic arch, thereby mimicking a mediastinal mass on CT or plain-chest radiographs [4].

Pericardial Fat Pad

An enlarged pericardial fat pad, usually associated with obesity, exogenous steroid therapy, and Cushing syndrome, may mimic a cardiophrenic angle mediastinal mass.

Mediastinal Lipomatosis

An excess of mediastinal fat, which is a benign condition usually seen in obese patients or in patients under exogenous steroid use, results in significant mediastinal widening. Patients are asymptomatic and do not require therapy.

Classification of Mediastinal Masses

Classification of a mediastinal mass on CT and MR is based on two main features: location and attenuation/signal. Although sometimes artificial, the mediastinum can be classified into three compartments: (a) anterior, comprising the structures and tissue situated in front of a line drawn along the anterior border of the trachea and the posterior border of the heart; (b) middle, located between this line and the anterior aspect of the vertebral bodies; and (c) paravertebral, when a mass is situated predominantly in the potential space adjacent to a vertebral body [5].

The attenuations/signals of fat and fluid as well as high attenuation/signal (higher than muscle) may be of diagnostic help. A fat attenuation/signal may be seen in thymolipomas, germ-cell tumors, lipomatosis, fat pads, liposarcomas, extramedullary hematopoiesis, and esophageal fibrovascular polyps. A fluid attenuation/signal may be seen with foregut duplication cysts, germ-cell tumors, thymomas, lymphomas, necrotic tumors, lymphangiomas, pericardial cysts, and thymic cysts. High-attenuation/signal lesions include hemangiomas, Castleman's disease, goiter, paraganglioma, vascular abnormalities, and vascular metastases.

Anterior Mediastinum

The anterior mediastinum is the site of origin of the majority of mediastinal masses, including thymoma and other thymic disorders (cysts), lymphangioma, germ-cell neoplasms (mature teratomas and malignant germ-cell tumors), Hodgkin's disease and non-Hodgkin's lymphoma, and mesothelial cyst (pericardial) [5-8]. Residents and medical students sometimes like to use the mnemonic '3T's' to help with remembering thymoma, teratoma, and 'terrible' lymphoma. Though this can be helpful, it can also be misleading, as it allows one to forget the other thymic lesions that may be present in the anterior mediastinum (cysts, carcinoid, carcinoma) and that not all anterior germ-cell tumors are benign.

Thymoma

This is by far the most common primary tumor of the anterior mediastinum. Men and women are equally affected and most of the lesions occur in patients >40 years. Thymomas are rare in children and adolescents. Myasthenia gravis occurs in approximately 30-50% of patients with this tumor. Less commonly, patients may present with other parathymic syndromes, such as pure red cell aplasia or hypogammaglobulinemia. Radiologically, thymomas commonly manifest as well-defined, lobulated, homogeneous, or heterogeneous mediastinal masses usually located anterior to the aortic root. Punctate or curvilinear calcifications can be detected on conventional radiographs. In up to one third of cases, necrosis, hemorrhage, and/or cystic changes can be demonstrated on cross-sectional imaging studies (Fig. 1) [5]. Cross-sectional imaging does not reveal the malignant potential of a thymoma

Fig. 1. Thymoma. CT shows a mass in the anterior mediastinum with uniform enhancement

unless pleural seeding is present. Therefore, the term 'invasive thymoma' is reserved for the visualization of an anterior mediastinal mass with pleural deposits.

Thymic Cysts

Thymic cysts represent approximately 3% of all anterior mediastinal masses and are most commonly found in children. They are generally considered developmental abnormalities caused by persistence of the thymopharyngeal duct. Radiologically, thymic cysts manifest as well-marginated, rounded masses that are characteristically located in the anterior superior mediastinum. On CT scans, they appear as sharply delineated masses with near-water attenuation (Fig. 2). Thymic cysts are usually unilocular but some may be multiloculated, with occasional visualization of linear wall calcification. On MR, thymic cysts have a very high signal attenuation on T2-weighted images but variable signal intensity on T1-weighted images, depending on the degree of proteinaceous material or hemorrhage present [5, 6]. They should not enhance with gadolinium. Occasionally, multiple thymic cysts may be present in HIV patients and in those with Langerhans cell histiocytosis.

Lymphangioma

Lymphangiomas are rare, benign lesions of lymphatic origin, representing 0.7-4.5% of all mediastinal tumors [5, 6, 8]. Most patients are asymptomatic, but occasionally they have symptoms of compression or pain. In adults, lymphangiomas are more often found in the mediastinum, whereas in children, especially those <2 years of age, lymphangiomas are usually discovered as a mass in the neck or axilla. CT scanning typically shows a uniformly cystic lesion with an attenuation equal to or slightly higher than that of water and insinuating throughout multiple mediastinal compartments (Fig. 3). On MR imaging, the cyst contents have increased signal intensity on T2-weighted images and can also have high signal intensity on T1-weighted images.

Germ-Cell Tumors

Most primary mediastinal germ-cell tumors are teratomas. These are a heterogeneous group of tumors that are derived from more than one germ-cell layer and thus contain different tissue types [9]. These tumors can be found in persons of any age, although they are most often detected in young adults. Teratomas account

Fig. 2. Teratoma. CT shows an anterior mediastinal mass with a combination of fat and soft-tissue attenuation

Fig. 3a, b. Pericardial cyst. **a** Posteroanterior chest radiograph shows a well-defined mass in the right cardiophrenic space. **b** CT shows the typical appearance of a pericardial cyst. Note the change in shape with the change in the patient's position

for 60-70% of mediastinal germ-cell tumors. Mature teratomas are by far the most frequent and occur more commonly in young women. Radiologically, such tumors manifest as a rounded or lobulated, well-defined, anterior mediastinal mass that usually protrudes to one side of the midline. The CT scan appearance of these lesions depends on the proportions of the various tissues of which they are composed. CT examination allows a confident diagnosis of a mature teratoma when a combination of fluid, soft-tissue, calcium, and fat attenuation is present [5, 9] (Fig. 2).

Germ-cell tumors are frequently cystic, and mature teratomas do not need to contain fat. When the soft-tissue component is proportionally greater than the cystic components, malignant germ-cell tumor may be suspected. Seminoma is the most common primary mediastinal germ-cell tumor [5, 9].

Pericardial Cysts

These are believed to arise from the persistence of blind segments of the ventral parietal recesses of the pericardium. Seventy percent occur in the right cardiophrenic angle as a well-defined soft-tissue opacity on conventional chest radiograph [5, 7]. On CT, pericardial cysts typically manifest as well-circumscribed, unilocular, nonenhancing masses with low (near-water) attenuation contents. They are located adjacent to the cardiac border, typically changing shape as the patient changes position (Fig. 3). On MR, pericardial cysts have low-signal intensity on T1-weighted images, homogeneous high-signal intensity on T2-weighted images, and do not enhance [7]. Pericardial cysts not infrequently communicate with the pericardial space and, therefore, may change in size between two CT examinations.

Fig. 4. Intrathoracic goiter. Middle mediastinal mass, posterior and lateral to the trachea. Note the typical coarse calcifications

Middle Mediastinum

The most common abnormalities of middle-posterior mediastinum are developmental anomalies of the aortic arch and aortic aneurysms, esophageal lesions and developmental cysts (bronchogenic and enteric cyst) [5]. The predominant mass in the middle superior mediastinum is the intrathoracic goiter.

Mediastinal Goiter

Mediastinal goiter is one of the most common mediastinal abnormalities seen in daily practice [6]. Patients are usually asymptomatic but rarely may present with pain or symptoms related to tracheal compression. Radiographically, mediastinal goiter appears as a sharply defined, smooth or lobulated mass that usually causes displacement and narrowing of the trachea. Coarse or ring-like calcifications are commonly associated with the lesion being visible on plain films. CT can show the extent of intrathoracic thyroid tissue and its connection with the thyroid gland (Fig. 4) [5, 6]. On CT, goiters should be heterogeneous in attenuation, with components that are of high attenuation. If the thyroid is enlarged and shows homogeneous low-attenuation, tumor infiltration should be suspected [7].

Developmental Cysts

Bronchogenic cyst is by far the most common form of foregut-duplication cysts, which result from abnormal ventral budding of the tracheobronchial tree. Bronchogenic cysts represent 50-60% of all mediastinal cysts. Approximately 80% occur in the paratracheal or subcarinal region, but they may also have an intrapulmonary location [6, 8]. On CT scanning, bronchogenic cysts are typically unilocular nonenhancing masses of water attenuation, intimately related to the airway. Calcification of the cyst wall can occur and sometimes the cyst's attenuation on CT can be higher because they may contain milk or calcium. On MR imaging, the cystic contents can exhibit low- or high-signal intensity on T1-weighted images and typically have homogeneous bright signal intensity on T2-weighted sequences [8] (Fig. 5). They should not enhance with gadolinium.

Enteric cysts are usually lined by alimentary epithelium. Esophageal duplication cysts comprise 10-15% of all alimentary-tract duplications and 60% are located adjacent to the lower esophagus [6, 8]. They can be found within or attached to the esophageal wall and rarely communicate with the esophageal lumen. On CT, esophageal duplication cysts appear as spherical nonenhancing intramural lesions with no esophageal communication, or sometimes showing a fibrous tract attached to the esophageal wall.

Often times, the foregut duplication cyst cannot be further classified as bronchogenic or enteric. No communi-

Fig. 5a, b. Bronchogenic cyst. **a** T2-weighted transverse MRI shows a high-signal round mass in the middle mediastinum. **b** T1-weighted coronal view confirms the location of the mass and its liquid content

cation to the trachea, bronchi or esophagus is demonstrated. In these cases, one must wait for the final surgical pathology, although it may not be more revealing. If the cyst has become infected or bled, the lining may become indistinct and further classification is not possible.

Paravertebral Region

This region is bounded in the front by the anterior surface of the vertebral column and in the back by the chest wall. The most common abnormalities of the paravertebral region are neoplasms of neural tissue arising from the peripheral nerves or sympathetic ganglia, infectious processes from the spine, bone and cartilage tumors, costovertebral traumatic lesions, and extramedullary hematopoiesis [6, 10].

Tumors of Neural Tissue

Neoplasms of neural tissue account for about 20% of all primary mediastinal neoplasms. Schwannoma, neurofibroma (plexiform and nonplexiform), and malignant schwannoma are tumors that arise from an intercostal nerve [6]. Their radiographic appearance consists of sharply defined round, smooth, or lobulated paraspinal masses. In 50% of cases they are associated with bone abnormalities, including expansion of the neural foramina, erosion of the vertebral bodies, and erosion and deformity of ribs [6]. Ganglioneuroma, ganglioneuroblastoma, and neuroblastoma are neural tumors arising from the sympathetic ganglia. They usually manifest radiographically as sharply defined oblong masses located along the anterolateral surface of the vertebral spine (Fig. 6). At times, a schwannoma can emulate a foregut duplication cyst (low-attenuating from the myelin). One must look for enhancement or bone-remodeling to help in the identification, as neither of these properties is routinely seen with duplication cysts.

Extramedullary Hematopoiesis

Extramedullary hematopoiesis is a rare disease that is usually associated with chronic hematologic diseases in which there is inadequate production or excessive destruction of blood cells [10]. Thalassemia and sickle-cell disease are the most common hematologic disorders associated with foci of extramedullary hematopoiesis in organs such as liver, spleen, and lymph nodes. Unilateral or bilateral masses of hematopoietic tissue can be occasionally found in the paravertebral region. The radiographic appearance consists of smooth and lobulated paravertebral masses situated in the lower chest. On CT scans, they may have a large fatty component [10]. This uncommon disorder should be considered in the differential diagnosis of a paravertebral mass in a patient with severe chronic anemia.

Fig. 6. Neurogenic tumor. T2-weighted tranverse MRI shows a posterior mediastinal mass. Ganglioneuroma confirmed at surgery

Vascular Abnormalities

Vascular anomalies of the mediastinum can occasionally be confused with mediastinal masses on plain film. Cross-sectional imaging is helpful in diagnosing them but the clinician must be well-acquainted with these entities to avoid propagating the confusion.

Tortuous vessels are perhaps the most common mediastinal vascular abnormality confused with mass on chest radiography. The right innominate artery (causing a right paratracheal opacity) and the left superior intercostal vein are two of the more common enlarged, tortuous variants [11].

Anterior to the aortic arch in the para-aortic region, two venous anomalies are frequently encountered: the left-sided vena cava and partial anomalous return of the left upper lobe [12]. The former drains from the left brachiocephalic vein to the coronary sinus and may be present with a right-sided superior vena cava. The latter represents the most common form of isolated anomalous drainage. In this entity the left upper lobe drains into the left brachiocephalic vein. The key to distinguishing partial anomalous return of the left upper lobe from a left superior vena cava is that the former does not connect to the coronary sinus, and no vessel is encountered anterior to the left mainstem bronchus. This is in distinction to the situation with a left superior vena cava, in which two vessels are encountered anterior to the left main-stem bronchus (the normal superior pulmonary vein and the left superior vena cava). Another venous anomaly is an azygos continuation of an interrupted inferior vena cava. In this condition, the azygos vein is responsible for all infrahepatic venous return. This entity should be suspected when the azygos vein is noticeably enlarged in a patient without superior vena cava thrombus or obstruction.

Aortic arch variations may also be encountered as an incidental mediastinal mass. They include double aortic arch, right arch with aberrant left subclavian artery, and left arch with aberrant right subclavian artery. Detailed analysis of the branching vessels should allow for accurate diagnosis.

References

1. Dixon AK, Hilton CJ, Williams GT (1984) Computed tomography and histological correlation of the thymic remnant. Clin Radiol 32:255-257
2. Winer-Muram HT, Gold RE (1980) Effusion in the superior pericardial recess simulating a mediastinal mass. AJR Am J Roentgenol154:69-71
3. Quint LE, Glazer GM, Orringer MB et al (1986) Mediastinal lymph node detection and sizing at CT and autopsy. AJR Am J Roentgenol 147:469-472
4. Mencini RA, Proto AV (1982) The high left and main pulmonary arteries: a CT pitfall. J Comput Assist Tomogr 6:452-459
5. Strollo DC, Rosado de Christenson ML, Jett JR (1997) Primary mediastinal tumors. Part II. Tumors of anterior mediastinum. Chest 112:511-522
6. Strollo DC, Rosado de Christenson ML, Jett JR (1997) Primary mediastinal tumors. Part II. Tumors of the middle and posterior mediastinum. Chest 112:1344-1357
7. Kim HC, Han MH, Kim KH (2003) Primary thyroid lymphoma: CT findings. Eur J Radiol 46:233-9
8. Müller NL, Fraser RS, Colman NC, Paré PD (2001) Radiologic diagnosis of diseases of the chest. WB Saunders, Philadelphia
9. Rosado de Christenson ML, Templeton PA, Moran CA (1992) Mediastinal germ-cell tumors: radiologic and pathologic correlation. Radiographics 12:1013-1030
10. Long JA Jr, Doppman JL, Nienhuis AW (1980) Computed tomographic studies of extramedullary hematopoiesis. J Comput Assist Tomogr 4:67-70
11. Cole TJ, Henry DA, Jolles H, Proto AV (1995) Normal and abnormal vascular structures that simulate neoplasms on chest radiographs: clues to the diagnosis. Radiographics 15:867-891
12. Dillon EH, Camputaro C (1993) Partial anomalous pulmonary venous drainage of the left upper lobe vs. duplication of the superior vena cava: distinction based on CT findings. AJR Am J Roentgenol 160:375-379

Current Approaches to Assessing Chronic and Acute Airway Diseases

P.A. Grenier

Département de Radiologie, Hôpital Pitié-Salpêtrière, Université Pierre et Marie Curie, Paris, France

Introduction

Multidetector computed tomography (MDCT) using thin collimation during a single breath hold has become the best imaging technique for assessing airway diseases. Volumetric high-resolution data sets provide a precise morphologic evaluation of both proximal and distal airways. The term 'airway diseases' covers acute and chronic inflammatory disorders as well as the fibrotic sequelae involving proximal and/or distal airways. Large-airway diseases include tracheal disorders, bronchiectasis, and broncholithiasis. Small-airway diseases include all infectious or inflammatory diseases involving the bronchioles. MDCT can also play a role in assessing obstructive lung diseases, a group of diffuse conditions associated with chronic airflow obstruction that includes chronic obstructive pulmonary disease (COPD), asthma, and obliterative bronchiolitis.

Techniques

MDCT acquisition is done over both lungs at full suspended inspiration, using thin collimation (0.6-1.5 mm) without any contrast material. The axial images are reconstructed with overlapping and thin-slice thickness (0.8-1.5 mm). Complementary low-dose (120 kV, 20-40 mAs) MDCT acquisition at full continuous expiration is often recommended and particularly useful for assessing tracheobronchial collapsibility and expiratory air trapping.

The images are interpreted at the workstation. Sequential visualization of the overlapped thin axial images in cine-mode allows the bronchial divisions to be followed from the segmental origin, to the distal bronchial lumens, and down to the smallest bronchi that can be identified on thin-section images. Moving and swiveling through the volume to select the plane that best displays the distribution of airway abnormality are highly recommended. Multiplanar reformation of variable thicknesses created on the selecting planes may be completed by intensity projection techniques. Minimum intensity projection can be applied to visualize airway dilatation and cystic changes, as well as to facilitate assessment of the presence and extent of expiratory air trapping. Maximum intensity projection is used in the display of the mucoid impactions seen in dilated bronchi, or of small, centrilobular, nodular linear opacities ('tree-in-bud' sign) indicating infectious bronchiolitis.

Volume rendering techniques (CT bronchography) consist of segmentation of the lumen-wall interface of the airways. This approach has proven to be of particular interest in diagnosing mild changes in airway caliber and understanding complex tracheobronchial abnormalities.

Virtual bronchoscopy provides an internal rendering of the tracheobronchial inner surface. It is used to detect inner nodulation, indicative of granulomatous or tumoral lesions in proximal airways.

Tracheal Disorders

Multidetector CT in which helical volumetric CT acquisition is combined with thin collimation during a single breath hold provides an accurate assessment of proximal airways, allowing multiplanar reformations and 3D rendering of very high quality. Complementary CT acquisition at suspended or continuous expiration allows the assessment of tracheobronchial collapsibility and expiratory air trapping.

- *Post-traumatic strictures* of the trachea are usually secondary to damage from a cuffed endotracheal or tracheostomy tube or to external neck trauma. The lesions consist of granulation tissue and, later, by dense mucosal and submucosal fibrosis associated with the distortion of cartilage plates. The two principal sites of stenosis following intubation or a tracheostomy tube are at the stroma and at the level of the endotracheal or tracheostomy tube balloon. The size of the narrowing is usually well seen at CT. The narrowing is often concentric. Post-intubation stenosis extends for several centimeters and typically involves the trachea above the level of the thoracic inlet. Post-tracheostomy stenosis typically begins 1-1.5 cm distal of the inferior margin of the tracheostomy stoma and involves 1.5-2.5 cm of tracheal wall. Multiplanar reformations are particu-

larly helpful in defining accurately the site, length, and degree of stenosis. In select cases, the degree of stenosis may also be assessed by virtual bronchoscopy.

- A number of *infections*, acute but more often chronic, may affect the trachea and proximal bronchi, resulting in focal or diffuse airway disease. Subsequent fibrosis may lead to localized airway narrowing. The most common causes of infectious tracheobronchitis are bacterial tracheitis in immunocompromised patients, tuberculosis, rhinoscleroma (*Klebsiella rhinoscleromatis*), and necrotizing invasive aspergillosis. On CT, the extent of irregular and circumferential tracheobronchial narrowing is clearly demonstrated, and in some patients an accompanying mediastinitis (opacification of the mediastinal fat) is evident. In active disease, the narrowed trachea and, frequently, one or the other main bronchi have an irregularly thickened wall. In the fibrotic or healed phase, the trachea is narrowed but has a smooth wall of normal thickness.

- In *Wegener's granulomatosis*, involvement of the large airways is a common manifestation. Inflammatory lesions may be present with or without subglottic or bronchial stenosis, ulcerations, and pseudotumors. Radiologic manifestations include thickening of the subglottic region and proximal trachea, which has a smooth symmetric or asymmetric narrowing over variable length. Stenosis may also be seen on any main lobar or segmental bronchus. Nodular or polypoid lesions may be present on the inner contour of the airway lumen.

- *Relapsing polychondritis* is a rare systemic disease of autoimmune pathogenesis that affects cartilage at various sites, including the ears, nose, joints, and tracheobronchial tree. Histologically, the acute inflammatory infiltrate present in the cartilages and perichondrial tissue induces progressive dissolution and fragmentation of the cartilage, followed by fibrosis. Symmetric subglottic stenosis is the most frequent manifestation in the chest. As the disease progresses, the distal trachea and bronchi may be involved. CT scans show smooth thickening of the airway wall associated with more or less diffuse narrowing. In the early stage, the posterior wall of the trachea is spared, but in advanced disease circumferential wall thickening occurs. The trachea may become flaccid with considerable collapse at expiration. Gross destruction of the cartilaginous rings with fibrosis may cause stenosis.

- Deposition of amyloid in the trachea and bronchi may be seen in association with systemic *amyloidosis* or as an isolated manifestation. The amyloid deposits form either multifocal or diffuse submucosal plaques or masses. The overlying mucosa is usually intact. Dystrophic calcification or ossification is frequently present. CT scans show focal or, more commonly, diffuse thickening of the airway wall and narrowing of the lumen. Calcification may also be present. Narrowing of the proximal bronchi can lead to distal atelectasis, bronchiectasis, or both, or obstructive pneumonia.

- *Tracheobronchopathia osteochondroplastica* is a rare disorder characterized by the presence of multiple cartilaginous nodules and bony submucosal nodules on the inner surface of the trachea and proximal airways. Men are more frequently involved than women and most patients are >50 years of age. Histologically, the nodules contain heterotopic bone, cartilage, and calcified acellular protein matrix. The overlying bronchial mucosa is normal and, because it contains no cartilage, the posterior wall of the trachea is spared. The chest radiograph may be normal or may demonstrate lobar collapse or infective consolidation. If the tracheal air column is clearly seen, multiple sessile nodules that project into the tracheal lumen and extending over a long segment of the trachea can be appreciated. On CT, tracheal cartilages are thickened and show irregular calcifications. The nodules may protrude from the anterior and lateral walls into the lumen; they usually show foci of calcification.

- *Saber-sheath trachea* is characterized by a diffuse narrowing involving the intrathoracic trachea. This entity is almost always associated with COPD. The pathogenesis of the lesion is obscure, but is probably an acquired deformity related to the abnormal pattern and magnitude of the intrathoracic pressure changes in COPD. On radiographs and CT, the condition is easily recognized by noting that the internal side-to-side diameter of the trachea is decreased to half or less of the corresponding sagittal diameter. On the postero-anterior radiograph and CT multiplanar reformations, the narrowing usually affects the whole intrathoracic trachea, with an abrupt return to normal caliber at the thoracic inlet. The trachea usually shows a smooth inner margin but occasionally has a nodular contour. Calcification of the tracheal cartilage is frequently evident.

- *Tracheobronchomegaly (Mounier-Kuhn disease)* refers to marked dilatation of the trachea and mainstem bronchi. It is often associated with tracheal diverticulosis, recurrent lower respiratory tract infection, and bronchiectasis. Atrophy affects the elastic and muscular elements of both the cartilaginous and membranous parts of the trachea. The diagnosis is based on radiologic findings. The immediately subglottic trachea has a normal diameter, but it expands as it passes to the carina, and this dilatation often continuous into the major bronchi. Prolapses of atrophic mucosa between cartilage rings give the trachea a characteristically corrugated outline on plain radiograph. The corrugations may become exaggerated to form sacculations or diverticula. On CT, a tracheal diameter of >3 cm (measured 2 cm above the aortic arch) and a diameter of 2.4 and 2.3 cm for the right and left bronchi, respectively, are diagnostic criteria. Additional findings include tracheal scalloping or diverticula (especially along the posterior membranous tracheal wall).

- *Tracheobronchomalacia*, resulting from weakened tracheal cartilages, may be seen in association with a

number of disorders, including tracheobronchomegaly, COPD, diffuse tracheal inflammation such as relapsing polychondritis, and following trauma. On the radiographs, a reduction by almost 300% of the sagittal diameter at expiration is an excellent diagnostic indicator. At CT, the diagnosis is based on a narrowing of the diameter of the lumen by >50% on expiration compared with on inspiration. The increase in compliance is due to the loss of integrity of the wall's structural components and is particularly associated with damaged or destroyed cartilages. The coronal diameter of the trachea becomes significantly larger than the sagittal one, producing a lunate configuration to the trachea. The flaccidity of the trachea or bronchi is usually most apparent during coughing or forced expiration.

Dynamic expiratory multislice CT offers a feasible alternative to bronchoscopy in patients with suspected tracheobronchomalacia. Dynamic expiratory CT may show complete collapse or collapse of >75% of the airway lumen. Involvement of the central tracheobronchial tree may be diffuse or focal. The airway reduction can appear as oval- or crescent-shaped. The latter form is due to the bowing of posterior membranous trachea.

Tracheobronchial Fistula and Dehiscence

Multidetector MDCT with thin collimation is the most accurate technique to identify peripheral bronchopleural fistula, which is most commonly caused by necrotizing pneumonia or is secondary to traumatic lesions. Nodobronchial and nodobronchesophageal fistulas due to *Mycobacterium tuberculosis* infection are depicted either by the presence of gas in cavitated hila or by mediastinal lymphadenopathy adjacent to the airways. Tracheal diverticula and tracheobronchoesophageal fistula may also be diagnosed, even in adults. Malignant neoplasia, particularly esophageal, is the most common cause of tracheoesophageal fistula in adults. Occasionally, congenital fistulas are first manifested in adulthood. Infection and trauma are the most frequent non-malignant causes. MDCT has a high degree of sensitivity and specificity for depicting bronchial dehiscence occurring after lung transplantation. Bronchial dehiscence is seen as a bronchial wall defect associated with extraluminal air collections.

Bronchiectasis

Bronchiectasis is a chronic condition characterized by local, irreversible dilatation of the bronchi and is usually associated with inflammation. In spite of its decreased prevalence in developed countries, bronchiectasis remains an important cause of hemoptysis and chronic sputum production. Although the causes of bronchiectasis are numerous (Table 1), there are three mechanisms by which the dilatation can develop: bronchial obstruction, bronchial wall

Table 1. Mechanisms and causes of bronchiectasis

Bronchial obstruction
– Carcinoma
– Fibrous stricture (e.g., tuberculosis)
– Broncholithiasis
– Extensive compression (lymphadenopathy, neoplasm)

Parenchymal fibrosis (traction bronchiectasis)
– Tuberculosis
– Sarcoidosis
– Idiopathic pulmonary fibrosis

Bronchial wall injury
– Cystic fibrosis
– Childhood viral and bacterial infection
– Immunodeficiency disorders
– Dyskinetic cilia syndrome
– Allergic bronchopulmonary aspergillosis
– Lung and bone marrow transplantation
– Panbronchiolitis
– Systemic disorders (rheumatoid arthritis, Sjögren's syndrome, inflammatory bowel disease, yellow nail syndrome)
– Alpha-1-antitrypsin syndrome

Congenital
– Williams-Campbell syndrome

damage, and parenchymal fibrosis. In the first two mechanisms, the common factor is the combination of mucus plugging and bacterial colonization. Cytokines and enzymes released by inflammatory cells together with toxins released by the bacteria result in a vicious cycle of increasing airway wall damage, mucous retention, and bacterial proliferation. In the case of parenchymal fibrosis, dilatation of the bronchi is caused by maturation and retraction of fibrous tissue located in the parenchyma adjacent to an airway (traction bronchiectasis).

Pathologically, bronchiectasis has been classified into three subtypes, reflecting increasing severity of disease: (1) cylindrical, characterized by relatively uniform airway dilatation; (2) varicose, characterized by non-uniform and somewhat serpiginous dilatation; and (3) cystic. As the extent and degree of airway dilatation increase, the lung parenchyma distal to the affected airway shows increasing collapse of the fibrosis.

The CT findings of bronchial dilatations include lack of tapering of bronchial lumina (the cardinal sign of bronchiectasis), internal diameter bronchi greater than that of the adjacent pulmonary artery (signet-ring sign), visualization of bronchi within 1 cm of the costal pleura or abutting the mediastinal pleura, and mucus-filled dilated bronchi. In varicose bronchiectasis, the bronchial lumen assumes a beaded configuration. The string of cysts in cystic bronchiectasis can be seen by sectioning the irregularly dilated bronchi along their lengths. The cysts may also form a cluster, which is due to the presence of multiple dilated bronchi lying adjacent to each other. Clusters of cysts are most frequently seen in an atelectatic lobe. Air-fluid levels, resulting from retained secretion, may be present in the dependent portion of the dilated bronchi. The accumulated secretion within bronchiectatic airways is generally

easily recognizable by its lobulated glove-finger shape, or as a V- or Y-shaped density. CT may show a completely collapsed lobe containing bronchiectatic airways. A subtle degree of volume loss may be present in the lobes in relatively early disease.

Associated CT findings of bronchiolitis are seen in about 70% of patients with bronchiectasis. These abnormalities are especially common in patients with severe bronchiectasis and can even precede the development of bronchiectasis. The obstructive defect found at pulmonary tests in patients with bronchiectasis does not appear to be related to the degree of collapse of large airways, as seen on expiratory CT, or the extent of mucous plugging of the airway, but rather to obstructive involvement of the peripheral airways (obliterative bronchiolitis). The extent of CT evidence of small-airway disease (decreased lung attenuation, expiratory air trapping) commonly present in patients with bronchiectasis has proven to be the major determinant of airflow obstruction.

At the present time, MDCT with thin collimation is the most highly recommended technique to assess the presence and extent of bronchiectasis. The reliability of CT for distinguishing among the causes of bronchiectasis is somewhat controversial. An underlying cause for bronchiectasis is found in fewer than half of patients, and CT features alone do not usually allow a confident distinction between idiopathic bronchiectasis and bronchiectasis with a known cause. A bilateral upper lobe distribution is most commonly seen in patients with cystic fibrosis and allergic bronchopulmonary aspergillosis, a unilateral upper lobe distribution in patients with tuberculosis, and a lower lobe distribution in patients after childhood viral infections. However, CT remains of little value in diagnosing specific etiologies of bronchiectasis.

Broncholithiasis

Broncholithiasis is a condition in which peribronchial calcified nodal disease erodes into or distorts an adjacent bronchus. The underlying abnormality is usually granulomatous lymphadenitis caused by *M. tuberculosis* or fungi such as *Histoplasma capsulatum*. A few cases associated with silicosis have been reported. Calcified material in a bronchial lumen or bronchial distortion by peribronchial disease results in airway obstruction. This leads to collapse, obstructive pneumonitis, mucoid impaction, or bronchiectasis. Symptoms include cough, hemoptysis, recurrent episodes of fever, and purulent sputum. Broncholithiasis is more common in the right lobe, with obstructive changes particularly affecting the right middle lobe.

At CT, broncholithiasis is recognized by the presence of a calcified endobronchial or peribronchial lymph node, associated with bronchopulmonary complications due to obstruction (including atelectasis, pneumonia, bronchiectasis, and air trapping), in the absence of an associated soft-tissue mass.

Small-Airway Diseases

Although the visualization of normal bronchioles is impaired by the spatial resolution limits of thin-section CT, these airways may become directly visible when inflammation of the bronchiolar wall and accompanying exudate develop. While bronchiolar changes may also be too small to be visible directly, they can cause indirect signs that suggest small-airways involvement. Obstruction of the bronchioles may induce regional underventilation, leading to reflex vasoconstriction, and expiratory air trapping, both of which can be depicted on CT images. Four different CT patterns reflect small-airway pathology.

- *Tree-in-bud sign* consists of focal or multifocal areas of small centrilobular nodular and branching linear opacities. It reflects abnormal bronchiolar wall thickening and dilatation of the bronchiolar lumen, which is filled with mucus or pus, often associated with peribronchiolar inflammation. The branching pattern of dilated bronchioles and peribronchiolar inflammation give the appearance of a budding tree. Some variants have the same diagnostic value. They include clusters of centrilobular nodules linked together by fine linear opacities, or branching tubular or Y-shaped opacities without nodules. In every case, the key feature is the centrilobular location of these opacities, at a distance of at least 3 mm from the pleura. The tree-in-bud sign is characteristic of acute or chronic infectious bronchiolitis. It can also be seen in diffuse panbronchiolitis and diffuse aspiration bronchiolitis.
- *Poorly defined centrilobular nodules* usually reflect the presence of peribronchiolar inflammation in the absence of airway filling with secretion. When the finding is patchy in distribution, the list of entities that are potentially responsible is long. When the distribution of nodules is diffuse and homogeneous in distribution, the pattern is suggestive of bronchiolar disease or vascular entities. Bronchiolar diseases include respiratory bronchiolitis, bronchiolitis associated with hypersensitivity pneumonitis, and follicular bronchiolitis.
- *Areas of decreased lung attenuation* associated with *vessels of decreased caliber*, such as observed in bronchiolar disease, reflect bronchiolar obstruction, resulting in a decrease of perfusion. In acute bronchiolar obstruction, the decreased perfusion represents a physiologic reflex of hypoxic vasoconstriction, but in the chronic state there is vascular remodeling and the reduced caliber of the vessels becomes irreversible. Although the vessels within areas of decreased attenuation on thin-section CT may be of markedly reduced caliber, they are not distorted, as is the case in emphysema. The lung areas of decreased attenuation related to decreased perfusion can be patchy or widespread in distribution. They are

poorly defined or sharply demarcated, giving a geographical outline that represents a collection of affected secondary pulmonary lobules. Redistribution of blood flow to the normally ventilated areas causes increased attenuation of lung parenchyma in these areas. The combination of a patchwork of abnormal areas of low attenuation and normal lung or less-diseased areas, appearing normal in attenuation or hyperattenuated, yields mosaic-type attenuation. Because the vessels running in the abnormal hypoattenuated areas are reduced in caliber, whereas those running in normal areas are increased in size, the mosaic appearance is called 'mosaic perfusion'. This pattern is not always the result of bronchiolar disease but can also be caused by direct vascular obstruction. When it is caused by bronchiolar obstruction, mosaic perfusion is accentuated on expiratory CT because the low-attenuation areas show air trapping. Since the air is trapped, the cross-sectional area of the affected parts of the lung do not decrease in size on expiratory CT. Usually, the regional inhomogeneity of the lung density seen at end-inspiration on thin-section CT scans is accentuated on sections obtained at end-expiration or during expiration, as high-attenuation areas increase in density while low-attenuation areas remain unchanged. In case of more global involvement of the small airways, the lack of regional homogeneity of the lung attenuation is difficult to perceive on inspiratory scans and, as a result, mosaic perfusion becomes visible only on expiratory scans. In patients with particularly severe and widespread involvement of the small airways, the patchy distribution of hypoattenuation and the mosaic pattern are lost. Inspiratory scans yield an apparent uniformity of decreased attenuation in the lungs, while scans taken at end-expiration may appear unremarkable. In such patients, the most striking features on CT are the paucity of pulmonary vessels and the lack of change in the cross-sectional areas of the lung at comparable levels on inspiratory and expiratory scans.

A mosaic perfusion pattern associated with expiratory air trapping is seen on thin-section CT scans in patients with obliterative bronchiolitis regardless of etiology, bronchiolitis associated with hypersensitivity pneumonitis, and asthma.

Obliterative bronchiolitis, characterized by submucosal circumferential fibrosis along the central axis of terminal bronchioles, is the result of a variety of causes or, rarely, is idiopathic (Table 2). Bronchial wall thickening and bronchiectasis, both central and peripheral, are also commonly present.

- *Lobular areas of air trapping* may appear on expiratory CT scans whereas there is no attenuation abnormality on inspiratory CT scans. This phenomenon reflects the presence of air trapping in areas where partial airway obstruction is present. These areas are commonly well-demarcated, reflecting the geometry

Table 2. Causes of and association with obliterative (constrictive) bronchiolitis

Post-infection
- Childhood viral infection (adenovirus, respiratory syncytial virus, influenza, parainfluenza)
- Adulthood and childhood (*Mycoplasma pneumoniae*, *Pneumocystis carinii* in AIDS patients, endobronchial spread of tuberculosis, bacterial bronchiolar infection)

Post-inhalation (toxic fumes and gases)
- Nitrogen dioxide (silo filler's disease), sulfur dioxide, ammonia, chlorine, phosgene
- Hot gases

Gastric aspiration
- Diffuse aspiration bronchiolitis (chronic occult aspiration in the elderly, patients with dysphagia)

Connective-tissue disorders
- Rheumatoid arthritis
- Sjögren's syndrome

Allograft recipients
- Bone marrow transplant
- Heart-lung or lung transplant

Drugs
- Penicillamine
- Lomustine

Ulcerative colitis

Other conditions
- Bronchiectasis
- Chronic bronchitis
- Cystic fibrosis
- Hypersensitivity pneumonitis
- Sarcoidosis
- Microcarcinoid tumorlets (neuroendocrine cell hyperplasia)
- *Sauropus androgynus* ingestion

Idiopathic

of individual or joined lobules. This pattern is frequently observed in smokers and in patients with asthma, obliterative bronchiolitis, bronchiolitis associated with hypersensitivity pneumonitis, or sarcoidosis.

Chronic Obstructive Pulmonary Disease and Asthma

In patients with COPD, thickening of the bronchial wall is often present. Thin-collimation MDCT acquisition and multiplanar reformations associated with minimum intensity projections show air-filled outpouchings or diverticula in addition to the lumen of the main lobar or segmental bronchi. These abnormalities reflect the enlargement of mucous glands and are related to the loss of subepithelial connective tissue and to the herniation of airway mucosa between small muscle bundles. Due to the deficit of bronchial cartilage, the lumen of segmental and subsegmental bronchi may show exaggerated collapse on expiratory CT scans, particularly in the lower lobes.

In asthmatic patients, the main CT abnormalities include bronchial wall thickening, bronchial dilatation, mosaic perfusion, and expiratory air trapping.

Thickening of the bronchial wall, as measured at CT, has proved to be prominent in patients with more severe asthma. It is correlated with the duration and severity of disease and the degree of airflow obstruction.

The mosaic perfusion pattern is frequent in patients with moderate persistent asthma. In severe persistent asthma, diffuse decreased lung attenuation and expiratory air trapping make the pattern difficult to distinguish from that of obliterative bronchiolitis.

Expiratory CT can show abnormal air trapping even in patients who have normal inspiratory scans and before lung function deteriorates. The extent of such air trapping correlates with the severity of the asthma. This reflects the luminal obstruction of the airways and is potentially, but not always, reversible. In patients with persistent asthma, the absence of a change in air-trapping scores after inhalation of bronchodilator suggests that the air trapping reflects permanent changes resulting from small-airway remodeling.

Suggested Reading

Boiselle PM, Lee KS, Lin S, Raptopoulos V (2006) Cine CT during coughing for assessment of tracheomalacia: preliminary experience with 64-MDCT. AJR Am J Roentgenol 187:175-177

Dodd JD, Souza CA, Muller NL (2006) Conventional high-resolution CT versus helical high-resolution MDCT in the detection of bronchiectasis. AJR Am J Roentgenol 187:414-420

Grenier PA, Beigelman-Aubry C, Fetita C et al (2002) New frontiers in CT imaging of airway disease. Eur Radiol 12:1022-1044

Hansell DM, Armstrong P, Lynch DA et al (2005) Imaging of Diseases of the Chest, 4th edn. Elsevier Mosby, Philadelphia

Kwong JS, Muller NL, Miller RR (1992) Diseases of the trachea and main-stem bronchi: correlation of CT with pathologic findings. Radiographics 12:645-657

Müller NL, Fraser RS, Lee KS, Johkoh T (2003) Diseases of the Lung. Radiologic and Pathologic Correlations. Lippincott Williams & Wilkins, Philadelphia

Naidich DP, Webb WR, Grenier PA et al (2005) Imaging of the Airways. Functional and Radiological Correlations. Lippincott Williams & Wilkins, Philadelphia

Current Approaches to Imaging Acute and Chronic Airway Disease

M.L. Storto

Department of Radiology, University of Chieti, Chieti, Italy

Introduction

The spectrum of diseases that affect the airways is immense, ranging from disorders of the trachea to diseases of the respiratory bronchioles. Moreover, the investigation of airway diseases is challenging to both physiologists and physicians, especially when dealing with small-airway diseases.

In recent years, the introduction of computed tomography (CT) has revolutionized our understanding of airway diseases, since it allows noninvasive visualization of changes involving both large and medium-sized bronchi together with insight into airway physiology. Furthermore, in small airways, high-resolution CT scanning can demonstrate morphological changes that are associated with dysfunctions too subtle to be identified by lung-function testing alone. By combining helical volumetric acquisition and thin-slice thickness of the entire thorax within a single breath-hold, multidetector-row CT (MDCT) allows a thorough assessment of both large and small airways. Here, MDCT protocols for imaging airways will be reviewed, together with a description of their clinical applications to most common airway diseases, including bronchial stenoses, bronchiectasis, and small-airway disease.

Computed Tomography Scanning

Technical Parameters

The use of narrow collimations (≤ 1.25 mm) is recommended when imaging airways with a MDCT scanner, in order to obtain high quality 2D and 3D reconstructions. State-of-the-art scanners allow imaging of the entire thorax within 5-15 s despite the use of very thin collimations. Such speed is of particular benefit in patients with airway disorders who do not tolerate longer breath-hold periods and in young children who are often unable to understand breathing instructions.

Overlapping reconstruction intervals of about 50% are also recommended to provide the highest morphological detail and to enhance the quality of reformatted images; however, this parameter is less important when very thin collimations are used. A high spatial frequency algorithm can be used to better demonstrate the sharp airway interface, although on occasion this may introduce excessive noise on subsequent 3D images. Thus, for most cases a soft-tissue reconstruction kernel is preferred.

A well-known advantage of MDCT is the ability to change the slice thickness before the raw data are erased. This way, high-resolution images, 1-mm thick and 10 mm apart, and resembling those from a traditional sequential HRCT study, can be obtained from the apices to the lung bases.

Most airway imaging can be done as a non-contrast study, although i.v. contrast material should be considered when the relationship of an airway abnormality to mediastinal vessels has to be assessed (e.g., congenital rings and slings) or when an endobronchial mass is present.

As always, radiation dose is a consideration, since MDCT results in a higher dose than required by single-row detector CT (SDCT), particularly if narrow collimations are used. However, because of the high natural contrast between air and soft-tissue structures, significant dose reduction can be achieved in airway studies without impairing image quality. As a matter of fact, using an animal model, Phillip Boiselle recently demonstrated that a six-fold dose reduction (from 240 to 40 mA) is possible while preserving the quality of 2D and 3D images. The use of 40 mA also resulted in a dose that was fourfold lower than the standard dose of SDCT. Limiting the length of volumetric acquisition to the area of known or suspected abnormality also significantly reduces the dose of radiation.

Expiratory CT

Expiratory CT scans can be useful in the evaluation of patients with a variety of obstructive lung diseases, including patients with tracheobronchomalacia, in whom the degree of abnormal airway collapse has to be assessed, and patients with small-airway disease, for evaluation of the presence and extent of air trapping. Moreover, expiratory CT scans may be of great value in the follow-up of patients at risk of developing an obstructive disease, such as lung transplant recipients. In

some cases, expiratory CT scans are able to demonstrate air trapping in the absence of abnormalities on inspiratory scans. For this reason, Webb recommends the routine use of expiratory scans in a patient's initial high-resolution CT evaluation.

Air trapping is diagnosed when an area of decreased attenuation on inspiratory scans remains lucent and shows little change in volume on expiratory scans. Abnormal air trapping is a feature of small-airway disease, but it may also be seen beyond any bronchial obstruction, or in patients with asthma, chronic obstructive pulmonary disease (COPD), emphysema, and sarcoidosis.

Expiratory CT scans are usually done during suspended respiration after a forced exhalation (post-expiratory CT scans). Three to five scans at predefined levels or scans at 2- to 4-cm intervals have been proposed by different authors. Each of the post-expiratory scans is then compared with the inspiratory scan that most closely duplicates its level in order to detect air trapping. Anatomic landmarks, such as pulmonary vessels, bronchi, and fissures, are used to localize corresponding levels.

Expiratory imaging can also be done during continuous expiration (dynamic expiratory CT). In general, with this technique, a series of scans is obtained at a single level during a 6-s period, as the patient inspires and then forcefully exhales. Patients are instructed to breathe in deeply and then breathe out as rapidly as possible. Images are reconstructed using a high spatial frequency algorithm. Although one or more of the images obtained during the rapid phases of expiration will show motion artifacts, images near full expiration contain few artifacts and thus allow optimal assessment of lung attenuation and air trapping. To decrease radiation exposure, a low-dose technique (40 mA) is recommended for the dynamic exhalation acquisition. According to some authors, the presence and extent of air trapping are better demonstrated on dynamic scans than on post-expiratory ones. A possible reason for this improvement is a small increase in the degree of expiration (and therefore a greater increase in lung attenuation) during continuous expiratory CT, which leads to better detection of air trapping. Moreover, patients may have greater difficulty in maintaining their breath after a complete exhalation than in performing an active exhalation.

Finally, expiratory imaging can be carried out using MDCT and 2D or 3D reconstructions, again during exhalation. Volumetric imaging ensures that the entirety of the central airways is imaged. In this case, the beginning of the volumetric acquisition is coordinated with the onset of the patient's expiratory effort. The use of paired inspiratory-dynamic expiratory MDCT has been proposed in patients with tracheobronchomalacia, before therapeutic procedures such as stent placement and tracheoplasty. In addition, MDCT during inspiration and expiration can also be used for the global assessment of lung attenuation, with the advantage that it also provides anatomic detail.

Image Post-processing

Reformatted 2D and 3D images are frequently used after volumetric CT of the airways, since they can help overcome the limitations of axial images by providing a more easily comprehensible display of the tracheobronchial tree. For example, these images have been shown to improve the detection of airway stenoses, the assessment of craniocaudal extent of disease, and the evaluation of complex, congenital airway abnormalities. Additional benefits include enhanced diagnostic confidence of interpretation and therapeutic planning before surgery or interventional procedures. Moreover, by reducing the large CT dataset to a relatively small number of images, reformatting facilitates communication between the radiologist and referring physician.

As already noted, 2D and 3D images do not create new information; instead, they represent an alternative presentation of CT data that is often more visually accessible and more anatomically meaningful than axial images. Nonetheless, axial images allow a more comprehensive review of all thoracic structures and should always serve as a point of reference for optimal interpretation of reformatted images.

The most useful and frequently used post-processing techniques for airway display include multiplanar reformations and volume rendering.

Multiplanar reformations allow better evaluation of the craniocaudal extent of vertically oriented diseases than allowed by axial scans. They are of particular value in the detection and evaluation of mild or focal tracheobronchial stenosis (Fig. 1), the assessment of congenital

Fig. 1. A 67-year-old man with tracheal stenosis after tracheal intubation. The coronal reformatted image clearly shows the location and longitudinal extent of stenosis

Fig. 2. Patient status following right pneumonectomy with anastomosis of the left bronchus to the trachea; a stent has been placed in the distal trachea. The coronal oblique multiplanar image shows air leakage at the distal end of the stent (*arrow*), indicative of anastomotic dehiscence

Fig. 3. Multidetector-row computed tomography (MDCT) of the central airways in a 56-year-old patient who had undergone sleeve lobectomy of the right upper lobe. Three-dimensional volume rendering (virtual broncography) shows a focal anastomotic stenosis

abnormalities of the tracheobronchial tree, and the diagnosis of bronchial dehiscence following lung transplantation or surgery (Fig. 2). Underestimation of a stenosis, however, may occur if the reformation plane is not adequately chosen. This can be avoided by simultaneous reading of the native cross-sectional images and the selection of a reformation plane from the 3D reconstructed image of the airways.

Volume-rendering technique uses a percentage-based probabilistic classification to assign a continuous range of values to a voxel, allowing the percentage of individual tissue types to be reflected in the final image while 3D spatial relationships and high fidelity to the original data acquisition are maintained. In this way, volume rendering is less susceptible to volume-averaging artifacts, which are a particular problem in airway imaging because of the air-soft tissue interface and the small caliber of peripheral branches. When applied to central airways, volume rendering allows reconstruction of 3D images of the airways visualized in a semi-transparent mode, similar to conventional bronchograms (virtual bronchography) (Fig. 3). Virtual bronchography has proved to be useful for diagnosing mild changes in airway caliber and for understanding complex tracheobronchial abnormalities.

Virtual bronchoscopy provides an internal rendering of the tracheobronchial walls and lumen, thus simulating an endoscopist's view of the internal surface of the airways. Powerful computers permit real-time rendering, up to 15-25 images/s, and allow a 'virtual survey' within the airways. Virtual endoscopy is applicable to the central airways, including the subsegmental bronchi, and allows accurate reproduction of major endoluminal abnormalities, with an excellent correlation with fiber-optic bronchoscopy results regarding the location, severity, and shape of airway narrowing (Fig. 4). Virtual endoscopy also allows assessment of the bronchial tree beyond an obstructive lesion and visualization of peribronchial structures through bronchial walls. This helps in planning transbronchial, transtracheal, or transcarinal needle punctures. Despite these advantages, virtual endoscopy remains very sensitive to partial volume averaging effects and motion artifacts; moreover, discontinuities in the walls of airways can be artifactually created. In addition, virtual endoscopy is unable to identify the causes of bronchial obstruction; mild stenosis, submucosal infiltration, and superficial spreading tumors are not identified.

Minimum intensity projection (minIP) imaging is a simple form of volume rendering in which pixels encode the minimum voxel value encountered by each ray. Airways are visualized because air contained within the tracheobronchial tree has a lower attenuation than the surrounding pulmonary parenchyma. Numerous drawbacks have limited the use of minIP in the assessment of airway disease. For example, minor partial volume averaging leads to underestimation of airway caliber; this effect increases with increasing effective slice thickness, decreasing bronchial diameter, and horizontal course of a bronchus. Sometimes, high-grade stenoses can be imaged as pseudo-occlusions, whereas the intraluminal growth of eccentric tumors is generally underestimated and may even be completely missed. Intraluminal structures of higher den-

Fig. 4a, b. A 52-year-old patient with bronchogenic carcinoma. Both the axial image (**a**) and virtual bronchoscopy (**b**) show tumor extending within the lumen of the bronchus intermedius, which is clearly reduced in caliber

Fig. 5a, b. Endobronchial spread of tuberculosis. The coronal MIP images at anterior (**a**) and posterior (**b**) levels show multiple foci of centrilobular nodules and branching linear opacities ('tree-in-bud' sign). Consolidation is also seen in the right upper lobe and superior segment of the left lower lobe

sity, such as stents, are not displayed. Other air-containing structures, such as the esophagus, may simulate tracheal fistulas if all angles of view are not carefully analyzed.

In *maximum intensity projection (MIP)*, pixels encode the maximum voxel value encountered by each ray. This technique highlights high-density structures and is commonly used in CT angiography; however, it can also be applied to volumetric CT of airways for a better understanding of centrilobular opacities and to assess the presence of 'tree-in-bud' sign (Fig. 5).

Clinical Applications

Tracheobronchial Stenosis

The usefulness of volumetric CT acquisition in assessing the central airways and trachea has been investigated in several reports.

Airway stenoses may be etiologically classified as those extrinsic to the tracheobronchial wall and those that are intrinsic. Primary tracheal tumors are uncommon, whereas the most common referral for airway-

stenosis evaluation is as a result of invasion of an extrinsic bronchogenic or esophageal carcinoma or their adenopathy. Tracheal or bronchial stenoses may also be the result of inflammatory diseases or fibrosis after surgery, endoscopic maneuvers, and radiation therapy. In these cases, the main clinical questions asked include the site and length of the stenosis, its degree and distance from the carina or the vocal cord, and the caliber of normal trachea or bronchus above the stenotic segment. Whether the lung parenchyma beyond the stenosis is salvageable and will reinflate after therapy is also an important determination. Once other criteria have been fulfilled, the ability of imaging to depict the central extent of tumor spread along the airway may be the decision point between resectable and non-resectable disease. Volumetric CT with coronal, sagittal, and 3D images have been found to be extremely helpful in assessing major airways and addressing all these issues. Imaging is also important in the follow-up of patients undergoing thoracic surgery or endoscopic procedures, in order to search for complications such as recurrence of stenosis and stent displacement.

In patients with diffuse airway disease or multiple stenotic segments, MDCT can be of value in the detection of additional areas of stricture beyond a stenosis that is not traversable by the bronchoscope.

Analysis of the shape, attenuation, and distribution of disease on CT images can help in determining the cause of a bronchial stenosis. For example, a fatty density within an endobronchial mass is almost always indicative of bronchial lipoma or hamartoma. Broncholithiasis is characterized by calcified lymph nodes in a peribronchial location associated with distal atelectasis or pneumonia.

Bronchiectasis

Sequential high-resolution CT is accepted as a reliable method for imaging bronchiectasis; however, it has some limitations in that the gaps between CT slices can result in focal areas of bronchiectasis being overlooked within these 'skip' regions. In addition, depiction of the bronchi along the long axis is limited in axial imaging, which may prevent recognition of slight bronchial dilatation in mild cylindrical bronchiectasis. As a matter of fact, the most reliable sign of cylindrical bronchiectasis, the lack of tapering of the bronchial lumen, is sometime difficult to perceive on successive CT scans. Volumetric CT can overcome these difficulties with its ability to scan the whole thorax in a single breath-hold and to perform multiplanar image reconstruction. Not only the identification of bronchiectasis is improved with volumetric CT but also interobserver agreement for the presence and extent of bronchiectasis is better with helical CT than with sequential thin-section CT scans. For all these reasons,

some authors have proposed MDCT with thin collimation and a low-dose protocol as the routine examination for diagnosis and assessment of bronchiectasis.

Small-Airway Disease

High-resolution CT still represents the most reliable imaging technique to assess patients with diseases of the small airways, and MDCT with 3D images also has its place. For example, both the presence and distribution of centrilobular nodules and the 'tree-in-bud' sign can be better appreciated on MIP images than on thin-section CT scans (Fig. 5); this is particularly true in those patients showing only faint and few centrilobular nodules. In the same way, MDCT followed by minIP reconstructions may be of help in assessing the extent of air trapping in patients with constrictive bronchiolitis.

In summary, MDCT provides high-quality volume imaging that is effective in the assessment of the airways and lung parenchyma. It offers excellent quality multiplanar and 3D images. MDCT also allows simultaneous reconstruction of thick- and thin-slice images from a single set of raw data, permitting comprehensive assessment of the lungs and mediastinum without the need for multiple patient exposures. Nevertheless, further clinical studies are required to elucidate the importance of high-resolution volume imaging in the assessment of patients with suspected airways disease or infiltrative lung diseases. Although the technique has several advantages, including very fast scanning times allowing high throughput, there are certain disadvantages, including an increased radiation dose and a large number of images to interpret.

Suggested Reading

Beigelman-Aubry C, Hill C, Guibal A et al (2005) Multi-detector row CT and prostprocessing techniques in the assessment of diffuse lung disease. Radiographics 25:1639-1652

Boiselle PM (2003) Multislice helical CT of the central airways. Radiol Clin North Am 41:561-574

Chooi WK, Morcos SK (2004) High resolution volume imaging of airways and lung parenchyma with multislice CT. Br J Radiol 77:S98-S105

Grenier PA, Beigelman-Aubry C, Fetita C et al (2002) New frontiers in CT imaging of airway disease. Eur Radiol 12:1022-1044

Grenier PA, Beigelman-Aubry C, Fetita C, Martin-Bouyer Y (2003) Multidetector-row CT of the airways. Semin Roentgenol 38:146-157

Lawler LP, Corl FM, Haponik EF, Fishman EK (2002) Multidetector row computed tomography and 3-dimensional volume rendering for adult airway imaging. Curr Probl Diagn Radiol 31:115-133

Takahashi M, Murata K, Takazakura R et al (2000) Bronchiolar disease: spectrum and radiological findings. Eur J Radiol 35:15-29

Webb WR, Müller NL, Naidich DP (2001) High-resolution CT of the Lung, 3rd edn. Lippincott, William & Wilkins, Philadelphia

Volumetric Computed Tomography of the Tracheobronchial Tree

G. Papaioannou, C. Young, C. Owens

Department of Radiology, Great Ormond Street Hospital for Children, NHS Trust, London, UK

Introduction

Imaging of the airways with 2D and 3D reconstructions has significantly improved with the advent of multidetector-row computed tomography (MDCT) scanners. These scanners allow for volumetric acquisition of isotropic datasets. As a result, the scanning time is significantly reduced, and large anatomic regions are covered within seconds with optimal intravenous contrast material enhancement. MDCT scanners have significantly improved the image quality by dramatically reducing artifacts resulting from partial volume averaging and motion. Additionally, fast and user-friendly scanner workstations allow for post-processing of impressive multiplanar 2D and 3D reconstructions, which are desirable to clinicians for comprehensive pre-surgical planning purposes [1, 2].

MDCT Applications for Imaging of the Pediatric Airway

The introduction of 16-slice MDCT with its wide spectrum of applications has transformed the approach to imaging the airways and thoracic vessels of infants and children. With MDCT, scanning techniques may vary when different collimations are selected: the narrowest collimation is employed when partial volume effects need to be minimal and 3D post-processing images of optimal quality, e.g., in computed tomographic angiography (CTA) and cardiac CT [3].

Preparation of the Child: Is Sedation Always Needed?

Due to the faster scanning times of MDCT scanners, routine sedation of pediatric patients is no longer required. In the neonate, recent feeding usually provides tranquility, while children over 3 years of age tend to cooperate after the procedure has been explained through play therapy and verbal reassurance. As a result, CT waiting lists have shortened.

Breathing During the Scan

Ideally, scans should be performed in suspended inspiration at total lung capacity, but this is not often possible in the younger patients. Experience has proved that quiet breathing is more successful than the confusion created over attempts to acquire the scans in suspended inspiration [4]. When subtle air-trapping due to small airways disease is suspected, a few supplementary expiratory sections may be obtained. If the child is too young to breath-hold, decubitus scans may replace expiratory scans, the dependent lung behaving as the 'expiratory' lung and the non-dependent lung behaving as the 'inspiratory' lung [4].

Which Protocol Should Be Applied?

Planning the examination protocol is essential as this may facilitate diagnosis. The differences between a 'routine' scan of the chest and a Combi-scan/CTA, as applied in our institution, are summarized in Table 1.

When dealing with children, the issue of performing a low-dose examination is crucial. Radiation dose is a contentious issue in pediatrics as it is well-established that the lifetime cancer mortality risks attributable to CT examinations are considerably higher than for adults [1, 2]. As proposed by the ALARA ('as low as reasonably achievable') principle, the selection of appropriate scanning parameters focuses on optimization of the image quality while delivering the lowest possible radiation dose and shifting the risk-benefit balance towards benefit [1, 2, 5].

Technical parameters that need to be selected for any scan include: collimation thickness, tube current [milliamperage (mA)], and kilovoltage (kV). The collimation thickness is the minimum section thickness that can be acquired once the scan is finished, and in a 16-row MDCT scanner it is usually 1.5 mm. Thinner collimation (0.75 mm) increases the radiation dose by approximately 30% with our in-house reduced protocol and is applied only in selected cases of vascular abnormalities, visualization of small structures, and cardiac CT (Table 2). The axial images are reconstructed at 5-mm thickness and archived to the picture archiving and communication system (PACS) system within our hospital.

Methods adopted to minimize radiation dose in MDCT include:

Table 1. Imaging protocols of the pediatric chest with 16-row MDCT scanner

	Routine Scan	CombiScan/CTA
Indication	Strictures Tumors Tracheomalacia Peripheral-airways disease	Cardiovascular anomalies Small tracheobronchial stenoses
Anatomic area	Thoracic inlet to diaphragm	
Tube collimation (mm)	1.5	0.75
Slice-width reconstructed (mm)	5	3
Table-feed (mm/rotation ')	24	12
Exposure factors	100 kVp 20-75 effective mAs (dependent on patient weight) 0.75-s scan time	100 kVp 20-75 effective mAs (dependent on patient weight) 0.75-s scan time
Respiration	Suspended inspiration; single breath-hold where possible 3-5 expiratory scans for tracheomalacia/small-airways disease	
Contrast material	None	Yes (triggering for CTAs)
Algorithm	Soft tissue	Soft tissue plus reconstruction on bony algorithm for high-resolution CT of the lungs

Table 2. Dose comparison for different scanning protocols in a phantom study at our institution

	Effective dose (mSv)									
	Volume (1.5 mm)		Combi (0.75 mm)		HRCT		CTA		CXR	
	M	F	M	F	M	F	M	F	AP	LAT
<15kg	0.77	0.90	0.9	1.05	0.36	0.42	1.30	1.51	0.00487	0.00799
15-24 kg	0.93	1.09	1.13	1.31	0.36	0.42	1.62	1.89	0.00874	0.01086
25-34 kg	1.34	1.56	1.58	1.84	0.54	0.63	2.24	2.62	0.01163	0.00968
35-44 kg	2.11	2.46	2.48	2.89	1.00	1.17	2.57	3.0	0.01769	0.01452

CTA, CT angiography; *CXR*, chest X-ray; *HRCT*, High-resolution computed tomography; *AP*, anteroposterior; *LAT*, lateral

1. Applying a dose-modulation function, in which the system samples the patient thickness and adjusts (e.g., reduces) the exposure accordingly when the tube is in the AP/PA position, as patients are narrower in AP than in the side-to-side orientation.
2. Reduction of the kilovoltage to 100 kVp when imaging the thorax. Further reduction to 80 kVp is possible for CTA, but as resolution of the parenchyma is not ideal this is applied only if lung pathology is unlikely.
3. Selecting a tube collimation of 1.5 mm. The 0.75 mm collimation improves spatial resolution but, as already mentioned, it increases the radiation dose and is therefore reserved for CTA or when thin-slice reconstruction is indicated.
4. Appropriate mAs selection that is dependent on the patient's weight or cross-sectional diameter.

Unlike the single slice scanner, an increase or decrease in table-feed time on the MDCT scanner only affects the overall scanning time. An increase in table speed results in a concomitant increase in mA, and this has no effect on the dose delivered. The tube current is automatically compensated to ensure that the preset effective and total mAs is delivered, i.e., a fast table movement results in an automatic increase in the mA, keeping the mAs constant.

Anatomic Coverage

For imaging of the pediatric thorax, anatomic coverage extends from the thoracic inlet to the diaphragm. Greater degrees of coverage may be warranted in certain clinical cases, such as an extralobar pulmonary sequestration that may be present in the upper abdominal cavity. In order to increase spatial resolution, the field of view (FOV) should closely approximate the cross-sectional area of the body part being studied [2].

Injection of Contrast Medium

When imaging the airways, intravenous non-ionic contrast material is only administered if paratracheal abnormalities, such as vascular rings, anomalous origin of the pulmonary artery, and mediastinal masses are suspected [2].

Table 3. Suggested delay times from the injection of contrast medium

	Manual injection	Pressure injector
Scan initiation time delay	10 s from termination of injection	25 s from start of injection
Flow rate		2 ml/s
Age range	All age groups	All age groups

An intravenous cannula should be preferably placed in situ on the ward so that the child will not associate CT with venopuncture especially in cases in which subsequent scans may be required. Non-ionic contrast is administered at a dose of 2.0 ml/kg in up to a maximum of 50 ml via a 20/22G cannula, using a power-injector or hand injection (when the cannula is placed in the hand or the wrist). The power-injector has the advantage of instilling contrast with a constant delivery rate. A flow-rate of 2.0 ml/s is used, rising to 2.5 ml/s for cardiac studies. Central lines are used for injection in conjunction with clinical agreement and are more desirable, as the experience is more pleasant for the child than having to undergo repeated cannulation. The delay time between the start of injection and the start of the scan can be empirical (Table 3).

In the case of complex vascular anatomy, the radiologist should be present for the examination. In those cases, low-dose planning scans are done at a pre-determined anatomic level and the injection of contrast medium is triggered by the radiologist. The volumetric scan begins when the contrast has reached the relevant pre-selected vascular structure.

Post-processing of the Volumetric Data

Four reconstruction displays are used in the post-processing of volumetric data: multiplanar reformations or reconstructions (MPRs), 3D shaded-surface displays (SSDs), multi-projective volume reconstructions (MPVRs), and 3D volume renderings (VRs). In fact, the axial images include all the information about the anatomy of the airways that is provided with 2D and 3D reformats. However, post-processing gives added value to imaging and increases diagnostic confidence, whereas axial scans are usually numerous, and oblique structures as well as interfaces and surfaces parallel to the axial plane are poorly demonstrated and sometimes occult.

Multiplanar Reformations

The additional diagnostic information in different planes provided by MPRs is as accurate as that obtained with the axial scans due to the nature of the isovolumetric acquisition of the data [3]. MPRs are 1-voxel-thick, 2D tomographic sections that can be displayed in coronal, sagittal, or parasagittal planes, or in a single tomographic 'curved' plane, along the axis of a structure of interest, e.g., a bronchus or a feeding vessel [2, 3]. They are real-time, easy-to-reconstruct images that can be produced as soon as the axial sections are completed. MPRs impressively demonstrate small focal lesions and the vertical extent of a bronchial stenosis, which may go undiagnosed from the axial source CT images. They are also invaluable prior to surgical remodeling of vascular rings and the tracheobronchial tree [3]. However, to avoid misinterpretations due to partial volume effects, e.g. overestimation of the degree of a stenosis, overlapping and thinner cuts should be obtained when the raw data are processed.

Three-Dimensional Imaging

This diagnostic tool is only used in certain cases as it frequently requires more time and post-processing skills to provide information already included and demonstrated in the axial images and MPRs. There is no doubt however that the 3D reformatted images may further increase the diagnostic confidence which eventually affects patient management, particularly pertinent in pre-surgical assessment. Communication with the referring clinicians is simplified as they portray spatial relationships of important anatomic structures.

Three-Dimensional Shaded-Surface-Displays

These techniques are only applied in the imaging of the central airways and they are usually more visually impressive than clinically useful. However, their generation from original data is time-consuming and they carry the risk of loss of density information due to problems with thresholding.

Multi-projective Volume Reconstructions

This method consists of 'selective' 3D images that resemble the 2D MPRs and which depict peripheral airways better than individual sections. MPVR combines the spatial resolution of thin sections with the anatomical display of thicker slices, and all the information acquired in the raw data set is used. The routine CT images are combined in multiples to create an image that is thicker in voxels, the volume 'slab', which constitutes an interactive sum of axial-, coronal-, and sagittal-reconstructed sections [2, 3]. By using different algorithms and setting thresholds, maximum or minimum intensity voxels can be highlighted within the slab. For evaluation of the airways, minimum intensity projections (MIPs) within the slab are usually applied [2]. Slabs are time-consuming and should be reserved for of the visualization of complex morphologies.

Three-Dimensional Volume Renderings

The main technique for 3D reformatting of the airways and the vascular structures of the mediastinum is 3D VR. This technique is particularly useful for displaying structures that course parallel or oblique to the transverse plane, those

that develop or extend into multiple planes, and short focal areas of narrowing [2, 3]. However, preliminary editing is still necessary and can be time-consuming, altering the usual work patterns in CT. In VR, different anatomic tissues are represented by proportional values that are assigned to every voxel and depend on the range of tissue attenuation values in the original data set. Voxels are selected by the probability of belonging to the object of interest; thus, they are displayed in different colors, or several shades of gray, different transparency, or different opacity. This 3D segmentation technique is better albeit more complicated than the others previously mentioned; however, some information is lost during processing so that the axial images are still indispensable for the radiologist to assess extraluminal disease and to identify artifacts.

Virtual Bronchoscopy

The inner surface of air-containing tracheobronchial tree can be displayed with virtual bronchoscopy (VB), which is performed with either polygonal SSD or direct VR. VB is a non-invasive and accurate technique that can provide 'bronchoscopic' views of the central and the peripheral airways. As is the case with fiber-optic bronchoscopy, virtual bronchoscopy is considered to be supplementary to CT; likewise, referral to the axial sections is valuable to recognize artifacts and to gain perception of the orientation within the virtual airways. VB uses perspective surface rendering, which takes advantage of the natural contrast between the airway and the surrounding tissues [1]. The point for viewing is located intraluminally, so that external structures do not overlap and editing requires less time. Sub-millimeter (0.75-mm) slice thickness allows deeper penetration and visualization of the bronchial surface down to bronchial diameters of <5 mm; it is associated, however, with an inevitable increase in radiation dose [6].

Again, VB practically never adds anything particularly new to the established diagnosis; thus, it is reserved for use in patients in whom traditional bronchoscopy is not applicable (e.g., children at risk) or when precise navigation to guide airway interventional procedures is not possible, or in emergencies, such as airway (tracheal) stenosis in an infant who cannot be evaluated otherwise [2]. However, compared to fiber-optic bronchoscopy, VB precludes any therapeutic maneuvering. It is incapable of detecting endoluminal lesions <2-3 mm, and provides limited information about mucosal details making differentiation between pathologic processes and retained secretions difficult [1-3, 6-8]. Additionally, as VB is affected by partial volume effects, severe stenoses may be misinterpreted as occlusions. Therefore, the threshold level is of great importance for displaying accurate simulations [9].

Peripheral Airways

Modern volumetric techniques have partially overcome the difficulty of demonstrating 3D images of the peripheral airways. Data are acquired and reconstructed at a later time, allowing for thin-slice high-resolution images at any level. In this way, a whole affected bronchiectatic segment can be displayed on a single MPR/VR oblique section with images that resemble those of conventional bronchography and which may therefore influence the approach for tissue sampling [3, 10]. If there is suspicion of small-airways disease, some additional expiratory cuts may be useful.

Clinical Applications of Volumetric Imaging of the Pediatric Airways

Selection of the most appropriate scanning CT protocol for each individual case is paramount in imaging of the airways in the pediatric population. Ultimately, the best protocol is the one that provides the most relevant information at the lowest radiation burden possible. The indications include: (1) congenital bronchial anomalies (e.g., accessory bronchi, bronchial hypoplasia and atresia, and bronchopulmonary foregut malformations), (2) tracheobronchial strictures (congenital and acquired) or tumors, (3) tracheomalacia, and (4) peripheral (small)-airways disease.

Tracheobronchial Anomalies

Some form of congenital variant is found in 1-12% of adult patients who undergo bronchoscopy [1, 11]. Tracheobronchial anomalies may be associated with recurrent episodes of pulmonary infection and airway obstruction but usually go undiagnosed with conventional imaging [1, 12].

Tracheal bronchus, with an incidence of 0.2-5%, represents an aberrant bronchus that usually arises from the right tracheal wall above the carina and ventilates the apical segment of the upper lobe (Fig. 1) [1, 13]. If the right upper lobe bronchus has a normal trifurcation, then the tracheal bronchus is supernumerary and may end blindly, also called tracheal diverticulum. Its presence may be associated in some patients with other abnormalities of the lung or within the spectrum of VACTREL (V=vertebral, A=anorectal atresia, C=cardiac, T=tracheobronchial, R=renal, E=esophageal, L=lumbosacral/limb abnormalities) association. Diagnosis of tracheal bronchus should be considered early in the clinical course of intubated patients with recurrent right-upper-lobe complications [11].

Patients with bronchial atresia may present with a variety of findings depending on age (water-density mass in newborns, bronchocoele and air-trapping during childhood, and solitary pulmonary nodule or area of emphysema in adults). In doubtful cases, MPRs help identify mucoid impaction and bronchocoele, showing a branching structure radiating from the hilum [13].

Bronchopulmonary foregut malformations are anomalies of pulmonary development that are due to abnormal budding of the embryonic foregut and tracheobronchial tree. They include duplication cysts, which are characterized by an isolated portion of lung tissue communicating

Fig. 1. Volume rendered 16-slice virtual bronchoscopy (VB) multi-detector-row computed tomography (MDCT) image at the level of the carina, showing a more cephalad origin of apical accessory bronchus (*curved arrow*)

with the upper GI tract or the central nervous system, such as occurs with bronchogenic cysts, enteric cysts, and neurenteric cysts. Symptoms are usually provoked by the size and the location of the cysts, which may cause compression of the trachea or bronchi leading to distal collapse and air-trapping. Infection is less commonly encountered.

The spectrum of pulmonary underdevelopment includes agenesis of the bronchus and lung (pulmonary agenesis), presence of a rudimentary blind-ending bronchus without lung tissue (pulmonary aplasia), and bronchial hypoplasia with variable reduction of the lung tissue (pulmonary hypoplasia) (Fig. 2) [13].

Fig. 2. Coronal oblique multiplanar reformation (MPR) in a 4.5-month-old boy with trisomy 21. There is hypoplasia of the right lung and diaphragmatic eventration. The aberrant right subclavian artery (*arrow*) was an incidental finding

The sequestration spectrum includes congenital pulmonary airway malformations (CPAMs; previously termed congenital cystic adenomatoid malformations), pulmonary sequestrations, and hybrid lesions that histologically consist of both entities (Fig. 3). CT defines the location, extent and anatomic relationships of sequestrations, and evaluates their density. MPRs and VRs can impressively demonstrate the arterial feeder from a subphrenic aortic branch and detect venous drainage into the systemic or pulmonary circulation, for extra- and intra-lobar sequestrations respectively (Fig. 3, IId and IIe). Enhancement of the cystic wall implies infection.

Tracheomalacia is a rare condition in which there is softening of the tracheal wall. This is caused by an abnormality of the cartilaginous ring and hypotonia of the myoelastic elements. There is dynamic collapse of the trachea during expiration, which leads to airway obstruction with development of wheeze, cough, stridor, dyspnea, cyanosis, and recurrent respiratory infections [13].

Congenital tracheal stenosis is a rare disorder characterized by a fixed tracheal narrowing caused by complete tracheal cartilage rings. Approximately 50% of the congenital tracheal stenoses are focal, located usually in the lower third of the trachea, 30% are generalized, and 20% are funnel-shaped [13]. The bronchi are usually of normal size.

Areas of malacia or stenosis of the bronchial cartilage are thought to be the etiological factors in the development of congenital lobar emphysema/over-inflation through a check-valve mechanism, which consists of progressive distension-hyperinflation of a lobe, most commonly the left upper lobe. CT will typically show hyperinflation of the affected lobe without destruction of the alveolar walls and will help to differentiate it from other conditions (Fig. 4).

Acquired trachoebronchial stenoses may result from prolonged intubation (post-intubation webs) or at anastomosis sites following surgical intervention/lung transplant. In patients in whom the axis of the stenosis is vertical or slightly oblique, the stenosis is usually difficult to perceive from the axial images alone and MPRs/VRs are useful adjunctive tools (Fig. 5).

Airway Compression of Cardiovascular Origin

This relatively common complication of cardiovascular diseases may go unrecognized for some time. Compression is caused either because of an underlying anomalous anatomic relationship between the tracheobronchial tree and the vascular structures, e.g., a double aortic arch, or it is extrinsic, caused by enlarged cardiac or pulmonary vascular structures, e.g., congenital heart disease, dilated pulmonary arteries (Fig. 6). In children with unexplained respiratory distress, stridor, wheezing, dysphagia, and apnea, a high index of suspicion is required to identify these lesions, which cause mechanical airway compression [14, 15].

Fig. 3a-e. Combi-scan in an 11-month-old child with a hybrid congenital pulmonary airway malformations (CPAM) lesion in the right lower lobe. **a** Coronal MPR in lung-window setting shows the air-filled cystic component of the lesion. Axial slice (**b**) and coronal MPR (**c**) show, additionally, a large arterial feeder (*arrows*). This is, however, better-visualized and -appreciated with an oblique MIP along the axis of the vessel (**d**) and with coronal anterior and posterior 3D VRs (**e**). These images additionally demonstrate the pulmonary venous drainage of the lesion, i.e., intralobar sequestration (*curved arrows*)

Fig. 4. Axial CT slice in an infant with mediastinal shift, as seen on chest X-ray, shows hyperinflation of the left upper lobe without destruction of the alveolar walls, in keeping with congenital lobar emphysema

A vascular ring is an aortic arch anomaly in which the trachea and the esophagus are completely surrounded by vascular structures. They are formed because components of the aortic-arch complex persist or regress abnormally. If the airway is incompletely encircled, then a vascular sling is produced [13-15]. The most common and clinically serious type of vascular ring is the double aortic arch, which represents the persistence of both right and left embryonic fourth arches joining the aortic portion of the truncoaortic sac to their respective dorsal aortae [14]. It typically consists of a right and a left arch that encircle the trachea and esophagus in a tight ring, joining distally to form a common descending aorta (Fig. 7). Another vascular sling can be produced by an abnormal origin of the left pulmonary artery from the right pulmonary artery (Fig. 8) [14].

Fig. 5a-c. Chest CT (1.5-mm collimation, post i.v. injection of contrast) in a 10-month-old boy with recurrent wheezing due to congenital tracheal stenosis treated previously with tracheoplasty. **a** There is mild stenosis of the trachea and the origin of the right main bronchus (*arrow*), which is appreciated with difficulty on the axial scans, but is nicely shown in coronal MPRs (**b**). Virtual bronchoscopy in the patient was unnecessary. **c** Bronchogram and bronchoscopy confirmed a stenosis in the right main bronchus (*arrow*) caused by granulation tissue

Fig. 6a-d. Cardiac CT (0.75-mm collimation, post i.v. injection of contrast medium) in a 6-month-old girl with absent pulmonary valve syndrome. **a** Axial CT slice post-injection of contrast medium shows massive dilatation of the main and the left pulmonary arteries, with possible compression of the left main bronchus. **b** This is also appreciated on serial oblique MIPs (*arrows*), and becomes more apparent on the oblique minimum intensity projection (MIP) along the axis of the left main bronchus (**c**) and on the 3D VR (**d**)

Local Extension of Neoplasms

MPRs/VRs, with reference to the axial images, are the method of choice to stage hilar or mediastinal neoplasms (Figs. 9, 10) [3].

Peribronchial Air Collections

MPRs/VRs are helpful in demonstrating small extra-luminal air collections and leakages of surgical anasto-

moses, especially in orthotopic lung or heart/lung transplant patients [3].

Peripheral Airways

MPRs/VRs that are obtained using MDCT technology have allowed more accurate visualization of the distal airways. VR technique is applied in thin, overlapping, transverse reconstructed sections with the use of a high-resolution algorithm. The 'Combi scan' MDCT protocol,

Fig. 7a-c. a Axial image of the complete vascular ring around the trachea and the esophagus, formed by double aortic arch, with injection of contrast material. **b** 3D VR image of double aortic arch from a left anterior oblique view. **c** Volume slab showing the resulting significant narrowing of the trachea

Fig. 8a, b. a Contrast-enhanced 16-slice MCDT (0.75-mm collimation) shows marked tracheal narrowing and the aberrant origin of the left pulmonary artery from the right pulmonary artery (pulmonary sling). **b** 3D VR demonstrates an elongated and stenotic trachea and identifies a separate bronchus for the right upper lobe

Fig. 9a, b. Combi-scan of the chest in a 15-year-old girl with laryngeal/pulmonary papillomatosis. **I.** There is irregular narrowing of proximal tracheal wall that is well-demonstrated on axial slices (**a**, left panel) and on coronal MPRs (**a**, right panel; **b**, left panel). Intrapulmonary cavitating lesions are also demonstrated. Same findings impressively demonstrated on 3D VR (**b**, right panel)

with the possibility of high-resolution reconstructions, allows for detailed parenchymal evaluation of the entire chest and simultaneous imaging of the mediastinum, with the disadvantage of increased radiation burden (Table 2).

Conclusions

The applications of CT in imaging of the pediatric chest have been enhanced by MDCT with 2D and 3D reconstructed imaging. Obtaining high-quality scans should always be attempted at the lowest radiation dose possible. CT and bronchoscopy are supplementary examinations in the diagnostic work-up of children with tracheobronchial pathologies. Although 2D and 3D rendering techniques are not first-line diagnostic tools, they have significantly reinforced diagnostic confidence even in complex cases. In specific scenarios, they may supply information that, compared to conventional axial scans, is more easily interpreted among the different specialties. In the future, applications of virtual tracheobronchial endoscopy are anticipated to include interactive virtual-reality guidance in surgical procedures of the airways.

Key Learning Points

– MDCTs provide increased volume coverage per time unit at high axial and temporal resolution.

Fig. 10a, b. Myofibroelastic tumor in a child with a history of cough and hemoptysis. Infiltration of the right main bronchus from this heterogeneous soft-tissue mass is seen on axial slices (**a**) and coronal MPRs (**b**)

– With MDCTs, sedation is required infrequently and scanning can be performed during quiet breathing.
– For all pediatric applications, the highest image quality with the lowest possible radiation dose should be pursued.
– Thin-collimation (0.75 mm) scans for imaging of the pediatric chest should only be obtained if complex vascular structures need to be imaged or parenchymal subtle abnormalities are suspected; for these situations, contrast injection is recommended.
– Among the variable post-processing techniques with MDCTs, MPRs are of higher value, since they are not time-consuming, are as accurate as axial images, and may offer additional information regarding small and vertically oriented structures.
– VB practically never adds new information to the established diagnosis but is preferred by pulmonologists and is specially applied in patients in whom actual bronchoscopy is not feasible.
– Tracheobronchial anomalies include a wide spectrum of congenital and acquired abnormalities that usually go unrecognized and should be suspected when lower respiratory tract symptoms persist on an unjustified basis; vascular rings should be considered in the differential of extrinsic compression of the airways.

Multiple-Choice Questionnaire

1 Multiplanar reconstructions (MPRS) with MDCTs are:
 a. Less accurate than axial images (F)
 b. Less accurate but more impressive than axial images (F)
 c. As accurate as axial images (T)
 d. As accurate as axial images, more impressive, and occasionally more helpful (T)
2 Radiation dose with MDCTs is increased:
 a. If MPRs are to be processed (F)
 b. If cardiac CT is performed (T)
 c. If SSD reconstructions are produced (F)
 d. If VB is requested (T)
 e. If Combi-scan is performed (T)
3 Regarding vascular rings/slings:
 a. A double aortic arch results from the persistence of right and left embryonic fourth arches joining of the aortic portion of truncoaortic sac to their respective dorsal aortae (T)
 b. A double aortic arch results from persistence of right and left embryonic third arches with joining of the aortic portion of truncoaortic sac to their respective dorsal aortae (F)
 c. A pulmonary artery sling is associated with long-segment tracheal stenosis (T)
 d. A pulmonary sling is produced by an abnormal origin of the right pulmonary artery from the left pulmonary artery (F)
 e. Tracheal accessory bronchus is present in 0.1% of the population (F)

Acknowledgement

This article has been summarized from: Papaioannou G., Young C., Owens
C. (2006) Volumetric CT of the Tracheobronchial Tree.
Radiology Update
CME Journal 5(3):115-125, with permission

References

1. Heyer C M, Kagel T, Lemburg SP et al (2004) Evaluation of tracheobronchial anomalies in children using low-dose multidetector CT: report of a 13-year-old boy with a tracheal bronchus and recurrent pulmonary infections. Pediatr Pulmonol 38:168-173
2. Siegel MJ (2003) Multiplanar and three-dimensional multi-detector row CT of thoracic vessels and airways in the pediatric population. Radiology 229:641-650
3. Salvolini L, Bichi SE, Costarelli L, De Nicola M (2000) Clinical applications of 2D and 3D CT imaging of the airways - a review. Eur J Radiol 34:9-25
4. Owens C (2004) Radiology of diffuse interstitial pulmonary disease in children. Eur Radiol 14:L2-L12
5. Slovis TL (2003) Children, computed tomography radiation dose, and the As Low As Reasonably Achievable (ALARA) concept. Pediatrics 112:971-972
6. Khan MF, Herzog C, Ackermann H et al (2004) Virtual endoscopy of the tracheo-bronchial system: sub-millimeter collimation with the 16-row multidetector scanner. Eur Radiol 14:1400-1405
7. Dheda K, Roberts CM, Partridge MR, Mootoosamy I (2004) Is virtual bronchoscopy useful for physicians practising in a district general hospital? Postgrad Med J 80:420-423
8. Finkelstein SE, Schrump DS, Nguyen DM et al (2003) Comparative evaluation of super high-resolution CT scan and virtual bronchoscopy for the detection of tracheobronchial malignancies. Chest 124:1834-1840
9. Hoppe H, Dinkel HP, Walder B et al (2004) Grading airway stenosis down to the segmental level using virtual bronchoscopy. Chest 125:704-711
10. Remy J, Remy-Jardin M, Artaud D, Fribourg M (1998) Multiplanar and three-dimensional reconstruction techniques in CT: impact on chest diseases. Eur Radiol 8:335-351
11. Wong KS, Wang CR, Hsieh KH (1998) Demonstration of tracheal bronchus associated with tracheal stenosis using direct coronal computed tomography. Pediatr Pulmonol 25:133-135
12. Kosucu P, Ahmetoglu A, Koramaz I et al (2004) Low-dose MDCT and virtual bronchoscopy in pediatric patients with foreign body aspiration. AJR Am J Roentgenol 183:1771-1777
13. Berrocal T, Madrid C, Novo S et al (2004) Congenital anomalies of the tracheobronchial tree, lung, and mediastinum: embryology, radiology, and pathology. Radiographics 24:e17
14. Kussman BD, Geva T, McGowan FX (2004) Cardiovascular causes of airway compression. Paediatr Anaesth 14:60-74
15. Lee KH, Yoon CS, Choe KO et al (2001) Use of imaging for assessing anatomical relationships of tracheobronchial anomalies associated with left pulmonary artery sling. Pediatr Radiol 31:269-278

CT Evaluation of the Pediatric Chest in Routine Practice

M.J. Siegel

Washington University School of Medicine, Mallinckrodt Institute of Radiology, St. Louis, MO, USA

Introduction

This article reviews the applications of CT in the evaluation of common chest problems in children, in particular mediastinal masses and congenital lung anomalies. Normal anatomy and anatomic variants and CT techniques are also discussed.

Techniques

Two basic protocols suffice for most pediatric CT examinations. For metastases, a focal lung or mediastinal mass, or trauma, CT with thicker slice collimation (>1 mm) and higher pitch (>1.5) is used. If vascular or airway disorders are suspected, thinner collimation (<1.0 mm) and a smaller pitch (=1) are used. Tube current and voltage are adapted to the patient's dimensions [1, 2].

Intravenous contrast agent is given via a power injector when a 22-gauge or larger cannula can be placed in an antecubital vein. Flow rates are 1.5-2.0 ml/s for a 22-gauge catheter and 2.0-3.0 ml/s for a 20-gauge catheter. Manual injection is used when intravenous access is through a peripheral access line in the dorsum of the hand or foot. For conventional CT examinations, the scan delay time is 30 s after the onset of contrast administration. CT angiography is done with a bolus-tracking method. A default time of 12-15 s is used if the automated triggering fails.

CT examinations are carried out with breath-holding at suspended inspiration in cooperative patients, usually children over 5-6 years of age. Scans are obtained during quiet respiration in sedated children and in those who are unable to cooperate with breath-holding instructions.

Normal Anatomy

In patients <5 years of age, the thymus usually has a quadrilateral shape with convex or straight lateral margins (Fig. 1). Later in the first decade, the thymus is triangular or arrowhead-shaped with straight or concave

Fig. 1. Normal CT appearance of the thymus in a 6-month-old boy. The thymus (*T*) is quadrilateral in shape with slightly convex lateral borders and a wide retrosternal component. The attenuation of the thymus is equal to that of the chest-wall musculature

margins; by 15 years of age, it is triangular in nearly all individuals (Fig. 2). In prepubertal children, the thymus is homogeneous, with an attenuation equal to that of the chest-wall musculature. In adolescents, the thymus may be heterogeneous, containing areas of fat deposition. Occasionally, the thymus extends either cranially above the brachiocephalic vessels or into the posterior thorax [3,4].

Mediastinal lymph nodes generally are not seen on CT prior to puberty. In adolescents, small normal nodes (not exceeding 1 cm in their widest dimension) occasionally can be identified.

The contour of the azygoesophageal recess is convex laterally in children <6 years of age, straight in children between 5 and 12 years of age, and concave in adolescents or young adults [5]. Recognition of the normal dextroconvex appearance of this recess in young children is important so that it is not mistaken for lymphadenopathy.

Fig. 2. Normal CT appearance of the thymus in a 17-year-old girl. The thymus (*T*) has assumed a triangular shape but still abuts the sternum. The heterogeneity corresponds to the presence of fatty infiltration

Fig. 4. Rebound thymic hyperplasia in a 4-year-old boy receiving chemotherapy for Wilms' tumor. The CT scan was obtained 3 months after the start of chemotherapy. The thymus (*T*) is diffusely enlarged but maintains a triangular configuration

Mediastinal Masses

Anterior Mediastinal Masses

Soft-Tissue Attenuation

Lymphoma is the most common cause of an anterior mediastinal mass of soft-tissue attenuation in children, with Hodgkin's disease occurring three to four times more frequently than non-Hodgkin's lymphoma [1-3, 6-8]. Lymphoma may manifest as nodal or thymic enlargement. Thymic lymphoma appears as an enlarged quadrilateral-shaped gland with convex, lobular lateral borders (Fig. 3). Nodal disease ranges from mildly enlarged

Fig. 3. Thymic Hodgkin's disease with thymic infiltration in an 11-year-old girl. A large mass (*M*) with biconvex borders fills the anterior mediastinum, compressing the superior vena cava (*black arrow*). Note the pretracheal adenopathy (*white arrow*)

nodes in a single area to large conglomerate masses in multiple regions. Both forms of involvement show soft-tissue attenuation and little if any enhancement after intravenous administration of contrast medium.

Rebound thymic hyperplasia is defined as a >50% increase in the size of the thymus compared to baseline and is most often associated with chemotherapy, particularly therapy with corticosteroids. The overgrowth is usually seen several months after the start of chemotherapy and between courses of chemotherapy. Rare causes of hyperplasia include myasthenia gravis, red cell aplasia, and hyperthyroidism. CT features are a diffusely enlarged thymus, which usually maintains a triangular shape (Fig. 4) [1-3, 6, 7]. The attenuation is similar to that of the normal organ and also of tumor. The absence of other active disease and a gradual decrease in the size of the thymus on serial CT scans supports the diagnosis of rebound hyperplasia as the cause of thymic enlargement.

Thymoma and thyroid abnormalities are rare causes of anterior mediastinal masses in children.

Fat Attenuation

Germ-cell tumors are the second most common cause of an anterior mediastinal mass in children and the most common cause of a fat-containing lesion. Approximately 90% are benign. On CT, benign teratoma is a well-defined, thick-walled cystic mass containing a variable admixture of water, calcium, fat, and soft tissue (Fig. 5) [1-3, 6, 7, 9, 10]. Low-attenuation fluid components predominate. By comparison, malignant germ-cell tumors contain a predominance of soft-tissue attenuation components (Fig. 6). Central areas of necrosis or cyst formation are common, especially in

Fig. 5. Benign teratoma in an 18-year-old girl. A large, well-circumscribed, heterogeneous mass containing a predominance of low-attenuation fluid with scattered areas of calcifications and fat occupies the right lobe of the thymus. The *arrow* indicates the left thymic lobe

Fig. 7. Cystic hygroma in a 6-month-old girl. A septated low-attenuation mass infiltrates the superior mediastinum and right axilla

Fig. 6. Teratocarcinoma. A large, anterior mediastinal, soft-tissue mass containing calcifications and some low-density areas, representing necrosis, displaces the mediastinal vascular structures to the right

Fig. 8. Thymic cyst. Contrast-enhanced CT demonstrates replacement of the thymus by a homogeneous, water-attenuation mass (*M*)

nonteratomatous malignant tumors. Local infiltration with encasement or invasion of mediastinal vessels or airways also is frequent.

Thymolipoma is an infrequent cause of an intrathymic tumor. At CT, it appears as a heterogeneous mass containing fat and some soft-tissue elements. Thymolipoma does not compress or invade adjacent structures [11].

Fluid Attenuation

Lymphangiomas are developmental tumors of the lymphatic system and are almost always inferior extensions of cervical lymphangiomas [1-3]. At CT, they appear as non-enhancing, thin-walled, multiloculated masses with near-water attenuation (Fig. 7). Hemorrhage can cause a

sudden increase in tumor size and can increase CT attenuation.

Thymic cysts usually are congenital lesions resulting from persistence of the thymopharyngeal duct, but they can occur after thoracotomy. Typically, these cysts are thin-walled, homogeneous masses of near-water attenuation on CT (Fig. 8).

Middle Mediastinal Masses

Frequent causes of middle mediastinal masses are lymph-node enlargement and congenital foregut cysts [1-3, 6, 7]. Mediastinal lymphadenopathy is usually the result of lymphoma or granulomatous disease. On CT, adenopathy can appear as discrete, round, soft tissue masses, or as a single soft-tissue mass with poorly de-

Fig. 9. Middle mediastinal adenopathy in a 15-year-old boy with histoplasmosis. Axial CT shows a bulky mass (*M*) of coalesced lymph nodes in the subcarinal area. Adenopathy is also present in the left hilum

fined margins (Fig. 9). Calcification within lymph nodes suggests old granulomatous disease, such as histoplasmosis or tuberculosis. Areas of low attenuation suggest tuberculosis.

Foregut cysts include bronchogenic and enteric cysts [12]. Bronchogenic cysts are lined by respiratory epithelium and most are located in the subcarinal or right paratracheal area. Enteric cysts are lined by gastrointestinal mucosa and are located in a paraspinal position in the middle to posterior mediastinum. CT findings are those of a well defined, round, non-enhancing mass of near-water attenuation, which reflects the serous contents of the cyst (Fig. 10).

Posterior Mediastinal Masses

Posterior mediastinal masses are of neural origin in approximately 95% of patients and may arise from sympathetic ganglion cells (neuroblastoma, ganglioneuroblastoma, or ganglioneuroma) or from nerve sheaths (neurofibroma or schwannoma). Rarer causes of posterior mediastinal masses in children include paraspinal abscess, lymphoma, neurenteric cyst, lateral meningocele, and extramedullary hematopoiesis [1-3].

On CT, ganglion-cell tumors appear as fusiform, paraspinal masses extending over the length of several vertebral bodies and with soft-tissue attenuation. Calcifications are seen in up to 50% of these tumors (Fig. 11). Nerve-root tumors tend to be smaller, spherical, and occur near the junction of a vertebral body with an adjacent rib. Both types of tumors may invade the spinal canal.

Fig. 11a, b. Neuroblastoma in a 2-year-old girl. **a** Axial CT shows a large, right, paraspinal soft-tissue mass (*M*). **b** Sagittal multiplanar reformatted image shows the tumor extending over the length of several vertebral bodies. The craniocaudal extent of the mass is better defined on the reformatted image

Fig. 10. Duplication cyst in a 15-year-old girl. Contrast-enhanced CT shows a homogeneous, cyst (*C*) of near-water-density in the right paratracheal area (middle mediastinum)

Congenital Pulmonary Lesions

Congenital lung anomalies include a variety of conditions involving the pulmonary parenchyma, the pulmonary vasculature, or a combination of both.

Anomalies with Normal Vasculature

Congenital lobar emphysema, cystic adenomatoid malformation, and bronchial atresia are anomalies resulting from abnormal bronchial development. Chest radiography often suffices for diagnosis. CT is used to confirm the diagnosis and to determine the extent of disease in patients in whom surgery is contemplated.

Congenital lobar emphysema is characterized by hyperinflation of a lobe [13, 14]. It is believed to be due to bronchial obstruction. CT shows a hyperinflated lobe with attenuated vascularity, compression of ipsilateral adjacent lobes, and a mediastinal shift to the opposite side (Fig. 12). The left upper lobe is involved in about 45% of patients, the right middle lobe in 30%, the right upper lobe in 20%, and two lobes in 5% [13].

Cystic adenomatoid malformation is characterized by an overgrowth of distal bronchial tissue resulting in the formation of a cystic mass. Type I (50% of patients) is defined as a single cyst or multiple large cysts (>2 cm in diameter), type II (41%) as multiple small cysts (1-10 mm in diameter). Type III (9%) appears on visual inspection to be a solid lesion but contains microscopic cysts [15, 16]. In neonates, the anomaly appears as a multiloculated, thin-walled mass containing air-filled cysts surrounded by septations (Fig. 13). In older children, the cysts may have thicker walls and contain fluid or air; air-fluid levels may be seen [1-3].

Bronchial atresia results from abnormal development of a segmental or subsegmental bronchus. It rarely causes symptoms and is usually discovered on chest radiographs obtained for other indications. CT features include overaerated lung distal to the atresia

and a round, ovoid, or branching density near the hilum, representing mucoid impaction just beyond the atretic bronchus (Fig. 14) [17].

Fig. 13a, b. Cystic adenomatoid malformation. **a** Type I lesion in a neonate; a multilocular mass in the right upper lobe contains a dominant large cyst. **b** Type II malformation in a neonate; CT shows a complex mass in the left lower lobe containing multiple small cysts

Fig. 12. Congenital lobar emphysema in a 6-month-old boy. CT through the upper thorax shows a hyperinflated left upper lobe with attenuated vascularity

Fig. 14. Bronchial atresia in a 15-year-old girl. CT shows an ovoid soft-tissue nodule (*arrow*) in the left lower lobe. The nodule is surrounded by overaerated lung, due to collateral air drift

Anomalies with Abnormal Vasculature

Sequestration, hypogenetic lung syndrome, and arteriovenous malformation (AVM) are congenital anomalies characterized by abnormal vasculature. When the sequestered lung is confined within the normal visceral pleura and has venous drainage to the pulmonary veins, it is termed 'intralobar' or 'congenital'. The sequestered lung is termed 'extralobar' or 'acquired' when it has its own pleura and venous drainage to systemic veins [18, 19]. Contrast-enhanced CT demonstrates opacification of the anomalous vessel immediately following enhancement of the descending thoracic aorta (Figs. 15, 16) [20-22]. The CT appearance of the pulmonary parenchyma depends on whether or not the sequestered lung is aerated. When the sequestration communicates with the remainder of the lung, usually after being infected, it ap-

Fig. 17. Scimitar syndrome with partial anomalous venous return. Coronal CT scan shows the anomalous vein (*arrow*) entering the intrahepatic inferior vena cava. Note that the right hemithorax is smaller than the left and that there is a mediastinal shift to the right. (Case courtesy of Dr Edward Lee, Children's Hospital, Boston, MA, USA)

Fig. 15. Intralobar sequestration in a 10-year-old girl with recurrent left lower lobe pneumonia. CT demonstrates the anomalous arterial supply (*arrow*) to the sequestered lung (*S*) arising from the thoracic aorta

Fig. 18. Pulmonary arteriovenous malformation (AVM). Coronal maximum-intensity projection CT at soft-tissue windows shows multiple nodular AVM (*arrows*) with its feeding arteries and draining veins. AVMs can be reliably diagnosed on CT based on their morphology

pears cystic; a sequestration that does not communicate appears as a homogeneous density, usually in the posterior portion of the lower lobe.

Hypogenetic lung syndrome, also referred to as scimitar syndrome, is characterized by a small right lung, ipsilateral mediastinal displacement, a corresponding small pulmonary artery, and partial anomalous pulmonary venous return from the right lung to the inferior vena cava (Fig. 17) [23]. Other associated

Fig. 16. Extralobar pulmonary sequestration in a 2-week-old girl with a left paraspinal mass seen on chest radiographs. Coronal CT shows the anomalous arterial vessel (*arrow*) arising from the distal aortal and supplying the sequestered left lower lobe (*S*)

anomalies include systemic arterial supply to the hypogenetic lung, accessory diaphragm, and horseshoe lung. Horseshoe lung is a rare anomaly in which the posterobasal segments of both lungs are fused behind the pericardial sac.

Pulmonary AVM is a direct communication between a pulmonary artery and vein without an intervening capillary bed [1-3]. AVMs appear as rounded or lobular masses with rapid enhancement and washout after intravenous administration of contrast medium. Maximal-intensity projections or 3D volume-rendered reconstructions are particularly useful to show the feeding and draining vessels (Fig. 18) [24].

References

1. Siegel MJ (2006) Pediatric applications. In: Lee KTL, Sagel SS, Stanley RJ, Heiken JP (eds) Computed Body Tomography with MRI Correlation, 4th ed. Lippincott Williams & Wilkins, Philadelphia, pp 1727-1791
2. Siegel MJ (2003) Pediatric chest applications. In: Fishman EK, Jeffrey B (eds). Multislice Helical CT, 3rd ed. Lippincott Williams & Wilkins, Philadelphia, pp 159-182
3. Siegel MJ (1999) Mediastinum. In: Siegel MJ (ed) Pediatric Body CT. Lippincott Williams & Wilkins, Philadelphia, pp 65-100
4. Siegel MJ (1993) Diseases of the thymus in children and adolescents. Postgrad Radiol 13:106-132
5. Miller FH, Fitzgerald SW, Donaldson JS (1993) CT of the azygoesophageal recess in infants and children. Radiographics 13:623-634
6. Merten DF (1992) Diagnostic imaging of mediastinal masses in children. AJR Am J Roentgenol 158:825-832
7. Meza MP, Benson M, Slovis TL (1993) Imaging of mediastinal masses in children. Radiol Clin North Am 31:583-604
8. Bisset GS III (1995) Hodgkin's disease. In: Siegel BA, Proto AV (eds) Pediatric Disease (Fourth Series) Text and Syllabus. Am Coll Radiol, Reston, VA, pp 130-164
9. Quillin SP, Siegel MJ (1992) CT features of benign and malignant teratomas in children. J Comput Assist Tomogr 16:723-726
10. Rosado-de-Christenson ML, Templeton PA, Moran CA (1992) Mediastinal germ cell tumors: radiologic and pathologic correlation. Radiographics 12:1013-1030
11. Rosado-de-Christenson ML, Pugatch RD, Moran CA, Galobardes J (1994) Thymolipoma: analysis of 27 cases. Radiology 193:121-126
12. Haddon MJ, Bowen A (1991) Bronchopulmonary and neurenteric forms of foregut anomalies. Imaging for diagnosis and management. Radiol Clin North Am 29:241-254
13. Cleveland RH (1993) Congenital lobar emphysema. In: Siegel BA, Proto AV (eds) Pediatric Disease (Fourth Series) Text and Syllabus. Am Coll Radiol, Reston, VA, pp 96-129
14. Daltro P, Fricke B, Kuroki L et al (2002) CT of congenital lung lesions in pediatric patients. AJR Am J Roentgenol 183:1497-1506
15. Kim WS, Lee KS, Kim IO et al (1997) Congenital cystic adenomatoid malformation of the lung: CT-pathologic correlation. AJR Am J Roentgenol 168:47-53
16. Rosado-de-Christenson ML, Stocker JT (1991) Congenital cystic adenomatoid malformation. Radiographics 11:865-886
17. Al-Nakshabandi N, Lingawi S, Muller NL (2000) Congenital bronchial atresia. Can Assoc Radiol 51:47-48
18. Frazier AA, Rosado de Christenson ML, Stocker JT et al (1997) Intralobar sequestration: radiologic-pathologic correlation. Radiographics 17:725-745
19. Rosado Rosado-de-Christenson ML, Frazier AA, Stocker JT, Templeton PA (1993) Extralobar sequestration: radiologic-pathologic correlation. Radiographics 13:425-441
20. Franco J, Aliaga R, Domingo ML, Plaza P (1998) Diagnosis of pulmonary sequestration by spiral CT angiography. Thorax 53:1089-1092
21. Ko SF, Ng SH, Lee TY et al (2000) Noninvasive imaging of bronchopulmonary sequestration. AJR Am J Roentgenol 175:1005-1012
22. Lee E, Siegel MJ, Foglia R (2004) Evaluation of angioarchitecture of pulmonary sequestration in pediatric patients using 3D MDCT angiography. AJR Am J Roentgenol 183:183-188
23. Konen E, Raviv-Zilka L, Cohen RA et al (2003) Congenital pulmonary venolobar syndrome: spectrum of helical CT findings with emphasis on computerized reformatting. Radiographics 23:1175-1184
24. Hoffman LV, Kuszyk BS, Mitchell SE et al (2000) Angioarchitecture of pulmonary arteriovenous malformation: characterization using volume-rendered 3D CT angiography. Cardiovasc Intervent Radiol 23:165-170

Imaging of the Newborn Chest

R. Cleveland[1], V. Donoghue[2]

[1] Radiology Department, Children's Hospital, Harvard Medical School, Boston, MA, USA
[2] Radiology Department, Children's University Hospital, Dublin, Ireland

Introduction

This paper reviews the common spectrum of disorders of the neonatal chest. Emphasis is on radiographic changes that have been produced by the introduction of new therapeutic maneuvers, particularly the use of artificial surfactant in treating hyaline membrane disease and the survival of profoundly premature newborns (less than 650 grams). A discussion of meconium aspiration syndrome, neonatal pneumonia, transient tachypnea of the newborn, congenital lymphangiectasia and congenital heart disease is also included. The effect on the neonatal chest radiograph of extracorporeal membrane oxygenation and high frequency ventilation are also mentioned [1]. A review of 'surgical' lesions is also included [2].

Although cross-sectional and ultrasound imaging have specific but limited roles in assessing the newborn chest, the standard chest radiograph remains the most common imaging tool. Diseases that affect the neonate's chest significantly overlap in their radiographic and clinical appearances. Therefore, an open exchange of information between the neonatologist and the radiologist is critical to the intelligent interpretation of these images.

The main disease entities of concern are hyaline membrane disease (HMD), chronic lung disease (BPD), meconium aspiration syndrome (MAS), neonatal pneumonia, and transient tachypnea of the newborn (TTN). Congenital lymphangiectasia may mimic the findings of MAS or neonatal pneumonia. Congenital heart disease may be present in a fashion that is easily confused with a pulmonary parenchymal process. This is most common when the heart remains normal in size, but there is pulmonary venous hypertension. Specific infective organisms, such as *Chlamydia trachomatis* or viruses, that are acquired during or following birth may be present within the neonatal period, with clinical and radiographic findings that are easily confused with one or several of the above-mentioned entities.

Hyaline Membrane Disease

Hyaline membrane disease is a manifestation of pulmonary immaturity, seen predominantly in children less than 36-38 weeks of gestational age and weighing less than 2.5 kg. HMD remains the leading cause of death in live-born infants. The death rate is highest in the most premature infants, with few deaths occurring in infants weighing more than 1.5 kg. Males are affected almost twice as often as females. HMD is more common in whites than in blacks. The disease results from a deficiency of surfactant in the lungs, which leads to the inability to maintain acinar distention. Exposure to air rapidly leads to the development of hyaline membranes containing fibrin and cellular debris. There frequently is epithelial necrosis beneath the hyaline membranes. By the second day of life, repair has begun as evidenced by the proliferation of type 2 pneumocytes (which produce surfactant) and increased secretions. The lungs are almost impossible to inflate and on gross inspection appear similar to liver. Clinically, the infants are usually symptomatic within minutes of birth, with grunting, nasal flaring, retractions, tachypnea, and cyanosis; however, it may be a few hours before symptoms are recognized. Although the initial radiographic findings may be noted minutes after birth, occasionally the maximum radiographic findings are not present until 12-24 h of life.

The rigid, noncompliant lungs and the associated hypoxia and acidosis often result in persistent pulmonary hypertension. As pulmonary resistance decreases, there may be the onset of left to right shunting across a patent ductus arteriosus. This may be recognized radiographically before clinical symptoms or a murmur may develop. Shunting is heralded by the development of pulmonary edema and a suddenly enlarging heart size. The ductus arteriosus can only respond to stimuli to close if it is term or near term in development. These stimuli include a normal oxygen level, a normal pH, and normal levels of prostaglandin E1 and E2. In the premature newborn with HMD, the ductus is open, but the pulmonary and systemic pressures may be equal or the pulmonary pressure may exceed the systemic pressure, precluding left to right shunting. These babies are usually hypoxic and acidotic with high levels of prostaglandin E1 and E2. By several days of life, as the pulmonary resistance drops, if the ductus is not responsive or the stimuli are not present, the ductus arteriosus will remain open allowing

left to right shunting and the development of congestive heart failure. Treatment with indomethacin (by inhibiting production of prostaglandin) may produce ductal closure but at the risk of inducing gastrointestinal perforation and/or osteoarthropathy. Surgery may be required to close a persistent patent ductus arteriosus.

Sudden diffuse opacification of the lungs in HMD may be seen with other conditions. A frequent cause is decreasing ventilatory settings, including inspiratory pressure, PEEP, or rate. Less commonly, diffuse pulmonary hemorrhage is a cause. Sudden catastrophic intracranial hemorrhage may produce central nervous system (CNS)-mediated edema.

Since Northway's original description of bronchopulmonary dysplasia (BPD), in 1967 [3], many changes have occurred in the management and outcome of children with HMD. Much has been learned about the specific toxic effects of oxygen and assisted ventilation. Babies of much lower gestational age and birth weight are surviving with BPD, particularly since the advent of high-frequency ventilation and the use of artificial surfactant. The likelihood of developing BPD or retinopathy of prematurity and the severity of these conditions in any particular baby has diminished due to the successful attempts at keeping inspired oxygen at or below 60% (FiO$_2$ <0.6), keeping ventilatory pressures and rate as low as possible, and extubating as soon as possible. Infants at greatest risk for chronic lung disease (BPD) are the profoundly premature who require longer courses of assisted ventilation at greater pressures and rate and a higher inspired oxygen concentration (FiO$_2$ of 0.6-1.0). Infants with air-leak phenomenon (pneumothorax, pneumomediastinum, or pneumopericardium) also usually require prolonged treatment with a higher oxygen concentration. With the exception of an occasional baby, usually in one of these two latter groups, it is rare to see the development of the classic four stages of BPD described by Northway [3]. In children successfully managed with short courses of assisted ventilation and FiO$_2$ <0.4-0.6, the usual radiographic course is to evolve from HMD to a hazy diffuse opacification of the lungs to normal over a period of several days to 2-3 weeks.

Since glucocorticoids accelerate lung maturation, the incidence of RDS in babies born at under 32 weeks gestations can be significantly reduced by administering betamethasone to the mother during the 2 days prior to delivery.

Several emerging technologies have greatly altered the clinical and radiographic evaluation of children with HMD. Two modes of treatment are now being used in an attempt to reduce the incidence of pneumothorax, traditionally seen in up to 25% of ventilated babies with HMD. Artificial surfactant is being given at birth, with up to three or four additional doses in the first 48 h in selected cases. This treatment modality has significantly improved the early management and survival of these children, although the long-term consequences of their disease, such as BPD, have not been clearly altered [4-6]. The use of ar-

tificial surfactant has produced several significant changes in the radiographic configurations. The surfactant is given as liquid boluses via an ET tube. Usually, the surfactant is not evenly distributed throughout the lungs; therefore, it is common to see areas of lung that rapidly improve in aeration alternating with areas of unchanged HMD. The uneven distribution produces a radiograph that may simulate other entities, such as neonatal pneumonia or MAS. In addition, the surfactant may reach the level of the acinae, causing sudden and effective distention of multiple acinar units and thereby producing a radiographic configuration quite suggestive of pulmonary interstitial emphysema (PIE) [7]. In these situations, close communication with the neonatologist to ascertain clinical status is mandatory to the intelligent interpretation of the radiograph. Babies with surfactant effect generally improve at this point, those with PIE deteriorate.

High-frequency ventilation (HiFi) (10-15 hertz, 600-900 cycles/min) has also been employed to reduce the incidence of barotrauma [8]. For both of these modalities, the overall improvement in the long-term prognosis has yet to be determined. The radiographs of babies receiving HiFi are not significantly altered from those of babies treated with conventional ventilator therapy. However, the degree of pulmonary inflation is used to adjust mean airway pressure (MAP). Ideally the dome of the diaphragm should project over the eighth to tenth posterior rib if MAP is appropriately adjusted.

A limited number of institutions have successfully managed most of their premature infants with nasal CPAP, and thus have avoided many of the complications of intubation.

With advances in medical management, more profoundly premature babies are being maintained and rescued. It is not uncommon today for babies weighing as little as 650 grams to be successfully treated and to survive their prematurity. The radiographic presentation of these babies may differ from that of the more gestationally mature infant. In this profoundly premature age group, it is common that initial radiographs performed within the first few hours to 2 days of life are normal or nearly normal with only minimal evidence of HMD. Then, suddenly, over a period of 2-3 days, the radiographic pattern may evolve into one reflecting much coarser and somewhat irregularly distributed lung disease, similar to that seen in stage three BPD (a situation originally described as occurring at several weeks of age) [3].

Meconium Aspiration Syndrome

Meconium aspiration syndrome is the result of intrapartum or intrauterine aspiration of meconium. It most commonly occurs in babies who are post mature (the mean gestational age for MAS has been reported as 290 days or 10 days past the expected day of delivery), small for gestational age, or when there has been intrauterine stress causing hypoxemia. Although there is meconium

staining of the amniotic fluid in approximately 10-15% of live births, MAS, which is diagnosed by the presence of meconium in the airway below the vocal cords, is seen in 1-5% of newborns.

The radiographic findings in MAS vary, in part secondary to the severity of the aspiration. The tenacious meconium often will cause both medium and small-airway obstruction, even after vigorous endobronchial suctioning. This typically will cause areas of atelectasis alternating with areas of overinflation. The meconium is an irritant to bronchial mucosa and may cause a chemical pneumonia. This increases the risk for subsequent gram-negative bacterial infection. Hypoxia usually results, with all factors combining to produce pulmonary hypertension, referred to as persistent fetal circulation (PFC). As vigorous suctioning and aggressive therapy with endotracheal intubation and ventilatory support are often required, it is not surprising that air-leak phenomenon is encountered, with pneumothorax present in 25-40% of cases. Occasionally, however, babies with MAS requiring ventilatory support will have a normal chest X-ray or possibly only a pneumothorax. Small pleural effusions are also seen in approximately 10% of cases. The chest X-rays of infants with MAS may be indistinguishable from those of children with neonatal pneumonia. Due to the difficulty in excluding neonatal pneumonia and the possibility of developing a superimposed pneumonia in MAS, most of these infants are treated with antibiotics.

In spite of optimal care, there is a persistent mortality rate of up to 25% in babies with MAS. Recently, this was addressed by the use of extracorporeal membrane oxygenation (ECMO). Since ECMO has potentially life-threatening side effects, including hemorrhage, frequently into the brain, its use is limited to babies who have failed conventional therapy. Although selection criteria are evolving, the usual practice is to attempt conventional therapy for 1-2 days before resorting to ECMO. Survival rates with ECMO have been excellent. The most critical factor in weaning from ECMO is not simply improved pulmonary mechanics, but a reduction of pulmonary vascular pressure to below systemic pressure. Some investigators have postulated a primary abnormality of the pulmonary microcirculation in MAS, while others feel that the increased pressures within the airways, produced by assisted ventilation, is the cause of PFC in these babies. ECMO, which bypasses the lungs, allows pulmonary inflation to be at a minimum while maintaining physiologic levels of oxygen tension and saturation [9-11]. Therefore, the lungs of infants on ECMO are usually nearly or completely airless.

Neonatal Pneumonia

Neonatal pneumonia is seen in less than 1% of live-born infants; premature infants are at increased risk. It may be acquired in utero, during labor, at delivery, or shortly after birth. The major risk factor for intrauterine development of pneumonia is prolonged rupture of the maternal membranes, particularly if labor is active during this period. Some organisms, particularly viruses, may cross the placenta. Group B streptococcus infections are currently the most common cause of pneumonia in the newborn, with an incidence of 3/1000 live births, and are acquired in utero or during labor and delivery. Both clinically and radiographically, it may be difficult to distinguish neonatal pneumonia from HMD. Chest radiographs may reveal lung disease identical to that of HMD; however, pleural effusions are associated with pneumonia (in up to 67% of cases) and essentially never with uncomplicated HMD. In neonatal pneumonia, the lungs may reveal irregular patchy infiltrates or occasionally be normal. There may be mild cardiac enlargement with pneumonia but it is unusual with uncomplicated HMD [12]. Infections with other bacterial organisms may produce radiographic findings identical to those described above in group B streptococcal infections. HMD and neonatal pneumonia frequently co-exist.

Several infants with late-onset (at several days of life) right-sided diaphragmatic hernia in association with neonatal pneumonia were described [13]. At surgery, there were no distinguishing characteristics of the hernia to suggest a specific effect of the pneumonia or of sepsis. These cases presumably represent a late onset of herniation of the liver and intestine through a pre-existing, congenital diaphragmatic defect.

Transient Tachypnea of the Newborn

Transient tachypnea of the newborn is also referred to as retained fetal lung liquid. Fetal lung liquid is an ultrafiltrate of fetal serum. Under normal circumstances, it is cleared from the lungs at or shortly after birth via the tracheobronchial system (30%), the interstitial lymphatics (30%), and the capillaries (40%). TTN is most commonly seen in infants born by cesarean section but may also be identified in children who are quite small or who have experienced a precipitous delivery. The lungs usually are diffusely affected, with a variable characterization ranging from an appearance similar or identical to HMD, a coarse interstitial pattern similar to pulmonary edema, or an irregular opacification as may be seen with meconium aspiration or neonatal pneumonia. A pleural effusion is a common accompaniment. A transient slight cardiac enlargement may occur. The hallmark of this process is a relatively benign clinical course (i.e., tachypnea) compared to the overall severity of disease suggested by chest X-ray and rapid clearing (1-2 days). In particularly severe cases, where clearing may require up to 3 days, there should be a rapid improvement on each successive image.

Focal retention of fetal lung liquid within congenital lobar emphysema has been recognized for several years. A recent publication suggested that the retention occurs only, or mainly, within polyalveolar lobes, in contrast to classic congenital lobar emphysema [14].

Congenital Lymphangiectasia

Babies with congenital lymphangiectasia may present with symptoms similar to those of HMD. The lungs may be normal or reveal a course interstitial infiltrate secondary to the distended and abnormally draining lymphatics. There may be generalized overinflation. Pleural effusions may be present. A particularly large pleural effusion should suggest this diagnosis or it may be related to a traumatic chylous or hemorrhagic effusion. The presence of a chylous effusion without a history of trauma is suggestive of congenital lymphangiectasia, although isolated chylous effusions do occur. This diagnosis is best made by sampling of the pleural effusion following the administration of fatty foods.

Congenital Heart Disease

Cases of congenital heart disease may closely mimic several of the entities mentioned previously. The presence of pulmonary interstitial edema may be difficult to distinguish from HMD, neonatal pneumonia or TTN.

A particularly confusing constellation of chest findings may occur in those congenital heart lesions producing obstruction to pulmonary venous return but without significant cardiac enlargement. This includes congenital obstructing lesions that occur at the level of the mitral valve or between the mitral valve and the pulmonary venous system. Specifically, these lesions include mitral valve stenosis, supravalvular mitral stenosis, cor triatriatum, stenosis of a common pulmonary vein, or total anomalous pulmonary venous connection (TAPVC) with obstruction. Physiologically, TAPVC may present with or without obstruction. If obstruction is sufficient, children will present in the first week of life with cyanosis (in severe cases) or with signs of pulmonary edema, dyspnea, and feeding difficulties (in less severe cases). A chest radiograph will show evidence of pulmonary venous hypertension but without an enlarged heart. If there is little or no obstruction to venous return, the children usually present with high output failure at 6-12 months of age and have a radiograph suggestive of congestive heart failure. Several recent reviews have estimated an overall incidence of obstruction in TAPVC of 50-65%. With supradiaphragmatic draining veins, obstruction has been noted in up to 53% of patients. Essentially, all subdiaphragmatic draining veins are obstructed [15].

If the heart is significantly enlarged, the likelihood that the baby has true congestive heart failure is suggested. Within the first week of life, before the pulmonary vascular resistance drops sufficiently to allow left to right shunting, congestive heart failure is usually secondary to pressure overload, obligatory volume overload, or myocardial dysfunction. The lesions most commonly producing this phenomenon include critical aortic stenosis, hypoplastic left heart syndrome, coarctation of the aorta (interruption of the aortic arch), myocarditis, dysrhythmias, myocardial ischemia, and arterial venous fistula. Significant arterial shunting outside the heart, such as vein of Galen aneurysm, hepatic hemangioma, or hemangioendothelioma, may also produce congestive failure in this time period. By the second week of life, after pulmonary resistance has dropped sufficiently, volume overload lesions are the predominant cause for congestive failure. This includes ventricular septal defect, endocardial cushion defect, patent ductus arteriosus, aortopulmonic window, as well as milder forms of those lesions potentially presenting within the first week of life. Children with untreated hypoplastic left-heart syndrome may live beyond the first week and are therefore a potential category of children having congestive heart failure in the older age group [16].

Chlamydia Pneumonia

Chlamydia pneumonia is caused by a bacterial-like intracellular parasite, *Chlamydia trachomatis* [17-19], which is acquired from the mother by direct contact during vaginal delivery. This organism is widely distributed, having been identified in the vagina of up to 13% of women tested. Up to 50% of babies infected become symptomatic with conjunctivitis, the most common manifestation, which usually appears around 5-14 days of life. Pneumonia develops in 10-20% of infected babies, appearing between 2 weeks and 3 months of age. However, since the average age of onset is 6 weeks, *Chlamydia* infection is somewhat unusual in the neonatal age group. Cough, sometimes paroxysmal and associated with tachypnea, is the most common symptom of this disease. It may be preceded by nasal obstruction or discharge. Up to 50% of infants with chlamydia pneumonia will have conjunctivitis and up to 50% will have peripheral eosinophilia, with absolute blood eosinophil levels in excess of $300/mm^3$. Not uncommonly, the findings on chest radiograph are far worse than would be predicted by physical examination and may range from a purely interstitial process to a focal alveolar infiltrate. Hyperinflation is generalized, pleural effusions are uncommon. Occasionally, there is a diffuse coarse linear opacification closely mimicking congenital lymphangiectasia, obstructed pulmonary venous return, or possibly bacterial pneumonia or meconium aspiration.

Lines and Tubes

What is considered to be the 'correct' position of various lines and tubes used for support purposes varies from institution to institution. The following discussions reflect the current practice in our institutions. Since opinion concerning 'safe and appropriate' positioning changes frequently and differs between institutions and physicians,

the following should not be taken as recommendations but merely a reporting of current practice at the authors' institutions.

Endotracheal Tubes

Endotracheal tubes (ETT) in neonates do not have inflatable cuffs. Therefore, many neonatal intensivists attempt to maintain the ETT tip within the intrathoracic trachea, i.e., between the thoracic inlet and the carina. The thoracic inlet is anatomically defined as a plane extending from the first thoracic vertebral body (T1) to the medial end of the clavicles. At the level of the thoracic inlet, the trachea is midway between the T1 vertebral body and the medial end of the clavicles. For purposes of chest-X-ray assessment, the level of the thoracic inlet in reference to the trachea is the midpoint between the body of T1 and the medial end of the clavicles.

It has been demonstrated that the tip of the ETT in neonates may move a distance equal to the length of the intrathoracic trachea when the head is moved from complete flexion to complete extension. Thus, the 'correct' position of an ETT must relate to head position and the level of the ETT tip, which moves inferiorly with flexion of the head and superiorly with extension of the head [20]. Accordingly, if the chin is flexed upon the chest wall, the ETT tip should be very slightly above the carina. If the head is quite extended and rotated laterally, the ETT tip should be slightly below a point midway between the TI vertebral body and the clavicles. Some institutions will reference the ETT tip to a vertebral body. Since differences in X-ray-beam angle, i.e., straight anterior-posterior versus lordotic, will alter the way the ETT tip projects over the spine, using only the vertebral level is a less accurate means of assessment.

Enteric Tubes

Nasogastric and orogastric tubes should be positioned so that their tips project in the expected region of the stomach. Due to the relative sizes of premature and full-term neonates and commercially available tubes, an appropriately positioned tube often unavoidably, will have the side port in the esophagus.

Enteric tubes are often placed into the small bowel for feeding purposes. Ideally, these tubes should follow a course that corresponds to the normal positioning of the stomach, pylorus, duodenum, and proximal jejunum, with the duodenal-jejunal junction (DJJ; also referred to as the ligament of Treitz) in the left upper quadrant of the abdomen, roughly at the craniocaudal level of the pylorus. However, the course of enteric tubes, particularly those in place for several days, will often straighten, mimicking the positioning of midgut malrotation. In these situations, it may be prudent to slightly withdraw the tube so that it is proximal to the DJJ and inject opaque contrast material at the bedside to document placement of the DJJ.

Central Venous Lines

The 'correct' position of central venous lines (CVL), including peripherally inserted central catheters (PICCs), is highly controversial. Some authorities insist that these lines should never be within the right atrium (RA), whereas others insist that they must be within the RA. The best policy is to know the manufacturer's recommendations, the planned use of the catheter, and any existing institutional or governmental policies concerning the 'correct' position of the CVL in use.

For most PICC, many neonatologists prefer to have the tip situated within the superior vena cava (SVC). Based on the course of the PICC, the level of the confluence of the innominate veins, which represents the superior extent of the SVC, can usually be estimated. The junction of the SVC and RA (SVC/RA junction) can be estimated by projecting the lateral margin of the RA to its junction with the SVC. As discussed in the section concerning ETT, some institutions use the thoracic spine level as the point of reference; however, because of reasons discussed in connection with ETT position, this is felt by many clinicians to be a less accurate method of determining intravascular position.

Umbilical Arterial Catheters

There are two commonly used practices for umbilical arterial catheter (UAC) placement: the 'high line' position and 'low line' position. Both are meant to minimize the potential for development of thromboembolic propagation into the main braches of the aorta. Occasionally, there may be a need or preference for placement of peripheral arterial lines.

Since the aorta lies adjacent to the spine, the UAC tip position can be reliably referenced to the vertebral level. The branching of the aorta in newborns is slightly different from that of older children and adults. The ductus arteriosus is frequently initially open in both full-term and premature newborns. It joins with the aorta at the level of the forth thoracic vertebra (T4). The expected level of abdominal aortic branching in newborns is two vertebral bodies higher than in adults. In newborns, the best assumptions are that the celiac axis arises at T10-11, the superior mesenteric artery at T11, the renal arteries at T12-L1, the inferior mesenteric artery at L1, and the iliac bifurcation at L3.

The goal of UAC placement following 'high line' positioning is to have the tip between the ductus arteriosus and the celiac axis, i.e., between T4 and T10. Most neonatologists, therefore, attempt to have the tip between T6 and T9. For 'low line' placement, the tip should be at or below L3. However, the iliac bifurcation lies roughly at L3; thus, lines with their tips in the iliac artery risk being displaced. As a result most institutions follow a 'high line' policy.

Umbilical Venous Catheters

In contrast to UAC, the tip position of umbilical venous catheters (UVCs) is not reliably referenced to the verte-

bral level. The reason is as explained for ETTs and CVLs. Since the venous anatomy is not adjacent to the spine, variability in patient positioning and X-ray-beam angle will significantly alter the projected UVC tip position in relationship to the spine. Therefore, reference should be to the venous anatomy. This may be stated as below, within, or above the liver. Rarely, the UVC will descend in the inferior vena cava (IVC). Most clinicians consider the preferred UVC tip position to be at the IVC and right atrial junction (IVC/RA junction). When the catheter extends more superiorly, a statement should be made as to where the tip resides, i.e., in the RA, the right ventricle, the pulmonary artery, across the foramen ovale into the left atrium or pulmonary veins, up the SVC, into the neck, etc.

Abnormalities of the Lung Bud and Vascular Development

The most common abnormalities of the lung bud and of vascular development that lead to respiratory distress in the neonatal period include chylothoraces, congenital cystic adenomatoid malformation (CCAM), occasionally associated with pulmonary sequestration, pulmonary hypoplasia and pulmonary venolobar syndrome, and congenital lobar emphysema. Rarer anomalies include bronchial atresia, pulmonary agenesis, and neurenteric cysts.

Chylothorax

The etiology of chylothorax is not known. Late maturation of the thoracic duct has been proposed and may explain the resolution of the abnormality following repeated episodes of aspiration. Trauma has also been proposed as a cause, but this does not explain the fact that the effusion may be seen antenatally. The chest radiograph demonstrates an effusion that maybe unilateral or bilateral and, when large, may opacify the entire hemithorax. The diagnosis is confirmed by aspiration of the fluid, which is initially clear and has a high lymphocyte count. The fluid will have a milky appearance once the infant has a feed containing fat. The condition resolves following aspiration; frequently, repeated aspiration is necessary.

Congenital Cystic Adenomatoid Malformation

This condition is the result of hamartomatous development of the terminal respiratory structures, which results in a multicystic mass. The cysts may communicate with each other but seldom with the airway. CCAM involves a lobe or part of a lobe in the majority of patients; bilateral lesions are extremely rare. Stoker et al. classified CCAM into three histological types [21]. Type I comprises multiple cysts greater than 2 cm in diameter. This is the commonest form and accounts for approximately 60-70% of the abnormalities. Type II includes cysts less than 2 cm in diameter. Type III lesions are bulky with microcysts and are extremely rare. More recently, a type IV CCAM, consisting of a large cyst lined by alveolar type

cells, was described. The chest radiograph at birth usually shows an opaque mass that, if large, may cause a mediastinal shift. If it lies adjacent to the hemidiaphragm, it may be difficult to distinguish from a congenital diaphragmatic hernia. With time, the cysts become air-filled. Computed tomography (CT) has a role in defining the extent of the abnormality. The condition may be diagnosed antenatally, and more than 50% become smaller on sequential obstetric sonograms [22]. It is well-known that chest CT is superior to chest radiograph in showing residual lesions [23, 24]. The development of infection and malignancy, in particular rhabdomyosarcoma and pulmonary blastoma, has been reported in patients with CCAM. Nevertheless, the need for surgery and its timing is controversial in asymptomatic patients. Pulmonary sequestration may be associated with CCAM; both conditions are probably in a spectrum of related lung abnormalities [25, 26] and are associated with other anomalies. In particular, infants with type II CCAM have an increased incidence of cardiac, renal, and chromosomal anomalies. Pulmonary sequestration is associated with cardiac anomalies, diaphragmatic hernias, and gastric duplication [27].

Extralobar Pulmonary Sequestration

This condition is due to a segment of lung parenchyma that lacks a connection with the tracheobronchial tree and whose blood supply originates from a systemic artery. It is thought to result from abnormal diverticulation of the foregut or aberrant lung buds, which if beneath the pleura are intralobar, and if outside the pleura are extralobar. Extralobar pulmonary sequestrations occur most frequently on the left side. In neonates, sequestrations that are large enough to cause respiratory distress are usually extralobar [28]. They are separate from the lung and have their own pleural covering as well as their own systemic artery, which occasionally courses in a cranial direction from the abdominal aorta through the diaphragm to supply the lesion. On histological examination, there may be features of immature lung parenchyma or a hamartomatous-type lesion similar to CCAM. As mentioned above, hybrid lesions are also seen [25]. Ultrasonography with Doppler examination may show the soft-tissue mass and its blood supply pre-operatively. The abnormality can also be elegantly demonstrated using contrast enhanced CT or magnetic resonance (MR) imaging.

Congenital Lobar Emphysema

Focal areas of bronchomalacia, kinks, webs, mucosal folds, and crossing vessels have all been implicated in the etiology of congenital lobar emphysema. In this focal large airway abnormality, the lobe is enlarged and overdistended [22]. If chest radiography is done very early in the course of the disease, the over-distended lobe may be fluid-filled. Once the fluid is resorbed, the lobe appears hyperlucent and overdistended. There may be at-

electasis of the adjoining lobes and a mediastinal shift to the contralateral side. The chest CT scan shows a similar appearance. The upper lobes are most commonly involved – the left more often than the right. The right middle lobe is rarely involved.

Pulmonary Hypoplasia

Pulmonary hypoplasia may be secondary to oligohydramnios; for example, in Potter sequence or to a large intrathoracic mass, such as a diaphragmatic hernia. Unilateral pulmonary hypoplasia, usually right-sided, is associated with a small or absent pulmonary artery with a mediastinal shift to the affected side. This latter abnormality does not usually present in the neonatal period.

Abnormalities of the Diaphragm

Congenital Diaphragmatic Hernia (Bochdalek Type)

This results from a defect in the diaphragm as a result of failure of closure of the pleuroperitoneal canal, which should occur by the tenth week of gestation. The fetal bowel, which migrates outside the abdominal cavity, returns by the tenth to twelfth week but moves into the chest if the diaphragm has not completely formed. The presence of bowel loops in the thorax results in hypoplasia of one or both lungs, which depends on the number of bowel loops present and the length of time the abnormality is present. However Tenbrink et al. [29] concluded that the mass effect adjacent to the lung does not adequately explain all the pulmonary findings in congenital diaphragmatic hernia, as other mass lesions do not affect the lungs to the same degree. They suggested that a primary teratogenic abnormality in the lung leads to its failure to induce diaphragmatic closure. The condition may be diagnosed antenatally and is left-sided in 90% of patients. It is associated with other congenital cardiac, genitourinary, CNS, and chromosomal abnormalities in 10-50% of infants. Direct intrauterine repair of the hernia was pioneered in the early 1990s [30]. Fetal tracheal ligation, known as PLUG (plug the lung until it grows), has been shown to increase alveolar and vascular growth [31]. However, neither technique has found worldwide favor to date. The prognosis ultimately is dependent upon the degree of pulmonary hypoplasia, which in turn depends largely, but not entirely, on the size of the herniated contents [32].The presence of the stomach in the thorax is related to a poorer prognosis, as it indicates that the diaphragmatic defect is large. The chest radiograph initially shows opacification with significant mediastinal shift to the contralateral side. Over the subsequent hours, air outlines the bowel loops. The abdominal radiograph, which should also be obtained, will show a scaphoid appearance of the abdomen due to absence of bowel loops from their normal location in the abdomen. This helps to differentiate the condition from CCAM or a large pleur-

al effusion. Right-sided diaphragmatic hernias may involve herniation of the liver or kidney in addition to the bowel loops. Ultrasonography may also be helpful as it is useful in outlining the presence of the diaphragm and in detecting the presence of fluid-filled bowel loops prior to their filling with air. It is also able to detect the liver or kidney in a right-sided lesion. It is seldom necessary to use a contrast material to confirm the presence of bowel loops in the chest.

Initial therapy includes continuous deflation of the bowel loops, mechanical ventilation, and the use of nitric oxide to produce pulmonary vasodilatation. If this treatment is unsuccessful, the infant may be treated with ECMO. Repair is undertaken after the infant's condition has been stabilized. Following repair of the diaphragmatic defect, the chest radiograph shows the true volume of the underlying lungs.

Eventration of the Diaphragm

This condition is usually asymptomatic, but is very rarely large enough to cause neonatal respiratory distress as a result of the reduction in overall diaphragmatic function and the mass effect of the upwardly displaced structures beneath it.

Conclusions

The chest radiograph remains the most common and most useful imaging tool in the diagnosis of conditions that contribute to respiratory distress in the newborn period, in particular those which cause lung parenchymal disease. A detailed clinical history should be obtained prior to interpretation of the images. Many of the developmental lung-bud and vascular conditions, together with congenital diaphragmatic hernias, are now diagnosed antenatally and the radiologist is required to help more with therapy than with diagnosis. Ultrasonography and, occasionally, CT may also be necessary for further evaluation in these instances.

References

1. Cleveland RH (1995) A radiologic update on medical diseases of the newborn chest. Pediatr Radiol 25:631-637
2. Donoghue V (ed) (2002) Radiological Imaging of the Neonatal Chest. Springer-Verlag, Berlin Heidelberg New York
3. Northway WH, Rosan RC, Porter DY (1967) Pulmonary disease following respirator therapy of hyaline-membrane disease: bronchopulmonary dysplasia. N Engl J Med 276:357-368
4. Couser RJ, Ferrara TB, Ebert J et al (1990) Effects of exogenous surfactant therapy on dynamic compliance during mechanical breathing in preterm infants with hyaline membrane disease. J Pediatr 116:119-124
5. Leichty EA, Donovan E, Purohit D et al (1991) Reduction of neonatal mortality after multiple doses of bovine surfactant in low birth weight neonates with respiratory distress syndrome. Pediatrics 88:19-28

6. Anonymous (1991) Surfactant replacement therapy for respiratory distress syndrome. Pediatrics 87:946-947
7. Jackson JC, Troug WE, Standaert TA et al (1991) Effect of high-frequency ventilation on the development of alveolar edema in premature monkeys at risk for hyaline membrane disease. Am Rev Respir Dis 143:865-871
8. Swischuk LE (1977) Bubbles in hyaline membrane disease. Differentiation of three types. Radiology 122:417-426
9. Brudno DS, Boedy RF, Kanto WP (1990) Compliance, alveolar-arterial oxygen difference, and oxygenation index changes in patients managed with extracorporeal membrane oxygenation. Pediatr Pulmonol 9:19-23
10. Gregory GA, Gooding CA, Phibbs RH, Tooley WH (1974) Meconium aspiration in infants – a prospective study. J Pediatr 85:848-852
11. Anonymous (1988) Lung function in children after neonatal meconium aspiration Lancet 2:317-318
12. Leonidas JC, Hall RT, Beatty EC et al (1977) Radiographic findings in early onset neonatal group B streptococcal septicemia. Pediatrics 59(Suppl):1006-1011
13. McCarten KM, Rosenberg HK, Borden S, Mandell GA (1981) Delayed appearance of right diaphragmatic hernia associated with group B streptococcal infection in newborns. Radiology 139:385-389
14. Cleveland RH, Weber B (1993) Retained fetal lung liquid in congenital lobar emphysema: a possible predictor of polyalveolar lobe. Pediatr Radiol 23:291-295
15. Cleveland R (1993) Total Anomalous Pulmonary Venous Connection: Case 10. In: Siegel MJ, Bisset GS, Cleveland RH et al (eds) ACR Pediatric Disease (4th series) Test and Syllabus. American College of Radiology, Reston, pp 272-302
16. Freed MD (1984) Congenital Cardiac Malformations. In: Avery ME, Taeusch HW (eds) Schaffer's Diseases of the Newborn, 5th edn. WB Saunders, Philadelphia, pp 243-290
17. Schachter J (1978) Chlamydial infections (first of three parts). N Engl J Med 298:428-435
18. Schachter J (1978) Chlamydial infections (second of three parts). N Engl J Med 298:490-495
19. Schachter J (1978) Chlamydial infections (third of three parts). N Engl J Med 298:540-549
20. Todres ID, deBros F, Kramer SS (1976) Endotracheal tube displacement in the newborn infant. J Pediatr 89:126-127
21. Stocker JT, Madewell JE, Drake RM (1977) Congenital cystic adenomatoid malformation of the lung. Classification and morphologic spectrum. Hum Path 8:155-171
22. Garel L (2002). In: Donoghue V (ed) Radiological Imaging of the Neonatal Chest. Springer-Verlag, Berlin Heidelberg New York
23. Winters WD, Effmann EL, Nghiem HV et al (1997). Disappearing fetal lung masses: importance of postnatal imaging studies. Pediatr Radiol 27: 535-539
24. van Leeuwen K, Teitelbaum DH, Hirschl RB et al (1999) Prenatal diagnosis of congenital cystic adenomatoid malformation and its postnatal presentation, surgical indications, and natural history. J Pediatr Surg 34:794-798
25. Cass DL, Crombleholme TM, Howell LJ et al (1997) Cystic lung lesions with systemic arterial blood supply: a hybrid of congenital cystic adenomatoid malformation and bronchopulmonary sequestration. J Pediatr Surg 32:986-999
26. Samuel M, Burge DM (1999) Management of antenatally diagnosed pulmonary sequestration associated with congenital cystic adenomatoid malformation. Thorax 54:701-706
27. Sohaey R, Zwiebel WJ (1996) The fetal thorax: noncardiac chest anomalies. Semin Ultrasound CT MRI 17:34-50
28. Schwartz DS, Reyes-Mugica M, Keller MS (1999) Imaging of surgical diseases of the newborn chest. Intrapleural mass lesions. Radiol Clin North Am 37:1067-1078
29. Tenbrink R, Tibboel D, Gaillaird JI et al (1990) Experimentally induced congenital diaphragmatic hernia in rats. J Pediatr Surg 25:426-429
30. Harrison MR, Adzick NS, Flake AA et al (1993) Correction of congenital diaphragmatic hernia in utero VI. Hard-earned lessons. J Pediatr Surg 28:1411-1418
31. Hedrick MH, Estes JM, Sullivan KM et al (1994) Plug the lung until it grows (PLUG): a new method to treat congenital diaphragmatic hernia in utero. J Pediatr Surg 29:612-617
32. Donnelly LF, Sakurai M, Klosterman LA et al (1999) Correlation between findings on chest radiography and survival in neonates with congenital diaphragmatic hernia. AJR Am J Roentgenol 173:1589-1593

The Pulmonary Vessels: A Modern Approach

J. Vilar Samper[1], D.F. Yankelevitz[2]

[1] Servicio de Radiología, Hospital Universitario Dr. Peset, Valencia, Spain
[2] New York Cornell Medical Center, New York, NY, USA

Introduction

Radiology has always been involved with the analysis of the pulmonary vasculature. A chest radiograph is a unique piece of information since it is the only radiographic examination that can depict veins and arteries without the need to inject a contrast agent. Instead, the natural contrast between the density of air and water permits excellent analysis of the vessels in the lungs.

Today, new imaging techniques have propitiated a further advance in the visualization and analysis of the pulmonary vessels.

In this article, information concerning the pulmonary vasculature and related diseases that are of particular importance to the radiologist are discussed.

Pulmonary Embolism

Thromboembolic disease is frequent and often lethal [1]. In Spain, it constitutes 2% of all hospitalizations and hospital mortality is between 6 and 15% [2]. The risk factors associated with pulmonary embolism (PE) are mainly related to age, immobilization, cancer, and certain alterations in blood coagulation. PE usually originates in the legs and pelvis. Other sites of thrombosis are the heart and arms, especially after trauma or placement of intravenous catheters.

Venous thrombosis and PE are manifestations of the same disease and should thus be treated as a single disease. PE is treated with anticoagulant therapy. Low-molecular-weight heparins are used initially. However, while this is a very effective treatment, complications may occur. Approximately 10% of patients have complications and the reported mortality is around 0.6% [2].

Diagnosis of Pulmonary Embolism

The introduction of CT angiography (CTA) has dramatically changed the management of PE. In a published series, the percentage of emergency cases studied with CT increased from 9 to 83%, while nuclear medicine studies diminished from 87 to 17% [3].

In 2004, in our hospital clinical suspicion of PE accounted for 0.8% of all emergencies and 25% of the CT studies in those patients were positive for PE. This increase in the demand for PE imaging studies obliges the clinician to properly select candidate patients in order to avoid overdiagnosis or underdiagnosis. Therefore the diagnosis must be approached as a continuum in which clinicians and radiologists work together. An initial clinical workup is mandatory and should define the degree of probability of PE according to different published scales (Wells, Geneva). Once the probability of PE has been determined, a D dimer test should be carried out. Imaging is indicated when the clinical probability and D dimer results suggest PE.

Chest Radiograph

The chest radiograph should not be used to diagnose PE since very frequently there will be no specific signs of embolism. The main utility of the radiograph is to diagnose alternative diseases and as a guide to interpreting ventilation-perfusion studies, since only those without signs of chronic obstructive pulmonary disease can be considered as reliable. In PE, there may be signs such as cardiomegaly, pleural effusion, elevation of the diaphragm of local atelectasis. Nonetheless, nearly 25% of the chest radiographs in PE are normal [4].

Ventilation-Perfusion Gammagraphy

The PIOPED (Prospective Investigation of Pulmonary Embolic Disease) investigation demonstrated that ventilation-perfusion gammagraphy (VPG) is an excellent test in patients with a clinical and gammagraphic high probability of PE and in those with a low clinical probability and a normal scan [5]. The problem is that these scenarios occur in less than 35% of the cases; therefore, most patients will have an indeterminate result. Another problem associated with VPG is that its availability is low as an emergency procedure. Currently, VPG is indicated in patients with allergy to iodine or severe renal insufficiency [1, 6]. The radiation dose delivered by VPG is slightly lower than that of CT although the dose to the fetus in pregnant women is higher [7, 8].

Computed Tomography and Pulmonary Angiography

The main advantage of CT is direct visualization of the thrombus. In fact, this technique is an arteriography without the disadvantages of percutaneous puncture. There are other associated advantages of CTA:

1. Availability: in most centers, CT is available on a 24-h basis.
2. It allows alternative diagnosis that explains the patient's symptoms [9].
3. CTA detects signs of right-heart failure and pulmonary vascular obstruction, both of which have a high mortality [10].
4. CT venography of the lower limbs can be obtained as part of the same procedure.

Multidetector CT (MDCT) machines have a high temporal and spatial resolution, and thus can depict small subsegmental arteries, although the importance of isolated thrombi in these arteries is unclear. Some authors consider that such thrombi are only significant when associated with right-heart failure. A recent meta-analysis demonstrated that the sensitivity of CT is similar to that of arteriography in the diagnosis of PE [11]. Other studies demonstrated that the use of CT in a diagnostic protocol of PE reduces patient mortality and is cost-effective when compared to arteriography [12].

It is perhaps more important to know the ability of CTA to rule out PET. In patients with a negative CTA who were not treated, the recurrence of PE was <2%, which is similar to the results obtained with arteriography or VPG [13-15]. Thus, it may be concluded that CTA, and especially MDCT, can reliably exclude PE.

The radiation dose of a CTA is also an aspect to consider. The usual dose is around 1.8 mSv [7], but further reductions may be obtained with new machines, especially by current modulation. Other factors that influence the radiation dose are kVp, pitch, and the length of the area studied.

Technique

The main aspects of the technique are described in Tables 1 and 2. The direction of the scan should be caudo-cranial to avoid respiratory artefacts and artefacts due to excess contrast material in the superior vena cava. It is important to use adequate Ma settings to avoid signal noise, which may result in false-positive findings in small vessels (Fig. 1). Fine collimation (1.5 mm) is also mandatory in order to detect smaller emboli and to avoid partial volume artefacts [16, 17]. The amount of contrast agent must be adjusted to the duration of the scan, with faster machines requiring less. However, if a CT venography of the lower extremities is planned, then the contrast dose should not be <120 ml. The most common problems related to use of the technique are described in Table 2.

Table 1. Computed tomography angiography (CTA): Main technical parameters

Collimation	1-1.5 mm; 2 mm in very obese patients
MaS	150 (maximum in obese patients)
Kv	120-140
Scan direction	Caudo-cranial
Contrast	120 ml 4/s Delay with test bolus, bolus tracking. or fixed: 15 s + scan time
Visualization	Workstation

Table 2. Problems and solutions in pulmonary CTA

Problems	Solutions
Motion	Fast scan (multidetector): <20 s Caudo-cranial direction
Partial volume	Thickness: <1.5 mm Multislice, multiplanar
Noise	High mAs, high kVp
Insufficient vascular opacification	High injection rate (≥4 ml/s) Adequate timing

Fig. 1. Computed tomography angiography (CTA) artefact due to insufficient mAs. Noise in the pulmonary arteries impedes a confident diagnosis

Image Analysis

Since images have to be viewed with varying windows and planes, they must be visualized in a work station. Each lung is visualized separately, and good knowledge of the pulmonary vascular anatomy is mandatory. Multiplanar reconstructions are of particular help in the analysis of vessels that run in the horizontal plane, partial-volume phe-

Fig. 2a, b. CTA pitfall. **a** Apparent eccentric filling defect in the left pulmonary artery (*arrow*). **b** Same case. The next slice shows that the filling defect was due to partial volume of lymphoid tissue (*arrow*)

Fig. 3a, b. CTA pitfall. **a** There is an apparent embolus in a segmental artery (*arrow*). **b** Same patient. Slightly above the previous slice and small window change: air can be seen in the same structure indicating that it is a bronchus partially filled with mucus (*arrow*)

Table 3. Artefacts: causes and solutions

Artefact	Cause	Solution
Poor vascular opacification	Beginning or end of injection	Examine vessels of the same slice
Artery or bronchus?	Mucus-filled bronchus	Follow the slices and change windowing
Artery or vein?	Irregular contrast of pulmonary veins	Follow the vessel
Distortion of vessels with low density	Motion (respiratory or cardiac)	Lung window better recognizes motion
Hypodense area in lobar arteries near hila	Normal lymphatic tissue	Follow the slices
		Use multiplanar reconstructions

nomena, and adenopathy in the hilar region (Fig. 2). Windowing may aid in distinguishing an artery from a mucus-filled bronchus or a vein (Table 3, Fig. 3) [16].

Diagnostic criteria

Thrombi may produce intraluminal filling defects that may be central, eccentric, or that totally occlude the ves-

sel (Fig. 4). Sometimes, an enlargement of the artery may be noted [16, 17].

Severity: CT allows prognostic evaluation of PE according to:
1. Quantification. The method of Quanady can be used to quantify the amount of vascular occlusion. A study by Wu et al. demonstrated that this method is able to predict mortality [10].

Fig. 4. a Pulmonary embolism showing typical intravascular filling defects (*arrows*) in CTA. **b** Large embolus in the right pulmonary artery

2. Right-heart failure. The transverse diameter of the right ventricle should be smaller than that of the left ventricle in the axial CT scan. An increase in the diameter of the right-ventricle and, especially, bulging of the interventricular septum towards the left ventricle are signs of right ventricular overload, and should always be reported [18].

Magnetic Resonance

MR is not usually as readily available as CT in an emergency scenario. Nevertheless, MR angiography can also be used as an imaging tool for PE. In our institution, MR imaging is indicated for pregnant women and patients with contrast allergy.

Arteriography

Most of the recent evidence indicates that angiography should be replaced by CT in the diagnosis of PE. In cas-

es of chronic pulmonary embolism, and especially when an interventional procedure, such as thrombectomy or fibrinolysis, is indicated angiography can be used [2, 6].

Congenital Anomalies of the Pulmonary Vessels in the Adult

Pulmonary Artery Sling

This condition is also defined as an anomalous origin of the left pulmonary artery. In these patients, the left pulmonary artery originates from the right one. The diagnosis is usually made in infancy due to the symptoms that are produced by compression of the airway and esophagus. Sometimes, this entity can be diagnosed in adults, such as in the case shown in Fig. 5.

The differential diagnosis is established initially with other space-occupying lesions in the middle mediastinum. CT with contrast and MR will show the typical findings. Barium swallow shows a posterior extrinsic compression of the esophagus. In infants, a tracheal cartilaginous ring can accompany pulmonary artery sling and in this case can be life-threatening [19, 20].

Anomalous Drainage of the Pulmonary Veins

This congenital disorder may appear in association with other anomalies, especially hypogenetic lung and bronchial anomalies. It occurs almost always in the right lung and can be partial or total. The use of CT has increased the detection of anomalous veins, most of which are without clinical significance. Large anomalous venous drainage acts as a left-to-right shunt and may be accompanied by cardiac anomalies. Plain films generally

Fig. 5. Pulmonary sling. Magnetic resonance angiography. The left pulmonary artery originates from the right and travels behind the esophagus (Courtesy of Eva Castamer, M.D., Udiat, Spain)

Fig. 6. Partial anomalous pulmonary venous drainage. CTA. Multiplanar reconstruction. Abnormal vessel in the right lung draining into the inferior vena cava

Fig. 7a, b. Pulmonary arteriovenous fistula. **a** Chest X-ray shows a pulmonary nodule in the right lung (*arrow*). **b** Same patient. Pulmonary angiogram shows contrast enhancement of the suspected nodule, which has a feeding artery (*A*, *lower arrow*) and a draining vein (*V*, *upper arrow*)

clearly reveal the abnormalities, but CT with contrast or MR angiography will better depict the vascular connections and other associated findings [21-23] (Fig. 6).

Arteriovenous Malformations of the Lung

These can be found as an isolated lesion and are sometimes misinterpreted as a pulmonary nodule or as part of a generalized systemic disease (Rendu-Osler-Weber disease). Although usually asymptomatic, arteriovenous malformations may generate paradoxical embolism, with neurological symptoms, and hemoptysis. Imaging starts with the chest radiograph, which will usually show a nodular-tubular lesion most commonly in the lower lobes (Fig. 7). The proper timing of contrast injection is an important consideration in the CTA of such malformations and must be done with care [24]. MR imaging has also been used for their diagnosis. Angiography is reserved for embolization, which may be recommended in these cases.

References

1. Goldhaber SZ (2004) Pulmonary embolism. Lancet 363:1295-1305
2. Uresandi F, Blanquer J, Conget F et al (2004) Guidelines for the diagnosis, treatment, and follow-up of pulmonary embolism. Arch Bronconeumol 40:580-594
3. Trowbridge RL, Araoz PA, Gotway MB et al (2004) The effect of helical computed tomography on diagnostic and treatment strategies in patients with suspected pulmonary embolism. Am J Med 15116:84-70
4. Elliott CG, Goldhaber SZ, Visani L, DeRosa M (2000) Chest radiographs in acute pulmonary embolism results from the international cooperative pulmonary embolism registry Chest 118:33-38
5. The PIOPED investigators (1990) Value of the ventilation/perfusion scan in acute pulmonary embolism. Results of the Prospective Investigation of Pulmonary Embolism Diagnosis. JAMA 263:2753-2759
6. British Thoracic Society Standards of Care Committee Pulmonary Embolism Guideline Development Group (2003) British Thoracic Society guidelines for the management of suspected acute pulmonary embolism. Thorax 58:470-484
7. Wells PS, Anderson DR, Rodger M et al (2000) Derivation of a simple clinical model to categorize patients probability of pulmonary embolism: increasing the models utility with the SimpliRED D-dimer. Thromb Haemost 83:416-420
8. Winer-Muram H, Boone J, Brown H et al (2002) Pulmonary embolism in pregnant patients: fetal dose with helical CT. Radiology 224:487-490
9. Coche E, Verschuren F, Keyeux A et al (2003) Diagnosis of acute pulmonary embolism in outpatients: comparison of thin-collimation Multi-Detector row spiral CT and planar ventilation-perfusion scintigraphy. Radiology 229:757-765

10. Wu AS, Pezzullo JA, Cronan JJ et al (2004) CT Pulmonary Angiography: quantification of pulmonary embolus as a predictor of patient outcome. Initial Experience. Radiology 230:831-835

11. Moores LK, Jackson WL Jr, Shorr AF, Jackson JL (2004) Meta-analysis: outcomes in patients with suspected pulmonary embolism managed with computed tomographic pulmonary angiography. Ann Intern Med 141:866-874

12. Van Erkel AR, Van Rossum AB, Bloem JL et al (1996) Spiral CT angiography for suspected pulmonary embolism: a cost-effectiveness analysis. Radiology 201:29-36

13. Kavanagh EC, O'Hare A, Hargaden G, Murray JG (2004) Risk of pulmonary embolism after negative MDCT pulmonary angiography findings. AJR Am J Roentgenol 182:499-504

14. Quiroz R, Zou KH, Kifmueller F et al (2004) Negative spiral CT safely rules out acute PE: systematic analysis of patient outcomes studies. In: The Radiological Society of North America. Scientific Assembly and Annual Meeting Program 2004, 28 November - 3 December, Chicago, p. 605

15. Baile EM, King GG, Müller NL et al (2000) Spiral computed tomography is comparable to angiography for the diagnosis of pulmonary embolism. Am J Respir Crit Care Med 161:1010-1015

16. Wittram C, Maher MM, Yoo AJ et al (2004) CT angiography of pulmonary embolism: diagnostic criteria and causes of misdiagnosis. Radiographics 24:1219-1238

17. Washington L (2004) CT for thromboembolic disease: protocols, interpretation, and pitfalls. RSNA Categorical course in Diagnostic Radiology: Emergency Radiology, pp 33-45

18. Salah D, Qanadli SD, El Hajjam M et al (2001) New CT index to quantify arterial obstruction in pulmonary embolism comparison with angiographic index and echocardiography. AJR Am J Roentgenol 176:1415-1421

19. Zylak CJ, Eyler WR, Spizarny DL, Stone CH (2002) Developmental lung anomalies in the adult: radiologic-pathologic correlation. Radiographics 22:S25-S43

20. Mata JM, Caceres J, Lucaya J, Garcia-Conesa JA (1990) CT of congenital malformations of the lung. Radiographics 10:651-674

21. Salazar-Mena J, Salazar-Gonzalez J, Salazar E (1999) Meandering right pulmonary vein: a case of scimitar variant. Pediatr Radiol 29:578-580

22. Shi-Joon Yoo, Abdulmajeed Al-Otay, Paul Babyn (2006) The relationship between scimitar syndrome, so-called scimitar variant, meandering right pulmonary vein, horseshoe lung and pulmonary arterial sling. Cardiol Young 16:300-304

23. Baran R, Kir A, Tor MM et al (1996) Scimitar syndrome: confirmation of diagnosis by a noninvasive technique (MRI). Eur Radiol 6:92-94

24. Remy J, Remy-Jardin M, Wattinne L et al (1992) Pulmonary arteriovenous malformation: evaluation with CT of the chest before and after treatment. Radiology 182:809-816

Imaging of Pulmonary Infections

N. Howarth[1], P. Goodman[2]

[1] Institut de Radiologie, Clinique des Grangettes, Geneva, Switzerland
[2] Duke University Medical Center, Durham, NC, USA

Introduction

Pulmonary infections are one of the most frequent causes of morbidity and mortality throughout the world. In the immune-competent population, pneumonia is a major infectious disease, either in the more prevalent community-acquired form or as a nosocomial complication.

Radiography plays an important role in the detection and management of patients with pneumonia. Among all diagnostic tests, the chest film is among those essential for confirming or excluding the diagnosis. The chest radiograph will also help narrow the differential diagnosis, assist in the selection of direct additional diagnostic measures, and allow the clinician to monitor the course of disease. The diagnostic usefulness of the radiograph is maximized by integrating epidemiologic and clinical features of the individual patient. This article reviews the more important clinical and radiological principles regarding community-acquired, nosocomial, and opportunistic pneumonias.

Community-Acquired and Nosocomial Pneumonia

Community-acquired pneumonia (CAP) is defined as an acute infection of the pulmonary parenchyma in a patient who has developed the disease in the community, as distinguished from hospital-acquired (nosocomial) pneumonia. Community-acquired pneumonia is a common and serious illness with considerable morbidity and mortality, as approximately 20% of episodes result in patient hospitalization. Nosocomial pneumonia (NP) is *causally* associated with a mortality that is higher than that of any other type of infection acquired in the hospital. The differentiation between CAP, NP, and opportunistic pneumonia (OP) is of practical interest because varied treatments will need to be targeted against the offending pathogen. Although the spectrum of causative organisms differs between these disorders, considerable overlap exists on chest film and CT. The radiologic approach to diagnosing and monitoring CAP in the immunocompetent adult patient is reviewed here.

A pulmonary opacity on a chest radiograph is considered the 'gold standard' for diagnosing pneumonia when clinical and microbiologic features are supportive; thus a film should be obtained in most patients whenever possible. The radiographic appearances of CAP include homogeneous and heterogeneous opacities in focal and diffuse distribution. It is often taught that focal lobar homogeneous opacities are due to 'typical' bacteria (e.g., *S. pneumoniae*), whereas focal or diffuse heterogeneous opacities are due to 'atypical' organisms, (e.g. *M. pneumoniae*, viruses). However, radiologists cannot reliably differentiate the organism responsible for pneumonia on the basis of the radiographic appearance of the disease.

If the clinical evaluation does not support pneumonia, other causes of the radiographic abnormalities must be considered, such as malignancy, hemorrhage, pulmonary edema, and noninfectious inflammatory causes. However, if the clinical presentation favors pneumonia but the radiograph is normal, the radiograph may be falsely negative and further imaging may be warranted.

Case reports and animal experiments support the hypothesis that volume depletion produces initially negative radiographic findings that will become positive following rehydration. In particular, one population-based cohort study by Basi et al. found that 7% of patients with suspected CAP and negative initial studies developed changes consistent with CAP when repeat chest films were obtained.

A CT scan might be helpful for patients with negative chest radiography when there is a high clinical suspicion of pneumonia. CT scanning, especially with high-resolution CT (HRCT) protocols, is more sensitive than chest films for the evaluation of interstitial disease, extent of disease, cavitation, empyema, and hilar adenopathy. CT is not generally recommended for routine use because there are few data regarding its use in CAP, it is expensive, and there is no evidence that outcome is improved. Chest radiography thus remains the preferred method for initial imaging, with CT scanning or, rarely, magnetic resonance imaging (MRI) reserved for high-suspicion normal chest film cases or for further definition of the abnormality (e.g., cavitation, empyema, adenopathy, mass).

In patients with CAP, the primary task for the radiologist is to detect or to exclude pneumonia; a second task is to aid the clinician in determining the etiology. Identifying the causative organism to a high degree of likelihood is sometimes possible by integrating clinical and laboratory information with the radiographic pattern. However, establishing a specific etiology is very difficult due to the increasing spectrum of causative organisms and their overlapping radiographic features. In a prospective study of 359 adults with CAP, Fang and co-authors compared the radiographic, clinical, and laboratory features of patients with bacterial pneumonia (caused by *Hemophilus influenzae, Streptococcus pneumoniae, Staphylococcus aureus*, and aerobic gram-negative bacilli) with features from patients with atypical pneumonia (caused by *Mycoplasma pneumoniae* and *Chlamydia* species). The authors found no features that reliably differentiated these groups.

An extensive knowledge of the radiographic appearance of pulmonary infections will help to narrow the spectrum of possible organisms, and this will, in turn, help guide further diagnostic procedures and enable a more targeted antibiotic regimen. In this way, the radiologist is of significant help to the clinician. Beware, however, that erroneous over-interpretation of findings can be potentially misleading and dangerous. Special attention is required when typical patterns may be altered by pre- or co-existing lung disease, such as emphysema or malignancy.

Recognizing Specific Radiographic Patterns of Pulmonary Infections

Homogeneous Opacities (Airspace Disease)

Homogeneous opacities are usually caused by bacterial pneumonia. However, they can also be caused by certain viral, protozoal, and fungal infections, and may have non-infectious etiologies as well. Acute bacterial infections are characterized by a mostly homogeneous opacification of lung parenchyma, poorly-defined borders unless up against a fissure, and loss of clearly defined segmental boundaries. An air bronchogram is very common. Typical organisms are *Streptococcus pneumoniae*, most gram-negative bacilli, and *Legionella pneumophila*. Progression to complete lobar pneumonia may occur, particularly with *Legionella*. Involvement is unilateral or bilateral. Cavitation is rare with pneumococcal but typical with gram-negative disease. The lung volume is usually normal in gram-positive pneumonias and may be increased in gram-negative pneumonias (*Klebsiella sp.*).

Staphylococcus aureus is the prototype of organisms causing the radiographic pattern defined as bronchopneumonia. The parenchymal consolidation is typically segmental, scattered in distribution, and with a heterogeneous or, less commonly, homogeneous appearance. In more than half of the cases involving *Staphylococcus aureus,* the abnormalities are bilateral. Cavitation is common. *Mycobacterium tuberculosis, Pseudomonas aeruginosa,* and *Mycoplasma* are other organisms with a radiographic pattern that can resemble that of bronchopneumonia. In *P. aeruginosa* pneumonia, bilateral disease, lower lobe predominance, and abscess formation are also common. Resolution of the infiltrates may take several weeks, particularly with *Staphylococcus aureus* and *Mycoplasma* pneumonias.

The term 'atypical pneumonia' was originally applied to pneumonias with unusual, conflicting clinical, laboratory, and/or radiographic features. The term has also been applied to atypical bacterial, viral, protozoal, and fungal infections; however, it is currently reserved for pneumonias of bacterial origin, in which the organism is difficult to isolate. Among the group of 'atypical' bacterial community acquired pneumonias, *Legionella pneumophila* and, occasionally, *Mycoplasma pneumoniae* and *Chlamydia* may cause a homogeneous radiographic pattern indistinguishable from that of typical bacterial infections. Unilateral or bilateral disease may be due to such 'atypical' organisms.

Localized airspace disease may also be caused by *Mycobacterium tuberculosis*. The typical radiographic features of post-primary disease in the adult consist of areas of ill-defined heterogeneous opacities in the upper lobes, with or without cavitation. In primary tuberculosis, homogeneous opacity, with or without hilar and/or mediastinal lymphadenopathy, is typically seen. In some cases, differentiation of primary and post-primary disease may be difficult.

Invasive pulmonary aspergillosis (IPA) and mucor are fungal pneumonias seen almost exclusively in immunocompromised patients. Either disease may produce a homogeneous opacity, sometimes peripheral and wedge-shaped, sometimes segmental or lobar. Finally, viral (e.g., influenza) and protozoal organisms can cause a segmental homogeneous opacity that simulates bacterial infections.

Diffuse Heterogeneous Opacities (Interstitial or Mixed Alveolar-Interstitial Disease)

Community-acquired pneumonia can present with diffuse lung disease characterized by widely distributed heterogeneous opacities, sometimes reticular and/or nodular. The most common etiologies for this appearance are viruses and protozoa. In general, the precise etiology cannot be diagnosed because the patterns overlap. Diffuse bilateral lung disease is rarely seen in bacterial pneumonias and is also rare in patients with CAP. However, if identified in otherwise healthy people, diffuse disease is most commonly due to viral pneumonias, such as that caused by the *respiratory syncytial virus* (RSV). In RSV pneumonia, the chest radiograph shows discrete heterogeneous linear opacities in a perihilar distribution. In *Herpes varicellae* (*Varicella zoster*) pneumonia, diffuse-

ly distributed, nodular opacities are typical. Diffusely distributed fine nodules (miliary disease) may be seen with the hematogenous spread of tuberculosis.

Nodules

Nodules attributed to pulmonary infections are most often seen in nosocomial pneumonias and in immunocompromised patients. They may be caused by bacteria such as *Nocardia asteroides* and *M. tuberculosis*, septic emboli, and fungi. On chest film, *Nocardia asteroides* can cause single or multiple nodules with or without cavitation. IPA, mucor, and *Cryptococcus neoformans* infections may manifest as single or multiple nodules that often progress to wedge-shaped areas of opacity. Cavitation (sometimes with the 'crescent sign') is common later in the course of disease. In the appropriate clinical setting, CT may suggest the diagnosis of IPA by demonstrating the 'halo sign.'

Opportunistic Infections

Infectious agents that cause opportunistic pneumonia in humans include representatives from the classifications bacteria, virus, fungus, protozoa, and parasites. This section discusses some of these pathogens and their appearance on chest film and CT. Usually, the chest radiograph reveals the abnormality, but occasionally the increased sensitivity of CT is necessary to see the pneumonia. While the findings on chest imaging may not be totally pathognomonic of the underlying etiology of infection, they may be highly suggestive and will certainly lead to a reasonable differential diagnosis.

Human Immunodeficiency Syndrome

Since the first description of this disease and AIDS, *Pneumocystis jiroveci* (previously *P. carinii*) pneumonia (PCP) has been one of the most common complications. Patients with PCP typically present with increasing shortness of breath and may run a gradual or fulminant course of infection. Chest films classically reveal a bilateral, fine to medium reticulonodular pattern that is generally bilateral, but occasionally not. If the disease is not treated, the radiographic findings will show progressively increasing opacities; ultimately, bilateral homogeneous opacities may be seen. Upper lobe involvement is more common in patients when administered prophylactic pentamadine inhalation therapy was used. The appearance of the chest film may worsen a few days after the patient has been treated with intravenous trimethaprin-sulfamethoxadole, due to overhydration and the production of pulmonary edema, but this can be treated with diuretics. Otherwise, with treatment the radiographic course reflects steady improvement in the patient's condition until by day 11 complete resolution may be seen. In approximately 10% of patients, pneumatoceles develop. These are frequently in the upper lobes and resolve within 2 months. However, they may also lead to pneumothorax,

which can be extremely difficult to treat. Pneumothorax is seen in 5% of patients with PCP and AIDS. In about 10% of patients with PCP, the chest film may be normal. In some of those patients, a CT scan will show the typical geographic appearance of ground-glass opacities associated with PCP. Lymphadenopathy and pleural effusions are not part of the PCP picture.

Cytomegalovirus infection may mimic the look of PCP on chest film, with diffuse, bilateral, fine to medium reticulonodular opacities. On CT, centrilobular nodules and ground-glass opacities have been reported, and in a fairly large number of patients with cytomegalovirus (CMV) the presence of discrete nodules, sometimes several centimeters in size, may help in distinguishing between these two entities.

Disseminated fungal infections, such as histoplasmosis and coccidioidomycosis, generally produce bilateral, fairly symmetric, coarse nodular opacities on chest radiographs. The nodules and occasionally reticular opacities are larger than those seen with PCP and this may aid in distinguishing between the processes.

Tuberculosis will appear differently depending on the immune status of the patient. In patients with relatively normal CD-4 lymphocyte counts, TB will look much like it does in the general population. That is, with primary infection patients will present with a homogeneous lobar opacity and ipsilateral hilar and/or mediastinal adenopathy. With post-primary infection, patients will present with apical and posterior upper lobe and/or superior segment lower lobe heterogeneous opacities with or without cavitation. In patients with low CD-4 cell counts and primary infection, the chest film may show homogeneous lobar opacities with adenopathy similar to immune-competent hosts, but the chance of increased adenopathy is present. With post-primary disease, the bacterium disseminates more widely, creating a diffuse coarse nodular pattern on chest film similar to the pattern seen with fungal infections. Cavitation is not seen since the body's response is weak; well-formed granulomas and necrosis are also not usually seen. If the bacterium is sensitive to the appropriate therapy, then some resolution of the abnormal findings on chest film should be observed within one week.

Ordinary bacterial infections occur with increased frequency in patients with HIV disease. These usually appear as they do in normal hosts as homogeneous lobar opacities. They should begin to resolve within days after the institution of antibacterial therapy and complete resolution of abnormalities is seen in the majority of patients in about 2 weeks.

Two neoplasms, related to infections, may also be seen in patients with AIDS and could cause confusion in generating a differential diagnosis. Non-Hodgkin's lymphoma will produce well-defined nodules on chest film. The nodules range in size from about 1 cm to several centimeters. Solitary or multiple nodules may be noted. Lymphadenopathy and pleural effusions are also observed. The nodules have a tendency to grow extremely rapidly.

Whereas the nodules with NHL are very well-defined, those seen with Kaposi's sarcoma are not. This disease produces poorly marginated nodules that tend to coalesce. They occur most often in the perihilar lung and lower lobes. On CT, the distribution is along bronchovascular pathways. In almost all cases of Kaposi's sarcoma involvement in the lungs, cutaneous lesions will be seen.

Other Immune-Compromised Conditions

Increasing numbers of transplant procedures, both solid organ and bone marrow, have led to the widespread use of induced immunosuppression. Steroids are also being administered with increased frequency for a number of medical conditions. As a result, infectious complications in the setting of transplantation or steroid use have become a major problem. While prophylactic treatment (with anti pneumocystis, cytomegalovirus, and occasionally fungal drugs) of these patients leads to some reduction in the number of infections, not all cases are prevented. The appearances on chest film of PCP and CMV will be similar to that in patients with HIV infection and were described in the section above.

Other viral pathogens are seen with greater frequency in this setting, including varicella zoster, which may occur in patients with lymphoma and those undergoing steroid therapy. On chest film, varicella pneumonia usually produces bilaterally symmetric acinar opacities (nodules about 7-10 mm in diameter) that may coalesce as the disease worsens. CT shows similar-sized nodules and distribution as well as ground-glass opacities.

Among the fungal organisms seen with some regularity in this group of immunocompromised patients are cryptococcus and aspergillus. Cryptococcus has numerous types of presentation on chest film. Perhaps most common is the appearance of well-defined nodules, usually solitary but sometimes multiple. If the nodules become masses, the margins may be indistinct. The nodules may cavitate. Cryptococcus can also manifest as a lobar pneumonia or as diffuse heterogeneous reticulonodular opacities.

Aspergillus fumigatus is the usual species responsible for lung infections. The pattern of abnormality seen on chest film depends on the patient's immune status. In the setting of immunosuppression (neutropenia), the typical appearance is that of invasive aspergillosis. In this form of disease, the chest film initially demonstrates a poorly-marginated area or areas of homogeneous opacity that may resemble ordinary bacterial pneumonia in look and distribution, but such lesions are occasionally more round and distant from the subpleural lung than is the case in common community infections. In some cases, the disease is peripheral and wedge-shaped secondary to infarction caused by the angioinvasive obstruction of pulmonary vessels. In time, the lesions become more discrete and round, thus taking on the look of lung masses. As patients are treated and immune status improves, there may be cavitation within the masses with the formation of an air crescent. The cavity wall is generally of moderate thickness. The air crescent is created by the contained necrotic debris within the cavity. On CT, the areas of homogeneous opacity may initially show air bronchograms, and additional regions of involvement are commonly identified. A 'halo sign' may be observed. The halo is a ground-glass opacity that surrounds (frequently incompletely) a more opaque center of the lesion. The ground-glass portion is an area of hemorrhage and the central area is necrotic lung. The 'halo sign' was thought to be pathognomonic of invasive aspergillosis, but can be seen with other infections, neoplasms, and inflammatory diseases.

Take Home Messages: Usefulness of Imaging Methods in Pulmonary Infections

Despite the increasing use of CT imaging for the diagnosis of chest disorders, plain film radiography is still the primary imaging modality for patients with suspected pneumonia. The presence of a characteristic lung opacity on a chest radiograph is considered the 'gold standard' for diagnosing pneumonia. The radiologist's extensive knowledge of the radiographic appearances of pulmonary infections, their complications, and course is essential in aiding the referring clinician and ultimately the patient. CT imaging is useful in patients with CAP and NP when there is an unresolving or complicated chest film, and at times in immunocompromised patients with suspected pulmonary infections. CT can help in differentiating infectious from non-infectious abnormalities, and it may detect empyema, cavitation, and lymphadenopathy when chest films cannot. Immunocompromised patients with a clinical suspicion of pneumonia should undergo CT examination when the chest film is normal. This is especially true when the early diagnosis of pneumonia is critical, as is the case with immunocompromised and severely-ill patients.

To reiterate, no pattern of abnormality seen on chest films can be considered pathognomonic of a specific infection. However, the distribution and appearance of lung opacities, especially in conjunction with clinical information, should enable the radiologist to produce a useful, ordered list of most-likely possibilities helpful to our clinical colleagues and most importantly to their patients.

Acknowledgement

Special thanks to Professor CJ Herold, Department of Radiology, University of Vienna, Vienna General Hospital, Vienna, Austria for providing help and material for the extended abstract.

Suggested Reading

Albaum MN, Hill LC, Murphy M (1996) Interobserver reliability of the chest radiograph in community-acquired pneumonia. Chest 110:343-350

Bartlett JG, Dowell SF, Mandell LA et al (2000) Practice guidelines for the management of community-acquired pneumonia in adults. Infectious Diseases Society of America. Clin Infect Dis 31:347-382

Basi SK, Marrie TJ, Huang JQ, Majumdar SR (2004) Patients admitted to hospital with suspected pneumonia and normal chest radiographs: epidemiology, microbiology, and outcomes. Am J Med 117:305-311

British Thoracic Society Standards of Care Committee (2001) BTS Guidelines for the management of community acquired pneumonia in adults. Thorax Suppl. 4:IV1-IV64

Connolly JE Jr, McAdams HP, Erasmus JJ et al (1999) Opportunistic fungal pneumonia. J Thorac Imaging 14(1):51-62

Escuissato DL, Gasparetto EL, Marchiori E et al (2005) Pulmonary infections after bone marrow transplantation: high-resolution CT findings in 111 patients. AMJ Am J Roentgenol 185:608-615

Fang GD, Fine M, Orloff J et al (1990) New and emerging etiologies for community-acquired pneumonia with implications for therapy. A prospective multicenter study of 359 cases. Medicine (Baltimore) 69:307-316

Franquet T, Gimenez A, Hidalgo A (2004) Imaging of opportunistic fungal infections in immunocompromised patients. Eur J Radiol 51(2):130-138

Goodman P (2006) Radiographic Assessment of HIV-Related Diseases. In: Peiper L, Volberding P (eds) CD-ROM version. HIV InSite Knowledge Base

Goodman PC (2007) Pulmonary Infection in Adults. In: Grainger RG, Allison DJ (eds) RG Grainger & DJ Allison's Diagnostic Radiology: a Textbook of Medical Imaging, 5th ed. Churchill Livingstone, London-New York (in press)

Hansell DM, Armstrong P, Lynch DA, McAdams HP (2005) The immunocompromised patient. In: Imaging of Diseases of the Chest, 4th ed. Elsevier Mosby, Philadelphia, Chapter 6

Herold CJ, Sailer JG (2004) Community-acquired pneumonia and nosocomial pneumonia. Eur Radiol 14:E2-E20

Heussel CP, Kauczor HU, Ullmann AJ (2004) Pneumonia in neutropenic patients. Eur Radiol 14:256-271

Jung JI, Kim H, Park SH et al (2001) CT differentiation of pneumonic-type bronchioloalveolar cell carcinoma and infectious pneumonia. Br J Radiol 74:490-494

Kim EA, Lee KS, Primack SL et al (2002) Viral pneumonias in adults: radiologic and pathologic findings. Radiographics 22:S137

Leung AN (1999) Pulmonary tuberculosis: the essentials. Radiology 210:307-322

Leung AN, Brauner MW, Gamsu G et al (1996) Pulmonary tuberculosis: comparison of CT findings in HIV-seropositive and HIV-seronegative patients. Radiology 198:687-691

Lieberman D, Shvartzman P, Korsonsky I, Lieberman D (2003) Diagnosis of ambulatory community-acquired pneumonia. Comparison of clinical assessment versus chest X-ray. Scand J Prim Health Care 21:57-60

Mabie M, Wunderink RG (2003) Use and limitations of clinical and radiologic diagnosis of pneumonia. Semin Respir Infect 18:72-79

Mandell LA, Bartlett JG, Dowell SF et al (2003) Update of practice guidelines for the management of community-acquired pneumonia in immunocompetent adults. Clin Infect Dis 37:1405-1433

Melbye H (2002) Community pneumonia - more help is needed to diagnose and assess severity. Br J Gen Pract 52:886-888

Melbye H, Dale K (1992) Interobserver variability in the radiographic diagnosis of adult outpatient pneumonia. Acta Radiol 33:79-83

Metlay JP, Fine MJ (2003) Testing strategies in the initial management of patients with community-acquired pneumonia. Ann Intern Med 138:109-118

Metlay JP, Kapoor WN, Fine MJ (1997) Does this Patient have community-acquired pneumonia? Diagnosing pneumonia by history and physical examination. JAMA 278:1440-1445

Niederman MS, Mandell LA, Anzueto A et al (2001) American Thoracic Society. Guidelines for the management of adults with community-acquired pneumonia. Diagnosis, assessment of Severity, antimicrobial therapy, and prevention. Am J Respir Crit Care Med 163:1730-1754

Primack SL, Hartmann TE, Lee KS, Mueller NL (1994) Pulmonary nodules and the CT halo sign. Radiology 190:513-515

Reeders JW, Goodman PC (2001) Differential radiological patterns in AIDS at a glance. In: Reeders JW, Goodman PC (eds) Radiology of AIDS. Springer-Verlag, Heidelberg, pp 293-324

Reittner P, Müller NL, Heyneman L et al (2000) Mycoplasma pneumoniae pneumonia: radiographic and high-resolution CT. Features in 28 patients. AJR Am J Roentgenol 174:37-41

Speets AM, Hoes AW, van der Graal Y et al (2006) Chest radiography and pneumonia in primary care: diagnostic yield and consequences for patient management. Eur Resp J 28:933-938

Syrjala H, Broas M, Suramo I et al (1998) High-resolution computed tomography for the diagnosis of community-acquired pneumonia. Clin Infect Dis 27:358-363

Wagner AL, Szabunio M, Hazlett KS et al (1998) Radiologic manifestations of round pneumonia in adults. AJR Am J Roentgenol 170:723-726

Thoracic Imaging in the Intensive Care Unit

M. Maffessanti[1], U. Lucangelo[2], A. Pellegrin[1], G. Berlot[2]

[1] Department of Radiology, Cattinara Hospital, University of Trieste, Trieste, Italy
[2] Department of Perioperative Medicine, Intensive Care, and Emergency, Cattinara Hospital, University of Trieste, Trieste, Italy

Introduction

Imaging in the intensive care unit (ICU) has to deal with several disorders affecting the *critically ill patient*. In such patients, one or more organs are so compromised that management requires continuous monitoring of vital functions and their support through external devices, either mechanical or pharmacological. Above all, two functions of exceeding importance are often impaired and require external support: *respiration* and *circulation*. The task frequently involves the use of mechanical instruments and the administration of fluids and drugs, in turn, may interfere with, or even damage thoracic organs and structures.

This article deals with the respiratory and circulatory problems of the critically ill in the ICU, as well as the side effects and complications associated with the use of monitoring and support. The imaging techniques involved in the management of the critically ill are manifold, but the most important remains the chest X-ray (CXR). Plain films are valuable in identifying clinically suspected or unexpected new abnormalities, monitoring already known lesions, and in the management of mechanically ventilated patients.

The obstacles caused by low-quality films, repeatedly remarked upon by the older literature, have all but disappeared due to the present availability of high performance X-ray equipment, dedicated screen film systems, and the more widespread use of computed radiography. However, the need to obtain high-quality films should not be undervalued. The amount of information present in a radiograph is great, provided that the films are taken at the peak of the inspiratory cycle and that a projection respectful of the symmetries is used. Knowledge of selected technical and clinical information (patient's exact position, modalities of ventilation, etc.) is useful and often mandatory to evaluate adequately lung volumes, flow distribution, diffuse or focal abnormalities, and the status of the mediastinum and the heart. Last, but not least, the actual position of the devices must be taken into account so as to allow the radiologist to recognize misplacements or complications.

It is also very important for the radiologist to be aware that, when dealing with the critically ill patient, knowledge not only of morphology but also of physiology and physiopathology is mandatory. Moreover, correct interpretation of the films requires that the clinician be well-aware of the patient's respiratory and circulatory condition, as it is the key to understanding the images and often essential to assigning the radiological signs to their appropriate clinical context. Indeed, the main aim of this article is to present physiopathological and practical information useful for interpreting the radiological aspects based on clinical grounds.

Respiration

Many conditions identifiable on chest images are related to pathologies of the respiratory and/or circulatory systems. Their clinical presentation is commonly accompanied by respiratory difficulties, which in turn may lead to the derangement of one or more organs and systems, eventually to catastrophic consequences. A quick review of the physiopathology of these conditions and ready knowledge of the relevant normal and abnormal clinical parameters is helpful, and encourages productive discussion with the intensivist in the clinical radiology setting.

Parameters

Respiration serves to oxygenate the blood and to remove the volatile waste product of metabolism, carbon dioxide (CO_2) [1]. In charge of this process is the respiratory system; simply stated, its role is to maintain normal arterial blood PO_2, PCO_2, and pH [2]. Usually, the system is tightly controlled; in particular, the pH of arterial blood (pHa) is kept between 7.35 and 7.43 within 95% confidence limits. PHa is largely determined by the relative concentrations of bicarbonate (HCO_3^-) and carbon dioxide (CO_2) in the blood: the former is controlled principally by renal conservation or excretion of bicarbonate and hydrogen ion, the latter largely by pulmonary ventilation [2].

Since it is impossible to predict PaO_2 and $PaCO_2$ accurately using clinical criteria, the diagnosis of respiratory failure has to rely on arterial blood gas (ABG) analysis [1], usually performed via puncture of the radial artery.

The normal ABG values are shown in Table 1.

Table 1. Arterial blood gas (ABG) analysis (room air, sea level)

	Range	Units
pH	7.38-7.42	Absolute
PaO_2	75-100	mmHg
$PaCO_2$	38-42	mmHg
HCO_3^-	22-26	meq/l
O_2 sat	94-100	%

PaO_2 measures the effectiveness of oxygenation, $PaCO_2$ the effectiveness of ventilation [2]. ABG indicates the main reason for a respiratory failure, either failure of the lungs (hypoxemia with hypocapnia or normocapnia) or failure of the thoracic diaphragmatic pump (hypoxemia with hypercapnia; see below).

Another important parameter to contemplate when looking at the ABG is the amount of oxygen in the inhaled air. This is indicated as FiO_2 (fractional inspired oxygen concentration) and is given as fraction of a unit or as a percentage. For room air, the FiO_2 is equal to 0.21 (21%); through use of a ventilator this fraction can be enriched up to a FiO_2 of 1 (100%).

Hypoxemia

Hypoxemia is a reduction of the PaO_2 to <70 mmHg in room air; its consequences depend on the underlying disease entity. Although hypoxemia to <30 mm Hg and acute hypercapnia (up to 70 mm Hg, pH 7.16) may lead to coma and circulatory collapse, chronic exposure permit adaptation with more subtle effects. Thus, the ABG provides the most important way of diagnostically assessing the nature and severity of a respiratory or metabolic disturbance and of following its progression or resolution over time [1].

As for the gravity, hypoxemia is defined as shown in Table 2.

Unsuspected hypoxemia or hypercapnia can cause a constellation of central nervous system and cardiovascular signs and symptoms [2].

Acute Respiratory Failure

Respiratory failure is the inability of the respiratory system to maintain a normal state of gas exchange from the atmosphere to the cells, as required by the body. With few exceptions, respiratory failure is present if PaO_2 is <60 mm Hg in room-air breathing ($FIO_2 = 0.21$) or

Table 2. Definition of hypoxemia

Hypoxemia	mmHg
Mild	60-69
Moderate	50-59
Severe	<50

$PaCO_2$ is >45 mm Hg, but hypoxemia while breathing supplemental oxygen also indicates respiratory failure [2].

Acute respiratory failure (ARF) can result from impairment of lung ventilation or perfusion, or their coupling (the right ventricle and its output should be considered functionally as part of the respiratory system). While not defined as respiratory failure, dysfunctions of the heart, the pulmonary and systemic circulations, the oxygen-carrying capacity of the blood, and the systemic capillaries nonetheless have important implications for patients with respiratory failure [1].

ARF from diseases that directly affect the lungs (lung failure) involve the airways, alveolar spaces, interstitium, and pulmonary circulation, and such patients almost always present with low arterial PaO_2 but normal or low $PaCO_2$ – the latter distinguishing them from those with hypercapnic respiratory failure, in which the primary problem is alveolar hypoventilation. Examples of diseases that may lead to ARF include bacterial or viral pneumonia, aspiration of gastric contents, acute respiratory distress syndrome, pulmonary embolism, asthma, and interstitial lung diseases [2].

ARF resulting from disorders of the respiratory system other than the lungs (pump failure) usually causes hypercapnia [2]. The two pathways, lung failure and pump failure, are discussed in further detail below.

Lung Failure

Definition

Hypoxemic respiratory failure indicates disease affecting the lung parenchyma or pulmonary circulation. Affected patients have abnormally low arterial PO_2 but normal or low $PaCO_2$.

Causes

Causes of lung failure include bacterial or viral pneumonia, aspiration of gastric contents, acute respiratory distress syndrome, pulmonary embolism, asthma, and interstitial lung diseases.

Effects

Arterial hypoxemia increases ventilation by stimulating carotid-body chemoreceptors and leads to dyspnea, tachypnea, hyperpnea and, usually, hyperventilation. There may be cyanosis, which is especially marked in the distal extremities but also centrally prominent around the mucous membranes and lips.

Hypoxia in the tissues causes a shift to anaerobic metabolism, accompanied by the generation of lactic acid. Manifestations of hypoxemic respiratory failure are magnified in the presence of impaired tissue oxygen delivery: examples of this are the increased risk of myocardial ischemia from hypoxemia in a patient with coexisting coronary artery atherosclerosis or a patient with hypovolemic

shock who shows evidence of lactic acidosis in the presence of mild arterial hypoxemia [2].

Clinical Features

Manifestations of hypoxemic respiratory failure are the result of a combination of features of arterial hypoxemia and tissue hypoxia. Hypoxia may cause impaired mental performance, an increase of sympathetic nervous system activity accompanied by tachycardia, diaphoresis, and systemic vasoconstriction, leading to hypertension. Severe hypoxia, however, can lead to bradycardia, vasodilation, and hypotension as well as to myocardial ischemia, infarction, arrhythmias, and cardiac failure due to an increase of the pulmonary vascular resistance [2].

Pump Failure

Definition

Patients with pump failure have hypercapnic respiratory failure; by definition, the PCO$_2$ levels (PaCO$_2$) are raised. Since CO$_2$ is elevated in the alveolar spaces, O$_2$ is displaced from the alveoli and arterial PO$_2$ decreases. Thus, patients with pump failure usually have both hypercapnia and hypoxemia, unless the inspired gas is enriched with oxygen.

Causes

Examples of thoracic diaphragmatic pump failure include diseases that result in weakness of the respiratory muscles, central nervous system diseases that disrupt ventilatory control, and conditions that affect chest wall shape or size, such as kyphoscoliosis.

Effects

Increased arterial PaCO$_2$ is a central nervous system depressant, but the mechanism is primarily through a fall of pH in the cerebrospinal fluid, resulting from acute elevation of PaCO$_2$. The major differential diagnostic point is between hypercapnic respiratory failure due to pump disorders versus lung disease. Patients with lung disease will often have hypoxemia out of proportion to the degree of hypercapnia [2].

Clinical Features

Acute hypercapnia acts largely on the central nervous system. Symptoms of hypercapnia may overlap those of hypoxemia; consequently, dyspnea, tachypnea, and hyperpnea may be associated with hypercapnic respiratory failure just as often as bradypnea and hypopnea [2].

Ventilation Techniques

A subject with hypoxemia, in particular in the setting of ARF, must be supported artificially.

Spontaneous Ventilation

Physiologically, ventilation is entirely managed by the subject. Anytime the length or thickness of the thoracic cavity increases or decreases, simultaneous changes in lung volume occur. During inspiration, the pressure in the alveoli decreases to about -1 cm H$_2$O, this slight negative pressure is sufficient to move about 0.5 l of air into the lungs within the 2 s required for inspiration. During expiration, the opposite occurs: alveolar pressure rises to about +1 cm H$_2$O, which forces 0.5 l of inspired air out of the lungs during the 2-3 s of expiration. Control of ventilation consists of a network of sensors (chemoreceptors, lung receptors) that provide information to a central controller (pons, medulla), which activates an array of respiratory muscles: the diaphragm, intercostal muscles, abdominal muscles, and accessory muscles such as the sternomastoids [3].

Mechanical Ventilation

Most patients admitted to the ICU care require some form of respiratory support. This is usually because of hypoxemia or ventilatory failure, or both. The support offered ranges from oxygen therapy by face mask, through non invasive techniques, to full ventilatory support with endotracheal intubation [3].

The goals are to reverse life-threatening hypoxemia or acute progressive respiratory acidosis and to decrease the work of breathing. The most noticeable difference between wave-forms of mechanical and spontaneous ventilation is that the former uses positive pressures (hence the name 'positive pressure ventilation'), which may reach levels that are much higher than in the latter.

Oxygenotherapy

Oxygen is administered to treat simple hypoxemia. Patients should initially be given a high concentration; the amount can be subsequently adjusted according to the results of pulse oximetry and ABG analysis. Oxygen may be given by face mask, nasal prongs, or cannulas. A fixed-performance, high-flow air-entrainment mask can provide a known fractional inspired oxygen concentration (FiO$_2$), within a range 0.24-0.60 [3].

Non-invasive Positive Pressure Ventilation

If the patient remains hypoxemic on high-flow oxygen (15 l/min), continuous positive airways pressure (CPAP) may be used. Patients must be cooperative and have the strength to breathe spontaneously against a continuous positive pressure administered by a nasal or face mask. The technique improves oxygenation by recruiting underventilated alveoli and thus is most successful in those clinical situations in which alveoli are readily recruited, such as acute pulmonary edema and postoperative atelectasis. It is also helpful in immunocompromised pa-

tients with pneumonia. As intubation is avoided, the risks of nosocomial pneumonia are reduced [3].

Invasive Mechanical Ventilation

Endotracheal intubation and ventilation are the next steps in the management of respiratory failure. Inspiratory gas is pushed into the chest by the ventilator, which performs either a portion of or the entire work required to inflate the lungs and chest wall [4]. Tracheostomy is usually done electively when intubation is likely to be prolonged (>14 days), but it may also be done for the patient's comfort and to facilitate weaning from the ventilator.

No consensus exists on the best method of ventilation. However, one should keep in mind that the higher the degree of injury related to stretching and volume change of the respiratory system due to ventilator usage, the higher the risk of complications (volotrauma, commonly called barotrauma).

Circulation

Central Venous Pressure

Central venous pressure (CVP) describes the pressure in the thoracic vena cava near the right atrium (therefore, CVP and right atrial pressure are essentially the same); it is measured with a central venous catheter at the level of the superior vena cava. CVP is an important concept because it is a major determinant of the filling pressure (preload) of the right ventricle, which regulates stroke volume. A normal value in a spontaneously breathing patient is 5-10 cmH$_2$O, rising by 3-5 cmH$_2$O during mechanical ventilation. CVP is low under hypovolemic conditions and low or normal during sepsis. It rises in the presence of a tension pneumothorax, right cardiac failure, pericardial tamponade, and fluid overload conditions.

Pulmonary Arterial Pressure

The lungs are the only organs that receive the entire cardiac output, which is delivered at a mean resting pulmonary arterial pressure of 15 mmHg. The pulmonary circulation is a low-pressure, low-resistance circuit capable of handling large increases in pulmonary blood flow (up to six-fold with strenuous exercise) with only small changes in pressure. The maintenance of a low pulmonary capillary pressure is vital in preserving the function of the blood-gas barrier. The pressure within the right heart and pulmonary arteries must be measured through a Swan-Ganz catheter, which is a central venous catheter with a small inflatable balloon near the tip.

Pulmonary Capillary Wedge Pressure

When the Swan-Ganz catheter balloon is inflated in a distal pulmonary vessel, its tip measures the distal pressure. There is only a continuous column of fluid between the tip of the

catheter and the left atrium, without interference from heart valves and lung pathology. Therefore, pulmonary capillary wedge pressure (PCWP) is a good approximation of the pressure in the left atrium and provides evidence regarding venous return to the left side of the heart (Table 3).

Hypoxemia in the Intubated and Mechanically Ventilated Patient

In the ventilated patient, the causes of hypoxemia may be due to the patient or to the treatment itself. Causes due to the patient may be of systemic origin and include hyperthermia, pain, agitation, epilepsy, hemorrhage. Those of pulmonary and/or cardiac origin consist of atelectasis, contusion (in trauma patients), pneumonia, pleural effusion, aspiration, pulmonary edema, acute lung injury (ALI)/ARDS, fluid overload, asthma, reduced cardiac output, and pulmonary thromboembolism (with/without infarction). The latter group can usually be identified radiologically as diffuse or focal opacities. A reduced cardiac output and simple pulmonary thromboembolism without infarction may present as a diffuse or focal hyperlucency of the lung with oligemia.

Causes due to treatment itself include ventilator malfunctioning or disconnection, tracheal tube or cannula obstruction or malpositioning, insufficient FiO$_2$, and barotrauma; the latter also radiologically detectable.

Atelectasis

Definition

Atelectasis is defined as a collapse of the alveoli, with a reduction in the quantity of intrapulmonary air. In the ICU, it remains a frequent and severe complication occurring during spontaneous or mechanical ventilation.

Mechanisms

Postoperative diaphragmatic dysfunction is the major cause of alterations in respiratory mechanics and subsequent atelectasis. Moreover, general anesthesia decreases

Table 3. Pressures in the superior vena cava and right heart (normal values, mmHg)

	Mean	Range
Central venous pressure (CVP)	7	5-10
Right atrium	5	1-10
Right ventricle	25/5	15-30/0-8
Pulmonary artery (systolic/diastolic)	23/9	15-30/5-15
Pulmonary artery (mean)	15	10-20
Pulmonary capillary wedge pressure (PCWP)	10	5-15
Left atrium	8	4-12
Left ventricle (systolic)	130	90-140

total pulmonary compliance and favors the development of atelectasis in the dependent zones of the lung. Finally, reduction of mucociliary clearance and of the cough reflex contributes to the stagnation of bronchial secretions and favor atelectasis formation [4].

Risk Factors

Post-anesthesia alveolar hypoventilation, type of surgery, posture (maintaining the patient in a supine or lateral position), abdominal distention, pain that limits thoracic expansion, age, obesity, smoking attitude, chronic respiratory conditions, dehydration with hyperosmolarity, pathological conditions such as pneumothorax, and hemothorax are all risk factors for atelectasis. Patients in the postoperative period, in particular, ventilate at a greater respiratory rate and with a smaller tidal volume, with the usual consequence of alveolar collapse and reduction of functional residual capacity (FRC) under the closing volume [4].

Consequences

Tidal volume, vital capacity, and FRC are diminished, leading to a restrictive syndrome with reduction of pulmonary volumes. The immediate effect is the development of an intrapulmonary shunt and then eventually severe hypoxemia. Their severity is correlated with the degree of atelectasis. Infectious complications may also occur [4].

Radiology

Atelectasis is characterized by partial or lobar consolidation, more often seen in the lower lobes, particularly to the left. The radiographic hallmark of this collapse is an increased opacity of the left cardiac region and a concomitant disappearance of the diaphragm. Some degree of proximal air bronchogram can be seen. Due to the gravitational component of the process, reversing the patient to the upside down position may lead to a reduction of the opacities in the dependent dorsal lung and their horizontal appearance (well-demonstrated with CT) [5].

Contusion

Definition

Pulmonary contusion is an injury to the lung parenchyma that leads to edema and blood collection in the alveolar spaces, with subsequent loss of normal lung structure and function [6]. It is the most frequent finding after major blunt chest trauma. Aspiration is also common in trauma subjects and may not be distinguishable from the former [7].

Mechanisms

Following blunt trauma (e.g., deceleration, blast injury), a pressure wave compresses the thoracic cavity, injuring the

underlying lung. In young people, the pliable chest wall often returns to normal without rib fracturing; however, with increasing age, rib fractures are more common [7].

Risk Factors

Subjects with extensive or multiple injuries are at greater risk of having pulmonary contusions; these occur in approximately 20% of patients with blunt traumas and an Injury Severity Score >15 [6].

Consequences

Contusion develops over the course of 24 h. The majority of patients have minimal respiratory deficit; nevertheless, depending on the cause of the damage, the condition may lead to poor gas exchange, increased pulmonary vascular resistance, and decreased lung compliance. There is also a significant inflammatory reaction to blood components in the lung. Possible complications of extensive massive contusions are atelectasis, pneumonia, respiratory failure, and ARDS [6].

Radiology

Since contusions are hemorrhages inside lung parenchyma and alveoli, they show up as patchy or diffuse areas of airspace disease. The opacities are indistinguishable from those of any other cause of airspace disease, except for the absence of air bronchogram (the bronchi are filled with blood). Usually, in addition to their presence at the site of direct impact, contusion may also occur on the opposite side (counter-blow injury). The densities may mask underlying areas of *pulmonary laceration*, which may become apparent, after the contusion clears, as focal hyperlucencies (if they contain air) or well-delimitated roundish opacities (if they contain blood; *hematomas*). The hallmark of contusion is rapid resolution that may be complete within 24-48 h [6].

Pneumonia

Definition

Nosocomial pneumonia is the second most frequent hospital acquired infection after urinary tract infections. It is estimated that at least 5% of hospitalized patients will develop a nosocomial infection, and nosocomial pneumonia is responsible for 15% of all nosocomial infections [2]. However, the incidence among ventilated patients is much greater and is associated with a risk that may be as much as 20 times higher, with reported rates as high as 25-70% [4].

Mechanisms

Pneumonia develops from one of three mechanisms: (1) inhalation of an aerosol containing infectious microorganisms (common); (2) hematogenous seeding of microorganisms in

the lung (uncommon), or (3) aspiration of oropharyngeal flora (most common) [2]. Aerosol inoculation (nebulizers) or contamination of respiratory equipment (mechanical ventilators) is a well-known mechanism for respiratory nosocomial transmission. Colonization of the oropharynx with gram-negative bacteria increases from 35% in moderately ill patients to 73% in critically ill patients [4].

Risk Factors

Reservoirs such as dental plaque, sinuses, and nasal mucosa may serve as the initial reservoir for oropharyngeal colonization, but antibiotic therapy also seems to be one of the more important cofactors related to the development of pneumonia. Gastric colonization may occur with advanced age, achlorhydria, alterations in gastric juice secretion, and particularly with treatment with antacids or H_2 blockers prescribed for stress-bleeding prophylaxis in critically ill patients [4].

Consequences

Postmortem studies of human ventilator-associated pneumonia (VAP) have demonstrated that pneumonia in critically ill patients is a diffuse polymicrobial process with a nonhomogeneous distribution of micro-organisms. Furthermore, it is an ongoing dynamic structural process, showing different degrees of histological evolution, which are multifocal and predominate in lung-dependent zones. The association of pneumonia and diffuse alveolar damage is not an uncommon finding [4]. The mortality rates are in the range of 5-20% when pneumonia is due to gram-positive cocci, 30-50% with enteric gram-negative bacilli, and up to 70% with *Pseudomonas aeruginosa* infection [2].

Radiology

Although plain films cannot provide a specific microbial diagnosis in a patient with pneumonia, radiology has a central role in both initial evaluation and treatment. The chest radiograph documents the presence and extent of disease, cavitation, associated parapneumonic effusions, and abscess formation. Radiographically, nosocomial pneumonia is heralded by the development of new or worsening parenchymal opacities, usually multifocal. Development of cavitation helps to distinguish nosocomial pneumonia from other causes of parenchymal opacification, such as atelectasis, lung contusion, and pulmonary edema. The chest radiograph is also critical in evaluating the patient's response to therapy [2].

Pleural Effusion

Definition

Pleural effusion is a common development with pleural disorders and frequently indicates a significant underly-

ing systemic disease. The rate of fluid formation and reabsorption depends on Starling forces, the pleural lymphatics, and the pleural surface area. In the normal physiological state, the balance between these forces creates a gradient in which absorption of pleural fluid by the visceral pleura is favored. Only a small volume of fluid (0.1-0.2 ml/kg body weight) is maintained [4].

Mechanisms

Pleural effusions result when there is a breakdown in the balance between hydrostatic and cellular osmotic forces. An increase in hydrostatic pressure in the pulmonary capillaries favors the accumulation of pleural fluid. Inflammatory processes or neoplasms can increase capillary permeability and decrease fluid reabsorption by the visceral pleura, due to obstruction of the lymphatics [4].

Risk Factors

Cardiogenic pulmonary edema and fluid overload with hypovolemia are very typical reasons for pleural effusions. Pleural effusion occurs in up to 40% of patients with bacterial pneumonia. A parapneumonic effusion consists of intrapleural fluid in association with pneumonia or lung abscess; empyema is defined as pus in the pleural space [2].

Consequences

Pleuritic pain and cough are common findings in patients with pleural effusions. Dyspnea is also frequent. The possible causes are decreased vital capacity, pleural splinting, and mechanical distortion of the lung and chest wall [4].

Radiology

The distribution of fluid within the pleural space is largely affected by the elastic recoil of the lung and by gravity. Whereas small effusions and consolidations are frequently missed on the radiographs of supine subjects, larger amounts of fluid are responsible for unilateral densities, reduced visibility of the lower lobe vessels, and missing diaphragm, which can mimic basal atelectasis. However, an air bronchogram is not seen with the effusion, and a blunted costophrenic angle, an extrapulmonary pleural band, and an apical cap may be observed around the peripheral lung whenever the pleural liquid spills over enough to create tangency. The above mentioned features are the general rule; however, in particular conditions, very dense and homogeneous parenchymal consolidations, especially following extensive contusions in trauma patients, may not show an air bronchogram and thus will mimic effusions. Ultrasound and CT are valuable in differentiating which compartment is involved and to quantify the effusion whenever pleural drainage is considered [5].

Aspiration

Definition

Aspiration of gastric contents leading to ARDS is defined as an observed aspiration during intubation or witnessed vomiting in a patient with impaired airway protective mechanisms [2]. Gastric content with a pH <2.5 and a volume of 25-50 ml has been shown to be far more damaging than an equal volume of a more alkaline fluid; however, even the aspiration of particulate contents at neutral pH can have severe consequences [4].

Mechanisms

Initially, the inhalation of food particles results directly in mechanical obstruction of the airways, with distal collapse leading to increased shunt, loss of FRC, and an increase in the work of breathing. Later, in response to either acidic fluid or particulate matter, there is a chemical-injury-type response, with bronchorrhea, bronchoconstriction, and mucosal edema [4]. Studies have supported a contributory role for bacteria, partially digested food particles, gastric enzymes, and other noxious substances [2].

Risk Factors

The aspiration of gastric contents is a feared complication in the obtunded patient [4]. It is particularly common in subjects of advanced age, those with neurologic diseases resulting in impaired swallowing, or those who have advanced organ system failure. The potential for aspiration is increased by administration of sedatives, muscle relaxants, general anesthesia, local anesthesia to the pharynx and larynx, endotracheal intubation, enteral feeding, and in diabetics or other individuals with impaired gastrointestinal motility [2].

Consequences

The associated reduction in airway defenses increases the risk of bacterial infection [4]. Aspiration of gastric content and other syndromes of aspiration, including necrotizing pleuropulmonary infection and lung abscess, can lead to ARDS if there is a severe response to lung injury or in the presence of sepsis [2].

Radiology

Aspiration results in consolidations in dependent regions of the lung. Accordingly, the location of the pneumonia will vary depending on the patient's position at the time of aspiration. In the supine patient, the superior segments of the lower lobes, the posterior segment of the right upper lobe, and the posterior subsegment of the left upper lobe are involved, usually on both sides. The more direct continuation of the right main bronchus with the trachea results in a higher percentage of right-sided abnormalities in the supine patient. Due to frequent subsequent infection with anaerobes, cavitation and abscess formation may be seen. Effusions are infrequent. Patients who aspirate gastric contents may develop a chemical pneumonitis that shows characteristics consistent with noncardiogenic pulmonary edema [2].

Cardiogenic Pulmonary Edema

Definition

Cardiogenic pulmonary edema is an accumulation of water outside the vascular compartment of the lung. In the presence of a healthy alveolar-capillary membrane, the normal Starling forces (hydrostatic and colloid oncotic pressure) cooperate, thus preventing fluid from accumulating in the alveoli. A small excess of *extravascular lung water* remains in the pulmonary interstitium but it is thereafter removed by the lymphatics.

Mechanisms

Decreased plasma oncotic pressure and obstruction to lymphatic drainage only rarely lead to pulmonary edema but may be contributing factors in the setting of increased hydrostatic pressure. The most common cause of edema is hydrostatic pressure elevation due to cardiac disease.

Risk Factors

Loss of muscle mass (myocardial infarction), reduced myocardial contractility (cardiomyopathy), and modified cardiac kinetic (valvulopathies, severe arrhythmias) are common causes of cardiogenic edema. Co-factors are arrhythmogenic conditions, such as alkalosis, acidosis, hypoxemia, drugs, bronchoscopy, and the insertion of a Swan-Ganz catheter.

Consequences

When hydrostatic pressure increases in the microcirculation, the rate of transvascular fluid filtration rises: a transudate fills and freely moves throughout the interstitium following osmotic (from the periphery to the hylum) and hydrostatic (gravity dependent) gradients. Eventually, the alveoli and bronchi are also flooded with fluid. When the lung interstitial pressure exceeds the pleural pressure, fluid moves also across the visceral pleura, creating pleural effusion.

Radiology

Cardiogenic pulmonary edema initially may present at the level of the interstitial compartment as septal Kerley lines, hilar haze, vascular blurring, bronchial cuffing, and subpleural thickening. If the alveolar phase follows, homogeneous confluent basal infiltrates without air bronchogram become evident. The heart is enlarged. During

follow-up, the opacities may disappear swiftly in response to cardiac drugs and diuretics.

Acute Lung Injury/Acute Respiratory Distress Syndrome

Definition

Acute respiratory distress syndrome (ARDS) can be defined as the clinical syndrome resulting from the severe end of the spectrum of *acute lung injury (ALI)*, with damage to the alveolar epithelium and pulmonary vasculature resulting in increased capillary permeability edema. By definition, ALI does not result primarily from elevated left atrial or pulmonary capillary pressure [2].

Mechanisms

Dense, protein-rich fluid leaking out from the damaged endothelium expands in the extravascular space but does not follow either osmotic or gravity-dependent gradients. Thus, for the same level of hydrostatic pressure, the amount of fluid is larger than in cardiogenic edema. The level of hypoxemia distinguishes ARDS (PaO_2/FiO_2 <200) from ALI (PaO_2/FiO_2 <300).

Risk Factors

Trauma, sepsis, acute pancreatitis, aspiration of gastric content, pulmonary and extrapulmonary infection, tissue necrosis, severe burning, shock, fat embolism, massive blood transfusion, drug overdose, cranial trauma, near drowning, aspiration, cardiopulmonary bypass are risk factors for ALI/ARDS.

Consequences

Patients have severe dyspnea, tachypnea and respiratory distress, refractory hypoxemia (PaO_2/FiO_2 <200 regardless of PEEP) and decreased lung compliance. Features of congestive heart failure are notably absent. Early in ARDS, symptoms and signs are limited to the lungs. If *multiple organ system failure* develops, then clinical features of hepatic, renal, or central nervous system failure may become evident. Mortality was 50-60% in the mid-1980s, but fell to 30-40% in the late 1990s.

Radiology

ARDS usually presents in phases corresponding to the underlying pathology. In the first phase, during a period of hours, it is characterized by capillary congestion, endothelial swelling, exudation of inflammatory fluid into the interstitium, and only minimal fluid in the alveoli. At this point, the lung density on the chest film is normal or slightly reduced but the pulmonary volumes progressively reduce. Radiology is useful in this early stage because it excludes pneumothorax, atelectasis, iatrogenic complications, and cardiogenic pulmonary edema as the reasons

for the incipient respiratory failure. It also constitutes the baseline for follow-up of the patient.

In the second phase, which may last from days to weeks, there is sloughing of the epithelial lining of the lung (alveolar cells), flooding of airspaces, alveolar atelectasis, and hyaline membrane formation. Radiology shows patchy consolidations that are more homogeneously distributed throughout the lung than those occurring in CPE, and with only some gravity-dependent prevalence. There are also fewer tendencies to confluence and an obvious air bronchogram is typically visible. At this time, radiology should be used to evaluate the amount of fluids in the vascular and extravascular compartments of the lung, monitor their evolution, and detect complications during follow-up.

The late findings depend on the evolution of ARDS: the opacities may progressively resolve or the consolidations may regress, but a coarse reticular pattern with lung remodeling due to residual fibrosis persists. Alternatively, the aspect of the opacities changes little over time, documenting subsequent recurrence of the disease [5].

Fluid Overload

Definition

In the presence of active pulmonary disease, such as pneumonia, ARDS, or pulmonary edema, and suspected prerenal azotemia, aggressive fluid replacement may be implemented, but to the detriment of pulmonary gas exchange. Furthermore, in patients with vasodilatory shock or hypoalbuminemia, substantial edema may be present but the patient still has an insufficient circulating volume. In these settings, monitoring of intravascular pressure becomes invaluable [2].

Mechanisms

No formula exists to predict how much fluid should be given to expand plasma volume in critically ill patients [4]. Clearly, adequate cardiac output and oxygen delivery must be provided to sustain life. However, this is not a simple task because plasma exchanges with the extracellular fluid and is influenced by events occurring at the capillary wall and within endothelial cells. In addition, damage to epithelial cells causes loss of plasma volume into potential spaces [4].

Risk Factors

Sepsis and shock are major factors in diseases such as ARDS, and patients suffering from either often require massive additions of fluid because of hypotension and decreased tissue perfusion [2]. Other conditions that put patients at risk are trauma, burns, major surgery, hypercatabolic states (including sepsis), renal insufficiency, cachexia and dehydration, and imbalanced parenteral nutrition.

Consequences

Pulmonary congestion resulting from fluid overload may occur. Clinically, the evidence consists of respiratory distress with normal left-heart filling pressures and function. The effect of fluid overload is more pronounced when the primary problem involves either a decrease in plasma colloid oncotic pressure or changes in the pulmonary capillary membranes [1].

Radiology

When the patient is overloaded with fluids, the systemic intravascular volume increases and fluid moves from the intravascular to the extravascular space in the lung (i.e., pulmonary edema occurs). Fluid also accumulates in the pleural cavity and in the subcutaneous soft tissues, which increase in thickness.

Barotrauma (Volotrauma)

Definition

Barotrauma is somewhat of a misnomer since it is now understood that lung injury from barotrauma occurs because of excessive and repeated stretching of the lungs, regardless of the pressure. Therefore, a patient with very stiff or noncompliant lungs may require high pressures to ventilate; but because the lungs are not particularly stretched, barotrauma is uncommon in this situation. By contrast, a patient with very compliant lungs, such as are seen in bullous emphysema, requires very low pressures to stretch the lungs considerably. This type of patient is at high risk of barotrauma despite low ventilation pressure, because of the large volume changes [2].

Mechanisms

Air initially escapes into the interstitial spaces of the lungs and tracks along bronchovascular bundles toward the mediastinum. Subsequently, the patient may develop evidence of air surrounding mediastinal structures or pneumomediastinum. If the air separates the lungs and pleura from the inner surface of the chest wall, an extrapleural pneumothorax can form. Another way in which pneumothorax can evolve is through rupture of the lung directly into the space separating the visceral and parietal pleura [2].

Risk Factors

It is likely that both acute lung injury (i.e., thoracic trauma, ARDS) and some forms of chronic lung diseases (i.e., asthma, chronic obstructive pulmonary disease) are associated with an increased risk of barotrauma. ARDS positive-pressure ventilation, especially combined with PEEP, has been associated with explosive barotrauma, including interstitial emphysema and pneumothorax, but there continues to be debate about the rel-

ative contributions of underlying lung disease and positive-pressure ventilation [2].

Consequences

Between 60 and 90% of pneumothoraces in patients on positive-pressure ventilation are under tension. Mortality increases from 7 to 31% when there is a delay from 30 min to 8 h in diagnosing and treating pneumothoraces that occur in patients on ventilators. Avoiding high peak-inspiratory pressures and large tidal volumes reduces the risk of barotrauma and volotrauma, especially in vulnerable patients.

Radiology

Interstitial emphysema, pneumomediastinum, pneumothorax, and hypertension pneumothorax are the specific aspects of barotrauma itself that are seen on the radiograph. In some patients, when there is clinical and radiological evidence of air in the soft tissues and in the mediastinum following a maneuver such as endotracheal intubation, a CT examination is indicated. CT may reveal a complication from the maneuver, such as a tear of the trachea or of a main bronchus, improper positioning of the tube, or an anomalous distension and shape of the balloon [5].

References

1. Irwin RS, Rippe JM (2003) Irwin and Rippe's intensive care medicine, 5th edn. Lippincott Williams & Wilkins, Philadelphia
2. Bongard FS, Sue DY (2002) Current critical care diagnosis & treatment, 2nd edn. Lange Medical Books/McGraw-Hill, New York
3. Shelly PM, Nightingale P (1999) ABC of intensive care respiratory support. BMJ 318:1674-1677
4. Webb AR, Shapiro M, Singer M, Suter P (eds) (1999) Oxford Textbook of Critical Care. Oxford University Press, Oxford
5. Maffessanti M, Berlot G, Bortolotto P (1998) Chest roentgenology in the intensive care unit: an overview. Eur Radiol 8:69-78
6. www.trauma.org
7. www.medcyclopaedia.com

Suggested Reading

Gattinoni L, Caironi P, Pelosi P, Goodman LR (2001) What has computed tomography taught us about the acute respiratory distress syndrome? Am J Respir Crit Care Med 164:1701-1711

Gluecker T, Capasso P, Schnyder P et al (1999) Clinical and radiologic features of pulmonary edema. Radiographics 19:1507-1531

Guyton AC, Hall JH (1998) Textbook of Medical Physiology. WB Saunders, Philadelphia

Miller WT Jr, Tino G, Friedburg JS (1998) Thoracic CT in the intensive care unit: assessment of clinical usefulness. Radiology 209:491-498

Milne EN, Pistolesi M (1993) Reading the Chest Film: A Physiologic Approach. Mosby Year Book, Mosby, St. Louis

Vincent JL, Fink MP, Marini JJ et al (2006) Intensive care and emergency medicine progress over the past 25 years. Chest 129:1061-1067

Ware LB, Matthay MA (2000) The acute respiratory distress syndrome. N Engl J Med 342:1334-1349

Imaging Chest Trauma

R.A. Novelline

Harvard Medical School, and Department of Radiology, Massachusetts General Hospital, Boston, MA, USA

Introduction

Trauma is the third leading cause of death in the USA and the leading cause of death for those under 40 years of age. Approximately 25% of trauma deaths result from thoracic injuries. In the USA each year, more than 300,000 patients are hospitalized and more than 25,000 die as a consequence of chest trauma [1-3]. Blunt trauma accounts for 90% of chest trauma and the most common causes of blunt trauma are motor-vehicle collisions and falls [4, 5].

The imaging workup of patients with suspected thoracic injuries usually begins with a supine, portable chest film taken on arrival to the emergency center. Many obvious thoracic injuries, such as displaced rib fractures, as well as large pneumothoraces and hemothoraces can be quickly detected with this examination. Also, the chest film may confirm proper positioning of an endotracheal tube or nasogastric tube. Other conditions, including small pneumothoraces, small hemothoraces, lung laceration, aortic trauma, tracheobronchial injury, cardiac injury, diaphragm rupture, and thoracic spine injuries, require further imaging with CT. Today multidetector CT (MDCT) scanners can quickly and accurately diagnosis and display, with axial, multiplanar, and volumetric images, a wide variety of thoracic injuries. In the multiple-trauma patient, chest CT can be included as part of a *single acquisition total body trauma scan*, which also includes the patient's head, face, cervical spine, chest, abdomen, and pelvis; when indicated clinically, the scan can be continued downward to include the entire lower extremities.

MDCT Protocol for Suspected Thoracic Injury

Chest CT scans for suspected thoracic trauma should be performed with intravenous contrast material in order to demonstrate any sites of active bleeding and to opacify the heart, aorta, and thoracic blood vessels. Optimum vascular opacification may be obtained with an injection of 75-125 ml of 370 concentration at 3.0 ml/s, with scanning beginning after a 30-s delay. Scans should be ac-quired at thin detector configurations so that high-quality multiplanar and volumetric reformations can be produced from the thin axial images. Routine coronal and sagittal reformations of the chest are recommended for all chest-trauma patients, and optional volumetric (3D), maximal intensity projection (MIP), and curved plane reformations are recommended in positive cases to better show trauma pathology. A detector configuration of 4×1.25 mm is recommended for 4-slice scanners and 16×1.25 mm for 16-slice scanners. Current 64-slice scanners acquire axial slices of <1 mm (sub-mm) thickness. These thin slices can be used to produce high-quality routine coronal and sagittal reformations, and in positive cases are transmitted directly to a workstation for any indicated volumetric or other form of post-processing, such as 3D reformations of fractures and dislocations or CT arteriograms (CTAs) of vascular injuries. The thin slices can also be reformatted for viewing to 2.5- or 5.0-mm axial slices and transmitted to a picture archiving and communications system (PACS) along with the coronal and sagittal reformations for formal interpretation of the examination. All axial and multiplanar images should be reviewed on soft-tissue, lung, and bone windows.

Injuries of the Thoracic Skeleton

Skeletal injuries of the thorax may be apparent on plain-film examination, but nearly all are better-shown and more accurately diagnosed by CT. Upper-rib fractures occur with severe chest trauma and may be associated with injuries of the aorta, great vessels, and brachial plexus. Lower-rib fractures may be associated with injuries of the liver, spleen, and kidneys. Multiple fractures of the same rib involving three or more adjacent ribs may produce a flail segment of the chest wall with paradoxical motion during respiration, resulting in a 'flail chest,' with ventilatory compromise. Other common injuries of the thoracic skeleton include scapular fractures, sternal fractures, sternoclavicular dislocation, and thoracic spine injuries. Serious morbidity and even death have been associated with posterior dislocation of the clavicle at the sternoclavicular joint as the displaced clavicle head may

impinge on or injure the trachea, esophagus, great vessels, or major nerves in the superior mediastinum. Sternoclavicular dislocation is well shown by CT. Sternal fractures are usually not seen on the AP portable chest film but are nearly all visible at CT, especially on sagittal reformations. CT will also show any associated retrosternal hematomas. Sternal fractures, however, are shown on the lateral chest film and have a high association with aortic and cardiac injuries.

Fractures of the thoracic spine account for 15-30% of all spine fractures. The most vulnerable segment of the thoracic spine is at the thoracoabdominal junction, from T9 to T12. About 70% of thoracic-spine fractures are visible on plain films but CT will show nearly all. With the superior spatial resolution of MDCT technology, axial, coronal, and sagittal thoracic-spine reformations obtained from the chest-trauma CT imaging protocol will show more fractures than AP and lateral thoracic spine plain films [6].

Pleural Manifestations of Trauma

Non-penetrating trauma may be associated with hemothorax and pneumothorax. Blood can flow into the pleural space from injuries of the chest wall, diaphragm, lung, and mediastinal structures. CT can confirm a hemothorax when a pleural fluid collection in a trauma patient measures over 35-40 Hounsfield units (HU). Air can enter the pleural space as a result of a lung injury, tracheobronchial injury, or esophageal rupture. A pneumothorax may be seen in about 15-40% of patients with acute chest trauma [4]. Many small and even moderate-sized pneumothoraces that are not visible on the supine chest film can be easily identified at CT. A pneumothorax seen at CT which cannot be identified on a supine chest film is referred to as an 'occult' pneumothorax. A persistent pneumothorax after chest-tube suction suggests either a malfunctioning chest tube or bronchial injury. A tension pneumothorax is an emergency condition resulting from a lung or airway injury associated with a one-way accumulation of air within the pleural space. As intrapleural pressure rises, the mediastinal structures are compressed, decreasing venous return to the heart and leading to hemodynamic instability. Radiography and CT will show a mediastinal shift to the contralateral hemithorax, hyperexpansion of the ipsilateral thorax, and depression of the ipsilateral hemidiaphragm.

Pulmonary Contusion

Pulmonary contusion represents traumatic extravasation of blood and edema fluid into the interstitium and air spaces of the lung as a result of small-vessel trauma without significant parenchymal disruption. The injury is caused by energy transmitted directly to the lung from a blow to the overlying chest wall. On radiographs, contu-

sion will appear as patchy areas of consolidation, which, if extensive, may show diffuse homogeneous lung consolidation. Contusion may be absent on the initial chest film but is usually evident within 6 h of injury and resolves rapidly, within 3-10 days [7]. CT will show nonsegmental areas of consolidation often directly beneath the site of injury, and often sparing 1-2 mm of the subpleural lung parenchyma. The opacities may be single or multiple, and both coup and contra-coup contusions may be identified. Contusion is often seen surrounding pulmonary lacerations.

Pulmonary Lacerations

Pulmonary lacerations are tears of the lung parenchyma that fill with air, blood, or both. When filled with air, these injuries are called traumatic pneumatoceles, and when filled with blood they are referred to as traumatic hematoceles or lung hematomas. If both air and fluid are present, an air-fluid level may be identified. On chest films, lacerations may initially be obscured by surrounding lung contusion, but they are revealed when the contusion clears, a few hours or days after the injury; however, acute lung lacerations are nearly always detected by CT. Four types of pulmonary lacerations have been described with blunt trauma: compression rupture, compression shear, rib penetration injury, and adhesion tears [5]. They may also result from penetrating trauma, most frequently from stab wounds and gunshot wounds. Pulmonary lacerations are better shown and more extensively evaluated with CT than with plain films. Unlike pulmonary contusion, lung lacerations may take weeks or months to heal and may result in residual lung scarring.

Tracheobroncheal Injury

Tracheobronchial injuries are uncommon and >80% occur within 2 cm of the carina [8]. There is an equal frequency of rupture of the left and right main-stem bronchi. The most common findings on chest films are pneumomediastinum and subcutaneous emphysema; leakage of air through the rupture flows into the surrounding mediastinal soft tissues with subsequent dissection up into the neck. Large pneumomediastinums are easy to identify on plain films, however small ones may not be visible on the initial portable chest film. The majority of patients will have an associated pneumothorax. The clinical observation characteristic of this condition is a pneumothorax that does not resolve with chest-tube suction, due to continued leakage of air through the rupture. Nonetheless, resolution of a pneumothorax after chest-tube placement does not exclude the diagnosis. Another pathognomonic finding is that of a 'fallen lung,' which occurs when there is complete disruption of a main-stem bronchus. On the supine chest film, the lung falls laterally and posteriorly while in the upright posi-

tion it falls inferiorly. This appearance contrasts with the usual situation, in which a lung collapses toward the pulmonary hilus.

Other signs of tracheobronchial injury include a sharply angulated bronchus, bronchial discontinuity, or bronchial 'cut-off.' Abnormalities of an endotracheal-tube balloon may also be noted with tracheal injury. The balloon may appear over-inflated or more spherical as it actually herniates through a vertical laceration of the trachea. All of these findings are better-depicted at CT, which can show the actual tracheobronchial injury. In addition, CT will show more subtle, secondary signs, such as smaller pneumomediastinum, than the chest film.

Esophageal Rupture

Esophageal injury is rare with blunt trauma and is far more common with penetrating trauma or iatrogenic trauma. Blunt trauma may involve the upper thoracic esophagus or the lower esophagus just above the gastroesophageal junction. Plain films of the chest may show pneumomediastinum and subcutaneous emphysema. CT may show focal air collections at the site of the tear or an esophageal-wall hematoma. As lower injuries may rupture into the left pleural space, there may also be a left pneumothorax, left pleural fluid collection, and left lower-lobe atelectasis. The diagnosis is usually confirmed by the demonstration of oral contrast material that has extravasated at the site of injury.

Aortic and Great-Vessel Injuries

Approximately 8,000 cases of thoracic aortic injury occur in the US each year, and traumatic aortic rupture is responsible for 15-20% of all fatalities associated with motor-vehicle accidents [4]. Approximately 90% of patients with traumatic aortic rupture die before emergency treatment can be instituted. Most aortic injuries involve the junction of the posterior aortic arch and descending aorta, just distal to the origin of the left subclavian artery [5, 9]. The proposed mechanism of injury is rapid deceleration, resulting in differential forces acting on the proximal descending aorta between fixed and more mobile segments.

A normal chest radiograph has a high negative predictive value (98%) but a low positive predictive value for aortic injury [10]. The chest-film findings suggestive of aortic injury include mediastinal widening >8 cm, loss of the normal aortic arch, a left apical pleural cap, displacement of the nasogastric tube to the right, widened paraspinal lines, and loss of the descending aortic line. Most of the plain-film findings of aortic injury are non-specific. While the gold standard for the diagnosis of aortic injury has been aortography, at most trauma centers today aortography has been replaced with MDCT.

The sensitivity of CT has been reported to be 92-100% and the specificity 62-100% for the detection of aortic injury [11-13]. The CT findings include both indirect signs, such as mediastinal hematoma surrounding the posterior aortic arch and proximal descending aorta, as well as direct signs of intimal tear/flap, aortic contour abnormalities, thrombus protruding into the aortic lumen, false aneurysm formation, pseudocoarctation, and extravasation of intravenous contrast material. If only direct signs are considered, the sensitive and negative predictive value remains at 100% but the specificity increases to 96% [13]. The accuracy of aortic-trauma detection with CT has been improving in parallel with technological improvements in CT scanning. Current-generation fast scanners decrease motion artifacts and provide higher quality two- and three-dimensional reformations for diagnosis and surgical planning. Also, these scanners can scan the chest with cardiac gating during diastole to eliminate aortic pulsatile motion artifacts that may be confused with an acute aortic injury. Today, patients with no direct evidence of aortic injury at CT and no mediastinal hematoma around the expected site of injury do not require further imaging workup to rule out aortic trauma.

Cardiac Injuries

Cardiac and pericardial injuries are uncommon with blunt thoracic trauma but do occur with severe blows to the anterior chest. They include cardiac contusion, cardiac rupture, pneumopericardium, hemopericardium, cardiac tamponade, and cardiac-valve injury. Hemopericardium from a cardiac injury or cardiac rupture can quickly produce cardiac tamponade with hemodynamic compromise. Cardiomegaly will be shown on the plain chest film; CT or cardiac ultrasound can confirm hemopericardium.

Diaphragmatic Injury

Diaphragmatic rupture is seen in about 5% of patients undergoing laparotomy or thoracotomy for trauma [14]. The postulated mechanism is a sudden increase in either intrathoracic or intra-abdominal pressure against a fixed diaphragm. Left-sided injuries are more common, with a reported ratio of left-to-right injuries of 3:1, while 4.5% of patients have bilateral rupture [15].

The chest film may show hemothorax, pneumothorax, loss of the visualized hemidiaphragm, apparent elevation of the hemidiaphragm, visualization of herniated abdominal organs into the thorax, and cephalad extension of a nasogastric tube into the thorax. Today, MDCT axial scans combined with high-quality coronal and sagittal reformations can show both large and small ruptures of the diaphragm, in addition to any abdominal organs that have herniated across the rupture.

References

1. Kshettry VR, Bolman RM (1994) Chest trauma. Assessment, diagnosis, and management. Clin Chest Med 15:137-146
2. Blaisdell F, Trunkey D (1994) Trauma Management III: Cervicothoracic Trauma, 2nd edn. Thieme Medical Publishers, New York
3. Mazurek A (1994) Pediatric injury patterns. Int Anesthesiol Clin 32:11-25
4. Groskin SA (1996) Selected topics in chest trauma. Semin Ultrasound CT MR 17:119-141
5. Collins J, Primack SL (2001) CT of non-penetrating chest trauma. Applied Radiology Online 30:1-10
6. Rhea JT, Sheridan RL, Mullins ME, Novelline RA (2001) Can chest and abdominal CT eliminate the need for plain films of the spine? Emerg Radiol 8:99-104
7. Wiot JF (1975) The radiologic manifestations of blunt chest trauma. JAMA 231:500-503
8. Spencer JA, Rogers CE, Westaby S (1991) Clinico-radiological correlates in rupture of the major airways. Clin Radiol 43:371-376
9. Williams JS, Graff JA, Uku JM et al (1994) Aortic injury in vehicular trauma. Ann Thorac Surg 57:726-730
10. Mirvis SE, Bidwell JK, Buddemeyer EU et al (1987) Value of chest radiography in excluding traumatic aortic rupture. Radiology 163:487-493
11. Gavant ML, Menke PG, Fabian T et al (1995) Blunt traumatic aortic rupture: detection with helical CT of the chest. Radiology 197:125-133
12. Mirvis SE, Shanmuganathan K, Miller BH et al (1996) Traumatic aortic injury: diagnosis with contrast-enhanced thoracic CT. Five-year experience at a major trauma center. Radiology 1200:413-422
13. Dyer DS, Moore EE, Mestek MF et al (1999) Can chest CT be used to exclude aortic injury? Radiology 213:195-202
14. Shah R, Sabanathan S, Mearns AJ et al (1995) Traumatic rupture of diaphragm. Ann Thorac Surg 60:1444-1449
15. Mueller CF, Pendarvis RW (1994) Traumatic injury of the diaphragm: report of seven cases and extensive literature review. Emerg Radiol 1:118-132

A Systematic Approach to X-Ray Analysis

K. Malagari

2nd Department of Radiology, Attikon University Hospital, National and Kapodistrian University of Athens, Athens, Greece

Introduction

The vast literature on the approach of X-ray interpretation confirms the difficulty of this subject. The process of image interpretation comprises perception and interpretation of the abnormality.

The pattern approach has many critics and indeed not all diagnostic problems can be solved by applying it, simply because it may not be feasible to include certain findings only within a specific pattern.

In this workshop, tips and tricks to increase the diagnostic yield of chest X-rays will be discussed.

Chest-Wall and Pleural Lesions

Most of the time, chest-wall and pleural lesions have the common characteristics of extrathoracic extrapulmonary lesions, notably, well-defined margins, tapered borders when seen on edge, and an incomplete border sign. Well-defined borders are formed by the interface between the pleura and the aerated lung, which may be compressed by the space-occupying effects of a lesion.

Irregular and shaggy borders indicate that the lung next to the lesion in question is either involved in the primary process (e.g., neoplastic or inflammatory) or that there is primary pulmonary disease that also involves the subpleural structures, namely, the pleura and/or chest wall. Tapered boarders are not seen when the lesion is viewed en face. In that situation, an incomplete border sign suggests the extrapulmonary nature of the abnormality.

A definite sign indicating that a lesion indeed involves the chest wall is bone destruction. This key observation suggests that the lesion consists of either a neoplastic or an inflammatory process. Actinomycosis is one of the aggressive granulomatous infections that involve the chest wall, pleura, and lung. Neoplastic diseases that cause bone destruction include metastasis, multiple myeloma, Ewing's tumor, and metastatic neuroblastoma. Bone indentation may be caused by neurinomas and schwannomas.

Pleural Opacities

These present with tapered borders when seen tangentially, but otherwise they are irregularly shaped. Multiple pleural densities may represent loculated pleural effusions, metastatic disease (usually adenocarcinomas), primary pleural tumors (mesothelioma), and malignant thymoma with a lepidic growth pattern.

Pleural effusions have a very long differential diagnosis. It is important to carefully examine the abnormality to determine whether it is bilateral or unilateral, and whether there is concomitant pericardial effusion. For this purpose, in addition to X-ray evidence, an ultrasound image of the costophrenic spaces and pericardium is vital in order to assess the potential presence of an underlying systemic disease. Correlation with the clinical history, the presence of cardiac enlargement, coexisting lung consolidation, or hilar enlargement provide key information that, in association with the results of pleural tap, allow the radiologist to narrow the diagnostic differential.

Diffuse Pleural Thickening

Prior infections (empyema, tuberculosis), neoplastic disease (mesothelioma, lymphoma), prior hemothorax, rheumatoid arthritis and systemic lupus erythematosus, and asbestos exposure are associated with diffuse pleural thickening. Coexistent pleural calcification suggests prior trauma and hemothorax, empyema (particularly TB-associated), and, together with pleural plaques, asbestos exposure, especially if the calcification is juxtadiaphragmatic.

Diaphragmatic Elevation

When bilateral, diaphragmatic elevation is usually the result of a shallow breath-hold, such as typical of obese patients. If the radiograph has been taken at total lung capacity (TLC), elevation indicates inhibited diaphragmatic movement due to thoracic disease (restricting disease

with small lung volumes), poor diaphragmatic motility (bilateral phrenic-nerve damage), or that the disease is of subdiaphragmatic etiology, namely, ascites.

When the two hemidiaphragms are separated by a significant distance (>5 cm), then the radiologist has to decide which one is abnormal (elevation or low position?).

The radiological search for the thoracic etiology of abnormal positions of the diaphragm includes looking for signs of pleural effusion, atelectasis, hypoplastic lung lobectomy, or tumor near the course of the phrenic nerve. Abdominal disease such as subdiaphragmatic inflammatory processes or space-occupying lesions may also be the source of an elevated hemidiaphragm. Local causes of diaphragmatic elevation include phrenic-nerve paralysis, diaphragmatic eventration, diaphragmatic hernias, or rupture of a hemidiaphragm.

However, the most common intrathoracic cause of an elevated hemidiaphragm is the presence of subpulmonic pleural effusion, which can be recognized by the acute convexity of the dome of the hemidiaphragm on the right side and the increased distance to the fundus of the stomach on the left side. An ultrasound will reveal the presence of even small amounts of fluid but, when not available, an X-ray image of the region with the patient in the lateral decubitus position will also confirm the diagnosis. An Alexander or sniff test with fluoroscopy or ultrasound will confirm an abnormal movement of the diaphragm in cases of phrenic-nerve paralysis.

Mediastinal Shift

A shift of the mediastinum is approached by first identifying the abnormal hemithorax.

Loss of volume of one lung is usually associated with other dynamic signs, such as small or irregular position of the ipsilateral hilum. The latter may be a more subtle sign of volume loss and, in fact, may be associated with a relatively oligemic lung compared to the contralateral side. Loss of volume may be attributed to atelectasis, hypoplastic lung. It is also possible that overexpansion of one hemithorax is the cause of the mediastinal shift.

Overexpansion (not attributed to an obvious space-occupying mass, cyst, or a tension pneumothorax) can be associated with a large bulla, congenital lobar emphysema, and, rarely, with air trapping. Swyer James syndrome can also be a cause of mediastinal shift if the involved lung is of considerable size or if the bronchiolitis occurred late during childhood.

In Swyer James syndrome, although there is localized air trapping in the involved lung, it is usually not overexpanded because in most cases the underlying bronchiolitis obliterans occurred when the subject was much younger; therefore, locally the lung did not grow in size. The key observation in addition to air trapping is the relative hyperlucency, oligemia, and decrease in size of the affected lobe or lung. Since the advent of computed tomography (CT), it has been shown that these areas may involve an entire lobe but also only segments. It must be pointed out that the complete algorithm for evaluating these abnormalities is beyond the scope of this article. However, in addition to undergoing CT examination, these patients need to proceed to bronchoscopy to exclude an endobronchial lesion.

An unusual cause of a small hemithorax, but one that is identifiable from the chest X-ray, is an extended pleural thickening that prevents normal movement of the chest wall, lung, and pleura. A typical example is the pleural thickening subsequent to empyema, TB, or mesothelioma.

Mediastinum

The perception of mediastinal abnormalities in chest radiographs can be improved by careful observation of the aortopulmonary window, azygoesophageal recess, retrotracheal area, supra-aortic triangle, and paraspinal lines.

Any convexity in a soft-tissue density that can be seen in the aortopulmonary window at radiography is abnormal. This area normally contains mediastinal fat, the left pulmonary recess of the pericardium, and, in some individuals, lung parenchyma (especially in patients with chronic obstructive pulmonary disease). The ligamentum arteriosum and the recurrent laryngeal nerve normally cross this space. The most common space-occupying lesion in this area is enlarged lymph nodes.

The azygoesophageal recess is normally relatively hyperlucent to the right side with a straight or concave interface with the right lung. Convex borders usually represent space-occupying lesions.

The retrotracheal area in the lateral view should be relatively translucent, otherwise it may indicate the presence of a middle mediastinal mass.

Lung Opacities

Widespread airspace opacities with a perihilar distribution may be seen in high-pressure pulmonary edema, alveolar proteinosis, pulmonary hemorrhage, or following the inhalation of noxious gases. The timing and correlation with clinical information is highly suggestive of the correct diagnosis.

Atelectasis

Depending on the type and anatomical location of the atelectatic lung, the density of the lung is variably increased. More constant and characteristic signs of atelectasis are those that indicate volume loss, i.e., alteration of the size and position of the hilae and displacement of fissures and pulmonary blood vessels. These are the most important signs pointing to atelectasis, since a shift of the mediastinum or hemidiaphragm may be compensated for by over-aeration and distention of the remaining aerated lung lobes.

An important consideration regarding solitary pulmonary nodules is first and foremost recognition. Perception is a major problem, and it is well-known that even nodules >1 cm may be missed, especially if they are in the parahilar, supraclavicular, or retrocardiac areas of the lung. Calcifications within a nodule are only appreciated by CT, which can identify both the presence and the pattern of calcification, facilitating further management of the patient. In addition, it must be stated that, today, it is by no means justifiable to assess the rate of growth with chest radiographs. Cavitation or air bronchograms within a nodule may be seen on chest X-rays, but CT is absolutely essential for correct evaluation. CT is also imperative to define whether the patient has one or multiple pulmonary nodules. Multiple pulmonary nodules may be malignant, benign (hamartomas, chondromas, or papillomatous), infective, granulomatous non-infective, congenital, or of miscellaneous origin, e.g., amyloidosis.

Diffuse Parenchymal Disease

Septal-line thickening is identified as Kerley B, C, and A lines and is also described as 'linear' pattern. When of recent origin, septal-line thickening can most often be attributed to pulmonary edema or lymphangitis carcinomatosa. Although high-resolution CT can identify septal lines also in patients with viral or mycoplasma pneumonia, pulmonary edema should be excluded even in the febrile patient. Interstitial pulmonary fibrosis and late-stage hemosiderosis may also cause septal-line thickening.

Diffuse small nodular opacities (miliary pattern) may be associated with miliary tuberculosis, and non-tuberculous granulomatous infections in endemic areas. In the non-febrile patient, a miliary pattern may be due to pneumoconiosis (notably silicosis, siderosis, berylliosis, and coal-miner's pneumoconiosis) or old viral infections (e.g., varicella pneumonia), Langerhans cell histiocytosis, alveolar microlithiasis, and, rarely, metastatic disease.

Suggested Reading

Armstrong P, Wilson AG, Dee P, Hansell D (2005) Imaging of diseases of the chest. Mosby, St. Louis

Cotran RS, Kumar V, Robin FL (1989) Inflammation and repair. In: Pathologic basis of disease, 4th edn. WB Saunders, Philadelphia, pp 39-86

Feigin DS (1987) Radiology of the chest: Chapter 6. In: Jacobs ER (eds) Medical imaging. A concise textbook. Igako Shoin Publishers, Tokyo and New York, pp 83-112

Felson B (1973) Chest roentgenology. WB Saunders, Philadelphia, pp 314-349

Fraser RS, Muller NL, Colman N, Pare PD (1990) Fraser's and Pare's diagnosis of diseases of the chest. WB Saunders, Philadelphia

Heitzman ER (1984) The lung: radiologic-pathologic correlations, 2nd edn. CV Mosby, St. Louis

Reed JC (1988) Chest radiology: patterns and differential diagnosis, 2nd edn. Year Book Medical Publications, Chicago

A Systematic Approach to Chest X-Ray Analysis

J.S. Klein

Department of Radiology, Fletcher Allen Health Care, Burlington, VT, USA

Introduction

This article reviews the approach to commonly encountered chest radiographic abnormalities, with a focus on the use of ancillary imaging studies for specific characterization of radiographic findings and to facilitate differential diagnosis.

Parenchymal Lung Diseases Associated with Increased Lung Density

Interstitial Lung Disease

The radiographic detection of diffuse interstitial lung disease can be difficult, as the findings may be subtle despite the presence of symptoms. The earliest indications of interstitial disease are loss of vascular sharpness and an increase in lung density. The most common classification of interstitial abnormalities is to divide the observed changes into reticular, nodular, and linear interstitial disease. Reticular lung disease is usually further subclassified as fine, medium, or coarse, depending upon the size of the intervening lucent areas. Fine reticular interstitial disease is also termed ground-glass opacity. It generally reflects a process that results in incomplete alveolar filling or lining, and therefore points to either interstitial or alveolar disease processes.

Since there are innumerable processes that can produce diffuse interstitial opacities, the differential diagnosis of diffuse interstitial disease depends primarily on the associated clinical and ancillary radiographic findings, as well as on more specific characterization of the findings as seen on high-resolution CT scan. In patients with acute interstitial abnormalities, the differential diagnosis is brief and primarily includes cardiac and infectious conditions. Table 1 lists the radiographic findings that, when identified in association with interstitial opacities, help limit the differential considerations.

Air-Space Disease

The findings of air-space disease are opacities that tend to obscure the underlying parenchyma. They are often ill-

Table 1. Ancillary findings in patients with interstitial lung disease and differential considerations

Finding(s)	Disease
Hilar lymph node enlargement	Sarcoidosis, ,lymphangitic carcinomatosis, viral pneumonia
Clavicular/bony erosions	Rheumatoid associated UIP
Pleural effusions	Infection, edema
Pleural plaques	Asbestosis
Hyperinflation	LCH, stage IV sarcoidosis, LAM/TS, emphysema with UIP
Esophageal dilatation	Scleroderma associated UIP, recurrent aspiration
Conglomerate masses	Silicosis, sarcoidosis, talcosis
Basilar sparing	LCH, sarcoidosis
Basilar predominance	UIP, aspiration

LAM/TS, lymphangioleiomyomatosis/tuberous sclerosis; *LCH,* Langerhans cell histiocytosis; *UIP,* usual interstitial pneumonia

defined, tend to coalesce over time, and can produce lobar or segmental opacification with air bronchograms that obscure the silhouettes of adjacent mediastinal structures and the diaphragm. The approach to air-space disease is best considered by determining the distribution of opacities, as the finding is very nonspecific and simply reflects the presence of material (blood, edema fluid, inflammatory cells, tumor cells, or proteinaceous material) within the alveoli. The differential diagnosis of air-space disease is shown in Table 2.

Solitary Pulmonary Nodule

The primary goal of the radiologist when identifying a focal opacity on chest radiography is to determine whether the finding truly reflects a solitary pulmonary nodule (SPN). Identification of the opacity on orthogonal radiographic projections and methods of excluding abnormalities that may produce a nodular opacity on a single radiographic view, such as nipple shadows, skins lesions, and bone islands or healing rib fractures, are excluded by comparison with prior chest radiographs. To

Table 2. Differential diagnosis of air-space opacification (ASO)

Finding(s)	Disease
HFocal/segmental ASO	Pneumonia, contusion, infarct, lung cancer (BAC)
Lobar disease	Pneumonia, endogenous lipoid pneumonia, BAC
Patchy ASO	Infection, cryptogenic organizing pneumonia, BAC, metastases, emboli
Diffuse ASO	Edema, hemorrhage, pneumonia
Perihilar ASO	Edema, hemorrhage
Peripheral ASO	Eosinophilic pneumonia, ARDS, contusion
Rapidly changing/resolving ASO	Edema, eosinophilic pneumonia, hemorrhage

ARDS, acute respiratory distress syndrome; *BAC*, bronchioloalveolar carcinoma; *COPD*, chronic obstructive pulmonary disease

this end, additional radiographic views and techniques, such as nipple markers, oblique or apical lordotic projections, and in some cases chest fluoroscopy, may be necessary. Once a new or enlarging SPN has been identified, thin-section CT will almost invariably be needed for further evaluation. The differential diagnosis of a SPN is shown in Table 3.

Parenchymal Lung Diseases Associated with Decreased Lung Density

Emphysema

The ability to discern an abnormal decrease in lung density is more difficult than the detection of increased den-

Table 3. Differential diagnosis of the solitary pulmonary nodule

Granuloma
Bronchogenic carcinoma (adenoacarcinoma most common)
Hamartoma
Solitary metastasis
Focal organizing pneumonia
Hematoma

Table 4. Lung processes associated with decreased lung attenuation

Peripheral ASO	Eosinophilic pneumonia, ARDS, contusion
Localized lucency (lucencies)	Bullae, cyst, pneumatocele, cavity
Unilateral hyperlucency	Swyer-James syndrome, bronchial obstruction (e.g., carcinoid tumor)
Multifocal lucency	Asthma, constrictive bronchiolitis
Diffuse hyperlucency	Emphysema, asthma, constrictive bronchiolitis

sity, owing to the intrinsic low attenuation of normal lung parenchyma. Furthermore, technical factors, including overpenetration, can produce a false appearance of lung hyperlucency. The radiologist must exclude technical issues and abnormalities of the chest wall before determining that the lungs are indeed hyperlucent.

Diseases that cause an abnormal decrease in lung attenuation may be localized, unilateral, multifocal, or diffuse (Table 4). Emphysema is the most common cause of diffuse hyperlucency, and is usually recognized by associated findings, including low and flattened diaphragms, an increase in the anteroposterior diameter with enlargement of the retrosternal air space, and attenuation of vascular markings (particularly in the upper lobes) with bullae containing thin walls.

Evaluation of a Mediastinal Mass

Mediastinal masses may be asymptomatic (e.g., bronchogenic cyst), symptomatic, e.g., as a result of compression or invasion of adjacent mediastinal structures (intrathoracic thyroid goiter), or come to attention in patients examined for possible malignancy (e.g., thymoma in a patient with myasthenia gravis). Radiographically, a mediastinal mass is characterized by sharp demargination, obtuse borders with the adjacent lung, and an incomplete border sign where it arises from the mediastinum. While, in the past, precise localization guided the specific imaging evaluation, presently virtually all mediastinal abnormalities are assessed by multidetector CT evaluation for localization and characterization of the mass. Common causes of mediastinal masses, based upon the primary site of origin, are detailed in Table 5.

Table 5. Differential diagnosis of mediastinal masses

Superior	Anterior	Middle	Posterior
Thyroid goiter	Lymphoma	Bronchogenic carcinoma	Schwannoma
Lymphangioma	Thymic neoplasm	Lymph-node enlargement/mass	Ganglion cell tumor
Lymphadenopathy	Germ-cell neoplasm	Foregut cyst	Hiatal hernia
			Aortic aneurysm

Hilar Enlargement

Hilar disease can represent a number of conditions (Table 6). Radiographically, there is an increased hilar density, a lobulated and enlarged hilar shadow, or a discrete hilar mass. CT with contrast enhancement is necessary for further evaluation of suspected hilar disease.

Cardiac and Pericardial Disease

Although echocardiography has become the primary technique to evaluate cardiac and pericardial disease, chest radiography can provide important information regarding the presence of cardiac or pericardial processes. These can cause symptoms that overlap with those of lung disease, including dyspnea and chest pain. Direct radiographic findings of cardiac disease are primarily cardiac enlargement or an abnormal cardiac contour. Pericardial disease may manifest as an enlarged cardiomediastinal silhouette, pericardial calcification, or a positive stripe sign indicating the presence of pericardial effusion as seen on lateral chest radiography. The causes of an enlarged cardiomediastinal silhouette are listed in Table 7.

Pleural Disease

Pleural disease may take on of several forms radiographically: pleural mass, focal or diffuse smooth or nodular thickening or calcification, or penumothorax. The characteristics of a pleural mass are similar to those of a mediastinal mass: a sharply-marginated peripheral opacity with obtuse margins and an incomplete border. The common etiologies of a pleural mass are listed in Table 8. The appearance of pleural air depends upon the amount, patient position (upright vs. supine), and the presence or absence of pleural adhesions.

Chest-Wall Disease

Lesions of the chest wall are recognized radiographically when they protrude from the skin surface to be outlined by air, or when associated with rib, vertebral, sternal, clavicular, or scapular involvement. Most patients will present with chest-wall pain. Common causes of chest-wall masses with rib involvement are listed in Table 9.

Suggested Reading

Evans AL, Gleeson FV (2004) Radiology of pleural disease: State of the art. Respirology 9:300-312

Strollo DC, Rosado de Christenson M, Jett JR (1997) Primary mediastinal tumors, part 1. Tumors of the anterior mediastinum. Chest 112:511-522

Winer-Muram HT (2006) The solitary pulmonary nodule. Radiology 239:34-49

Table 6. Etiologies of an enlarged hilum or hila

Unilateral	Bilateral
Bronchogenic carcinoma	Sarcoidosis
Infection (granulomatous)	Metastatic lymphadenopathy
Metastatic lymphadenopathy	Pulmonary hypertension
Bronchogenic cyst	Lymphoma
Valvular pulmonic stenosis (left)	Infection (granulomatous)

Table 7. Causes of an enlarged cardiomediastinal silhouette

Cardiomegaly
Pericardial effusion
Thymic enlargement (i.e., hyperplasia, thymolipoma)

Table 8. Differential diagnosis of a pleural mass

Loculated pleural effusion (pseudotumor)
Lipoma
Localized fibrous tumor of pleura
Metastatic lesion

Table 9. Common causes of a chest wall mass involving the ribs

Metastasis	Enchondroma
Myeloma	Abscess
Fibrous dysplasia	Chondrosarcoma
Eosinophilic granuloma	

High-Resolution CT in Diffuse Interstitial Lung Disease

S.R. Desai[1], T. Franquet[2]

[1] Department of Radiology, King's College Hospital, London, UK
[2] Department of Radiology, Hospital de Sant Pau, Barcelona, Spain

Introduction

High-resolution computed tomography (HRCT) is rightly considered by radiologists and physicians to be an important technique in the investigation of patients with suspected diffuse lung disease. In those cases in which biopsy would previously have been mandatory, the diagnostic process has been revolutionized by HRCT. For example, in patients with the entity of usual interstitial pneumonia, the appearance of the disease on HRCT is characteristic enough for an accurate radiological diagnosis to be made, rendering biopsy unnecessary [1-3]. A similar scenario is the patient with suspected sarcoidosis; in such cases the HRCT images will allow a radiological diagnosis to be made with greater confidence, again obviating the need for more invasive procedures.

HRCT Technique

Two technical features differentiate HRCT imaging from conventional (i.e., 10-mm collimation) CT. Firstly, in HRCT, collimation of the X-ray beam is narrower. This results in a reduced section thickness and thus increases the likelihood that a small lesion will have dimensions comparable to the size of a voxel, resulting in significantly improved spatial resolution. Secondly, unlike in conventional CT, in HRCT a dedicated algorithm is used to reconstruct the data [4]. The 'high-frequency' algorithm takes advantage of the intrinsically high contrast environment of the lung parenchyma, so that the natural density differences between aerated lung and the interstitium are enhanced [4]. The conspicuity of vessels, small bronchi, and interlobular septa is therefore greater than in conventional (thick-section) CT images [5]. An important 'downside' of high-frequency algorithms is the increased visibility of image noise; however, in practice, this rarely hampers radiological interpretation.

HRCT in Diffuse Interstitial Lung Disease

The diffuse interstitial lung diseases (DILDs) are a heterogeneous group of disorders that principally affect the lung parenchyma [2]. Within the 'umbrella' term DILD, it is possible to categorize a number of entities. Firstly, there are DILDs that are secondary to a known cause (for example, lung disease secondary to exposure to certain drugs or as a consequence of collagen vascular diseases). Secondly, there is the large and interesting group of idiopathic interstitial pneumonias. Thirdly, there are the granulomatous diseases that affect the lung parenchyma; and fourthly, a group of less common diffuse lung diseases, such as Langerhans' cell histiocytosis and lymphangioleiomyomatosis.

In patients with established diffuse lung disease, HRCT improves the detection of subtle parenchymal abnormalities. Accordingly, ground-glass opacification, small cystic air spaces, traction bronchiectasis/bronchiolectasis. and the irregular interfaces along pleural surfaces and bronchovascular structures are better appreciated on HRCT images [6]. An important caveat is that, in patients with nodular infiltrates, the HRCT appearances may be misleading, and on thin-section images the dimensions of nodules and pulmonary vessels may be comparable, making their distinction difficult [6]. Thankfully, the spectrum of CT features that denote interstitial lung disease is limited and manageable: a reticular pattern, thickening of interlobular septa, honeycombing, nodules, and ground-glass opacification are the typical CT signs of interstitial disease [7].

Unlike conventional chest radiography, HRCT depicts the macroscopic abnormalities seen by the pathologist. This was elegantly demonstrated in a study by Müller and colleagues, which showed that CT features in patients with cryptogenic fibrosing alveolitis reflected the histopathological changes [8]. A reticular pattern was seen in seven out of nine patients and corresponded to areas of irregular fibrosis at microscopy.

Not surprisingly, because there is no anatomical superimposition, the sensitivity of HRCT is better than that of chest radiography. However, a more important issue is the confidence and accuracy with which diagnosis can be made. In a study of 118 patients with a variety of biopsy-confirmed interstitial lung diseases (including cryptogenic fibrosing alveolitis, sarcoidosis, lymphangitis carcinomatosa, and Langerhans' cell histiocytosis), experi-

enced chest radiologists were asked to provide up to three diagnoses, based independently on chest radiographs and CT [9]. For their first-choice diagnosis, the radiologists were asked to assign a level of confidence. An important finding of the study was that, compared to the chest radiograph, a confident diagnosis was made nearly *twice* as often when based on HRCT images. The second, and perhaps more striking, message was that when experienced radiologists were confident of the diagnosis, they were almost always correct [9]. In contrast, a confident diagnosis on chest X-ray (incidentally, high confidence was only assigned in one quarter of the cases) was associated with a significantly lower rate of correct diagnoses.

The results of subsequent studies have not always been as impressive [10]. Due to problems of study design, the majority of these comparative investigations probably undervalued the true utility of HRCT [1]. For example, there was no recourse to pre-test probabilities for the observers in early HRCT series, such that clinical practice was not realistically or accurately reflected. Secondly, since the advent of HRCT, radiologists (particularly those interested in thoracic diseases) have become increasingly familiar with the spectrum and, more importantly, histopathological significance of HRCT abnormalities. Consequently, it is likely that there has also been a proportionate increase in the confidence of experienced observers when making a diagnosis based on HRCT. Some justification for the last statement comes from a study conducted in the early 1990s that addressed the clinically vexing issue of 'end-stage' lung disease [11]. In that study, two experienced thoracic radiologists independently made correct first-choice diagnoses in just under 90% of cases; and nearly two-thirds of these were made with high confidence. On first inspection, these data seem less than impressive. However, the results of open-lung biopsy (the purported 'gold-standard' for diagnosing diffuse lung disease) are also often disappointing. Thus, when considered in this context, the capabilities of HRCT can be put into perspective.

Basic HRCT Patterns

The basic HRCT patterns described below are common to many disease processes and are usually non-specific. However, their distribution and temporal evolution are often characteristic enough for diagnostic purposes.

Reticular Pattern

A netlike (reticular) pattern represents linear opacities that intersect one another. The most important form occurs in intralobular interstitial thickening and it reflects infiltration and thickening of the intralobular interstitium. The latter refers to the interstitial network of structures supporting the secondary pulmonary lobules, excluding the interlobular septa. Intralobular interstitial thickening is a common HRCT finding in patients with usual interstitial pneumonia (UIP). The typical HRCT findings of UIP are honeycomb-

ing and reticulation. A reticular appearance can also be due to the infiltration of structures by infection, malignant cells (lymphangitic carcinomatosis), pulmonary edema, the presence of abnormal protein (alveolar proteinosis), or simply edema fluid from cardiac failure (Fig. 1).

Linear Pattern

In this pattern, an interlobular septum marginates part of a secondary pulmonary lobule. Thickening of interlobular septa is commonly seen in patients with a variety of interstitial lung diseases and can result from fibrosis, interstitial fluid, and infiltration by cells or other material. Interlobular septal thickening may be smooth, nodular, or irregular. Smooth thickening is commonly seen in patients with pulmonary edema or hemorrhage, lymphangitic carcinomatosis, and amyloidosis (Fig. 2). Nodular or

Fig. 1. Idiopathic interstitial fibrosis. Close-up high-resolution computed tomography (HRCT) (2-mm collimation) view shows peripheral honeycombing and marked reticulation (*arrows*)

Fig. 2. Pulmonary edema. HRCT (2-mm collimation) shows bilateral smooth thickening of the interlobular septa due to interstitial edema (*arrows*). A bilateral ground-glass pattern is also visible. Pleural effusions are present (*asterisks*)

beaded thickening occurs in sarcoidosis, lymphangitic carcinomatosis, and amyloidosis.

Ground-Glass Opacity

Ground-glass opacity is defined as 'hazy increased attenuation of the lung with preservation of bronchial and vascular margins' [12]. The significance of ground-glass opacities depends on the clinical scenario. This finding can be made with HRCT while plain films are still negative. Ground-glass opacity may be caused by partial filling of air spaces, interstitial thickening, partial collapse of alveoli, normal expiration, or increased capillary blood volume. It must not be confused with consolidation, in which bronchovascular margins are obscured, but may be associated with an air bronchogram. A large number of diseases can be associated with ground-glass opacity on HRCT (Fig. 3). In acute diffuse lung disease, ground-glass attenuation as the main pattern is suggestive of acute interstitial pneumonia (AIP), acute or subacute hypersensitivity pneumonitis, pulmonary edema, pulmonary hemorrhage, or drug-induced disease. The most common causes of ground-glass opacity in chronic diffuse lung disease include UIP, nonspecific interstitial pneumonia (NSIP), desquamative interstitial pneumonia (DIP), and respiratory-bronchiolitis-associated interstitial lung disease (RB-ILD). A 'crazy-paving' pattern represents the superimposition of a linear pattern on a background of ground-glass opacity. This pattern, initially described in alveolar proteinosis, can also be seen in bronchioloalveolar cell carcinoma and exogenous lipoid pneumonia (Fig. 4).

Honeycombing

Honeycombing is a process characterized by the presence of cystic spaces, with thick, clearly definable

Fig. 4. Alveolar proteinosis. HRCT (2-mm collimation) shows bilateral ground-glass opacification with a superimposed reticulation ('crazy-paving' pattern)

fibrous walls lined by bronchiolar epithelium. These spaces usually average 1 cm in diameter and their walls have a thickness of 1-3 mm. A honeycomb pattern represents the presence of terminal lung disease ('end-stage lung'). At this stage, no specific diagnosis can be reached by biopsy techniques. The determination of the presence or absence of honeycombing on HRCT in patients with idiopathic interstitial pneumonia is of great importance. An additional and important function of HRCT is to guide the surgeon away from the honeycombed region and towards areas of ground glass opacities, where earlier stages of disease are more likely to be found. A confident diagnosis of UIP can be established on the basis of characteristic HRCT findings. Honeycombing may have an atypical distribution, particularly in asbestosis, sarcoidosis, NSIP, drug-related fibrosis, and hypersensitivity pneumonitis (Fig. 5).

Fig. 3. Respiratory bronchiolitis. HRCT (2-mm collimation) shows bilateral patchy areas of ground-glass opacification in a subpleural distribution. These CT findings in heavy smokers are suggestive of this diagnosis

Fig. 5. Honeycombing in idiopathic pulmonary fibrosis. HRCT (2-mm collimation) shows bilateral peripheral honeycombing and reticulation

Nodules

A nodular pattern refers to multiple round opacities ranging in diameter from 1 mm to 1 cm. Nodules can also be characterized according to their margins (e.g., smooth or irregular), the presence or absence of cavitation, and distribution (e.g., centrilobular, perilymphatic, or random). Multiple small smooth or irregularly marginated nodules in a perilymphatic distribution are characteristic of sarcoidosis (Fig. 6). Numerous small nodules of ground-glass opacity, in a centrilobular distribution, are characteristic of the subacute stage of extrinsic allergic alveolitis or respiratory bronchiolitis (Fig. 7).

Miliary nodules, as small as 1 mm in diameter, can easily be detected by HRCT, an important advantage over plain radiography. A random distribution of military nodules can be seen with hematogenous spread of tuberculosis, fungal infection, or metastases.

Cysts

Cysts are commonly present in parenchymal disease. The term 'cyst' is non-specific and refers to a thin-walled (usually <3 mm thick), well-defined, circumscribed, air- or fluid-containing lesion ≥1 cm in diameter, with an epithelial or fibrous wall. Although the precise mechanism of cystic changes is not fully understood, they can be found whenever lung destruction occurs, such as in end-stage fibrosis, emphysema, or infection. Lung diseases characterized by cysts include Langerhans' cell histiocytosis, lymphangioleiomyomatosis, lymphocytic interstitial pneumonia, post-infectious pneumatoceles, and amyloidosis (Fig. 8). Recently, lung cysts were reported in association with extrinsic allergic alveolitis (Fig. 9). Dilated bronchi secondary to bronchiectasis may also appear as cystic changes. The relationship of nearby vessels to the cys-

Fig. 6. Sarcoidosis. HRCT (2-mm collimation) shows bilateral small nodules associated with irregular thickening of the interlobular septa (*black arrows*) and fissures (*white arrows*)

Fig. 8. Lymphangioleiomyomatosis. HRCT (2-mm collimation) shows diffuse, bilateral, thin-walled rounded cysts

Fig. 7. Respiratory bronchiolitis in a heavy-smoker. HRCT (2-mm collimation) shows diffuse, bilateral, ill-defined ground-glass nodules in a centrilobular location

Fig. 9. Extrinsic allergic alveolitis. HRCT (2-mm collimation) shows a diffuse bilateral ground-glass pattern. Note the presence of multiple thin-walled cysts in both lungs (*arrows*)

tic process can often be helpful in the characterization of the lesion, with central vessels seen in centrilobular emphysema.

HRCT Appearances in the More Commonly Encountered Diffuse Lung Diseases

A working knowledge of the histopathological changes in various diseases will allow the radiologist to understand and predict the HRCT findings [13]. This is illustrated in the following section, in which the HRCT appearances of three diseases relatively familiar to a practicing thoracic radiologist are illustrated.

Idiopathic Pulmonary Fibrosis

The expected histopathological diagnosis in patients with the clinical entity of cryptogenic fibrosing alveolitis (CFA, known in North America as idiopathic pulmonary fibrosis) is UIP [2]. At microscopy, there is temporally heterogeneous fibrosis intermingled with areas of unaffected lung parenchyma. Within the areas of fibrosis, there will be honeycombing and tractional dilatation of the airways. The disease has a characteristic basal and subpleural predilection. Thus, on HRCT, the typical patient with CFA will have evidence of a basal and subpleural reticular pattern with honeycombing. Traction bronchiectasis is commonly seen within the reticular pattern [14].

Sarcoidosis

Non-caseating epithelioid-cell granulomata are the histopathological hallmark of sarcoidosis [15]. The granulomata have the tendency to distribute along the lymphatics. Thus, lymphatic pathways surrounding the axial interstitium that invests bronchovascular structures and those located subpleurally (including the subpleural lymphatics along the fissures) are typically involved. Not surprisingly, a nodular infiltrate (presumably reflecting conglomerate granulomata) with a propensity to involve the bronchovascular elements is a characteristic CT finding [16, 17]. Subpleural nodularity is also commonly seen. In the later stages of the disease there may be obvious signs of established lung fibrosis, with upper-zone volume loss, parenchymal distortion, and traction bronchiectasis. Due to the bronchocentric nature of the disease, signs of small-airways disease are seen at CT in some patients with sarcoidosis [18].

Extrinsic Allergic Alveolitis

Exposure to a range of organic antigens will cause lung disease in some people, probably due to an immunologically mediated response [15]. In the subacute stage, there is an interstitial infiltrate comprising lymphocytes

and plasma cells, with a propensity to involve the small airways (bronchioles). Scattered non-caseating granulomata may be seen. Predictably, at CT, there is diffuse ground-glass opacification, ill-defined centrilobular nodules, and lobular areas of decreased attenuation on images performed at end-expiration [19, 20]. The CT appearances in subacute extrinsic alveolitis may be identical to those of patients with RB-ILD [21]. However, consideration of the smoking history may help in the differentiation: a history of smoking is the norm in the vast majority of patients with RB-ILD, whereas cigarette smoke appears to protect against the development of extrinsic allergic alveolitis.

In summary, the advent of HRCT has had a major impact on clinical practice. Indeed, HRCT is now an integral component of the clinical investigation of patients with suspected and established interstitial lung disease.

References

1. Wells AU (1998) Clinical usefulness of high resolution computed tomography in cryptogenic fibrosing alveolitis. Thorax 53:1080-1087
2. King TE Jr., Costabel U, Cordier JF et al (2000) Idiopathic pulmonary fibrosis: diagnosis and treatment. International consensus statement. Am J Respir Crit Care Med 161:646-664
3. Hunninghake GW, Zimmerman MB, Schwartz DA et al (2001) Utility of a lung biopsy for the diagnosis of idiopathic pulmonary fibrosis. Am J Respir Crit Care Med 164:193-196
4. Mayo JR, Webb WR, Gould R et al (1987) High-resolution CT of the lungs: an optimal approach. Radiology 163:507-510
5. Murata K, Khan A, Rojas KA, Herman PG (1988) Optimization of computed tomography technique to demonstrate the fine structure of the lung. Invest Radiol 23:170-175
6. Remy-Jardin M, Remy J, Deffontaines C, Duhamel A (1991) Assessment of diffuse infiltrative lung disease: comparison of conventional CT and high-resolution CT. Radiology 181:157-162
7. Webb WR, Müller NL, Naidich DP (1996) HRCT findings of lung disease. In: Webb WR, Müller NL, Naidich DP (eds) High-resolution CT of the lung, 2 edN. Lippincott-Raven, Philadelphia, pp 41-108
8. Müller NL, Miller RR, Webb WR et al (1986) Fibrosing alveolitis: CT-pathologic correlation. Radiology 160:585-588
9. Mathieson JR, Mayo JR, Staples CA, Müller NL (1989) Chronic diffuse infiltrative lung disease: comparison of diagnostic accuracy of CT and chest radiography. Radiology 171:111-116
10. Padley SP, Hansell DM, Flower CD, Jennings P (1991) Comparative accuracy of high resolution computed tomography and chest radiography in the diagnosis of chronic diffuse infiltrative lung disease. Clin Radiol 44:222-226
11. Primack SL, Hartman TE, Hansell DM, Müller NL (1993) End-stage lung disease: CT findings in 61 patients. Radiology 189:681-686
12. Nowers K, Rasband JD, Berges G, Gosselin M (2002) Approach to ground-glass opacification of the lung. Semin Ultrasound CT MR 23:302-323
13. Colby TV, Swensen SJ (1996) Anatomic distribution and histopathologic patterns in diffuse lung disease: correlation with HRCT. J Thorac Imaging 11:1-26
14. Desai SR, Wells AU, Rubens MB et al (2003) Traction bronchiectasis in cryptogenic fibrosing alveolitis: associated computed tomographic features and physiological significance. Eur Radiol 13:1801-1808

15. Colby TV, Carrington CB (1995) Interstitial lung disease. In: Thurlbeck WM, Churg AM (eds) Pathology of the lung, 2 edn. Thieme Medical Publishers, New York, pp 589-737
16. Lynch DA, Webb WR, Gamsu G et al (1989) Computed tomography in pulmonary sarcoidosis. J Comput Assist Tomogr 133.:405-410
17. Brauner MW, Grenier P, Mompoint D et al (1989) Pulmonary sarcoidosis: evaluation with high-resolution CT. Radiology 172:467-471
18. Hansell DM, Milne DG, Wilsher ML, Wells AU (1998) Pulmonary sarcoidosis: morphologic associations of airflow obstruction at thin-section CT. Radiology 209:697-704
19. Remy-Jardin M, Remy J, Wallaert B, Müller NL (1993) Subacute and chronic bird breeder hypersensitivity pneumonitis: sequential evaluation with CT and correlation with lung function tests and bronchoalveolar lavage. Radiology 189:111-118
20. Hansell DM, Wells AU, Padley SPG, Müller NL (1996) Hypersensitivity pneumonitis: correlation of individual CT patterns with functional abnormalities. Radiology 199:123-128
21. Desai SR, Ryan SM, Colby TV (2003) Smoking related interstitial lung diseases: histopathological and imaging perspectives. Clin Radiol 58:259-268

Diseases of the Chest Wall, Pleura, and Diaphragm

J. Verschakelen[1], P. Vock[2]

[1] Department of Radiology, University Hospitals, Leuven, Belgium
[2] Department of Radiology, University Hospital (Inselspital), Bern, Switzerland

Diseases of the Chest Wall

In contrast to the visceral organs (lung, mediastinum), the symmetry of the chest wall allows radiographic detection of tiny changes overlaying the deeper structures. Except in skeletal disease, calcification, and emphysema, chest radiography will often only reveal nonspecific signs, whereas sectional methods, i.e., ultrasound (US), computed tomography (CT), and magnetic resonance imaging (MRI), permit the identification, characterization, and assessment of many diseases.

Specific Radiographic Patterns of Chest-Wall Disease

Soft-tissue emphysema is recognized on radiographs and, by its expansion through loose tissue, demonstrates the continuity between the chest wall, the neck, the mediastinum, and the abdominal wall. Calcifications, whether dystrophic or metastatic, are similarly well seen on X-ray films. Soft-tissue swelling and tumors first have to be differentiated from asymmetries due to technical reasons, including contralateral surgery (e.g., of the breast), atrophy, such as seen in hemiplegia, or simply right/left-handedness. Beyond a regionally increased absorption, specific signs may be present that help to detect and distinguish chest-wall diseases from intrathoracic ones. Depending on the angle of projection, chest-wall diseases often extend beyond the parietal pleura and may even bulge the skin. Medially, they are not limited by the mediastinum but may well continue over the midline. In case of pedunculation, analogous to the breast gland, they have a sharp, inferiorly convex, lower but no recognizable upper contour. Smaller lesions, similar to the nipples, may produce 'nodules' in one projection but usually will not project into the lung on the orthogonal second view. Chest-wall tumors sometimes involve the skeleton, such that bone changes will often be detected more easily. Finally, when they grow into the chest, chest-wall disease will behave as extrapulmonary lesions; like pleural disease, they are usually sharply marginated, convex towards the hilum, have no air bronchogram, and form an obtuse angle with the adjacent normal pleura. Any skeletal pathology may also involve the chest wall. Rib erosions are a unique and relatively specific sign found at the lower or upper contour, Concave osteolytic defects of 2-4 mm at the lower border are seen with enlarged intercostal collateral arteries, but sometimes also with venous collaterals or nerve disease.

Congenital Diseases of the Chest Wall

In the soft tissues, the Poland syndrome corresponds to an absence of the major pectoral muscle. It is often accompanied by an absent breast gland and syndactyly, whereas polythelia means multiple nipples along the mammary crest. Lymphangioma and lymphangio-hemangioma often extend from the neck to the chest wall and are best analyzed by CT or MRI. Hemolytic anemia (thalassemia) may induce extramedullary hematopoiesis, causing paravertebral pseudotumors but of course also expansion of the ribs. There is a large spectrum of anomalies of the ribs, sternum (funnel chest, pigeon chest, defects), scapula, clavicle, and spine.

Inflammatory Diseases of the Chest Wall

Non-infectious, mostly rheumatic disorders often involve the joints, cartilage, and soft tissues of the chest wall. Of these, Tietze syndrome and sternocostoclavicular hyperostosis deserve special mention. Chest-wall infection may arise through the skin (including wounds), extend from the lung and pleura (empyema) or the abdominal wall, or be due to hematogenous spread. Radiography – when the lung is not involved – shows the signs typical for extrapulmonary disease (see previous section), whereas CT or MRI demonstrate the exact multicompartmental location. Bone scintigraphy will show the distribution of inflammatory activity in the entire body. US helps guide diagnostic aspiration and drainage.

Trauma of the Chest Wall

Though not as critical as trauma to the visceral organs, injury to the bones and soft tissues of the chest wall is much more frequent. Chest instability may result both from vertebral fractures and multiple rib fractures (flail

chest), requiring surgical stabilization. Sternal fracture, diagnosed on lateral projections or CT, is often missed on supine radiographs.

Neoplasms of the Chest Wall

Primary tumors of the chest wall may be benign or malignant and arise in the skeleton (all types of chondrogenic neoplasms, angioma, Langerhans' cell histiocytosis, Ewing and osteo-sarcoma, plasmocytoma) or the soft tissues (hemangioma, skin tumors, fibrous and neurogenic neoplasms). Radiographs show bony destruction, expansion, and calcification and/or simply the non-specific signs of extrapulmonary lesions (see 'Congenital Diseases of the Chest Wall'). CT or MRI can be used to localize, differentiate, and stage these neoplasms. Secondary tumors arise from hematogenous or lymphatic spread (in malignant lymphoma and organ tumors), or from continuous infiltration from neighboring regions, as most often seen in lung cancer and pleural mesothelioma. Again, cross-sectional imaging is required for staging, treatment planning, and follow-up [1].

Other Diseases of the Chest Wall

These include degenerative and metabolic disorders, sometimes with typical manifestations, such as seen in diffuse idiopathic skeletal hyperostosis (DISH) or hyperparathyroidism (rugger jersey spine). Obstructive arterial and venous vascular disease often causes the formation of chest-wall collaterals (see 'Congenital Diseases of the Chest Wall'). Iatrogenic disorders mainly include complications after surgery and following the insertion of central venous catheters or drains, but also occur as sequelae after therapeutic irradiation.

Diseases of the Pleura

The chest radiograph is still the most important and widely used means of demonstrating and following the progress of pleural disease, although US, CT, and MRI play a role in a number of specific situations [2, 3]. Grossly, pleural disease manifests as an accumulation of fluid or air in the pleural space, as pleural thickening (with or without calcification), or as the presence of a pleural mass.

Pleural Effusion

While all types of pleural effusion are radiographically identical, historical, clinical, and other radiological features may help limit the diagnostic possibilities. US, CT, and MRI can help to specify the diagnosis [2-4]. The goals of diagnostic imaging are: (1) detection of the effusion and differentiation from other pathological pleural processes; (2) detection of underlying pulmonary, cardiac, mediastinal, or abdominal pathology; (3) when pos-

sible, obtaining a specific diagnosis. A small amount of free fluid may be undetectable on an erect PA chest radiograph, as it tends initially to collect under the lower lobes. Such small subpulmonic effusions can be demonstrated by US or CT [2, 3]. Fluid can also loculate between visceral pleural layers in fissures or between visceral and parietal layers, usually against the chest wall. It is unusual for this to happen without some additional radiographic clue to the presence of pleural disease. Both US and CT can be used to distinguish loculated fluid from solid lesions. In addition, US and especially CT allow characterization of the morphology of pleural thickening – which often accompanies a pleural effusion – distinguishing between malignant (nodular, with focal masses) and benign thickening, the latter typically being uniform. CT can also identify any underlying lung disease that might have provoked an effusion and it facilitates percutaneous aspiration and biopsy.

Pneumothorax

The diagnosis of pneumothorax is usually made with the chest radiograph, which also detects complications and predisposing conditions and helps in management. Iatrogenic causes apart, the commonest type of pneumothorax in the adult is so-called primary spontaneous pneumothorax, which nearly always results from the rupture of an apical pleural bleb. High-resolution CT (HRCT) can be helpful to detect these abnormal apical airspaces, which are not visible on the chest X-ray [5]. A large number of conditions predispose to the development of a secondary pneumothorax. Pneumothorax can be a complication of histiocytosis X, lymphangioleiomyomatosis, chronic obstructive pulmonary disease (COPD), and lung metastasis of an osteogenic sarcoma.

Visualization of a visceral pleural line (usually at the apex on an erect chest film) separated from the chest wall by a transradiant zone devoid of vessels is the typical sign of a pneumothorax. Interpretation can be difficult with avascular lung apices, as in bullous disease and when clothing or dressing artifacts create linear shadows, tubes, and skin folds. Diagnosis is especially difficult when images are obtained with the patient in the supine position. In this case, pleural air rises and collects anteriorly, particularly medially and basally, and may not extend far enough posteriorly to separate lung from the chest wall at the apex or laterally [6]. Signs that nonetheless suggest a pneumothorax under these conditions are: (1) ipsilateral transradiancy, either generalized or hypochondrial; (2) a deep, finger-like costophrenic sulcus laterally; (3) a visible anterior costophrenic recess seen as an oblique line or interface in the hypochondrium; (4) a transradiant band parallel to the diaphragm and/or mediastinum with undue clarity of the mediastinal border; (5) visualization of the undersurface of the heart and of the cardiac fat pads as rounded opacities suggesting masses; and (6) diaphragm depression. In case of doubt, a CT can be performed.

Pleural Thickening

Pleural thickening is common and usually represents the organized end-stage of various active processes, such as infective and non-infective inflammation (including asbestos exposure [7] and pneumothorax) and hemothorax. When generalized and gross, the condition is termed a fibrothorax and it may cause significant ventilatory impairment. Radiologically, pleural thickening gives fixed shadowing of water density, most commonly located in the dependent parts of the pleural cavity. On US, benign pleural thickening produces a homogeneous echogenic layer just inside the chest wall. It is not reliably detected unless it is ≥1 cm thick. CT, however, is very sensitive at detecting pleural thickening, which is most easily assessed on the inside of the ribs, where there should normally be no soft-tissue opacity. Pleural calcification is most commonly seen following asbestos exposure, empyema (usually tuberculous), and hemothorax.

Pleural Tumors

Localized tumoral thickening of the pleura can be a mass originating from the pleura itself, such as a fibrous tumor (localized mesothelioma) [8], or a pleural lipoma, but is more frequently a pleural metastasis usually resulting from an adenocarcinoma. The plain radiographic findings of a fibrous tumor are a pleural-based, well-demarcated, rounded, and often slightly lobulated mass (2-20 cm in diameter) which may, because of pedunculation, show marked positional variation with changes in posture and respiration. Such tumors usually form an obtuse angle with the chest wall and may reach enormous sizes. CT findings are similar to those observed on plain radiography, i.e., a large mobile mass, often heterogeneous because of necrosis and hemorrhage, frequently enhancing after contrast administration and rarely calcified. Malignant types are usually >10 cm in size and may invade the chest wall. Typically these tumors show low signal intensity on both T1- and T2-weighted images, although tumors with intermediate to high signal intensity have been described. Lipomas are asymptomatic benign tumors that are usually discovered incidentally on chest radiographs as sharply defined pleural masses. Diagnosis is easy with CT because this approach delineates the pleural origin and the fatty composition. Pleural metastases are very often accompanied by pleural effusion, which may be the only finding on a chest radiograph. CT, MRI, and US are more sensitive techniques to demonstrate pleural metastasis as the cause of the pleural effusion.

Diffuse tumoral thickening of the pleura can be caused by malignant mesothelioma or by pleural metastasis. The two entities are usually indistinguishable with imaging. Diffuse malignant mesothelioma presents on a chest radiograph as an irregular and nodular pleural thickening with or without associated pleural effusion. Tumor extension into the interlobar fissures, accompanying pleural effusion, and invasion in the chest wall are better appreciated with CT. MRI may be superior to CT in determining the extent of disease because it allows better evaluation of the relationship of the tumor to the structures of the chest wall, the mediastinum, and the diaphragm. In most cases, however, CT and MR provide similar information that often can be improved for N- and M-stage disease by positron emission tomography (PET) [9, 10]. Sonography may provide a supplementary method for biopsy and surgery planning.

Diseases of the Diaphragm

The diaphragm is a thin, flat musculotendinous structure that separates the thoracic cavity from the abdominal cavity. Being a respiratory muscle, it has an important role in respiration. Radiology of the diaphragm is difficult mainly because there is no imaging technique that can clearly and entirely visualize the diaphragm. On conventional chest film, the diaphragmatic muscle is only visible when air is present above and below it. The only imaging modalities that can visualize the diaphragm itself are US, CT, and MRI, although visualization is usually partial and dependent on the presence of pleural disease in the case of US, and on the presence of subdiaphragmatic fat when in the case of CT or MRI [11-13].

Diaphragmatic Hernia

Bochdalek Hernia

Large Bochdalek hernias usually become evident in the neonatal period. Small asymptomatic Bochdalek hernias are sometimes an incidental finding in adults and can cause a smooth focal bulge seen on a lateral chest film centered approximately 4-5 cm anterior to either posterior diaphragmatic insertion. On CT, the diagnosis of Bochdalek hernia can be made when a soft-tissue or fatty mass is seen abutting the upper surface of the posteromedial aspect of either hemidiaphragm. This mass is in continuity with subdiaphragmatic structures through a diaphragmatic defect presenting as a discontinuity of the soft-tissue line of the diaphragm [14].

Morgagni Hernia

The incidence of Morgagni hernia detected in the neonatal period, because of respiratory symptoms, is low. In older children and adults, Morgagni hernia is often an incidental finding since there are mostly no symptoms. Although the weak area is caused by an embryonal failure of muscularization, herniation of the abdominal contents to the thorax can be acquired as a result of increased intra-abdominal pressure due to severe effort, trauma or obesity. On chest film, Morgagni hernia presents as a variably sized, rounded density in the right (or rarely left) anterior cardiophrenic angle, possibly containing gas shadows. A herniated liver can be identified on CT, MRI, or US [14].

Hiatal Hernia

In hiatal hernia, there is herniation of a part, or seldom, of the entire stomach or of another abdominal structure (fat, pancreas pseudo-cyst) through the esophageal hiatus. Diagnosis can be made on conventional PA and lateral chest film and confirmed by a barium study. Hiatal hernias are often an incidental finding on CT [14].

Traumatic Diaphragmatic Rupture

Blunt trauma and penetrating wounds of the chest are the most frequent causes of traumatic diaphragmatic rupture. Clinical symptoms are often very aspecific, but missing a diaphragmatic rupture can have severe consequences when strangulation of the herniated viscera occurs. Thus, special attention has to be given to small changes in the diaphragmatic contour or basal lung translucency when a conventional chest film of a patient with trauma to the lower chest or the pelvis is interpreted. Diagnosis is easier when a gas and fluid shadow is seen in the thorax. However, radiological signs are very often aspecific and can be limited to a localized density in close relationship to the diaphragm. The chest film may even be completely normal [15].

Barium studies can be helpful in making the correct diagnosis and may reveal an extrinsic narrowing at the border of the stomach or bowel at the point where either structure passes the diaphragmatic tear.

Ultrasound can be diagnostic if both the diaphragm and the herniated organs can be visualized [16]. However, this technique is limited by the often-minimal visualization of the diaphragm itself, tenderness over the upper abdomen, and the presence of gas in the herniated bowel.

Multislice CT is superior because of its high image quality and its ability to produce reformatted images. CT signs of diaphragmatic rupture include discontinuity of the diaphragm with direct visualization of the diaphragmatic injury; herniation of abdominal organs with the liver, bowel, or stomach in contact with the posterior ribs ('dependent viscera sign'); thickening of the crus ('thick crus sign'); constriction of the stomach or bowel ('collar sign'); active arterial extravasation of contrast material near the diaphragm; and, in case of a penetrating diaphragmatic injury, depiction of a missile or puncturing instrument trajectory.

When the rupture is missed at the time of the trauma and the patient has recovered from the associated lesions, a 'latent 'phase of diaphragmatic rupture can occur. Symptoms and signs are then caused by recurrent herniation of abdominal structures through the diaphragmatic defect and are again often aspecific. CT and MRI can be helpful to detect these missed tears [17].

Tumors of the Diaphragm

Tumors of the diaphragm are rare lesions that are often difficult to assess and classify clinically as well as roentgenographically. Malignant tumors are more frequent than benign tumors and can be primary or secondary. CT and MRI may be helpful in providing a specific diagnosis [18]. CT attenuation values can be used to diagnose lipoma or cystic tumors. Visualization of an interrupted diaphragmatic soft-tissue line can be helpful to differentiate herniation of fat from lipoma. Visualization of the peridiaphragmatic area in frontal or sagittal views with spiral and multidetector CT or MRI can give additional information.

Eventration

Eventration of the diaphragm is defined as an abnormally high or elevated position of one leaf of the intact diaphragm as a result of paralysis, aplasia, or atrophy of varying degrees of muscle fibers. In the area of eventration, the normal diaphragmatic muscle fibers are replaced by a thin layer of connective tissue and a few scattered muscle fibers. Eventration can be congenital, resulting from the congenital failure of proper muscularization of a part or the entire diaphragmatic leaf. Eventration can also be acquired and is then the result of long-lasting paralysis causing atrophy and scarring of the diaphragmatic muscle. On conventional chest X-ray, partial eventration presents as a semicircular or semi-oval homogeneous shadow of soft-tissue density arising from the diaphragm that becomes more prominent on deep inspiration. CT as well as US and MRI can be helpful to differentiate this entity from pleural, mediastinal, and pericardial tumors or cysts. Differentiation from herniation and diaphragmatic paralysis may be difficult [19].

Paralysis of the Diaphragm

The most common cause of unilateral paralysis of the diaphragm is involvement of the phrenic nerve by tumor. But there are also many other causes. Fluoroscopy is the easiest imaging tool to use for the evaluation of diaphragmatic dysfunction. However, in experienced hands, US is also valuable to study and monitor diaphragmatic movement [20]. Four signs indicate diaphragmatic paralysis: (1) elevation of the diaphragm above the normal range; (2) diminished, absent, or paradoxical movement on inspiration; (3) mediastinal shift on inspiration; and (4) paradoxical movement during sniffing.

All these signs need not be present simultaneously, but paradoxical movement during sniffing is generally considered as the sine qua non of diaphragmatic paralysis.

Other Causes of Diaphragmatic Dysfunction

Diaphragmatic fatigue, hiccups, and diaphragmatic flutter are other causes of diaphragmatic dysfunction. The role of radiology in the diagnosis and follow-up of these diseases is limited.

Local irritation of the diaphragm can also cause diaphragmatic dysfunction (decreased motion or even paralysis). Peridiaphragmatic inflammation or infections, such as lower-lobe pneumonia or subdiaphragmatic abscess, are the most common causes. Diaphragmatic function usually returns after the inflammatory condition resolves.

Fluoroscopy and US show decreased movement and often-paradoxical motion. CT and US can aid in the diagnosis of peridiaphragmatic disease.

References

1. Tateishi U, Gladish GW, Kusumoto M et al (2003) Chest wall tumors: radiologic findings and pathologic correlation, parts 1 and 2. Radiographics 23:1477-1508
2. Muller NL (1993) Imaging of the pleura. Radiology 186:297-309
3. Koh DM, Burke S, Davies N, Padley SP (2002) Transthoracic US of the chest: Clinical uses and applications. Radiographics 22:e1
4. Yang P-C, Luh K-T, Chang D-B et al (1992) Value of sonography in determining the nature of pleural effusion: analysis of 320 cases. AJR Am J Roentgenol 159:29-33
5. Lesur O, Delorme N, Fromaget JM et al (1990) Computed tomography in the etiologic assessment of idiopathic spontaneous pneumothorax. Chest 98:341-347
6. Rhea JT, van Sonnenberg E, McLoud TC (1979) Basilar pneumothorax in the supine adult. Radiology 133:593-595
7. Roach HD, Davies GJ, Attanoos R et al (2002) Asbestos: when dust settles – an imaging review of asbestos-related disease. Radiographics 22:S167-S184
8. Rosado-de-Christenson ML, Abbott GF, McAdams HP et al (2003) From the archives of the AFIP: Localized fibrous tumors of the pleura. Radiographics 23:759-783
9. Wang ZJ, Reddy GP, Gotway MB et al (2004) Malignant pleural mesothelioma: evaluation with CT, MR imaging, and PET. Radiographics 24:105-119
10. Flores RM (2005) The role of PET in the surgical management of malignant pleural mesothelioma. Lung Cancer 49(Suppl 1):S27-S32
11. Gierada DS, Slone RM, Fleishman MJ (1998) Imaging evaluation of the diaphragm. Chest Surg Clin N Am 8:237-280
12. Verschakelen JA, Marchal G, Verbeken E et al (1989) Sonographic appearance of the diaphragm in the presence of pleural disease: a cadaver study. J Clin Ultrasound 17:222-227
13. Brink JA, Heiken JP, Semenkovich J et al (1994) Abnormalities of the diaphragm and adjacent structures: findings on muliplanar spiral CT scans. AJR Am J Roentgenol 163:307-310
14. Eren S, Çiri_ F (2005) Diaphragmatic hernia: diagnostic approaches with review of the literature. Eur J Radiol 54:448-459
15. Eren S, Kantarci M, Okur A (2006) Imaging of diaphragmatic rupture after trauma. Clin Radiol 61:467-477
16. Walz M, David A, Schmitz J, Muhr G (1993) Value of ultrasound diagnosis after blunt chest trauma. Intensiv Notfallbehandlung 18:74-79
17. Sattler S, Canty TG Jr, Mulligan MS et al (2002) Chronic traumatic and congenital diaphragmatic hernias: presentation and surgical management. Can Respir J 9:135-139
18. Schwartz EE, Wechsler RJ (1989) Diaphragmatic and paradiaphragmatic tumors and pseudotumors. J Thorac Imaging 4:19-28
19. Eren S, Ceviz N, Alper F (2004) Congenital diaphragmatic eventration as a cause of anterior mediastinal mass in the children: imaging modalities and literature review. Eur J Radiol 51:85-90
20. Bih LI, Wu YT, Tsai SJ et al (2004) Comparison of ultrasonographic renal excursion to fluoroscopic diaphragmatic excursion for the assessment of diaphragmatic function in patients with high cervical cord injury. Arch Phys Med Rehabil 85:65-69

Chest Manifestations of Systemic Diseases

E.A. Kazerooni

Department of Radiology, Medical Center Drive, University of Michigan Medical Center, Arbor, MI, USA

There are numerous systemic diseases, both acquired and hereditary, that affect the thorax. The many radiologic manifestations of these diseases may involve the lungs and pleura as well as cardiovascular, neurologic, hematologic and osseous structures of the thorax. What follows is a summary of the more common of these entities.

Collagen Vascular Diseases

Scleroderma (Progressive Systemic Sclerosis)

Demographics and Clinical Manifestations

The incidence of scleroderma is 2-12 per million, with the usual onset before age 45 and a three-fold higher incidence in women than in men. PSS is characterized by sclerosis and atrophy of the skin, GI tract, musculoskeletal system, lungs, and heart, as well as arteritis and thickening of blood vessels. It affects the skin in 90% of patients, the vascular system, esophagus, and intestines in 80%, lungs in 45%, heart in 40%, kidneys in 35%, and musculoskeletal system in 25% of patients. In addition, there is an association with primary biliary cirrhosis. The clinical presentation includes fever, lassitude, and weight loss. Antinuclear antibodies are present in 30-80% of patients; anti-topoisomerase or antiScl-70 is present with diffuse cutaneous involvement. Anti-centromere antibody is present in a third of patients with scleroderma, and two-thirds of patients with CREST syndrome (calcinosis, Raynaud's, esophageal dysmotility, sclerodactyly, telangiectasias) [1-4].

Radiologic Manifestations

Basilar interstitial pneumonitis and fibrosis are the radiologic manifestations of scleroderma [3]. The basilar distribution is more pronounced in scleroderma than in other collagen vascular diseases. On radiographs there may be fine/coarse basilar reticulations with small lung volumes due to the restrictive process of the disease. High-resolution computed tomography (HRCT) demonstrates inter- and intralobular septal thickening, subpleural lines and micronodules, ground-glass opacity, and honeycombing. The findings may be very similar to those of the usual interstitial pneumonia (UIP) form of idiopathic interstitial pneumonia; however, in scleroderma the disease progresses more slowly. Esophageal dysmotility results in a dilated air-filled esophagus and findings of aspiration pneumonia. Pulmonary arterial hypertension occurs in 6-60% of patients, and sclerosis of cardiac muscle may result in cor pulmonale [5]. Pleural involvement is rare. There is an increased risk of lung cancer (adeno- and bronchoalveolar).

Rheumatoid Arthritis

Demographics and Clinical Manifestations

The prevalence of RA is as high as 2%. The usual age of onset is between 25 and 55 years, and the occurrence is three times more common in women than in men. In most cases, RA begins insidiously, causing ill health and chronic joint deformity. Rheumatoid factor is positive in 50-70% of patients. Although the brunt of the disease occurs in the joints, extra-articular manifestations of this systemic connective tissue disease are present in up to 76% of patients (Table 1). Therefore, RA is better termed 'rheumatoid disease' [1-3, 6-8]. Indeed, 2-54% of patients with RA develop rheumatoid lung disease, which occurs five times more often in men than in women.

Table 1. Thoracic manifestations of rheumatoid arthritis

Pleura	Effusion
	Thickening
	Pneumothorax
Lungs	Diffuse interstitial fibrosis
	Necrobiotic nodules (rheumatoid nodules)
	Bronchial abnormalities
	Caplan syndrome
Cardiovascular	Cardiac enlargement
	Pulmonary arteritis
Osseous	Erosive arthritis
	Facet joint ankylosis
	Rib erosions
	Osteoporosis and compression fractures

Radiologic Manifestations

Pleural abnormalities are the most frequent thoracic manifestation and include a unilateral exudative pleural effusion in 90% of patients (protein content >4 g/dl, a low glucose content of <30 mg/dl that does not rise during intravenous glucose infusion), which may change little over months. The fluid has a low white cell count, many lymphocytes, and is usually positive for rheumatoid factor, LDH, and RA cells [9]. Bilateral large effusions may also be seen. Pleural disease is nine times more common in men than in women and may antedate arthritis. In addition, pleural thickening may occur, usually bilaterally, with pleural fibrosis and adhesions being common findings at autopsy. Pneumothorax may be present secondary to rupture of rheumatoid nodules, which are often cavitary, or end-stage fibrotic lung disease.

Diffuse interstitial fibrosis is seen in 2-6% of patients and is most frequent in cases of seropositive RA [9]. This restrictive lung disease, with lower-lobe subpleural predominance, is often indistinguishable from usual interstitial pneumonitis (UIP form). As such, it manifests as irregular septal lines, honeycombing, or a reticulonodular pattern. HRCT improves early detection. Rheumatoid lung disease has a more benign course than UIP [3, 9, 10].

Necrobiotic nodules are well-circumscribed masses in the lungs, pericardium, and visceral organs. They are identical pathologically to the subcutaneous nodules, and are seen with advanced disease. These nodules are usually multiple, non-calcified, peripherally occurring, and range in size from 3 mm to 7 cm. They may cavitate, typically with a thick wall and smooth border. Necrobiotic nodules are often found in conjunction with subcutaneous nodules that wax and wane [1, 3, 6, 9, 10]. Bronchial abnormalities, such as bronchiectasis or bronchiolitis obliterans, occasionally occur. Bronchiectasis is mainly seen in women with longstanding seropositive disease, while bronchiolitis obliterans is rare but frequently fatal. Follicular bronchiolitis is defined as hyperplasia of BALT (bronchus-associated lymphoid tissue) and as such classified as a lymphoproliferative disorder. Nonetheless, in two-thirds of cases it occurs in RA patients. HRCT demonstrates nodular opacities 1-3 mm in size (rarely up to 10 mm) in a centrilobular and peribronchovascular distribution.

Pulmonary arteritis is a rare manifestation of RA. It consists of fibroelastoid intimal proliferation that may result in pulmonary arterial hypertension and cor pulmonale [9]. Cardiopericardial silhouette enlargement is also unusual, and may result from a pericardial effusion or myocarditis with congestive cardiac failure. Various bone abnormalities may be seen on chest X-ray or CT, including erosive arthritis, ankylosis of vertebral facet joints, osteoporosis, and vertebral-body collapse secondary to steroid therapy. Caplan syndrome is the coexistence of coal-workers pneumoconiosis and RA.

Systemic Lupus Erythematosus

Demographics and Clinical Manifestation

Systemic lupus erythematosus has an incidence of 1 in 2000, is usually diagnosed between 20 and 40 years of age, and is nine times more common in women than in men. SLE is more prevalent in East Asia and especially in the USA, where the incidence in African-American women is as high as 1 in 250 and in whom the disease often has a more severe course. There is an increased incidence of HLA B8 and DR3 antigens in SLE patients. The disease may be exacerbated by sunlight and infection. Furthermore, a lupus-like syndrome may be induced by certain medications, such as hydralazine, oral contraceptives, phenothiazines, and procainamide. The most common early features are fever, arthralgia, general ill health, and weight loss. The 'butterfly' rash on the face is characteristic. Antinuclear antibodies are present in 95% of patients. Antibodies to double-stranded DNA are considered diagnostic, although Sm antibodies are more specific. Hypergammaglobulinemia occurs in 77% of patients, LE cells in 80%, and a false positive Wasserman test for syphilis in 24%. SLE affects the joints in 90% of patients, skin in 80%, kidneys in 60%, lungs in 50%, cardiovascular system in 40%, and nervous system in 35%. It also involves the blood and lymphatic systems [1-3, 8]. SLE affects the respiratory system more often than other connective tissue diseases.

Radiologic Manifestations

Pleural effusion is the most common manifestation, with recurrent small bilateral pleural effusions in 70% of patients. There may be pleural thickening. Pericardial effusion from pericarditis is common, whereas cardiomegaly from primary lupus cardiomyopathy is rare [11, 12]. Acute lupus pneumonitis is characterized by ground-glass opacity/consolidation at the lung bases, evolving when chronic to basal interstitial pulmonary fibrosis in approximately 3% of patients. Alveolar hemorrhage also manifests as ground-glass opacity or consolidation. Bibasilar fleeting plate-like atelectasis secondary to infection or infarction may occur. Patients with SLE have an increased incidence of pulmonary emboli secondary to circulating antiphospholipid antibodies (Table 2).

Table 2. Thoracic manifestations of systemic lupus erythematosus

Pulmonary	Ground-glass opacity (pneumonitis or hemorrhage)
	Consolidation (pneumonitis or hemorrhage)
	Atelectasis
	Pulmonary embolism
Pleural	Effusion (pleuritis)
	Thickening
Cardiovascular	Pericardial effusion (pericarditis)
	Cardiomegaly (cardiomyopathy)

Polymyositis/Dermatomyositis

Demographics and Clinical Manifestations

These diseases have an incidence of 1-8 per million, a bimodal age distribution with an early peak at 5-15 years and a later peak at 45-65 years, and a four times higher incidence in women than in men. Patients have an increased incidence of HLA A1, B8, DR3, and DR5 antigens. Clinical presentation may be acute or chronic, with proximal muscle weakness, a heliotrope or violaceous skin rash in dermatomyositis, and telangiectasias over the joints of the hand. Dysphagia occurs in up to 50% of affected individuals. Skin and muscle changes may occur together or 2-3 months apart. General ill health and fever are common. Disease is associated with the anti-Jo1 antibody. In 10% of cases there is an underlying malignancy, with carcinomas of lung, breast, stomach, and ovary being the most common. In men presenting over the age of 50, 60% have carcinoma, usually bronchogenic carcinoma.

Radiologic Manifestations

Chest radiographs are often normal. Basal interstitial pulmonary fibrosis indistinguishable from UIP or nonspecific interstitial pneumonitis (NSIP) occurs in up to 10% of patients. Bronchiolitis obliterans and bronchiolitis obliterans organizing pneumonia also occur. When pharyngeal muscle paralysis accompanies polymyositis, aspiration pneumonia may develop. Diaphragmatic elevation with small lung volumes is also seen.

Sjögren's Syndrome

Demographics and Clinical Manifestations

Sjögren's syndrome consists of the clinical triad of keratoconjunctivitis sicca, xerostomia, and recurrent parotid-gland swelling. It may occur in isolation, in which case it is referred to as primary SS (pSS); however, the majority of patients have coexistent collagen vascular disease (secondary SS, sSS), usually most commonly RA. Sjögren's is nine times more common in women than in men, with a peak incidence in women around 55 years of age. Pleuropulmonary manifestations are found in 10% to as high as 75% of patients, depending on the associated collagen vascular disease. Clinical symptoms include hoarseness, cough, dyspnea, and recurrent infections, although many patients have no respiratory symptoms. Antinuclear antibodies, rheumatoid factor (IgM, anti IgG), and antibodies against the salivary glands are detected in 80% of patients. There is a two-fold increased incidence of developing lung cancer (adeno- and bronchioloalveolar carcinoma). Extraglandular manifestations include arthritis, Raynaud's syndrome, splenomegaly, lymph-node enlargement, involvement of the kidneys, liver, and GI tract, mononeuritis, and vasculitis.

Radiologic Manifestations

Radiographic findings include nodular and reticulonodular opacities predominantly in the lower lungs. Early HRCT findings are thick interlobular septa, bronchiectasis, centrilobular nodules (follicular bronchiolitis), and tree-in-bud sign. Focal air trapping indicates follicular bronchiolitis. As disease progresses, fibrotic changes such as traction bronchiectasis, honeycombing, and irregular septal lines are seen in a subpleural location, indistinguishable from scleroderma. Mediastinal lymph nodes are usually not enlarged; when they are, lymphoma should be suspected. LIP is characterized by the combination of ground-glass opacities and diffusely distributed thin-walled cysts; thickened bronchovascular interstitium, centrilobular nodules and patchy consolidation may also be seen (Table 3).

Vasculitis

Systemic Vasculitides with Pulmonary Involvement

There are many systemic vasculitides that can involve lungs. They are categorized according to the size of the vessels primarily involved, and whether or not they are associated with elevated anti-nuclear cytoplasmic antibody (ANCA). These disorders have manifestations in many organ systems, especially skin and kidneys, and are frequently accompanied by pulmonary hemorrhage.

Antiglomerular Basement Membrane Disease (Goodpasture's Disease)

Demographics and Clinical Manifestations

Goodpasture's disease is rare, with an incidence of 1 in 2 million, an age of onset at 20-30 years. It is two to nine times more common in men than in women and is essentially a disease of young white males, as it is rare in African-Americans. There is an increased incidence of HLA DR2 antigen. Anti-GBM disease comprises a triad of glomerulonephritis, circulating antibodies against the glomerular and alveolar basement membranes, and pulmonary hemor-

Table 3. Thoracic manifestations of Sjögren's syndrome

Pulmonary	Atelectasis (diaphragmatic elevation) Fibrosis Vasculitis (pulmonary hypertension)
Pleural	Effusion (pleuritis) Thickening
Lymphoproliferative	Lymphocytic interstitial pneumonia Lymphocytic bronchitis Focal polyclonal lymphoproliferation (low-grade lymphoma) Malignant lymphoma Amyloidosis

rhage [1, 2, 20]. When there is lung involvement it is termed Goodpasture's syndrome. Hemoptysis is the most common and earliest manifestation, usually preceding renal disease by several months. It has a poor prognosis, with one series showing 96% mortality and a mean survival of only 15 weeks [6]. Therapy includes immunosuppression and the removal of circulating antibodies by plasmaphoresis.

Radiologic Manifestations

Acute pulmonary hemorrhage appears as diffuse or multifocal consolidation or ground-glass opacities, often with a perihilar or basilar distribution and sparing the costophrenic angles. It may be asymmetric or unilateral. Over time, the alveolar pattern is replaced by reticulation that usually resolves in 2 weeks. With repeated hemorrhage, interstitial fibrosis develops, causing a permanent reticular pattern. Hilar lymph nodes may be enlarged acutely [13, 14].

Wegener's Granulomatosis

Demographics and Clinical Manifestations

The incidence of Wegener's granulomatosis is 3 per million, with a mean onset at 40 years and a slightly higher occurrence in men (1.3:1). There is an increased incidence of HLA B8 and DR2 antigens. While the onset is usually acute or subacute, it may also be indolent. Positive cANCA is found in 85% of patients [1, 2, 6]. The disease triad consists of respiratory tract necrotizing (upper and lower) granulomatous inflammation, systemic small vessel vasculitis, and necrotizing glomerulonephritis.

Radiologic Manifestations

The upper respiratory tract is involved in all patients, with cartilage destruction in the nasal cavity and mucosal thickening of sinuses. Pulmonary involvement occurs in 85-90% of cases. The classic appearance is multiple irregular nodules or masses, up to 9 cm in size, predominantly in the mid/lower lungs. Cavitation is present in 25-50% of patients; occasionally there may be a single nodule. Patchy airspace disease due to pulmonary hemorrhage is more common than masses. Tracheobronchial thickening and stenosis are not uncommon. Pleural effusions occur in up to 25% of patients, but lymph-node enlargement is rare. Wegener's granulomatosis is termed 'limited' in the absence of renal disease [6, 13, 15, 16].

Hematological Disorders

Sickle Cell Disease

Demographics and Clinical Manifestations

Sickle cell disease includes disorders characterized by hemoglobin S (HbS). The homozygous form (HbSS) is called sickle cell anemia, the heterozygous form (HbSA) is sickle trait, and there are heterozygous variants. Up to 13% of African-Americans have sickle trait. The disease presents after the sixth month of life, after fetal hemoglobin has been replaced by HbS. Red blood cells containing HbS have a reduced capability for oxygen transfer and at lower oxygen tensions are less plastic, adopting a 'sickle' shape. This leads to increased blood viscosity and stasis in areas of slow flow or high metabolism.

Radiologic Manifestations

Sickle cell anemia mainly affects bones/bone marrow, brain, kidneys, and spleen, but also the thorax [1, 2]. Chronic anemia results in cardiomegaly and pulmonary plethora due to a high-output cardiac state. Acute chest syndrome is a frequent cause of hospitalization, and consists of a triad of fever, clinical findings of a pulmonary process, and radiologic pulmonary disease that includes lobar or segmental airspace disease, atelectasis, and/or pleural effusions. The syndrome may be caused by pneumonia or infarction, and distinguishing the two can be difficult. Sickle cell patients are at increased risk of infection, particularly Streptococcus pneumoniae, Haemophilus influenzae, and Mycoplasma, but also Salmonella and Staphylococcus, owing to autosplenectomy. In children, acute chest syndrome is usually due to infection. Infarcts are more frequent in adults, although most cases of sickle cell crisis are still due to infection. Pulmonary infarction is often associated with evidence of infarction elsewhere, such as in the abdomen, muscle, and bone (Table 4) [6, 18-20].

Chronic anemia and infarction result in coarsening and diffuse sclerosis of the thoracic skeleton. Infarcts in the central portion of vertebral bodies result in a characteristic 'H' shape. Periosteal reaction may be due to infarction or infection. Infarcts of the humeral head result in focal sclerosis, called 'snow-capping.' Ribs may be short [7]. Sickle cell patients have an increased incidence of gallstones secondary to increased hemoglobin turnover. Children may have splenomegaly, while most adults have autosplenectomy manifesting as a large gastric air bubble.

Table 4. Thoracic manifestations of sickle cell disease

Lung/pleura	Consolidation (infection or acute chest syndrome)
	Atelectasis
	Pleural effusion
Cardiac	Cardiomegaly
	Increased pulmonary blood flow
Osseous	Osteosclerosis
	H-shaped vertebral bodies
	Humeral head infarcts (focal sclerosis or periosteal reaction)
	Short ribs
Abdominal	Splenomegaly
	Splenic infarction (small and/or calcified spleen)
	Cholelithiasis

Lymphoproliferative Disorders

There are many forms of lymphoproliferative disease in the lung: Their radiologic manifestations include solitary and multiple masses within the lung and/or mediastinum, as well as solitary and multiple lung nodules, ground-glass opacity, consolidation, and reticulation. The more common entities are discussed below.

Leukemia

Demographics and Clinical Manifestations

Leukemias are a heterogeneous group of hematopoietic cells neoplasms. They may be of myeloid or lymphoid cell origin, and acute or chronic in presentation (Table 5). There is an overall incidence of 13 per 100,000, varying by type of leukemia and age. Acute leukemias are more common in children and young adults; chronic leukemias more common in older adults. Abnormalities can be divided into three categories: (1) leukemic infiltration of the lung, intrathoracic lymph nodes, pleura, and chest wall; (2) complications of the disease or its treatment; and (3) graft-versus-host disease [1, 2, 21, 22].

Radiologic Manifestations

Leukemic infiltration of the lungs is common pathologically, but rarely a cause of opacities on radiographs. Although it is better seen on HRCT, it is often nonspecific in appearance, as hemorrhage, infection, and edema (complications of the disease and treatment) may resemble leukemic infiltration [23]. T-cell leukemias may cause massive mediastinal lymph-node enlargement that resolves quickly with treatment. Pleural effusions are common. Subpleural and chest-wall deposits may occur, with extraparenchymal masses associated with rib destruction, known as chloromas (most commonly with myeloid leukemias) [6].

Acute graft-versus-host disease occurs 20-100 days after bone marrow transplantation. The effects on the lungs are usually minimal, with the brunt of the disease affecting the skin, gastrointestinal tract, and liver. After 100 days, it is termed chronic graft-versus-host disease. Radiographs are frequently normal, but when abnormal there may be diffuse or patchy perihilar airspace disease. More severe disease results in a diffuse interstitial pattern. Bronchiolitis obliterans is the most common finding in chronic graft-versus-host disease. It is best appreciat-

ed on HRCT, which may demonstrate bronchial wall dilation and thickening, mosaic attenuation, and air trapping on expiration [24].

Multiple Myeloma

Demographics and Clinical Manifestations

The incidence of multiple myeloma is 3 per 100,000. The disease usually presents in the fifth to eighth decade of life (98% of patients >40 years of age), is twice as common in men than in women, and twice as more common in blacks than in whites. Multiple myeloma is defined as a malignant proliferation of plasma cells from a single clone, as diagnosed by monoclonal gammopathy on serum electrophoresis [1, 2].

Radiologic Manifestations

While lung involvement is rare, lymph-node enlargement and pleural effusions can occur. Myeloma predominantly affects bone. On chest X-ray this can be seen as a generalized osteoporosis of the ribs and vertebrae, with widespread osteolytic lesions. Expansile lytic rib lesions and extrapleural soft-tissue masses that erode the ribs may be found. Plasmacytomas may occur in unexpected locations.

Langerhans' Cell Histiocytosis

Demographics and Clinical Manifestations

This poorly understood group of disorders is characterized by the proliferation of Langerhans' cells, possibly due to an immunoregulatory defect. It is subdivided into three diseases according to age and severity of onset: (1) Letterer-Siwe disease, which is an acute disseminated fulminant form that occurs in neonates; (2) Hand-Christian-Schuller disease, which is a chronic disseminated less-severe form occurring in children age 5-10 years; and (3) eosinophilic granuloma, which is the most benign form and usually occurs in young adults, predominantly affecting the lungs and bones. Lung involvement occurs in 20% of patients and is termed pulmonary Langerhans' cell histiocytosis. It has an incidence of 1-5 per million and an onset at 20-40 years. Once thought to be a male-predominant disease, it is now considered equally prevalent in both sexes. This may reflect changing smoking patterns, as there is a strong association with cigarette smoking. It is much rarer among African-Americans [1, 2, 6].

Radiologic Manifestations

The lungs are initially involved, with multiple upper-lobe stellate nodules 3- to 10-mm in size and sparing the costophrenic angles; this is defined as the granuloma stage. On HRCT, the nodules have a centrilobular distribution with normal intervening lung. Small irregular cysts are seen. HRCT is extremely useful in the evalua-

Table 5. The common leukemias

Myeloid leukemias	Acute myeloid leukemia
	Chronic myeloid leukemia
Lymphoid leukemias	Acute lymphoblastic leukemia
	Chronic myeloid leukemia
	Hairy-cell leukemia

tion of nodules and cysts. Alveolar consolidation is rare but can occur when the alveoli fill with histiocytes and eosinophils. Abnormality progresses to a reticulonodular pattern and finally culminates in fibrosis, large cystic spaces, and honeycombing. One-third of patients have increased lung volumes. Spontaneous pneumothorax is common [25]. Rib involvement results in well-defined osteolytic lesions, which may be expansile. Involvement of vertebral bodies may cause severe collapse, with vertebra plana.

Sarcoidosis

Demographics and Clinical Manifestations

Sarcoidosis has an incidence of 2-10 per 100,000 and an onset at 20-40 years with a second peak in the sixth decade of life. Although the incidence is equal in white men and women, it is ten times more common in black women than in black men, and 17 times more common in blacks than whites. The incidence is increased in people with blood group A. Sarcoidosis may also be familial. It is a chronic multisystem disorder of unknown etiology and characterized by non-caseating epithelioid cell granulomas, usually presenting with fever, malaise, polyarthralgias (ankles and knees), erythema nodosum, and thoracic lymph-node enlargement. Although sarcoidosis predominantly affects the chest, it affects the skin (erythema nodosum, lupus pernio and/or scar infiltrates) in up to 70% of patients. Generalized lymph-node enlargement occurs in 30%, myopathy in 25%, ocular involvement in 15% (keratoconjunctivitis or uveitis), hepatosplenomegaly in 10%, osseous involvement in 5-10%, parotitis in 5%, and CNS involvement in 3-5% [1, 2, 6].

Radiologic Manifestations

The triad of bilateral hilar lymph-node enlargement and right paratracheal lymph-node enlargement (Garland's triad or 1-2-3 sign) is seen in up to 80% of patients, making it the most common thoracic manifestation. Lymph-node enlargement ranges from barely detectable to massive; the lymph nodes are usually lobulated and well-marginated. Symmetry is an important diagnostic feature, as this is not usually seen in the common alternative diagnoses (lymphoma, tuberculosis, and metastatic disease) [6, 26]. Other nodes may be enlarged, particularly the anterior mediastinal and subcarinal lymph nodes, but this is difficult to see on chest X-ray although readily apparent on CT. Posterior mediastinal node enlargement is uncommon, whereas the abdominal nodes are occasionally enlarged. The staging system for sarcoidosis is based on the chest X-ray findings (Table 6). In most patients (60-70%), especially those with erythema nodosum and arthralgias, lymph-node enlargement completely resolves. Lymph nodes can show calcification, yielding an eggshell pattern [26]. Sarcoidosis

Table 6. Chest radiography staging of sarcoidosis

Stage	Lymph-node enlargement	Interstitial lung disease
0	No	No
I	Yes	No
II	Yes	Non-fibrotic
III	No	Non-fibrotic
IV	No	Fibrotic

is the second most common cause of eggshell lymph-node calcification (after silicosis/coal-worker's pneumoconiosis).

Lung disease develops in 30-40% of patients, at which time lymph-node enlargement often decreases. Lung involvement is initially characterized by small, well-defined nodules in a perilymphatic distribution adjacent to the subpleural surface/fissures, along thickened interlobular septa, and adjacent to vessels in the lobular core. The nodules may be evenly distributed throughout both lungs, but predominating in the upper and mid-lungs; however, in most cases they are clustered in the perihilar and peribronchovascular region or grouped in small areas. Confluence of granulomas results in large mostly ill-defined opacities or consolidations. Nodules measuring between 1 and 4 cm in diameter are seen in up to 25% of patients (so-called nodular sarcoidosis).

Interstitial lung disease in sarcoidosis is initially not fibrotic, but fibrotic lung disease may develop once lymph-node enlargement has resolved. Conglomerate masses mostly in a perihilar location represent areas of fibrosis and cause characteristic traction bronchiectasis.

While peribronchial and perivascular granulomatous infiltration is common, symptomatic bronchial obstruction is not. Thoracic lymph-node enlargement may cause compression of the trachea or bronchi. Tracheal involvement is rare but may result in strictures (smooth, irregular or nodular). Sarcoidosis of the larynx is uncommon.

Large-vessel arteritis is rare, whereas arteritis of the small vessels is more common. The latter often occurs with granulomas that result in vessel narrowing, but not usually necrosis or thrombosis. Coronary artery involvement has been described. Aortic involvement, either aneurysmal dilation or stenosis and occlusion, with a clinical picture similar to Takayasu's arteritis is rare. Pulmonary arteritis or extrinsic compression by enlarged lymph nodes is similarly rare. Although mediastinal lymph-node enlargement may be massive, superior vena cava syndrome is very rare. Myocardial involvement may result in ventricular arrhythmias or heart block, cardiomyopathy, and congestive failure [26]. Granulomas may be found on the visceral or parietal pleura; pleural effusions are uncommon, occurring in only 2% of patients. Sarcoidosis of bone occurs in 5-20% of patients; the phalanges are usually affected with a lace-like pattern. Although histologic involve-

ment of the liver and spleen are common in sarcoidosis, it is seldom of clinical or radiologic significance, manifesting as organomegaly or diffuse heterogeneous nodularity [6, 26]. Similarly, the kidneys may be involved.

Neurocutaneous Syndromes (The Phakomatoses)

Neurofibromatosis (von Recklinghausen's Disease)

Demographics and Clinical Manifestations

Neurofibromatosis type 1 (von Recklinghausen's disease) is an autosomal dominant disease with an incidence of 1 per 3000. Half of the cases are sporadic mutations, and there is no gender or racial predominance. The abnormal gene is located on chromosome 17. There is an association with multiple endocrine neoplasia type IIb (pheochomocytoma, medullary thyroid carcinoma, and multiple neuromas) and a ten-fold increased incidence of congenital heart disease [1, 2].

Radiologic Manifestations

The cutaneous tumors can be seen as nodules on radiographs and CT. If they are projected outside the lungs, a diagnosis of cutaneous nodules can easily be made on radiographs; otherwise, they may be mistaken for lung nodules. The ribs may be abnormal, being thin and/or twisted (ribbon ribs). Kyphoscoliosis of the thoracolumbar spine occurs in 10-60% of patients. There may also be developmental and modeling abnormalities of the vertebrae, such as posterior vertebral scalloping, enlargement of intervertebral foramina, and an absence or remodeling of the pedicles [36, 37]. Lung involvement has a prevalence of 20%, affecting men and women equally and manifesting as basilar predominant interstitial fibrosis, with upper and mid-lung thin-walled bullae. Malignant neural tumors may metastasize to the lungs [6, 27].

Neural tumors can arise from the chest wall or intercostal nerves and may erode the ribs, causing rib notching. Neural tumors, especially neurofibromas, neurilemmomas, schwannomas, and their malignant counterparts, arise in the mediastinum. They can be localized or diffuse, and are more common on the left. These tumors often arise from the vagus nerve and present as slowly growing, smoothly marginated masses that may be of soft-tissue or lower attenuation on CT due to lipid-rich neural sheath cells. Neurofibroma and schwannoma are isointense, with nerve tissue on T1-weighted images and high signal intensity on T2-weighted images. Although they may be asymptomatic, large lesions can cause local compression. Malignant transformation is possible [6]. Additional mediastinal masses include lateral meningoceles or, rarely, pheochromocytomas. Lateral meningoceles usually oc-

cur at the apex of kyphoscoliosis and are more common on the right. They are associated with vertebral developmental/modeling abnormalities.

Tuberous Sclerosis (Bourneville's Disease)

Demographics and Clinical Manifestations

Tuberous sclerosis is an autosomal dominant disorder with low penetrance. The incidence is 7 per million and the disease occurs equally in men and women [1, 2]. The abnormal gene is located on chromosome 16; spontaneous mutations account for 50-80% of cases. Tuberous sclerosis is characterized by a triad of adenoma sebaceum, seizures, and mental retardation.

Radiologic Manifestations

Pulmonary involvement occurs in 1-2% of cases and is indistinguishable from lymphangioleiomyomatosis. Spontaneous pneumothorax is a frequent finding. Lung disease may appear as a reticular or reticulonodular pattern on radiographs, with small nodules measuring 1-2 mm. Over time, the reticular elements become more marked, with cysts visible on radiographs. On HRCT, the cysts are usually <1 cm in size, smooth-walled, and uniformly distributed throughout the lungs. Lung volume is either normal or enlarged due to this obstructive lung disease. Bone cysts or sclerotic vertebrae may be seen [27-29]. Associated renal angiomyolipomas may help to establish the diagnosis in equivocal cases.

Although not a neurocutaneous disorder, the pulmonary features of lymphangiomyomatyosis (LAM) are virtually identical to those of tuberous sclerosis. LAM is characterized by a triad of (1) gradually progressive interstitial lung disease with uniform, smooth-walled cysts, (2) recurrent chylous pleural effusions, and (3) recurrent pneumothoraces. It is a rare disorder, occurring exclusively in premenopausal women. At HRCT, the appearance is the same as that of tuberous sclerosis, except that nodules are not seen. LAM may be a forme fruste of tuberous sclerosis, with occasional patients having renal angiomyolipomas.

Acknowledgements

This article has been summarized from 'Pulmonary manifestations of systemic diseases' by Paul Cronin, Smita Patel, and Barry H. Gross. In: Kazerooni EA and Gross BH (eds) The Core Curriculum – Cardiopulmonary Radiology. Lippincott, Williams and Wilkins 2003.

References

1. Weatherall DJ, Ledingham JGG, Warrell DA (1996) Oxford Textbook of Medicine, 3rd edn. Oxford University Press, Oxford

2. Fauci AS, Braunwald E, Isselbacker KJ et al (????) Harrison's Principles of Internal Medicine, 14th edn. McGraw-Hill, New York
3. Wiedemann HP, Matthay RA (1989) Pulmonary manifestations of collagen vascular diseases. Clin Chest Med 10:677-722
4. Owens GR, Follansbee WP (1987) Cardiopulmonary manifestations of systemic sclerosis. Chest 91:118-127
5. Minai OM, Dweik RA, Arroliga AC (1998) Manifestations of scleroderma pulmonary disease. Clin Chest Med 19:713-731
6. Armstrong P, Wilson AG, Dee P, Hansell DM (2000) Imaging of Diseases of the Chest, 3rd edn. Harcourt, Orlando, FL
7. Sperber M (1990) Radiologic Diagnosis of Chest Disease. Springer-Verlag, Heidelberg Berlin
8. Hunninghake GW, Fauci AS (1979) Pulmonary involvement in collagen vascular diseases. Am Rev Respir Dis 119:471-503
9. Tanoue LT (1998) Pulmonary manifestations of rheumatoid arthritis. Clin Chest Med 19:667-685
10. Remy-Jardin M, Remy J, Cortet B et al (1994) Lung changes in rheumatoid arthritis: CT findings. Radiology 193:375-382
11. Wiedemann HP, Matthay RA (1992) Pulmonary manifestations of systemic lupus erythematosus. J Thorac Imaging 7:1-18
12. Murin S, Wiedemann HP et al (1998) Pulmonary manifestations of systemic lupus erythematosus. Clin Chest Med 19:641-665
13. Seo JB, Im JG, Chung JW et al (2000) Pulmonary vasculitis: the spectrum of radiological findings. Br J Radiol 73:1224-1231
14. Ball JA, Young KR Jr (1998) Pulmonary manifestations of Goodpasture's syndrome. Antiglomerular basement membrane disease and related disorders. Clin Chest Med 19:777-791
15. Sullivan EJ, Hoffman GS (1998) Pulmonary vasculitis. Clin Chest Med 19:759-776
16. Gonzalez L, Van Ordstrand HS (1973) Wegener's granulomatosis. Review of 11 cases. Radiology 107:295-300
17. Choi YH, Im JG, Han BK et al (2000) Thoracic manifestation of Churg-Strauss syndrome: radiologic and clinical findings. Chest 117:117-124
18. Leong CS, Stark P (1998) Thoracic manifestations of sickle cell disease. J Thorac Imaging 13:128-134
19. Bhalla M, Abboud MR, McLoud TC et al (1993) Acute chest syndrome in sickle cell disease: CT evidence of microvascular occlusion. Radiology 187:45-49
20. Edwards JR, Matthay KK (1989) Hematologic disorders affecting the lungs. Clin Chest Med 10:723-746
21. Blank N, Castellino RA (1980) The intrathoracic manifestations of the malignant lymphomas and the leukemias. Semin Roentgenol 15:227-245
22. Klatte EC, Yardley J, Smith EB et al (1963) The pulmonary manifestations and complications of leukemia. AJR Am J Roentgenol 89:598-609
23. Primack SL, Muller NL (1994) High-resolution computed tomography in acute diffuse lung disease in the immunocompromised patient. Radiol Clin North Am 32:731-744
24. Worthy SA, Muller NL (1997) Pulmonary complications after bone marrow transplantation: high-resolution CT and pathologic findings. Radiographics 17:1359-1371
25. Kulwiec EL, Lynch DA, Aguayo SM et al (1992) Imaging of pulmonary histiocytosis X. Radiographics 12:515-526
26. Lynch JP, Kazerooni EA, Gay SE (1997) Pulmonary sarcoidosis. Clin Chest Med 18:755-785
27. Aughenbaugh GL (1984) Thoracic manifestations of neurocutaneous diseases. Radiol Clin North Am 22:741-756
28. Medley BE, McLeod RA, Houser OW (1976) Tuberous sclerosis. Semin Roentgenol 11:35-54
29. Bell DG, King BF, Hattery RR et al (1991) Imaging characteristics of tuberous sclerosis. AJR Am J Roentgenol 156:1081-1086

Pulmonary Manifestations of Systemic Diseases

C. Schaefer-Prokop

Department of Radiology, Academic Medical Center, Amsterdam, The Netherlands

The following review focuses on pulmonary manifestations of granulomatous diseases (sarcoidosis), connective tissue diseases, vasculitis (Wegener granulomatosis and Church-Strauss), and Goodpasture syndrome. Rare pulmonary manifestations associated with other diseases, such as tuberous sclerosis and lymphangioleiomyomatosis, Erdheim-Chester disease (rare non-Langerhans cell histiocytosis), storage diseases (Gaucher, Niemann Pick), systemic amyloidosis, and relapsing polychondritis, as well as manifestations of neoplastic diseases (e.g., lymphoma) are not considered herein. Langerhans cell histiocytosis shows a pulmonary involvement that is associated with a systemic manifestation only in children and not in adults.

Granulomatous Diseases

Pulmonary Sarcoidosis

Sarcoidosis is a systemic disorder of unknown origin. It is characterized by non-caseating epitheloid-cell granulomas in multiple organs; however, morbidity and mortality are closely related to pulmonary manifestations, which occur in >90% of patients. The CT appearance of pulmonary sarcoidosis varies greatly and is known to mimic many other diffuse infiltrative lung diseases. These include Loffgren syndrome (fever, bilateral adenopathy, eythema nodosum, and arthralgia) and lupus pernio (cutaneous lesions, bone cysts and pulmonary fibrosis).

The histology of pulmonary sarcoidosis consists of noncaseating granulomas rimmed by lymphocytes and fibroblasts in a perilymphatic distribution, which may resolve or cause fibrosis. The disease may occur at any age, but mostly affects individuals between 20 and 40 years of age, and only rarely those over 65 years of age. Females are affected more often than males. The prognosis is mostly good, with disease resolution occurring in <2 years; mortality is 1-5%.

The chest X-ray shows lymphadenopathy, reticulonodular opacities predominantly in the upper lobes (rarely, larger nodules), and fibrosis with honeycombing and volume loss, predominantly in the upper lobes and segment 6.

Staging based on chest X-ray is as follows:

Stage 0 Normal chest radiograph (>50% at presentation)
Stage I Bilateral hilar and paratracheal lymphadenopathy
Stage II Lymphadenopathy and nodular opacities
Stage III Nodular opacities without lymphadenopathy or signs of fibrosis
Stage IV Signs of fibrosis with or without lymphadenopathy.

Computed tomography (CT) and high-resolution CT (HRCT) show small, well defined nodules in a characteristic perilymphatic distribution in relation to the subpleural surface. The nodules are located adjacent to the major fissures, along thickened interlobular septa, and adjacent to vessels in the lobular core. There may also be even distribution of the nodules throughout both lungs, with a predominance in the upper and middle lung zones. However, in most cases they are clustered in the perihilar and peribronchovascular region, with relative sparing of the lung periphery, or they are grouped in small areas uni- or bilaterally. Confluence of granulomas results in larger nodules (1-4 cm, nodular sarcoid, galaxy sign) or ill-defined opacities (ground-glass or consolidations, up to 10 cm, alveolar sarcoidosis). There may be irregular thickening of the bronchial wall, with narrowing of the large and small airways (mosaic pattern). Lymphadenopathy is noted in up to 50% of patients on CT. Calcifications may be bilateral, more focal than complete, eggshell-like, or with an amorphous cloud-like pattern. In up to 20% of patients, pulmonary fibrosis with septal thickening, traction bronchiectasis, and honeycombing (stage IV) may be observed. Conglomerate masses mostly in a perihilar location represent areas of fibrosis with characteristic traction bronchiectasis.

Important take-home points regarding pulmonary sarcoidosis are:
- Caveat complications: Aspergilloma in cavitations with hemoptysis (stage IV) and pneumothorax (more common with alveolar sarcoid).
- Sarcoidosis may present with very characteristic HRCT features, obviating further invasive diagnosis.
- Sarcoidosis may also present less typically, e.g., lower lobe predominance mimicking idiopathic pulmonary fibrosis (IPF), subpleural consolidations mimicking eosinophilic pneumonia, thus requiring further diagnosis.

- Sarcoid is a frequent differential diagnosis when analyzing diffuse lung disease.
- Airflow obstruction is common and occurs in association with fibrotic changes, especially in the large airways, but also in earlier disease stages (small-airway obstruction).

Connective-Tissue Disorders

Involvement of the respiratory system in rheumatology or connective-tissue disorders (CTDs) is common and results in significant morbidity and mortality. Many of the diseases are characterized by a specific serological antibody (Table 1). The underlying mechanism of that group of autoimmune mediated diseases is still unknown. The most important factor contributing to poor outcome in patients with CTD is the presence of lung fibrosis. Early HRCT screening for lung involvement in patients with CTD is therefore justified.

The histological pattern is like that of usual interstitial pneumonia (UIP), the most frequent pattern in biopsies from patients with IPF. Cryptogenic fibrosing alveolitis appears to be relatively rare in patients with CTD. The presence of a combination of radiological and histological patterns, e.g., those of nonspecific interstitial pneumonia (NSIP), lymphocytic interstitial pneumonia (LIP)/follicular bronchiolitis and organizing pneumonia, should initiate further diagnostic work-up for a CTD. Recent publications suggested a prevalence of distinct histological patterns between the various CTDs: NSIP in systemic sclerosis, organizing pneumonia in polymyositis/dermatomyositis, follicular bronchiolitis and UIP in rheumatoid arthritis, and chronic bronchiolitis in Sjögren's syndrome (Table 2).

Diffuse alveolar damage can complicate the clinical course of patients with CTD. The outcome is critical, especially for those with preexisting interstitial lung disease.

Pulmonary Scleroderma

Progressive systemic sclerosis is a generalized CTD affecting multiple organ systems (skin, lungs, arteries, heart and kidneys), but it has the highest incidence of lung fi-

Table 1. Serological markers of connective tissue disorders (modified from Sperber M [1999])

	ANA	Rheumatoid factor	ACA	Anti DNA	Anti RNA	CPK
Rheumatoid arthritis		x				
Systemic lupus erythematosus	x			x		
Systemic sclerosis)	x		x			
Polymyositis/dermatomyositis						x
Mixed connective-tissue disease	x				x	
Sjögren's syndrome	x	x				

ANA, Anti-nuclear antigen; *ACA*, anticentromere; *CPK*, creatinin phosphokinase

Table 2. Prevalence of patterns in connective-tissue disorders (modified from Hansell DM et al. [2005])

Pattern	Progressive systemic sclerosis	Rheumatoid arthritis	Polymyositis/ dermatomyositis	Sjögren's syndrome	Mixed connective-tissue disease	Systemic lupus erythematosus
Usual interstitial pneumonia	+	+++	+	+	+	+
Nonspecific interstitial pneumonia	++++	+	++	+	++	+
OP	+	+++	+++		+	+
Diffuse alveolar damage	+	++	++			+++
LIP		+		++		
Alveolar hemorrhage	+	+	++		+	+++
Upper-lobe fibrosis		+				
Aspiration	++		++		+	
Pulmonary hypertension	+++			+	+	+
Bronchiectasis		+++		++		
Obliterative bronchiolitis		+++				+
Necrobiotic nodules		+++				
Pleural effusion	+	+++				+++
Diaphragm dysfunction			++		+	+

OP, Organizing pneumonia; *LIP*, lymphocytic interstitial pneumonia

brosis. In this case, it is referred to as fibrosing alveolitis of systemic sclerosis. The lung is the fourth most common organ involved, after skin, arteries and esophagus. Patients can be of any age, but are mostly middle-aged The 5-year survival of patients with progressive systemic sclerosis is 70%. Most commonly, death is from aspiration pneumonia and respiratory failure.

The histology of progressive systemic sclerosis consists of overproduction and tissue deposition of collagen. Lung fibrosis presents with a pattern typical of either NSIP (80%, cellular or fibrotic) or UIP (20%). The demographics of the disease reveal a 3:1 preponderance in women.

The chest X-ray findings include symmetric reticulonodular densities, small cystic destruction and honeycombing, with a predominantly basal location. The observed volume loss is disproportionate to the symptoms. The hemidiaphragms are elevated due to muscle atrophy. Patients also show signs of recurrent infection due to aspiration. Esophageal dilatation is seen as a fluid-air-level. Pleural effusion is found in <15% of patients.

On CT/HRCT, the spectrum of fibrotic changes ranges from ground-glass with or without fine intralobular reticular densities (NSIP pattern) to honeycombing associated with traction bronchiectasis (UIP pattern). These changes show a subpleural and basal predominance. Frequently, the findings remain consistent over a period of years, with no or very little progression. The esophagus is dilated and the lung parenchyma shows postinfectious changes. There is mild lymphadenopathy, which is usually not seen on chest X-ray, as well as mild pleural thickening (pseudoplaques). In addition, signs of pulmonary hypertension (enlarged pulmonary artery), independent of interstitial fibrosis and reflecting small-vessel disease (intimal proliferation, medial hypertrophy, myxomatous changes), is present. Cardiomyopathy, due to ischemia or based on infiltrative cardiomyopathy is another component of progressive systemic sclerosis.

Important take-home points to consider in patients with progressive systemic sclerosis are:
- Dilated esophagus should be looked for in patients with a newly diagnosed fibrosis.
- Systemic sclerosis should be considered in patients with newly diagnosed, fine reticular and microcystic parenchymal changes.
- Signs of pulmonary hypertension (out of proportion to the extent of lung disease) and reflecting vasculopathy should be noted.
- There is an increased risk of cancer, generally by a factor of 1.8-6.5, in patients with this disease. Moreover, for lung cancer there is an 18-fold increased risk for adenocarcinoma and bronchoalveolar carcinoma.
- Scleroderma features (clinical and radiological) are seen in CREST (limited cutaneous systemic sclerosis: calcinosis, Raynaud, esophageal dysmotility, sclerodactyly, teleangiectasis), mixed connective tissue disease), graft vs. host disease, carcinoid syndrome, and drug reactions. Up to 25% of all patients showing sys-

temic sclerosis-like features suffer from an overlap syndrome, with symptoms of one or more CTDs.
- In progressive systemic sclerosis, the outcome is similar for patients with UIP and NSIP, and is more strongly linked to the disease severity at presentation.

Rheumatoid Arthritis

This disease consists of subacute or chronic inflammatory polyarthropathy of unknown cause. Associated lung findings include fibrosis (mostly UIP pattern), organizing pneumonia, airways disease (bronchitis and bronchiolitis), pleural disease (pleuritis sicca) and (large) cavitating nodules (pulmonary nodules are always associated with subcutaneous nodules). Pleural involvement is the most common thoracic manifestation of rheumatoid arthritis.

Histologically, rheumatoid nodules (pathognomonic), lymphoid follicles, UIP and NSIP patterns of fibrosis, and signs of organizing pneumonia are seen. The incidence of rheumatoid arthritis shows a 3:1 female to male predominance. However, extra-articular disease is more common in men, and more common in smokers. While patients may be of any age, the disease mostly occurs in middle-aged individuals. The 5-year survival is 40%, with death from infection, respiratory failure, or cor pulmonale.

Chest X-ray findings indicative of rheumatoid arthritis include signs of pleural disease, such as thickening or an effusion which may be transient, persistent over months, or relapsing, but is usually asymptomatic. Pleural findings are more commonly seen in men than in women. Other findings include lower-zone fibrosis (honeycombing) and volume loss. Pulmonary involvement may also include a cryptogenic organizing pneumonia (COP) pattern of disease. Nodules (5 mm-7cm) show signs of cavitation in 50% of affected patients, may be PET positive, and are a more frequent finding in smokers. They also represent an increased risk for pneumothorax.

Airway disease is also evident radiographically, presenting as bronchial wall thickening and bronchiectasis. Consolidations are present in patients with organizing pneumonia. Signs of recurrent infectious disease are also observed.

CT/HRCT findings of rheumatoid arthritis include pleural disease (thickening, effusion, empyema), pulmonary fibrosis with honeycombing, traction bronchiectasis, and parenchymal distortion (UIP pattern, indistinguishable from that of IPF). Ground-glass and reticular densities (NSIP pattern) and features of a COP pattern of disease are seen. Nodules (up to 7cm in size) may mimic neoplasm, are frequently subpleural, and cavitate in >50% of affected patients. obliterative bronchiolitis with a mosaic pattern is rarely seen. There are also signs of follicular bronchiolitis (subpleural, centrilobular, unsharp nodules <1 cm). While systemic vasculitis affecting the small vessels, usually in the skin, is found in rheumatoid arthritis, pulmonary vasculitis is exceptionally rare. Cardiac signs include cor pulmonale and pericarditis. Sclerosing mediastinitis is very rare.

Important take-home points concerning rheumatoid arthritis are:
- Pleural abnormalities are the most common abnormal thoracic findings.
- Parenchymal fibrosis is evident in 5% of chest X-rays but in up to 40% of HRCT findings. It is mostly of the UIP pattern and indistinguishable from IPF.
- Associated nodules and pleural disease help to differentiate rheumatoid arthritis from IPF.
- There is an increased risk for empyema in patients with pleural disease.
- Patients with (cavitating) nodules are at increased risk for pneumothorax.
- Many of the available treatment options for rheumatoid arthritis are associated with lung toxicity (see www.pneumotox.com).

Pulmonary Dermatomyositis/Polymyositis

This idiopathic, immune-mediated, inflammatory myopathic disorder has multiple systemic manifestations. Females are affected twice as often as males. Patients may be of any age but are mostly middle-aged. Pulmonary involvement is associated with a poorer prognosis. The 5-year survival rate ranges from 35 to 77%. Findings consistent with diffuse alveolar damage are predictive of poor prognosis.

In the lungs, the histological findings have prognostic implications. Most typical is a mix of various findings that include UIP and NSIP pattern (cellular and fibrotic type) patterns of fibrosis and organizing pneumonia.

The chest X-ray of patients with pulmonary dermatomyositis/polymyositis shows fibrotic changes, with a subpleural and basal distribution. Volume loss can be observed. Other findings include sequelae after recurrent aspiration pneumonia and consolidations. The differential diagnosis includes aspiration or organizing pneumonia.

The CT/HRCT findings depend on the nature of the parenchymal changes. Ground-glass (diffuse alveolar damage), fine reticular densities (NSIP pattern) honeycombing and traction bronchiectasis (UIP pattern), and consolidations (COP pattern) may be present simultaneously.

There disease shows a basal and subpleural predominance. Frequently, sequelae of aspiration pneumonia and/or opportunistic pneumonia are seen.

Important take-home points to keep in mind when evaluating patients with suspected pulmonary dermatomyositis/polymyositis are:
- A mixture of radiological and histological findings, including NSIP-, UIP-, COP-, and diffuse alveolar-type damage, is suggestive of pulmonary dermatomyositis/polymyositis.
- The disease is sometimes associated with other collagen-vascular diseases (systemic lupus erythematosus, scleroderma, rheumatoid arthritis, Sjögren's syndrome).

- There is an increased risk for malignancy (especially of the breast, lung, ovary, and stomach) which is concurrently diagnosed within 1 year in up to 20% of patients.
- Whole-body magnetic resonance imaging (short tau inversion recovery, STIR) is used to demonstrate inflammatory soft-tissue burden.

Sjögren's Syndrome

Primary Sjögren's syndrome is a systemic inflammatory disorder affecting exocrine glands (dry mouth and dry eye). The incidence of extraglandular involvement of the lung varies from 9 to 75%. The secondary form of Sjögren's syndrome is associated with collagen-vascular disease (systemic lupus erythematosus, rheumatoid arthritis, and pulmonary dermatomyositis/polymyositis). There is a well-established association with LIP and an overlap between LIP, amyloid deposition, sarcoidlike reactions, and Sjögren's syndrome. Middle-aged women are affected much more often than men, the ratio being 9:1.

Histologically, the tissues of patients with Sjögren's syndrome show widespread tissue infiltration by polyclonal B lymphocytes.

The chest X-ray findings in this disease consist of bilateral interstitial opacities, consolidations, bilateral nodules, and pleural effusion (when associated with cardiovascular disease, such as systemic lupus erythematosus, or rheumatoid arthritis).

CT/HRCT findings include pulmonary fibrosis with either a UIP or a LIP pattern. The latter consists of diffuse ground-glass opacities and thin-walled cysts, that, while widely distributed, show a subpleural predominance. Airway disease, e.g., bronchiolitis with air-trapping, tree-in-bud sign, and bronchitis, is common. Additional findings are organizing pneumonia and pulmonary hypertension.

Important take-home points in evaluating patients with Sjögren's syndrome are:
- Generally, the risk for malignoma is doubled, and there is an up to 40 times increased risk for developing a lymphoma. In this context, mediastinal lymphadenopathy (visible on chest X-ray) and new intrapulmonary consolidations are suggestive for the development of nodular lymphoid hyperplasia or a malignant lymphoma.
- Pleural effusion suggests an association with a collagen-vascular disease (rheumatoid arthritis or systemic lupus erythematosus).

Systemic Lupus Erythematosus

This chronic collagen vascular disease involves blood vessels (vasculitis with and without pulmonary hypertension), serosal surfaces, joints (pericardiac effusion, pleural effusion), kidneys, central nervous system, and skin. Thoracic manifestations are seen in up to 70% of patients. The disease occurs ten times more often in women

than in men. The etiology is unknown. The most common causes of death related to this chronic (10 years) disease are sepsis and renal failure.

Histologically, hematoxylin bodies are pathognomonic but they are rarely seen in the lungs. Alveolar hemorrhage reflects endothelial damage.

Chest X-ray shows evidence of (painful) pleural disease, with thickening or effusion (usually small). Consolidations may be of various origin. Consequently, the differential diagnosis should consider opportunistic infection, hemorrhage, pneumonitis, organizing pneumonia, and infarcts. The diaphragm may be elevated due to muscle dysfunction, with plate-like atelectasis and signs of shrinking lung syndrome. Other findings are cardiac enlargement (pericardial effusion) and lung fibrosis (seen in <5% of patients).

CT/HRCT will reveal mild adenopathy in 20% of patients. Ground glass and/or consolidations, due to hemorrhage, pneumonia, pneumonitis, are seen. Airway disease manifests as tree-in-bud sign, bronchiectasis, and bronchial wall thickening. Fibrosis (UIP pattern) is seen in up to 15% of patients, and in autopsy in up to 30%. Pulmonary hypertension occurs primary to vasculitis and secondary to chronic embolism. Cavitating nodules indicate areas of infarct.

Important take-home points in the diagnosis of systemic lupus erythematosus include:
- Acute pneumonitis with diffuse hemorrhage is rare but has a very high mortality. It is mostly associated with renal infiltration and multi-organ failure.
- Patients are at increased risk for opportunistic infections.
- There is increased risk for pulmonary embolism; increased levels of antiphospholipid antibodies are present in 40% of patients.
- Patients with drug-induced systemic lupus erythematosus have a better prognosis.

Pulmonary Vasculitis/Diffuse Alveolar Hemorrhage

Non-infectious systemic necrotizing vasculitides are a large and varied group of disorders characterized by inflammation and necrosis of blood vessels (Table 3). Pulmonary involvement is seen in Wegener granulomatosis, Goodpasture syndrome, Church-Strauss disease, microscopic polyangiitis, Behçet disease, and Takayasu disease. The combined involvement of the lungs and kidneys by some of these diseases is also described as pulmonary-renal syndrome.

Wegener Granulomatosis

The classic form of Wegener granulomatosis affects the sinuses, kidneys, and lungs resulting in a frequent triad of symptoms comprising sinusitis and/or tracheobronchitis, pathological chest X-ray (with or without signs of hemoptysis), and microhematuria. However, any part of the body may be affected. Females and males are affected equally and at any age (mostly age 40-55). Airway involvement is more frequent in men. The most common cause of death is renal failure. With treatment, the 24-month survival is 80%.

Histologic findings include necrotizing granulomatous vasculitis of the small to medium-sized vessels, without associated infection. Serologically, up to 90% of patients are positive for c-ANCA (circulating antineutrophil cytoplasmic antibodies). However, c-ANCA findings should not replace histological confirmation!

The chest X-ray findings in Wegener granulomatosis include the presence of single or multiple nodules, 50% of which are cavitating. The cavitations may be thick-walled. There are multifocal, non-segmental, or diffuse consolidations, the latter due to hemorrhage and/or vascular necrosis. Pleural effusion is seen in 20% of patients.

Table 3. CT findings associated with pulmonary vasculitis syndromes (modified from Marten K et al. [2005])

Vasculitis	Size of involved vessels[a, b]	Pulmonary-renal syndrome	Pulmonary hemorrhage	Pulmonary hypertension
Wegener	Small	50-75%	In up to 8%, diffuse	–
Church Strauss	Small	Up to 25%	Very rare, diffuse	–
Microvascular polyangiitis	Small	In 75-100%	Very rare, diffuse	–
Polyarteritis nodosa	Medium	–	Very rare, diffuse (associated with hepatitis B)	–
Giant-cell arteritis	Large	–	Rare, focal	Rare
Takayasu	Large	–	Rare, focal	Rare
Rheumatoid arthritis	CTD	–	Very rare, diffuse	Up to 60%
Systemic sclerosis	CTD	–	Rare, diffuse, with necrotizing vasculitis	10-60%
Mixed connective-tissue disease	CTD	–	Rare, diffuse	Up to 45%
Systemic lupus erythematosus	CTD	Up to 60%, late	In 4% (but potentially more frequent), diffuse	5-45%

[a] According to the Chapel Hill classification, 2000
[b] *CTD*, Connective tissue disease

In patients with airway involvement, segmental or lobar atelectasis may be seen.

On CT/HRCT multiple nodules with or without a CT halo sign (hemorrhage) may be visible. Cavitations show thick walls. Peripheral wedge-shaped consolidations represent infarcts and may cavitate. Diffuse consolidations or ground-glass opacities representing areas of hemorrhage are present. Preexisting fibrotic changes reflect preexisting disease. In addition, there is concentric thickening of the tracheal or bronchial walls with a reduction in their diameters.

Atelectasis and pleural effusion are also components of this disease.

Important take-home points to consider in Wegener granulomatosis are:
- Rapid enlargement of nodules suggests superinfection or hemorrhage.
- Subglottic stenosis is often visible on chest X-ray but may be overlooked.
- No response to treatment (within one week) suggests superinfection.

Church-Strauss

Church-Strauss syndrome is caused by a small-vessel systemic vasculitis that almost exclusively occurs in patients with asthma and is characterized by marked peripheral eosinophilia. Clinically, radiologically, and pathologically the syndrome combines features of Wegener granulomatosis and eosinophilic pneumonia (i.e., allergic granulomatosis and angiitis). Many other organs may be involved, including the heart (up to 40%), the skin (up to 40%), and the musculoskeletal system (up to 50%). Five-year survival is reported in up to 80% of patients; 50% of deaths are related to cardiac involvement.

Histological findings demonstrate small-vessel (arteries and veins) vasculitis, with eosinophilic infiltrates and vascular and extravascular granulomas. Serology findings include myeloperoxidase (MPO)-ANCA positivity in up to 70% of patients, and serum eosinophilia.

Chest X-ray and CT/HRCT findings during the eosinophilic and vasculitic phase consist of transient, multifocal, and non-segmental consolidation without a zonal predilection. Frequently, the subpleural findings mimic those seen eosinophilic pneumonia, with ill-defined nodules or masses sometimes present. Cavitations of nodular opacities are uncommon. There may be diffuse consolidations due to hemorrhage. Interstitial markings are the result of edema with cardiac and/or renal involvement. Eosinophilic pleural effusions are seen in up to 30% of patients.

Important take-home points in the diagnosis of Church-Strauss syndrome are:
- The disease may be drug-induced.
- The potential for cardiac involvement (enlargement, insufficiency with pulmonary congestion, pericarditis) should be noted.

Goodpasture Syndrome

This disease is characterized by a combination of glomerulonephritis and diffuse alveolar hemorrhage. Young men are much more often affected than young women, with the ratio of (F:M=1:9). The disease also occurs in elderly women. With early treatment, the prognosis is good. Recurrent episodes result in lung fibrosis.

Histologically, a linear deposition of IgG along the glomerular basement membranes is seen. Thus, renal biopsy is used to establish the diagnosis. The serology of these patients is c-ANCA or p=ANCA positivity in 30% and anti-basement-membrane antibodies in >90%.

The chest X-ray findings depend on the degree of hemorrhage and range from ground glass opacities to consolidations. Mostly findings show a symmetric distribution with sparing of the subpleural space. Pleural effusions are very rare.

Similarly, CT/HRCT findings range from ground glass to dense consolidations dependant on the severity of hemorrhage. In the subacute stage, there is increasing overlay by reticular densities ('crazy paving'). Recurrent disease results in fibrosis.

Important take-home points that aid in the diagnosis of Goodpasture syndrome are:
- The disease has an acute onset; hemoptysis occurs in 80-95% of patients.
- With therapy, there is rapid and progressive improvement (within days).
- Sparing of the subpleural space and the basal sinus is typical. If this is not the case, another diagnosis should be considered.
- Pleural effusions are uncommon. If they occur, a different diagnosis should be considered.

Suggested Reading

Connective-Tissue Disorders

Akira M, Hara H, Sakatani M (1999) Interstitial lung disease in association with polymyositis/dermatomyositis: long term follow up CT evaluation in seven patients. Radiology 210:333-338

Hansell DM, Armstrong P, Lynch DA, Page McAdams H (2005) Imaging diseases of the chest, 4th edn. Mosby, London, p 534

Aquino SL, Webb RW, Golden J (1994) Bronchiolitis obliterans associated with rheumatoid arthritis: findings on HRCT and dynamic expiratory CT. J Comput Assist Tomogr 18:555-558

Bankier AA, Kiener HP, Wiesmayr MN et al (1995) Discrete lung involvement in systemic lupus erythematosus: CT assessment. Radiology 196:835-840

Demosthenos B, Wells AU, Nicholson Ag et al (2002) Histopathologic subsets of fibrosing alveolitis in patients with systemic sclerosis and their relationship to outcome. Am J Respir Crit Care Med 165:1581-1586

Desai SR, Nicholson AG, Stewart S et al (1997) Benign pulmonary lymphocytic infiltration and amyloidosis: computed tomographic and pathologic features in three cases. J Thorac Imag 12:215-220

Desai SR, Veeraraghavan S, Hansell DM et al (2004) CT features of lung disease in patients with systemic sclerosis: comparison with idiopathic pulmonary fibrosis and nonspecific interstitial pneumonia. Radiology 232:560-567

Douglas WW, Tazelaar HD, Hartman TE et al (2001) Polymyositis-Dermatomyositis-associated interstitial lung disease. Am J Respir Crit Care Med 164:1182-1185

Franquet T, Gimenez A, Monill JM et al (1997) Primary Sjögren's syndrome and associated lung disease. AJR Am J Roentgenol 169:655-658

Holzmann H, Jacobi V, Werbner RJ, Stahl E (1994) Lungenmanifestation bei progressiver systemischer Sklerodermie: CT Befunde. Hautarzt 45:471-475

Honda O, Jokhoh T, Ichikado K et al (1999) Differential diagnosis of lymphocytic interstitial pneumonia and malignant lymphoma on high resolution CT. AJR Am J Roentgenol 173:71-74

Hunninghake GW, Fauci AS (1979) Pulmonary involvement in the collagen vascular diseases. Am Rev Respir Dis 119:471-503

Ikezoe J, Johkoh T, Nohno N et al (1996) High resolution CT findings of lung disease in patients with polymyositis/dermatomyositis. J Thorac Imag 11:250-259

Johkoh T, Ikezoe J, Kohno N (1994) High resolution CT and pulmonary function tests in collagen vascular disease: comparison with idiopathic pulmonary fibrosis. Eur J Radiol 18:113-121

Johkoh T, Müller NL, Pickford HA et al (1999) Lymphocytic interstitial pneumonia: thin section CT findings in 22 patients. Radiology 212:567-572

Kocheril SV, Appleton E, Somers EC et al (2005) Comparison of disease progression and mortality of connective tissue disease-related interstitial lung disease and idiopathic interstitial pneumonia. Arthritis and Rheumatism 53:549

Lakhanapal S, Lie JT, Conn DL et al (1987) Pulmonary disease in polymyositis / dermatomyositis: a clinicopathological analysis of 65 cases. Ann Rheum Dis 47:23-9

Lynch JP, Hunninghake GW (1992) Pulmonary complications of collagen vascular disease. Ann Rev Med 43:17-35

Mayberry JP, Primack SL, Müller NL (2000) Thoracic manifestations of systemic autoimmune diseases: radiographic and high resolution CT findings. Radiographics 20:1623-1635

Meyer CA, Pina JS, Taillon D et a (1997) Inspiratory and expiratory high resolution CT findings in a patient with Sjögren's syndrome and cystic lung disease. AJR Am J Roentgenol 168:101-103

Nicholson AG, Colby TV, Wells AU (2002) Histopathological approach to patterns of interstitial pneumonia in patients with connective tissue disorders. Sarcoidosis Vasc Diff Lung Dis 19:10-17

Ooi GC, Ngan H, Peh WC et al (1997) Systemic lupus erythematosus patients with respiratory symptoms: the value of HRCT. Clin Radiol 52:775-781

Owens GR, Fino GJ, Hernert DL (1983) Pulmonary function in progressive systemic sclerosis: comparison of CREST syndrome variant with diffuse scleroderma. Chest 84:546-550

Parambil JG, Myers JL, Ryu JH (2006) Diffuse alveolar damage: uncommon manifestation of pulmonary involvement in patients with connetive tissue diseases. Chest 130:553

Remy-Jardin M, Remy J, Cortet B et al (1994) Lung changes in rheumatoid arthritis: CT findings. Radiology 193:375-382

Remy-Jardin M, Remy J, Wallaert B et al (1993) Pulmonary involvement in progressive systemic sclerosis: sequential evaluation with CT, pulmonary function tests, and bronchoalveolar lavage. Radiology 188:499-506

Reuter M, Schnabel A, Wesner F et al (1998) Pulmonary Wegener's granulomatosis: correlation between high-resolution CT findings and clinical scoring of disease activity. Chest 114:500-506

Scheja A, Akesson A, Wollmer P et al (1993) Early pulmonary disease in systemic sclerosis: a comparison between carbon monoxide transfer and static lung compliance. Ann Rheum Dis 52:725

Schurawitzki H, Stiglbaur R, Graninger W et al (1990) Interstitial lung disease in progressive systemic sclerosis: high resolution CT versus radiography. Radiology 176:755-759

Sperber M (ed) (1999) Diffuse lung disorder. Springer, London, Berlin, Heidelberg, p 329Tanaka N, Kim JS, Newell JD et al (2004) Rheumatoid arthritis-related lung diseases: CT findings. Radiology 232:81

Tansey D, Wells AU, Colby TV et al (2004) variations in histological patterns of interstitial pneumonia between connective tissue disorders and their relationship to prognosis. Histopathology 44:585

Tazelaar HD, Viggiano RW, Pickersgill J et al (1990) Interstitial lung diseases in polymyositis and dermatomyositis. Clinical features and prognosis as correlated with histologic findings. Am Rev Respir Dis 141:727-733

Wells AU Cullinan P, Hansell DM et al (1994) Fibrosing alveolitis associated with systematic sclerosis has a better prognosis than lone cryptogenic fibrosing alveolitis. Am J Respir Crit Care Med 149:1583-1589

Wells AU, duBois RM (1993) Bronchiolitis in association with connective tissue disorders. Clin Chest Med 14:655-666

Wells AU, Hansell DM, Corrin B et al (1992) High resolution computed tomography as a predictor of lung histology in systematic sclerosis. Thorax 47:738-742

Wells AU, Rubens MB, duBois RM, Hansell DM (1993a). Serial CT in fibrosing alveolitis: prognostic significance of the initial pattern. AJR Am J Roentgenol 161:1159-65

Wells AU, Hansell DM, Rubens MB et al (1993b) The predictive value of appearances on thin section computed tomography in fibrosing alveolitis. Am Rev Respir Dis 148:1076-1082

Wells AU, Hansell DM, Rubens MB et al (1997) Functional impairment in long cryptogenic fibrosing alveolitis and fibrosing alveolitis. Am Rev Resp Dis 148:1076-1082

Vasculitis

Attali P, Begum R, Romdhane HB et al (1998) Pulmonary Wegener's granulomatosis: changes at follow up CT. Eur Radiol 8:1009-1013

Cordier JF, Valeyre D, Guillevin L et al (1990) Pulmonary Wegener's granulomatosis. A clinical and imaging study of 77 cases. Chest 97:906-912

Fenlon HM, Doran M, Sant SM et al (1996) High resolution CT in systemic lupus erythematosus. AJR Am J Roentgenol 166:301

Haworth SJ, Savage CO, Carr D et al (1985) Pulmonary haemorrhage complicating Wegener's granulomatosis and microscopic polyarteritis. Br Med J (Clin Res Ed) 290:1175-1178

Jennette JC, Falk RJ, Andrassy K et al (1994) Nomenclature of systemic vasculitides: Proposal of an international conference. Arthris Rheumatol 37:187

Jennette JC, Falk RJ (2007) Nosology of primary vasculitis. Curr Opin Rheumatol 19:10-16

Marten K, Schnyder P, Schirg E et al (2005) Pattern-based differential diagnosis in pulmonary vasculitis using volumetric CT. AJR Am J Roentgenol 184:720-733

Specks U, Deremee RA (1990) Granulomatous vasculitis. Wegener's granulomatosis and Churg Strauss syndrome. Rheum Dis Clin North Am 16:377-397

Susanto I, Peters JI (1997) Acute lupus pneumonitis with normal chest radiograph. Chest 111:1781-1783

Worthy SA, Muller NL, Hansell DM, Flower CD (1998) Churg strauss syndrome: the spectrum of pulmonary CT findings in 17 Patients. AJR Am J Roentgenol 170:297-300

Clinical 3D and 4D Imaging of the Thoracic Aorta

D. Fleischmann[1], D.C. Miller[2]

[1] Department of Radiology, Stanford University Medical Center, Stanford
[2] Department of Cardiothoracic Surgery, Stanford University Medical Center, Stanford, CA, USA

Introduction

Modern day CT angiography (CTA) has replaced diagnostic angiography for the evaluation of thoracic aortic diseases. The development of CTA with retrospective ECG gating has been driven by coronary artery CTA, but it also provides significant benefits to imaging of the thoracic aorta. Retrospective ECG gating virtually eliminates cardiac pulsation artifacts and has therefore extended the clinical applicability of CTA to finally also include the aortic root. Moreover, ECG gating allows cardiac phase-resolved ('time-resolved') cine imaging and visualization, adding a 'fourth dimension' (4D) to this technique.

The first immediate clinical benefit of motion-free 3D imaging of the thoracic aorta is improved visualization and thus characterization of acute aortic dissection and its variants. In addition to the ability to visualize a dissection flap all the way to the aortic root and into the coronary arteries, it has become possible to precisely localize the site of intimal tears, which is increasingly important in the stent-graft era. Furthermore, motion-free images allow the detection of less-common, subtle but clinically equally important intimal lesions, which have been notoriously difficult to detect in vivo with any imaging modality [1]. We therefore use ECG gating routinely at our institution in all patients with acute aortic syndromes. The second clinical scenario in which ECG-gated thoracic CTA plays a central role, and thus has become a routine application at our institution as well, is in pre- and postoperative 3D and 4D imaging of patients with aortic-root diseases.

The purpose of this article is to explain the techniques of image acquisition as well as 3D and 4D visualization of the thoracic aorta using ECG-gated CTA. The clinical topics of this review focus on the practical application of this technique in the setting of acute aortic dissection with its variants, and on surgical treatment planning of patients with aneurysms of the aortic root.

CT Imaging Technique

A summary of the CT scanning and reconstruction parameters used with a 16-channel GE Lightspeed scanner and a 64-channel Siemens Sensation scanner are provided in Tables 1 and 2. A gated chest CTA is usually preceded by a non-enhanced CT series. Non-enhanced images are critical for the identification of intramural hematomas in the acute setting, and are indispensable for the identification of surgical graft material and the differentiation of calcifications, Teflon pledgets, or glue from small leaks. CT scanning of nearly the entire thorax with retrospective ECG gating can be obtained with all 16- or more channel CT systems. The scanning range includes the origins of the supra-arch vessels down to the base of the heart. With 16-channel systems it is not possible to use the thinnest available collimation (e.g. 0.625, as would be used for a coronary CTA). A nominal section thickness of 1.25 mm is certainly adequate for visualization of the thoracic aorta, the aortic valve, and the course and origin of the coronary arteries. This protocol is not sufficient to rule out coronary artery stenoses, however. With 64-channel CT, we use a reconstructed section thickness of 1 mm for our gated chest protocol, and no pre-medication unless visualization of the coronary arteries is specifically requested. In the latter situation, we administer oral beta-blockers and sublingual nitroglycerin according to our coronary CTA protocol, but we use the larger scanning range (and longer scan time) for the entire chest. Except for obese patients (a tube output limited to 700 eff. mAs results in greater image noise), this protocol is technically and clinically equivalent to a coronary CTA (850 eff. mAs) and thus allows significant coronary artery disease to be ruled out.

Other than in coronary CTA, in which the reconstruction of one or very few datasets (e.g., a diastolic dataset at 65% of the RR-interval) suffices, gated chest studies require the reconstruction of several phases through the cardiac cycle. We generally reconstruct images through the entire chest at 65% of the RR-interval, and then reconstruct ten phases (from 0% through 90% of the RR-interval) of the heart and relevant portion of the thoracic aorta. These ten datasets can then be viewed as a cine-loop. In order to maintain similar image noise throughout the cardiac cycle, ECG dose modulation is not used in our gated chest protocol.

Good arterial opacification is a key element of CTA in general, and even more so if small structures, such as the aortic valve leaflets or tiny aortic-wall irregularities, are of diagnostic interest. We use high-concentration contrast medium (350-370 mg/ml) for all CT angiograms. For a 16-channel gated chest, we generally inject 5 ml/s (4.5-

Table 1. Scanning and injection parameters for retrospectively EKG-gated computed tomography angiography (CTA) of the thorax

	16-channel CT (GE LightSpeed 16)	64-channel CT (Siemens Sensation 64)
Premedication	none	None, or betablockers and sublingual nitroglycerine[a]
Pre-contrast series	Contiguous 2.5 mm	Contiguous 3 mm
Scanning range/direction	Above the aortic arch to the hiatus of diaphragm, cradio-caudal	
Tube voltage/current	120 kV/400 mA	120 kV/700 eff. mAs
Detector configuration	16×1.25mm	2×32×0.6-mm
Section thickness/reconstruction interval	1.25/0.8	1.0/0.7 0.75/0.5 mm[a]
Reconstruction phases	65% of RR-interval (entire scanning range), 0-90% of RR-interval (10 phases) of ascending aorta and heart (depending on the pathology)	
Scan time	~20-25 s	
Contrast medium	High-concentration (≥350 mg I/ml)	
Injection parameters	5 ml/s injection for duration of scan + 8 s (typically, 140 ml)	Biphasic injection, body-weight-based (see below)
Scanning delay	Minimum delay (automated bolus triggering, region of interest in ascending aorta)	

[a] If performed as a coronary CTA at the same time, the same premedication and thin-section thickness can be used with 64-channel systems

Table 2. Scanning and injection parameters for retrospectively EKG-gated CTA of the thorax with non-gated CTA of the abdomen and pelvis. All other acquisition and reconstruction parameters are as in Table 1

Scanning range	Above the aortic arch to the diaphragm (gated chest portion, and from the diaphragm to the lesser trochanter (non-gated portion)		
Scan time	Total scan time: ~20 s (gated chest) + 5 s interscan-delay + ~10 s (abdomen)		
Contrast medium	Biphasic, body-weight-adjusted injection protocol		
Injection parameters	Phase I (5s) injection rate (volume):		Phase II (total scan time of 5 s) injection rate:
	<55 kg	4.0 ml/s (20 ml)	3.2 ml/s (×scan time-5s)
	<65 kg	4.5 ml/s (23 ml)	3.6 ml/s (×scan time-5s)
Average	~75 kg	5.0 ml/s (25 ml)	4.0 ml/s (×scan time-5s)
	>85 kg	5.5 ml/s (28 ml)	4.4 ml/s (×scan time-5s)
	>95 kg	6.0 ml/s (30 ml)	4.8 ml/s (×scan time-5s)

6ml/s) for the duration of the scan time +8 s (e.g., for a 20-s scan we inject for 28 s, resulting in a total of 140 ml) (Table 1). The 8-s safety cushion compensates for the delay between the arrival of contrast medium in the ascending aorta and the initiation of the CTA acquisition above the aortic arch, inherent in the use of automated bolus triggering. For 64-channel gated chest studies and for all gated chest + abdomen and pelvis CTAs, we prefer biphasic injections. Biphasic injections with a short first high-flow-rate injection, followed by a second lower flow-rate maintenance injection provide bright vessel opacification at moderate total volumes of contrast for these relatively long scan times [2]. It is particularly important to set the total injection duration equal to the total-scan time, which also takes into account the (scanner-specific) 'interscan' delay between the gated portion (through the chest) and the non-gated CTA sequence through the abdomen and pelvis (Table 2). If this is ignored, abdominal and pelvic arterial opacification can be suboptimal or even inadequate for planning endovascular access.

3D and 4D Visualization

Powerful visualization tools are needed to take full advantage of the high-resolution multi-phase volumetric datasets. We use the AquariusNET server and thin client application (TeraRecon, Inc, San Mateo, CA) which allows to manage up to 28,000 CT slices simultaneously. While axial source images are always reviewed and remain the basis for diagnosis, real-time rendering and interaction with all ten phases of the cardiac cycle is key to analyzing aortic-root morphology and function. The possibility of cine viewing (looping through the datasets reconstructed at different RR-intervals) allows the selection of the best phase for a given abnormality. Moreover, cine-viewing provides invaluable dynamic information that is not obvious on static images from the systolic or diastolic phases only. Examples are small puffs of contrast-medium indicating the site of a small intimal tear or leak, and motion

abnormalities and functional deformities of the valve leaflets.

In addition to real-time interactive 2D, 3D and 4D (cine 3D) viewing of the datasets during image interpretation, it is important to also establish a consistent proto-col of 2D, 3D, and 4D documentation for communicating the findings to the physicians involved in the patient's care. A typical set of images and movie clips of the thoracic aorta and the aortic root in a patient before surgical repair of a thoracic aortic aneurysm is provided in Fig. 1.

Fig. 1a-f. Visualization of the thoracic aorta and the aortic root. Preoperative ECG-gated computed tomography angiography (CTA) of the chest in a 73-year-old woman with thoracic aortic aneurysm (64-channel CT, 0.75-mm section thickness, premedication with oral beta-block-er and sublingual nitroglycerine). (**a**) Volume-rendered view shows the ascending aortic aneurysm and generous aortic root. Measurements were obtained in oblique coronal and LAO views centered at the aortic valve (**b, c**) *Green* Anulus, *blue* sinuses of Valsalva, *yellow* sino-tubular junction, *light blue* mid ascending aorta (**b, c**). Normal coronary anatomy is shown in (**d**). The aortic valve is visualized 'from above' using MinIP (**e**) and volume-rendered (**f**) images and movie clips. Note the small central valvular coaptation defect in (**f**), consistent with mild aortic regurgitation. Coronary arteries and/or sinuses of Valsalva are annotated as left (*L*), right (*R*), or non-coronary (*NC*)

An overview of commonly used rendering parameters employed at our institution is provided in Table 3.

Basic 2D multiplanar reformations (MPR) are commonly viewed in sagittal, coronal, or arbitrarily oblique cross-sections to make an initial diagnosis. We use 3D volume rendering (VR), maximum intensity projections (MIPs), and minimum intensity projections (MinIPs) to further interrogate the data. Typically, a slab of variable thickness is navigated through the dataset interactively, quite similar to the way a patient's body would be interrogated with an ultrasound probe. Familiarity with the principles of VR and a basic understanding of opacity transfer function settings is helpful to adjust parameters. For example, rendering the vessel lumen transparent (in order to visualize the aortic valve) usually requires adjusting the parameters to the degree of vessel opacification and image noise. This is straightforward with an intuitive user interface and preset templates. Thin (1-4 mm) MinIP slabs are ideally suited for visualizing low-attenuation structures (valve leaflets, tendinous chords) within high-attenuation surroundings (contrast-medium-opacified blood). Increasing the MinIP slab thickness makes very thin valves more visible in a noisy environment, but at the same time increases the thickness of the leaflets. Routinely inverting the gray scale of MinIP (Fig. 1e) images clearly identifies them as such, and thus distinguishes MinIPs from MIPs. MinIPs should not be used to visualize calcified valves.

The selection of rendering techniques, thickness, and orientation of the interrogating slab depends on the pathology at hand. In the acute setting, axial images alone are usually sufficient to make the diagnosis. Two-dimensional MPRs and 3D (or 4D) views are only generated if necessary to convey a particularly relevant finding, such as the location of an intimal tear relative to the supra-arch vessels before stent grafting. On the other end of the spectrum are elaborate, fairly standardized images, movie clips and measurements before surgical aortic-root reconstruction.

Surgical Anatomy of the Thoracic Aorta

The thoracic aorta begins at the ventriculo-aortic junction (often, but not semantically correctly referred to as the aortic anulus) and extends to the level of diaphragmatic hiatus, where it becomes the abdominal aorta. Diseases of the thoracic aorta - notably aortic dissection - commonly extend into the abdominal aorta and its branches. Therefore, imaging of the thoracic aorta requires that the chest, abdomen, and pelvic vasculature are imaged in their entirety. From a surgical perspective, the thoracic aorta is divided into four anatomic segments (Fig. 2): the aortic root, the ascending aorta (tubular portion), the transverse aorta (aortic arch), and the descending thoracic aorta.

- The *aortic root* consists of the *aortic anulus*, the *sinuses of Valsalva*, and the *sinotubular junction* (or ridge). The aortic anulus (Latin: small ring) at the site where the cusp hinges insert is not a planar anatomic structure since the ventriculo-arterial junction is not ring; rather,

Table 3. Post-processing techniques and parameters for preoperative visualization of the thoracic aorta

	Rendering technique and parameters	Views/images
Chest wall, 3D	VR, full-volume or slab; adjust transfer function to visualize bony and cartilaginous portions of the ribs	In patients with scoliosis and pectus excavatum (Marfan's), and in all re-do procedures, to show position of heart and vessels, notably the right coronary artery, relative to the sternum
Aorta, 3D overview[a]	VR, 5- to 8-cm thick slab, CTA-transfer function (opaque vessels)	'Candy cane' view; usually a LAO projection; shows which segments are involved as well as the position and orientation of the aorta in the chest
Aorta, diameters	Thin-slab MIPs (5 mm) Ascending Transverse Descending aorta MPR orthogonal	Thin-slab MIPs are obtained in LAO view; more than one image is required in very tortuous aortas. 'True' diameters should be obtained from MPR images oriented normal to the vessel axis if needed (e.g., stent-grafting)
Aortic root, 3D and 4D[b]	VR, 2- to 4-cm slab, transfer function adjusted to render vessel lumen transparent; adjustments needed to display calcifications as well Thin-slab MinIP (1-3 mm); inverted gray-scale Or thin slab MIP (1-3 mm) if calcified	View directed at the valve from above ('anesthesiologist perspective'). Provides 'inside' view of the 'hollow' sinuses, coronary origins, and aortic valve Capture systolic and diastolic views, as well as a cine-loop movie clips of aortic valve
Aortic-root, measurements[c]	MPRs or thin MIPs Anulus Sinuses of Valsalva Sinotubular junction	Oblique coronal and LAO (~3-chamber) views, with plane through center of valve, orthonormal measurements (e.g., at sinuses of Valsalva level)

VR, Volume rendering; *MIP*, maximum intensity projection; *MinIP*, minimum intensity projection; *MPR*, multiplanar reformation
[a] See Fig. 1a
[b] See Fig .1d-f
[c] See Fig. 1b, c

Fig. 2. Schematic view of the surgical anatomy of the thoracic aorta and the aortic root. *SOV* sinuses of Valsalva, *STJ* sinotubular junction, *arrow* aortic isthmus, *triangle* 'ductus bump'

it is a complex 'coronet' or crown-shaped three-dimensional structure. In between the three commissures are the subanular 'inter-leaflet triangles', one of which is the membranous septum. The normal anulus measures 27 mm in diameter or less, and is usually oval. The three sinuses of Valsalva (left, right, and non-coronary) contain the aortic valve with its three cusps. The left and right sinus of Valsalva give rise to the left and right coronary arteries, respectively. The highest points of the valve commissures/leaflet insertions are located at the level of the sinotubular junction, which is also the landmark separating the aortic root from the tubular portion of the ascending aorta.

— The *ascending aorta* refers to the aortic segments above the sinotubular ridge and proximal to the brachiocephalic artery.

— The *transverse aorta* or aortic arch is the segment containing the three supra-aortic branches; it begins proximal to the brachiocephalic artery and ends distal to the subclavian artery.

— The *descending thoracic* aorta begins distal to the left subclavian artery. The proximal portion of the descending aorta can be quite elongated, higher within the chest than the transverse aorta, and (misleadingly) assume the shape of an arch. Another anatomic feature of the normal descending thoracic aorta is a mild narrowing distal to the subclavian artery, the so called aortic neck or isthmus, and a smooth dilatation in the adjacent more distal portion of the aorta, anatomically referred to as the aortic spindle, but better known as the 'ductus bump.' The latter should not be confused with an aneurysm or a traumatic aortic transection.

The diameter of the normal thoracic aorta encompasses quite a wide, poorly defined range, and depends on the anatomic segment as well as the subject's age, sex, and body size [3]. In general, the aorta is larger proximally than distally. Men have larger aortic diameters than women. Aortic diameters increase throughout adult life with normal aging.

Aortic-Root Diseases

When the diameter of the aortic anulus exceeds 27 mm and the sinuses of Valsalva (SOV) are enlarged, the term 'anuloaortic ectasia' is used. For practical and imaging purposes, it is also sufficient to define a thoracic aortic aneurysm using a single diameter as a threshold. We use the term 'aneurysm' for any aortic segment (SOVs, sinotubular junction, ascending, transverse, and descending thoracic aorta) with a diameter >4 cm. The terms (mild/moderate) dilatation or ectasia are used for apparently wider segments that are ≤4 cm in diameter. Some patients, typically the elderly with long-standing hypertension, have diffuse aortic ectasia, in which the entire thoracic and abdominal aorta is moderately dilated.

Morphologically, thoracic aortic aneurysms can be described as saccular, fusiform, or diffuse. The most important descriptors, however, are the maximum diameter and the anatomic extent relative to the above-mentioned segments. An aortic-root aneurysm, ascending aneurysm, arch aneurysm, descending aneurysm, or any combination thereof each has its respective surgical implications.

The maximum diameter of a thoracic aortic aneurysm is an important predictor for the risk of dissection or rupture. In asymptomatic patients with Marfan syndrome or other congenital aortic diseases, surgical repair is indicated when the maximum aneurysm diameter reaches 5 cm (2.75 cm/m² body surface area) [4]. In patients with degenerative or atherosclerotic aneurysms, surgical repair is usually indicated when the maximum aneurysm diameter reaches 6-7 cm. Most thoracic aortic surgical authorities today use a '2×' rule, in which the diameter of a contiguous normal aortic segment is the denominator and the maximal aortic size is the numerator. If this ratio exceeds 2, surgical (or stent-graft) consideration is warranted as the risks of operation usually are less than the risk of aortic catastrophe within the next year. The ratio normalizes the dilated segment to the patient's normal aortic size and is valid in petite women as well as large men. In patients with Marfan syndrome and a positive family history of aortic catastrophe who are treated in centers with a documented clinical track record of successful valve-sparing aortic-root replacement and an operative mortality risk <1%, prophylactic operation is indicated when the aortic root is even smaller than the 2× the size of the normal distal ascending aorta, e.g., as small as 3.5-4 cm [5]. Other methods include normalizing aortic size to BSA or using the area of the maximally dilated segment (cm²) divided by the patient's height (in meters) (if >10 cm²/m, then operation should be con-

sidered). The indication for elective surgical repair of aortic-root aneurysms is usually determined by the presence and degree of aortic-valve incompetence due to stretching and subsequent non-coaptation of the valve cusps [6]. It should also be noted that the term 'sinus of Valsalva aneurysm' applies to aneurysms of a single sinus, rather than a dilatation of all sinuses (which should be described as root aneurysm) [7].

The etiology of aortic-root aneurysms is dominated by congenital, often inherited disorders and syndromes. The great majority of patients undergoing aortic-root replacement have either Marfan syndrome or bicuspid aortic valve (BAV) associated aneurysms. Other, less common heritable disorders are Ehlers Danlos (type IV) syndrome, and familial aortic aneurysm and dissection. While genetically diverse, all of these disorders result in strikingly similar pathologic features, traditionally (although misleadingly) referred to as 'cystic medial necrosis'; that is, elastolysis (degeneration and fragmentation of elastic fibers and collagen), mucoid degeneration (accumulation of basophilic ground substance in cell-depleted layer of the vessel wall; no cysts), smooth-muscle-cell loss and dedifferentiation (no necrosis). Similar degenerative changes can also be seen in normal aging and in patients with severe hypertension.

The aortic root can also be involved in degenerative atherosclerotic aneurysms of the ascending aorta. Other than in typical Marfanoid aortic-root aneurysms, in which the sinotubular junction is effaced resulting in the typical pear-shaped proximal aorta, the waist at the sinotubular junction is usually preserved in degenerative aneurysms of the ascending aorta. Involvement and dilatation of the sinotubular junction can nevertheless result in reduced cusp coaptation and aortic-valve incompetence (Fig. 1F). Other causes of aortic-root and ascending-aortic disease include infectious and inflammatory conditions, such as syphilis and giant cell (Takayasu) arteritis. Aortic dissection is discussed below.

Sinus of Valsalva aneurysms are also thought to be congenital in origin, caused by a developmental defect. This is supported by the frequent association with ventricular septal defects (30-60%), bicuspid aortic valve (~10%), and other congenital abnormalities. SOV aneurysms most commonly originate from the right sinus (65-85%), less commonly from the non-coronary sinus (10-30%), and rarely from the left sinus (<5%).

Marfan Syndrome

The incidence of Marfan syndrome is 1:3,000-1:5,000. This genetic disease can be inherited (autosomal dominant with variable penetrance) or occure as a spontaneous mutation of the fibrillin-1 gene [8]. The cardiovascular system (aortic aneurysm and dissection, mitral-valve prolapse), eye (ectopia lentis), and musculoskeletal system (dolichostemomelia, arachnodactyly, scoliosis, pectus deformity) are affected. Diagnosis is based on clinical criteria (Ghent nosology). Progressive aortic root dilatation

leads to aneurysm and dissection, which are the leading causes of morbidity and mortality. Thoracic aortic dissection occurs in 40% of patients. Prophylactic aortic-root and ascending-aortic repair is indicated when the aortic diameter approaches 5 cm. Valve-sparing aortic-root replacement represents a reasonable alternative to composite valve-graft repair. Survival is excellent and complications are rare with either technique, but the long-term durability of valve-sparing aortic-root replacement has yet not been established (Fig. 3).

Bicuspid Aortic-Valve Disease

The incidence of bicuspid aortic-valve disease is very high, approximately 1:100 (4 million affected individuals in the USA). It has a 4:1 male predominance and familial aggregation. The disease is associated with coarctation of the aorta, patent ductus arteriosus, and coronary artery anomalies. While the most common fate is calcific aortic stenosis (85%), aortic-root enlargement, irrespective of altered hemodynamics, is highly prevalent (approx. 50%). Root enlargement is considered a precursor to aneurysm and dissection, and regular surveillance (echocardiography) is indicated [9]. Thoracic aortic dissection occurs in 5% of patients. Aneurysms involve the root as well as the ascending aorta, and typically extend into the (proximal) aortic arch (Fig. 4). Elective surgical repair is indicated when the aortic diameter approaches 5 cm, or when valvular complications occur. Valve-sparing aortic-root replacement is a reasonable alternative in patients whose valves are well-functioning.

Pre- and Postoperative CT Angiography of the Aortic Root

A basic understanding of surgical treatment options and techniques is helpful for diagnostic image interpretation, treatment planning, and particularly for post-operative follow-up. A detailed discussion of surgical techniques for treating aortic root and thoracic aortic diseases is beyond the scope of this article and can be found elsewhere [10]. Surgical access to the thoracic aorta is either from a median sternotomy (for the aortic root, ascending, and transverse aorta), or from a left lateral thoracotomy (arch and descending thoracic aorta). While a single tube-graft often suffices to replace the tubular portion of the ascending aorta, replacement or reconstruction of the aortic root is significantly more complex since the aortic valve and the coronary arteries have to be addressed. Several dedicated procedures using various graft/tissue materials have been derived over the years, i.e., composite valve graft and variants, valve-sparing procedures, homograft, pulmonary autograft (Ross procedure), stentless and bioprosthetic porcine root. Aortic-root replacement commonly requires the simultaneous replacement of parts or the entire ascending aorta, and may require partial (hemiarch) or complete replacement of the transverse aorta. Surgical replacement of the aortic arch is particu-

Fig. 3a-f. Valve-sparing aortic-root replacement in a patient with Marfan syndrome. Preoperative volume-rendered image (**a**) of the thoracic aorta in a 27-year-old man with Marfan syndrome shows aneurysmal dilatation predominantly of the aortic root. Transparent-blood rendering (**b**) and a view 'from above the valve' (anesthesiologists perspective) (**c**) illustrate remarkable dilatation of the sinuses of Valsalva. Intraoperative photographs demonstrate (**d**) the flaccid aortic valve and the residual sinus tissue surrounding the valve commissures after resection of the sinuses of Valsalva. Note the sutures through the ventriculo-aortic junction, which is used to anchor the graft. The excised right coronary button (*R*) with the right coronary artery ostium is seen. (**e**) The aortic valve is seen resuspended within the proximal graft, which is anchored to the ventriculo-aortic junction (not shown). (**f**) An anterior view of the completed reconstruction of the aortic root with its neo-sinuses and the reimplanted right coronary artery (*R*), and the second tube graft replacing the tubular portion of the ascending aorta. Sinuses of Valsalva are annotated as left (*L*), right (*R*), or non-coronary (*NC*)

Fig. 4a-c. Bicuspid aortic valve (BAV) disease. Volume-rendered diastolic (**a**) and systolic (**b**) images of the aortic root (transparent blood) in a 53-year-old woman show three sinuses of Valsalva (*R* right, *L* left, *NC* non-coronary) but two leaflets. In diastole (**a**), a raphé is seen between the right and non-coronary portions of the closed valve. In systole (**b**), however, the right and the non-coronary valve tissue are clearly fused (*R+NC*) to form a common valve leaflet. Note the typical shape of BAV-associated aneurysms, which involve the root, have their maximum diameters in the ascending aorta, and extend into the aortic arch. Compare with the normal descending aorta

larly challenging since reconstruction of the arch branches mandates hypothermic circulatory arrest and antegrade cerebral perfusion to protect the brain.

Aortic Root Replacement: Valve Sparing and Composite Valve Graft

Historically, the traditional surgical method of aortic-root replacement consists of a single graft that contains a mechanical valve - the so-called composite valve graft (CVG) [11]. In this procedure, the coronary artery ostia are reimplanted.

One increasingly popular alternative to CVG that avoids anticoagulation is valve-sparing aortic-root replacement. The basic idea is to replace the walls of the aortic root, while preserving the patient's own valve. Again, the coronary ostia need to be reimplanted. The various techniques of valve-sparing aortic-root replacement can be categorized into two broad groups [12]: (1) the Yacoub remodeling procedure, in which a scalloped graft is sewed to the residual portions of sinus tissue [13], and (2) the Tirone David reimplantation procedure, in which the proximal graft anastomosis is anchored at the ventriculo-aortic junction below the level of the cusps, and the valve commissures are then sewn inside the graft [14].

At our institution, a variant of the Tirone David [14] reimplantation technique (T. David-V, Stanford modifica-

tion) using two separate grafts has been the preferred approach since December 2002 [12]. The modified technique gives the surgeon unlimited flexibility to individualize the dimensions and 3D geometry of the root reconstruction according to the patient's specific pathoanatomy and creates 'neo-sinuses' in the vascular graft that mimic SOVs (Fig. 3).

Preoperative imaging and visualization with accurate measurements of the aortic anular and sinotubular junction diameter and cusp height help the surgeon to conceptualize the size of the graft, which is 'necked-down' (plicated) proximally to create the necessary anular size. Imaging also facilitates the determination of the appropriate diameter and height of the graft neo-sinuses and the size of the second graft above the neo-sinotubular junction.

Preoperative CT Angiography Image Evaluation

Image interpretation always includes a complete evaluation of the thorax by reviewing the transverse source images. The specific information sought in preoperative ECG-gated CTA of the thoracic aorta is listed below, and should be included in the radiological report. This information is supplemented by the respective 2D images, 3D images, and video clips (Table 3, Fig. 1):

- Type and size of aneurysm: Anatomic extent (e.g. aortic root aneurysm ± anuloaortic ectasia; ± involvement of ascending aorta; ± tapering into arch).
- Measurements: Diameters of anulus, SOVs, sinotubular junction, ascending, transverse and descending aorta.
- Aortic valve: Normal or abnormal; tricuspid vs. bicuspid. If bicuspid, describe morphology (one or two sinuses of Valsalva; which cusps are fused ± raphé); leaflet thickness, normal/abnormal motion (pliable or limited motion due to stretching of cusp edges), stenosis or incompetence [often caused by stretching of valve (central coaptation defect), or by valve prolapse (asymmetric coaptation defect)].
- Coronary-artery anatomy (and pathology): normal or abnormal coronary-artery anatomy. Note: variants can add significant complexity to surgery. Image-quality permitting (64-channel CT with modified coronary protocol), the presence/absence of coronary artery stenoses should be reported.

Other surgically relevant findings, such as the location/angle of the sternum relative to the mediastinal structures in patients with scoliosis or pectus excavatum, should also be included in the report. Attention should be given to postoperative changes from prior procedures (e.g., course of existing CABG grafts), if present.

Postoperative CT Angiography Image Evaluation

The first postoperative (pre-discharge) CT after aortic-root replacement is routinely obtained with retrospective ECG gating, in order to detect any early postoperative complications. Knowledge of the specific surgical proce-

dure is often required to unambiguously interpret postoperative findings. Non-enhanced images are essential to identify graft material and may be the only clue as to what procedure was done when the (sometimes remote) surgical history is obscure. Post-operative image interpretation specifically attempts to:

- Identify grafts: On non-enhanced images, surgical grafts are slightly hyperdense. Also look for felt strips (reinforced anastomoses), felt pledgets (reinforced sutures), and BioGlue (after dissection repair), which should not be confused with small anastomotic leaks (on contrast-enhanced images).
- Detect potential pitfalls: Graft folds (at graft angles, or when the graft is plicated) or a so-called elephant trunk (free ending graft dangling in the descending aorta with its proximal anastomosis often in the region of the aortic neck and without a distal anastomosis) can simulate redissections. Tied-off graft cannulation sites, graft stumps (e.g., to the right axillary artery) or graft limbs (arch), which are used in cardiopulmonary bypass or cerebral perfusion (right axillary artery), can mimic small leaks or pseudoaneurysms. Unusual grafts (e.g., Cabrol aorto-coronary interposition graft) as well as unusual and 'historic' procedures (e.g., wrapping of the aortic wall around the graft, as in the original Bentall procedure) can be very difficult to interpret without the surgical history.
- Search for leaks and pseudoaneurysms: Proximal, distal, and graft to graft anastomoses, as well as coronary buttons should be evaluated. Small leaks (peri- supra- or infravalvular) may not be visible in all phases of the cardiac cycle! Review systolic and diastolic views! Pseudoaneurysms can also occur at arterial or cardiac cannulation sites.
- Rule out postoperative hematoma: Small amounts of retrosternal, pericardial, or periaortic fluid and stranding in the mediastinal fat are normal early postoperative findings. Consider adding a delayed phase (non-gated) CT acquisition to rule out small extravasations.
- Exclude infection: Graft infections and sternum osteomyelitis are rare but difficult to treat late complications. Imaging findings range from extensive abscess-like fluid collections with rim enhancement and contained ruptures, to small amounts of perigraft fluid collections. Minimal soft-tissue density abnormalities may harbor infected and necrotic tissue and further imaging (white cell scan) should be recommended in the proper clinical setting.

Acute Aortic Dissection Variants

Imaging plays a central role in the diagnostic evaluation and management of patients with acute conditions of the aorta - the so-called acute aortic syndromes (Table 4). Modern multidetector-row CT technology has become increasingly available in the 24/7 emergency setting, with sensitivity and specificity both approaching 100%

Table 4. Acute aortic syndromes

Dissection and variants
 Classic dissection
 Intramural hematoma
 Limited intimal tear
Penetrating atherosclerotic ulcer
 Intramural hematoma
 Pseudoaneurysm/contained rupture
Rupturing aortic aneurysm

for the detection of acute aortic disorders, and with the ability to detect alternative findings [15]. With the advent and increasing use of endovascular stent-grafting [16, 17], CT has also assumed a critical role in treatment planning. Stent-grafting requires not only accurate 3D measurements and localization of the intimomedial flap, but also a clear depiction of the site of the intimal tear as the primary treatment target. Covering the culprit intimal tear in the descending aorta may be a viable treatment strategy even in patients with (retrograde) type A dissection.

We have found retrospective ECG-gating of the thoracic aorta to be very helpful in the characterization of aortic dissections, and we use this technique routinely in patients presenting with acute aortic syndromes. Near-motion-free images allow identification of the site of the intimal tear, the location of the intimomedial flap, and its motion, which can be delineated even when extending into the aortic root and coronary arteries. Another consequence of using increasingly powerful CT equipment in the evaluation of acute aortic diseases is the ability to see more subtle abnormalities and variants of aortic dissections, and their evolution over time, which may ultimately expand our understanding of these disorders.

Classic Aortic Dissection and Intramural Hematoma

Aortic dissection is an uncommon yet potentially catastrophic clinical event. The incidence has been estimated at 5-30/million/year (vs. 4,400/million/year for acute myocardial infarction in the USA). Acute aortic dissection is the most common acute aortic condition requiring urgent surgery. While the initiating event leading to aortic dissection is unknown, the common feature in most patients is a structural abnormality of the aortic media. Degeneration of the elastic fibers and smooth muscle cells of the aortic media is seen in patients with Marfan syndrome (and other heritable disorders leading to aortic aneurysms and dissections; see above) and in patients with hypertension. Intimal disease (atherosclerosis) is not a prerequisite for aortic dissections.

Classic aortic dissection is characterized by the presence of an entry tear in the intima and a clear separation between layers of the aortic media, resulting in two separate flow channels, i.e., the true lumen, and the false

Fig. 5a-d. Aortic dissection variants. (**a**) The layers of the normal aortic wall consist of the intima, the media, and the adventitia. Most of the substance of the aortic wall is media (*gray*). Neither the intima nor the adventitia (*black inner and outer contours* of the aortic wall) is visible on CT. All dissection variants have an abnormal media in common, historically referred to as 'cystic media necrosis' (see text for details). Classic aortic dissection (**b**) occurs within the outer third of the medial layer, resulting in two channels of blood flow. Note that the tissue separating the true and false lumen is mostly media tissue, and correctly should be termed the intimomedial flap (in lieu of intimal flap). (**c**) When the separation plane within the media is filled with stationary blood, instead of flowing blood, this is an intramural hematoma (*IMH*). A limited intimal tear (**d**) is a partial-thickness tear (*arrowheads*) through the intima and inner portion of the media, thus exposing the residual media/adventitia, which tends to bulge out (*small arrows*) relative to the remainder of the aortic circumference

lumen (a channel entirely within the media) (Fig. 5). The relative flow of blood and the shape of the true and false lumens are highly variable and probably depend on the size of the entry tear, the degree of media degeneration, the presence, location, number, and size of re-entry tears (where false-lumen blood flow reenters or communicates with the true lumen). Neither the size of the channels nor the orientation and degree of arterial enhancement necessarily allow identification of the true and false lumen, respectively. However, modern CT technology provides reliable identification of the flow channels by analyzing the entire aorta and tracing the respective lumens. This is particularly important when ischemic complications occur (cerebral, renal, mesenteric, or lower limb).

Involvement of the ascending aorta in acute dissection is a surgical emergency owing to its high mortality if left untreated. Fluid seeping through the diseased wall can lead to pericardial tamponade. Ascending dissections can extend into the SOVs and into the coronary artery ostia,

causing valve incompetence, myocardial ischemia, and leading to frank rupture.

There is considerable overlap between intramural hematoma (IMH) and aortic dissection, in terms of underlying media degeneration, patient population, and risk of rupture. IMH is considered a variant of classic dissection, where the above mentioned layer within the aortic media is not filled with flowing, but with stationary blood (Figure 5). Presenting features are similar, progression to dissection may occur, and treatment considerations are similar to classic dissection [18].

Limited Intimal Tear (Limited Dissection)

So-called isolated or limited intimal tears are probably the least common and less well-known intimomedial lesions of the aorta. The true prevalence and spectrum of these lesions is unknown but, if specifically searched for, may be up to 5% of patients undergoing acute ascending aortic repair [1]. The clinical implications are identical to those of other acute aortic syndromes, and surgical repair is indicated in these cases, which usually affect the ascending aorta. Chronic limited tears have also been described, notably in patients with Marfan syndrome.

Owing to their morphology, these lesions are particularly difficult to detect on imaging studies. In fact, the nine patients described in Sevensson's original description were all diagnosed intraoperatively despite multiple preoperative noninvasive and invasive studies [1].

Pathologically these lesions represent partial-thickness linear or stellate tears through the intima and underlying superficial media, exposing the deeper media and adventitia [1]. The edges of the tear may show limited undermining but, oddly enough, this does not result in a more extensive separation between the torn and intact layers of the aortic wall, as one might expect. Intramural blood has not been described as a typical feature of this lesion, but we have observed both a tiny intimal flap and a small intramural hematoma at the two ends of a longitudinal tear in a patient imaged with ECG-gated CTA (Fig. 6). The edges of the tear are separated from each other, probably due to stretching of the residual aortic wall (consisting of remaining intact media and adventitia) or some elastic recoil of the torn layer, resulting in an eccentric bulge of the aorta. An eccentric bulge may be the only imaging sign of this significant lesion, and these lesions have been under-diagnosed with all imaging modalities (US, CT, MR). It is not clear what determines whether a classic dissection with a septum, intramural hematoma, or limited intimal tear occurs.

While it is reasonable to assume that the sensitivity of ECG-gated CTA will improve the detection of these subtle ascending aortic lesions, this has not been established. The main implication for the radiologist is therefore to be aware of the fact that these subtle lesions indeed exist and should be searched for with the appropriate technique and in the right clinical setting.

Fig. 6a-d. Limited intimal tear of the ascending aorta. Non-enhanced CT image (**a**) and ECG-gated axial CTA images (**b**, **c**) show a small intramural hematoma at the level of the proximal aortic arch (*arrow* in **a**). Note the displaced small calcification, indicating the location of the intima. In the proximal ascending aorta, a single image (**b**) demonstrates a small flap, consistent with an undermined edge of a limited intimal tear. Image (**c**), immediately superior to (**b**), shows the edges of the limited intimal tear (*arrowheads*) and the bulge of the exposed residual aortic wall (*small arrows*). The full longitudinal extent of the lesion is shown in a thin-slab maximum intensity projection image (**d**): The tear extends from the proximal ascending aorta to the proximal arch, with a length >6 cm

Anatomic Classification of Aortic Dissection

We use the 1970 Stanford classification to describe the type of dissection and the extent of the intimal (intimo-medial) flap [19]. In addition, we specifically describe the site of the primary intimal tear (PIT), as advocated by Griepp's Mt. Sinai cardiovascular surgical group [20], which was not included in the original Stanford classification scheme. The definition of a Stanford type A dissection is based on the presence of a dissection flap in the ascending aorta, whereas a Stanford type B dissection - irrespective of the location of the PIT [ascending, arch, descending (retro-A dissection), or abdominal aorta] - is defined by the absence of a dissection flap in the ascending aorta. Note that the definition of type A vs. type B is thus exclusively based on the involvement or not of the ascending aorta. This is clinically meaningful because it predicts the expected biological behavior of the process if untreated, and therefore dictates management; for example, ascending aortic involvement (acute type A dissection) mandates emergency surgical repair. While most type B dissections commonly involve the descending aorta distal to the subclavian artery and frequently the abdominal aorta, this is not how type B dissections are strictly defined (despite the notorious propagation of misinterpretation in the literature). Type B dissections also include those that involve the transverse aorta (aortic arch) due either to the PIT being located in the arch or to retrograde propagation of the false lumen back up into the arch. Regardless of arch involvement, most patients with acute type B dissections are treated conservatively unless complications, such as rupture, leak, distal body malperfusion due to true lumen collapse, rapid false lumen expansion, refractory pain, malignant hypertension, or branch-vessel ischemia, require urgent surgical or stent-graft intervention. The terms type A and type B are also used to describe the location of aortic intramural hematoma (IMH). More detailed anatomic descriptions of the location of IMH have recently been proposed in the literature [18].

Penetrating Atherosclerotic Ulcer

Penetrating atherosclerotic ulcers (PAUs) are a rather distinct entity within the acute aortic syndromes. Pathologically, these lesions are defined as ulcers of the inner lining of the aorta (usually, a thickened intima with chronic atherosclerotic change) that penetrate through the internal elastic lamina into the aortic media, which may result in a local aortic-wall hematoma. Alternatively, the ulcer may penetrate through the entire aortic wall and result in a (contained) rupture.

The radiologic diagnosis of a PAU is based on the presence of an ulcer-like aortic-wall lesion (the internal elastic lamina is not visible on imaging studies) that typically protrudes beyond the aortic circumference and is associated with a local intramural hematoma or signs of rupture. Clinical correlation is important, since ulcer-like lesions can be an incidental finding in asymptomatic patients, representing either an ulcerated plaque (not penetrating into the media) or a chronic, healed (reendothelialized) ulcer. There is a continuum between the latter lesions and atherosclerotic aneurysms.

Penetrating aortic ulcers can be considered a consequence of a diseased intima (i.e., atherosclerosis), in contradistinction to aortic dissection and its variants. In these latter entities, intimal disease is not a prerequisite, but degenerative changes of the elastic fibers and smooth muscle cells of the aortic media are the rule. This is also in keeping with the observation that in older patients with significant atherosclerotic plaques PAUs tend to occur in the descending thoracic aorta. More than one PAU is not uncommon in a given patient. The fact that both PAUs and the dissection-complex can result in the accumulation of blood in the aortic wall as an intramural hematoma may be considered a mere coincidence. The IMH seen in patients with PAUs are usually more focal than those seen in patients with IMH alone. If 'intimal flaps' are seen in patients with PAUs, these may be regarded as deep overhanging edges of an ulcer rather than true dissections. Nonetheless, some morphologic overlap and ambiguity on imaging studies does occur. The therapeutic consequences in the appropriate clinical setting are the same for any morphology, independent of the semantics.

CT Angiography Image Evaluation in Acute Aortic Syndromes

The diagnostic evaluation of patients with acute aortic syndromes is based on a thorough review of the transverse source images. Simple 2D reformations can be very helpful in the assessment of aortic dissections. ECG gating substantially improves the quality of images of the aortic root and ascending thoracic aorta. Three- and 4-dimensional visualization is helpful for treatment planning. The specific information sought in patients with acute aortic syndromes should comprise:

- Lesion characterization: Dissection and its variants vs. PAU. The presence of intramural hematoma and flow channels should be determined on non-enhanced images.
- Anatomic extent: The extent of the intimo-medial flap (Stanford Type A vs. Type B) the site of intimal tear should be described.
- True vs. false lumen and side-branch involvement: The entire aorta should be scrutinized in order to identify true and false lumens, notably in the presence of side-branch ischemia.
- Complications: Pericardial fluid and signs of rupture, e.g., periaortic hematoma and hemothorax should be noted. Mild periaortic stranding should be mentioned if present, but is not a definite sign of rupture in stable/asymptomatic patients. Signs of organ (kidneys, bowel) malperfusion should also be looked for.

– Stent-graft planning: Measurements of aortic diameters, distance of the intimal flap and tear from the subclavian and left carotid artery origins should be measured. Femoral and pelvic vessel size and tortuosity should be assessed for stent-graft planning.

References

1. Svensson LG, Labib SB, Eisenhauer AC, Butterly JR (1999) Intimal tear without hematoma: an important variant of aortic dissection that can elude current imaging techniques. Circulation 99:1331-1336
2. Fleischmann D, Rubin GD, Bankier AA, Hittmair K (2000) Improved uniformity of aortic enhancement with customized contrast medium injection protocols at CT angiography. Radiology 214:363-371
3. Roman MJ, Devereux RB, Kramer-Fox R, O'Loughlin J (1989) Two-dimensional echocardiographic aortic root dimensions in normal children and adults. Am J Cardiol 64:507-512
4. Davies RR, Gallo A, Coady MA et al (2006) Novel measurement of relative aortic size predicts rupture of thoracic aortic aneurysms. Ann Thorac Surg 81:169-177
5. Kim SY, Martin N, Hsia EC et al (2005) Management of aortic disease in Marfan syndrome: a decision analysis. Arch Intern Med 165:749-755
6. Bonow RO, Carabello BA, Kanu C et al (2006) ACC/AHA 2006 Guidelines for the management of patients with valvular heart disease: a report of the American College of Cardiology/American Heart Association Task Force on Practice Guidelines (writing committee to revise the 1998 Guidelines for the Management of Patients With Valvular Heart Disease): developed in collaboration with the Society of Cardiovascular Anesthesiologists: endorsed by the Society for Cardiovascular Angiography and Interventions and the Society of Thoracic Surgeons. Circulation 114:e84-e231
7. Ring WS (2000) Congenital Heart Surgery Nomenclature and Database Project: aortic aneurysm, sinus of valsalva aneurysm, and aortic dissection. The Annals of Thoracic Surgery 69:147-163
8. Judge DP, Dietz HC (2005) Marfan's syndrome. Lancet 366:1965-1976
9. Fedak PW, Verma S, David TE et al (2002) Clinical and pathophysiological implications of a bicuspid aortic valve. Circulation 106:900-904
10. Gardner TJ, Spray TL, Rob C (2004) Operative cardiac surgery. Arnold (distributed in the USA by Oxford University Press) London, New York
11. Bentall H, De Bono A (1968) A technique for complete replacement of the ascending aorta. Thorax 23:338-339
12. Miller DC (2003) Valve-sparing aortic root replacement in patients with the Marfan syndrome. J Thorac Cardiovasc Surg 125:773-778
13. Sarsam MA, Yacoub M (1993) Remodeling of the aortic valve anulus. J Thorac Cardiovasc Surg 105:435-438
14. David TE, Feindel CM (1992) An aortic valve-sparing operation for patients with aortic incompetence and aneurysm of the ascending aorta. J Thorac Cardiovasc Surg 103:617-621
15. Hayter RG, Rhea JT, Small A et al (2006) Suspected aortic dissection and other aortic disorders: multi-detector row CT in 373 cases in the emergency setting. Radiology 238:841-852
16. Dake MD, Kato N, Mitchell RS et al (1999) Endovascular stent-graft placement for the treatment of acute aortic dissection. N Engl J Med 340:1546-1552
17. Dake MD, Wang DS (2006) Will stent-graft repair emerge as treatment of choice for acute type B dissection? Semin Vasc Surg 19:40-47
18. Evangelista A, Mukherjee D, Mehta RH et al (2005) Acute intramural hematoma of the aorta: a mystery in evolution. Circulation 111:1063-1070
19. Daily PO, Trueblood HW, Stinson EB et al (1970) Management of acute aortic dissections. Ann Thorac Surg 10:237-247
20. Ergin MA, O'Connor J, Guinto R, Griepp RB (1982) Experience with profound hypothermia and circulatory arrest in the treatment of aneurysms of the aortic arch. Aortic arch replacement for acute arch dissections. Journal of thoracic and cardiovascular surgery 84:649-655

Clinical Applications of 3D CT Imaging in Thoracic Pathology

M. Prokop

Department of Radiology, University Medical Center, Utrecht, The Netherlands

Thoracic vascular imaging is moving away from catheter angiography towards non-invasive techniques, and in particular computed tomography angiography (CTA). The three-dimensional imaging capabilities of CT and its ease of use have been the main reason for this change. However, 3D imaging is not limited to the vascular system; it also has useful but underused applications in routine chest CT, high-resolution CT (HRCT), or trauma cases. This article will present the basic rules for data acquisition for 3D imaging in chest CT and CTA, briefly discuss the various techniques for exploring a 3D data set, and finally focus on clinical applications that can improve chest imaging in daily routine as well as in situations in which it is important to gain as much information as possible about the three-dimensional extent of the anatomy and pathology of interest.

Acquisition Technique

Optimal three-dimensional imaging requires a near isotropic data acquisition. In CT, this is possible with thin-section imaging, in which the in-plane and through plane resolution are similar. In practice, this is synonymous with thin sections (ideally <1.25mm thickness).

Single-Slice CT

Isotropic imaging with single-slice CT is limited to very short scan ranges (e.g., 6 cm for protocols with 1-mm collimation, pitch 2, and a 30-s scan duration). It may be used in the evaluation of focal bronchial abnormalities or tumors, but in clinical practice it is seldom applied.

For the aorta, pulmonary artery, and bronchial system, a scanning protocol with 3-mm collimation and a pitch between 1.6 and 2 can be applied if the scan range is limited to only part of the chest (top of the diaphragms to 1 cm above the aortic arch). Despite a scan range of <20 cm, the scan duration should be >30 s. This requires meticulous patient instruction to avoid breathing artifacts.

For routine imaging, a 5-mm collimation with a pitch around 1.7 is necessary to cover the whole chest within one breath-holding period. Again, proper patient in-

struction is mandatory. However, this protocol will suffer from substantial anisotropy (effective section thickness 6-7mm) and will only suffice in the assessment of gross abnormalities, e.g., of the aorta, or for general anatomic orientation.

Reconstruction increments should ideally be half the effective section thickness, i.e., 0.7-1 mm for the near-isotropic protocol, 2 mm for evaluation of the central organs, and 3-4 mm for the whole chest.

Multislice CT

Isotropic imaging of the whole chest is possible with all multislice scanners (4-slice and more). At thin collimation (1-1.25 mm), 4-slice scanners still require scan durations between 20 and 30 s, which makes them vulnerable to breathing artifacts towards the end of the scan. The 10- to 64-slice scanners require only 5-15s, even at submillimeter collimation. However, since scans are now much faster, breathing artifacts may occur towards the beginning of the scan if the patient has not fully stopped breathing when the scan is started. Still, in very dyspneic or uncooperative patients, no breath-hold should be attempted because artifacts will be major if patients continue breathing after a failed breath-holding maneuver. Instead, such patients should be asked to hyperventilate before the scan (if possible) and then told to breathe shallowly. Breathing artifacts with fast scanners will be minor, and 3D evaluation will still be possible.

In general, a collimation between 0.5 and 1.25 mm is used with multislice scanners. The pitch factor should be set around 1.5 for 4-slice units, around 1.25 for 10- to 16-slice scanners, and around 0.9 for 32- to 64-slice scanners. Cone-beam artifacts are reduced at lower pitch and the increase in scan speed with more detector rows is such that a minor reduction in pitch can be afforded.

As with single-slice CT, reconstruction increments should theoretically be about half the effective section thickness but they need not be smaller than the pixel size in the scan plane. In practice, this pixel size becomes the determining factor for the choice of the reconstruction increment: at a field of view of between 250 and 350 mm, the pixel will vary between 0.5 and

0.7 mm (512 matrix). For practical reasons, we set the reconstruction increment to 0.7 mm for all but small or pediatric patients.

The reconstructed section thickness can be chosen (almost) arbitrarily with multislice scanners. However, it has to be equal to or larger than the slice collimation. If the chosen section thickness is identical to the collimation, then the image noise will usually be substantially higher - a situation that should be avoided for 3D imaging. As a consequence images of between 0.8 and 1.0 mm thickness should be reconstructed for 10- to 64-slice scanners and images of 1.25- to 1.6-mm thickness for 4-slice scanners. Since image noise will increase substantially in the imaging of large patients, even thicker sections (1.5-2.5 mm) and/or additional smoothing filter kernels should be applied in such situations.

With 16- to 64-slice scanners, ECG-gating becomes an option. This technique has been developed for imaging of the heart but it can also be applied to 3D imaging of the thoracic aorta, which otherwise will suffer from substantial pulsation artifacts, especially in young patients or those with high blood pressure, aortic valve disease, or acute aortic dissections. Since the use of ECG gating will increase the scan duration substantially, the slice collimation will have to be increased with 16-slice units. With 64-slice scanners, ECG-gated imaging of the whole chest can be achieved within 20-35 s.

Rendering Techniques

The most common techniques for exploring 3D data in CT are multiplanar reformations (MPRs) and maximum intensity projections (MIPs). Minimum intensity projections (MinIPs) or volume rendering techniques (VRTs) are reserved for more specialized applications. During the course various tips and tricks will be demonstrated for optimizing these viewing techniques with respect to image quality but also with respect to time-efficient use in clinical practice.

Multiplanar Reformations

Multiplanar reformations (MPRs) are the basis for 3D image evaluation with CT. They allow for interactive exploration of a CT data set similar to that obtained with ultrasound (but after data acquisition has been accomplished). MPRs should be standard for a large variety of clinical imaging tasks.

One of the most important tasks of MPR is noise reduction: by increasing the MPR thickness, image noise can be controlled without losing in-plane resolution. This is usually the first step in the process of interactive analysis of a 3D CT data set.

MPR can be used to display the craniocaudal extent of disease, to improve anatomic delineation, for tumors, the spine, aortic arch abnormalities (Fig. 1), the

Fig. 1. Parasagittal reformation of the aorta in a trauma patient. Note the irregularity of the aortic lumen at a typical position in the proximal descending aorta, indicative of traumatic injury. Also note the extensive mural hematoma in the descending aorta

bronchial system, or the lung parenchyma, to name but a few.

MPR can either be incorporated into a standard protocol (e.g., coronal and sagittal MPR for staging of bronchogenic carcinoma) and be performed by technologists or be done interactively by the radiologists during image evaluation. In general, we combine both approaches: routine MPR for most indications and additional interactive MPR wherever necessary.

Maximum Intensity Projections

Maximum intensity projections (MIPs) are most popular for vascular imaging (CTA) but are also useful for evaluation of the lung parenchyma. For the whole scan volume, a suitable subvolume, or an image slab, MIPs display the maximum CT number in the viewing direction and therefore optimize the display of high-density structures, such as contrast-enhanced vessels, but also lung nodules and bones.

MIPs require the choice of a subvolume that is free from structures whose densities are higher than that of the structure to be visualized. In practice, MIPs for the chest are usually applied to thin slabs of 5- to 20-mm thickness, which can be interactively moved through the data volume much in the same way as MPRs.

MIPs are less useful for the aorta, but play a role in evaluating the supra-aortic vessels, the bronchial arteries, and, most importantly, the pulmonary arteries (Fig. 2). Recently, MIPs have turned out to be most efficient when used to search for pulmonary nodules, be it in the case of metastases, lung cancer screening, or simply as a final step in any chest CT. MIPs have also been successfully employed for identifying and classifying subtle HRCT findings (Fig. 3).

Fig. 2. Maximum intensity projection (MIP) in a patient with bronchogenic cancer and encasement of the pulmonary arteries on the right (*arrowheads*) as well as pulmonary embolus on the left (*arrow*)

Fig. 3. Comparison of a 1-mm thick axial high-resolution CT (HRCT) image (**a**) and a 10-mm thick maximum intensity projection (MIP) (**b**) for the differentiation of centrilobular abnormalities. Correct classification of the tree-in-bud phenomenon is much easier on MIP images

Minimum Intensity Projections

Minimum intensity projections (MinIPs) display pixels with the lowest density in the viewing directions. Their use has been advocated in assessing the central bronchial system. However, because MinIPs lack depth information, they turn out to be quite useless for most such clinical applications. Instead, for evaluation of lung density changes, such as mosaic patterns, and for the display of bronchiectases, MinIPs are well-suited because they suppress the anatomic background (vessels) and only display the lung parenchyma and dilated bronchi.

Volume-Rendering Techniques

These allow for a vast variety of display options, be it for the vessels, the skeleton, the bronchi, or the lung parenchyma. Volume rendering images can yield surface as well as density information and can be easily color-coded.

Volume-rendering techniques (VRTs) are the best approach to visualizing the thoracic aorta because depth information is preserved and 3D orientation is facilitated. Bone removal can improve the display of paravertebral portions of the aorta; but in general some parts of the skeleton should remain in the image to facilitate anatomic orientation. Complex anatomy is preferentially displayed by VRTs (Fig. 4).

VRTs can be targeted to display density gradients, such as at the aortic or bronchial wall, and can thus be used for luminal evaluation. With densities color-coded in the range of the lung parenchyma, VRT improves the visualization of subtle variations in lung density, such as occur in mosaic perfusion or bronchiolitis obliterans.

Shaded Surface Displays

This older technique can be used as an alternative to VRTs but it is less versatile and more prone to artifacts. For this reason, shaded surface displays (SSDs) are hardly used anymore.

Virtual Endoscopy

Virtual endoscopy is a technique that uses VRT or SSD combined with perspective rendering to gain endoscopy-like images of interior surfaces. While it is very useful

Fig. 4. Volume rendering of an aberrant arterial supply of a pulmonary sequester. Note the excellent anatomic orientation

for evaluation of the colon, virtual endoscopy plays a minor role in the chest. Neither virtual bronchoscopy nor virtual angioscopy have made their way into routine clinical practice.

Image Noise

Noise is the most important enemy of 3D evaluation tools other than MPR. Too much noise will increase the background density in MIPs and decrease the background in MinIPs. While this effect is less critical for MIPs, it can substantially deteriorate the evaluation of smaller structures on MinIPs. On MIPs, however, irregular contours of high-density may occur due to image noise. Similar effects are seen on images obtained with VRTs.

Noise will increase with thinner sections, use of higher-resolution filters for image reconstruction, and especially in obese patients. In fact, every additional 4 cm of soft tissue roughly cuts the number of photons that hit the CT detector in half and will increase the noise by the square root of 2 (i.e. by ca. 40%).

The image quality achieved with MIPs, MinIPs, or VRTs can therefore be improved by using lower-resolution filters or by increasing the thickness of the reconstructed sections. Some manufacturers offer edge-preserving filters that reduce noise without sacrificing image details. If thick MPRs are first reconstructed perpendicular to the viewing plane (i.e., coronal planes for the AP viewing direction), then noise can be reduced without sacrificing spatial resolution in the viewing direction.

Clinical Applications

Oncologic Imaging

Staging of primary tumors of the chest requires excellent anatomic orientation. For this reason, coronal and sagittal MPR should be routinely reconstructed. This is best done in a standardized fashion by CT technologists. Interactive MPR will only be necessary in complex cases. Such an approach ensures correct assignment of tumors to pulmonary lobes and improves the evaluation of tumor invasion into the mediastinum or chest wall. For vascular encasement and stenoses, MIPs are advantageous.

The search for lung metastases is substantially improved if ~10-mm thick MIPs, rather than axial sections, are evaluated. This is best done interactively at a workstation. Since vessel cross-sections resemble nodules on axial sections, small and central metastases can easily be missed. With MIPs, vessels retain their tubular shape while the contrast with nodules remains intact. Thus, MIPs facilitate the detection of difficult nodules and therefore should be adopted as the standard approach to this imaging task.

In lung cancer screening, MIPs play the same role. For small nodules, growth may be the main criterion to differentiate malignant from benign disease. Three-dimensional measurements by automated segmentation and volumetry are much more reliable than diameter measurements in the determination of growth.

High-Resolution CT

If HRCT is done using volumetric data acquisition rather than (classical) discontinuous scanning, coronal MPRs should be reconstructed on a standard basis by CT technologists. This improves evaluation of the extent of disease and facilitates the comparison of inspirational depth on inspiratory and (low-dose) expiratory scans.

MIPs of ~10-mm thickness improve the differentiation between centrilobular nodules and tree-in-bud sign (Fig. 3) and allow better detection of micronodules in sarcoidosis or pneumoconiosis patients, as well as identification of the initial signs of interstitial lung disease that may be missed on axial sections.

For the identification of mosaic patterns in ground-glass disease, chronic embolism, or air trapping, MinIPs of 5- to 10-mm thickness remove anatomic background (i.e., smaller vessels) and make the detection of density difference much easier. For the detection of discrete density changes, color-coded VRTs applied to analysis of the lung parenchyma (20-30mm thickness) can be very advantageous.

For peripheral bronchiectases, MinIPs (~10-mm thick) well-demonstrate the extent of the disease, and MIPs (also ~10-mm thick) better display small mucous plugs.

Standard Chest CT

Standard chest CT relies on axial sections. Additional coronal or sagittal MPR are useful but not mandatory on a routine basis. However, if interactive evaluation is easily available (e.g., good integration in a PACS workstation), thin-slab MIPs in axial directions should be evaluated in order not to miss small nodules. Sagittal MPRs can be helpful in order to evaluate the vertebral column. When performed on a regular basis, it is surprising how many nodules or vertebral abnormalities would have been missed if they had been evaluated on axial sections only.

Interactive evaluation using MIPs or MPRs can be helpful in patients with more complex pathology: MIPs for the evaluation of vascular structures and discrete parenchymal abnormalities, and MPRs for the assessment of spatial relationships to the chest wall, mediastinum, and lung segments.

Computed Tomography Angiography

CT angiography (CTA) profits most from 3D rendering techniques, even if single-slice scanning has been used.

Aorta

Evaluation of the aorta requires standard reconstruction of coronal and oblique MPRs (Fig. 1) that are adapted to

the position of the aortic arch (very much like the position of parasagittal slabs in magnetic resonance angiography). MIPs play no major role in CT, mainly because VRTs yield superior image quality and retain depth information. In addition, only rough segmentation is needed for VRTs, while MIPs require the removal of all superimposing bony structures. Bone removal for VRTs can be limited to cutting away the sternum and removal of the lateral portions of the chest. Simple cutting functions suffice for this task. The result is a superior demonstration of the aorta from the arch to its descending portion. It is useful for evaluating aneurysms as well as dissections or congenital abnormalities, such as coarctation.

In case of an ECG-gated acquisition, less pulsation artifacts are seen in the ascending aorta and even the evaluation of the (proximal) coronaries may become feasible. Four-dimensional evaluation (MPRs) allows valvular function and dynamic processes, such as obstruction of the true lumen during diastole in acute dissection, to be examined.

Pulmonary CTA

This technique relies on the evaluation of thin axial sections. The first step is to exclude those intraluminal emboli that only obstruct the lumen incompletely. They are usually found in more central locations and are more easily detected than complete occlusions of smaller peripheral vessels. The latter are subject to partial volume effects (even with new multislice scanners) and therefore may have a slightly decreased contrast enhancement. Differentiation from occlusions may therefore be difficult and is facilitated by MIP (Fig. 2). By evaluating MIPs of ~10-mm thickness, both in the axial and coronal plane, it is much easier to differentiate between real occlusions and partial volume effects: for this purpose one has to compare the density of a suspicious vessel with that of a 'normal' vessel of similar size and orientation. If the density is substantially lower, then a peripheral embolus should be suspected.

MPRs can be helpful for differentiating lymph nodes from occluded central vessels but are rarely necessary with thin-section imaging.

MinIPs and color-coded VRTs of the lung parenchyma improve the detection of signs of mosaic perfusion in patients with suspected chronic thrombembolic pulmonary hypertension.

Volume rendering becomes important for examination of pulmonary arteriovenous malformations or congenital abnormalities, such as aberrant veins or pulmonary sequestration (Fig. 4).

Trauma

The evaluation of chest trauma mainly profits from sagittal MPRs of the spine, which in turn facilitates identification of vertebral fractures. For this reason, sagittal (and coronal) reformations should be reconstructed routinely by CT technologists. Coronal reformations may help further classify vertebral fractures and identify sternal fractures.

Parasagittal MPRs are vital for establishing the extent of (and sometimes detecting) aortic tears, which can then be better visualized with VRTs.

MIPs approximately 1 cm in thickness can be helpful in analyzing the extent of severe trauma involving chest contusion in order to identify active contrast extravasation that may otherwise escape detection.

For further evaluation of the data (not a first-line task), coronal curved planar reformations (CPRs) of the sternum or vertebral column can optimize the display of these regions. VRTs can be helpful for visualizing complex fractures but also provide a good overview of fractured ribs.

Conclusions

Modern CT techniques require 3D exploration for optimized use of the available information. Of these, thick MPRs are the most important, but MIPs, MinIPs, and VRTs should be used regularly in clinical practice for imaging tasks as diverse as nodule detection, subtle findings in HRCT, CTA of the aorta and pulmonary arteries, and evaluation of thoracic trauma, to name but a few. This review has discussed the efficient use of these techniques in clinical practice.

Suggested Reading

General

Cody DD (2002) The AAPM/RSNA physics tutorial for residents - topics in CT: image processing. Radiographics 22:1255-1268
Rubin GD, Napel S, Leung AN (1996) Volumetric analysis of volumetric data: achieving a paradigm shift. Radiology 200:312-317
Shin HO, Stamm G (2002) Basic techniques of image processing in cross-sectional imaging [German]. Radiologie Up2date 2:283-303

Multiplanar Reformations

Chooi WK, Matthews S, Bull MJ et al (2003) Multislice helical CT: the value of multiplanar image reconstruction in assessment of the bronchi and small airways disease. Br J Radiol 76:536-540
Eibel R, Brüning R, Schöpf UJ et al (1999) Image analysis in multiplanar spiral CT of the lung with MPR and MIP reconstructions [German]. Der Radiologe 39:952-957

Maximum Intensity Projection

Bhalla M, Naidich DP, McGuinness G et al (1996) Diffuse lung disease: assessment with helical CT - preliminary observations of the role of maximum and minimum intensity projection images. Radiology 200:341-347
Gruden JF, Ouanounou S, Tigges S et al (2002) Incremental benefit of maximum-intensity-projection images on observer detection of small pulmonary nodules revealed by multidetector CT. AJR Am J Roentgenol 179:149-157
Napel S, Rubin GD, Jeffrey RB Jr (1993) STS-MIP: a new reconstruction technique for CT of the chest. J Comput Assist Tomogr 17:832-838

Remy-Jardin M, Remy J, Artaud D et al (1996) Diffuse infiltrative lung disease: clinical value of sliding-thin-slab maximum intensity projection CT scans in the detection of mild micronodular patterns. Radiology 200:333-340

Valencia R, Denecke T, Lehmkuhl L et al (2006) Value of axial and coronal maximum intensity projection (MIP) images in the detection of pulmonary nodules by multislice spiral CT: comparison with axial 1-mm and 5-mm slices. Eur Radiol 16:325-332

Minimum Intensity Projection

Fotheringham T, Chabat F, Hansell DM et al (1999) A comparison of methods for enhancing the detection of areas of decreased attenuation on CT caused by airways disease. J Comput Assist Tomogr 23:385-389

Remy-Jardin M, Remy J, Gosselin B et al (1996) Sliding-thin-slab minimum intensity projection technique in the diagnosis of emphysema: histopathologic-CT correlation. Radiology 200:665-672

Shaded Surface Display

Addis KA, Hopper KD, Iyriboz TA et al (2001) Optimization of shaded surface display for CT angiography. Acad Radiol 8:976-981

Volume Rendering

Calhoun PS, Kuszyk BS, Heath DG et al (1999) Three-dimensional volume rendering of spiral CT data: theory and method. Radiographics 19:745-764

Gluecker T, Lang F, Bessler S et al (2001) 2D and 3D CT imaging correlated to rigid endoscopy in complex laryngo-tracheal stenoses. Eur Radiol 11:50-54

Kuszyk BS, Heath DG, Bliss DF et al (1996) Skeletal 3-D CT: advantages of volume rendering over surface rendering. Skeletal Radiol 25:207-214

Shin HO, Galanski M (2002) Interactive direct volume rendering of CT-data: technical principle and applications [German]. RöFo Fortschr Röntgenstr 174:342-348

Virtual Endoscopy

Hopper KD, Lyriboz TA, Mahraj RPM et al (1998) CT bronchoscopy: optimization of imaging parameters. Radiology 209:872-877

Rogers LF (1998) A day in the court of lexicon: virtual endoscopy. AJR Am J Roentgenol 171:1185

Cardiac and Pericardiac Imaging for the Chest Radiologist

A. de Roos[1], D. Revel[2]

[1] Department of Radiology, Leiden University Medical Center, Leiden, The Netherlands
[2] Department of Radiology, Hopital L. Pradel-Universite Claude-Bernard Lyon 1, Lyon, France

Introduction

A number of imaging techniques are available for evaluating the thorax. Currently, conventional and digital chest radiography, multidetector-row computed tomography (MDCT), and magnetic resonance imaging (MRI) are the most widely used. The particular focus of the chest radiologist is imaging of the lungs, mediastinum, chest wall, and large vessels, with less attention given to the interpretation of cardiac and pericardiac diseases. The purpose of this article is to draw attention to those cardiac/pericardial diseases that can be detected on MDCT and MRI of the chest. A short description of the technology will be provided, followed by a discussion of the normal cardiovascular anatomy and the presentation of case material to illustrate the most common diseases that can be diagnosed.

Description of the Technology

Digital Chest X-ray

Chest radiography is widely used as the first-line examination for evaluating possible heart and pulmonary pathologies. Digital chest systems have been introduced in many hospitals, allowing digital chest radiography to be done using various technical approaches owing to improvements in X-ray detector technology. Digital electronic X-ray detectors can be broadly classified as those based on thin-film transistor (TFT) arrays and those based on the older, charged-coupled device (CCD) design. Accordingly, these two types of electronic X-ray detectors consist of either direct conversion detectors that immediately convert X-ray photons into an electric charge (TFT-based flat-panel systems) or indirect conversion detectors (TFT array or CCD-based). In the latter, a scintillator converts the X-rays into visible light; that is, into an electric charge which is directly read-out by a TFT or CCD detector array. Our institution uses a dedicated digital chest unit based on an indirect conversion detector system employing a multilinear CCD array with slot-scan technology. Slot-scan technology collimates the X-rays into a narrow, horizontally fan-shaped beam that matches the size and shape of the detector. The CCD detector is integrated with a scintillator of thallium-doped cesium iodide to convert the X-rays into visible light (i.e., indirect conversion) that is guided to the CCD by fiber-optic coupling. Full-size chest radiographs (44 _ 44 cm) are thus routinely obtained with high diagnostic quality. It has been concluded that, for most diagnostic applications, 0.2-mm pixel spacing (2.5 lp/mm) is adequate, whereas the current system has a standard resolution of 3.1 lp/mm. Detective quantum efficiency (DQE) is generally accepted as the best single, objective indicator of image fidelity. This measurement combines spatial resolution (i.e., modulation transfer function) and image noise to provide an estimate of the signal-to-noise ratio. DQE values >60% for current digital systems are considered to indicate excellent performance, whereas the values of other systems (e.g., screen-film systems) are <30%.

Multidetector-Row CT

MDCT is currently undergoing rapid technological evolution. The technique has great potential for evaluating chest and heart disease. Our institution currently uses a 64-row MDCT with retrospective segmental reconstruction for cardiovascular imaging. The rapid acquisition time allows breath-hold imaging during peak enhancement of a compact bolus of iodinated contrast material. Shorter acquisition times reduce the total amount of contrast material needed, but require higher rates of iodine administration. Retrospective segmental reconstruction algorithms allow anatomic and functional evaluation of the heart. Cardiac imaging requires estimation of the scan delay time by using a test bolus or automated detection of contrast-material arrival in, for example, the ascending aorta. Non-ionic contrast material containing 400 mg iodine per ml is advocated. The reconstruction window has to be selected for individual coronary arteries in order to optimize image quality.

Improved imaging of aortic dissection and pulmonary embolism is now feasible by using fully isotropic submillimeter acquisitions in a few seconds. Reduction of

the radiation dose is desirable. Recent developments include the use of highly effective detector systems, on-line tube-current modulation, and noise-reduction techniques to lower the radiation dose.

Magnetic Resonance Imaging

The MRI techniques for chest imaging are still evolving. While chest imaging can be performed with the standard body coil, a dedicated phased-array coil is helpful for improving the quality of cardiac images as it allows parallel imaging (SENSE; sensitivity encoding) by using various coil elements. For example, three elements (SENSE-factor=3) speed up the examination three-fold. The improvement in speed can also be traded off for improved spatial resolution. Breath-holding during image acquisition will minimize respiratory motion artefacts. Navigator technology traces the position of the diaphragm and allows chest imaging while the patient breathes freely. Free-breathing navigator MR angiography is commonly used to image the coronary arteries. Motion from the heart itself is 'frozen' via ECG triggering. Previously, the registration of a good ECG for triggering in the MRI was often problematic. However, robust vector-ECG technology is currently available and yields optimal and reliable triggering.

The set-up of a chest MRI study starts with a series of scout views for general orientation and planning of additional acquisitions. Simple transverse image orientation is generally used to visualize the morphology of the chest. Conventional spin-echo images have largely been replaced by new black blood pulse sequences for evaluating the anatomy. A black blood sequence consists of a non-selective 180° pulse to invert the signal, followed by a slice-selective 180° pulse (double-inversion technique). Blood with an inverted signal flows into the slice plane. After a delay time, the blood signal is zero and actual data acquisition is performed with a fast spin-echo pulse train during a breath-hold. Flow artefacts are efficiently suppressed, thereby providing high-quality images with exquisite anatomical detail. Movie loops of the heart can be obtained with gradient-echo pulse sequences. Recently, a major improvement of the image quality of these bright blood techniques has been achieved. Balanced fast-field echo (b-FFE) or true fast imaging with steady-state precession (true-FISP) pulse sequences yields movie loops of consistent and reliable image quality. A very good contrast is seen between the flowing blood (bright) and cardiac walls (dark). Acquisitions are performed during breath-holding. Contraction of the heart, flow, and valvular motion are well-visualized, similar to echocardiography. Slice thickness may be chosen depending on the structures under investigation (mostly 8- to 10-mm slice thickness). Movie loops can be obtained in simple transverse orientation and sometimes in angulated orientations to image the heart (short-axis; long-axis). Flow mapping is an additional MRI pulse sequence for measuring flow in large and medium-sized vessels. Flow can be expressed in ml/s (volume flow) or cm/s (velocity). The technique is a very helpful and reliable approach for measuring flow parameters. Finally, gadolinium-enhanced MR angiography is a widely used and practical technique to study large-vessel disease in the chest and elsewhere in the body. Delayed-enhancement MRI has gained widespread acceptance for infarct imaging and the assessment of viable myocardium. Areas of delayed enhancement after gadolinium administration are also observed in other disease entities such as myocarditis, but commonly have a subepicardial distribution, unlike infarcts.

Description of the Normal Anatomy

Transverse sections obtained with CT or MRI extend from the base of the heart to the cranial portion of the liver to depict the cardiovascular anatomy. In these sections, parts of the normal pericardium are visualized, most consistently anterior to the right ventricle. The normal pericardial thickness is <2 mm, and the low signal intensity/density line of the pericardial layers contrasts well with the surrounding epicardial and pericardial fat. The pericardium is composed of fibrous tissue and some fluid (10-50 ml) within the pericardial sac. The superior pericardial recess extends posterior to the ascending aorta and can be mistaken for a lymph node or dissecting flap. At the base of the heart, the size and spatial relationship of the aorta and pulmonary artery are depicted. The aorta is normally located to the right and posterior to the pulmonary artery or the right ventricular outflow tract. Sometimes the tricuspid nature of the aortic and pulmonary valve can be visualized. The right ventricle is normally located anteriorly and to the right, has a triangular shape, reveals the moderator band as an intracardiac muscular structure, and has a muscular outflow tract (infundibulum). The left ventricle is located posteriorly and to the left, has an elliptical shape, and lacks a moderator band and infundibulum. The atria also have distinct anatomic features. The right atrium is located to the right and has a broad-based triangular appendage. The tricuspid valve, between the right atrium and right ventricle, is located closer to apex than the mitral valve between the left-sided left atrium and left ventricle. The left atrium has a narrow tubular appendage and characteristically receives four pulmonary veins. A number of normal variants should be recognized (e.g., Chiari network in the lateral wall of the right atrium; pericardial recess posterior to the ascending aorta; lipomatous change of atrial septum; thin fossa ovalis). The cardiovascular anatomy can be visualized also with dynamic CT or MRI. In particular, the newer MRI techniques show ventricular function, flow, and valve function in exquisite detail. The normal left ventricle has homogeneous wall thickening during contraction (especially endocardial inward motion should thus be noted). The normal end-diastolic wall thickness is <1 cm (local or diffuse hypertrophy should be noted).

Regional or global function abnormalities are easily recognized by visual inspection of the movie loop. Opening and closing of the valves is well-visualized with current techniques, thereby allowing the diagnosis of stenotic and thickened valve leaflets. The overall size, shape, and spatial relationships of the cardiac compartments and large vessels are well-depicted on transverse CT or MRI images. Recognition of abnormal spatial relationships between vascular structures and other anatomic landmarks (e.g., trachea) is the basis for diagnosing a number of entities, such as vascular ring and pulmonary sling. Finally, knowledge of the normal anatomy of the coronary vessels is required for the recognition of anatomic variations and to localize coronary artery stenosis. CT and MRI are clinically used to diagnose variations in the normal course and origin of the coronary arteries. These imaging techniques mainly visualize the proximal parts of the coronary arteries. The ostium of the right coronary artery (RCA) is located in the right sinus of Valsalva at the level of the aortic ring and courses to the right and anterior between the right atrium and pulmonary outflow tract. The left main coronary artery (LCA) directs to the left between the pulmonary artery and left atrial appendage and then divides into two major branches, namely, the left anterior descending (LAD) and the left circumflex (LCX) arteries. The LAD runs anteriorly in the interventricular sulcus (along the septum) to the apex of the heart, whereas the LCX runs posteriorly in the atrioventricular groove. CT and MRI visualize proximal segments of the RCA, left main LCA, LAD, and, with greater difficulty, the proximal LCX (a deeply lying structure). The spatial relationship between the origin of these coronary vessels, the aortic root, and the pulmonary artery is easily appreciated, allowing the detection of an anomalous course of these vessels. Vascular anomalies and variants may be seen as incidental findings on CT or MRI of the chest.

The Most Common Cardiac/Pericardial Diseases

Pericardial Effusion

Cross-sectional imaging by CT or MRI is very sensitive in the detection of generalized or loculated pericardial effusions. Some fluid in the pericardial sac contributes to the apparent thickness and should be considered normal. Commonly, free-flowing fluid accumulates first at the posterolateral aspect of the left ventricle, when the patient is imaged in the supine position. Estimation of the amount of fluid is possible to a limited extent based on the overall thickness of the crescent of fluid. Compared to cardiac ultrasound, CT and MRI may be particularly helpful in detecting loculated effusions, owing to the wide field of view provided by these techniques. Hemorrhagic effusions can be differentiated from a transudate or an exudate based on signal characteristics (high signal on T1-weighted images) or density (high-density clot on CT). Pulsation artefacts may cause local areas of

low signal in a hemorrhagic effusion. Effusions are often incidentally noted on CT scans obtained for other indications. Pericardial thickening (thickness >4 mm) is difficult to differentiate from a small generalized effusion. Both entities will reveal a low signal/density line that is thicker than the normal pericardial thickness. In acute pericarditis, the pericardial lining can show intermediate signal intensity and may enhance after gadolinium administration.

Constrictive Pericarditis

Pericardial thickening may result in constrictive pericarditis. In this entity, pericardial thickening will hamper cardiac function, with hemodynamic consequences. Many disease conditions can lead to constrictive pericarditis (infection, tumor, radiation, heart surgery, etc.).The diagnostic features include thickened pericardium in conjunction with signs of impaired right ventricular function: dilatation of caval veins and hepatic veins, enlargement of the right atrium, and the right ventricle itself may be normal or even reduced (tubular, sigmoid) in size due to compression. Localized pericardial thickening may also cause functional impairment (localized constrictive pericarditis). Sometimes constriction may occur despite a normal appearance of the pericardium. Pericardial calcifications are easily visualized by CT but may be difficult or impossible to appreciate on MRI.

Pericardial Tumor

A pericardial cyst is most commonly located at the right cardiophrenic angle. On T1, it appears either as a low signal or an intermediate signal due to high protein content, or with a characteristic light-bulb appearance on T2. Unusual tumors may arise from the pericardium (mesothelioma, angiosarcoma, etc.). Malignant primary tumors have many overlapping imaging features and generally cannot be differentiated. The role of cross-sectional imaging is to establish a diagnosis and to define the extent of the lesion (invasion of cardiac structures, veins, pericardium, etc.). Sometimes lesions may have helpful signal characteristics to suggest a specific diagnosis, e.g., high-signal fat on T1 or low-density fat on CT in lipoma/liposarcoma. Secondary tumors are much more common than primary tumors. Lung cancer may invade the mediastinal and cardiac structures directly or indirectly. The most common secondary tumors affecting the heart are lung cancer, breast cancer, and lymphoma. Metastatic pericardial disease commonly presents as hemorrhagic effusion. Tumor nodules may enhance after intravenous gadolinium administration.

Intracardiac Masses

Myxomas comprise up to 50% of all primary cardiac tumors and may first be identified by cardiac ultrasound in patients referred for suspected cardiac embolism or as an

incidental finding on cross-sectional imaging. Myxomas mostly originate from the left atrium, although they may arise from the right atrium or even from the ventricle. Variations in the histological structure (myxoid matrix, areas of hemorrhage, cysts and calcifications, thrombotic material) can affect the appearance of myxomas on CT or MRI. They are generally polypoid, often pedunculated, smooth-appearing lesions of variable size. Dynamic MRI reveals their mobility. Signal characteristics are variable (generally, intermediate on T1 spin-echo MRI and low-signal on gradient-echo MRI due to hemorrhage or calcifications). Contrast uptake may be demonstrated after gadolinium administration due to the vascularity of the lesion. A cardiac thrombus can have similar and overlapping imaging features, although the location is most commonly the left atrial appendage or left ventricle adjacent to an infarcted region. Other differentiating features are the high signal of fresh thrombus (methemoglobin) on T1-weighted spin-echo MRI, the very low signal intensity of a thrombus using gradient-echo MRI (susceptibility effect), and the usual lack of contrast enhancement after gadolinium administration.

Cardiac lipoma is a frequently occurring benign tumor of the heart but it may become quite large and thereby compromise cardiac function. The lesion may arise from the myocardium itself, with the interatrial septum being a preferred location. Typical high signal on T1-weighted spin-echo MRI is helpful for making the diagnosis. There is a lack of contrast enhancement. Lipoma and liposarcoma are usually difficult to differentiate.

Aortic Disease

Evaluation of the aorta is a common referral for CT or MRI after initial assessment with other techniques (chest radiography, ultrasound, etc.). Furthermore, aneurysms and other chronic diseases of the aorta are often incidentally noted on cross-sectional imaging. Thoracic aortic aneurysms are common (found in 10% of autopsies) and are frequently associated with atherosclerosis. Aortic atherosclerosis is considered to be the origin for thromboemboli in many patients presenting with stroke; therefore, the recognition of aortic wall disease may have important clinical implications. Treatment of thoracic aortic aneurysms depends on size, anatomy, growth rate, the presence of complications, underlying cause, and involvement of adjacent structures such as the aortic valve. MDCT and MRI are both well-suited to image aortic disease and its complications. The method selected will depend on the availability of the scanner, speed and ease of the examination, costs, and local expertise and preferences. Initial diagnosis of aortic dissection is commonly performed by MDCT. First and foremost, the exam must confirm or refute the diagnosis of dissection. Second, the study must determine whether or not the dissection involves the ascending aorta (type A is an indication for surgery). The speed and ease of image acquisition make MDCT an attractive first-line modality. In this regard, it may also be preferred in patients with acute chest pain

and in trauma patients (diagnosis of aortic rupture). In acute chest pain, MDCT is currently the preferred approach to diagnose pulmonary embolism. Other common causes for acute chest pain may become evident on cross-sectional imaging (pneumonia, pericarditis, dissection, chest wall disease, etc.). MRI may be reserved for follow-up of aortic disease in stable patients. Dynamic MRI permits the detection and quantification of aortic valvular insufficiency by demonstrating flow across the aortic valve. Although coronary involvement may be useful information before surgery for dissection, it is not routinely obtained due to the invasiveness of coronary X-ray angiography. Possibly, coronary MR angiography can provide this additional information in the near future.

An important differential diagnosis of aortic dissection is intramural hematoma (IMH), which presents with a similar clinical picture and risk profile as classical dissection. IMH is probably a variant of aortic dissection and not a separate disease. Rupture of the aortic vasa vasorum may initiate the process of hemorrhage within the aortic wall ('dissection without intimal flap'). Cross-sectional imaging techniques (ultrasound, MDCT, MRI) are better-suited to diagnose IMH than angiographic approaches (X-ray, MR angiography, CT angiography) due to the lack of intraluminal abnormalities. Aortic ulcers occur in the presence of aortic atherosclerosis and clinically may mimic subacute dissection or IMH. Neither the prognosis nor the outcome has been defined. Penetrating aortic ulcers have a predilection for the descending and abdominal aorta. Cross-sectional imaging may reveal a localized ulcer within the aortic wall, sometimes with adjacent intramural hemorrhage.

Marfan syndrome, an inherited connective tissue disease that results from mutations in genes coding for fibrillin, commonly affects the aorta. Cardiovascular involvement decreases life expectancy, primarily from progressive aortic root dilatation (typical pear shape of the aortic root) and consequent aortic insufficiency, dissection, and aortic rupture. MRI of the lumbar spine may add a major diagnostic criterion to establish the diagnosis of Marfan syndrome by demonstrating dural ectasia. A number of congenital malformations of the aorta are also regularly referred for imaging (coarctation, vascular ring, variants of anatomy, etc.). Pseudocoarctation can present as an abnormal aortic contour on chest radiography and may require further evaluation. CT and MRI are regularly requested to differentiate solid tumors from vascular lesions, which may present with unusual appearances on routine chest radiography.

A number of MRI techniques are currently used for the evaluation of ischemic heart disease. These may be applied also for general chest imaging, incidentally revealing cardiac pathology. Black-blood MRI is usually applied for morphological imaging of the chest. Similar to CT images, cardiac and mediastinal disease may be diagnosed. Images may be obtained after gadolinium administration and may incidentally reveal enhancing lesions within the heart. For example, myocardial infarction or

myocardial scar will be seen as a bright region within the myocardium after gadolinium administration ('delayed hyperenhancement'). Balanced fast-field echo imaging is now routinely used to visualize vascular and cardiac structures. These images are displayed as movie loops in an echocardiographic format and reveal anatomy as well as function. For example, depressed left ventricular function is easily observed in patients with cardiomyopathy or after multiple infarcts. Also, regional myocardial dysfunction due to infarction, ischemia, scar, or aneurysm formation is visualized. Thrombus within the atrium or ventricle is recognized as a dark structure within the heart. MDCT is now also used to evaluate cardiac function. The CT information can also be displayed as a movie loop, so that functional abnormalities can be recognized. MDCT and MRI are both used for coronary artery imaging. Recognition of the normal coronary artery anatomy is therefore part of the CT or MR examination. Incidental findings, an abnormal course of a vessel or structure, or unusual spatial arrangements can be seen. CT images regularly show localized or diffuse coronary calcifications, which are a sign of atherosclerosis. Finally, valve motion and thickness should be noted on cine-MRI. Thickening of the aortic valve leaflets due to calcifications are easily visualized. In patients with stenotic or regurgitant valves, the abnormal flow across the valve can be appreciated using cine MRI. Valve calcifications are well-depicted on CT imaging.

Miscellaneous

After initial evaluation of the patient by echocardiography, regularly further cross-sectional imaging by CT or MRI is requested to solve any remaining problems. Unusual pathology may be diagnosed or excluded by CT or MR imaging. For example, Ebstein's disease of the tricuspid valve is well-recognized on cine MRI, whereas the diagnosis may be difficult to establish with echocardiography. Postsurgical complications (e.g., retained surgical material, hemorrhage, fistulas, pseudoaneurysm, conduits) are also commonly referred for cross-sectional imaging. Sometimes it is difficult to differentiate solid from vascular structures based on chest radiography or echocardiography, and CT and MRI may therefore be indicated. In conclusion, cross-sectional CT or MR imaging is commonly requested for problem solving of suspected cardiovascular chest abnormalities.

Suggested Reading

Chotas HG, Dobbins JT, Ravin CE (1999) Principles of digital radiography with large-area, electronically readable detectors: a review of the basics. Radiology 210:595-599

Higgins CB, De Roos A (2003) Cardiovascular MRI and MRA. Lippincott Williams & Wilkins, Philadelphia

Ohnesorge BM, Becker CR, Flohr TG, Reiser MF (2001) Multislice CT in cardiac imaging. Springer-Verlag, Berlin - Heidelberg - New York

Applications of Magnetic Resonance Imaging in Cardiac Disease

M.Y. Desai[1], D.A. Bluemke[2]

[1] Division of Cardiology, Department of Medicine, Cleveland Clinic, Cleveland, OH, USA
[2] Russell H. Morgan Department of Radiology and Radiological Sciences, Johns Hopkins University, Baltimore, MD, USA

Introduction

Magnetic resonance (MR) imaging is widely recognized as providung an accurate and reliable means of assessing the function and anatomy of the heart and great vessels. Previously, the means to obtain images of the cardiovascular system were compromised by extremely long examination times and software that was available only at specialized centers. With the recent development of specialized cardiovascular MR scanners, cardiac MR applications have become more widely used on a routine basis. In this article, the technical aspects of MR scanning of the cardiovascular system are outlined, followed by a discussion of its applications to the heart and aorta.

Understanding the Basic Pulse Sequences

It is extremely helpful to understand the strategy behind the MR pulse sequence being used. This allows the radiologist to determine the length of time for the acquisition and the corresponding imaging strategy to be employed. A fundamental characteristic of all pulse sequences is that the image is generated in the frequency domain, also referred to as 'k-space.' Fourier reconstruction is then employed to generate the image. The 'k-space' representation of the image is a pixel array that is generated one line at a time, and typically 128-256 lines must be generated. Traditionally, each line of the image required one heart beat to acquire, thus imaging times were relatively long. For example, if 256 lines were generated, 256 heart beats at 60 beats per min required 256/60=4.3 min. An improvement in imaging speed by a factor of 4-64 times or more is now commonplace. The most useful pulse sequences are briefly explained below.

Spin-Echo Imaging

Spin-echo images are the fundamental MR pulse sequences used to evaluate the cardiovascular system. As in all other parts of the body, a complete examination consists of T1- and T2-weighted images. T1 images clearly display the anatomy, while T2 images accentuate pathologic changes, such as edema from infarction or the relationship of a tumor to the pericardium. Advantages of spin echo are excellent signal-to-noise ratio (SNR) as well as excellent contrast between the heart, epicardial fat, and adjacent structures. The primary disadvantage is that these are very time-consuming sequences. As in the example discussed above, they require between 128 and 256 heart beats or more to acquire, depending on the desired resolution. Blood is typically made to appear dark ('black blood' images) and no cine information is obtained. Despite these drawbacks, echo images remain important for: (1) imaging of congenital anomalies, (2) pericardium evaluation, (3) assessment of right ventricular dysplasia, and (4) identification of cardiac tumors.

Fast/Turbo Spin-Echo Imaging

Fast, or turbo, spin-echo imaging reduces acquisition times by an acceleration factor typically ranging from 16 to 32. Parallel imaging can further accelerate speed by a factor of two to three. Essentially all spin-echo images of the cardiovascular system are now acquired with fast/turbo spin echo imaging, usually during a breath-hold.

Cine-Gradient Echo Imaging

Cine-gradient echo images are used to evaluate motion gated to the cardiac cycle. Information from 4-12 cardiac cycles is used in order to obtain cine information during the entire cardiac cycle. This is termed 'segmented k-space cine' MR imaging. Older MR scanners use so-called conventional gradient-echo pulse sequences in combination with 'gradient moment nulling,' or 'flow compensation' to make blood appear bright ('bright-blood images'). In nearly all new MR scanners, however, 'steady-state free precession' (SSFP, also known as TrueFISP, Fiesta, balanced fast-field echo) images are used with segmented k-space acquisition. SSFP images are acquired very rapidly, and the blood is of very high signal intensity compared to the ventricular wall. Due to the large amount of signal available, the

SSFP technique is often combined with parallel imaging. The latter improves imaging speed by a factor of two to three.

The different and emerging clinical applications of cardiac MR imaging are described below.

Assessment of Ventricular Function

Ejection fraction and ventricular volumes can be measured in three dimensions accurately, noninvasively, and with high reproducibility using MR imaging. For this reason, it has become the 'gold standard' to which other modalities are compared [1]. Simpson's rule is applied to determine the ejection fraction and volumes. For assessment of volumes and mass, bright-blood gradient-echo sequences are most often obtained, with 10-30 phases per cardiac cycle. Breath-holding techniques with acquisition times of about 6-12 s are preferred in order to reduce blurring of the endocardial border. Generally, for accurate measurement of volume and mass, entire coverage of the left ventricle with short-axis views from the mitral plane are recommended. Slice thickness should not exceed 10 mm; in the presence of subtle changes, the thickness should be reduced appropriately. MR imaging is the method of choice for longitudinal follow-up in patients undergoing therapeutic interventions [2]. From a research perspective, the sample size needed to detect left ventricular parameter changes in a clinical trial is far less, in the range of one order of magnitude, with MR imaging than with 2D echocardiography, which markedly reduces the time and cost of patient care and pharmaceutical trials [3].

A unique MR technique called myocardial tagging (SPAMM technique) has been developed. It labels the heart muscle with a dark grid and enables 3D analysis of cardiac rotation, strain, displacement, and deformation of different myocardial layers during the cardiac cycle (Fig. 1). This helps in assessing regional wall motion of the myocardium [4, 5].

Assessment of Cardiomyopathies

Magnetic resonance imaging is a noninvasive tool that has a high degree of accuracy and reproducibility in the visualization of left and right ventricular morphology and function [6]. It is also superior to echocardiography in the determination of ventricular mass and volumes [3, 7] and is fast becoming the method of choice for in vivo identification of the phenotype of cardiomyopathies [1].

Dilated Cardiomyopathy

In dilated cardiomyopathy (DCM), MR imaging is useful in the study of ventricular morphology and function (Fig. 2). Gradient-echo sequences are obtained, as these have low inter- and intra-observer variability with respect to the determination of left ventricular mass and volumes [6]. MR imaging is also employed in the analysis of wall thickening [8], impaired fiber shortening [9], and end-systolic wall stress, which is a very sensitive parameter of a change in left ventricular systolic function [10]. This approach can accurately assess the morphology and function of the right ventricle, which is also frequently affected in DCM [11]. MR spectroscopy has been used to reveal changes in phosphate metabolism in DCM [12]. A ratio of phosphocreatine to adenosine triphosphate has some prognostic value in assessing the disease.

Contrast-enhanced T1-weighted images are also helpful in detecting changes characteristic of acute myocarditis. The increased gadolinium accumulation is thought to be due to inflammatory-hyperemia-related increased flow, slow wash-in/wash-out kinetics, and diffusion into necrotic cells. There is some evidence of similar changes in chronic DCM [13]. Contrast-enhanced MR imaging

Fig. 2. Bright-blood image showing a dilated, thin left ventricle (*LV*) due to a large anterior-wall infarct, with a mural thrombus adjacent to the infarcted myocardium (*arrows*)

Fig. 1. Cardiac magnetic resonance tagging. Magnetic strips are placed in the heart and then followed throughout the cardiac cycle in order to measure regional contraction of different portions of the heart

increases the sensitivity of endomyocardial biopsy by allowing visualization of inflamed areas, which aids in determining the biopsy site [14].

Hypertrophic Cardiomyopathy

Due to its high accuracy, MR imaging is becoming the preferred method to assess morphology, function, tissue characterization, and degree of left ventricular outflow tract (LVOT) obstruction in patients with hypertrophic cardiomyopathy (HCM) (Fig. 3). It is also very accurate in assessing left ventricular mass, regional hypertrophy patterns, and different phenotypes of the disease (e.g., apical HCM) [7]. Post-surgical changes after myomectomy can also be reliably monitored [15]. The turbulent jet during systolic LVOT obstruction is also easily detected with suitable echo times (about 4 ms). MR imaging reveals the systolic anterior motion of the mitral valve in the four-chamber view or with a short-axis view at the valvular plane [16]. Mitral regurgitation can also be well-documented and quantified by MR techniques [17]. MR spectroscopy reveals changes in phosphate metabolism in patients with HCM [18]. Also in these patients, MR analysis of blood flow in the coronary sinus can indicate alterations in coronary flow reserve [19]. A relatively newer technique is to measure the effective LVOT area by MR planimetry during systole. This method has the potential to overcome the problem of interstudy variability of the LVOT gradient due to its independence from the hemodynamic status [20]. There are preliminary data that MR assessment of diastolic function may be superior to conventional echocardiography parameters. Analysis of the early untwisting motion of the myocardium may aid in assessing diastolic function [21]. Other functional changes can be evaluated by myocardial tagging; these

include a reduction in posterior rotation, reduced radial displacement of the inferoseptal myocardium, and reduced 3-D myocardial shortening and heterogeneity of regional function [17]. MR imaging allows the follow-up of patients who have undergone surgical or pharmacologic interventions [16], and easily detects acute and chronic changes after septal artery ablation [22].

Arrhythmogenic Right Ventricular Dysplasia

Arrhythmogenic right ventricular dysplasia (ARVD) is a rare disorder in which there is fibrofatty replacement of the right ventricular free wall. MR imaging is rapidly becoming the diagnostic technique of choice for ARVD (Fig. 4), as it allows visualization of the ventricular cavities and walls, with excellent depiction of the myocardial anatomy. T1-weighted spin-echo images reveal fatty infiltration, thinned walls, and dysplastic trabecular structures. Axial and short-axis views are usually recommended for optimal results [17]. Standard gradient-echo images reveal characteristic regional changes in wall motion, localized early-diastolic bulging, wall thinning, and saccular aneurysmal out-pouchings [23, 24]. However, MRI is not as specific as endomyocardial biopsy in the detection of myocardial fat [25], although biopsy may be falsely negative. Currently, the working group classification proposed by Mckenna et al. is the recognized standard to arrive at a diagnosis of ARVD [26].

Restrictive Cardiomyopathy

Primary infiltration of the myocardium by fibrosis or other tissues leads to the development of restrictive cardiomyopathy, which is characterized by normal left ventricular size and systolic function, severe diastolic dys-

Fig. 3. Long-axis view of the heart (black-blood image) shows a severely thickened left ventricular wall due to hypertrophic cardiomyopathy (*arrows*)

Fig. 4. Axial black-blood image of the heart showing enlargement of the right ventricle (*RV*) as well as increased (similar to fat) signal in the RV free wall (*arrow*), consistent with fatty deposits compatible with arrhythmogenic RV dysplasia. *LV*, Left ventricle

function, and biatrial enlargement. This condition needs to be differentiated from constrictive pericarditis, which is a primary disease of the pericardium rather than the myocardium. Left ventricular size and thickness are quantified using gradient-echo sequences. Atrial enlargement is assessed in a four-chamber view. The potential presence of mitral regurgitation should also be examined.

The following different restrictive diseases can be effectively evaluated using MR imaging [17].

Sarcoidosis

The incidence of myocardial involvement in systemic sarcoidosis is 20-30%, and up to 50% [27] of the deaths in sarcoidosis may be due to cardiac involvement. MR imaging is a useful tool in the assessment of this disease. Sarcoid lesions may lead to different signal intensities, most likely due to different disease stages. In some instances, high-intensity areas in T2-weighted images have been reported, while in others a central low-intensity area surrounded by a high signal ring on T1- and T2-weighted imaging has been described [28]. Gadolinium has also been reported to accumulate in sarcoid lesions and is thought to be due to fibrotic non-active granulomatous nodules and the inflammatory response of the surrounding tissue [29]. Thus, T2-weighted imaging followed by T1-weighted spin-echo techniques in short- and long-axis views with and without gadolinium could be useful to detect and/or exclude sarcoid granulomas. Occasionally, MR imaging can be useful in guiding endomyocardial biopsy to evaluate sarcoidosis [17].

Hemochromatosis

Extensive iron deposits leading to wall thickening, ventricular dilatation, congestive heart failure, and death characterize cardiac hemochromatosis. Usually, the iron deposits are subepicardial; hence, endomyocardial biopsy may fail to confirm the diagnosis [17]. However, due to the very strong paramagnetic properties of iron, MR imaging can be used to detect iron deposits. MR images of this disease show extensive signal loss in native T1- and T2-weighted images [30]. The pattern of focal signal loss in a dysfunctional myocardium associated with an abnormally 'dark' liver might be sufficient to confirm the diagnosis of systemic hemochromatosis. Left ventricular function in patients with cardiac hemochromatosis can be accurately assessed by MR techniques, which are also useful in the follow-up of patients receiving intensified medical therapy [17].

Amyloidosis

Infiltration of the heart by amyloid deposits is found in almost all patients with primary amyloidosis and in 25% of patients with familial amyloidosis. MR imaging can be useful in the detection of amyloidosis and its differentiation from HCM. A thickness of the atrial septum or right atrial posterior wall >6 mm is fairly specific for amyloid infiltration and consistent with previously published echocardiographic data [31]. Tissue characterization in cardiac amyloidosis has not been well-studied. However, one study reported a decrease in the signal intensity of the amyloid-infiltrated myocardium compared to the reference tissue [31]. The mechanism underlying this hypointensity is uncertain, but is likely due to abnormal interstitium and fibrosis.

Assessment of Myocardial Viability

The concept of myocardial viability is of great significance in patients with ischemic heart disease, in terms of achieving the maximum benefit from revascularization [32]. Revascularization improves the function of viable myocardium, but not of myocardium that has been replaced by fibrous scar. It is therefore imperative to distinguish between scar and viable myocardium. Contrast-enhanced MR imaging is coming of age in terms of its ability to accurately predict myocardial viability. Two enhancement patterns have been described. The first is seen on first-pass perfusion images and consists of an area of hypoenhancement within the infarcted region, which has been found to correlate with microvascular obstruction and is related to 'no reflow' inside the infarct zone [33]. The second can be observed 10-30 min after contrast injection (delayed hyperenhancement, DHE) and is depicted with a breath-hold inversion-recovery gradient-echo sequence (Fig. 5). This pattern of DHE, seen after acute as well as chronic myocardial infarction, reflects nonviable, infarcted tissue and fibrosis, respectively. In patients with a chronic myocardial infarction, DHE can accurately locate and determine the extent and transmurality of the infarct [33-35]. Thus, because of its high spatial resolution, high reproducibility, and predictive value, MRI is fast becoming the reference standard for the assessment of myocardial viability. Further development of necrosis-specific contrast agents and refinement of MR spectroscopy to assess regional chemistry and metabolism will enhance the utility of this imaging strategy.

Fig. 5. Delayed gadolinium short-axis image of the heart in a patient with a prior myocardial infarction. The bright high-signal portion of the anterior and anterolateral wall (*arrows*) of the left ventricle is the area of prior infarction

Assessment of Pericardial Disease

Evaluation of the pericardium is ideally suited to MR imaging (Fig. 6). T1-weighted spin-echo imaging demonstrates normal pericardium as a thin band (<2 mm) of low signal, bordered by epicaridal and pericardial fat, which have a high signal. Since pericardial thickness varies at different levels, it is generally recommended to measure the thickness in axial images at the level of the right atrium, right ventricle, and left ventricle. A thickness of >4 mm is considered abnormal and suggestive of fibrous pericarditis, either acute or chronic (due to surgery, uremia, tumor, infection or connective tissue disease) [36]. Contrast-enhanced MR imaging may help to better delineate the pericardium in patients with effusive-constrictive pericarditis [37]. Breath-hold or real-time cine-gradient-echo images of the ventricles and phase-velocity mapping of the cardiac valves may aid in assessing the significance of pericardial pathology. These techniques are also useful in detecting other disorders, such as congenital absence of pericardium, pericardial cysts, or pericardial effusion undetected by other modalities.

Evaluation of Cardiac and Paracardiac Masses

Primary cardiac tumors are rare (0.002-0.3% incidence), and the majority (75%) are benign. Metastatic tumors are 20- to 40-fold more common than primary tumors. MR imaging is excellent for delineating the morphologic details of a mass, including extent, origin, hemorrhage, vascularity, calcification, and effects on adjacent structures.

Fig. 7. Black-blood image of the heart in a long-axis view shows a mass (*arrow*) posterior to the right atrium (*RA*) that was subsequently diagnosed as lipoma. *LV*, Left ventricle; *RV*, right ventricle; *DA*, descending aorta

Protocols include the combined use of axial black-blood sequences and axial bright-blood cine images. Functional MR images are useful to study the pathophysiologic consequences of the mass.

Specifically, benign myxomas (the most common cardiac tumor) appear brighter than myocardium on T2 weighting, and cine images may reveal the characteristic mobility of the pedunculated tumor. Lipomas (Fig. 7) are brighter on spin-echo T1-weighted images and the diagnosis is verified by a decrease in signal intensity using a fat-suppression technique.

Evaluation of Congenital Heart Disease

Due to its unparalleled resolution and 3D imaging capacity, MR imaging plays an important role in diagnosing and serially following patients with various congenital heart diseases, complementary to echocardiography. It is a very good tool for identifying and sizing atrial and ventricular septal defects. Phase-velocity mapping at the level of the shunt also allows calculation of the shunt fraction (Qp/Qs ratio). The different imaging sequences, including MR angiography, facilitate the diagnosis of lesions such as anomalous pulmonary venous return, transposition of the great vessels, aortic rings, truncus arteriosus, double-outlet right ventricle, tetralogy of Fallot, pulmonary atresia, and pulmonary artery stenosis. They can also be used to follow these patients for effects and complications after corrective surgery. Venous anomalies, such as persistent superior vena cava and interruption of the inferior vena cava with azygos continuation, can be diagnosed with MR angiography.

Fig. 6. Black-blood image of the heart in long-axis view shows a thickened pericardium (*arrows*). *LV*, Left ventricle; *RV*, right ventricle; *DA*, descending aorta. Pericardial thickening ≥4 mm is abnormal and indicative of constrictive pericarditis

Evaluation of Valvular Diseases

Echocardiography with color Doppler is usually the first-line imaging modality for diagnosing valvular diseases. MR imaging is generally reserved for use when other modalities fail or provide suboptimal information. Double-inversion recovery sequences can show valve morphology and evidence of secondary changes, such as chamber dilatation, myocardial hypertrophy, post-stenotic changes in the great vessels, and thrombus in any of the chambers. Semi-quantitative assessment of valvular stenosis or regurgitation can be obtained by measuring the area of signal void on gradient-echo images. The duration or extent of the signal void correlates with the severity of aortic stenosis, and the total area of signal loss correlates with the severity of mitral regurgitation. This technique has a very high sensitivity (98%), specificity (95%), and accuracy (97%) for diagnosing aortic and mitral regurgitation. The signal void, however, is dependent upon certain scan parameters, such as echo time, voxel size, and image orientation relative to flow jet. Phase-contrast MR allows the severity of valvular stenosis to be assessed (by measuring the peak jet velocity) by calculating the valve orifice area and transvalvular pressure gradient.

Evaluation of Myocardial Perfusion and Ischemia

Magnetic resonance imaging is emerging as a reliable and useful tool in the assessment of regional left ventricular perfusion. Currently, it relies upon monitoring the first pass of contrast agents. After rapid injection of intravenous contrast material, there is marked signal enhancement first in the right ventricular cavity, then in the left ventricular cavity, and then in the left ventricular myocardium. This is completed within 20-30 s and involves a prolonged breath hold. Gradient-echo sequences have been used for single-slice (mid-cavity, short-axis) perfusion MR imaging in humans [38]. Recently, echo planar techniques have been employed for ultrafast multislice MR imaging. The peak signal intensity is related to the concentration of the contrast agent in the local tissue and is directly proportional to the coronary blood flow. Perfusion MR at rest and after infusion of pharmacologic agents (adenosine and persantine) has been compared to standard methods (angiography or radionuclide scintigraphy) and demonstrated reasonable sensitivity (67-83%) and specificity (75-100%). Additionally, the assessment of wall motion further improved the performance of MR imaging.

Coronary Artery Imaging

Imaging of the coronary arteries using MR still remains a very challenging proposition and is thus predominantly relegated to research centers. In patients with left-main or three-vessel disease, MR has a sensitivity of 100%, specificity of 85%, and accuracy of 87% for the diagnosis of coronary artery disease [39]. The drawback of current MR technology is its inability to visualize smaller distal vessels [39]. However, with the development of more sophisticated sequences, better contrast agents, routine non-invasive MR coronary angiography might soon become a reality.

Nonetheless, the role of MR imaging in assessing for an anomalous origin and course of a coronary artery is well-established. MR techniques have shown excellent results in the definition and identification (93-100% cases) of anomalous coronary arteries. Also, MR imaging can aid in classifying cases that could not be classified with other diagnostic methods or that were misclassified by conventional angiography [40].

Conclusions

Magnetic resonance imaging is the newest, most complex and rapidly emerging non-invasive test of choice for patients with a multitude of cardiovascular problems. Its role in becoming the dominant imaging modality in every facet of cardiology cannot be understated. At the same time, this technique is entering an important phase in its evolution, with an anticipated exponential growth in its current applications and the development of new ones.

References

1. Task Force of the European Society of Cardiology, in collaboration with the Association of European Pediatric Cardiologists (1998) The clinical role of magnetic resonance in cardiovascular disease. Eur Heart J 19:19-39
2. Doherty NE 3rd, Seelos KC, Suzuki J et al (1992) Application of cine nuclear magnetic resonance imaging for sequential evaluation of response to angiotensin-converting enzyme inhibitor therapy in dilated cardiomyopathy. J Am Coll Cardiol 19:1294-1302
3. Semelka RC, Tomei E, Wagner S et al (1990) Normal left ventricular dimensions and function: interstudy reproducibility of measurements with cine MR imaging. Radiology 174(3 Pt 1):763-768
4. Reichek N (1999) MRI myocardial tagging. J Magn Reson Imaging 10:609-616
5. Bogaert J, Bosmans H, Maes A et al (2000) Remote myocardial dysfunction after acute anterior myocardial infarction: impact of left ventricular shape on regional function: a magnetic resonance myocardial tagging study. J Am Coll Cardiol 35:1525-1534
6. Benjelloun H, Cranney GB, Kirk KA et al (1991) Interstudy reproducibility of biplane cine nuclear magnetic resonance measurements of left ventricular function. Am J Cardiol 67:1413-1420
7. Bottini PB, Carr AA, Prisant LM et al (1995) Magnetic resonance imaging compared to echocardiography to assess left ventricular mass in the hypertensive patient. Am J Hypertens 8:221-228
8. Kasper EK, Agema WR, Hutchins GM et al (1994) The causes of dilated cardiomyopathy: a clinicopathologic review of 673 consecutive patients. J Am Coll Cardiol 23:586-590

9. MacGowan GA, Shapiro EP, Azhari H et al (1997) Noninvasive measurement of shortening in the fiber and cross-fiber directions in the normal human left ventricle and in idiopathic dilated cardiomyopathy. Circulation 96:535-541

10. Fujita N, Duerinekx AJ, Higgins CB (1993) Variation in left ventricular regional wall stress with cine magnetic resonance imaging: normal subjects versus dilated cardiomyopathy. Am Heart J 125(5 Pt 1):1337-1345

11. Sechtem U, Pflugfelder PW, Gould RG et al (1987) Measurement of right and left ventricular volumes in healthy individuals with cine MR imaging. Radiology 163:697-702

12. Neubauer S, Krahe T, Schindler R et al (1992) 31P magnetic resonance spectroscopy in dilated cardiomyopathy and coronary artery disease. Altered cardiac high-energy phosphate metabolism in heart failure. Circulation 86:1810-1818

13. Friedrich MG, Strohm O, Schulz-Menger J et al (1998) Contrast media-enhanced magnetic resonance imaging visualizes myocardial changes in the course of viral myocarditis. Circulation 97:1802-1809

14. Bellotti G, Bocchi EA, de Moraes AV et al (1996) In vivo detection of Trypanosoma cruzi antigens in hearts of patients with chronic Chagas' heart disease. Am Heart J 131:301-307

15. Franke A, Schondube FA, Kuhl HP et al (1998) Quantitative assessment of the operative results after extended myectomy and surgical reconstruction of the subvalvular mitral apparatus in hypertrophic obstructive cardiomyopathy using dynamic three-dimensional transesophageal echocardiography. J Am Coll Cardiol 31:1641-1649

16. White RD, Obuchowski NA, Gunawardena S et al (1996) Left ventricular outflow tract obstruction in hypertrophic cardiomyopathy: presurgical and postsurgical evaluation by computed tomography magnetic resonance imaging. Am J Card Imaging 10:1-13

17. Friedrich MG (2000) Magnetic resonance imaging in cardiomyopathies. J Cardiovasc Magn Reson 2:67-82

18. Jung WI, Sieverding L, Breuer J (1998) 31P NMR spectroscopy detects metabolic abnormalities in asymptomatic patients with hypertrophic cardiomyopathy. Circulation 97:2536-2542

19. Kawada N, Sakuma H, Yamakado T et al (1999) Hypertrophic cardiomyopathy: MR measurement of coronary blood flow and vasodilator flow reserve in patients and healthy subjects. Radiology 211:129-135

20. Schulz-Menger J, Strohm O, Waigand J et al (2000) The value of magnetic resonance imaging of the left ventricular outflow tract in patients with hypertrophic obstructive cardiomyopathy after septal artery embolization. Circulation 101:1764-1766

21. Stuber M, Scheidegger MB, Fischer SE et al (1999) Alterations in the local myocardial motion pattern in patients suffering from pressure overload due to aortic stenosis. Circulation 100:361-368

22. Suzuki J, Shimamoto R, Nishikawa J et al (1999) Morphological onset and early diagnosis in apical hypertrophic cardiomyopathy: a long term analysis with nuclear magnetic resonance imaging. J Am Coll Cardiol 33:146-151

23. Blake LM, Scheinman MM, Higgins CB (1994) MR features of arrhythmogenic right ventricular dysplasia. AJR Am J Roentgenol 162:809-812

24. Ricci C, Longo R, Pagnan L et al (1992) Magnetic resonance imaging in right ventricular dysplasia. Am J Cardiol 70:1589-1595

25. Menghetti L, Basso C, Nava A et al (1996) Spin-echo nuclear magnetic resonance for tissue characterization in arrhythmogenic right ventricular cardiomyopathy. Heart 76:467-470

26. Corrado D, Fontaine G, Marcus FI et al (2000) Arrhythmogenic right ventricular dysplasia/cardiomyopathy: need for an international registry. Study Group on Arrhythmogenic Right Ventricular Dysplasia/Cardiomyopathy of the Working Groups on Myocardial and Pericardial Disease and Arrhythmias of the European Society of Cardiology and of the Scientific Council on Cardiomyopathies of the World Heart Federation. Circulation 101:E101-E6

27. Flora GS, Sharma OP (1989) Myocardial sarcoidosis: a review. Sarcoidosis 6:97-106

28. Otake S, Banno T, Ohba S et al (1990) Muscular sarcoidosis: findings at MR imaging. Radiology 176:145-148

29. Seltzer S, Mark AS, Atlas SW (1991) CNS sarcoidosis: evaluation with contrast-enhanced MR imaging. AJNR Am J Neuroradiol 12:1227-1233

30. Siegelman ES, Mitchell DG, Semelka RC (1996) Abdominal iron deposition: metabolism, MR findings, and clinical importance. Radiology 199:13-22

31. Fattori R, Rocchi G, Celletti F et al (1998) Contribution of magnetic resonance imaging in the differential diagnosis of cardiac amyloidosis and symmetric hypertrophic cardiomyopathy. Am Heart J 136:824-830

32. Senior R, Kaul S, Lahiri A (1999) Myocardial viability on echocardiography predicts long-term survival after revascularization in patients with ischemic congestive heart failure. J Am Coll Cardiol 33:1848-1854

33. Kim RJ, Fieno DS, Parrish TB et al (1999) Relationship of MRI delayed contrast enhancement to irreversible injury, infarct age, and contractile function. Circulation 100:1992-2002

34. Kim RJ, Chen EL, Lima JA, Judd RM (1996) Myocardial Gd-DTPA kinetics determine MRI contrast enhancement and reflect the extent and severity of myocardial injury after acute reperfused infarction. Circulation 94:3318-3326

35. Kim RJ, Wu E, Rafael A et al (2000) The use of contrast-enhanced magnetic resonance imaging to identify reversible myocardial dysfunction. N Engl J Med 343:1445-1453

36. Masui T, Finck S, Higgins CB (1992) Constrictive pericarditis and restrictive cardiomyopathy: evaluation with MR imaging. Radiology 182:369-373

37. Watanabe A, Hara Y, Hamada M et al (1998) A case of effusive-constrictive pericarditis: an efficacy of GD-DTPA enhanced magnetic resonance imaging to detect a pericardial thickening. Magn Reson Imaging 16:347-350

38. Atkinson DJ, Burstein D, Edelman RR (1990) First-pass cardiac perfusion: evaluation with ultrafast MR imaging. Radiology 174(3 Pt 1):757-762

39. Kim WY, Danias PG, Stuber M et al (2001) Coronary magnetic resonance angiography for the detection of coronary stenoses. N Engl J Med 345:1863-1869

40. McConnell MV, Ganz P, Selwyn AP et al (1995) Identification of anomalous coronary arteries and their anatomic course by magnetic resonance coronary angiography. Circulation 92:3158-3162

Magnetic Resonance of the Heart

D. Pennell

Cardiovascular Magnetic Resonance Unit, Royal Brompton Hospital, London, UK

Introduction

Cardiovascular magnetic resonance (CMR) is a developing field with enormous potential because of its major attributes of high image quality and resolution combined with non-ionising radiation and versatility. With recent major technological advances, there have been great improvements in acquisition speed and quality that makes the use of CMR in a wide range of cardiac conditions robust and valuable. This article reviews the fundamentals of CMR and its current clinical applications.

Fundamentals of Cardiovascular Magnetic Resonance

There are essentially three types of imaging sequence that are used in the cardiovascular system: In *spin-echo imaging*, the blood appears black and good-quality anatomical imaging is obtained. In *gradient-echo imaging*, the blood is white and the high-quality cine imaging is used to identify regional myocardial function and abnormal flow patterns. The gradient-echo technique of *velocity mapping* uses the phase of the MR signal to measure velocity; it usually behaves like 2-dimensional Doppler, but unlike Doppler it can measure flow directly and can be extended into seven dimensions for complex flow-dynamics problems [1]. CMR therefore consists of applications of these sequences and their variants, which allows determination of cardiac physiology, anatomy, metabolism, tissue characterisation, and vascular angiography.

For dedicated CMR, the environment typically incorporates medical gases, full invasive and non-invasive physiological monitoring telemetry, stress infusion pumps for adenosine and dobutamine, a power injector for contrast studies, and full resuscitation equipment and drugs. Experience has demonstrated that acutely ill and anaesthetised patients can be safely managed within the magnet in experienced centres. Modern CMR scanners incorporate ultrafast technology that allows real-time imaging (up to 50 frames per second), and ultrafast applications for assessing coronary artery disease (CAD). Currently, most scans are still gated to the electrocardio-gram, and in some cases also to the respiratory cycle using advanced diaphragm-monitoring techniques.

CMR is as safe as echocardiography. It is also safe for scanning all prosthetic heart valves and for patients with sternal wires, joint replacements, and retained epicardial pacing leads. There is abundant evidence that stents are safe to scan any time after insertion [2]. Pacemakers are problematic. Although recent MR experience is encouraging, this should only be considered in centres of specialist experience. Other implantable electronic devices, including defibrillators and cerebrovascular aneurysm clips, are currently a contraindication to CMR. Claustrophobia occurs in about 4% of patients but such patients frequently respond to low-dose diazepam.

Established Clinical Indications

Aorta

The aorta is well-imaged by CMR over its entire length. Three-point plane definition techniques are useful for imaging in the long axis of the aorta with reference to points in the ascending and descending limbs and the arch. The 'candy cane' view shows the extent of dissections and the location of coarctation. Closer interrogation of specific regions can also be made with orthogonal planes. CMR has been shown to be more accurate than transoesophageal echocardiography (TE) and computed tomography (CT) in evaluating acute dissection [3], although TE is often simpler to organise. CMR is ideal for the long-term follow-up of these patients in order to exclude aneurysm formation and other complications. In coarctation, Doppler is often problematic, and CMR is ideal in answering clinical issues, as well as being cost-effective [4]. In addition, CMR can demonstrate the net flow in collaterals as an index of stenosis severity.

Congenital Heart Disease

Echocardiography is ideal for monitoring congenital disease in the young, but with growth into adulthood and after corrective surgery, CMR plays a larger role and is of-

ten complementary to TE. TE is better at defining fine structure, such as valve morphology, whereas CMR is superior for flow, conduits and great-vessel anatomy [5]. In centres with expertise in both techniques, invasive catheterisation is reserved mainly for pressure measurements.

Angiography

For non-coronary angiography, CMR has become the investigation of choice. MR angiography (MRA) is fast, non-invasive, simple and safe, requiring only a peripheral intravenous injection of gadolinium, and 4-20 s of 3D acquisition on modern scanners. The data can be displayed in a rotating cine, which can, on the latest scanners, be time-resolved (4D angiography). This has proved useful for visualising the pulmonary arteries. Major applications have been shown for the aorta, renal and leg arteries [6], but the technique is not limited to these areas. Recently, thrombus imaging with CMR in the venous system has been demonstrated [7], and comparisons with established techniques for detection of deep-vein thrombosis and pulmonary embolism are under way.

Masses and Tumours

CMR defines the size, extent and relation of cardiac masses to surrounding tissues [8]; in addition, tissue characterisation and enhancement with gadolinium yield valuable information. T1- and T2-weighted images vary between masses according to their biochemical composition; for example, pericardial cysts have a characteristic high signal on T2 imaging, and the fat content of tumours can be selectively ascertained using fat suppression. Gadolinium enhancement reflects tumour vascularity; therefore, positive enhancement typically occurs in malignancy, although this is not excusive as vascular benign tumours such as myxoma and haemangioma also enhance. These additional characterisation features are very useful clinically in the guidance of diagnosis and surgery.

Assessment of Cardiac Volumes, Mass and Function

Ventricular function, volumes and mass are important prognostic indicators in CAD and other cardiac disease. Current clinical techniques (echocardiography, radionuclide ventriculography) have now been shown to be less accurate and reproducible than CMR [9], which has become the new gold standard. The interstudy reproducibility of CMR has been recognised by the pharmaceutical industry, which is using CMR for drug development studies in order to reduce the sample size [10], which reduces costs significantly. Comparisons of the current clinical techniques with CMR show that mean values in population vary between techniques by small amounts, but that individual variation can be very substantial [11]. If individual patient clinical decisions are based on numerical thresholds, then CMR is the preferred technique. The acquisition of these parameters by CMR is now achievable in a few minutes, and analysis techniques can also be completed quickly.

Flow and Shunts

CMR is useful for the measurement of flow in the heart and great vessels. The signal phase can be encoded for velocity and used to produce 2D velocity maps corresponding with the anatomical images. By measuring the area of a vessel and the mean velocity within the vessel, absolute measurements of instantaneous flow can be derived. When run in cine mode, flow curves are generated in which the area under the curve represents true flow in the vessel. This is very valuable in the non-invasive measurement of the pulmonary to systemic flow ratio in cardiac shunting and in a number of other clinical scenarios.

Valvular Heart Disease

Echo is excellent for investigating valvular disease, but CMR has its particular uses. In valvular regurgitation, echo may not easily determine the severity of the regurgitant flow. With CMR, the regurgitation can be measured directly using reverse-flow measurement in diastole [10]. Extension to assessment of mitral regurgitation involves the subtraction of aortic flow from true left-ventricular stroke volume, measured using the multislice technique. This approach is especially useful when surgery is being considered and clinical and echo results are not concordant, or there is doubt. For valvular stenosis, Doppler is very reliable for assessment and CMR is required less often, but useful if echo assessment fails. Experience suggests that CMR is a valuable alternative to echocardiography when flow across the valve is very eccentrically orientated.

Pericardium

The pericardial thickness is a guide to the presence of constriction and can be measured using CMR. The thickness is slightly greater than that measured with pathological studies due to chemical-shift artefact, caused by fat overlying the thin fibrous pericardial tissue. The normal CMR thickness of pericardium is therefore quoted as <4 mm. The pericardium appears black on CMR because of its low water content, although in acute inflammation it can enhance with gadolinium and appear bright. The thickness of the pericardium needs to be distinguished from any pericardial effusion. Pericardial effusion is commonly black on spin-echo images, but bright on gradient-echo cines, and this is a useful means of differentiation. Pericardial calcification is not well-seen by CMR, as calcium appears black, and therefore may simply appear as a localised area of pericardial thickening. CT is the best technique for showing calcium.

Cardiomyopathy

CMR is very useful in the assessment of cardiomyopathy such as arrhythmogenic right ventricular cardiomyopathy (ARVC), thalassaemia and dilated/hypertrophic cardiomyopathy. ARVC, which typically affects young men, causes right ventricular tachycardia and sudden death. It is familial and many gene abnormalities of the cellular desmosome have been discovered, which reveals the disease to be one of impaired intercellular integrity. Fibrofatty replacement occurs on the basis of injury and repair. The disease presents with abnormalities of the right ventricle (15% also have left ventricular involvement). These are best delineated by CMR, as they can be subtle and localised [12]. The late stages, with a large poorly functioning right ventricular and widespread fat infiltration, is readily identified, but the early stages, characterised by discrete areas of fat infiltration, regional hypokinesia, localised myocardial thinning and abnormal trabeculations pose a greater challenge, and CMR appears to be the best technique. Experience is required to differentiate these findings from normal variants. In particular, the normal patterns of epicardial fat distribution associated with the coronary arteries must be understood.

The assessment of myocardial iron overload has been problematic in clinical practice, but recently a T2* CMR technique has been established that allows reproducible quantification of the iron concentration [13]. Results show that iron loading in the myocardium is not correlated with that in other tissues, such as the blood and liver, and must be examined separately. T2* values <20 ms indicate iron overload, and nearly all cases of heart failure (the commonest cause of death in these patients) occur when the myocardial T2* is <10 ms. The technique has shown that removing cardiac iron is best achieved using oral chelators. T2* CMR combined with targeted chelation has considerably reduced the premature mortality from heart failure in thalassaemia.

In dilated cardiomyopathy, CMR has shown intramural mid-wall striae of fibrosis in one-third of patients, and no fibrosis in about half. These findings are very useful for distinguishing dilated cardiomyopathy from heart failure due to coronary artery disease. Recently, the presence and extent of late gadolinium enhancement has been shown to predict outcome in dilated cardiomyopathy.

Hypertrophic cardiomyopathy can usually be diagnosed by echocardiography, but there are circumstances when CMR is very useful. If the condition is suspected but not confirmed by echo, CMR is ideal as a second-line investigation. CMR also shows the distribution of hypertrophy, especially in isolated basal and apical hypertrophy, and is superior for quantification of myocardial mass. Late gadolinium enhancement occurs in hypertrophic cardiomyopathy and is associated with a worse prognosis. Finally, CMR is valuable for the assessment of septal ablation techniques in locating the size and extent of infarction and assessing rest and stress outflow tract gradients.

Coronary Anomalies

Coronary anomalies occur in approximately 1% of the population and are usually clinically silent. Their importance lies in the occurrence of sudden death in patients who have a coronary artery passing between the great vessels (aorta and pulmonary artery). This may occur because of compression or kinking during exercise. X-ray coronary angiography commonly identifies the anomalous origin of the coronary artery, but is poor at defining the proximal course and the relation to the great vessels. Coronary CMR is now a robust technique for showing the origin and course of the proximal coronaries and also the three-dimensional relations of the great vessels. Several studies have shown that CMR is superior to X-ray angiography for this purpose. More recently, coronary CMR has been applied to evaluate patients with congenital heart disease, in whom the incidence of coronary anomaly is up to 30%. Defining the course by X-ray angiography is even more complex due to altered positions of the great vessels and ventricles [14].

Developing Indications

Detection of Myocardial Infarction

The technique of late enhancement with gadolinium has been developed, in which the heart is imaged 10-15 min after injection. The gadolinium concentrates in the necrotic (acute infarction) or scar tissue (chronic infarction) due to an increased partition coefficient, and the infarcted area becomes bright [15]. There is very close correlation of the volume of signal enhancement and infarct size in animal models of acute infarction. The technique has high resolution and can define the transmural extent of necrosis and scar. In addition, a different technique, known as *early enhancement* (at 1-2 min after gadolinium injection) can be used to define the extent of microvascular obstruction in infarctions. Microvascular obstruction has already been shown to predict remodelling and adverse cardiac events after infarction.

Assessment of Myocardial Viability

The technique of late enhancement has clinical application to the assessment of viability in that the percentage transmural replacement of normal myocardium by scar can thus be determined. Segments with <50% transmural replacement showed improved function with revascularisation, whilst those with higher grades of transmural replacement fail to improve [16]. It is anticipated that the late enhancement technique will make substantial clinical impact in the management of infarction and its sequelae.

Dobutamine stress testing

Dobutamine CMR was first used for the detection of ischaemia in CAD a decade ago, but modern comparisons with stress echocardiography have shown significantly improved diagnosis related to improved results from those patients in whom echocardiographic image quality was suboptimal or poor [17]. Results from several centres have begun to establish this technique, and where available, it can be considered as a first-line approach if acoustic windows are limited.

CMR Techniques in Development

Myocardial Perfusion

SPECT is a widely used technique to assess perfusion, but a safer technique would be medically welcome, providing it can maintain the same valuable diagnostic and prognostic information and is cost effective. Perfusion CMR may be a contender for this role. This technique consists of a baseline first-pass perfusion study and a repeat study during adenosine stress. Gadolinium is used as the contrast agent. Areas of reduced perfusion appear as dark areas in the myocardium surrounded by normal-enhancing areas. One of the advantages of perfusion CMR is high resolution, which allows the visualisation of subendocardial perfusion defects in vivo for the first time. Quantitative analysis tools have been developed that examine the slope of signal increase during the first pass and the myocardial perfusion reserve index [18]. Other advantages of perfusion CMR include the speed of the examination (1 h compared with typically 2-6 h for a nuclear examination), and the easy combination with other techniques, such as late enhancement. Recent multicentre studies suggested that CMR is more accurate than myocardial perfusion SPECT for detection of coronary artery disease.

Atherosclerotic Plaque

Further down the road for clinical use is the technique of plaque imaging. CMR can be used to depict plaques and interrogate their lipid constituents as well as the integrity of the fibrous cap, which are factors that determine the propensity to plaque rupture and thrombus formation. T2 imaging has proved so far to be the most helpful, and validation of results against pathology has been achieved in the aorta and carotids. Latest results have also shown plaques in the coronary arteries [19].

Coronary Imaging

Much work has been devoted to the non-invasive assessment of the coronary artery lumen by CMR. There have been tremendous improvements in techniques, notably in the development of 'navigators' which allow patients to breathe freely during the acquisition, whilst increasing resolution [20]. Most recently, 3D breath-hold techniques during contrast-agent infusion have shown good results. It is likely that coronary CMR will prove useful in CAD at some point in the future, but currently its clinical robustness needs improvement, and the issue of preventing coronary motion during the acquisition has to be improved further. However, the success of the technique for coronary anomalies is established and vein-graft imaging by CMR is now straightforward. In this area, coronary CT has advantage because of superior resolution, although in established coronary disease, interpretation is considerably hindered by coronary calcium. CT is good for detecting early coronary disease, prior to excessive calcium deposition.

References

1. Kilner PJ, Yang GZ, Wilkes AJ et al (2000) Asymmetric redirection of flow through the heart. Nature 404:759-761
2. Strohm O, Kivelitz D, Gross W et al (1999) Safety of implantable coronary stents during H-1 magnetic resonance imaging at 1.0 and 1.5T. J Cardiovasc Magn Reson 1:239-1245
3. Nienaber CA, von Kodolitsch Y, Nicolas V et al (1993) The diagnosis of thoracic aortic dissection by noninvasive imaging procedures. N Engl J Med 328:1-9
4. Therrien J, Thorne SA, Wright A et al (2000) Repaired coarctation: a 'cost-effective' approach to identify complications in adults. J Am Coll Cardiol 35:997-1002
5. Hirsch R, Kilner PJ, Connelly M et al (1994) Diagnosis in adolescents and adults with congenital heart disease. Prospective assessment of the individual and combined roles of magnetic resonance imaging and transoesophageal echocardiography. Circulation 90:2937-2951
6. Owen RS, Carpenter JP, Baum RA et al (1992) Magnetic resonance imaging of angiographically occult runoff vessels in peripheral arterial occlusive disease. N Engl J Med 326:1577-1581
7. Moody AR (1997) Direct imaging of deep-vein thrombosis with magnetic resonance imaging. Lancet 350:1073
8. Frank H (2002) Cardiac masses. In: Manning WJ, Pennell DJ (eds) Cardiovascular magnetic resonance. Churchill Livingstone, Philadelphia, pp 342-353
9. Bellenger NG, Davies LC, Francis JM et al (2000) Reduction in sample size for studies of remodelling in heart failure by the use of cardiovascular magnetic resonance. J Cardiovasc Magn Reson 2:271-278
10. Bellenger NG, Burgess M, Ray SG et al on behalf of the CHRISTMAS steering committee and investigators (2000) Comparison of left ventricular ejection fraction and volumes in heart failure by two-dimensional echocardiography, radionuclide ventriculography and cardiovascular magnetic resonance: are they interchangeable? Eur Heart J 21:1387-1396
11. Blake LM, Scheinmann MM, Higgins CB (1994) MR features of arrhythmogenic right ventricular dysplasia. AJR Am J Roentgenol 162:809-812
12. Dulce MC, Mostbeck GH, O'Sullivan M et al (1992) Severity of aortic regurgitation: interstudy reproducibility of measurements with velocity encoded cine MR imaging. Radiology 185:235-240
13. Anderson LJ, Holden S, Davies B et al (2001) Cardiovascular T2* (T2 star) magnetic resonance for the early diagnosis of myocardial iron overload. Eur Heart J 22:2171-2179
14. Taylor AM, Thorne SA, Rubens MB et al (2000) Coronary artery imaging in grown-up congenital heart disease: complementary role of MR and x-ray coronary angiography. Circulation 101:1670-1678

15. Kim RJ, Fieno DS, Parrish RB et al (1999) Relationship of MRI delayed contrast enhancement to irreversible injury, infarct age, and contractile function. Circulation 100:185-192

16. Kim RJ, Wu E, Rafael A et al (2000) The use of contrast-enhanced magnetic resonance imaging to identify reversible myocardial dysfunction. N Engl J Med 343:1445-1453

17. Nagel E, Lehmkuhl HB, Bocksch W et al (1999) Noninvasive diagnosis of ischemia induced wall motion abnormalities with the use of high dose dobutamine stress MRI. Comparison with dobutamine stress echocardiography. Circulation 99:763-770

18. Panting JR, Gatehouse PD, Yang GZ et al (2001) Echo planar magnetic resonance myocardial perfusion imaging: parametric map analysis and comparison with thallium SPECT. J Magn Reson Imaging 13:192-200

19. Fayad ZA, Fuster V, Fallon JT et al (2000) Noninvasive in vivo human coronary artery lumen and wall imaging using black-blood magnetic resonance imaging. Circulation 102:506-510

20. Botnar RM, Stuber M, Danias PG et al (1999) Improved coronary artery definition with T2-weighted, free breathing, three dimensional coronary MRA. Circulation 99:3139-3148

CT and CT Nuclear Imaging of the Heart

P.A. Kaufmann[1], H. Alkadhi[2]

[1] Nuclear Medicine and Cardiology, Department of Medical Radiology, University Hospital, Zurich, Switzerland
[2] Institute of Diagnostic Radiology, Department of Medical Radiology, University Hospital, Zurich, Switzerland

Over the past decades, conventional coronary angiography has been the only accepted 'gold standard' method for clinical imaging of coronary artery disease (CAD). However, coronary angiography is costly, causes patient discomfort, and is associated with a small but distinct procedure-related morbidity (1.5%) and mortality (0.15%). Moreover, the accuracy of coronary angiography is severely hampered by significant intraobserver as well as interobserver variability in defining the anatomic relevance of stenoses (up to 50%) [1, 2] – a problem that is underlined by the poor correlation with post-mortem coronary pathology findings [3, 4]. In addition, angiographic findings are unable to predict the physiologic relevance of a coronary stenosis [2, 5-8].

In 2002, about 2 million conventional coronary angiography procedures were carried out in Europe [9]. Interestingly, the fact that percutaneous coronary intervention (PCI) was performed in only a third of these procedures implies that coronary angiography was and is mostly used as purely diagnostic tool. The associated economic burden and the inconvenience to patients have prompted an intensive search for alternative, noninvasive means for coronary artery imaging [10]. Indeed, over the last 5 years there has been an impressive growth in the literature on non-invasive techniques for the assessment of CAD. In particular, the introduction of multidetector computed tomographic scanners with submillimeter spatial resolution and subsecond gantry rotations has revolutionized the field of cardiac imaging by enabling 'direct' non-invasive imaging of the coronary arteries. As a result, purely diagnostic coronary angiography may not be considered an acceptable procedure in the near future.

Coronary Angiography by Multidetector-Row Computed Tomography

The latest advances in computed tomography (CT) technology using multidetector-row CT systems with 64-slices and dual source CT has led to the achievement of a non-invasive means to obtain excellent-quality images of the coronary artery tree (Fig. 1). Nevertheless, even with 64-slice CT there is a decline in diagnostic accuracy that is mainly associated with the presence of severe vessel-wall calcification and motion artifacts [11]. For routine clinical use, CT coronary angiography (CTA) needs to provide reliable visualization of the complete coronary artery tree. The temporal resolution of 64-slice CT sometimes is insufficient for artifact-free visualization of the coronary arteries due to their heterogeneous motion throughout the cardiac cycle, which typically affects distal vessel segments of the left circumflex (LCX) artery and the mid-section of the right coronary artery (RCA). As this most often occurs in patients with high and variable heart rates [12], it was considered necessary with 64-slice CT to control patient heart rate prior to scanning by administering beta-blockers and/or benzodiazepines. The most recently developed dual-source CT scanner system further improved temporal resolution to a heart-rate-independent 83 ms by simultaneously acquiring data with two X-ray tubes and two detectors mounted onto the gantry with a 90° angular offset. A preliminary study using dual-source CT reported high accuracy in the diagnosis of CAD, with a sensitivity of 96% and a specificity of 98% [13]. The authors of that study did not control heart rate with beta-blocking medication and reported a low rate of not-evaluable segments of only 1.4% – all in distal segments or side branches.

With 64-slice and dual-source CT scanners, the consistently high negative predictive value (approaching 100%) allows the reliable exclusion of significant CAD in a non-invasive manner. This severely challenges the role of conventional coronary angiography as a purely diagnostic tool.

Additional benefits from cardiac CT derive from its ability to accurately evaluate ventricular function with an accuracy that is similar to that of the current standard of reference, magnetic resonance imaging [14]. In addition, cardiac valvular morphology and function can be assessed with results similar to those obtained with echocardiography [15, 16], and approximately 70% of the lung parenchyma [17] can be covered without the need for additional radiation or contrast media.

Fig. 1a-d. Dual-source computed tomography (CT) coronary angiography (mean heart rate during scanning 78 bpm) in a 49-year-old female patient with atypical chest pain and inconclusive stress testing. CT ruled-out coronary artery disease in a non-invasive means. Volume-rendered 3-D image (**a**), curved multiplanar reformations along the centerline of the right coronary artery (**b**), as well as curved multiplanar reformations along the centerline of the left anterior descending (**c**) and left circumflex (**d**) arteries demonstrate normal coronary arteries with no calcifications or stenoses

Hybrid Imaging

It has become the clinical standard to require proof of ischemia by a non-invasive test before considering revascularization procedures [18, 19]. As illustrated in Fig. 2, a purely morpho-anatomical method is insufficient at predicting the functional relevance of a stenosis [6]. Thus, an accurate, non-invasive technique for the evaluation of CAD should provide complementary information on coronary anatomy and the pathophysiologic implications of lesion severity. Currently, the integration of functional and morphological information is done by mentally combining coronary angiography findings with those from myocardial perfusion imaging (MPI). Unfortunately, the planar nature of coronary angiography projections and the axial slice-by-slice display of cardiac MPI render a subjective integration difficult, leading to inaccurate allocation of the coronary lesion to

its subtended myocardial territory. There have been several attempts to fuse conventional coronary angiography with MPI [20-22]. However, this approach does not allow non-invasive preplanning of the intervention, as information regarding the coronary anatomy is obtained only during conventional coronary angiography. In addition, the time-consuming process of fusing coronary angiography with MPI prevents rapid decision-making during an ongoing intervention. Consequently, this approach has not been adopted into daily clinical routine. Ideally, complementary information should be obtained completely non-invasively, allowing proper planning of the elective intervention.

We have recently shown that combining MPI with multislice CTA is a feasible and interesting approach for non-invasive complementary morpho-anatomical and functional CAD assessment [23, 24], providing useful information for clinical decision-making [25].

Fig. 2a-h. 64-slice CT coronary angiography (mean heart rate during scanning 69 bpm) in a 56-year-old male patient with atypical chest pain, a positive family history, and dyslipidemia. Volume-rendered 3-D images show multiple calcifications (*arrows*) in the left anterior descending artery (LAD) (**a**) and in the right coronary artery (RCA) (**b**). It is important to note that no diagnosis should be done on volume rendered 3-D images. Curved multiplanar reformations allow calcifications involving the LAD (**c**), the proximal segment of the first diagonal branch (**d**), the left circumflex (**e**) and the RCA (**f**) to be localized. However, even with reformations luminal narrowing can sometimes be difficult to estimate. The angiographic view (**g**) confirms severe overall calcifications. Myocardial perfusion scan (adenosine stress/rest Tc-99m-tetrofosmin protocol) (**h**) reveals slightly inhomogeneous perfusion but neither ischemia nor scarring, indicating that none of the lesions were pathophysiologically relevant

The Future of Non-invasive Cardiac Imaging with CT and Nuclear Methods

Developments in non-invasive cardiac imaging using CT and nuclear methods are anticipated to proceed in two directions.

First, the most recent multidetector-row CT scanner technology appears to be robust with respect to coronary artery assessment in patients with acute chest pain, thereby optimizing the triage of those patients for further invasive or non-invasive workup and therapy [26]. In addition, initial experience indicates that multidetector row CT allows the evaluation of acute and chronic myocardial pathologies, with results similar to those obtained with magnetic resonance imaging [27]; however, at the same time it also provides accurate information about the status of the coronary arteries.

Second, the very encouraging preliminary data suggest that hybrid imaging has the potential to be implemented into clinical practice, eventually leading to a reduction in the frequency or overuse of angioplasty and stent placement, key cost drivers in interventional cardiology practice. Occasionally, in patients whose lesions are unsuitable for angioplasty, bypass surgery may be considered directly without the need for preoperative diagnostic coronary angiography [28]. Furthermore, new ligands are currently under investigation that will allow imaging of plaques in vulnerable vessels (aorta, carotids, coronaries). Optimal fusion (inherent to hybrid scanners) of molecular images with those generated by CT angiography will allow exact allocation of the vulnerability to the specific anatomic lesion.

References

1. Galbraith JE, Murphy ML, Desoyza N (1981) Coronary angiogram interpretation: interobserver variability. JAMA 240:2053-2059
2. White CW, Wright CB, Doty DB et al (1984) Does visual interpretation of the coronary arteriogram predict the physiologic importance of a coronary stenosis? N Engl J Med 310:819-824
3. Vlodaver Z, Frech R, Van Tassel RA, Edwards JE (1973) Correlation of the antemortem coronary arteriogram and the postmortem specimen. Circulation 47:162-169
4. Arnett EN, Isner JM, Redwood DR et al (1979) Coronary artery narrowing in coronary heart disease: comparison of cineangiographic and necropsy findings. Ann Int Med 91:350-356
5. Zijlstra F, van OJ, Reiber JH, Serruys PW (1987) Does the quantitative assessment of coronary artery dimensions predict the physiologic significance of a coronary stenosis? Circulation 75:1154-1161
6. Topol EJ, Nissen SE (1995) Our preoccupation with coronary luminology. The dissociation between clinical and angiographic findings in ischemic heart disease. Circulation 92:2333-2342
7. Pijls NH, De BB, Peels K et al (1996) Measurement of fractional flow reserve to assess the functional severity of coronary-artery stenoses. N Engl J Med 334:1703-1708
8. Bech GJ, De Bruyne B, Bonnier HJ et al (1998) Long-term follow-up after deferral of percutaneous transluminal coronary angioplasty of intermediate stenosis on the basis of coronary pressure measurement. J Am Coll Cardiol 31:841-847
9. Maier W, Abay M, Cook S et al (2005) The 2002 European registry of cardiac catheter interventions. Int J Cardiol 113:299-304
10. Achenbach S, Daniel WG (2001) Noninvasive coronary angiography – an acceptable alternative? N Engl J Med 345:1909-1910
11. Leschka S, Alkadhi H, Plass A et al (2005) Accuracy of MSCT coronary angiography with 64-slice technology: first experience. Eur Heart J 26:1482-1487
12. Leschka S, Wildermuth S, Boehm T et al (2006) Noninvasive coronary angiography with 64-section CT: effect of average heart rate and heart rate variability on image quality. Radiology 241:378-385
13. Scheffel H, Alkadhi H, Plass A et al (2006) Accuracy of dual-source CT coronary angiography: first experience in a high pre-test probability population without heart rate control. Eur Radiol 16:2739-2747
14. Juergens KU, Grude M, Maintz D et al (2004) Multi-detector row CT of left ventricular function with dedicated analysis software versus MR imaging: initial experience. Radiology 230:403-410
15. Alkadhi H, Wildermuth S, Bettex DA et al (2006) Mitral regurgitation: quantification with 16-detector row CT – initial experience. Radiology 238:454-463
16. Alkadhi H, Wildermuth S, Plass A et al (2006) Aortic stenosis: comparative evaluation of 16-detector row CT and echocardiography. Radiology 240:47-55
17. Haller S, Kaiser C, Buser P et al (2006) Coronary artery imaging with contrast-enhanced MDCT: extracardiac findings. AJR Am J Roentgenol 187:105-110
18. Smith SC Jr, Dove JT, Jacobs AK et al (2001) ACC/AHA guidelines of percutaneous coronary interventions (revision of the 1993 PTCA guidelines) – executive summary. A report of the American College of Cardiology/American Heart Association Task Force on Practice Guidelines (committee to revise the 1993 guidelines for percutaneous transluminal coronary angioplasty). J Am Coll Cardiol 37:2215-2239
19. Klocke FJ, Baird MG, Lorell BH et al (2003) ACC/AHA/AS-NC guidelines for the clinical use of cardiac radionuclide imaging – executive summary: a report of the American College of Cardiology/American Heart Association Task Force on Practice Guidelines (ACC/AHA/ASNC Committee to Revise the 1995 Guidelines for the Clinical Use of Cardiac Radionuclide Imaging). Circulation 108:1404-1418
20. Schindler TH, Magosaki N, Jeserich M et al (1999) Fusion imaging: combined visualization of 3D reconstructed coronary artery tree and 3D myocardial scintigraphic image in coronary artery disease. Int J Card Imaging 15:357-368
21. Schindler TH, Magosaki N, Jeserich M et al (2000) 3D assessment of myocardial perfusion parameter combined with 3D reconstructed coronary artery tree from digital coronary angiograms. Int J Card Imaging 16:1-12
22. Faber TL, Santana CA, Garcia EV et al (2004) Three-dimensional fusion of coronary arteries with myocardial perfusion distributions: clinical validation. J Nucl Med 45:745-753
23. Anonymous (2006) 2006 Image of the Year: focus on cardiac SPECT/CT. J Nucl Med 47:14N-15N
24. Gaemperli O, Schepis T, Kaufmann PA (2007) SPECT-CT fusion imaging integrating anatomy and perfusion. Eur Heart J 28:145
25. Namdar M, Hany TF, Koepfli P et al (2005) Integrated PET/CT for the assessment of coronary artery disease: a feasibility study. J Nucl Med 46:930-935
26. Hoffmann U, Nagurney JT, Moselewski F et al (2006) Coronary multidetector computed tomography in the assessment of patients with acute chest pain. Circulation 114:2251-2260
27. Gerber BL, Belge B, Legros GJ et al (2006) Characterization of acute and chronic myocardial infarcts by multidetector computed tomography: comparison with contrast-enhanced magnetic resonance. Circulation 113:823-833
28. Wijns W (2005) The diagnosis of coronary artery disease: in search of a 'one-stop shop'? J Nucl Med 46:904-905

Diagnosis of Congenital Heart Disease I

C.B. Higgins

Department of Radiology, University of California San Francisco, San Francisco, CA, USA

Morphological Evaluation of Congenital Heart Disease

Depiction of the anatomy of simple and complex forms of congenital heart disease constitutes the most common clinical indication for magnetic resonance imaging (MRI) of the heart at many centers in the United States. The most frequently applied noninvasive technique for the assessment for congenital heart disease is echocardiography. Consequently, MRI is used in situations in which the information provided by echocardiography is incomplete or cannot be obtained. MRI using the ECG-gated spin-echo technique has been shown to have high diagnostic accuracy for demonstrating the morphologic aspects of many forms of congenital heart disease, including both simple and complex lesions. Due to the ready availability of echocardiography and its greater familiarity, the major uses of MRI in the evaluation of congenital heart disease are aimed at specific indications in which the information is either unique or supplementary to that obtained with echocardiography.

The current indications for the use of MRI for the morphologic diagnosis of congenital heart disease include: evaluation of coarctation of the aorta, aortic arch anomalies and other vascular rings, pulmonary venous connections and pulmonary venous obstructions, the assessment of pulmonary arterial dimensions and sites of obstruction or atresia, the evaluation of complex cyanotic anomalies including various types of single ventricle (uni-ventricular connections), and postoperative follow-up of congenital heart disease. Perhaps the most frequent use of MRI is, and in the future will be, for monitoring the morphology of cyanotic congenital heart disease and, to some extent, evaluating the success of complex operations used in its treatment. MRI also permits precise assessment of the morphology of the supracardiac as well as intracardiac aspects affected by these complex operations. Moreover, it has also accurately demonstrated residual obstructions of the central or branch pulmonary arteries after operations involving the pulmonary arteries. This is particularly the case for surgery to correct tetralogy of Fallot, pulmonary atresia, and truncus arteriosus.

For the evaluation of coarctation of the aorta, MRI has been effective in demonstrating the site, extent and sever-

ity of the coarctation, and the status of the aortic arch. In the evaluation of vascular rings, sagittal and transverse tomograms demonstrate the severity of airway compression as well as the precise anatomy of the vascular anomaly. For complex lesions, such as single ventricle, the tomographic nature of MRI allows depiction of the atrioventricular and arterioventricular connections, which is necessary in defining the anatomy of the lesions. Likewise, MRI has been effective in defining the anatomy of surgical procedures used in the correction of these complex cyanotic congenital heart lesions. A number of studies have compared the normal anatomy with complications following use of the Rastelli procedure, Fontan procedure, Jatene procedure, Norwood procedure, and other operations involving the great vessel and cardiac levels. Most of these operations influence the size of stenoses involving the pulmonary arteries. Recent studies have demonstrated that MRI is more effective than echocardiography in detecting abnormalities in the right and left pulmonary arteries occurring residual to or as a complication of previous operative procedures.

Functional Evaluation of Congenital Heart Disease

Depiction of the morphology of congenital heart disease is the most important aspect in the diagnosis of the many forms of this disease. However, the functional aspects of congenital heart disease are also important and in some cases are critical to patient management. A number of new magnetic resonance techniques have been devised or already applied to the assessment of several functional aspects of congenital heart disease. Evaluation of the volumes and functions of both ventricles has been achieved using cine-MRI and more recently, breath-hold cine-MRI. Compared to echocardiography and other imaging techniques, MRI has the advantage of providing better quantification of right ventricular volume and function. Many congenital heart lesions, especially cyanotic lesions, frequently afflict and alter the dimensions and shape of the right ventricle. Consequently, a three-dimensional imaging technique that provides direct measurements of right ventricular volume and mass is im-

portant in the management of a number of types of congenital heart disease. The determination of adequate volume and function of two ventricles may be important in surgical consideration and in the decision as to whether to perform a bi-ventricular or uni-ventricular reconstruction in complex congenital lesions.

The measurement of blood flow in the great vessels and cardiac chambers may be extremely important in the assessment of congenital heart disease. The velocity-encoded cine-MRI technique can provide measurements of blood flow in the ascending aorta and pulmonary artery simultaneously. This technique has been used to measure the difference between pulmonary arterial flow and aortic flow in order to calculate the volume of left-to-right shunts and the pulmonary to systemic flow ratio (Q_p/Q_s) of shunts. The Q_p/Q_s derived from velocity-encoded cine-MRI close correlates with the same measurement derived from oximetric data obtained during cardiac catheterization in patients with atrial septal defects. Moreover, this technique has been used to separately measure flow in the right and left pulmonary arteries, and has shown that the sum of flow measured in the right and left pulmonary artery is equivalent to the flow measured in the main pulmonary artery in normal individuals. This technique has been used to quantify the distribution of blood flow in the right and left pulmonary arteries in patients with congenital lesions, in whom blood flow to the two lungs is grossly unequal as a consequence of stenoses within the branches of the right or left pulmonary artery, after construction of systemic to pulmonary shunts, or in atresia or hypoplasia of one of the hilar pulmonary arteries. Velocity-encoded cine-MRI has also been used to estimate the peak velocity across stenoses in order to calculate the gradient across them. This information has been useful in the assessment of congenital heart disease as it allows the gradient across pulmonary valvular stenoses, pulmonary arterial stenoses, and Rastelli conduits to be estimated. Several recent studies have also shown a correlation between estimates of the gradients across valvular stenoses and those across coarctation of the aorta with measurements made at cardiac catheterization.

Velocity-encoded cine-MRI has recently been applied to determine the volume of the collateral circulation in coarctation of the aorta. The rationale in this application is to demonstrate greater flow in the distal descending aorta than in the proximal descending aorta. The increase in flow from the proximal to the distal aorta is presumed to occur as a result of retrograde flow in the intercostal arteries and other branches of the descending aorta. In normal volunteers, the total flow in the distal part of the descending aorta was slightly decreased compared with the flow in the proximal part of the descending aorta because of normal antegrade flow through the intercostal arteries. However, in patients with hemodynamically significant coarctation (>20 mm gradient), velocity-encod-

ed cine-MRI measurements demonstrated a substantial increase in the distal aorta compared to the proximal part of the descending aorta. The increase in flow was presumably due to the retrograde flow in branches of the descending aorta. In that study, there was a significant linear relationship between the volume of collateral flow measured by velocity-encoded cine-MRI and the morphologic severity of the stenosis, as measured by the percent reduction in luminal diameter of the aorta at the site of the coarctation. It thus seems likely that this technique can provide a new method for defining the hemodynamic significance of a coarctation.

The Future of MRI in Congenital Heart Disease: Catheterless Cardiac Catheterization

The multifaceted morphologic and functional information provided by MRI suggests that this technique has the potential to replace cardiac catheterization while providing the same information. In recent years, the volume of cardiac catheterization has declined considerably due to the capability of echocardiography for evaluating morphology and function in congenital heart disease. The combination of echocardiography and MRI should eliminate a substantial amount of cardiac catheterizations. In the future, the major use of cardiac catheterization in congenital heart disease may be to apply interventional therapeutic procedures.

Under optimal circumstances of application, MRI can supply most of the information for which cardiac catheterization is currently used. This information includes morphologic, pressure, and oximetric data in order to define the pressure gradient across stenoses, the volume of shunts, and the presence and severity of pulmonary arterial hypertension. Currently, the morphology of congenital heart disease is defined by ECG-gated, spin-echo, and cine-MRI with a precision that rivals and usually surpasses that provided by catheterization. Quantitative function of both ventricles can be provided by cine-MRI, and the accuracy and reproducibility of this approach should be better than that obtained with cardiac angiography because of the three-dimensional imaging. As discussed above, velocity-encoded cine-MRI can be used to estimate the gradients across valves and great arteries and to calculate the volume of left-to-right shunts. However, the reliability of this method for estimating gradients across stenoses under a variety of pathologic circumstances has not yet been established. Moreover, it is now theoretically possible to estimate pulmonary arterial pressure by examining the jet of tricuspid regurgitation usually present in patients with pulmonary arterial hypertension. However, no studies have documented the capability of MRI to provide an estimate of pulmonary arterial pressure.

Diagnosis of Congenital Heart Disease II

I.L.D. Tonkin

Division of Cardiovascular, Interventional, and Pediatric Radiology, University of Tennessee Health Science Center, Memphis, TN, USA

Introduction

Recent advances in diagnostic radiology have radically altered the approach to the diagnosis of congenital heart disease (CHD). Sophisticated trans-thoracic and trans-esophageal echocardiography is perhaps the best-known example. Additionally, state of the art magnetic resonance (MR) and multidetector computed tomography (CT) scanners, each with cardiac packages, can render diagnostic angiocardiography unnecessary at times. With an accurate diagnosis, interventional angiocardiography, embolotherapy, surgical correction, or even cardiac transplantation can be accomplished for palliation or cure.

In spite of these imaging breakthroughs, many if not most CHD patients, independent of age, are referred to the radiologist with a request for a chest radiograph, either one or two views. The accompanying patient report usually includes a few, brief clinical observation (e.g., cyan-otic infant, shortness of breath, enlarged heart, murmur). Consequently, the traditional approach to treating such patients, i.e., situs evaluation, vascular pattern assessment, and cardiac contour/chamber analysis, still merits review. Most importantly, this approach follows directly from the underlying pathophysiology seen in CHD, in which there are deranged flow dynamics and cardiac chamber alterations. With this in mind, this article describes a schematic approach to assessing the most common forms of CHD, without technically addressing specific CT/MR protocols, which are covered elsewhere in the IDKD.

Approach to the Plain Chest Radiograph in Patients with Heart Disease

The situs of heart disease is inferred based on the anatomy of the atria (Fig. 1), the anatomy of the tracheo-

Fig. 1. Normal cardiac anatomy. From Netter FH (1969), and from Elliott LP (1991), with permission

Fig. 2. Types of situs. *RL*, Right lung; *LL*, left lung; *RA*, right atrium; *LA*, left atrium. From Tonkin ILD (1992), with permission

bronchial tree, the position of the pulmonary arteries, location of the thoracic and abdominal viscera, and isomerism (symmetric morphology) (Figs. 1, 2). Situs solitus, or normal situs, is defined by the position of the stomach (and liver), the cardiac apex, and the aortic arch. In this type of situs, the patient's bronchial and atrial anatomies suggest right and left sidedness in the normal positions. Accordingly, situs inversus refers to a reverse of the normal situs. Situs indeterminus (situs ambiguous) is further described with respect to either bilateral right isomerism (sidedness), such as occurs in asplenia syndrome, or bilateral left isomerism, as seen in polysplenia syndrome. Bilateral right isomerism consists of bilateral eparterial bronchi and right-sided atrial structures, the absence of a spleen, and an increased incidence of congenital heart disease. In bilateral left isomerism, there are multiple splenules along the greater curvature of the stomach, bilateral left isomerism with bilateral hyperarterial bronchi, and bilateral left pulmonary arteries extending over the bronchi. There is also a bilateral left atrial anatomy with bilateral left atrial appendages, as well as abnormal systemic venous connections and azygos or hemiazygos continuation with interruption of the hepatic segment of the inferior vena cava. Bilateral left isomerism is associated with a lower incidence of CHD.

The Pulmonary Vasculature in CHD

The pulmonary vasculature in CHD patients can be difficult to evaluate and requires considerable experience. The radiographs of these patients are difficult to interpret and must be 'overread' in order to identify the vascular defects. Pulmonary vascularity may be normal, increased, or decreased. Increased vascularity is associated with pulmonary overcirculation (shunt vascularity), pulmonary venous hypertension, or pre-capillary hypertension (pulmonary arterial hypertension). In addition, there may be systemic collaterals from the aorta and major aortopulmonary collateral arteries (MAPCAs). An overview of the four main groups of CHDs with respect to the pulmonary vascular pattern is provided in Table 1.

Group 1 CHDs: Increased Pulmonary Vascularity Without Cyanosis

Due to the difference in pressure and resistance between the greater and lesser circulation, the communication between the two circuits results in increased pulmonary blood flow with increased blood flow through the left atrium, which is enlarged in all cases unless it is decom-

Table 1. Congenital heart disease classification by pulmonary vascular pattern

Acyanotic		Cyanotic	
Group 1	Group 2	Group 3	Group 4
↑PBF	PVH or normal	↓PBF	↑PBF
Left to right shunts	LV inflow or outflow obstruction; muscle disease	Right to left shunts due to RV inflow or outflow obstruction	Admixture lesions
	Group 2a: Neonatal Group 2b: Childhood or later	Group 3a: Normal heart size; VSD present Group 3b: Cardiomegaly; intact septum	

PBF, Pulmonary blood flow; *PVH*, pulmonary vascular hypertension; *LV*, left ventricle; *RV*, right ventricle; *VSD*, ventricular septal defect

Table 2. Acyanotic CHD with increased pulmonary blood flow (left to right shunts)

Common	Rare
Ventricular septal defect	Aortic pulmonary window
Atrial septal defect	Sinus of Valsalva aneurysm
Patent ductus arteriosus	Coronary artery fistula
Endocardial cushion defect (atrioventricular septal defect)	Left ventricle to right atrium shunts
Partial anomalous pulmonary venous return	

pressed by a large atrial communication. Table 2 lists the group of acyanotic CHDs characterized by increased pulmonary blood flow, some of which are described below in greater detail.

Ventricular Septal Defect

The most common congenital cardiac anomaly is ventricular septal defect (VSD): It occurs as an isolated lesion in 20% of CHD patients and is present with other anomalies in another 5% of patients. Four types of VSD can be distinguished: (1) membranous VSD (80%), (2) muscular (10%), (3) A-V canal type (5%), and (4) supracristal (5%).

The radiographic findings seen on cardiac imaging of VSD consist of increased pulmonary vascularity, acyanosis, an enlarged pulmonary artery, and an enlarged left atrium.

Atrial Septal Defect

Of the five recognized types of atrial septal defect (ASD), the most common is septus secundum, abnormal resorption of the fossa ovalis. In the septum primum type, the defect is situated low, near the mitral valve, and consists of a partial atrioventricular canal. In sinus venosus, the third type of ASD, the most common defect results in partial anomalous pulmonary venous return, as the right upper lobe pulmonary vein drains into the vena cava. An inferior vena caval defect can rarely occur. In patients with a stretched patent foramen ovale, the defect is functional due to right atrial enlargement and right atrial hypertension.

The radiograhic findings on cardiac imaging of ASD can include increased pulmonary vascularity, acyanosis (clinically evident), the absence of left atrial enlargement, and an enlarged right ventricle. Atrial-level CT/MR imaging with contrast enhancement will detect and identify the type of ASD and show alterations in pulmonary venous return.

Atrioventricular Septal Defects (Endocardial Cushion Defect)

In atrioventricular septal defects, also known as endocardial cushion defect, three types of defects are recognized. In the partial form there is low atrial septal de-

fect, ostium primum type, and a cleft in the mitral valve. In the intermediate form, there is low and a small VSD, whereas complete endocardial cushion defect consists of low ASD, a large VSD, and complete clefts within the atrioventricular valves.

Patent Ductus Arteriosus

In this acyanotic CHD, imaging may reveal a prominent aorta. A characteristic murmur is heard on auscultation (Figs. 3, 4).

Fig. 3. Fetal circulation with patent ductus arteriosus. From Tonkin ILD (1992), with permission

Fig. 4. Schematic illustration of the defects in patent ductus arteriosus (*PDA*) and aortic pulmonary window (*APW*). *Ao*, Aorta; *PT*, pulmonary trunk; *LIG ART*, ligamentus arteriosus. From Gedgaudas E et al. (1985), with permission

Miscellaneous Left-To-Right Shunts

The common feature of these CHDS is left-to-right shunting. In aortic pulmonary window (Fig. 4), the shunt arises from the connection between the ascending aorta and main pulmonary artery. Patient with ruptured aortic sinus of Valsalva aneurysm will present with a continuous murmur and shunt vasculature. The aneurysm itself is not evident on the plain radiograph but may be seen at echocardiography, MR imaging, or double subtraction angiography. Coronary-artery fistula is defined as a communication between a coronary artery and either a chamber of the heart or a component of the systemic or pulmonary circulation. The rare patient with left ventricular to right atrial shunt will present with clinical features of atrial shunt but have a murmur resembling that of VSD as well as right atrial enlargement.

Group 2 CHDs: Acyanotic with Pulmonary Vascular Hypertension or Normal Vascularity

Either valvular obstruction or obstruction of the great vessels may be associated with pulmonary vascular hypertension or normal vascularity. Obstruction of the great vessels will occur in patients with coarctation of the aorta (Fig. 5a, b), either preductal or postductal (juxtaductal), and in those with pulmonary valve stenosis.

Stenosis of the Aortic Valve

Aortic stenosis may be supravalvular, valvular or manifest as hypertrophic obstructive cardiomyopathy (idiopathic hypertropic subaortic stenosis; IHSS). The most common form of aortic valve stenosis involves the bicuspid valve (Fig. 6). In the USA, 2% of the population is estimated to have this type of CHD. It is thus the most common congenital heart lesion in all age groups (Fig. 6).

Obstruction of the Great Vessels: Coarctation of the Aorta, Pulmonary Valve Stenosis, and Venous Obstruction

The clinical findings of coarctation are decreased femoral pulses in the lower extremities. In the juxtaductal form of the disease (Fig. 6b), the radiographic findings include rib notching of ribs 3-8 in school-age children, normal pulmonary vascularity, and a normal-size

Fig. 6. Aortic valve stenosis. From Netter FH (1969)

heart with a left ventricular contour. Other findings are an abnormal aortic arch with a characteristic '3' sign and a 'reverse 3' sign with barium in the esophagus. An abnormal aortic valve is found in 50-85% of these patients.

Stenosis and partial fusion of the pulmonary valve results from fused or dysplastic valve leaflets. Pulmonary vascularity is normal as is the size of the heart. However, the main pulmonary artery is enlarged and a prominence of the left proximal pulmonary artery can be seen.

Pulmonary venous obstruction causes usually a characteristic granular pattern in infancy that is sometimes indistinguishable from respiratory distress syndrome (RDS, or hyaline membrane disease). The presence of an air bronchogram may help to identify RDS. Redistribution of pulmonary blood flow occurs later in life. These lesions place an increased demand on the right ventricle, which consequently hypertrophies. The heart size is usually normal or slightly enlarged.

Other CHDs – Venous Obstruction

Congenital mitral stenosis is a very rare form of CHD. It is associated with hypertrophy of the right ventricle and left atrial enlargement.

In cor triatriatum, left atrial enlargement is also sometimes visible along the right heart border. Cardiac imaging

Fig. 5a, b. Coarctation of the aorta. **a** Pre-ductal (*infantile*); **b** juxtaductal (*postductal*).From Elliott LP (1991), with permission

Fig. 7. Pulmonic valve stenosis stenotic and partially fused pulmonary valve. *Ao*, Aorta; *PA*, pulmonary artery; *RA*, right atrium; *LA*, left atrium; *RV*, right ventricle; *LV*, left ventricle. From Gedgaudas E et al. (1985), with permission

Fig. 8 a-d. Vascular compression anomalies. **a** Double aortic arch; **b** anomalous innominate artery; **c** right arch, with an aberrant left subclavian artery (usually a vascular ring), or left arch, with an aberrant rightsubclavian artery (usually not a ring); **d** pulmonary sling. From Berdon WE et al. (1972), with permission

with CT/MR demonstrates the presence of a membrane in the left atrium, an accessory chamber, and restricted ASD.

Patients with stenosis of individual pulmonary veins will have unilateral pulmonary edema but not left atrial enlargement.

Left atrial enlargement is also not a feature of total anomalous pulmonary venous return below the diaphragm. In this condition, the heart is of normal size.

Congestive heart failure results from a variety of primary cardiomyopathies.

The four most common vascular compression anomalies are illustrated in Fig. 8.

Group 3 CHDs: Decreased Pulmonary Blood Flow

Group 3A: Decreased Pulmonary Flow with Cyanosis

Perhaps the best-described CHD of this group is tetralogy of Fallot (Fig. 9). The radiographic findings on cardiac imaging are decreased pulmonary vascularity, right ventricular hypertrophy ('coeur in sabot'), an inapparent pulmonary artery segment, and a large aorta. In 25% of afflicted patients, the right arch is involved, sometimes with a boot-shaped heart. Palliative surgery includes a Blalock-Taussig shunt or a central shunt (Fig. 10 a, b).

Fig. 9. Tetralogy of Fallot. *Ao*, Aorta; *LA*, left atrium; *LV*, left ventricle. From Amplatz K, Moller JH (1994), with permission

Fig. 10a, b. Surgical treatment of tetralogy of Fallot. **a** Blalock-Taussig shunt; **b** central shunt. From Amplatz K, Moller JH (1994), with permission

Fig. 11. Major aortopulmonary collateral arteries (MAPCAs). From Mullins CE et al. (1988), with permission

Embolotherapy has been used to occlude the MAPCAs of patients with tetralogy of Fallot (Fig. 11). Gelfoam, Ivalon, and platinum coils have been used as embolic material.

Group 3B (Cardiomegaly)

In this group of cyanotic CHDs, cardiomegaly and an intact ventricular septum are the predominant features. Several examples are shown in Figs. 12-14.

Fig. 12. Pulmonary stenosis or atresia. Note the intact ventricular septum, the very large heart, and the markedly decreased pulmonary vascularity. From Amplatz K, Moller JH (1994), with permission

Fig. 13. Tricuspid atresia. Left axis deviation is noted on the ECG. On a chest radiograph, the left ventricle may be normal or have a rounded contour. *Ao*, Aorta; *PA*, pulmonary artery; *LA*, left atrium; *RV*, right ventricle; *LV*, left ventricle. From Gedgaudas E et al. (1985), with permission

Fig. 14. Ebstein's anomaly, in which the tricuspid valve is abnormally formed, may feature a very large heart. A characteristic murmur is present. From Netter FH (1969)

Group 4 CHDs: Cyanosis with Increased Pulmonary Blood Flow

This group of CHDs includes transposition of the great vessels (the most common), truncus arteriosus, total anomalous pulmonary venous connection (TAPVC) above the diaphragm, the 'tingles' (involving a single ventricle or atrium), and tricuspid atresia (without right ventricular outflow tract obstruction).

D-transposition of the Great Vessels

The reversal of the connections of the aorta and pulmonary artery is the most common neonatal cyanotic congenital heart lesion. The transposition results in arterioventricular concordance and ventriculoarterial discordance (Fig. 15).

The radiographic findings on cardiac imaging of a D-transposition include normal to increased pulmonary vascularity, an inapparent pulmonary artery segment, right-heart prominence, and an 'egg' or 'apple on string' appearance.

Truncus Arteriosus

Cardiac imaging of truncus arteriosus will reveal increased pulmonary vascularity, a right aortic arch (35% of patients), and an elevated left pulmonary artery (type I truncus arteriosus) (Fig. 16).

Total Anomalous Pulmonary Venous Connection

In this CHD, all of the pulmonary veins are anomalously connected. Four variations of TAPVC have been described. It should be noted that left atrial enlargement is never seen in patients with TAPVC.

In type I TAPVC, the connections are supracardiac and involve the left vertical vein, innominate vein, superior vena cava, and right atrium. This condition is sometimes referred to as 'snowman's heart'. Type II TAPVC is at the cardiac level, with connections to the coronary sinus or right atrium. In type III disease, the connections are infra diaphragmatic, with drainage into the portal vein. In type IV, the connections are mixed, with various flows of the pulmonary veins to the right side of the heart (Fig. 17).

Fig. 16. Truncus arteriosus. Three variants of the condition are recognized. From Elliott (1991), with permission

Fig. 17. Total anomalous pulmonary venous return above the diaphragm, to the coronary sinus, and below the diaphragm. From Elliott (1991), with permission

Fig. 15. Complete transposition of the great arteries. From Elliott (1991), with permission

The 'Tingles'

In CHD patients with a single ventricle ('tingle ventricle'), there will be situs anomalies and an inapparent pulmonary artery segment except for a double-outlet right ventricle. Other forms of this abnormality are single atrium ('tingle atrium') and tricuspid atresia (without right ventricular outflow tract obstruction).

Hypoplastic Left Heart

The radiographic findings in patients with hypoplastic left heart include a normal to mildly enlarged heart (1-3 days), pulmonary edema, severe pulmonary venous obstruction, and right to left shunt across the posterior descending artery. Echocardiography is diagnostic and will demonstrate an enlarged right heart and pulmonary artery as well as an underdeveloped left heart and ascending aorta. CT/MR imaging will also show the underdeveloped left heart. A hypoplastic ascending aorta and aortic valve can be seen on angiography, which also reveals the positions of the coronary arteries, posterior descending artery, and brachiocephalic arteries (Fig. 18).

Clinical Information

The presence or absence of cyanosis and the age of the patient are important factors to consider in the diagnosis of CHDs. Diagnostic accuracy is increased by obtaining a detailed clinical history, a chest radiograph, ECG, and echocardiogram. CT and MR imaging will often provide invaluable diagnostic information, as will cine angiocardiography or digital subtraction angiography. Interventional procedures may also be required.

Suggested Reading

Amplatz K, Moller JH (1993) Radiology of Congenital Heart Disease. Mosby Year Book, St. Louis

Berdon WE, Baker DH (1972) Vascular anomalies and the infant lung; rings, slings and other things. Semin Roentgenol 7:39-64

Chen Q, Guuhathakurta S, Vadalapali G et al (1999) Cor triatriatum in adults: three new cases and a brief review. Texas Heart Inst J 26:206-210

Elliott LP (1991) Cardiac Imaging in Infants, Children and Adults. JP Lippincott, Philadelphia

Gedgaudas E, Moller JH, Castaneda-Zuniga WR, Amplatz K (1985) Cardiovascular Radiology. WB Saunders, Philadelphia

Gomes AS, Lois JF, George B et al (1987) Congenital abnormalities of the aortic arch: MR imaging. Radiology 165:691-695

Higgins CB, deRoss A (2006) MRI and CT of the Cardiovascular System. Lippincott Williams and Wilkins, Philadelphia

Higgins CB, Silverman NH, Kersting-Sommerhoff BA, Schmidt, K (1990) Congenital Heart Disease. Raven Press, New York

Jolles H, Henry DA, Rupp SB (1988) General case of the day – cor tiatriatum. Radiographics 8:1227-1231

Kandarpa K (1989) Handbook of Cardiovascular and Interventional Radiologic Procedures. Little Brown, Boston/Toronto

Kellenberger CJ, Yoo S, Büchel ERV (2007) Cardiovascular MR imaging in neonates and infants with congenital heart disease. Radiographics 27:5-18

Laya BF, Goske M, Morrison S et al (2006) The accuracy of chest radiographs in the detection of congenital heart disease and in the diagnosis of specific congenital cardiac lesions. Pediatr Radiol 36:677-681

Lee EY, Siegel MJ, Chu CM et al (2004) Amplatzer atrial septal defect occluder for pediatric patients: Radiographic appearance. Radiology 233:471-476

Medellin GJ, DiSessa TC, Tonkin ILD (1989) Interventional catheterization in congenital heart disease. Radiol Clin North Am 27:1223-1240

Miller SW (2005) Cardiac Radiology – The Requisites. Mosby, St Louis

Milne ENC, Pistolesi M (1992) Reading the Chest Radiograph: A Physiologic Approach. Mosby, St Louis

Mullins CE, Mayer DC (1988) Congenital Heart Disease: A Diagrammatic Atlas. Alan R. Liss, New York

Netter FL (1969) The Ciba Collection of Medical Illustrations. Vol. 5, Heart. Ciba, New York

Strife J, Bisset GS (1991) Cardiovascular System, Chapt 5. In: Kirks DR (ed) Practical Pediatric Imaging, 2nd edn. Little Brown, Boston/Toronto

Swischuk LE, Sapire DW (1986) Basic Imaging in Congenital Heart Disease., Williams and Wilkins, Baltimore

Tonkin ILD (2000) Imaging of pediatric congenital heart disease. J Thor Radiol 15:274-279

Tonkin ILD (1992) Pediatric Cardiovascular Imaging. Pennsylvania, WB Saunders, Philadelphia

White RD, Higgins CB (1989) Magnetic resonance imaging of thoracic vascular disease. J Thorac Imag 4:34-50

White RD, Zisch RJ (1991) Magnetic Resonance Imaging of Pericardial Disease and Paracardiac and Intracardiac Masses, Chapt 53. In: Elliott LP (ed) Cardiac Imaging in Infants, Children and Adults. JB Lippincott, Philadelphia, pp 420-433

Fig. 18. Hypoplastic left heart. From Elliott (1991), with permission

Interventional Techniques in the Thorax of Adults

B. Ghaye, R.F. Dondelinger

Department of Medical Imaging, University Hospital Sart Tilman, Liège, Belgium

Non-vascular Interventions

Percutaneous Transthoracic Needle Biopsy

Percutaneous lung biopsy was first described by Leyden, in 1883, and was carried out in order to establish the infectious nature of lung disease. Currently, percutaneous tissue sampling of a pulmonary, pleural, or mediastinal lesion is indicated when histological diagnosis will further influence the diagnostic strategy and therapeutic options, or modify tumor staging and the sequence of cancer treatment. Cost efficiency by shortening hospital stay has also been demonstrated [1].

Indications

The main indications for percutaneous transthoracic needle biopsy (PTNB) can be summarized as follows [2]: (1) pulmonary nodule(s) without specific diagnostic criteria on computed tomography (CT) that ascertain benignity; (2) a pulmonary nodule(s) or mass suggestive of malignancy in a patient whose surgery will be postponed or replaced by chemotherapy and/or radiotherapy – for example, a patient who refuses invasive diagnostic procedures and therapy but may change his or her mind when irrefutable proof of malignancy is established by percutaneous biopsy; (3) pulmonary nodule(s) in a patient with a history of extrapulmonary primary malignancy and who is either in clinical remission or who presents with several primary malignancies; (4) a residual non-regressive lesion following radiotherapy or chemotherapy; (5) tissue sampling for therapeutic sensitivity tests; (6) measurements of tumor markers or hormone dependence; (7) analysis of DNA, chronic diffuse pulmonary infiltrates in selected patients, pleural nodule or mass of indeterminate origin, mediastinal mass, or adenopathy. The requirement for preoperative diagnosis of a solitary pulmonary nodule varies between institutions but also depends on the pretest probability of diagnosing a lesion that would obviate an unnecessary thoracoscopy or thoracotomy, and on the demand of the patient [3]. Concerning the X-ray and CT characteristics of pulmonary nodules, the following observations should be noted: 43% of nodules with a diameter <1 cm are benign 97% of nod-

ules with a diameter >3 cm are malignant 33% of primary malignant nodules have regular contours 46% of benign nodules are spiculated 26% of benign nodules and 5% of malignant nodules show microcalcifications on CT 21% of benign and 40% of malignant nodules contain an air bronchogram. Overall, a correct diagnosis is established with CT in 66-98% of patients [4]. PTNB is a useful alternative to mediastinoscopy or mediastinotomy for tissue diagnosis of enlarged hilar or mediastinal lymph nodes. All areas of the mediastinum are accessible to PTNB. Furthermore, the technique is faster, better tolerated, and less expensive [5]. Percutaneous puncture is also indicated in other conditions: intracavitary injection for treatment of secondary aspergillomas [6] insertion of a harpoon or injection of methylene blue or black carbon as a localizer prior to pleuroscopic or video-assisted thoracic surgery (VATS) of lung nodules or of highest yield areas for infiltrative disease [7-10], and percutaneous brachytherapy of pulmonary malignancy [11]. Lesions with a diameter <3 cm and seated in the outer third of the lung or near a fissure are usually considered for PTNB examination.

Contraindications

Vascular structures, such as aneurysm or pulmonary arteriovenous malformation, hydatid cyst, meningocele and mediastinal pheochromocytoma, are absolute contraindications of PTNB. The correct diagnosis should instead be established with cross-sectional imaging. The following are relative contraindications: puncture of both lungs on the same day, puncture of only one functional lung, chronic respiratory insufficiency, pulmonary arterial hypertension, cardiac insufficiency, recent myocardial infarct, angina, severe emphysema, and bullae situated in the vicinity of the pulmonary lesion. A coagulation defect should be recognized and corrected before sampling. Cough, dyspnea, and reduced patient cooperation are other limiting factors. Mechanical ventilation is a relative contraindication of PTNB.

Technique

PTNB is preferentially done under uni- or biplanar fluoroscopy control, when the target can be precisely local-

ized [12, 13]. It should be remembered that projection of a lesion can vary over 4 cm when the patient's position changes from supine to prone. The needle path should avoid traversing intercostal vessels (i.e., needle entry is optimally defined at the mid-intercostal space). A lesion that is difficult to see with fluoroscopy can be localized with CT [14]. CT is particularly useful for lesions that are situated at the apex and the base of the lung, in the posterior sulcus, or at the pulmonary hilum. Mediastinal and hilar vascular structures surrounding a lesion are recognized with contrast-enhanced CT. In complex situations, CT may reveal a tumor obscured by atelectasis, obstructive pneumonia, or pleural effusion. Central tumor necrosis is recognized on the basis of central low densities after intravenous contrast injection. The biopsy needle should be directed to the viable tumor component, which is situated at the periphery of the lesion. CT recognizes the pleural fissures and avoids lobar transgression. Non-aerated lung or symphyses established between a pulmonary lesion and the pleura allow use of this needle pathway and thus minimize the risk of pneumothorax. PTNB performed at the site of pneumonectomy to disclose local cancer recurrence is best monitored with CT. Spiral scanning did not prove to be superior to conventional CT in the monitoring of percutaneous lung biopsy in our experience, based upon a prospective comparative study [15]. It is more time-consuming and should be applied only in those cases in which identification of the needle tip is problematic in a non-cooperative patient or when an oblique pathway of the needle is necessary. Real-time CT (fluoro-CT or continuous CT) is now becoming widely available and makes CT control even more expedient [16]. Slices or a lung volume can be acquired continuously, which allows reliable control of the procedure. Ultrasound (US) can be used to guide the puncture of pleural or subpleural lesions [17]. A large number of cutting or aspiration biopsy needles, including automatic pistols with a needle caliber of <1 mm and a variable tip design, are currently used. Almost all needles allow cytological and histological samples and give similar rates of results and complications. Several percutaneous passes are performed when the anticipated risk of complications is low.

Results

PTNB has an accuracy varying from 80 to 95% in the confirmation of malignancy [14, 18-26]. In a comparative study, sputum and bronchial aspiration alone were diagnostic of cancer in 5.4% of patients, PTNB alone in 72.6%, and both techniques were in agreement in 22% [25]. Inadequate cytologic smears were noted in up to 17% of patients and allowed no interpretation in 9% in a larger series [27]. Additional false-negative diagnoses were obtained in about 5% and were caused by inadequate sampling, tumor necrosis, crushed cells, or errors in sampling reading. The negative predictive value of percutaneous pulmonary biopsy is 84-96% and false-positive re-

sults are noted in 2-4% of patients [12, 27]. Diagnostic accuracy for small nodules (15 mm) is similar to that for larger lesions [28]. The following criteria should be fulfilled to ascertain that a lung nodule is benign: a technically successful biopsy, adequate aspiration that is not normal lung, no suspicion of cancer in the aspirated cells, and normal bronchoscopy. If a specific diagnosis of benign can be reached, no further exploration is required. Most frequently, a non-specific and non-malignant inflammatory process is evidenced on cytological smears. Such lesions should be followed up for 2 years [22]. If the sampled material is inadequate or insufficient, or in case of a cytologic or clinical suspicion of malignancy, the biopsy should be repeated. The literature reports a mean specific benign diagnosis in 25% of patients. Most mediastinal lesions are of metastatic or lymphomatous origin. Results of PTNB are similar to those of lung biopsy, when metastatic adenopathies are considered. Mediastinal non-Hodgkin's lymphoma can be more accurately diagnosed when either smears or tissue fragments are compared with a previous sampling or a sampling from another, extrathoracic site is available. Confirmation of Hodgkin's disease is difficult, particularly the scleronodular type or following mediastinal radiotherapy. Inconclusive results are obtained in tumors of the thymus or other primary malignant neoplasms of the mediastinum and in malignant pleural tumors, even when large cutting needles are used. Examination of the entire resected specimen often remains mandatory. Nevertheless, recent studies have demonstrated that cutting-needle biopsies provide diagnostic material sufficient to guide therapy from 83-95% of lymphoma patients as well as from patients with diffuse pleural thickening [3].

Complications

Pneumothorax is the most frequent complication following PTNB, with an incidence of 8-60%. Less than 5% of patients have persistent clinical symptoms and require aspiration or drainage. Factors influencing pneumothorax are: age, collaboration, respiratory function, elasticity of lung parenchyma, biopsy technique, experience of the surgeon, duration of the procedure, number of needle passes, diameter and flexibility of the needle, emphysema, difficult localization of the target, depth and diameter of the target, mechanical ventilation, and cavitary lesion. Special care should be taken with patients who have undergone thoracic surgical intervention resulting in a potential communication between both pleural spaces, which increases the risk of bilateral pneumothorax. The best prevention of complications is to perform the procedure rapidly and to reduce the number of passes by inspecting the quality of the smears or fragments after each puncture. Pneumothorax is further prevented by the roll-over technique, which consists in turning the patient, following biopsy, for 15-30 min onto the side that was punctured. All patients should be maintained in the recumbent position for 4 h after the biopsy, and then an erect chest

radiograph is obtained. If no pneumothorax is present, compliant patients can be discharged. Asymptomatic patients with a pneumothorax covering one third or less of the lung field are also discharged if the pneumothorax remains stable for 3-4 h. The patient and the accompanying persons are advised to return to the hospital when symptoms suggestive of complications (cough, chest pain, shortness of breath) are noticed. When a large or symptomatic pneumothorax persists, in our experience, a Heimlich valve is inserted under fluoroscopy control. A 7-10F catheter with multiple side holes is inserted in the pleural cavity using the trocar or the angiographic catheter exchange technique. The pneumothorax is aspirated with a syringe, the valve is connected, and its function is checked before the patient is discharged. The catheter is sutured to the skin and the Heimlich valve is loosely attached to the patient's waist. Some patients may be sent home and recalled the next day for a control chest X-ray. In our experience, the pneumothorax disappeared in all cases. If the pneumothorax occurs during mediastinal biopsy, biopsy is completed before the pneumothorax is treated. In the literature, small-bore catheter drainage of iatrogenic pneumothorax was reported to be successful in 75-97% of patients [29-32]. Complications include thoracic pain, pleural effusion, and superinfection. To reduce the risk of pneumothorax or pulmonary hemorrhage during mediastinal biopsy, small amounts of saline can be injected with a small-gauge needle in order to distend the extrapleural tissue, which allows access to most mediastinal lesions, using an exclusive extrapleural pathway without transgression of the visceral pleura [33]. Similarly, extrapleural injection of saline displaces the pleura, allowing for transpleural access to subpleural pulmonary lesions [34]. When a localization wire is placed, dislodgement of the harpoon occurs in 3-10% of patients.

Hemoptysis or hemorrhage is encountered in less than 10% of PTNB procedures, and most are not life-threatening [18, 27, 29]. This complication can be impressive for the patient, but rarely requires specific treatment, as hemorrhage is almost always self-limited. A limited perinodular alveolar hemorrhage is commonly observed on CT and can obscure the nodule, rendering further punctures impossible with fluoroscopy control. Alveolar blood is usually not released to the exterior. Codeine can be given to reduce the cough. Other complications, such as mediastinal emphysema, thoracic-wall hematoma, hemothorax, cardiac tamponade, empyema, bronchopleural fistula, lung torsion, implantation metastasis along the needle tract, air embolus, and sudden death, are rarely observed [35, 36]. The mortality rate of PTNB is estimated at 0.02% [19].

Clinical Usefulness of PTNB

A recent study on the influence of PTNB on treatment showed that management was altered in 51% of patients and unaltered (i.e., confirmed a diagnosis of a resectable malignancy or provided non-diagnostic results) in 49%.

Surgery was avoided in 83% of patients in whom biopsies altered treatment [37]. When the pretest hood likely of malignancy of a resectable lesion is high, thoracotomy is appropriate since preoperative PTNB or fiberoptic bronchoscopy (FOB) is unlikely to alter patient management [3]. Otherwise, PTNB and FOB must be considered complementary and PTNB performed only after a negative FOB. In patients with indeterminate pulmonary nodules, VATS may be the method of choice, as it provides simultaneous diagnosis and treatment and reduces the total cost of care.

Future Direction

The sensitivity of transbronchial needle aspiration (TBNA) for hilar and mediastinal malignancy varies from 34% to more than 90%, according to the experience of the operator and the equipment that is used [38-40]. Nevertheless, one large survey of chest physicians reported that only 12% routinely performed TBNA [41]. Virtual bronchoscopy (VB) is a 4D image reconstruction technique that produces simulated endobronchial images obtained from a spiral CT data set. Recent studies have achieved automatic matching between FOB and VB to guide TBNA of enlarged hilar or mediastinal lymph nodes [40, 42]. Preliminary results show that merging of VB and FOB could improve the results of TBNA, even when small needles (22G) are used [40].

Percutaneous Aspiration and Drainage of Thoracic Fluid Collections

Thoracic fluid collections of various origin, located in the pleura, pericardium, lung, or mediastinum, can be aspirated or drained percutaneously with imaging guidance. Percutaneous therapy is an important refinement compared to blind bedside technique and compares favorably with surgery. Diagnostic fluid aspiration includes cytological, bacteriological, and chemical analyses. Confirmation of malignant cells, exudative fluid, blood, lymph, bile, amylase, clear fluid, or gross pus provide information regarding etiology. Fluoroscopy, US, and CT can be used as guidance modalities, either alone or in combination. The choice of the imaging technique depends on technical characteristics, availability, and location of the collection and operator expertise. Loculated pleural effusions may be treated by thoracocentesis, thoracoscopy, surgically or CT-guided thoracostomy tube drainage, open drainage or thoracotomy and pleural decortication. Imaging guidance best insures proper catheter positioning.

Guidance Modalities

Fluoroscopy

Uni- or biplanar fluoroscopy is used for percutaneous drainage of large pleural and pulmonary collections [31, 43-50]. The patient is placed in a sitting or a posterior

oblique position with the involved side up. A free pneumothorax is drained by a cephalad anterior approach, the patient being in an upright position. Pulmonary abscesses can be drained with fluoroscopy control when a broad contact with the pleura is demonstrated. If a catheter is inserted in a pulmonary or pleural collection with US or CT control, definitive adjustment of the tip of the catheter is easily achieved with fluoroscopy control [51]. For this purpose, we use a combined CT and angiography suite equipped with a single table that pivots on a vertical axis. The patient is examined by fluoroscopy while remaining still for a few seconds [52]. Opacification of thoracic cavities is best documented with fluoroscopy.

Ultrasonography

Ultrasound is particularly indicated to guide bedside percutaneous aspiration and catheter drainage of pericardial and pleural fluid, even of reduced amount [31, 44-46, 51, 53-56]. Pulmonary abscesses that are located in a subpleural location can also be included. Shifting of free pleural fluid during respiratory movements and change of the patient's position is easily observed with US. The percutaneous approach is done with the patient in the position that optimally displays access to the fluid collection.

Computed Tomography

This approach offers exquisite anatomical display of all thoracic structures and allows percutaneous access to all spaces with equal ease [31, 44-47, 51, 57-60]: Most catheters can be inserted with the patient remaining in a supine position. The optimal percutaneous entry point to a pulmonary abscess is defined according to its pleural contact as well as the locations of pleural fissures and vascular structures. CT is particularly useful for the percutaneous approach to the mediastinum, pleural fissures, and pulmonary abscesses with reduced pleural contact. It is the optimal modality to confirm pneumothorax or pneumomediastinum following a percutaneous procedure.

Drainage Techniques

The number and size of percutaneous drainage catheters should be adapted to the number and extent of collections and to the viscosity of the fluid to be drained. Small 7-9F flexible catheters are well-tolerated and sufficient for the short-term drainage of water-like fluid. The trocar technique is the most expedient and can be used in combination with the tandem technique (a trocar is inserted parallel to an 18-gauge needle placed in the collection for aspiration), which is useful for large collections and pulmonary abscesses with a broad pleural contact. The angiographic catheter exchange technique or Seldinger technique is more rarely used in the thorax and most suitable for mediastinal collections or small or encapsulated pleural pockets that are located in the paramediastinal

pleural space [58]. Percutaneous access through the thickened pleura can be difficult, even when regular chest tubes are used, since stiff dilators and guide wires may be required. Chest drainage catheters are connected to continuous negative water-seal suction. Gentle saline irrigation is performed on the ward to increase drainage and maintain catheter patency.

Pleural Empyema

Empyemas develop secondary to preexisting pulmonary, mediastinal, or thoracic-wall infection, spread of cervical or abdominal infection, trauma, surgical or other invasive thoracic procedures, or lung abscess they may also arise from the hematogenous spread of infection. Of the patients with pleural empyema, 50% have coexisting pneumonia. The clinical signs may be torpid and the time interval between the onset of empyema and diagnosis can be several weeks. While antibiotic therapy is necessary, without effective fluid drainage, medical treatment will fail. CT discloses satellite pleural pockets that form rapidly due to pleural adhesions they can be aspirated or drained with small-caliber catheters. Pleural fluid, encapsulated in a fissure, can also be adequately drained with CT control with or without transgression of the collapsed lung parenchyma by the catheter. The diameter of the catheter varies from 7 to 30F according to the viscosity of the fluid.

Indications depend on the evolutionary stage of the pleural effusion [61]. Class 1 and 2 effusions, i.e., those in the exudative phase, are an obligatory transitional phase before the empyema is formed and do not require drainage. Pleural effusion of class 3 can still be treated by complete aspiration of the pleural fluid, but the recurrence rate is 75%. A collection of class 4, i.e., those at the fibrinopurulent stage, should be drained with mid-sized 8-l4F catheters, whereas class 5 effusions regularly require large-bore 20-30F catheters. If drainage is attempted during class 4, pleural thickening may increase to 10 mm within a week. At class 6, fibroblasts infiltrate the thickened pleura and limit expansion of the underlying lung due to pleural peeling.

Technical success is obtained in almost all cases. Multiple catheters are required in 30% of cases. Clinical success is achieved in 70-89% of patients and depends on the stage of empyema. With a history of illness in excess of 1 month before drainage, the procedure may fail in spite of the insertion of multiple catheters. Usually, the duration of percutaneous drainage is about 1 week, although single-session catheter treatment has been described [55]. Radiologically guided drainage procedures exhibit a similar efficiency in patients in whom previous surgical tubes have failed, as in patients treated in a first intent. The failure of percutaneous drainage varies from 12 to 28%. In patients with chronic empyema, pleural thickening can prevent the insertion of a closed catheter. Failure of the pleural cavity to collapse and obliterate occurs in 5-12% of patients and favors recurrence, which requires additional drainage. Opacification of the pleural

catheter with propyliodine oil can reveal unexpected bronchopleural fistulae. Massive bronchopleural fistulae are an indication for surgery. Thick pleural peels often resolve spontaneously after weeks or months and regression can be followed by serial CT examinations. In selected patients, pleural decortication should only be considered if pleural thickening persists [59]. Irrigation and lavage are done when blood or viscous material is present. Intrapleural injection of fibrinolytic agents has been proven to be efficient in the prevention of fibrin deposition and secondary loculation of the empyema (classes 5 and 7 of Light) [47, 49, 61-75]. By reducing the number of pleural pockets, the number of drainage catheters, the length of drainage and hospitalization are also reduced and progressive fibrosis of the pleural surfaces is prevented. Intrapleurally injected fibrinolytic agents do not diffuse through the pleura, and blood coagulation tests are not affected. Urokinase is preferred to streptokinase to avoid possible allergic reactions. Recent surgical branchial suture, macroscopic bronchopleural fistula, and recent trauma should be considered as a relative contraindication of intrapleural injections of fibrinolytic agents [76]. Larger prospective studies are required to evaluate the effect of daily administration of intrapleural fibrinolytic agents on morbidity, mortality, and the need for surgical intervention.

Malignant Pleural Effusion

Recurrent malignant pleurisies are usually drained with soft 8F catheters. Sclerosing drugs (doxycyclin, bleomycin) that limit mesothelial cell secretion are injected through the catheter when basal out- put volume has decreased to ≤100 ml per day. Obstruction of the pulmonary interstitium by metastatic lymphangitis can impede re-expansion of the lung and is a contraindication to treatment. Complete regression of the pleural effusion is obtained in 61-81% of patients and partial resolution in up to 95%, which is equal to the response with larger thoracostomy tubes [48, 56, 77]. In 20-40% of patients, a pneumothorax 'ex vacuo' will appear due to a stiff and non-compliant lung after chronic compression. In 50% of those patients, the lung will re-expand within the next few days, but in the other 50% air will persist until fluid has re-accumulated. Nevertheless, even in the latter situation, dyspnea can be dramatically improved.

Posttraumatic Hemothorax

Massive hemothorax should be drained to reduce compression of the underlying lung parenchyma and prevent encapsulation and adherences. Large-bore catheters are mandatory and pleural lavage can be useful. In selected cases, careful angiographic workup is indicated, including catheterization of all potentially involved intercostal, internal mammary, and inferior phrenic arteries. Active arterial bleeding is treated by hemostatic embolization with gelfoam, polyvinyl alcohol particles, or coils.

Gaseous Collection

Post-biopsy or spontaneous pneumothorax can be drained percutaneously with small-caliber catheters [30-32]. The pneumothorax is evacuated for patient comfort and safety or to continue PTNB if accurate localization of the lesion becomes difficult. Most pneumothoraces can be connected to a Heimlich valve and, when recurrent, chemically pleurodesed. Percutaneous drainage of pulmonary pneumatocele has also been described [78].

Pulmonary Abscess

Pyogenic pulmonary abscesses occur rarely today, due to progress in antibiotic treatment and more efficient eradication of the cause. They are mainly seen in adults whose general condition is debilitated by cancer, alcoholism, malnutrition, diabetes and immune deficiency. Pulmonary abscess results from hematogenous spread, infection of a preexisting pulmonary cavity (emphysematous bulla, posttraumatic pneumatocele or pseudocyst, tuberculosis, fungus), pulmonary infarction, or tumor. A pulmonary abscess can complicate pneumonia with or without bronchial obstruction. If the abscess resists medical treatment, percutaneous drainage in addition to postural and bronchoscopic drainage is required.

A percutaneous diagnostic aspiration with an 18-gauge needle can precede catheter insertion in doubtful cases. Bullae may frequently contain an air-fluid level, but are not necessarily infected. An abscess with a diameter of 1-3 cm is adequately treated by a single percutaneous aspiration and antibiotics. Endoscopic transbronchial placement of a catheter inside a lung abscess can be planned with CT and monitored with fluoroscopy control. Transbronchial drainage is less comfortable for the patient than a percutaneous approach. Contamination of the opposite lung is also a risk with the transbronchial technique. Mechanical ventilation is not a contraindication for percutaneous abscess drainage [79]. Pyogenic lung abscesses are often located in the periphery of the lung and usually they do not break through the lobar fissure. Pleural symphyses are rapidly established. The broad pleural contact allows planning of a percutaneous access such that the normal lung parenchyma is not crossed by the drainage catheter. Pleural empyema by direct contamination is unlikely to occur when the trocar technique is used in practice, there is no difference whether an empyema or a large lung abscess is drained. The trocar technique is the preferred drainage modality. Generally, 7-14F catheters are adequate. The drainage catheter is connected to a negative water-seal aspiration. Pulmonary abscesses have a relatively thick wall and do not collapse rapidly after aspiration. The duration of drainage varies, and the cavity may close only after 4 or 5 weeks. Decompression should be done slowly in order to avoid rupture of a vessel or a so-called Rasmussen pseudoaneurysm that is incorporated or located close to the abscess wall. Lavage of a pulmonary abscess is dangerous

due to the risk of bronchogenic spread of pus. Injection of contrast medium through the drainage catheter does not add significant information, but patency of the catheter should be maintained by daily injection of a minimal amount of saline. Daily chest radiographs are imperative for monitoring regression of the abscess cavity and for the early detection of complications.

Cure of the abscess is obtained in 73-100% of patients but overall mortality is high, due to poor general condition or the presence of underlying disease [53, 57, 58, 60, 79-84]. Surgery is indicated when extensive necrosis of the lung parenchyma or life-threatening hemorrhage occurs. Temporizing percutaneous drainage cures the abscess, but surgery may be required to remove necrotized tissue or for pleural decortication.

Mediastinal Collection

Mediastinal abscesses result from circumscribed mediastinitis. They are among the most challenging infections to treat, as the prognosis of diffuse mediastinitis is poor. CT distinguishes diffuse infiltration of mediastinal planes from circumscribed abscess, but separation between acute mediastinitis and post-surgical changes can remain problematic in the early phase. Most purulent mediastinal collections result from trauma, either penetrating transthoracic injury or perforation of the esophagus. Thoracic and mediastinal surgery can be followed by mediastinal abscess formation, and other intra- or extrathoracic infections can also spread to the mediastinum. CT is the most useful modality for the diagnosis and planning of percutaneous drainage of mediastinal collections. Abscesses in the anterior mediastinum are drained by a parasternal approach, avoiding the internal mammary vessels. Abscesses that are located in the middle and posterior mediastinal compartment are treated by paravertebral and extrapleural approaches. In selected cases, a percutaneous cervical descending approach following the pathway of the infection can be used [2]. Multiple catheters are often necessary and are placed either at both sides of the thoracic spine, or the sternum, or in the upper and lower parts of the mediastinum. Esophageal perforation is usually treated conservatively [85]. An endo-esophageal catheter can be inserted through the esophageal tear or in combination with a percutaneous drainage catheter placed at the site of leakage. When a fistulous tract is present between the mediastinal abscess and an empyema or a subphrenic abscess, percutaneous drainage of these collections may resolve the mediastinal abscess [86]. Only a limited number of patients with percutaneous drainage have been described in the literature [57, 85-87]. Cure is obtained in 83-100% of patients, according to the radiological literature, which does not consider the 30-day mortality rate. Other mediastinal fluid collections, such as pancreatic pseudocysts, pleuropericardial or bronchogenic cysts, infected tumor, lymphocele, or hematoma, can be aspirated or drained percutaneously.

Pericardial Fluid Collection

Diagnosis of this condition is confirmed with transthoracic or transesophageal US [88]. Causes of pericardial effusion include cardiac insufficiency, malignant tumors, postoperative effusion, pericarditis, hypothyroidism, connective tissue disease, and trauma. Percutaneous aspiration of pericardial fluid is indicated for diagnosis percutaneous drainage prevents cardiac tamponade. Clinical signs of tamponade include dyspnea, tachycardia, compromised venous return, and paradoxical pulse. Large amounts of pericardial fluid can be drained under CT control, sometimes with an atypical left anterolateral puncture. However, most effusions are evacuated with US guidance by a subcostal or a subxiphoid approach. The angiographic catheter exchange technique is mainly used, with the initial puncture being done with an 18-gauge or a 5F Teflon-sheathed needle. A 5-7F pig-tail catheter is placed in the pericardial space [89]. Technical success of the procedure and decompression of the heart are achieved in almost all patients when the effusion is of sufficient amount. The duration of drainage is several days only. Chylopericardium can be difficult to drain and may require thoracic duct ligation or pericardectomy.

Percutaneous Drainage of Tension Pneumomediastinum

Tension pneumomediastinum results from barotrauma in patients with increased pulmonary resistance who are mechanically ventilated, with an elevated PAP and PEEP. Alveolar rupture results in interstitial emphysema that migrates to the mediastinum along the bronchovascular sheaths. When the mediastinal air fails to escape, due to adhesions or scarring, tension pneumomediastinum develops. CT shows unequivocally the air collection in the mediastinum. It mainly dissects the anterior mediastinal fat planes, compressing the mediastinal vessels and the heart. Compromised venous return, cardiac and respiratory insufficiency, and anuria strongly indicate rapid decompression. A left-sided pneumothorax is usually associated with this condition.

Usual treatment of tension pneumomediastinum is mediastinostomy. Percutaneous catheter drainage is an alternative emergency treatment. A soft 12F or 14F drainage tube can be inserted into the mediastinum behind the sternum with CT guidance by a left anterolateral percutaneous approach. Multiple side holes are necessary to avoid catheter occlusion during negative water-seal aspiration. When a left pneumothorax is also present, the mediastinal catheter should be inserted before exsufflation of the pleural air collection [90].

Complications of Percutaneous Catheter Drainage

Complications occur in approximately 5% of patients and are mainly due to an inadequate catheter-insertion technique [43, 46, 51, 80, 81, 87]. Injury to an intercostal artery can produce a hemothorax or a hematoma of the

thoracic wall. Life-threatening hemorrhage is rare but can be observed following rupture of the wall of a pulmonary abscess, erosion of a branch of the pulmonary artery, or transfixation of an internal mammary or mediastinal vessel by the catheter. Patients undergoing pericardial drainage are prone to most of the clinically significant complications, such as hemopericardium with tamponade, dysrhythmia, pneumopericardium, or superinfection. The thoracic catheter can be introduced erroneously in the subdiaphragmatic space, liver, or spleen when cross-sectional imaging is not used properly. When the catheter creates a communication between a pulmonary abscess and the pleural space, a secondary empyema or a bronchopleural fistula may be established. When normal lung is crossed with a large-bore catheter, as may occur when the trocar technique is used, pulmonary infarction can result. A pleural sinus tract through the chest wall can persist if the patient has undergone previous irradiation, but chest-wall gangrene is rare. Transient bacteremia and hemoptysis can occur during catheter insertion. Pneumothorax is a potentially frequent complication, but can be avoided by proper cross-sectional imaging. Complications are best avoided by the proper planning of a percutaneous approach with CT control. When fluoroscopy is used predominantly as a guidance modality for thoracic drainage procedures, the overall complication rate is as high as 20%, most being minor events. Other side-effects include subcutaneous emphysema, local skin infection at the entry point of the catheter, discomfort during breathing, rib erosion, and catheter leakage, bending, breakage, or obstruction

Endoluminal Tracheobronchial Stenting

Indications

Tracheobronchial airway obstruction is a relatively common condition. Various therapeutic options are available and depend on the cause (benign vs. malignant), location (central vs. peripheral), and origin (intrinsic vs. extrinsic) of the stenosis. The patient's condition and the prognosis of disease must also be considered. Whenever possible, in patients with malignant obstruction or benign stenosis, surgery is the treatment of choice [91]. With progress in technique, local treatment by bronchoscopy (laser, cryotherapy, electrocautery, photodynamic therapy, brachytherapy) has been used with increasing frequency [91-96]. Balloon dilatation leads to a rapid improvement of the respiratory function after treatment of malignant and benign bronchial stenosis, but relief of symptoms is often short-lasting [97, 98]. Therefore, indications for the placement of a stent in the tracheo-bronchial tree have increased in frequency. The procedure can be done under radiological and/or bronchoscopic control [98, 99]. Compared to surgery, stent insertion is a simple palliative method, resulting in immediate improvement in acute respiratory distress from airway obstruction [98]. In non-surgical patients with malignant disease, indications of tracheobronchial stenting are: extrinsic compression or submucosal disease,

tracheo-esophageal fistula, and obstructive endobronchial tumor unresponsive to endobronchial treatment by debulking or resection [98-107]. In benign stenosis, surgery may not be indicated in patients with a short life expectancy or with extensive airway stenoses. Stent insertion for benign stenosis has been reported in the following conditions: iatrogenic (post-intubation or post-anastomotic stricture), tracheo-bronchial malacia in children, extrinsic compression from vascular structures or fibrosing mediastinitis, tracheobronchial infection (tuberculosis), and systemic disease (Wegener's granulomatosis, relapsing polychondritis and amyloidosis) [98, 99, 101, 107-113].

Technique

Precise measurements of the diameter of the tracheal and bronchial lumen and location of the stenosis compared to anatomical landmarks are obtained with spiral CT before the procedure. Stents are inserted under sedation or anesthesia, following previous dilatation or laser ablation of the stenosis under fluoroscopic and endoscopic control. Two types of endobronchial stents are currently available in the tracheo-bronchial tree: silicone stents (Dumon, Dynamic, Reynders, and others) [98-100, 103, 105, 107] and metallic stents, the latter including either balloon-expandable stents (Palmaz and Strecker) or self-expanding stents (Gianturco, Wallstent, Ultraflex) [98, 99, 104, 107, 109, 110, 114, 115]. Most metallic stents are available in covered and non-covered versions. None of these stents are ideal thus, the type of stent to be used is a matter of debate and is often dictated by availability and individual preference. Most metallic stents can be inserted on an outpatient basis.

Results

The placement of a stent leads to an immediate and significant decrease of symptoms as well as improvement in respiratory function in 80-95% of the patients. Most of the patients with severe respiratory impairment are able to be discharged following treatment. As results depend on optimal positioning of the prosthesis and some of the stents show a poor visualization under fluoroscopy, new advances in CT fluoroscopy are promising guiding techniques that allow precise and real-time control of stent insertion in selected cases.

Complications

Complications are related to the type of stent and include early or late stent migration (1-19%), infection (3-22%), deformation or breakage (1-36%) and stent obstruction by secretions, granulation formation, or tumor overgrowth (6-21%). Other complications, such as major hemorrhage and tracheobronchial fistula, are rare. New developments in stent configuration and composition seem to be associated with easier introduction and a lower rate of complications.

Percutaneous Ablation of Thoracic Malignancies

Indications

Only 15-30% of the patients presenting with pulmonary malignancies are surgical candidates [116, 117]. However, these patients frequently present with poor general condition or comorbid cardiopulmonary disease and consequently are at high surgical risk or exhibit insufficient reserve to tolerate lobectomy. In these circumstances, external-beam radiation therapy with or without chemotherapy are alternative treatment options, resulting in a modest improvement in survival but often at the expense of substantial toxicity for the patient [117]. In the continuing search for better therapeutic regimens, minimally invasive percutaneous ablation of focal malignant disease has emerged. Preliminary studies on the percutaneous electrochemical polarization of cancer [118] have resulted in the development of new modalities, including percutaneous brachytherapy [119] and radiofrequency tumor ablation. Focal malignant disease located in the liver, kidney, breast, thyroid, head and neck, bone, and recently in the thorax has been treated by radiofrequency energy as an adjuvant or a substitute to other therapeutic modalities [116, 120-122]. Various energy sources have been investigated, including radiofrequency (RF) [116, 117, 120, 123], microwaves [124], cryotherapy, and laser therapy [125]. RF ablation, which is the most frequently used technique, works by delivering energy into the lesion through an inserted probe [120, 126]. Lesions located in the lung, mediastinum, pleura, or chest wall have been safely treated under CT guidance, mainly using RF energy. Lung tumors seem well-suited for RF ablation, due to the isolation effect of air in normal lung tissue surrounding the lesion, which may concentrate the RF energy inside the target [127]. Normal lung tissue rapidly heals from thermal injury, and damage to the surrounding unaffected lung remains minimal. Due to differences in resistance to electric flow between air-containing and condensed lung parenchyma, it is safer to wait for resolution of inflammatory consolidation in contact with the lesion before performing RF ablation [117]. The condition of hypoxia and limited blood flow found in the center of a necrotic tumor, which typically renders cells more resistant to radiation therapy and chemotherapy, makes them more sensitive to RF ablation, as heat dissipation is decreased [126]. Synergistic effects of associated RF ablation and brachytherapy in the same session have been reported in patients unlikely to tolerate external radiation therapy [126, 128, 129]. RF ablation alone or in conjunction with radiation therapy and/or chemotherapy may be considered for T1-T3, N0, M0 tumors in non-surgical candidates or in patients who refuse surgery [120, 126, 128, 130, 131]. Lesions located in the chest wall, tumor recurrence in the radiation field, and intractable symptoms, such as cough, hemoptysis, or pain, are particularly well-suited indications for RF ablation. Patients with extra-thoracic malignancies may present with multi-focal thoracic disease refractory to aggressive chemotherapy and not amenable to surgical metastatectomy or radiation therapy [116,130-133]. When applicable, surgical resection of metastasis has been shown to be safe and to provide extended survival [133]. RF ablation can be applied in patients with a small number of pulmonary lesions or in those with larger symptomatic lesions [126, 133].

Technique

The procedure is usually performed with the patient under conscious sedation on an outpatient basis or followed by an overnight hospital stay [116, 117, 120, 122, 126, 128, 129, 131-133]. Other advantages over surgical resection include repeatability as well as reduced morbidity, mortality, and cost [126-133]. The technical ease of needle placement is similar to percutaneous biopsy [116]. Accurate probe deployment is greatly facilitated by the use of CT fluoroscopy [133]. RF energy is delivered at a high frequency of 400-500 kHz through a needle electrode positioned into the targeted tissue. The ionic agitation resulting from the alternating current around the probe results in frictional or resistive heating of the tissue, coagulation necrosis, and cell death. The degree and extent of ablation are dependent upon the energy applied, inherent tissue impedance, the rate of tissue cooling, and tissue vaporization. Various probe designs include single or clustered tips, or umbrella-like deployment of the tip, allowing for maximal distribution of energy and an increase in the size of the thermal lesion created [121]. Devices or algorithms that allow the creation of larger thermal lesions are being developed, such as probes with internal cooling or pulsed administration of RF energy [121]. An intratumoral temperature greater than 90°C must be achieved to ensure adequate thermocoagulation. The amount of RF energy cannot be standardized, as the heat capacity of tumors varies, depending on tumor size, local blood flow, histological composition, and previous treatment. Simultaneous multiple probes, probe repositioning, and sequential applications are frequently required for large lesions until all treatment areas encompass the volume of the tumor mass. A linear relationship between the diameter of the lesion and the ablation time has been demonstrated [117]. The localized edema or hemorrhage that occurs around ablated nodules is frequently used as the treatment endpoint [116, 117].

Follow-up

The type of follow-up appropriate to determining the results of ablation remains challenging [116, 130]. Lesion size alone is not believed to be a reliable measurement of successful ablation during the first 6-12 months [116, 122, 134]. The time interval to demonstrate shrinkage in size as a result of scar formation has yet to be established [116, 117]. Early peripheral rim enhancement consistent with inflammatory granulation tissue must be differentiated from the persistence of tumor tissue [122]. CT densitom-

etry or positron emission tomography (PET) can help as an indicator of success of treatment [116, 133, 134]. MRI has also been used in an experimental model to monitor the ablation procedure and to evaluate therapeutic efficacy [123]. Cavitation, which is most often transient, may be seen due to development of a fistula with adjacent bronchi [126, 133]. Pre-ablation tumor size <3-5 cm is associated with a higher rate of complete tumor necrosis or longer survival [117, 130, 134]. Repeated procedures may be necessary in patients showing persistent viable tumor tissue [117, 133, 134]. The procedure is well-tolerated, although the patient may experience mild to moderate pain or cough during the RF application [117, 133].

Complications

Complications are generally minor [116]. Pneumothorax is the most frequent (10-50%), and the rate of chest tube is similar or slightly higher to that reported after TNB (10-30%) [116, 117, 120, 122, 126, 128, 130-134]. Small pleural effusion, usually self-limited, may occur with peripheral lesions [116, 122, 126, 130, 131, 133]. Pain [132, 133], fever [117, 120, 133], pneumonia [117, 120, 130], ARDS [117], lung abscess [134], and massive bleeding [130, 135] have been reported. No neurological impairment from cerebral embolization of gas bubbles, resulting from tissue heating and charring, has been observed so far [136]. In a large international survey, two deaths were reported in 493 patients (0.4%) [131]. Both patients presented with tumor close to the hilum, which should thus be considered with caution for RF treatment. The use of anticoagulant or antiplatelet drugs must be discontinued before the ablation procedure. The presence of a pacemaker is an absolute contraindication, while other metallic implants are relative contraindications, depending on their proximity to the procedure site [135]. Large studies are needed to determine long-term ablation effectiveness and to further refine indications and assess the effect on quality of life and survival. The technical aspects of percutaneous ablation for lung lesions, such as the development of smaller probes adapted to small lesions, await improvement [116].

Vascular Interventions

This section focuses on the treatment of hemoptysis, pulmonary arteriovenous malformation and pseudoaneurysm, superior vena cava (SVC) obstruction, and percutaneous retrieval of vascular foreign bodies.

Bronchial Artery Embolization

Indications

Hemoptysis can be classified as massive (>300 ml in 24-48 h), moderate (3 or more episodes of >100 ml within a week), or chronic (quantitatively small episodes of he-moptysis repeated over the course of weeks or months). Massive hemoptysis carries a high mortality rate in patients treated conservatively, and many patients are unfit for lung resection. When surgery is performed in an acute situation, morbidity is high and a mortality rate of 35% has been reported [137-140]. The most frequent causes of bleeding include tuberculosis, chronic infection, bronchiectasis, aspergilloma, pneumoconiosis, bronchogenic carcinoma, pulmonary metastasis, and pulmonary infarction [139-143]. Chest radiography and bronchoscopy should be obtained immediately to localize the site of bleeding. CT may be considered in non-critical patients to search for the underlying cause or to determine the exact bleeding site whenever chest radiographs are inconclusive. In patients with massive hemoptysis requiring urgent embolization, angiography is recommended as the initial intervention. Following embolization, surgery can be carried out in a second intent for localized disease [140]. In moderate or chronic hemoptysis, bronchial embolization is the only treatment when the condition is unresponsive to medical treatment in the following situations: recurrent hemoptysis following surgery, post-radiation lung, unresectable carcinoma, bilateral pulmonary disease, inadequate lung function to tolerate resection, failure to localize a bleeding source roentgenographically and/or bronchoscopically, and large transpleural connections between the bronchial and non-bronchial systemic arterial supply.

Technique

A thoracic aortogram is always obtained to map all bronchial arteries and systemic non-bronchial feeders of the bleeding site. All bronchial arteries are then selectively opacified, beginning with the vessels directed to the suspected bleeding area. Arteries with an increased caliber as well as those with a tortuous course and parenchymal hypervascularity can thus be found. Contrast extravasation in the lung parenchyma or in the bronchial lumen is not required to decide on embolization. Vaso-occlusion is best done through a microcatheter inserted coaxially through a diagnostic catheter, the tip of which is placed in the proximal portion of the vessel or at its ostium. Microcatheters, which can be placed selectively distal to the origin of a spinal artery, are not occlusive. In addition, they allow for optimal catheter stability and safety during embolization while avoiding reflux of embolization material [143-145]. Polyvinyl alcohol particles, gelfoam, and dextran microspheres are among the agents that are in frequent clinical use. Additional bronchial and non-bronchial collaterals (internal and external thoracic arteries, periscapular arteries, cervical arteries, intercostal arteries, and inferior phrenic artery) are catheterized and may be treated when their contribution to the hypervascular area is shown on angiography [139, 146, 147]. Non-bronchial systemic collaterals may resume the distal bronchial circulation after a previous bronchial embolization and may thus be responsible for bleeding recurrence [148, 149].

Results

In a review of the recent literature, bleeding (predominantly massive) was controlled in an acute setting in 75-90% of the patients [150]. Bleeding recurrence rate was 16-48%. In one study in which long-term outcome was assessed, the Kaplan-Meier curves showed a recurrence rate of 18% within 7 days, 24% within 1 month, 33% within 6 months, and 38% within 1 year. No further recurrences occurred between 1 and 2 years after embolization [150]. Recurrence can be caused by incomplete bronchial embolization, recanalization of an embolized artery, development of extrapulmonary systemic collaterals (short-term recurrence), or progression of the underlying disease (long-term recurrence) [143, 151]. Usually, recurrent hemoptysis responds to a second embolization procedure. Bleeding from a pulmonary artery should be suspected if the bronchial arteries are angiographically normal or if embolization of the bronchial and non-bronchial arteries fails to stop the bleeding.

Complications

Complications are encountered in 1% of patients. A post-embolization syndrome (pleuritic pain, fever, dysphagia, leukocytosis) lasting for 5-7 days but responsive to symptomatic treatment may ensue [150]. Bronchial-wall or esophageal-wall necrosis, inadvertent facial or abdominal visceral embolization, myocardial infarction, and spinal cord infarction are rare complications that can be avoided by proper technique.

Pulmonary Artery Embolization

Arteriovenous malformation

Indications

Pulmonary arteriovenous malformations (PAVMs) are arteriovenous shunts that represent a potential source of paradoxical emboli through a right to left shunt, without altering pulmonary artery pressure or cardiac output. Other potential complications include systemic oxygen desaturation resulting in polycythemia, and hemoptysis or hemothorax caused by rupture of the aneurysmal sac. Most PAVMs are congenital and multiple, being part of the hereditary hemorrhagic telangiectasia (Rendu-Weber-Osler) syndrome, while a minority are acquired, mainly secondary to vascular damage [143, 152-154]. PAVMs can be classified as simple (one segmental feeding artery and one draining vein) or complex (several segmental feeding arteries and one or several draining veins) [154-156]. Before 1980, surgical lobectomy or pulmonary wedge resection was the only valid therapy. Selective embolization is at present considered the treatment of choice for PAVMs that show a feeding artery >3 mm in diameter. In fact, large shunts are associated with an increased incidence of paradoxical emboli, which potentially cause severe neurological complications [153-160]. Multiple microscopic shunts are usually present in addition to the visible fistulae, and small AVMs may increase in size during the patient's lifetime. Endoluminal embolization offers the advantage of maximal preservation of normal lung parenchyma around the malformation, particularly in patients with multiple and bilateral PAVMs.

Technique

Pre-embolization thin-section helical CT with 3D reconstruction of the PAVM is an important step in identifying all small feeding arteries, which may be responsible, when not recognized, for persistent shunting following embolization of the main feeder only [156]. Selective transcatheter embolization of all feeding arteries is done using steel coils with attached cotton strands. All catheter and guidewire exchanges as well as coil introduction into the catheter are carried out 'under water' to avoid air embolism to the brain. Compact placement of endoluminal coils and the choice of large 'tornado-' or 'nest-' shaped coils, or the use of a controlled coil detachment technique, are important points for successful treatment to avoid transfistulous coil migration. The site of groin access should be alternated in multiple interventions to avoid femoral vein thrombosis.

Results

The closure rate of PAVMs is 98% and results in palliation of the right to left shunt as well as probable prevention of the hemorrhagic and thromboembolic complications caused by major PAVMs [143]. There is no evidence-based benefit on patient survival. Multiple treatment sessions are needed in 20-40% of cases. Embolization can fail in patients with an unrecognized persistent feeding artery recruitment of feeders, including bronchial arteries in 4% of the cases recanalization of occluded feeders or growth of other PAVMs.

Complications

Potential complications are encountered in <10% of the patients and include pulmonary infarction distal to the occlusion, pleurisy, sepsis, and retrograde pulmonary embolism in patients with polycythemia.

Pseudoaneurysm

Destructive processes of any origin, including trauma (particularly iatrogenic, i.e., Swan-Ganz catheterization), infection, tumor, and inflammatory disease, can erode the wall of a pulmonary or bronchial vessel, and lead to the formation of a pseudoaneurysm [161, 162]. Prompt therapy is required, as false aneurysms are at risk of enlargement and rupture, which causes lethal hemoptysis in >50% of patients [163]. Multiple therapeutic procedures have been used to control pulmonary artery bleeding.

Palliative measures include Swan-Ganz balloon tamponade of the affected vessel and endobronchial tube placement with PEEP. Surgical management generally comprises resection of the involved lobe or, in selected cases, aneurysmectomy [163]. Endoluminal catheter embolization of the parent artery with steel coils has emerged as an alternative non-invasive technique, particularly in emergency cases [164]. Intrasaccular embolization with steel coils has the advantage of preserving the distal pulmonary artery and sparing pulmonary function distal to the pseudoaneurysm.

Percutaneous Recanalization and Stenting of the Superior Vena Cava and Innominate Veins

Rationale

The potential of the venous system to collateralize and the usually non-acutely lethal nature of SVC obstruction are the main reasons why medical management and radiotherapy are preferred to other invasive therapeutic procedures for correction. Percutaneous transluminal angioplasty (PTA) is rarely successful in large vein obstruction, due to elastic recoil of the venous wall and/or persistent perivascular compression. The rationale for using expandable metal stents in benign and malignant SVC obstruction is the immediate and permanent achievement of venous patency.

Indications

Potential indications for percutaneous stenting of the SVC and innominate veins are mainly primary or secondary malignant tumors with mediastinal location, such as bronchogenic carcinoma, lymphoma, or metastatic adenopathy, and benign stenoses related to central venous lines, hemodialysis shunts, and, rarely, postoperative anastomotic stenoses, or fibrosing mediastinitis [165-169]. The advantage of endoluminal disobstruction over radiation therapy or chemotherapy is the immediate correction of disabling symptoms and the still possible application in patients who have already received maximum radiation dose. Patients with imminent SVC obstruction should be treated before they become fully symptomatic, e.g., when encasement of the innominate vein-SVC bifurcation is suspected, as a Y-shaped stricture is technically more difficult to treat than a straight vein segment. Multiple and bilateral stents may be required to treat the bifurcation and regional thrombolysis might be necessary to clear the lumen from thrombosis before stenting. Patients receiving nephrotoxic chemotherapy or other nephrotoxic drugs and those in whom extensive tumor lysis with hyperuricemia, hypercalcemia, and emesis-related dehydration are expected may also benefit from SVC disobstruction to increase tolerance of high-volume hydration, even if clinical symptoms of venous stasis are not prominent.

Relative contraindications include preterminal patients with malignant disease, extensive chronic venous thrombosis, endoluminal tumor growth, and upper limb paralysis. Occlusion of the ostium of the azygos vein is not a contraindication. Mechanical thrombectomy using rotational catheters or other devices should not be used in the SVC system, because of the risk of pulmonary embolism by a jugular vein thrombosis that may become mobilized after successful clearance of the downstream veins. Patients with simultaneous tracheobronchial and mediastinal vein obstruction should undergo stenting of the airways first.

Technique

Although SVC stenting is a straightforward procedure in simple cases, it can become extremely complex in patients with extensive obstruction. Phlebographic demonstration by a bilateral arm injection of contrast medium is mandatory before treatment, to locate the obstruction as well as to appreciate its hemodynamic significance, extent of collateral venous drainage, and any congenital variants and allow planning of the stenting procedure. In patients with severe edema of the upper limbs, puncture of the axillary vein may be targeted by a peripheral injection of a hand vein with carbon dioxide. In case of acute or subacute venous thrombosis, local catheter-directed thrombolysis with an infusion of 70,000-100,000 IU of urokinase per hour or of another plasminogen activator, may be indicated. Chronic occlusion is recanalized with catheter-guidewire techniques by a unilateral or bilateral axillary vein or a femoral vein approach, or a combination of both. Self-expandable and flexible metal stents are placed, when necessary, multiply and bilaterally and in an overlapping position. Stent placement in the subclavian vein is prohibited because of the risk of subclavian vein thrombosis or stent fragmentation by external clavicular compression. Stents in large veins should be oversized by 25-50% compared to the diameter of a fully dilated normal vein. PTA is not indicated prior to stenting in malignant disease, but should be performed after stenting to establish optimal venous return immediately. In stenosis of benign origin, PTA is indicated prior to stenting to probe the degree of stenosis and for precise localization of the maximum of resistance within the stenosed venous segment. Peri-procedure heparinization is advised in all cases [170, 171].

Results

Following successful restoration of flow in the SVC and innominate veins, complete or significant relief from symptoms is obtained in 68-100% of patients with malignant disease [165-171]. Delayed reintervention is only rarely required for a follow-up of 16 months. The type of bare metal stent is irrelevant to clinical results. Covered stents are generally not indicated, as endoluminal tumor extent is an exceptional observation. The most prominent clinical symptoms are corrected within a few hours face and neck edema resolves in 1-2 days, and upper limb edema in 2-4 days. Benign SVC obstruction has been ob-

served with increasing frequency in recent years. Generally, patients with a benign stenosis present at the moment of treatment with extensive thrombosis due to delayed patient referral. Overall, similar results may be obtained in stenosis of malignant and benign origin, although a longer observation time in the benign group allows for more delayed complications to occur. Hemodialysis-related central venous stenoses are particularly prone to the formation of exuberant intimal hyperplasia within the stent or the formation of stenosis in the adjacent venous segment. Repeated PTA or placement of an additional stent may be required during the first years of follow-up. Stents should not be placed in arm veins, as secondary obstruction is the rule [170, 173-176].

Complications

Complications of venous disobstruction are few. Local thrombolysis may lead to hemorrhagic complications. Stent-related complications include misplacement or migration, incomplete stent opening, formation of de novo thrombosis, and pulmonary embolism. Vein perforation, significant infection, and phrenic nerve deficit by stent compression or at the puncture site are rare complications.

Percutaneous Vascular Foreign-Body Retrieval

Indications

Since its introduction, percutaneous catheter-mediated vascular foreign-body retrieval has emerged as the treatment of choice, as it allows thoracotomy and open-heart surgery to be avoided. The growing clinical application of intravascular devices in interventional radiological practice has increased the patient's risk of central venous embolization of many types of foreign materials besides the classical lost central venous lines. These include Swan-Ganz catheters, ventriculo-atrial shunts, port-a-caths, cardiac stimulator lines, and pacemaker electrodes. All intravascular embolized foreign bodies should be retrieved, as they are potentially associated with serious complications according to their type and location. A 21-71% long-term serious morbidity and a 25% death rate were reported [177-181]. Expected complications from a foreign body that is partially or entirely blocked in the right heart are ventricular arrhythmia, myocardial infarction, myocarditis, recurrent pericardial effusion, tamponade, and sepsis. Foreign bodies blocked in the pulmonary circulation may be responsible for thromboembolism and sepsis. Relative contraindications of catheter retrieval are free-floating thrombus attached to the foreign body and chronic incorporation of the foreign body in a thrombus or vessel wall.

Technique

Vascular foreign bodies are located with fluoroscopy and, when necessary, phlebographic demonstration. Extraction devices are relatively inexpensive and based on the loop-snare technique, helical basket entrapment, the grasping forceps technique, or a combination of the above and other catheter-guidewire dislodgment techniques. The procedure is carried out under fluoroscopic control and with local anesthesia. Large and uncompressible foreign bodies may require a femoral venotomy for extraction. Large stents retrieved from a pulmonary artery or from the heart may become abandoned in an iliac vein.

Results

The literature reports a success rate of over 90% following closed percutaneous retrieval [181]. The procedure may fail when no free ends of an endovascular line are available for snaring, when small catheter fragments are lodged too far in a small pulmonary artery branch, or when small objects are incorporated in the wall of cardiac chambers, lodged in a thrombosed vein, or have perforated outside the venous wall. Failure of percutaneous extraction is obviated by early treatment, without waiting for clinical symptoms to occur. Complications from percutaneous retrieval are rare but include transient arrhythmia, further distal pulmonary embolization of a friable foreign body, and thrombosis at the puncture site.

References

1. Dicato M, Freilinger J, Dondelinger RF, Kurdziel JC (1990) Economic considerations. In: Dondelinger RF, Rossi P, Kurdziel JC, Wallace S (eds) Interventional Radiology. Thieme, Stuttgart, pp 142-155
2. Dondelinger RF (1991) Interventional Radiology of the Chest: Percutaneous Procedures. In: Imaging of the Chest (Syllabus). European Congress of Radiology (ECR), Vienna. Springer, Heidelberg, pp 165-175
3. Klein JS, Zarka MA (1997) Transthoracic needle biopsy: an overview. J Thorac Imaging 12:232-249
4. Minami M, Kawauchi N, OkaH et al (1992) High-resolution CT of small lung nodules: malignancy versus benignancy. Radiology 185:357
5. Protopapas Z, Westcott JL (1996) Transthoracic needle biopsy of mediastinal lymph nodes for staging lung and other cancers. Radiology 199:489-496
6. Giron JM, Poey CG, Fajadet PP et al (1993) Inoperable pulmonary aspergilloma: Percutaneous CT -guided injection with glycerin and Amphotericin B paste in 15 cases. Radiology 188:825-827
7. Strautman FR, Dorfman GS, Haas RA (1992) Prebiopsy wire localization of a small peripheral lung nodule. J Vasc Intervent Radiol 3:391-393
8. Shah RM, Spirn PW, Salazar AM et al (1993) Localization of peripheral pulmonary nodules for thoracoscopic excision: Value of CT-guided wireplacement. AJR Am J Roentgenol 161:279-283
9. Templeton PA, Krasna M (1993) Localization of pulmonary nodules for thoracoscopic resection: use of needle-wire breast-biopsy system. AJR Am J Roentgenol 160:761-762
10. Spirn PW, Shah RM, Steiner RM et al (1997) Image-guided localization for video-assisted thoracic surgery. J Thorac Imaging 12:285-292
11. Brach B, Buhler C, Hayman MH et al (1994) Percutaneous computed tomography-guided fine needle brachytherapy of pulmonary malignancies. Chest 106:268- 274

12. Dahlgren S, Nordenstrom B (eds) (1966) Transthoracic Needle Biopsy. Almquist and Wiksel, Stockholm
13. Flower CDR, Verner GI (1979) Percutaneous needle biopsy of the thoracic lesions: an evaluation of 300 biopsies. Clin Radiol 30:215-218
14. Van Sonnenberg E, Casola G, Ho M et al (1988) Difficult thoracic lesions: CT-guided biopsy experience in 150 cases. Radiology 167:457-461
15. Ghaye B, Dondelinger RF (1999) Percutaneous CT guided lung biopsy: Sequential versus spiral scanning. A randomized prospective study. Eur Radiol 9:1317-1320
16. Katada K, Kato R, Anno H et al (1996) Guidance with real-time CT fluoroscopy: Early clinical experience. Radiology 200:851-856
17. Yang PC, Luh KT, Lee YC et al (1991) Lung abscesses: US examination and US-guided transthoracic aspiration. Radiology 180:171-175
18. Westcott JL (1980) Direct percutaneous needle aspiration of localized pulmonary lesions: results in 422 patients. Radiology 137:31-35
19. Greene R (1982) Transthoracic Needle Aspiration Biopsy. In: Athanasoulis CA, Pfister RC, Greene R, Roberson GH (eds) Interventional Radiology. Saunders, Philadelphia, pp 587-634
20. Calhoun P, Feldman PS, Armstrong P et al (1986) The clinicat outcome of needle aspirations of the lung when cancer is not diagnosed. Ann Thorac Surg 41:592-596
21. Greene R, Szyfelbein WM, Isler RJ et al (1985) Supplementary tissue-core histology from fine-needle transthoracic aspiration biopsy. AJR Am J Roentgenol 144:787-792
22. Khouri NF, Stitik FP, Erozan YS et al (1985) Transthoracic needle aspiration biopsy of benign and malignant lung lesions. AJR Am J Roentgenol 144:281-288
23. Horrigan TP, Bergin KT, Snow N (1986) Correlation between needle biopsy of lung tumors and histopathologic analysis of resected specimens. Chest 90:638-640
24. Winning AJ, Mclvor J, Seed WA et al (1986) Interpretation of negative results in fine needle aspiration of discrete pulmonary lesions. Thorax 41:875-879
25. Johnston WW (1988) Fine needle aspiration biopsy versus sputum and bronchial material in the diagnosis of lung cancer. A comparative study of 168 patients. Acta Cytol 32:641-645
26. Chang MJ, Stutley JE, Padley SPG, Hansell DM (1991) The value of negative needle biopsy in suspected operable lung cancer. Clin Radiol 44:147-149
27. Sinner WN (1975) Wert und Bedeutung der perkutanen transthorakalen Nadelbiopsie für die Diagnose intrathorakaler Krankheitprozesse. Rofo 123:197-202
28. Westcott JL, Rao N, Colley DP (1997) Transthoracic needle biopsy of small pulmonary nodules. Radiology 202:97-103
29. Perlmutt LM, Johnston WW, Dunnick NR (1989) Percutaneous transthoracic needle aspiration: a review. AJR Am J Roentgenol 152:451-455
30. Perlmutt LM, Braun SD, Newman GE et al (1987) Transthoracic needle aspiration: Use of a small chest tube to treat pneumothorax. AJR Am J Roentgenol 148:849-851
31. Casola G, van Sonnenberg E, Keightley A et al (1988) Pneumothorax: radiologic treatment with small catheters. Radiology 166:89-91
32. Reinhold C, Illescas FF, Atri M, Bret PM (1989) Treatment of pleural effusions and pneumothorax with catheters placed percutaneously under imaging guidance. AJR Am J Roentgenol 152:1189-1191
33. Langen HJ, KIose KC, Keulers P et al (1995) Artificial widening of the mediastinum to gain access for extrapleural biopsy: clinical results. Radiology 196:703-706
34. KIose KC (1993) CT-guided large-bore biopsy: extrapleural injection of saline for safe transpleural access to pulmonary lesions. Cardiovasc Intervent Radiol 16:259-261
35. Ayar D, Golla B, Lee JY, Nath H (1998) Needle-track metastasis after transthoracic needle biopsy. J Thorac Imaging 13:2-6
36. Wong RS, Ketai L, Ternes RT et al (1995) Air embolus complicating transthoracic percutaneous needle biopsy. Ann Thorac Surg 59:1010-1011
37. Lee SI, Shepard JO, Boiselle PM et al (1996) Role of transthoracic needle biopsy in patient treatment decisions. Radiology 201:269
38. Schenk DA (1995) The Role of Transbronchial Needle Aspiration in Staging of Bronchogenic Carcinoma. In: Wang KP, Mehta AC (eds) Flexible Bronchoscopy. Blackwell Science, Cambridge, pp 215-221
39. Wang KP (1995) Transbronchial needle aspiration and percutaneous needle aspiration for staging and diagnosis of lung cancer. Clin Chest Med 16:535-552
40. McAdams HP, Goodman PC, Kussin P (1998) Virtual bronchoscopy for directing transbronchial needle aspiration of hilar and mediastinal lymph nodes: a pilot study. AJR Am J Roentgenol 170:1361-1364
41. Prakash UB, Offord KP, Stubbs SE (1991) Bronchoscopy in North America: the ACCP survey. Chest 100:1668-1675
42. Bricault I, Ferretti GR, Arbib F, Cinquin P (1996) Automatic matching between real and virtual bronchoscopy: a guidance for trans-bronchial needle aspiration. Radiology 201:359
43. Westcott JL (1985) Percutaneous catheter drainage of pleural effusion and empyema. AJR Am J Roentgenol 144:1189-1193
44. Hunnam GR, Flower CDR (1988) Radiologically- guided percutaneous catheter drainage of empyemas. Clin Radiol 39:121-126
45. Merriam MA, Cronan JJ, Dorfman GS et al (1988) Radiographically guided percutaneous catheter drainage of pleural fluid collections. AJR Am J Roentgenol 151:1113-1116
46. Silverman SG, Mueller FR, Sailli S et al (1988) Thoracic empyema: management with image-guided catheter drainage. Radiology 169:5-9
47. Moulton JS, Moore PT, Mencini RA (1989) Treatment of loculated pleural effusions with transcatheter intracavitary Urokinase. AJR Am J Roentgenol 153:941-945
48. Parker LA, Charnock GC, Delany DJ (1989) Small bore catheter drainage and sclerotherpay for malignant pleural effusions. Cancer 64: 1218-1221
49. Lee KS, Im JG, Kim YH et al (1991) Treatment of thoracic multiloculated empyemas with intracavitary urokinase: a prospective study. Radiology 179:771-775
50. Lambiase RE, Deyoe L, Cronan JJ, Dorfman GS (1992) Percutaneous drainage of 335 consecutive abscesses: result of primary drainage with 1-year follow-up. Radiology 184:167-179
51. Casola G, Neff CC, Friedman PI et al (1984) CT and ultrasound-guided catheter drainage of empyemas after chest-tube failure. Radiology 151:349-353
52. Capasso P, Trotteur G, Flandroy P, Dondelinger RF (1996) A combined CT and angiography suite with a pivoting table. Radiology 199:561-563
53. Parker LA, Melton JW, Delany DJ, Yakaskas BC (1987) Percutaneous small bore catheter drainage in the management of lung abscesses. Chest 92:213-218
54. Moore PV, Mueller PR, Sirmeone JF et al (1987) Sonographic guidance in diagnostic and therapeutic interventions in the pleural space. AJR Am J Roentgenol 149:1-5
55. Cummin AR, Wright NL, Joseph AE (1991) Suction drainage: a new approach to the treatment of empyema. Thorax 46:259-260
56. Morrison MC, Mueller PR, Lee MJ et al (1992) Sclerotherapy of malignant pleural effusion through sonographically placed small-bore catheters. AJR Am J Roentgenol 158:41-43
57. Bali WS Jr, Bisset GS, Towbin RB (1989) Percutaneous drainage of chest abscesses in children. Radiology 171:431-434
58. Dondelinger RF, Kurdziel JC (1990) Percutaneous drainage of thoracic fluid collections. In: Dondelinger RF, Rossi P, Kurdziel JC, Wallace S (eds) Interventional Radiology. Theme, Stuttgart, pp 142-155

59. Neff CC, van Sonnenberg E, Lawson DW, Patton AS (1990) CT follow-up of empyemas: pleural peels resolve after percutaneous catheter drainage. Radiology 176:195-197

60. van Sonnenberg E, D'Agostino HB, Casola G et al (1991) Lung abscess: CT-guided drainage. Radiology 178:347-351

61. Light RW, Rodriguez RM (1998) Management of parapneumonic effusions. Clin Chest Med 15:373-382

62. Bergh NP, Ekroth R, Larsson S, Nagy P (1977) Intrapleural streptokinase in the treatment of haemothorax and empyema. Scan J Thorac Cardiovasc Surg 11:265-268

63. Berglin E, Ekroth R, Teger-Nilsson AC, William-Olsson G (1981) Intrapleural instillation of streptokinase: effects on systemic fibrinolysis. Thorac Cardiovasc Surg 29:124-126

64. Fraedrich G, Hoffman D, Effenhauser P, Jander R (1982) Instillation of fibrinolytic enzymes in the treatment of pleural empyema. Thorac Cardiovasc Surg 30:36-38

65. Aye RW, Froese DP, Hill LD (1991) Use of purified streptokinase in empyema and hemothorax. Am J Surg 161:560-562

66. Henke CA, Leatherman JW (1992) Intrapleurally administered streptokinase in the treatment of 8 acute loculated non-purulent parapneumonic effusions. Am Rev Respir Dis 145:680-684

67. Robinson LA, Moulton AL, Fleming WH (1994) Intrapleural fibrinolytic treatment of multiloculated thoracic empyemas. Ann Thorac Surg 57:803-814

68. Taylor RF, Rubens MB, Pearson MC, Barnes NC (1994) Intrapleural streptokinase in the management of empyema. Thorax 49:856-859

69. Moulton SM, Benkert RE, Weisiger KR, Chambers JA (1995) Treatment of complicated pleural fluid collections with image-guided drainage and intracavitary urokinase. Chest 108:1252-1259

70. Park CS, Chung WM, Lim MK et al (1996) Transcatheter instillation of urokinase into loculated pleural effusion: analysis of treatment effect. AJR Am J Roentgenol 167:649-652

71. Jerjes-Sanchez C, Ramirez-Rivera A, Elizalde JJ et al (1996) Intrapleural fibrinolysis with streptokinase as an adjunctive treatment in hemothorax and empyema. Chest 109:1514-1519

72. Ternes RT, Follis F, Kessler RM et al (1996) Intrapleural fibrinolytics in management of empyema thoracis. Chest 110:102-106

73. Davies RI, Traill ZC, Gleeson FV (1997) Randomised controlled trial of intrapleural streptokinase in community acquired pleural infection. Thorax 52:416-421

74. Bouros D, Schiza S, Patsourakis G et al (1997) Intrapleural streptokinase versus urokinase in the treatment of complicated parapneumonic effusions. A prospective, double-blind study. Am J Respir Crit Care Med 155:291-295

75. Chin NK, Lim TK (1997) Controlled trial of intrapleural streptokinase in the treatment of pleural empyema and complicated parapneumonic effusions. Chest 111:275-279

76. Godley PI, Bell RC (1984) Major hemorrhage following administration of intrapleural Streptokinase. Chest 86:486-487

77. Seaton KG, Patz EF Jr, Goodman PC (1995) Palliative treatment of malignant pleural effusions: Value of small-bore catheter thoracostomy and doxycycline sclerotherapy. AJR Am J Roentgenol 164:589-591

78. Sewall LE, Franco AI, Wojtowycz MM, McDermott JC (1993) Pneumatoceles causing respiratory compromise. Treatment by percutaneous decompression. Chest 103:1266-1267

79. Rice TW, Ginsberg RJ, Todd TRJ (1987) Tube drainage of lung abscesses. Ann Thorac Surg 44:356-359

80. Vainrub B, Musher DM, Guinn GA et al (1978) Percutaneous drainage of lung abscess. Am Rev Respir Dis 117:153-160

81. Lorenzo RL, Bradford BF, Black J, Smith CD (1985) Lung abscesses in children: diagnostic and therapeutic needle aspiration. Radiology 157:79-80

82. Rami-Porta R, Bravo-Bravo JL, Alix-Trueba A, Serrano-Munoz F (1985) Percutaneous drainage of lung abscess. J Thorac Cardiovasc Surg 89:314-317

83. Yellin A, Yellin ED, Lierman Y (1985) Percutaneous tube drainage: the treatment of choice for refractory lung abscess. Ann Thorac Surg 39:266-270

84. Ha HK, Kang MW, Park JM et al (1993) Lung abscess. Percutaneous catheter therapy. Acta Radiol 19 34:362- 365

85. Meranze SG, LeVeen RF, Bute DR et al (1987) Transesophageal drainage of mediastinal abscesses. Radiology 165:395-398

86. Carrol CL, Jeffrey RB Jr, Federle MP, Vernacchia FS (1987) CT evaluation of mediastinal infections. J Comput Assist Tomogr 11:449- 453

87. Gobien RP, Stanley JH, Gobien BS et al (1984) Percutaneous catheter aspiration and drainage of suspected mediastinal abscesses. Radiology 151:69-71

88. Callahan JA, Seward JB, Nishimura RA et al (1985) Two-dimensional echocardiographically guided pericardiocentesis: experience in 117 consecutive patients. Am J Cardiol 55:476-479

89. Szapiro D, Ghaye B, Dondelinger RF (1996) Pericardial tamponade: CT-guided percutaneous drainage. J Intervent Radiol 11:129-131

90. Dondelinger RF, Coulon M, Kurdziel JC, Hemmer M (1992) Tension mediastinal emphysema: Emergency percutaneous drainage with CT guidance. Eur J Radiol 15:7-10

91. Bolliger CT (1999) Multimodality Treatment of Advanced Pulmonary Malignancies. In: Bolliger CT, Mathur PN (eds) Interventional Bronchoscopy (Respiratory Research, Vol 30). Karger, Basel, pp 187-196

92. Cavaliere S, Foccoli P, Toninelli C et al (1994) Nd:YAG laser therapy in lung cancer: an 11-year experience with 2,253 applications in 1,585 patients. J Bronchol 1:105-111

93. Mathur PN, Wolf KM, Busk MF et al (1996) Fiberoptic bronchoscopic cryotherapy in the management of tracheobronchial obstruction. Chest 110:718-723

94. Sutedja G, van Boxem TJ, Schramel FM et al (1997) Endobronchial electrocautery is an excellent alternative for Nd:YAG laser to treat airway tumors. J Bronchol 4:101-105

95. McCaughan JS, Williams TE (1997) Photodynamic therapy for endobronchial malignant disease: a prospective fourteen-year study. J Thorac Cardiovasc Surg 114:940-947

96. Huber RM, Fischer R, Hautmann H et al (1997) Does additional brachytherapy improve the effect of external irradiation? A prospective, randomized study in central lung tumors. Int J Radiat Oncol Biol Phys 38:533-540

97. Cohen MD, Weber TR, Rao CC (1984) Balloon dilatation of tracheal and bronchial stenosis. AJR Am J Roentgenol 142:477-478

98. Liermann D, Becker HD, Rust M (1997) Endoprostheses in the Tracheobronchial System. In: Adam A, Dondelinger RF, Mueller PR (eds) Textbook of Metallic Stents. Isis Medical Media, Oxford, pp 129-142

99. Rafanan AL, Mehta AC (2000) Stenting of the tracheobronchial tree. Radiol Clin North Am 38:395-408

100. Bolliger CT, Probst R, Tschopp K et al (1993) Silicone stents in the management of inoperable tracheobronchial stenoses. Indications and limitations. Chest 104:1653-1659

101. Petrou M, Goldstraw P (1994) The management of tracheobronchial obstruction. A review of endoscopic techniques. Eur J Cardiothorac Surg 8:436-441

102. Becker HD (1995) Stenting the central airways. J Bronchol 2:98-106

103. Dumon JF, Cavaliere S, Diaz-Jimenez JP et al (1996) Seven-year experience with the Dumon prosthesis. J Bronchol 3:6-10

104. Wilson GE, Walshaw MJ, Hind CR (1996) Treatment of large airway obstruction in lung cancer using expandable metal stents inserted under direct vision via the fiberoptic bronchoscope. Thorax 51:248-252

105. Freitag L, Tekolf E, Stamatis G, Greschuchna D (1997) Clinical evaluation of a new bifurcated dynamic airway stent. A five year experience in 135 patients. Thorac Cardiovasc Surg 45:6-12

106. Nicholson DA (1998) Tracheal and oesophageal stenting for carcinoma of the upper oesophagus invading the tracheobronchial tree. Clin Radiol 53:760-763

107. Freitag L (1999) Tracheobronchial Stents. In: Bolliger CT, Mathur PN (eds) Interventional bronchoscopy (Respiratory Research, Vol 30). Karger, Basel, pp 171-186

108. Freitag L, Tekolf E, Steveling H et al (1996) Management of malignant esophagotracheal fistulas with airway stenting and double stenting. Chest 110:1155-1160

109. Sawada S, Fujiwara Y, Furui S et al (1993) Treatment of tuberculous bronchial stenosis with explandable metallic stents. Acta Radiol 34:263-265

110. Rousseau H, Dahan M, Lauque D et al (1993) Self-expandable prostheses in the tracheobronchial tree. Radiology 188:199-203

111. Strausz J (1997) Management of postintubation tracheal stenosis with stent implantation. J Bronchol 4:294-296

112. Dechambre S, Dorzee J, Fastrez J (1998) Bronchial stenosis and sclerosing mediastinitis: an uncommon complication of external thoracic radiotherapy. Eur Respir J 11:1188-1190

113. Filler RM, Forte V, Chait P (1998) Tracheobronchial stenting for the treatment of airway obstruction. Pediatr Surg 33:304-311

114. Nakajima Y, Kurihara Y, Niimi H et al (1999) Efficacy and complications of the Gianturco-Z tracheobronchial stent for malignant airway stenosis. Cardiovasc Intervent Radiol 22:287-292

115. Hautmann H, Bauer M, Pfeifer KJ, Huber RM (2000) Flexible bronchoscopy: a safe method for metal stent implantation in bronchial disease. Ann Thorac Surg 69:398-401

116. Suh RD, Wallace AB, Sheehan RE et al (2003) Unresectable pulmonary malignancies: CT-guided percutaneous radiofrequency ablation-preliminary results. Radiology 229:821-829

117. Lee JM, Jin GY, Goldberg SN et al (2004) Percutaneous radiofrequency ablation for inoperable non-small cell lung cancer and metastases: preliminary report. Radiology 230:125-134

118. Nordenstrom BE (1985) Fleischner lecture. Biokinetic impacts on structure and imaging of the lung: the concept of biologically closed electric circuits. AJR Am J Roentgenol 145:447-467

119. Brach B, Buhler C, Hayman MH et al (1994) Percutaneous computed tomography-guided fine needle brachytherapy of pulmonary malignancies. Chest 106:268-274

120. Dupuy DE, Zagoria RJ, Akerley W et al (2000) Percutaneous radiofrequency ablation of malignancies in the lung. AJR Am J Roentgenol 174:57-59

121. Gazelle GS, Goldberg SN, Solbiati L, Livraghi T (2000) Tumor ablation with radio-frequency energy. Radiology 217:633-646

122. Steinke K, King J, Glenn D, Morris DL (2003) Radiologic appearance and complications of percutaneous computed tomography-guided radiofrequency-ablated pulmonary metastases from colorectal carcinoma. J Comput Assist Tomogr 27:750-757

123. Miao Y, Ni Y, Bosmans H et al (2001) Radiofrequency ablation for eradication of pulmonary tumor in rabbits. J Surg Res 99:265-271

124. Murakami T, Shibata T, Ishida T et al (1999) Percutaneous microwave hepatic tumor coagulation with segmental hepatic blood flow occlusion in seven patients. AJR Am J Roentgenol 172:637-640

125. Vogl TJ, Eichler K, Straub R et al (2001) Laser-induced thermotherapy of malignant liver tumors: general principles, equipment(s), procedure(s), side effects, complications and results. Eur J Ultrasound 13:117-127

126. Dupuy DE, Mayo-Smith WW, Abbott GF, DiPetrillo T (2002) Clinical applications of radio-frequency tumor ablation in the thorax. Radiographics 22:S259-S269

127. Goldberg SN, Gazelle GS, Compton CC, McLoud TC (1995) Radiofrequency tissue ablation in the rabbit lung: efficacy and complications. Acad Radiol 2:776-784

128. Nishida T, Inoue K, Kawata Y et al (2002) Percutaneous radiofrequency ablation of lung neoplasms: a minimally invasive strategy for inoperable patients. J Am Coll Surg 195:426-430

129. Jain SK, Dupuy DE, Cardarelli GA et al (2003) Percutaneous radiofrequency ablation of pulmonary malignancies: combined treatment with brachytherapy. AJR Am J Roentgenol 181:711-715

130. Herrera LJ, Fernando HC, Perry Y et al (2003) Radiofrequency ablation of pulmonary malignant tumors in nonsurgical candidates. J Thorac Cardiovasc Surg 125:929-937

131. Steinke K, Sewell PE, Dupuy D et al (2004) Pulmonary radiofrequency ablation – an international study survey. Anticancer Res 24:339-343

132. Kim TS, Lim HK, Lee KS et al (2003) Imaging-guided percutaneous radiofrequency ablation of pulmonary metastatic nodules caused by hepatocellular carcinoma: preliminary experience. AJR Am J Roentgenol 181:491-494

133. King J, Glenn D, Clark W et al (2004) Percutaneous radiofrequency ablation of pulmonary metastases in patients with colorectal cancer. Br J Surg 91:217-223

134. Akeboshi M, Yamakado K, Nakatsuka A et al (2004) Percutaneous radiofrequency ablation of lung neoplasms: initial therapeutic response. J Vasc Interv Radiol 15:463-470

135. Vaughn C, Mychaskiw G 2nd, Sewell P (2002) Massive hemorrhage during radiofrequency ablation of a pulmonary neoplasm. Anesth Analg 94:1149-1151

136. Rose SC, Fotoohi M, Levin DL, Harrell JH (2002) Cerebral microembolization during radiofrequency ablation of lung malignancies. J Vasc Interv Radiol 13:1051-1054

137. Gourin A, Garzon AA (1974) Operative treatment of massive hemoptysis. Ann Thorac Surg 18:52-60

138. Bobrowitz ID, Ramakrishna S, Shim YS (1983) Comparison of medical versus surgical treatment of major hemoptysis. Arch Intern Med 143:1343-1346

139. Magilligan DJ Jr, Ravipati S, Zayat P et al (1981) Massive hemoptysis: control by transcatheter bronchial artery embolization. Ann Thorac Surg 32:392-400

140. Remy-Jardin M, Remy J (1991) Embolization for the Treatment of Hemoptysis. In: Kadir S (ed) Current Practice of Interventional Radiology. BC Decker, Philadelphia, pp 194-202

141. Fernando HC, Stein M, Benfield JR, Link DP (1998) Role of bronchial artery embolization in the management of hemoptysis. Arch Surg 133:862-866

142. Cremaschi P, Nascimbene C, Vitulo P et al (1993) Therapeutic embolization of bronchial artery: a successful treatment in 209 cases of relapse hemoptysis. Angiology 44:295-299

143. Knott-Craig CJ, Oostuizen JG, Rossouw G et al (1993) Management and prognosis of massive hemoptysis. Recent experience with 120 patients. J Thorac Cardiovasc Surg 105:394-397

144. Saluja S, Henderson KJ, White RI Jr (2000) Embolotherapy in the bronchial and pulmonary circulations. Radiol Clin North Am 38:425-447

145. Tanaka N, Yamakado K, Murashima S et al (1997) Superselective bronchial artery embolization for hemoptysis with a coaxial microcatheter system. J Vasc Intervent Radiol 8:65-70

146. White RI Jr (1999) Bronchial artery embolotherapy for control of acute hemoptysis. Chest 115:912-914

147. Keller FS, Rösch J, Lofflin TG et al (1987) Nonbronchial systemic collateral arteries: significance in percutaneous embolotherapy for hemoptysis. Radiology 164:687-692

148. Jardin M, Remy J (1988) Control of hemoptysis: systemic angiography and anastomosis of the internal mammary artery. Radiology 168:377-382

149. Tamura S, Kodama T, Otsuka N et al (1993) Embolotherapy for persistent hemoptysis: the significance of pleural thickening. Cardiovasc Intervent Radiol 16:85-88

150. Garcia-Medina J, Casal M, Fernandez-Villar A (1999) Embolization of bronchial arteries in patients with hemoptysis: influence of underlying pathology on outcome. J Intervent Radiol 14:171-180

151. Cohen AM, Doershuk CF, Stern RC (1990) Bronchial artery embolization to control hemoptysis in cystic fibrosis. Radiology 175:401-405

152. Dines DE, Seward JB, Bernatz PE (1983) Pulmonary arteriovenous fistulas. Mayo Clin Proc 58:176-181

153. Burke CM, Safai C, Nelson DP, Raffin TA (1986) Pulmonary arteriovenous malformations: a critical update. Am Rev Respir Dis 134:334-339

154. White RI Jr, Lynch-Nyhan A, Terry P et al (1988) Pulmonary arteriovenous malformations: techniques and long-term outcome of embolotherapy. Radiology 169:663-669

155. Andersen PE, Kjeldsen AD, Oxhoj H, Vase P (1999) Percutaneous transluminal treatment of pulmonary arteriovenous malformations. J Intervent Radiol 14:164-170

156. Remy J, Remy-Jardin M, Wattinne L, Deffontaines C (1992) Pulmonary arteriovenous malformations: evaluation with CT of the chest before and after treatment. Radiology 182:809-816

157. Remy J, Remy-Jardin M, Giraud F, Wattinne L (1994) Angioarchitecture of pulmonary arteriovenous malformations: clinical utility of three-dimensional helical CT. Radiology 191:657-664

158. White RI Jr, Mitchell SE, Barth KH et al (1983) Angioarchitecture of pulmonary arteriovenous malformations: an important consideration before embolotherapy. AJR Am J Roentgenol 140:681-686

159. Hugues JM, Allison DJ (1990) Pulmonary arteriovenous malformations: the radiologist replaces the surgeon. Clin Radiol 41:297-298

160. White RI, Pollak JS (1994) Pulmonary arteriovenous malformations: options for management. Ann Thorac Surg 57:516-524

161. Dutton JA, Jackson JE, Hugues JM et al (1995) Pulmonary arteriovenous malformations: results of treatment with coil embolization in 53 patients. AJR Am J Roentgenol 165:1119-1125

162. Ghaye B, Trotteur G, Dondelinger RF (1997) Multiple pulmonary artery pseudoaneurysms: intrasaccular embolization. Eur Radiol 7:176-179

163. Ungaro R, Saab S, Almond CH, Kumar S (1976) Solitary peripheral pulmonary artery aneurysms: pathogenesis and surgical treatment. J Thorac Cardiovasc Surg 71:566-571

164. Remy J, Smith M, Lemaître L et al (1980) Treatment of massive hemoptysis by occlusion of a Rasmussen aneurysm. AJR Am J Roentgenol 135:605-606

165. Putman JS, Uchita BT, Antonovic R, Rösch J (1988) Superior vena cava syndrome associated with massive thrombosis: treatment with expandable wire stents. Radiology 167:727-728

166. Dondelinger RF, Goffette P, Kurdziel JC, Roche A (1991) Expandable metal stents for stenoses of the venae cavae and large veins. Semin Intervent Radiol 8:252-263

167. Rosch J, Uchida BT, Hall LD et al (1992) Gianturco self-expanding stents: clinical experience in the vena cava and large veins. Cardiovasc Intervent Radiol 15:319-327

168. Irving JD, Dondelinger RF, Reidy JF et al (1992) Gianturco self-expanding stents: clinical experience in the vena cava and large veins. Cardiovasc Intervent Radiol 15:328-333

169. Furui S, Sawada S, Kuramoto K et al (1995) Gianturco stent placement in malignant caval obstruction: analysis of factors for predicting the outcome. Radiology 195:147-152

170. Dondelinger RF, Capasso P, Tancredi T, Trotteur G (1997) Metal Stents in the Venous System. In: Adam A, Dondelinger RF, Mueller PR (eds) Textbook of Metallic Stents. Isis Medical Media, Oxford

171. Trerotola SO (1994) Interventional radiology in central venous stenosis and occlusion. Semin Intervent Radiol 11:291-304

172. Gaines PA, Belli AM, Anderson PB et al (1994) Superior vena caval obstruction managed by Gianturco Z stent. Clin Radiol 49:207-208

173. Glanz S, Gordon DH, Butt KM et al (1987) The role of percutaneous angioplasty in the management of chronic hemodialysis fistulas. Ann Surg 206:777-781

174. Quinn SF, Schuman ES, Hall L et al (1992) Venous stenoses in patients who undergo hemodialysis: treatment with self-expandable endovascular stents. Radiology 183:499-504

175. Beathard GA (1992) Percutaneous transvenous angioplasty in the treatment of vascular access stent. Kidney Int 42:1390-1397

176. Vorwerk D, Aachen G, Guenther RW et al (1993) Self-expanding stents in peripheral and central veins used for arteriovenous shunts: five years of experience. Radiology 189(P):174

177. Fisher RG, Ferreyo R (1978) Evaluation of current techniques for nonsurgical removal of intravascular iatrogenic foreign bodies. AJR Am J Roentgenol 130:541-548

178. Richardson JD, Grover FL, Trinkle JK (1974) Intravenous catheter emboli: experience with twenty cases and collective review. Am J Surg 128:722-727

179. Burri C, Henkeneyer H, Passler H (1971) Katheterembolien. Schweiz Med Wschr 101:1537-1541

180. Schuler S, Hetzger R, Stegman T, Borst HG (1986) Surgical therapy of intracardiac infected pacemaker electrodes and catheter remnants. Z Kardiol 75:151-155

181. Dondelinger RF, Lepoutre B, Kurdziel JC (1991) Percutaneous vascular foreign body retrieval: experience of an 11-year period. Eur J Radiol 12:4-10

Interventional Techniques in the Adult Thorax

D. Vorwerk

Department of Radiology, Klinikum Ingolstadt, Ingolstadt, Germany

Introduction

Interventional radiology in the thorax is widespread. Although most people associate the practice with nonvascular interventions, such as lung biopsy, in fact, a huge variety of different nonvascular and vascular interventions are performed within thoracic structures (Tables 1, 2), and more, such as radiofrequency ablation of lung tumors, will probably come into the field. In the following, some of the most essential interventions are discussed.

Nonvascular Interventions

In the nonvascular field, CT-guided lung biopsies are the best-known and most frequently performed interventions in this part of the body. Fine-needle aspiration for cytology

Table 1. Nonvascular interventions

– Pulmonary, pleural, and mediastinal biopsy
– Marker placement prior to surgical removal
– Abscess drainage from pleural, pulmonary and mediastinal origin
– Breast biopsy
– Radiofrequency ablation of lung tumors and metastases

Table 2. Vascular interventions

Arterial interventions	Balloon angioplasty of supra-aortic vessels
	Endoluminal stent placement into the thoracic aorta
	Transarterial embolization of bronchial arteries
Venous interventions	Stents for the treatment of superior vena cava syndrome
	Percutaneous venous catheter placement
	Catheter maintenance
	Foreign-body removal
Pulmonary artery interventions	Embolization of peritoneovenous shunts
	Mechanical thrombectomy of pulmonary emboli

and miniaturized cutting needles for histology not exceeding 18-20 G are used for this purpose. Automated biopsy guns have several advantages, offering excellent sampling quality and the possibility to perform repeated biopsies with a single access. Fine-needle aspiration is preferred if an object for biopsy is located close to central and vascular structures, in order to avoid major bleeding complications.

Laurent et al. [1] compared the accuracy and complication rate of fine-needle aspiration vs. an automated biopsy device. The studied consisted of two consecutive series of 125 (group A) and 98 (group B) biopsies carried out using 20-22 G coaxial fine-needle aspiration (group A) and an automated 19.5 gauge coaxial biopsy device (group B). Groups A and B comprised, respectively, 100 (80%) and 77 (79%) malignant lesions and 25 (20%) and 18 (21%) benign lesions. No significant difference was found between the two series concerning patients, lesions, and procedural variables. For a diagnosis of malignancy, a statistically significant difference in sensitivity was found between the results obtained with the automated biopsy device and those with fine-needle aspiration (82.7% vs. 97.4%, respectively). For a diagnosis of malignancy, the false-negative rate of the biopsy result was significantly higher ($p < 0.005$) in group A (17%) than in group B (2.6%). For a specific diagnosis of benignity, no statistically significant difference was found between the two groups (44% vs. 26%), but the automated biopsy device yielded fewer indeterminate cases. There was no difference between the two groups concerning the incidence of pneumothorax, which was 20% in group A and 15% in group B, or that of hemoptysis, which was 2.4% in group A and 4% in group B. The authors concluded that, for the diagnosis of malignancy, automated biopsy devices have a lower rate of false-negative results and a complication rate similar to that of fine-needle aspiration.

Richardson et al. [2] surveyed 5,444 lung biopsies in the UK. Complications included pneumothorax (20.5% of biopsies), pneumothorax requiring chest drain (3.1%), hemoptysis (5.3%), and death (0.15%). The timing of post-procedure chest radiography was variable. In centers that predominantly performed cutting-needle biopsies, the pneumothorax rates were similar to those of centers performing mainly fine-needle biopsies (18.9% vs.

18.3%). There is great variation in practice throughout the UK. Most procedures are carried out on a day-case basis. Small pneumothoraces are common but infrequently require treatment.

Post-biopsy pneumothorax as a rather frequent complication can be treated relatively simply in most cases. In asymptomatic patients we recommend not evacuating the pneumothorax earlier than 4 h after biopsy in order to achieve a durable success. In symptomatic patients or those with drainage failures following a single-needle approach, percutaneously introduced Heimlich valves are recommended.

Minimally invasive thoracoscopic procedures have become increasingly popular and offer a valid alternative if the patient has only a single pulmonary nodule that can be removed for diagnostic as well as therapeutic purposes. In such cases, interventional radiology can be of practical benefit in the procedure by CT-guided hook marking of the nodule, which allows it to be easily identified during thoracoscopy and thus facilitates its removal.

Poretti et al. [3] described their experience with percutaneous CT-guided placement of hook-wires to localize such nodules before video-assisted thoracoscopy (VATS). In their study, 19 patients with newly diagnosed intrapulmonary nodules underwent CT-guided hook-wire (X-Reidy set) localization. Subsequently, the patients underwent VATS resection of their lesions, which required a mean time of 30 min (range 10-48 min). In all patients, resection of the nodules was successful. Eight patients developed an asymptomatic pneumothorax. In four patients, in whom the tumor was hit directly by the needle, local bleeding occurred. One patient experienced hemoptysis. However, dislocation of the hook-wire system did not occur in any of the patients.

Other nonvascular interventions include abscess drainage from the lung, the pleura, and the mediastinum (Fig. 1).

Fig. 1. Planning CT for drainage of a mediastinal abscess. Patient is in a supine position; the access tract is planned through the paravertebral space

Breast Biopsy

Breast biopsy is of increasing importance in daily practice, as in European countries more and more lesions detected during screening programs are either indicative of malignancy or at least suspicious and not clearly classifiable. A growing number of patients also request a definitive diagnosis even for an otherwise benign-appearing lesion.

Breast biopsy may be performed by ultrasound or MR guidance, or under stereotactic mammographic guidance. For lesions that are detectable by ultrasound, ultrasound guidance is a quick and relatively easy approach that allows online monitoring of the biopsy procedure. Microcalcifications are best detected and biopsied under mammographic guidance. In addition to core biopsy using 14 G needles, vacuum aspiration biopsy using a 10 G needle is recommendable, as it allows removal of larger portions of tissue which makes the procedure safer and the obtained sample more representative. Soft-tissue structures that are detectable by mammography but have no clear correlation in ultrasound should be examined by mammographic core biopsy. MR-positive lesions that have no clear correlations in other modalities should be evaluated by MR-guided core biopsy or placement of a marker under MR guidance followed by surgical resection.

Vascular Interventions

Vascular interventions can be divided between arterial and venous interventions (Table 2).

In the former, balloon angioplasty of supra-aortic arteries such as the subclavian artery, implantation of thoracic endografts, and embolization of bronchial arteries should be mentioned. Relatively rarely performed are transarterial techniques for tumor treatment, such as chemoperfusion of the lateral thoracic, mammary, and bronchial arteries in order to treat bronchial or breast cancer.

Vascular interventions involving the pulmonary artery include occlusion of arteriopulmonary fistulas, particularly in patients with Rendu-Osler-Weber syndrome. Local thrombolysis or thrombodestruction of pulmonary emboli is an intervention used relatively rarely but it offers a promising alternative in emergency cases involving pulmonary embolism.

In the venous area, central venous stents are used to treat malignancies and, in dialysis patients, to recanalize central venous stenoses in order to allow successful drainage. In addition, stents are employed in the placement and maintenance of central venous catheters, fibrin-sheath stripping, and the removal of foreign bodies.

Not all these interventions can be discussed here in depth, but embolization of the bronchial arteries and treatment of malignant venous stenoses should be emphasized, since neither is well-known but either one could be helpful in treating patients with acute symptoms.

Bronchial Artery Embolization

This procedure is not a simple intervention for many reasons. Firstly, the anatomy of the bronchial artery varies and the size of the artery is frequently very small, making cannulation difficult. Feeders to bronchial artery bleeding sources – which are mainly arteriopulmonary fistulae due to tumoral or inflammatory changes – can originate not only from the bronchial but also from many other arteries in the thorax such as the subclavian artery, the thyreocervical trunk or the mammary or costal arteries. Moreover, there is a variation in collaterals in the region that does include the spinal arteries.

As embolization material, particles, glue, and coils can be used, but a golden rule is to seal the artery as close as possible to the bleeding source; otherwise, recurrence via collateral feeders may ensue.

Benign sources of bronchial bleeding include: bronchiectasis, chronic bronchitis, aspergillosis, tuberculosis, pneumonia, and abscesses. Malignant sources are predominantly bronchial cancers.

The results of percutaneous intervention are satisfactory. Kato et al. [4] treated 101 patients and reported 100% technical success, a 1-year success of 77.7% and a 5-year success of 2.5%. They described a better outcome in patients with tuberculosis and bronchitis than in those with pneumonia and abscesses.

Lee et al. [5] described their experience with bronchial artery embolization (BAE) in patients with massive, life-threatening hemoptysis. In a 5-year period, 54 patients were treated for massive hemoptysis. The underlying pathology included bronchiectasis (n=31), active tuberculosis (n=9), pneumoconiosis (n=3), lung cancer (n=2), and pulmonary angiodysplasia (n=1). Surgery was considered if the patient had acceptable pulmonary reserve and a bleeding source was clearly identified. If the patient was not considered fit for surgery, BAE was attempted. Hemoptysis ceased with conservative management in seven patients (13%) only. Of the 27 (50%) patients who underwent surgical resection the procedures included lobectomy (n=21), bilobectomy (n=4), and pneumonectomy (n=2). The in-hospital mortality after surgery was 15%. Postoperative morbidity occurred in eight patients, including the need for prolonged ventilatory support, bronchopleural fistulae, empyema, and myocardial infarction.

Twenty-one patients who could not be treated surgically underwent BAE, which was successful in 17 patients without any complications.

In the treatment of bleeding from bronchial carcinoma, Witt et al. [6] performed BAE using platinum coils with Dacron fibers in 30 consecutive patients. The aim was to compare immediate results of bleeding cessation, recurrence, and survival rates in patients treated with BAE vs. those managed conservatively. Active bleeding stopped immediately in all patients. In the two groups, the cessation of first-time hemoptysis (BAE 100% vs. non-BAE 93%) and the rates of bleeding recurrence

(BAE 50% vs. non-BAE 47%) were similar. Regarding recurrent bleeding, repeated BAE led to a definite cessation of pulmonary hemorrhage in every case. In contrast, all patients with recurrent hemoptysis without a repeated BAE (8 patients, 27%) and all patients with bleeding recurrence in the non-BAE group died from pulmonary hemorrhage (8 patients, 53%). The mean survival time of the BAE group was significantly longer than that of the non-BAE group. The authors therefore concluded that consistent BAE proved beneficial in tumorous pulmonary bleeding.

Malignant Venous Obstruction (SVC Syndrome): Implantation

Another percutaneous procedure that has gained in popularity is the placement of metallic stents to treat superior vena cava syndrome (Fig. 2). Unlike emergency radiation, stenting offers rapid relief of symptoms within a few hours or even immediately. The technique is relatively simple and can be achieved from either a brachial or a transfemoral approach. If the obstruction is associated with thrombus, some clinicians prefer to combine stenting with thrombolysis.

Lanciego et al. [7] used stent placement as the treatment of choice for the relief of symptoms. Wall-stent prostheses (n=73) were inserted in 52 cancer patients whose were diagnosed with superior vena cava syndrome, as confirmed by cavography or phlebography. A single stent was sufficient in 37 patients, two stents were

Fig. 2a, b. Malignant obstruction causing a superior vena cava syndrome (SVCS). **a** Subtotal stenosis of the vena cava due to tumor and partial thrombosis. **b** After placement of a 16-mm-wide self-expanding stent and subsequent balloon dilatation, patency is restored

required in 11, three stents in two, and four stents in another two patients. Contraindications for the procedure were severe cardiopathy or coagulopathy. Resolution of symptoms was achieved in all patients within 72 h. At follow-up, six obstructions, one partial migration to the right atrium, two incorrect placements, and four stent 'shortenings' were noted. All were successfully resolved by repeated stenting. Symptom-free survival ranged from 2 days to 17 months (mean: 6.4 months). The authors concluded that the wall-stent vascular endoprosthesis is effective in the initial treatment of superior vena cava syndrome of neoplastic origin.

Conclusions

Of the numerous vascular and nonvascular procedures in the thorax, some are only rarely performed while the use of others is confined to a few centers. However, at least a general knowledge of all of them and of the benefits they have to offer is essential for optimal patient management.

References

1. Laurent F, Latrabe V, Vergier B, Michel P (2000) Percutaneous CT-guided biopsy of the lung: comparison between aspiration and automated cutting needles using a coaxial technique. Cardiovasc Intervent Radiol 23:266-272
2. Richardson CM, Pointon KS, Manhire AR, Macfarlane JT (2002) Percutaneous lung biopsies: a survey of UK practice based on 5444 biopsies. Br J Radiol 75:731-735
3. Poretti FP, Brunner E, Vorwerk D (2002) [Simple localization of peripheral pulmonary nodules - CT-guided percutaneous hook-wire localization]. Rofo 174:202-207
4. Kato A, Kudo S, Matsumoto K et al (2000) Bronchial artery embolization for hemoptysis due to benign diseases: immediate and long-term results. Cardiovasc Intervent Radiol 23:351-357
5. Lee TW, Wan S, Choy DK et al (2000) Management of massive hemoptysis: a single institution experience. Ann Thorac Cardiovasc Surg 6:232-235
6. Witt Ch, Schmidt B, Geisler A et al (2000) Value of bronchial artery embolisation with platinum coils in tumorous pulmonary bleeding. Eur J Cancer 36:1949-1954
7. Lanciego C, Chacon JL, Julian A et al (2001) Stenting as first option for endovascular treatment of malignant superior vena cava syndrome. Am J Roentgenol 177:585-593

Imaging Breast Disease: Mammography and Breast Ultrasound

E.A. Sickles[1], R.A. Kubik-Huch[2]

[1] Department of Radiology, UCSF Medical Center, San Francisco, CA, USA
[2] Institut für Radiologie, Kantonsspital Baden, AG, Switzerland

Introduction

The gold standard among breast imaging techniques is mammography, which is a plain-film X-ray examination. The routine use of mammographic screening for clinically occult breast cancer is widespread, primarily due to favorable results from multiple randomized controlled trials and the development of improved methods of preoperative needle biopsy and localization. A large percentage of radiologists interpret mammograms, and daily caseloads in many practices involve 50 or more such examinations per day. Screening examinations comprise more than 75% of all mammography performed in most developed countries. As a result, the majority of detected lesions, both benign and malignant, are small and nonpalpable. In most general radiology practices, mammography accounts for at least 10% (sometimes as much as 20%) of all examinations performed.

In many countries, the widespread use of mammographic screening among asymptomatic women, coupled with a high level of general awareness of breast cancer as a public health problem, has prompted a series of governmental regulations affecting mammography. These regulations, although costly, also have resulted in an overall improvement in the quality of mammographic images and, due to the imposition of initial education, continuing education, and continuing experience requirements for radiologists, probably an improvement in the quality of mammographic interpretation as well.

Breast ultrasonography (US) also is widely used to aid in the diagnosis and management of either mammographically detected or palpable breast lesions. US reliably characterizes simple cysts, if rigorous interpretive criteria are used, thereby averting tissue diagnosis for these common, invariably benign lesions (Fig. 1). In addition, several sonographic features are sufficiently suggestive of malignancy to prompt biopsy (often resulting in a diagnosis of cancer), even in the absence of suspicious findings at mammography or clinical breast examination (Fig. 2). These are major reasons why US has become an integral part of modern breast imaging practice, although it has not yet been proved to be effective for screening asymptomatic women.

a

b

Fig. 1a, b. Simple cysts (benign, BI-RADS category 2 at US) in two different patients. Breast US reliably characterizes simple cysts. Criteria for this diagnosis include circumscribed margins, oval (or round) shape with parallel (wider-than-tall) orientation, anechoic center, and posterior enhancement, as well as thin echogenic capsule and thin edge shadows. Note that reverberation echoes projecting within the cyst lumen (*arrows,* **b**) may create an appearance of complexity. Sonographic scanning from different angles and optimizing the focal zone may eliminate much of the artifact

Fig. 2a, b. Multifocal carcinoma of the left breast (highly suggestive of malignancy, BI-RADS category 5 at US). Breast US demonstrates an irregularly shaped, hypoechoic mass with indistinct margins and some posterior shadowing, as well as focal hyperechoic spots probably representing calcifications. The normal tissue architecture is disrupted. A second smaller lesion (*arrows*) is seen lateral (**a**) and superior (**b**) to the larger mass

Fig. 3a-d. A 40-year-old patient with multifocal invasive ductal carcinoma of the right breast, pT2N2M0) **a** Mammography, mediolateral oblique views; **b** mammography, craniocaudal views; **c** US of the right breast; **d** US of the right axilla. Assessment: highly suggestive of malignancy (BI-RADS category 5). A large, partially circumscribed and partially irregular/indistinct mass is seen in the right breast at the 6 o'clock position (**c, d**). On craniocaudal view, a second lesion is seen in the central aspect of the breast close to the chest wall (*arrow*). In addition, three smaller circumscribed lesions are present in the axilla, two of which represent enlarged lymph nodes. US confirmed the presence of a partially circumscribed and partially irregular/indistinct hypoechoic mass, as well as axillary lesions that were subsequently found to represent metastatic lymph nodes

Imaging-guided breast interventional procedures permit accurate and less invasive approaches to tissue diagnosis than conventional surgical biopsy. Needle placement during preoperative mammographic localization is performed rapidly and with great precision using specially designed fenestrated breast compression paddles. In addition, a variety of hooked wires have been developed that anchor in breast tissue after deployment through the localizing needle. Highly accurate procedures for performing percutaneous tissue diagnosis also are in widespread use, based on either sonographic or stereotactic mammographic guidance. Coupled with either fine-needle aspiration or core biopsy, these approaches allow reliable diagnosis of most benign lesions without the need for surgical resection, thereby reducing morbidity and cost. Furthermore, the percutaneous diagnosis of malignancy prior to open surgery often permits the delivery of definitive surgical treatment in a streamlined and also less costly manner.

Circumscribed Noncalcified Mass

The major differential diagnostic possibilities for a circumscribed noncalcified mass seen at mammography are cyst, fibroadenoma, and circumscribed carcinoma (Fig. 3). Most circumscribed noncalcified masses identified at screening, are nonpalpable and <1 cm. These types of masses are initially evaluated with US, which can reliably diagnose a simple cyst, thereby eliminating the need for any further work-up. However, if the mass is solid but displays no sonographic features of malignancy, and if it continues to appear circumscribed at fine-detail mammography (using spot-compression with or without magnification), then it usually is assessed as being probably benign and managed with periodic mammographic surveillance. Tissue diagnosis is performed only for (1) those masses with suspicious imaging features at US or fine-detail mammography, (2) masses with suspicious features at palpation, and (3) masses that are seen to have enlarged since a prior examination. Thus, the few circumscribed masses that prove to be malignant are diagnosed readily but the great majority of benign masses are managed simply with mammography and US. A relatively small percentage of such masses are now evaluated by percutaneous biopsy, and only very few benign lesions are actually excised.

Grouped Microcalcifications

Most cases of grouped microcalcifications are detected at mammographic screening, and most screening-detected cancers are treated with breast preservation surgery. When grouped microcalcifications are detected (or even suspected) at screening, additional fine-detail imaging is usually obtained, using spot-compression

Fig. 4. Spot-compression magnification mammogram of the right breast. A group of microcalcifications is seen within dense breast tissue. Additional scattered calcifications were distributed throughout much of the right breast parenchyma. The calcifications are round and punctate, some larger and some smaller than 0.5 mm. Assessment: probably benign, BI-RADS category 3. The patient declined periodic mammographic surveillance; instead, stereotactic core biopsy was performed. Histology confirmed the suspected diagnosis of sclerosing adenosis

magnification mammography, to portray with greater clarity the shapes and extent of the calcifications (Figs. 4, 5). This permits classification of some otherwise 'suspicious' cases into more benign categories, such that truly benign lesions are managed by mammographic surveillance rather than by tissue diagnosis, thereby reducing morbidity and cost. This approach also provides additional information about the extent of disease prior to an appropriately indicated interventional procedure, which is very useful in planning exactly what type of intervention(s) to perform, especially if carcinoma is later found at biopsy.

Architectural Distortion

The mammographic feature of architectural distortion most often involves thin radiopaque lines (spiculation) radiating from a central point, with no definite mass visible at the center of the lesion. Another, less common manifestation of architectural distortion is focal retraction or distortion of the edge of the parenchyma at one of its interfaces with either the subcutaneous fat or retromammary fat/fascia. In the absence of an appropriate history of trauma or surgery, architectural distortion is sus-

Fig. 5a-d. First-screening mammography study in a 52-year-old asymptomatic woman. **a** Spot-compression magnification view of the right breast. Note the grouped, fine-linear and branching (casting) microcalcifications, highly suggestive of malignancy (BI-RADS category 5). **b** Preoperatively, mammographically guided hook-wire localization was performed. **c** Complete excision of the lesion was confirmed by a specimen radiograph. **d** Histology showed ductal carcinoma in situ (DCIS)

picious for malignancy or radial scar, and biopsy is appropriate (Fig. 6). In a retrospective study of 300 consecutive nonpalpable breast cancers, 9% were identified as architectural distortion. The likelihood of malignancy among findings characterized as architectural distortion is estimated to range from 10 to 35%, depending on case selection, patient age, and other factors.

Asymmetry

There are four types of asymmetry, all of which represent areas of fibroglandular-density tissue that is more extensive in one breast than the other. Asymmetry is usually distinguished from mass in that it demonstrates concave-outward rather than the convex-outward contours typical of a mass, and it is interspersed with fat rather than ap-

pearing denser in the center than at the periphery (typical of a mass). *Summation artifact* is caused by superimposition of normal fibroglandular breast structures on a given mammographic projection. As such, this finding will be visible on only one of the two standard views and will not be seen on additional views taken in different projections. The clinician must distinguish summation artifact from the other types of asymmetry described below, because it never represents breast cancer and should not be subjected to biopsy. A one-view-only mammographic finding is called an *asymmetry* prior to diagnostic imaging evaluation. Most (>75%) asymmetries represent summation artifacts; the rest are other types of asymmetry or masses. *Global asymmetry* (formerly called asymmetric breast tissue) represents a greater volume of fibroglandular tissue in one breast than in the corresponding location in the opposite breast, without an associated mass, mi-

Fig. 6a-c. A 65-year-old asymptomatic women referred for screening mammography. **a** Mammography, mediolateral oblique views; **b** mammography, craniocaudal views; **c** US of the left breast. Mammography shows a focal asymmetry as well as architectural distortion in the upper outer quadrant of the left breast (alternatively, the lesion could be described as a spiculated mass because it appears to be dense in its center). Note the cluster of microcalcifications superolateral and deep to the lesion. An irregular/indistinct hypoechoic lesion, non-parallel (taller-than-wide) in orientation, was confirmed at US (highly suggestive of malignancy, BI-RADS category 5). Histology showed invasive ductal carcinoma, pT2N0

crocalcifications, or architectural distortion. It is found in approximately 3% of screening mammography examinations. It almost always represents a normal variant, but occasionally it may indicate the presence of an underlying breast cancer if it corresponds to a palpable abnormality. In this latter clinical setting, the radiologist usually will recall the patient for additional imaging evaluation. *Focal asymmetry* (formerly called focal asymmetric density) is an asymmetry of fibroglandular-tissue density seen on two different mammographic projections but lacking the convex-outward contours and conspicuity of a mass. It usually represents an island of normal dense breast tissue, but its lack of specific benign characteristics may warrant further evaluation, especially if it is not interspersed with fat. In a retrospective study of 300 consecutive nonpalpable breast cancers, 3% were identified as focal asymmetries. The likelihood of malignancy among findings characterized as focal asymmetry (without associated mass, calcifications, architectural distortion, sonographic abnormality, or palpable correlate) is <1%. *Developing asymmetry* (formerly called developing

density or neodensity) is a focal asymmetry that is new, larger, or denser on current examination than on a previous one. To identify such a lesion, prior mammograms must be available for comparison. In a retrospective study of 300 consecutive nonpalpable breast cancers, 6% were identified as developing asymmetries. The likelihood of malignancy among findings characterized as developing asymmetry is estimated to be 10-15%.

Typical Breast Cancer

Mass

The great majority of cancers presenting as masses are nonpalpable and detected at mammographic screening, often smaller than 1 cm in greatest dimension and only rarely with signs of locally advanced disease. At the University of California – San Francisco (UCSF), 85% of the invasive cancers detected at screening have negative axillary lymph nodes, and 71% of invasive cancers are

stage 1 lesions. Most malignant masses found at screening have indistinct rather than spiculated margins. Presumably this is due to earlier detection, before sufficient desmoplastic reaction has formed to be visible as spiculation on standard screening images.

Calcifications

Due to the fairly widespread use of mammographic screening, a substantial percentage of cancers present with calcifications alone. These lesions generally are nonpalpable, many are ≤1 cm, and the great majority are stage 0 lesions (ductal carcinoma in situ, DCIS). At the UCSF, during each year over the past 15 years, DCIS has accounted for between 25 and 30% of all cancers detected at mammographic screening. These highly curable malignancies are now treated with breast preservation therapy, so long as they do not occupy a large volume of the breast in relation to overall breast size, to the extent that complete tumor excision would compromise cosmesis.

Breast Implants

Implant imaging with film-screen mammography does not include in the image field the most posterior portions of a breast implant, but the development of implant-displaced views has greatly improved visualization of native breast tissues anterior to the implant. This occasionally permits detection of a nonpalpable breast cancer that otherwise would not have been visible. Breast MRI also adds to the capabilities of modern mammography, by readily demonstrating extracapsular posterior-surface rupture and intracapsular rupture of a silicone-filled implant.

Reporting Breast Imaging Findings

Effective reporting of breast imaging findings requires the use of a logical structure, consistent terminology, straightforward assessment and associated management recommendations, all packaged in a clear and concise document. The American College of Radiology developed the Breast Imaging Reporting and Data System (BI-RADS) in the early 1990s in order to achieve these goals. BI-RADS is now widely used throughout North and South America, and is being used more extensively in other countries as well. A major advantage of BI-RADS is that it employs standardized terminology for imaging features, associated with specific evidence-based clinical assessment categories and management recommendations (Table 1). The most recent update of BI-RADS (4th edition, 2003) includes not only mammography but also breast US and MRI findings. When a patient has more than one breast examination on the same day, a single report should be produced, describing the imaging findings of the component examinations and including an integrated assessment that takes into account all findings and makes a single set of management recommendations.

Suggested Reading

American College of Radiology (2003) Breast Imaging Reporting and Data System (BI-RADS), 4th edn. American College of Radiology, Reston, VA

Azavedo E, Svane G, Auer G (1989) Stereotactic fine-needle biopsy in 2594 mammographically detected nonpalpable lesions. Lancet 1:1033-1036

Jackson VP (1995) The current role of ultrasonography in breast imaging. Radiol Clin North Am 33:1161-1170

Kopans DB (1989) Preoperative imaging-guided needle placement and localization of clinically occult breast lesions. AJR Am J Roentgenol 152:1-9

Kubik-Huch RA (2006) Imaging the young breast. Breast J Suppl S:35-S40

Liberman L, Feng TL, Dershaw DD et al (1998) US-guided core breast biopsy: use and cost effectiveness. Radiology 208:717-723

Parker SH, Burbank F, Jackman RJ et al (1994) Percutaneous large-core breast biopsy: a multi-institutional study. Radiology 193:359-364

Sickles EA (1980) Further experience with microfocal spot magnification mammography in the assessment of clustered microcalcifications. Radiology 137:9-14

Table 1. BI-RADS assessment categories and management recommendations

CT Severity Index	Points	Modified CT Severity Index	Points
Assessment	Category	Comments	Management recommendations
Incomplete	0	Use primarily for screening examinations	Additional imaging assessment (usually diagnostic mammography and ultrasound)
Negative	1	No findings described in report	Routine mammographic screening
Benign	2	Specific benign finding(s) described in report	Routine mammographic screening
Probably benign	3	Likelihood of malignancy <2%	Short-interval follow-up (usually 6 months)
Suspicious	4	Likelihood of malignancy 2-<95%	Tissue diagnosis (usually percutaneous biopsy)
Highly suggestive of malignancy	5	Likelihood of malignancy ≥95%	Appropriate action (usually biopsy)
Known biopsy-proven cancer	6	Already biopsied cancer, prior to surgical excision	Appropriate action (usually surgical excision)

Sickles EA, Filly RA, Callen PW (1984) Benign breast lesions: ultrasound detection and diagnosis. Radiology 151:467-470

Sickles EA (1986) Mammographic features of 300 consecutive non-palpable breast cancers. AJR Am J Roentgenol 146:661-663

Sickles EA (1995) Management of probably benign lesions. Radiol Clin North Am 33:1123-1130

Sickles EA (1998) Findings at mammographic screening on only one standard projection: outcomes analysis. Radiology 208:471-475

Stavros AT, Thickman D, Rapp CL et al (1995) Solid breast nodules: use of sonography to distinguish between benign and malignant lesions. Radiology 196:123-134

Steinbach BG, Hardt NS, Abbitt PL et al (1993) Breast implants, common complications, and concurrent breast disease. Radiographics 13:93-97

Suleiman OH, Spelic DC, McCrohan JL et al (1999) Mammography in the 1990s: the United States and Canada. Radiology 210:345-351

Ancillary Imaging Techniques and Minimally Invasive Procedures in the Diagnosis of Breast Cancer

A. Rieber-Brambs[1], M. Müller-Schimpfle[2]

[1] Department of Diagnostic and Interventional Radiology and Nuclear Medicine, Municipal Hospitals of Munich GmbH, Hospital Neuperlach, Munich, Germany

[2] Radiologisches Zentralinstitut, Städt Kliniken Frankfurt/M-Höchst, Frankfurt/Main, Germany

Magnetic Resonance Mammography

Magnetic resonance mammography (MRM) is one of the most important additional methods for the diagnosis of breast cancer. The technique is well-described and standardized, with reported sensitivities of about 90% and specificities of about 80%, depending on the indication for which MRM is used.

The MRM-based diagnosis of breast cancer is made according to certain criteria. The first is the signal intensity on T2-weighted images. Breast cancers have mostly a dark signal intensity, whereas some benign tumors, including cysts and hypercellular fibroadenomas, have a bright signal intensity. The second is the morphologic appearance. Breast cancers have mostly irregular and spiculated margins whereas benign tumors are usually well-shaped and round. Finally, and perhaps most importantly, the pattern of dynamic contrast enhancement must be well-noted. Breast cancers show an early contrast enhancement with a maximum of more than 100% in the first 3 min, followed by a plateau phenomenon, and a wash-out in the late sequences.

As is the case for screening mammography, the use of a Breast Imaging Reporting and Data System (BIRADS) classification for MRM is recommended (Table 1).

Some authors advocate the use of a point system to evaluate MRM results (Table 2). A visible lesion is assessed according to the following criteria, and points are given consistent with the following scheme:

Table 1. The Breast Imaging Reporting and Data System (BIRADS) classification system for magnetic resonance mammography

BIRADS level	Indication
1	Negative, routine follow-up
2	Benign, routine follow-up
3	Probably benign, short-interval follow-up (6 months)
4	Suspicious, biopsy recommended
5	Highly suggestive of malignancy, biopsy recommended
0	Additional diagnostic methods recommended

Table 2. Point system for evaluating magnetic resonance mammography results

	0 points	1 point	2 points
Shape	Round, oval	Spiculated, irregular	–
Margins	Circumscribed	Ill-defined	–
Contrast enhancement	Homogeneous	Heterogeneous	Rim
Initial contrast enhancement	<50%	50-100%	>100%
Post-initial contrast enhancement	Continuous	Plateau	Wash-out

After addition of the points, evaluation is done according to the scheme shown in Table 3:

The many indications for MRM are summarized below. In general, it can be stated that all are well-founded and make use of the high sensitivity of this technique.

Good indications for preoperative MRM in patients with known breast cancers are the detection of multifocal lesions, especially in lobular cancers; detection of contralateral carcinoma; monitoring during neoadjuvant chemotherapy; and evaluation of chest-wall invasion.

Good indications for postoperative MRM in breast-cancer patients are: in the diagnosis of recurrence; postoperative tissue reconstruction, e.g., transverse rectus abdominis musculocutaneous (TRAM) flap, latissimus dorsi flap; following silicone augmentation; and after lumpectomy, in

Table 3. BIRADS classification according to points

BIRADS level	Points	Comments
1	0	Negative
2	1-2	Benign
3	3	Probably benign, short-interval follow-up (6 months)
4	4-5	Suspicious, biopsy recommended
5	6-8	Highly suggestive of malignancy, biopsy recommended

the evaluation of patients with close or positive margins for residual disease.

Beside these indications, MRM can be recommended in the following cases:

- Axillary lymph-node metastases in unknown primary
- Patients with familial disposition for breast cancer
- Asymmetric opacity in mammography
- Suspicious retraction of the nipple without pathologic findings on mammography and sonography
- Abnormal ductal lavage cytology with negative physical examination, mammography, and ultrasound.

Nevertheless, the specificity of MRM is limited, which often precludes the reliable differentiation between benign and malignant lesions. In these cases, core needle biopsy or follow-up after 6 months are the methods of choice. MRM is usually not recommended in the differential diagnosis of fibroadenoma/carcinoma or inflammatory carcinoma/mastitis. In both of these cases, biopsy is the diagnostic method of choice. MRM is also not used in the diagnosis of non-invasive breast cancer, as here again biopsy is preferred. Biopsy or follow-up is recommended in the differential diagnosis of liponecrosis/recurrence in flaps. Mastopathic lesions that mimic carcinoma should be carefully followed. Surgery is recommended for those patients in whom tumor size following chemotherapy cannot be reliably determined. In the evaluation of scarring at <6 months, further evaluation or biopsy should be considered. The success of radiotherapy at a follow-up of 6 months should either be determined by biopsy or the waiting time should be extended before the patient's status is assessed.

Positron Emission Tomography

Positron emission tomography (PET) is a very promising method in oncology patients. Nevertheless, its use is limited in breast-cancer patients, and currently there are no routine indications in these patients. The main reason is the limited sensitivity (78.9%) of PET in the diagnosis of breast cancer. However, there are other reasons that justify the limited use of PET. For example, in the detection of multifocal lesions in breast cancer, MRM has a higher sensitivity than PET. In the diagnosis of axillary lymph-node metastases, sentinel node scintigraphy is superior to PET. As with MRM, false-negative results are reported in patients with a good response to chemotherapy. The reliable differentiation between mastitis and chemotherapy is not possible.

In summary, many further studies are still necessary before the use of PET in breast-cancer patients can be recommended with confidence.

Minimally Invasive Procedures

In most unclear cases, especially if the lesion is more or less suspicious, biopsy is necessary to obtain a definitive reliable diagnosis. Several biopsy methods are available:

Table 4. Comparison of fine-needle aspiration cytology (*FNAC*) and core needle biopsy (*CNB*)

	FNAC	CNB
Sensitivity (%)	85-88	91-98
Specificity (%)	55.6-90.5	73-100
Accuracy (%)	53.8-67.3	79-97

- Fine-needle aspiration cytology (FNAC; 18-25 G needle)
- Core needle biopsy (CNB; 14-16 G needle)
- Vacuum-assisted biopsy (extirpation of lesions ≤1 cm in diameter; 11-14 G needle
- 'Advanced Breast Biopsy Instrumentation' (ABBI): extirpation of lesions 5-20 mm in diameter.

The results of FNAC are limited. Instead, CNB or other techniques involving the use of thicker needles are recommended. A comparison of FNAC and CNB is shown in Table 4.

The results of vacuum-assisted biopsy are superior to these of CNB, which accounts for its increasing use. ABBI has also shown promising results, but the complication rate is high, making the use of this method problematic. Thicker needles allow histological evaluation to be made with greater diagnostic accuracy, nevertheless, tumors may still be histologically underestimated: In CNB (14-G needle) this occurs in about 20.4% of cases and in vacuum-assisted biopsy (11-G needle) in about 11.2% of cases, depending on the number of biopsies performed. For ten biopsies underestimation was 17.5%, while for more than ten biopsies the rate was 11.5%.

Currently, several considerations must be made regarding the use of percutaneous stereotactic vacuum-assisted biopsy. First, it is a diagnostic method, not a form of therapy. Thus, in histologically proven cancers the tumor must be surgically resected. BIRADS 1 and 2 are not indications for the use of this biopsy technique, while in BIRADS 3 it should be undertaken only after extensive discussion with the patient. For BIRADS 4, biopsy is obligatory but the most appropriate method should be chosen by the treating physician. For BIRADS 5, CNB is sufficient for confirmation of breast cancer and planning of surgical therapy. Vacuum-assisted biopsy is, however, recommended for clip-placement in patients receiving neoadjuvant chemotherapy and following complete extirpation of the lesion, in most cases.

About 40 min are required to perform a vacuum-assisted biopsy. Complete extirpation following assisted biopsy was reported in 32.5-61% of patients. Representative probes were obtained in 39-77.5% of the biopsies and no scars were visible by mammography in 96% of the patients.

Conclusions

The high sensitivity of MRM recommends its use for the detection of multifocal lesions or contralateral carcinoma

in known breast cancer or for the exclusion or detection of recurrent disease. PET is a promising method, but, at least for now, its use is restricted to clinical studies.

In the evaluation of most unclear or suspicious lesions, biopsy is recommended because the differentiation between benign and malignant lesions is limited with all imaging modalities. Vacuum-assisted biopsy seems to be superior to all other techniques, including FNAC, CNB, or ABBI. Nevertheless, to confirm a diagnosis of breast cancer or in the planning of surgical therapy CNB is usually sufficient.

Suggested Reading

Harms SE, Rabinovitch R, Julian TR et al (2004) Report of the working groups on breast MRI: Report of the breast cancer staging group. Breast J 10:S3-S8

Heywang-Köbrunner SH, Schreer I, Decker T, Böcker W (2003) Interdisciplinary consensus on the use and technique of vacuumassisted stereotactic breast biopsy. Eur J Radiol 41:232-236

Rieber A, Brambs H-J, Gabelmann A et al (2002) Breast MRI for monitoring response of primary breast cancer to neo-adjuvant chemotherapy. Eur Radiol 12:1711-1719

Rieber A, Kuehn T, Schramm K et al (2003) Breast-conserving surgery and autogeneous tissue reconstruction in patients with breast cancer: efficacy of MRI of the breast in the detection of recurrent disease. Eur Radiol 13:780-787

Rieber A, Schirrmeister H, Nüssle K et al (2002) Preoperative staglng of irivasive breast cancer with MR mammography and/or PFT: boon or bunk? Br J Radiol 75:789-798

Rieber A, Tomczak R, Merkle E et al (1997) Value of MR-mammography in the detection and exclusion of recurrent breast cancer. J Comput Assist Tomogr 21:780-784

Rieber A, Merkle E, Böhm W et al (1997) MRI of histologically confirmed mammary carcinoma: Clinical relevance 01' diagnostic procedures for detection of multifocal or contralateral secondary carcinoma. J Comput Assist Tomogr 21:773-779

Viehweg P, Rotter K, Laniado M et al (2004) MR Imaging of the contralateral breast in patients after breast-conserving therapy. Eur Radiol 14:402-408

Weir L, Worsley D, Bernstein V (2005) The value of FDG positron emission tomography in the management of patients with breast cancer. Breast J 11:204-209

PEDIATRIC SATELLITE COURSE
"KANGAROO"

Postnatal Imaging of Bronchopulmonary and Mediastinal Malformations

F.E. Avni, M. Cassart, A. Massez

Department of Medical Imaging, University Clinics of Brussels – Erasme Hospital, Brussels, Belgium

Introduction

Obstetrical ultrasound has induced a marked increase in the perinatal diagnosis of broncho-pulmonary and mediastinal malformations. The spectrum of malformations amenable to antenatal diagnosis is wide (Table 1). The numerous classifications and terminologies attempt to incorporate a common origin and association of many lesions, including variable foregut airway, lung, and vascular components. Aside from the classical anomalies, such as congenital cystic adenomatoid malformations (CCAM), and sequestration, other, less common ones can also be considered as part of the spectrum (pulmonary hypoplasia, pulmonary aplasia, tracheal bronchus, etc.).

Some authors have suggested that many of the bronchopulmonary malformations (BPMs) represent an obstructive malformation sequence with secondary pulmonary dysplastic changes. Differences in the level, timing, and degree of obstruction are responsible for the spectrum of anomalies. The vascular origin of the anomalies has also been emphasized. Pulmonary hyperplasia as encountered in CCAM (type III) or in laryngeal atresia is one type of dysplastic change. Microcystic parenchymal dysplasia as seen in bronchial atresia, sequestration, or congenital lobar emphysema (CLE) is the other type that is encountered.

There have been several reports on the natural history of such anomalies. Furthermore, nowadays, neonatal management is widely influenced by the prenatal findings.

The aim of the present work is to define criteria for the postnatal work-up of patients with antenatally suspected BPM and to concisely detail the findings on imaging

Table 1. Spectrum of bronchopulmonary malformations

Congenital cystic adenomatoid malformation
Sequestration
Congenital lobar hyperplasia
Bronchial atresia
Pulmonary cysts
(Laryngeal atresia)

techniques (mainly chest X-ray and CT scan) that, even in asymptomatic newborns, point to the presence of this group of malformations [1-3].

Bronchopulmonary Malformations

In Utero

Bronchopulmonary malformations are most often detected during the second trimester. Sonographically, the most common presentation at that stage is a hyperechoic space-occupying lesion that is either homogenous or contains small or large cysts. The mass causes a contralateral shift of the mediastinum. Since the spectrum of malformations is wide, a specific diagnosis cannot be made in utero unless a systemic vessel is demonstrated that vascularizes the lesion, suggesting the presence of a sequestration. However, at that stage, an exact differential diagnosis is not necessary, since many lesions are hybrid and include several different dysplastic tissues. Instead, the search for bilateral lesions and for other systemic malformations (e.g., skeletal, cardiovascular) is more important, as these will influence the in utero and postnatal prognoses. For instance, fetal hydrops and effusion may indicate a poor prognosis.

An important differential diagnosis to consider is diaphragmatic hernia. Its sonographic presentation may be confusing but the demonstration of small bowel loops, colon, and/or stomach in the thorax suggest the diagnosis.

The natural history of many BPMs consists of a relative (or absolute) decrease in volume such that the anomaly becomes increasingly difficult to recognize. This is especially the case when the mediastinum returns to the midline or the hyperechogenicity of the mass diminishes. Nonetheless, in either case it should not be assumed that the mass has completely disappeared [1, 2, 4-7].

A BPM should also be included in the differential diagnosis of a mediastinal mass (Table 2). Cystic lesions could correspond to a vascular malformation; therefore, the use of

Table 2. The differential diagnosis of a mediastinal mass in utero

Cystic lesions
 Bronchogenic cyst
 Duplication cyst
 Neurenteric cyst
 Vascular malformation
 Cystic lymphangioma
 Cystic teratoma

Solid/mixed type lesions
 Mediastinal sequestration
 Mediastinal teratoma

color Doppler is mandatory. Solid or mixed type lesions are more difficult to demonstrate and should suggest a mediastinal sequestration or a mediastinal teratoma [1, 2, 8, 9].

The Neonatal Period

In the neonatal period, the newborn affected by a BPM can be completely asymptomatic or present with respiratory distress due to airway compression. Noteworthy is the fact that the fluid within cystic malformations may rapidly be replaced by air and, due to air trapping, the cysts may subsequently enlarge. In such cases, asymptomatic newborns may acutely become symptomatic. For this reason and as a rule, all newborns with a prenatal diagnosis of BPM should undergo a neonatal work-up in order to determine the best treatment and follow-up. It should also be underlined that not all BPMs are detected prenatally; rather they can be an 'incidental' finding in a neonate [2-4].

Imaging Techniques and Findings

Chest X-ray

Chest X-ray is the basis of the neonatal work-up. Supine, frontal, and lateral views should be obtained during inspiration, while X-rays taken during expiration may be of interest in order to demonstrate air trapping. The potential findings on chest X-ray are listed in Table 3.

Table 3. Findings on chest X-rays in newborns with bronchopulmonary malformations

Abnormal aeration
 Hyperaeration of an entire lung Æ asymmetric aeration
 Hyperaeration of a lobe or segment
 Consolidation
 Partially aerated consolidation

Round nodular lesion
 Partially aerated round lesion
 Fluid air level
 Completely aerated cyst (bleb)

Increased vascular markings

'Silhouette' sign at the level of the diaphragm

Enlarged mediastinum X-ray

Several of the findings may be associated. Also, when successive X-rays are obtained within the first few days of life, an evolution from one pattern to another can be observed. This evolution is usually a clue to the diagnosis and corresponds to resorption of the fluid contained in a lesion (i.e., pulmonary cyst, CLE, CCAM). Associated vertebral anomalies should also be searched for.

It should be noted that a normal-appearing chest X-ray does not mean complete resolution of the malformation or the absence of anomaly. Therefore, complementary CT or MR imaging should be done as well [1, 10].

Chest CT

Helical chest CT is the method of choice for imaging a BPM and is particularly accurate in determining areas of abnormal aeration, air fluid level, bilateral lesions, and abnormal vascularization. Pre- and post-contrast enhancement scans are mandatory as they demonstrate abnormal systemic arterial vascularization in case of sequestration as well as peripheral dysplastic venous drainage. 3D volume rendering also allows better mapping of the anomaly. CT provides essential information regarding bronchial atresia, bronchomalacia, and tracheal bronchus. Finally, CT reveals cystic lesions in any location (parenchymal vs. mediastinal) and allows densities within the lesions to be measured [1, 10-12].

Chest Magnetic Resonance Imaging

This technique provides information similar to that obtained with CT, especially concerning vascularization of the malformation. T1, T2, and echo-gradient sequences should be obtained in order to optimally assess the anomaly. MR imaging of the chest does not allow parenchymal assessment but it may demonstrate any extension of these lesion towards the spine and spinal canal [9, 11].

Ultrasound

Ultrasound may be helpful in demonstrating lesions close to the diaphragm and in the mediastinum. It is also able to demonstrate systemic vessels emerging from the aorta towards a sequestration as well as the anatomical relationship between a cystic lesion and other structures of the mediastinum [10, 13].

Upper GI Tract Opacification

Since BPM, especially sequestration, may involve the esophagus or stomach, in selected cases (e.g., persisting opacity in a lower lobe) an upper GI series may be useful [1, 2].

Angiogram

Angiograms are no longer performed unless embolization of a sequestration is being considered as a thera-

peutic option. They are also periodically used to evaluate patients with complex cardiovascular malformations [1, 2].

Conclusions

The antenatal diagnosis of BPM has modified our postnatal approach and management of the newborns affected.

A systematic work-up should be proposed even in asymptomatic patients.

Chest X-ray and helical Ct should be performed in order to determine the best treatment.

References

1. Newman B (2006) Congenital bronchopulmonary foregut malformations: concepts and controversies. Pediatr Radiol 36:773-791
2. Johnson AM, Hublard AM (2004) Congenital anomalies of the fetal/neonatal chest. Semin Roentgen 39:197-214
3. Langston C (2003) New concepts in the pathology of congenital lung malformations. Semin Pediatr Surg 12:17-37
4. Pumberger W, Hörman M, Deutinger J et al (2003) Longitudinal observation of antenatally detected congenital lung malformations. Eur J Card Thor Surg 24:703-711
5. Dolkart LA, Reiners FT, Helmuth WV et al (1992) Antenatal diagnosis of pulmonary sequestration: a review. Obstetr Gynecol Surv 47:515-520
6. Rypens F, Grignon A, Avni F (2002) The fetal chest. In: Avni F (ed) Perinatal imaging. Springer Verlag, Berlin, pp 77-102
7. Richards DS, Langhans MR, Dolson LH (1992) Antenatal presentation of a child with CLE. J Ultrasound Med 11:165-168
8. Schwartz MI, Ranyar Chandran P (1997) Congenital malformations of the lung and mediastinum. J Pediatr Surg 32:44-47
9. Coran AG, Drongowski R (1994) Congenital cystic disease of the tracheo-bronchial tree in infants. Arch Surg 129:521-527
10. Paterson A (2005) Imaging evaluation of congenital lung abnormalities in infants and children. Radiol Clin North Am 43:303-323
11. Kang M, Khandelwal N, Ojihi V et al (2006) Multidetector CT angiography in pulmonary sequestration. J Comput Assist Tomogr 30:926-932
12. Daltro P, Fricke BL, Kuroki I et al (2004) CT of congenital lung lesions in pediatric patients. AJR Am J Roentgenol 183:1497-1506
13. Felker RE, Tonkin PLO (1990) Imaging of pulmonary sequestration. AJR Am J Roentgenol 154:214-249

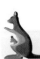

The Pediatric Airway

R. Cleveland

Radiology Department Children's Hospital, Harvard Medical School, Boston, MA, USA

Introduction

During infant respiration, not only the diameter but also the shape of the trachea may change dramatically. On expiration, the trachea often assumes a buckled configuration that deviates in an angular manner away from the side of the aortic arch at the level of the thoracic inlet. In addition, angular buckling associated with a widening of the pre-vertebral, retropharyngeal, and retrolaryngeal soft tissues may occur posteriorly and inferiorly at the thoracic inlet [1]. In fact, the width of the prevertebral soft tissues may increase to at least twice the AP width of the cervical vertebral bodies on expiration. This soft-tissue fullness may also be noted with flexion of the neck. As the infant matures, the amount of soft tissue decreases.

Besides the various developmental factors that influence airway maturity, certain diseases and congenital defects may also cause structural abnormalities. For example, when there is incomplete development of the elastic and connective tracheal tissue (tracheomalacia), only a *portion* of the intrathoracic trachea will collapse with expiration; while the remainder of airway maintains normal caliber during inspiration and expiration. In diagnosing tracheomalacia in infants and children, conventional fluoroscopy-guided airway studies are typically recommended. Computed tomography (CT) has proven more effective, however, in depicting the location, extent, and degree of tracheomalacia when it is used with a dynamic airway protocol that images the central airway at the end of inspiration and expiration. Furthermore, multi-detector CT (MDCT) with 3D central-airway reconstruction produces exquisitely detailed images of the entire central airway [3]. The size of the cervical trachea is affected by the pressure within its lumen. An excellent illustration of this is when the extrathoracic airway is obstructed or partially obstructed (as in croup). Under these circumstances, the entire cervical trachea may collapse with vigorous inspiration. Moreover, the cervical trachea can become significantly enlarged as the vocal cords close and there is a corresponding increase in positive pressure within the chest [4].

Disease processes such as prevertebral abscess, adenopathy, or tumor can also impact airway configuration. These pathologies are frequently characterized by prominent soft tissues but without the angled configuration that takes place during expiration. Rhabdosarcoma, lymphoma, primitive neuroectodermal tumors (PNET), and mesenchymal cell sarcomas (including germ cell and yolk sac tumors) most commonly develop in this location. These lesions generally obscure the normal prevertebral soft-tissue plains. Moreover, if the retropharyngeal soft-tissue fullness is more pronounced superiorly than inferiorly, it likely reflects pathology.

Laryngeal and Subglottic Airway

The junction of the underside of the true vocal cords and infraglottic larynx is less acute in infants and small children than it is in older children and adults; this results in a less prominent normal subglottic 'shoulder' effect. However, subglottic narrowing can and should be distinguished from normal sloping of the infraglottic larynx. In addition, during active breathing, the vocal cords are abducted producing a normal loss of the infraglottic 'shoulders' that can be recognized by the lack of vocal-cord apposition.

Inflammation of the epiglottis (epiglottitis) is classically associated with infection by hemophilus influenza type B (HIB) infection. Fortunately, relatively few cases of this disease are now reported since HIB vaccinations are widely available and strongly encouraged. Infections by non-type-B hemophilus influenza, however, occasionally occur. Other types of bacteria may also give rise to epiglottitis. The edema that is caused by the ingestion of hot foods or liquids may also resemble epiglottitis. Edema that results from hypersensitivity (e.g., an allergic reaction) may also appear anatomically similar to infection. Epiglottitis generally occurs in winter months and primarily affects children ages 3-6 years. The most clinically apparent symptom is epiglottic swelling; although the aryepiglottic folds and subglottic larynx may show evidence of inflammation as well.

Plain-film or fluoroscopy imaging may be used to definitively diagnose a suspected case of epiglottitis, but extreme caution must be exercised because the child's air-

way may become completely obstructed during imaging. If the head and neck are moved or straightened, the airway may become completely occluded. At times, the aryepiglottic folds or subglottic airway are involved, further complicating an imaging study. In certain cases, the epiglottis may be spared, but the aryepiglottic folds and/or subglottic airway are affected.

The edema that causes subglottic narrowing, associated with 'croup,' is characterized by labored breathing and a hoarse, brassy cough. While 'croup' is usually associated with infection by a parainfluenza virus, the term is also used to refer to the expanded complex of laryngotracheobronchitis. This disease primarily affects children 6 months to 3 years of age during the winter months. Whereas epiglottitis presents with a high probability of life-threatening airway obstruction, croup is generally more benign. In severe circumstances, intubation may be necessary. In the most severe cases, intrathoracic pressure may exceed oncotic pressure on inspiration resulting in pulmonary edema.

Staphylococcal organisms can give rise to tracheal bacterial infections known as bacterial croup or pseudomembranous tracheitis. This process may present with pseudomembrane formation and croup-like symptoms.

In infants and children, focal masses may appear in the subglottic airway. Focal granulation tissue may develop secondary to previous intubation or tracheotomy. Lesions may also be secondary to a subglottic hemangioma, which often arise concomitantly with cutaneous hemangiomata often of the head or neck. Subglottic hemangiomas are most often located posterolaterally, usually within 1-1.5 cm below the vocal cords, and frequently involute spontaneously by age 5 or 6 years. Although their detection can be accomplished by plain radiographs or conventional fluoroscopy-guided airway study, CT, and especially MDCT with its multiplanar and 3D imaging capabilities, can be helpful. Virtual tracheobronchoscopy is particularly useful for evaluating the degree of airway obstruction, which has been proven to correlate well with the findings of conventional tracheobronchoscopy. In patients above the age of 5 years, an isolated subglottic mass is more likely to be a papilloma than a hemangioma. Papillomata are caused by inoculation with the human papilloma virus, acquired during vaginal delivery. In up to 20% of patients, the viral infection may propagate down the airway and into the lung parenchyma, producing nodular, cavitary lung lesions [5]. Other tumors of the subglottic airway and trachea are seen only rarely in children [6].

Trachea and Mainstem Bronchi

The most commonly found intraluminal airway abnormalities in children are aspirated foreign bodies. Among very young children, single aspirated foreign bodies are distributed nearly equally between the two lungs. By age 15, the bronchial angles subtended from the trachea acquire a more adult configuration; at this stage, twice as many foreign bodies occur in the right lung [7]. However, even when a foreign body is suspected, an initial inspiratory chest film may not show this conclusively. In cases in which the diagnosis is uncertain, different imaging strategies can be adopted. For example, an obstructed lung or segment of lung is usually clearly depicted with fluoroscopy. When the lung is obstructed, the abnormal side or lobe does not respond to respiration. In other words, a lung that is filled with trapped air will remain filled. Likewise, a partially collapsed lung will remain similarly collapsed throughout respiration. The failure of the lung, or a segment of it, to exhibit a change in volume through the respiratory cycle is the critical observation. Under these circumstances, diaphragmatic excursion is unequal. On inspiration, when air is trapped in the obstructed lung, the mediastinum moves toward the abnormal side; on expiration, away from the side of obstruction. An alternative is to use bilateral decubitus chest images, but this approach often provides less convincing information since the decubitus images are often inadvertently obtained in an oblique position, which compromises the ability to accurately assess comparative lung volumes. When viewing right-lateral or left-lateral decubitus films, the normal dependent lung should appear deflated compared to the normal non-dependent lung. In older, more cooperative children, these altered dynamics are clearly demonstrated with comparative inspiration and expiration X-rays.

Relatively radiolucent foreign bodies within the airway are sometimes visible in only one projection. Esophageal foreign bodies lodged for extended periods may result in significant edema and inflammation, creating, at times, obstruction of the adjacent airway [8]. Extrinsic compression of the airway may result from mediastinal masses, such as bronchopulmonary foregut malformations (i.e., bronchogenic cysts, GI duplications, neurenteric cysts) as well as abnormal mediastinal vessels (i.e., double aortic arch, aberrant subclavian artery, pulmonary sling, anomalous innominate artery) [9]. Central-airway compression resulting from the abnormal mediastinal vessels can be identified based on plain radiographs; cross-sectional imaging by CT and MRI confirms this finding and provides useful preoperative data. The advantage of MRI is its ability to depict lung structure and function without exposing the patient to ionizing radiation. CT offers precise details of the central airway and lung parenchyma. With the introduction of MDCT and its multiplanar and 3D imaging capabilities, diagnosis and preoperative assessment of mediastinal vascular anomalies that result in central-airway compression have been significantly enhanced [3]. Mediastinal vascular anomalies, central-airway compression, and lung parenchyma can be separately evaluated with the same CT data by applying different CT reconstruction algorithms. The efficient use of imaging data thus minimizes exposure of the patient to the potentially harmful

effects of radiation, which is of particular concern in evaluating children. When extrinsic compression of the airway occurs in utero, airway cartilage development is impaired, which, in turn, may cause bronchomalacic or tracheomalacic segments to develop. With esophageal atresia, the dilated upper pouch compresses the trachea, compromising tracheal cartilage development in the segment adjacent to the dilated upper esophageal pouch. This structural aberration often produces significant tracheal narrowing and tracheomalacia. The narrowed, malacic segment of the trachea may persist even after the esophageal atresia is surgically corrected. Less commonly, the entire esophagus may be distended by obstruction at the esophagogastric junction. This may be related to chalasia, ectopic tracheal cartilages, or Chaga's disease. Significant tracheal narrowing is less common with these lesions than with esophageal atresia. Congenital tracheal or bronchial stenosis caused by a complete ring or 'o'-shaped configuration of the cartilages is often associated with pulmonary sling, which passes between the esophagus and trachea.

Peribronchial adenopathy that causes obstruction or endobronchial extension leading to obstruction is often associated with inflammatory processes, particularly tuberculosis. CT is especially useful in evaluating the location, extent, and associated airway compression or obstruction that arises from tuberculosis. It is also important to evaluate airways that are distal to the obstruction. CT has an advantage over conventional tracheobronchoscopy for evaluation of high-grade airway obstruction resulting from the peribronchial or mediastinal adenopathy. Although the airway distal to the obstruction can be evaluated with CT, conventional tracheobronchoscopy cannot be used if the obstruction is of high grade and the bronchoscope cannot be passed beyond the obstruction. Lymphoma, primary mediastinal tumors, or metastatic disease occurring in the mediastinum may cause similar extrinsic obstructions.

Several congenital variations are viewed as failures of tracheoesophageal differentiation from the primitive foregut. These include H-type tracheoesophageal fistula, laryngeal clefts, laryngotracheal clefts extending from the larynx to the carina (sometimes referred to as a common tracheoesophagus), and absence of the trachea where the mainstem bronchi arise directly from the distal esophagus. Duplication of the trachea occurs rarely [10]. Bronchial hypoplasia (or atresia), typically associated with pulmonary artery hypoplasia/atresia and congenitally hypoplastic/absent lung, are occasionally seen (predominantly on the right). In addition, 'scimitar syndrome,' a rare congenital disorder (1-3 in 100,000 live births), may also give rise to hypoplasia. This condition presents with an anomalous draining, usually involving the right, upper lobe pulmonary vein emptying into the inferior vena cava. Although the crescent-shaped 'scimitar' vein may be isolated and asymptomatic (scimitar sign), it may be associated with ipsilateral pulmonary, bronchial, and pulmonary artery hypoplasia (scimitar

syndrome). There may also be associated congenital heart disease, especially atrial septal defect (ASD), and, less commonly, ventricular septal defect (VSD) [11]. Scimitar syndrome is also associated with pulmonary sequestration [12].

Yet another unusual condition, known as 'pig bronchus,' occurs when the right upper lobe bronchus, multiple bronchi, or a bronchial segment arises directly from the trachea. Although this configuration is normal in pigs, it can be problematic for human beings. While adults with this defect are generally asymptomatic, it may be the source of recurrent right upper lobe atelectasis or pneumonia in children. This anatomic variant should be particularly suspected if a child is noted to develop right upper lobe atelectasis associated with placement of an ET tube deep within the trachea but not with less-advanced ET tubes.

Peripheral Bronchi

Among the most common acute inflammatory processes that occur in infants and very young children is bronchiolitis, which is characterized by coughing, wheezing, and fever [2]. It is typically viral (most often respiratory syncytial virus), and primarily affects the peripheral bronchi. From a radiographic standpoint, bronchiolitis is depicted by 'air trapping,' often with little or no other radiographic abnormalities. Diffuse bronchial-wall thickening (peribronchial thickening), however, is frequently apparent. Atelectasis appears less often; on sequential imaging it typically shows a shift in its distribution. Unfortunately, the radiographic course of bronchiolitis can create some confusion. Although hyperinflation is the most prevalent initial finding, as the process resolves the lungs generally show less air trapping but more atelectasis. Paradoxically, this apparent deterioration of multifocal lung disease is a sign that the inflammation is improving.

Bronchiolitis is the most common cause of acute bronchial-wall thickening. Chronic bronchial-wall thickening is most commonly seen in children with reactive airways disease or asthma. Radiographs of children with asthma or reactive airway disease generally show diffuse air trapping when patients are acutely symptomatic; however, diffuse bronchial-wall thickening is present even in asymptomatic patients. The recognition of bronchial-wall thickening is complicated since the prominence of the bronchial walls increases with age. As a guide, infants have only a minimal number of visible bronchial walls in the lung periphery, but many may be detected in the perihilar regions. With pathologic bronchial-wall thickening, more evidence of the process can be detected in the lung periphery, seen as 'o rings' and 'tram tracking.' Since the process affects the bronchi, which converge on the hilar regions, it may be most noticeably abnormal centrally and may be recognized by the presence of large, poorly marginated hilae, especially on the lateral image.

Diffuse bronchial-wall thickening is also the most common initial radiographic indicator of cystic fibrosis in infants and young children. In older children and adults, this often progresses to coarse bronchiectatic changes that are frequently perceived as nodules when fluid-filled or as cysts when air-filled. Less commonly, chronic recurrent pneumonia may result in bronchial-wall thickening. This is most often a consequence of one of two processes: (1) secondary to recurrent aspiration associated with a swallowing abnormality or a tracheoesophageal fistula, or (2) related to an immune deficiency. In these instances, the disease process may be uneven in distribution, as apposed to even distribution seen with early CF and asthma/reactive airway disease.

In congenital lobar emphysema (CLE), an estimated 50% of patients show some evidence of focal bronchial obstruction that manifests itself as an over-inflated, hyperlucent lobe. However, in the first few days of life, this may present with preferential trapping of fetal-lung liquid in the abnormal lobe. This, in turn, produces an over-inflated, opaque lobe in which the fluid slowly drains over the ensuing days, so that the affected lobe subsequently becomes hyperlucent. The distribution of CLE is roughly 43% in the left upper lobe, 32% in the right middle lobe, 20% in the right upper lobe, and 5% in two lobes [13]. With an over-inflated hyperlucent lobe and associated mediastinal shift to the contralateral side, congenital lobar emphysema is sometimes mistaken as tension pneumothorax. When this occurs, CT is useful in visualizing the underlying, over-inflated, and hyperlucent lung parenchyma. Further complicating a definitive diagnosis is a condition known as 'polyalveolar lobe,' which is clinically and radiographically indistinguishable from CLE. Although the distribution and demographics of polyalveolar lobe are similar to those of CLE, the former is characterized by a normal tracheobronchial tree but a greater number of alveoli [13]. It has been suggested that cases of suspected CLE in which there is preferential retention of fetal lung liquid are actually polyalveolar lobe [13].

Chronic lung disease of prematurity (bronchopulmonary dysplasia) develops over a period of several days as supplemental oxygen is delivered to the neonatal patient via an ET tube. It typically presents in premature infants with hyaline membrane disease, in which ciliated epithelial cells of the trachea and bronchi are destroyed and replaced with non-ciliated cells. The replacement of ciliated cells with non-ciliated ones leads to recurrent atelectasis and infections. There are also multifocal areas of atelectasis and fibrosis alternating with areas of focal over-expansion [14]. In premature infants with bronchopulmonary dysplasia who survive for several months or years, the radiographic and clinical depictions of the disease may closely resemble that of children with acute bronchiolitis or asthma. In addition, older children diagnosed at birth with pulmonary disorders,

including hyaline membrane disease, meconium aspiration, neonatal pneumonia, and diaphragmatic hernia, frequently develop reactive airway disease that is clinically recognizable or can be confirmed by pulmonary function studies [14].

Bronchiolitis obliterans (Swyer-James syndrome or Macleod syndrome) generally develops secondary to viral infection, although it can also arise from a bacterial or parasitic infection (i.e., mycoplasma). In adults, bronchiolitis obliterans is characterized by a hyperlucent small-volume lung; whereas in children the lung is over-expanded and hyperlucent, a discrepancy explained by diminished lung growth following onset of the disease. While air trapping is initially evident on imaging, proportionately less growth results in reduced lung volume compared to the normal lung. In addition, it has been established that many cases of bronchiolitis obliterans feature diffuse and irregularly affected lungs. Specifically, on CT both lungs may show abnormalities, including bronchiectasis [15], but one lung typically dominates.

Other inflammatory diseases may add to the diagnostic confusion. The early stages of follicular bronchitis [16] can radiographically and clinically resemble bronchiolitis. The disease, which some suspect is the same as that known as 'neuroendocrine cell hyperplasia,' usually presents within the first 6-8 weeks of life. However, contrary to the typically short-lived clinical course of bronchiolitis, the tachypnea and wheezing characteristic of follicular bronchitis persist for 2-3 years with increasingly worse symptoms. Radiographic findings initially suggest bronchiolitis because of air trapping, bronchial-wall thickening, and occasional instances of atelectasis. Recent work has identified a specific CT configuration for this disease [17]. By approximately 5 or 6 months of age, a diffuse, essentially interstitial process has evolved; by 8 years of age, symptoms and radiographic indicators have generally reverted to normal.

References

1. Cleveland RH (1996) The pediatric airway. Contemp Diagn Radiol 19:1-6
2. Bramson RT, Griscom NT, Cleveland RH (2005) Interpretation of chest radiographs in infants with cough and fever. Radiology 236:22-29
3. Lee EY, Siegel MJ, Hildebolt CF et al (2004) MDCT evaluation of thoracic aortic anomalies in pediatric patients and young adults: Comparison of axial, multiplanar, and 3D images. AJR Am J Roentgenol 182:777-784
4. Wittenborg MH, Gyepes MT, Crocker D (1967) Tracheal dynamics in infants with respiratory distress, stridor, and collapsing trachea. Radiology 88:653-662
5. Gruden JF, Webb WR, Sides DM (1994) Adult onset disseminated tracheobronchial papillomatosis: CT features. J Comp Ass Tomog 18:640-642
6. Mahboubi S, Behhah RD (1992) CT evaluation of tracheobronchial tumors in children. Inter J Pediatr Otorhinolaryngol 24:135-143
7. Cleveland RH (1979) Symmetry of bronchial angles in children. Radiology 133:89-93

8. Jaramillo D, Cleveland RH, Blickman JG (1991) Radiologic management of esophageal foreign bodies. Semin Intervent Radiol 8:198-203

9. Berdon WE, Baker DH (1972) Vascular anomalies and the infant lung: rings, slings, and other things. Semin Roentgenol 7:39-64

10. Karcaaltincaba M, Haliloglu M, Ekinci S (2004) Partial tracheal duplication: MDCT bronchoscopic diagnosis. AJR Am J Roentgeno 183:290-292

11. Dupuis C, Charaf LA, Breviere GM, Abou P (1993) 'Infantile' form of the scimitar syndrome with pulmonary hypertension. Am J Cardiol 71:1326-1330

12. Horcher E, Helmer F (1987) Scimitar syndrome and associated pulmonary sequestration: report of a successfully corrected case. Prog Pediatr Surg 21:107-111

13. Cleveland RH, Weber B (1993) Retained fetal lung liquid in congenital lobar emphysema: a possible predictor of polyalveolar lobe. Pediatr Radiol 23:291-295

14. Cleveland RH (1995) A radiologic update on medical diseases of the newborn chest. Pediatr Radiol 25:631-637

15. Padley SP, Adler BD, Hansell DM, Muller NL 1993 () Bronchiolitis obliterans: high resolution CT findings and correlation with pulmonary function tests. Clin Radiol 47:236-240

16. Bramson RT, Cleveland RH, Blickman JG, Kinane TB (1996) The radiographic appearance of follicular bronchitis in children. AJR Am J Roentgenol 166:1447-1450

17. Brody AS (2005) Imaging considerations: interstitial lung disease in children. Radiol Clin North Am 43:391-403

Acute Chest Infections in Children

C. Owens

Department of Radiology, Great Ormond Street Hospital for Children, NHS Trust, London, UK

Introduction

Radiation dose is a contentious issue in pediatrics, as it is well-established that the lifetime cancer mortality risks attributable to CT examinations are considerably higher than for adults. As proposed by the ALARA principle 'as low as reasonably achievable', the selection of appropriate scanning parameters focuses on the optimization of image quality whilst delivering the lowest possible radiation dose and shifting the risk-benefit balance towards benefit.

The technical parameters that need to be selected for any scan include collimation thickness and tube current (milliamperage, and kilovoltage). The collimation thickness is the minimum section thickness that can be acquired once the scan is finished, and in a 16-row MDCT scanner is usually 1.5 mm. Thinner collimation (0.75 mm) increases the radiation dose by approximately 30%

with our in-house reduced protocol and is applied only in selected cases of vascular abnormalities, visualization of small structures, in cardiac CTs, and when high-resolution thin-slice parenchymal lung imaging is required for detailed assessment of the lung parenchyma (Tables 1-3).

Table 2. High-resolution CT chest scanning parameters according to child's weight

	<15 kg	<30 kg	>30 kg
kVp	100	100	100
eff. mAs	20	30	55
Collimation (mm)	1	1	1
Scan slice width (mm)	1	1	1
Table-feed (mm)	10	10	10
Scan time (s)	0.36	0.75	0.75
CTDI (mGy)	0.21	0.32	0.59

Table 1. Volumetric CT chest scanning parameters (16 slice Somaton Scanner) according to child's weight when a routine (1.5-mm collimation) or 'Combiscan' (0.75-mm) protocol is used

	<15 kg		15-24 kg		25-34 kg		35-44 kg		45-55 kg	
	Volume	Combi	Volume	Combi	Volume	Combi	Volume	Combi	Volume	Combi
kVp	100	100	100	100	100	100	100	100	100	100
eff. mAs	20	20	25	25	35	35	55	55	75	75
Collimation (mm)	1.5	0.75	1.5	0.75	1.5	0.75	1.5	0.75	1.5	0.75
Scan slice width (mm)	5	5	5	5	5	5	5	5	8	8
Table-feed (mm)	24	12	24	12	24	12	24	12	24	12
Scan time (s)	0.5	0.5	0.5	0.5	0.5	0.5	0.5	0.5	0.5	0.5
CTDI (mGy)	0.9	1.0	1.13	1.31	1.58	1.75	2.48	2.75	3.38	3.75

Table 3. Dose comparison for different scanning protocols in a phantom study in our institution

	Effective dose (mSv)									
	Volume (1.5-mm)		Combi (0.75-mm)		HRCT		CTA		CXR	
	M	F	M	F	M	F	M	F	AP	LAT
<15kg	0.77	0.90	0.9	1.05	0.36	0.42	1.30	1.51	0.00487	0.00799
15–24 kg	0.93	1.09	1.13	1.31	0.36	0.42	1.62	1.89	0.00874	0.01086
25–34 kg	1.34	1.56	1.58	1.84	0.54	0.63	2.24	2.62	0.01163	0.00968
35–44 kg	2.11	2.46	2.48	2.89	1.00	1.17	2.57	3.0	0.01769	0.01452

HRCT, High-resolution computed tomography; *CTA*, CT angiography; *CXR*, chest X-ray

Methods adopted to minimize the radiation dose during MDCT include:

1. Applying a dose modulation function in which the system samples the patient thickness and adjusts (e.g., reduces) the exposure accordingly when the tube is in the AP/PA position, as patients are narrower in AP than in the side-to-side orientation.
2. Reduction of the kilovoltage to 100 kVp when imaging the thorax. Further reduction to 80 kVp is possible for CT angiography (CTA), but as resolution of the parenchyma is not ideal this is applied only if lung pathology is unlikely.
3. If possible, selecting a tube collimation of 1.5 mm. Although 0.7-5mm collimation improves spatial resolution, it increases the radiation dose and is therefore reserved for CTA or in those cases in which thin slice reconstruction is indicated.
4. Selection of an appropriate mAs, dependent on the patient's weight or cross-sectional diameter.

Unlike the single-slice scanner, an increase or decrease in table-feed time for MDCT scanners only affects the overall scanning time. An increase in table speed results in a concomitant increase in mA, which has no effect on the dose delivered. The tube current is automatically compensated to ensure that the preset effective and total mAs are delivered, i.e., a fast table movement results in an automatic increase in the mA while keeping the mAs constant.

The Immunocompetent Child

The roles played by imaging in the evaluation of community acquired pneumonias are multiple: confirmation or exclusion of pneumonia, characterization and attempts to predict the infectious agent, exclusion of other causes of symptoms, evaluation when resolution is slow or incomplete, and evaluation of related complications, such as suspected lung abscess (or cavitatory necrosis). The latter is more common and more benign in children than was previously believed, with only 41% of CT-proven cases visible on chest X-ray (CXR). Moreover the prognosis with conservative management is much better than in adults and there is relatively little lung scarring. CT is also valuable in detecting the presence of superinfected bronchopulmonary foregut malformations or underlying/ensuing bronchiectasis.

Mycobacterium tuberculosis

In children, pulmonary TB usually occurs as a result of primary infection acquired from an infected adult. Disseminated or extrapulmonary tuberculosis is relatively rare in children, raises the possibility of underlying immunodeficiency, and is classified as an AIDS indicator.

The radiological features of pulmonary TB are usually similar to those in immunocompetent individuals and include lobar consolidation, segmental or lobar atelectasis, pleural effusions, and lymphadenopathy. Pulmonary cavitation is uncommon. Large-volume lymphadenopathy is a frequent finding, the paratracheal and hilar regions being the most common sites. Occasionally, the chest radiograph appears normal. Miliary disease is uncommon, although when it occurs it may be indistinguishable from lymphocytic interstitial pneumonia.

Contrast-enhanced CT (CECT) and high-resolution CT (HRCT) are of particular value in the confirmation of mediastinal and miliary disease. Mediastinal lymphadenopathy is often large in volume; it typically demonstrates prominent peripheral enhancement following intravenous contrast. The classical HRCT feature of miliary tuberculosis is a reticulonodular infiltrate. In adults, the nodules are typically uniform in size, measuring 1-3 mm. However, in children, nodules are more varied in size and definition than described by the classic Fleischner criteria, which are based on the adult form of the disease.

The Immunocompromised Child

Immunodeficiency states in children may be sub-divided into two major groups; congenital (primary) and acquired (secondary). The spectrum of illness and imaging appearances are similar regardless of the underlying cause of immunodeficiency. All immunodeficiency states are associated with an increased susceptibility to infection and neoplasia, with lymphoproliferative disorders being the most frequent. However, the type of infection encountered and the risk of neoplasia are influenced by the underlying defect (whether predominantly humoral or cell-mediated), the use of immunosuppressive drugs or radiotherapy and the length of immunosuppression. A working knowledge of the underlying likely defect is therefore important when interpreting imaging functions in children with immunodeficiency states.

Primary, or congenital, immunodeficiency disorders are an inherited group of diseases resulting from innate defects of the immune system. Secondary or acquired immunodeficiency disorders occur as a consequence of infection with the human immunodeficiency virus (HIV), or secondary to immunosuppressive drug therapy or chemoradiotherapy (for hematological/solid-organ malignancies or as preparation for bone-marrow transplantation). Both primary and secondary immunodeficiency states result in an increased susceptibility to infection, with the respiratory tract being the most common disease site. Certain complications, however, particularly infectious ones, are common to all immunodeficiency states and extensive overlap in imaging findings is observed.

Primary Immunodeficiency Disorders

Background

Primary (congenital) immunodeficiency disorders (PID) represent a rare heterogeneous group of genetically determined disorders characterized by defects of cell-mediated immunity, antibody production, and/or the complement and phagocyte systems (Table 4).

Clinical manifestations vary according to the subtype of PID and include recurrent infections, infection with unusual or opportunistic organisms, failure to thrive, skin rashes, recurrent skin sepsis, and unusual wound healing. A family history of recurrent infections or premature death among siblings may also be revealed. Perhaps the most important, and frequent, clinical manifestation of PIDs is recurrent sinopulmonary infections which, if not adequately treated, may result in the development of obstructive lung disease, chronic respiratory failure, and ultimately premature death.

After infection, malignancy is the second leading cause of death. The lymphoproliferative disorders (LPDs) account for the majority of tumors, with Epstein-Barr virus being associated in approximately 30-60% of cases. The risk of developing a malignancy ranges from 1 to 25%. The children at greatest risk are those with Wiscott-Aldrich syndrome and combined variable immunodeficiency.

Pulmonary Complications

Diffuse Lung Disease

Common to all the primary immunodeficiency disorders is an inability to mount a normal or adequate antibody response to antigenic stimulation, resulting in susceptibility to bacterial infections, particularly of the respiratory tract. Bronchiectasis is a common complication, occurring in 20-40% of patients.

Typical radiographic features include hyperinflation and bronchial-wall thickening, with or without dilation. The chest radiograph is, nevertheless, insensitive and commonly appears normal or shows only subtle change. HRCT detects abnormalities not visible on the plain, thus improving diagnostic accuracy compared to the CXR. Moreover, it allows for an earlier diagnosis.

Pneumocystis carinii Pneumonia

Pneumonia caused by *Pneumocystis carinii* usually occurs in children whose primary immunodeficiency is undiagnosed and, indeed, is frequently the first indicator of an underlying immunodeficiency state. Classical radiographic appearances include hyperinflation with diffuse bilateral interstitial or nodular infiltrates that may be subtle initially but rapidly progress to widespread alveolar shadowing.

Angio-invasive Aspergillosis

The typical manifestation of angio-invasive pulmonary aspergillosis (IPA) consists of multi-focal areas of parenchymal inflammation caused by hematogenous dissemination of the organisms. IPA is associated with infarction and necrosis secondary to vascular obstruction.

Classical radiographic features include either solitary or multiple nodules or masses, with or without cavitation. In some cases, however, the chest radiograph appears normal or may demonstrate a focal infiltrate indistinguishable from a pyogenic pneumonia. Specific HRCT features have been described, probably the most characteristic being a 'halo' of ground-glass attenuation representing peri-lesional necrosis and hemorrhage, surrounding a central focal fungal nodule or infarct. A second commonly described feature of IPA is lesional cavitation with the formation of an air crescent. Occasionally, IPA manifests as a necrotizing pneumonia, with infiltration of local structures or organs. Although these classical features have been described, in many cases the imaging appearances are non-specific.

Secondary (Acquired) Immunodeficiencies

Immunodeficiency Secondary to Immunosuppressive or Myeloablative Chemoradiotherapy

Respiratory complications may be sub-divided into two broad categories: infectious and noninfectious. The frequency, range, and severity of pulmonary complications are influenced by the intensity and length of immunosuppression and are also dependent on whether the treatment goal is immunosuppression or myeloablation.

Table 4. Immunodeficiency disorders

Disorder	Inheritance
Combined immunodeficiencies	
Severe combined immunodeficiency	X, AR
Purine nucleosidase phosphorylase	AR
Common variable immunodeficiency	
Predominantly antibody deficiencies	
Selective Ig A deficiency	AR, AD, S
Selective Ig G subclass deficiency	AR, S
Hyper Ig M	X, AR
X-linked agammaglobulinemia	X
Well-defined immunodeficiencies	
Wiscott-Aldrich syndrome	X
Ataxia telangectasia	AR
DiGeorge syndrome	AD, S
Other immunodeficiencies	
X-linked lymphoproliferative disease	X
Hyper IgE syndrome	S
Phagocytic defects	
Chediak-Higashi syndrome	AR

AR, Autosomal recessive; *AD*, autosomal dominant; *S*, sporadic; *X*, X-linked

Stem-Cell Transplantation

Stem-cell transplantation (SCT) is followed by a temporal and predictable sequence of events. Initially, there is a marked transient neutropenia with neutrophil numbers returning to normal within 2-4 weeks. By contrast, lymphocyte recovery is more prolonged, with absolute numbers taking approximately 3 months to return to normal. Despite the recovery of lymphocyte numbers, cellular (B and T cell) and humoral (particularly anti0body production) immunity usually remains impaired for a further 6-12 months, and antibody production can take up to a year to return to normal.

The development of graft-versus-host disease (GVHD) and the resultant requirement for increased immunosuppression also delays immunological recovery and is associated with an increased risk of infectious pulmonary complications.

Pulmonary complications occur in 40-60% of patients following SCT and are responsible for 10-40% of transplant-related deaths. The type of pulmonary complication will be influenced by the type of underlying immune defect and may be subdivided into early (up to 100 days) and late (after 100 days) complications.

Early Pulmonary Complications

Infectious Complications

Within the early post-transplant period, the most frequently infecting organisms are bacteria and fungi, especially gram-negative organisms and *Aspergillus* sp. Children are also at risk for certain viral infections, the most important being respiratory syncytial virus (RSV) and herpes simplex virus (HSV).

Bacterial pneumonias occur in approximately 10% of patients during the pre-engraftment period and are associated with a high mortality.

Viral pneumonias, due, for example, to RSV, HSV, adenovirus, and varicella-zoster virus (VZV), typically occur within the early post-transplant period. RSV infection commonly leads to a devastating viral pneumonia, with a mortality rate approaching 50%.

Fungal pneumonia, (IPA) is reported to occur in approximately 4% of children undergoing SCT. Children are at particular risk during episodes of prolonged neutropenia, as are children receiving high-dose corticosteroids for the treatment of GVHD. The most common infecting organisms are *Aspergillus fumigatus* and *Aspergillus flavus*. Previously, the prognosis was dismal but the introduction of expensive albeit efficacious triple antifungal therapy has altered mortality rates in children. As a consequence of a profound neutropenia, the radiographic appearances of IPA may be atypical and, as a result, diagnosis is often delayed. A definitive diagnosis can be established only with certainty after histological confirmation of hyphae within lung tissue. Using EORTC criteria, the probability rates can be high and empirical therapy should be initiated in the presence of CT findings of multifocal nodules, perifissural consolidation, halo sign, and cavitation (which is probably less often observed in children than adults).

Acute Noninfectious Pulmonary Complications

Those occurring within the early post-transplant period include idiopathic pneumonia syndrome, pulmonary edema, pulmonary hemorrhage, pulmonary veno-occlusive disease, and relapse of the underlying malignancy.

Diffuse alveolar hemorrhage occurs in approximately 10% of patients undergoing allogeneic bone-marrow transplantation, usually at the time of engraftment. It is frequently associated with other pulmonary complications, particularly infection, and has a high mortality. The classical radiographic features are those of air space shadowing, which may be patchy, and multi-focal or more confluent consolidation with air bronchograms. Cessation of bleeding typically results in rapid clearing over a few days.

Idiopathic pneumonia syndrome is defined as diffuse lung injury for which no cause has been identified. GVHD and pre-transplant total body irradiation are contributing factors. It usually occurs 6-8 weeks following bone-marrow transplantation. Radiographic features are nonspecific and variable; they include diffuse air-space shadowing and/or interstitial infiltrates, often with a nodular component. They may be indistinguishable from adult respiratory distress syndrome (ARDS).

Late Pulmonary Complications

Infectious Pulmonary Complications

Patients continue to be at risk from bacterial infections even after engraftment, due to continuing defective humoral immunity. The most common infecting organisms are encapsulated bacteria such as *Streptococcus pneumoniae* and *Haemophilus influenzae*. Others include *Pneumocystis carinii* (particularly in those where antibiotic compliance is poor), cytomegalovirus and adenovirus.

Non-infectious Pulmonary Complications

These include obliterative bronchiolitis, diffuse alveolar damage, lymphocytic interstitial pneumonia, and relapse of the underlying disease.

Obliterative (constrictive) bronchiolitis (OB) is otherwise known as constrictive bronchiolitis and occurs secondarily to chronic pulmonary GVHD. OB is characterized by airflow limitation subsequent to submucosal and peribronchiolar inflammation, fibrosis and vascular sclerosis. It predominantly affects the medium-sized airways (respiratory bronchioles). Radiological features include hy-

perinflation, bronchial-wall thickening and/or dilation. In the majority, however, the chest radiograph appears normal or shows only subtle changes. HRCT improves diagnostic accuracy compared to the chest radiograph. Classical HRCT findings are patchy areas of lung hypoattenuation associated with a reduction in the number and caliber of vessels, with or without associated bronchiectasis or bronchial-wall thickening.

Solid-Organ Transplantation

As a consequence of long-term immunosuppressive therapy, recipients of solid-organ transplants are at risk of recurrent infections as well as an increased incidence of neoplasia, lymphoproliferative disorders being the most frequent. The type of organ transplantation in addition to the type and intensity of immunosuppression regimen used will influence the pulmonary complications encountered.

Post-transplant Lymphoproliferative Disorders

These represent a spectrum of disease ranging from polyclonal lymphoid hyperplasia to monoclonal malignant lymphoma. The majority of post-transplant LPDs are of B-cell origin and are almost invariably associated with Epstein-Barr virus (EBV) infection. The incidence varies from 1% in renal transplant recipients to 10% in heart and heart/lung transplant recipients. The time between transplant and onset varies from 1 month to several years.

The radiographic appearances of intrathoracic LPD are variable and range from discrete parenchymal nodules, which may be solitary or multiple, to diffuse or focal reticulonodular infiltrates or consolidation. These findings may or may not be associated with mediastinal lymphadenopathy. Since imaging appearances may mimic pyogenic or fungal infection, biopsy is usually required.

HIV-Associated Acquired Immunodefiency Syndrome

The human immunodeficiency virus (HIV) produces its dominant effects on T cells, with CD4 cells being the main site of viral replication. The virus also infects CD4-negative cells (B and T cells), resulting in defects in both cell-mediated and humoral immunity. Since the epidemic began, in the late 1980s over 3.8 million children have died of AIDS.

Pulmonary Complications

Pulmonary disease is the most common initial manifestation of HIV in children and is the primary cause of death in 50% of children with AIDS. The most common respiratory manifestations of HIV are bacterial pneumonias, *Pneumocystis carinii* pneumonia, and lymphocytic interstitial pneumonia.

Pneumocystis carinii pneumonia is frequently the initial manifestation of HIV, often presenting in early infancy. It is the most common opportunistic pulmonary infection in children with AIDS, occurring in up to 50%, and is the leading pulmonary cause of death. Radiographic appearances are variable and include hyperinflation with diffuse bilateral interstitial of nodular infiltrates and widespread alveolar shadowing. Asymmetric, focal, or patchy infiltrates are also frequent. In contrast to the disease in children with primary immunodeficiency disorders, cavitary nodules and cysts are common and occur in up to one-third of patients. Lymphadenopathy and pleural effusions are uncommon and, if present, an alternative diagnosis, such as lymphocytic interstitial pneumonia or TB, should be considered. Pneumothoraces and/or pneumomediastinum are a frequent complication. HRCT findings include patchy or diffuse ground-glass opacity, consolidation, cysts or cavities, centrilobular opacities, nodules, and interlobular septal thickening.

Lymphocytic interstitial pneumonitis occurs in approximately one-third of infected children. It makes up part of the diffuse infiltrate lymphocytosis syndrome and is thought to represent a direct 'hyperimmune' lung response to the presence of either HIV or Epstein-Barr virus. The disease appears to be restricted to those children expressing HLA DR 5 alleles and is associated with a slower rate of AIDS progression. Radiographic appearances include interstitial reticulonodular infiltrates that may progress to patchy air-space consolidation. In contrast to *Pneumocystis carinii* pneumonia, lymphadenopathy is common and often becomes more prominent during episodes of super-added infection.

Viral infections may occur as a result of a primary infection or due to reactivation of latent virus. The infecting viruses include RSV, influenza and parainfluenza viruses, CMV, and occasionally measles. Children infected with VZV often present with a more protracted illness than seen in immunocompetent children, and approximately 50% suffer from chronic or recurrent VZV infection. The risk of complications increases with increasing immunological impairment. The mortality rate in children with AIDS is 15%. The chest radiograph in VZV pneumonia patients typically shows evidence of bilateral diffuse reticulonodular infiltrates. The nodules are range in size from 3 to 10 mm; they often coalesce, resulting in focal areas of consolidation. Superimposed bacterial infection is common.

Mycobacterium tuberculosis may occur at any stage of HIV infection. As noted above, in children, it usually is the result of primary infection acquired from an infected adult. Disseminated or extrapulmonary tuberculosis is classified as an AIDS indicator in children. The radiological features are usually similar to those in immunocompetent controls and include lobar consolidation, segmental or lobar atelectasis, pleural effusions, and lymphadenopathy. Pulmonary

cavitation is uncommon. Large-volume lymphadenopathy is a frequent finding, the paratracheal and hilar regions being the most common sites.

Conclusions

Pulmonary complications are common in immunocompetent and immunodeficient children and CXR remains the first method of examination. Sadly, tuberculosis has returned to challenge us and the radiologist must keep this in mind when analyzing radiographs that show abundant lymphadenopathy, or consolidation that does not resolve with conventional anti-microbial therapy. A respiratory presentation is the most common initial manifestation of immunodeficiency states in children, with infectious complications being the most common. There is overlap in the radiological findings, and correlation with the cause and severity of the underlying immunodeficiency state is important when interpreting imaging findings.

All immunodeficiency states are also associated with an increased incidence of neoplasia, particularly lymphoproliferative disorders, the chest being a frequent site of disease. The radiological manifestations in addition to the clinical presentations are often atypical and may be misinterpreted as infection. It is therefore vital that both clinicians and radiologists be aware of the protean manifestations of these potentially treatable conditions.

Suggested Reading

Lucaya J, Strife JL (eds) (2002) Paediatric Chest Imaging. Chest Imaging in Infants and Children. Springer-Verlag, Heidelberg

Owens CM, Veys PA (2002) Respiratory Infections following Haemopoetic Stem Cell Transplantation. In: Childhood Respiratory Infections: British Medical Bulletin Vol 61. Oxford University Press, Oxford

Webb WR, Muller NL, Naidich DP (2001) Disease characterised primarily by parenchymal opacification. In: High Resolution CT of the Lung, 3rd edn. Lippincott-Williams & Wilkins, Philadelphia, pp 355-420

Vascular Malformations of the Pediatric Chest

M.J. Siegel

Washington University School of Medicine, Mallinckrodt Institute of Radiology, St. Louis, MO, USA

Aortic Anomalies

Left Arch with Aberrant Right Subclavian Artery

The left aortic arch with an aberrant right subclavian artery is the most common congenital abnormality of the aortic arch vessels and occurs in about 0.5-2% of the population [1, 2] (Fig. 1). The right subclavian artery is the last of the major arteries to arise from the aortic arch; thus, the order of branching is right common carotid, left common carotid, left subclavian, and right subclavian. A diverticulum-like outpouching, referred to as a Kommerell diverticulum, may be seen at the site of origin of the aberrant vessel. Patients are usually asymptomatic, since this lesion does not represent a true vascular-ring anomaly.

Double Aortic Arch

The term 'vascular ring' refers to encirclement of the trachea and esophagus by vascular and/or ligamentous structures. These anomalies of the aorta and its branch vessels are found in 0.5-3% of the population [1, 2]. The two common vascular rings are the double aortic arch and the right arch with an aberrant left subclavian artery.

A double arch occurs in 0.05-3% of the population. Double aortic arch is characterized by the presence of two aortic arches arising from a single ascending aorta. Each arch usually gives rises to a subclavian and carotid artery, before reuniting to form a single descending aorta, which is usually left-sided. As a result, the great vessels have a symmetric appearance in the superior mediastinum. Both limbs of the aorta are usually patent and functioning, with the right limb being larger and more cephalad than the left (Fig. 2). Occasionally, one limb, usually the left, contains an atretic segment [3]. The descending aorta may be on the left (more common) or right side. The double arch is generally an isolated anomaly and associated heart disease is rare. Patients are symptomatic because the two components of the arch encircle the trachea and esophagus.

Fig. 1. Left aortic arch with aberrant right subclavian artery in an adolescent male. Axial CT image shows a left aortic arch (*A*) and an aberrant right subclavian artery (*arrow*) coursing posterior to the trachea and esophagus

Fig. 2. Double aortic arch in a 6-month-old boy. Axial maximal intensity projection demonstrates right (*R*) and left (*L*) arches encircling the trachea. The high attenuation structure within the trachea is an endotracheal tube

Right Aortic Arch

Right Aortic Arch Anomalies

A right aortic arch occurs in approximately 0.05-0.2% of the population [1, 2]. There are two main types of right arch: one with an aberrant left subclavian artery and the other with mirror-image branching.

Right Aortic Arch with Aberrant Left Subclavian Artery

In this anomaly, the aortic arch is right-sided and the great arteries arise from the arch in the following order: left common carotid artery, right common carotid artery, right subclavian artery, and left subclavian artery. The left subclavian artery courses cephalad from right to left and passes behind the esophagus to reach the left arm (Fig. 3). An

aortic diverticulum may be present at the point of origin of the left subclavian artery. The descending aorta is right-sided. Patients may be symptomatic because the mediastinal vessels encircle the trachea and esophagus. This anomaly is rarely associated with congenital heart disease.

Right Aortic Arch with Mirror-Image Branching

In this anomaly, the aortic arch passes to the right of the trachea and esophagus and over the right main-stem bronchus (Fig. 4). The great arteries originate from the arch in the following order: left innominate artery, right carotid artery, and right subclavian artery. Since this is not a true vascular ring, symptoms of airway or esophageal compression are absent. A mirror-image right arch is almost always associated with congenital heart disease.

Cervical Aortic Arch (High-Riding Aortic Arch)

A cervical aortic arch is characterized by a high-riding elongated aortic arch, which extends cephalad in the mediastinum anterior to the brachiocephalic vein, usually to the level of the subclavian arteries; it may extend above the level of the clavicles into the cervical soft tissues (Fig. 5). Associated anomalies include absence of the innominate artery, origin of the contralateral subclavian artery from the descending proximal aorta, and a retro-esophageal course of the descending aorta with the aorta descending on the right side contralateral to the arch. A right-sided cervical arch is more common than a left-sided one [4]. Most patients are asymptomatic and the diagnosis is an incidental finding on imaging examinations.

Innominate Artery Compression

The innominate artery arises from the left aortic arch and crosses anterior and to the right of the trachea. As it crosses the mediastinum, it can compress the trachea

Fig. 3. Right aortic arch with aberrant left subclavian artery in a 10-year-old girl. Axial CT scan demonstrates a right aortic arch (*A*) with the aberrant left subclavian artery (*arrow*) crossing the mediastinum posteriorly

Fig. 4a, b. Right arch, mirror-image branching in a young adult. **a, b** Axial images show a right aortic arch (*A*) without a crossing vessel. The pulmonary artery (*PA*) is dilated following a patch-graft procedure for repair of pulmonic stenosis associated with tetralogy of Fallot

Fig. 5a, b. Right cervical arch in a 5-year-old boy. Axial (**a**) and sagittal (**b**) multiplanar reformatted CT scans show a right-sided aortic arch (*A*) ascending to the level of the thoracic inlet

anteriorly, resulting in stridor, cough, and dyspnea [5]. At CT, anterior compression of the trachea by the innominate artery is seen at or just below the level of the thoracic inlet (Fig. 6). Tracheomalacia is an associated anomaly.

Aortic Coarctation

Two major types of coarctation are recognized: pre-ductal (also known as the infantile form) and post-ductal (adult form) [6]. In the pre-ductal form of coarctation, narrowing of the aorta occurs immediately above the level of the origins of the left subclavian artery and the ligamentum arteriosum. This form of coarctation is associated with long segment narrowing of the aortic arch and other congenital heart disease. Collateral vessel formation is usually absent. Affected patients usually present in the first six months of life with heart failure.

In the post-ductal form, the coarctation is almost always located at the junction of the distal aortic arch and the descending aorta, immediately below the obliterated ductus arteriosus. The ascending aorta is usually dilated while the descending aorta just below the coarctation shows poststenotic dilatation (Fig. 7) [7]. Collateral circulation between the proximal and distal parts of the aorta is established via large intercostal and internal thoracic arteries. Patients are usually asymptomatic and the condition is recognized during evaluation of hypertension or a coexistent cardiac anomaly, usually a bicuspid aortic valve.

Pulmonary Arteries

Absence or Proximal Interruption

Proximal interruption or the absence of a main pulmonary artery is characterized by interruption of the right or left pulmonary artery, usually within 1 cm of its origin from the main pulmonary artery [8] (Fig. 8). The peripheral pulmonary arteries distally are diminutive and supplied by systemic collateral vessels. Collateral pathways include aortopulmonary anastomoses from the thoracic aorta, direct origin of a pulmonary artery from the aorta, and coronary

Fig. 6. Innominate artery compression in a 5-year-old boy. Tracheal compression by the right innominate artery (*arrow*) is seen just below the level of the thoracic inlet

Fig. 7. Aortic coarctation, post-ductal type, in a 4-year-old boy. Sagittal multiplanar reformation demonstrates high-grade focal constriction (*arrow*) of the aortic lumen just below the origin of the left subclavian artery (*S*). The posterior intercostal and internal mammary arteries are enlarged

Fig. 8. Absent main pulmonary artery. Axial CT image shows the right (*R*) and main (*M*) pulmonary artery crossing over to the left hemithorax and herniation of the right lung across the midline anteriorly. The left lung and left pulmonary artery are absent

to left pulmonary artery anastomoses. The affected lung is hypoplastic. Interruption of the left pulmonary artery is commonly associated with other anomalies, including right aortic arch, septal defects, patent ductus arteriosus, and tetralogy of Fallot. Interruption of the right pulmonary artery is usually an isolated finding. Patients may be asymptomatic and the diagnosis made as an incidental detection on imaging studies obtained for other clinical indications.

Pulmonary Sling

In pulmonary sling, the left pulmonary artery arises from the right pulmonary artery, passes above the right main bronchus, and then crosses between the trachea and esophagus to reach the left hilum [9] (Fig. 9). In most

cases, the anomalous artery compresses the right mainstem bronchus. The pulmonary sling usually comes to clinical attention in infants because of the compressive effect of the artery on the airway and/or associated tracheal or bronchial stenosis due to cartilaginous rings [9-11]. Cartilaginous rings cause long segment tracheal narrowing and a horizontal course of the main bronchi (i.e., T-shaped carina). The malformation may be asymptomatic in older individuals.

Patent Ductus Arteriosus

The ductus arteriosus represents persistence of part of the sixth aortic arch. Except for neonates, most patients with patent ductus arteriosus are asymptomatic and the lesion is usually diagnosed by the discovery of a murmur. The CT finding is that of a small tubular structure connecting the descending proximal aorta with the distal main or proximal left pulmonary artery (Fig. 10).

Pulmonary Veins

Partial Anomalous Venous Connection

In a partial anomalous venous connection, the pulmonary veins from one or more lobes have an anomalous connection, producing shunting of oxygenated blood into the right-heart circulation. The condition can be an isolated anomaly or associated with other anomalies of the lung or cardiovascular system [12, 13].

Partial Anomalous Drainage of the Left Upper Lung

The left upper lobe pulmonary vein usually empties into the left brachiocephalic or innominate vein. CT shows a

Fig. 9. Pulmonary artery sling in a 5-month-old girl. Axial CT demonstrates the left pulmonary artery (*L*) arising from the proximal right pulmonary artery (*R*), before crossing behind the trachea to reach the left lung

Fig. 10. Patent ductus arteriosus in an adolescent boy. Axial CT image demonstrates an enhancing tubular structure (*arrow*) arising from the descending aorta (*A*)

vertical vein coursing lateral to the aortic arch and aortopulmonary window. A normal left superior pulmonary vein is not identified in the left hilum; instead, a small lingular vein will be seen anterior to the left main bronchus (Fig. 11). Blood flow is caudocranial. Partial anomalous venous return needs to be distinguished from a persistent left superior vena cava [14]. Two vessels will be seen in the left hilum in the latter anomaly (the left cava and left pulmonary vein), whereas only one will be found in this location in anomalous venous return. In addition, the persistent left superior vena cava drains into the coronary sinus.

Fig. 11a, b. Anomalous left upper lobe pulmonary venous return in a young adult. **a** Axial CT image demonstrates an enlarged vein (*arrow*) lying lateral to the aortic arch. **b** Coronal 3D reconstruction shows the anomalous connection between the left superior pulmonary lobe vein (*arrows*) and brachiocephalic vein (*V*)

Partial Anomalous Drainage of the Right Upper Lobe

The right upper lobe drains into the superior vena cava, usually near the caval-right-atrial junction. A communication located posterosuperior to the oval fossa, termed a sinus venosus defect, is a common associated finding [15, 16]. Less often, anomalous drainage from the right lung is into the right atrium or azygos vein or to the azygos arch.

Abnormal Drainage of the Right Lower Lobe

The anomalous pulmonary vein from the right lower lobe usually drains to the inferior vena cava, although it may join with the suprahepatic part of the inferior vena cava, hepatic vein, portal vein, azygos vein, coronary sinus, or right atrium [17, 18] (Fig. 12). The scimitar or hypogenetic lung syndrome is a special form of anomalous pulmonary venous return from the right lung that is associated with a hypoplastic right lung and pulmonary artery, and mediastinal shift. Other associated anomalies include systemic arterial blood supply from the thoracic or abdominal aorta to the hypogenetic lung and horseshoe lung. The latter is a rare anomaly in which the posterobasal segments of both lungs are fused behind the pericardial sac [19].

Pulmonary Varix

Varicosity of the pulmonary vein can be congenital or the result of chronic pulmonary hypertension. Patients may be asymptomatic or present with hemoptysis. On CT, the varix enhances concurrently with the pulmonary veins, and there is continuity between the varix and the adjacent pulmonary veins or the left atrium (Fig. 13).

Fig. 12. Anomalous venous return from the right lower lobe. Coronal maximal intensity projection shows the anomalous pulmonary veins (*arrow*) emptying into the inferior vena cava

Fig. 13. Pulmonary vein varix. Axial CT shows a dilated pulmonary vein (*arrow*) entering the left atrium (*LA*)

Systemic Venous Anomalies

Persistent Left Superior Vena Cava

Left superior vena cava occurs in 1-3% of the general population [20, 21]. The persistent left superior vena cava lies lateral to the aortic arch and descends along the left side of the mediastinum, anterior to the left hilum, to enter the coronary sinus (Fig. 14). In most cases, there is an associated right superior vena cava, which is usually smaller than the left. The persistent left superior vena cava is usually an isolated finding, but it can be associated with congenital heart disease, usually atrial septal defects. The superior vena cava and coronary sinus may enhance intensely if contrast agent is injected into the left arm. The differential diagnostic considerations of the left superior vena cava include anomalous pulmonary venous drainage from the left upper lobe and superior intercostal vein, which is a normal finding.

Fig. 14. Left superior vena cava. Sagittal multiplanar reformation shows the longitudinal course of the left superior vena cava (*arrows*), which extends from the left subclavian vein to the coronary sinus

Azygos Continuation of the Inferior Vena Cava

In azygos continuation of the inferior vena cava, the infrahepatic segment of the inferior vena cava between the liver and renal veins fails to develop and the hemiazygos or azygos veins act as collateral vessels to return blood from the renal veins to the heart. The prevalence of this anomaly is about 0.6% [20, 22]. This anomaly may be isolated or associated with other anomalies, including situs abnormalities and polysplenia. CT findings include dilatation of the azygos arch, the azygos vein, and the superior vena cava caudal to the azygos junction, enlargement of the azygos and hemiazygos veins in the paraspinal and retrocrural areas, and absence of the suprarenal and intrahepatic portions of the inferior vena cava (Fig. 15). The hepatic veins drain into the right atrium.

Fig. 15a, b. Azygos continuation of the inferior vena cava. **a** Contrast-enhanced CT demonstrates a dilated azygos vein arch (*arrow*) draining into the superior vena cava (*S*). **b** A more caudal scan shows the dilated azygos vein (*arrow*) lateral to the descending aorta (*A*)